KU-689-968

Praise for *The Life and Death of Andy Warhol*

"By far the most revealing parts of Bockris's book (I doubt if there will ever be a better one, given that Bockris has been hard working, questioning, and a friend) concern Warhol's origins in industrial Pittsburgh. The origins of so much that was to come—the star worship, the insularity, the snobbery, even the soup cans—can be traced to those tough early years.... [This book] makes increasingly clear that far from being a weirdo-outcast Warhol was in fact a pretty accurate personification of his country.... Warhol emerges as a shy, nervous, vulnerable man who hid behind a carefully constructed facade of cool detachment."
—*Guardian*

"[*Warhol*] tells me the things I want to know about the artist, what he ate, what he wore, whom he knew (in his case ... everybody), at what time he went to bed and with whom, and, most important of all, his work habits."
—*Independent*

"An impressive and entertaining work, one which will be very hard to beat."
—*Financial Times*

ALSO BY VICTOR BOCKRIS
Transformer: The Lou Reed Story
Keith Richards: The Biography
Uptight: The Velvet Underground Story
Making Tracks: The Rise of Blondie
With William Burroughs
Ali: Fighter, Poet, Prophet

The Life and Death of

Andy Warhol

Victor Bockris

FOURTH ESTATE • *London*

This edition published in Great Britain in 1998 by
Fourth Estate Limited
6 Salem Road
London W2 4BU

Copyright © 1989 by Victor Bockris

10 9 8 7 6 5 4 3 2 1

The right of Victor Bockris to be identified as the author of
this work has been asserted by him in accordance with the
Copyright, Designs and Patents Act 1988.

A catalogue record for this book is available from
the British Library.

ISBN 1-85702-805-8

All rights reserved. No part of this publication may be
reproduced, transmitted, or stored in a retrieval system, in any
form or by any means, without permission in writing from
Fourth Estate Limited.

Printed and bound in Great Britain by The Bath Press, Bath

CONTENTS

The Honolulu Incident 1956 11
Hunkie Roots 1928–32 15
Slaves of Pittsburgh 1932–44 29
The Education of Andy Warhol 1937–45 49
Class Baby 1945–49 59
Kiss Me with Your Eyes 1949–52 78
The Odd Couple 1952–54 96
Everything Was Wonderful 1954–56 112
So What? 1956–59 121
The Birth of Andy Warhol 1959–61 135
The Campbell's Soup Kid 1961–62 144
Like a Machine 1962–64 161
Sex 1961–63 173
Violent Bliss 1963–64 188
Andy Warhol Uptight 1964–65 202
Femme Fatale 1965 216
Andy Warhol's Exploding Girls 1965–66 237
The Chelsea Girls 1966 253
The Original American Genius 1967 265
The Most Hated Artist in America 1967 277
You Can't Live if You Don't Take Risks 1968 285
The Assassination of Andy Warhol 1968 296
From Fuck to Trash 1968–72 313
An International Superstar 1970–72 334
The Death of Julia Warhola 1971–72 350
To Appreciate Life You Must First Fuck Death in the
 Gallbladder 1973–74 366
Andy Warhol Enterprises Takes Off 1974–75 376
Bad 1976–77 396
Dancing Under Fire 1977–78 407
Screech to a Halt 1978–80 422
A Bourgeois Maniac 1980–83 435
Too Much Work 1980–84 449
Andy Warhol's Last Loves 1982–86 460
Everything Is Boring 1985–86 471
Goodbye 1986–87 480
Afterword 495

The Last Interview 1987 501
Appendix:
 Exhibitions 502
 Films 506
 Books 508
Source Notes 510
Index 524

ACKNOWLEDGEMENTS

For inspiration, support, ideas and belief in this book I want to thank above all Andrew Wylie, Jeff Goldberg, Bobbie Bristol, Miles, Gerard Malanga, Stellan Holm, Steve Mass, John Lindsay, Ingrid von Essen, and Elvira Peake.

For sharing their experiences with me I want to thank everybody interviewed in the book who gave so generously of their time, particularly Paul Warhola, George Warhola, James Warhola, John Warhola, Margaret Warhola, and Ann Warhola, Billy Linich, Ondine, John Giorno, Nathan Gluck, and Ronnie Tavel.

For emotional support, lodging and aid through the five and a half years it took to complete the book, I want to thank Price Abbott, Susan Aaron, Legs McNeil, Rick Blume, Jeffrey Vogel, Otis Brown, Jo Fiedler, Kym Cermak, Gisela Freisinger, Debbie Harry, Chris Stein, Duncan Hannah, Beauregard Houston-Montgomery, Karen Mandelbaum, Rosemary Bailey, Stewart Myer, Christopher Whent, Claude Pelieu, Mary Beach, David Rosenbaum, Terry Sellers, Terry Spero, Miriam Udovitch, Maryann Erdos, Suzanne Cooper, Helen Mitsios, and Liza Stelle.

For advice I wish to thank William Burroughs, Dr James Fingerhut, Vincent Fremont, Allen Ginsberg, Lou Reed, Raymond Foye, Albert Goldman, and Paul Sidey.

Jeff Goldberg played a vital role in helping to organise and edit the manuscript during its fourth year.

Photo research: Gerard Malanga.

Heroin: copyright 1967, Oakfield Avenue Music Ltd, used with permission.

This book is dedicated to Fred Hughes

Few people have seen my films or paintings, but perhaps those few will become more aware of living by being made to think about themselves. People need to be made more aware of the need to work at learning how to live because life is so quick and sometimes it goes away too quickly.

Andy Warhol

The Life and Death of

Andy
Warhol

THE HONOLULU

INCIDENT

1956

I think once you see the emotions from a certain angle, you never can think of them as real again.

ANDY WARHOL

By the spring of 1956 Andy Warhol was at the top of his commercial-art career. At twenty-seven he was the best-known, highest-paid fashion illustrator in New York, making upwards of $100,000 a year, and was also represented by a bona fide art gallery. Or, as he described himself on the inner leaf of a *Vanity Fair* folder, he was 'the celebrated young artist, whose paintings have been hanging in more and more galleries, museums and private collections'. *Women's Wear Daily* dubbed him the Leonardo da Vinci of Madison Avenue. He was finally meeting a lot of the people he wanted to meet, including Cecil Beaton, whose feet he drew one day, in Philadelphia, and the actress Julie Andrews, a big and glamorous star in the gay world. And he was in love with a polished, assured young Kentuckian, Charles Lisanby, who designed sets for *The Gary Moore Show*, one of television's most popular programmes. Andy, who understood how important advertising was to become on television, was a TV fanatic. Everything was wonderful.

But throughout Andy's life, whenever everything seemed to be going right for him some problem would suddenly appear to threaten what he had worked so hard to achieve. Andy was so in love with Charles that their relationship was becoming a little difficult to sustain.

Charles adored Andy but he did not love him the way Andy loved Charles and they had never had sex or kissed or anything. Charles was quite aware of what Andy wanted and didn't want it and Andy knew that he didn't and never brought it up. Only it was getting a little difficult because Andy needed a lot of attention and he was beginning to get on Charles's nerves, or so Andy's art dealer, who was his confidant in the affair, believed. For the most part, Andy took the attitude that everything would work out eventually.

He thought he had his chance when Charles mentioned that he was planning to make a trip to the Far East in the summer to look at some oriental art and asked Andy if he wanted to come. Andy was very

11

casual about the whole thing. He didn't make much of it, but by the time they left on 19 June 1956 the trip had developed into a journey around the world (it was the same year as *Around the World in Eighty Days* came out). It was a very romantic notion and one can imagine how Andy felt as he settled into seat 8A in the first-class lounge of the Japan Airlines jet to Tokyo via San Francisco and Honolulu with Charles sitting next to him.

His hopes were dashed almost immediately. Charles and Andy had a confrontation on the second night of the trip in a hotel room in Honolulu. Andy had suggested they have separate rooms in San Francisco but when they got to Honolulu Charles said, 'This is ridiculous,' and got them a double with twin beds overlooking the beach. It was around three o'clock in the afternoon. Charles wanted to go out and cruise the beach immediately but Andy, appearing jet-lagged, hung back. As soon as Charles hit the beach he ran into a particularly beautiful young guy with a great story about how he had to pick up one soldier every day in order to support his family, and after talking to him for a while Charles suggested they go up to the room to take some pictures. As Charles walked down the corridor of the hotel to their room with the kid, he hoped that Andy had gone out but figured he could handle the situation if he hadn't. Finding that he had forgotten his key, Lisanby knocked on the door.

There was a long pause and then, furtively, with the chain on, Andy peeked out. 'Andy, open the door,' Charles said, 'we . . .'

Andy took the chain off the door and stepped back half a foot, still blocking the entrance, and said, 'Who's tha– what are you doing?' Suddenly he went berserk, screaming, 'How dare you bring someone back here?' and lifting both his hands up over his head to bring them crashing down on Charles.

'Andy, stop it! Calm down!' Charles cried, and grabbed hold of his wrists. 'Stop it!'

Andy screamed, 'How dare you? Get out of here and don't come back!', stepped back and slammed the door.

Unnerved by the incident, but apparently more intrigued by the kid's story than by Andy's uncharacteristic tantrum, Lisanby took the kid to a hotel and bought him exotic drinks for the balance of the afternoon, returning to their hotel around 7 p.m.

I still didn't have my key and he wouldn't open the door. I shouted, 'Andy, I know you're in there and you might as well open up because I can go and get another key!' and finally he opened the door. He walked back across the room and slouched on the bed droop-shouldered and said, 'I want to go home. There's no use in going on.'

He wasn't behaving angrily any more. He was very aloof, trying to ignore that anything at all had happened and ignore me and shake the whole thing

off. I was feeling very guilty. I wanted very much to stay his friend and I didn't want him to be angry with me and I didn't want him to hate me. I didn't want to lose Andy. I said, 'Yes we are going on. You've come this far and I won't let you go back.' I was very concerned because here was somebody who was obviously in torment and I realized this was a confrontation. He wanted to be persuaded to go on, and he wanted me to give in and decide that now was the time that something was going to happen, and I had to get out of that one.

I remember the windows and the ocean outside. It was still not sunset but it was getting close to it. I remember sitting beside him, I put my arms around him and I was trying to calm him down, and he really did totally break down crying and then it got worse and he couldn't stop. He really couldn't stop sobbing hysterically and crying on the bed. It was that he didn't want to be alone. Andy always wanted to be in his own centre but he wanted somebody to share it with.

I knew that he loved me, but he said, in a soft, trembling voice, 'I love you.' I said, 'Andy, I know, and I love you too.' And he said, 'It's not the same thing.' And I said, 'I know it's not the same thing, you just have to understand that, but I do love you.'

They stayed in that night. Charles ordered dinner. Andy did not want anything. The next morning Andy acted as if nothing had happened. In the afternoon he took some photographs of Charles in a swimsuit on the beach in front of the hotel. Before they left that evening for Tokyo Charles made it clear that there were to be no more such confrontations on the trip. It had been a very unusual scene, he reflected. He had never seen Andy express that kind of rage before – he had wanted to fight – and he would never see it again.

As far as Charles could tell, Andy had got over the incident completely once they put Hawaii behind them, and they had a wonderful time in the Far East travelling through Japan, Indonesia, Hong Kong, the Philippines and ending up in Bali. Andy proved to be a more courageous traveller than Charles, refusing to leave a restaurant when there was a small earthquake because the locals didn't, riding over a deep gorge on a narrow bridge without fear when Charles was terrified, wanting to try out the most authentic cuisines, but he was also totally impractical. He simply refused to accept any responsibility for the arrangements and Charles had to take care of everything, which constantly annoyed him.

Andy, of course, drew all the time. Charles took photographs and 8-mm film. In some places they were quite an exotic couple. Visiting a gay bar in Japan recommended by Lisanby's doctor who had been there on McArthur's staff, they were surrounded by fawning teenage boys. Deep in the jungle of Bali in the middle of the night at a traditional dance by teenage girls, they found themselves the only white men. Andy, Charles noticed, appeared to enjoy everything but would hold

back from engaging directly in any of the activities, living them, rather, vicariously through Charles, who danced with the boys and girls and took part in all the activities for him.

In his laconic fashion Andy went to the heart of the matter twenty years later in a comment on the trip:

> I was walking in Bali, and saw a bunch of people in a clearing having a ball because somebody they really liked had just died, and I realized that everything was just how you decided to think about it. Sometimes people let the same problems make them miserable for years when they should just say so what. That's one of my favourite things to say. So what.
>
> My mother didn't love me. So what.
>
> My husband won't ball me. So what.
>
> I don't know how I made it through all the years before I learned how to do that trick. It took a long time for me to learn it, but once you do you never forget.

This was a cornerstone of the attitude that would make Andy Warhol famous in the 1960s.

Charles always thought Andy could be a great artist. 'One day I was really trying to get him to start on becoming a better artist than he was being. I said, "What do you want to be? Don't you want to be a great artist?" '

Andy replied, 'I want to be Matisse.'

What he meant by that, Charles thought, was that he wanted to be in a position where whatever he did would be important.

> He said, 'I want to be famous.' There was a wonderful photograph of Matisse by Cartier-Bresson at that time in *Vogue* or *Harper's Bazaar*. What interested Andy in Matisse was not so much his work as the fact that Matisse had reached a point where all he had to do was tear out a little piece of paper and glue it to another piece of paper and it was considered very important and valuable. It was the fact the Matisse was recognized as being so world famous and such a celebrity that attracted Andy. This was, I thought, the key to his whole life.

HUNKIE ROOTS

1928–32

I come from nowhere.
ANDY WARHOL

Andy obscured his childhood in lies and myths from the moment he received any public attention. As soon as he was in college he was manufacturing stories about the hardships of his life and telling different people that he came from different places. There were always elements of truth in the shards of his background that he would divulge, but even his closest associates never really knew much about it. The biggest mystery was when and where he was born. He liked to tell people that he came from McKeesport, a small, ethnic workers' community south of Pittsburgh, but at other times he would say he was born in Philadelphia, or Hawaii, sometimes in 1928, sometimes 1925 or 1931. Later in life he staged his birth in an appropriately Götterdämmerung setting when he had an actress playing his mother in a film claim that she gave birth to him alone at midnight in the middle of a big fire.

In the Warhol myth, Andy was a Depression baby who was often reduced to eating soup made with tomato ketchup for dinner. His father was a coalminer whom he rarely saw and who died when he was young. His brothers bullied him and his mother was always sick. Nobody liked him and he never had any fun or friends. By the time he was twelve he had lost his skin pigment and his hair.

He gave people the impression that overcoming each obstacle had given him ambivalent feelings about his life. 'I think it's best to be born fast, because it hurts, and die fast, because it hurts, but I think if you were born and died within that minute, that would be the best life, because the priest says that way you're guaranteed to go to heaven.' He said that being born was a mistake, that it was 'like being kidnapped and sold into slavery'.

*

By the time Andy was born in his parents' second-storey bedroom on 6 August 1928, his father Ondrej (Andrew) and mother Julia Warhola had been living for nearly ten years in the narrow red-brick two-room shanty at 73 Orr Street, flanked by the murky Monongahela River and the notorious Hill district and just a mile from the city jail, in the Soho ghetto of Pittsburgh. Their first son, Paul, had been born on 26 June 1922, their second, John, on 31 May 1925. The Warholas were Rusyns

who had emigrated to America from the Ruthenian village of Mikova in the Carpathian Mountains near the borders of Russia and Poland in territory that was, at the turn of the century, part of the Austro-Hungarian Empire.

Andy's father (called Nonya by the boys and Andrei by Julia) was a bald, burly, muscular man with a big belly and massive upper arms, five foot nine and a half inches tall. His pudgy nose, protruding lips, ample sideburns, slight chin and pale skin gave him, at thirty-five, a resemblance to the Soviet premier Nikita Khrushchev. He had a good, steady job with the Eichleay Corporation, laying roads and uprooting and moving houses. This was a common practice in the days of predominantly wooden houses: a whole structure would literally be dug up and moved down the block or across the street to make way for new construction. The work sometimes took him out of town for weeks or months at a time. He earned $15–$25 for a six-day week of twelve hours a day.

It was said that he possessed a higher intelligence and moral outlook than the majority of his peers. He worked hard and saved his money diligently. Some of his countrymen who drank and gambled thought him too dour and tightfisted. By the late 1920s Andrei Warhola had several thousand dollars in postal savings bonds and was adding to his hoard every week.

Andy's mother Julia had had a more difficult time adjusting to life in America than her husband. When Andy was born, she was thirty-six. Her face was thin and drawn, she wore wire-rimmed glasses and her hair was beginning to turn grey. She always wore a long peasant dress under her apron, and her head was normally covered by a babushka. She could not speak a word of English. For a woman who was naturally gregarious and open, this was particularly painful, but Julia believed that, like Jesus, people were put on earth to suffer. She cried easily and thrived on recounting the disasters of her life in Europe during the First World War, the spectres of poverty, illness and death that would haunt her for ever. She prayed and wrote letters home to her two younger sisters in Mikova every day.

Religion played a large role in the Warhola house. They were devout Byzantine Catholics who observed the calendar of their faith, like celebrating Christmas on 6 January, punctiliously. Andy was christened and confirmed at the same time within a few weeks of birth. The name Andrew directly associated him not only with his father but with his maternal grandfather Ondrej Zavacky and his uncle Ondrej Zavacky. Byzantine Catholic ceremonies are sombre and majestic. The service commenced with an exorcism of the devil and ended with the anointment of the infant as an 'athlete for Christ'. Andrei was a stern man who murmured prayers before meals and enforced a strict solemnity on Sundays. After marching his family six miles to mass at the tiny

wooden church of St John Chrysostom's on Saline Street in the working-class neighbourhood of Greenfield, both he and Julia insisted that the remainder of the day be devoted to family life. Paul Warhola:

> We used to walk to church on Sunday morning. It felt like ten miles. At that time it was Greek Catholic. Today they refer to it as Byzantine Catholic. Sunday was a day of rest. You weren't even allowed to pick up a pair of scissors on Sunday. It was going to church and then taking off your church clothes and then no playing around or nothing. My dad was very tough on that. And Mother wouldn't do anything. No sewing, nothing. He was firm. You weren't allowed to get a pair of scissors to cut anything out. If you didn't go to church on Sunday you didn't get out that day. And we didn't have a radio or nothing so whatdya do? Mother used to tell us stories.

But, according to his brother John:

> Sunday was a joyous occasion, because we didn't have TV or radio then so people really visited with each other. Our first priority was religion. All these people who came over from Eastern Europe were very strict. My mother taught you she liked going to church better than material things. She never believed in being wealthy, she believed just being a real good person made her happy. I think religion formed Andy's character. The way we were brought up never to hurt anybody, to try to do everything right, to believe that you're just here for a short time and to build up your treasures and your spiritual things because you are going to leave the material things behind.

The Byzantine Catholic church was also the centre of all Ruthenian social activity. This removed the Warholas further from the majority of their neighbours, who were Roman Catholics, but this isolation from the rest of the community was offset considerably by the extended Warhola and Zavacky families. By the time they moved a few blocks away from Orr to a larger place at 55 Beelan Street in 1930, Julia's best friend and neighbour was her sister Mary and she had two brothers and another sister in nearby Lyndora. Andrei's brother Joseph also lived in the neighbourhood. All these sisters and brothers had families of their own, providing Andy with a large supportive network of aunts, uncles and cousins who maintained close ties with each other throughout his childhood.

Julia and Mary sang together at weddings, christenings and funerals and constantly dwelt on their past lives in Mikova. Mary was shy and nervous and already had a bit of a drinking problem; Julia was for ever talking and seemed to be loved by everyone. Mary's daughter Justina (Tinka) would visit and play house with Johnny as the father and Andy as the baby, and John recalled, 'Me and Andy used to keep a chicken on the front porch as a pet till my mother killed it for soup.'

Andek, as his mother called him, soon showed an unusual energy

and brightness. He was a chubby, wild little baby and they all noticed that he was picking up everything faster than his brothers had.

<p style="text-align:center">*</p>

The Pittsburgh Andy was born into presented a Hieronymus Bosch vision of modern times. Everything was in constant and rapid motion. Lying at the head of three rivers, the city was the vital conduit between east and west as well as producing the coal and steel essential to run industrial America. Trains steamed in and out day and night emitting shrieking whistles. Ships chugged up and down the orange and grey rivers, delivering and loading, their foghorns blasting the murky gloom of the sky. The vast machinery of the mills screamed, groaned and crashed out a machine-music opera of hell. Hundreds of thousands of workers moved back and forth from the mills, docks and mines to their bars and beds. It was a cartoon of the extremes of capitalism. Corruption at every level of civil government was so rife that human rights were largely ignored. And yet, even to the Warholas, Pittsburgh was a wild, vibrant, exciting, colourful city too, riding on a sea of constant coming and going, of commerce, politics, sex, alcohol and greed. It had more foreign newspapers than any other city in America. The photographer Duane Michaels, who grew up at the same time as Andy and later became friends with him, recalled:

> Because our rivers were orange I thought all rivers were orange. At night the steel mills lit up the sky; it was always an inferno. The mills made a lot of noise; you could hear the cranes dropping enormous things and booming all the time. There was a certain drama about it, kind of scary, too. When I was a kid, I thought it was terrific . . . just the best place to live.

Stefan Lorant wrote in his book *Pittsburgh: The Story of an American City*:

> It was the most picturesque place among the great cities of America. There was an eternal mist, an everlasting fog in the air. The silhouettes of the buildings and those of the boats were soft, at times hardly visible, more felt than seen. The figures of humans as they walked through the streets seemed unreal, like in fairyland.

The city sprawled over 50 square miles of hills and valleys with a population of 600,000 making it the sixth largest city in the United States. In the twenties it was booming. The majority of its inhabitants were immigrants employed by its two major industries, coal and steel, which had gradually transformed the city into something resembling a devil's workshop. Twenty-four hours a day Pittsburgh was ringed by fire. Huge balls of flame shot out of the maws of the steel mills, turning the night sky bizarre shades of fuchsia and chartreuse – colours that would later become Andy's favourites. In the hills that flanked the rivers, coke fires glowed like red animal eyes, and by day pollution

hung in an inky pall combining with the elements to produce the first industrial smog (a word coined in Pittsburgh). Pilots passing overhead could smell the coal fumes coming off the Monongahela River. John Warhola recalled, 'It was so smoky during the day, sometimes you didn't even see the sun just from all the smoke, smog and soot from the mills.' Cars would turn on their headlights, streetlamps would stay lit all day. According to the Warhol legend, Andy's first words were 'Look at the sunlight! Look at the sun! Look at the light!' All his life he loved the sun and hated the cold, dark weather. And the soot made it difficult to keep anything clean. Housewives would spend part of each morning, afternoon and evening sweeping the ore dust off the front porches; new buildings were quickly blackened; white shirt collars were ringed with soot by noontime. Society ladies sometimes wore gas masks to go shopping downtown.

A small group of industrialists, the Carnegie, Frick, Heinz, Mellon and Westinghouse families, dominated the city. They had made vast fortunes in a relatively short time. These 'Pittsburgh millionaires' lived in ornate Shadyside mansions constructed of imported materials and lavishly overfurnished. Houses with fifty rooms, private bowling alleys and ten bathrooms were not unusual. Ostentatious in their tastes and flamboyant in their lifestyles, the Pittsburgh millionaires were keen to be accepted by society. Their families constantly traversed Europe, buying up art and enticing aristocrats to marry their offspring. They paid little attention to the living conditions of their workforce. Pittsburgh was a city of dramatic contrasts. Andy's first years coincided with the onset of the Depression. 'Its smogged old neighbourhoods waited, empty,' wrote the Mellon family biographer Burton Hirsh. 'What light got through lay dull as suet along deserted tracks in the train yards, picked at the forks with which lumpy returnees in Father Cox's "Hunger Caravan" to Washington went after their soup kitchen dumplings. The city was scraping. The political apparatus seized.'

'Here was the very heart of industrial America,' wrote the great US journalist H. L. Mencken,

> the centre of its most lucrative and characteristic activity, the boast and pride of the richest and grandest nation ever on earth – and here was a scene so dreadfully hideous, so intolerably bleak and forlorn that it reduced the whole aspiration of man to a macabre and depressing joke. Here was wealth beyond computation, almost beyond imagination – and here were human habitations so abominable that they would have disgraced a race of alley cats. I am not speaking of mere filth. One expects steel towns to be dirty. What I allude to is the unbroken and agonizing ugliness, the sheer revolting monstrousness, of every house in sight.

Mencken's colleague O. Henry had little better to say about Pittsburgh. It was the 'low-downdest' hole in the surface of the earth, with people

who are 'the most ignorant, ill-bred, contemptible, boorish, degraded, insulting, sordid, vile, foul-mouthed, indecent, profane, drunken, dirty, mean, depraved'.

These descriptions fitted the Warhola family's neighbourhood. Like blacks, who were the only ethnic group below them on the social scale, Eastern Europeans, contemptuously labelled 'hunkies', were dismissed as incapable and untrustworthy. Their religion, language and customs seemed strange to native Americans; their children were ridiculed and abused in school. They were given lower-paying jobs, and those with professional skills, like the doctors, were confined to practising among their own people. Among hunkies themselves there was social stratification depending on their religion and country of origin. Because of the terrible treatment the Ruthenians had received at the hands of their neighbours the Ukrainians, Poles, Hungarians, Romanians, Moldavians and Slovaks, they had become isolated and suspicious, kept to their own people and their own language, Po nasemu ('in our own manner'), a mixture of Hungarian and Ukrainian.

Paul, John and Andy were brought up speaking Po nasemu. Mr Warhola read American newspapers daily and could speak English passably, but Julia stubbornly refused to learn it, and at home the family spoke only the native tongue. When Paul, the eldest child, started going to Soho Elementary School, his inability to speak English and his hunkie name made him an object of derision and abuse.

Perhaps the sociologist Philip Klein summed it up best in his report made in the early thirties when he wrote:

The drive of progress in Pittsburgh has been unusual in force and has emphasized certain contrasts of modern life . . . social stratifications have been deepened along most lines where stratification is possible – sectional, radical, political and economic. To understand Pittsburgh one must conceive of it as a huge factory with a national market as its perspective, drawing its resources from all parts of the land and looking to all parts for the disposal of its product . . . The forces that control its destinies are basically economic, are forces that move with the large strides of national progress and regression. The depression hit Pittsburgh harder than other areas where industries were less predominant. The factories of the city quickly cut back production, workers were dismissed overnight . . . The traditional optimism of the American people yielded to dismal pessimism. Hopelessness took hold of their spirits. Gone was the exuberance, the belief in easy money and easy living. Life grew as dark as the skies over the city . . .

'This is hell if there is a hell anywhere,' one miner was quoted as saying. 'No work, starving, afraid of being shot, it is a shame for a man to tell such bad truth.' During Prohibition the police turned a blind eye to liquor barons who rode in flashy cars up and down Sixth Street, otherwise known as the 'Great Wet Way', where cabarets like the White

Cat, the Devil's Cave and Little Harlem played to full houses. Neither did the police bother to patrol the worst immigrant slums of the Hill district, and roving bands of juvenile delinquents terrorized the tenants. Prostitution and the numbers racket were rife and alcoholism was endemic among Pittsburgh's workers. They lived in wooden houses, tenements and shacks clinging to the sides of steep hills. The hot cinders that filled the air made flash fires common and Andy grew up with and always had a fear of fire. Few houses had proper sewage systems; the majority depended on outside toilets without drainage. When it rained, the shit ran down the hills to join the piles of irregularly collected rubbish on which rickety, pale children played. Even on the borders of some of the better neighbourhoods there were littered streets, wrecked vacant houses and overflowing garbage cans so that on a summer's day these 'odours of the Middle Ages' led new arrivals to comment that they 'didn't like the smell of America'. Andy later described his hometown as 'the worst place I have ever been in my whole life'.

Not only was Pittsburgh's leading citizen Andrew Mellon one of the richest and most powerful men in America, he was also secretary of the treasury during the Coolidge and Hoover administrations. The Mellons were benefiting enormously from the Depression. The last thing they could afford was a revolt on the home front. The Mellons' mounted police force, locally known as the Cossacks, squashed workers' demonstrations with such brutality and regularity that the attacks came under a congressional investigation. In 1930 and 1931 they tear-gassed and shot protesters asking for relief.

For many it was a dismal, pessimistic time. For others it was an opportunity to question the very basis of American capitalism. When the Populist presidential candidate Father Cox marched his exhausted, hungry, jobless army of 15,000 men back into Pittsburgh from Washington on 8 January 1932, after making a plea to Congress and President Hoover for immediate relief and jobs, his warning that 'something must be done to avert violence' was no idle threat. As conditions in Pittsburgh and the nation worsened, the Mellons' brutal police were issued with machine guns.

Pittsburgh contained all the essential themes of the twentieth-century American spirit: confidence, drive, ambition, greed, power, naïveté, hope, chance, corruption, perversity, violence, entropy, chaos, madness and death – themes that would later appear in Andy's work.

Andy lived right in the middle of the turmoil. His father lost his job and was forced to rely on his precious savings and odd jobs to support the family. They were reduced to moving into a two-room apartment for six dollars a week at number 6 Moultrie Street between Fifth Avenue and the Monongahela, where the Brady Bridge now crosses the river. John Warhola described it:

The building was two storeys. We lived on the first floor. People rented the second floor. The bathtub was just a steel tub. We heated the water on the stove. The two rooms were the kitchen and the bedroom. Three of us slept on one bed. The neighbourhood wasn't dangerous. Nothing was as dangerous as it is now. In the evenings we stayed right around the house. You wouldn't go no further than right across the street. We always played on the street. There wasn't hardly any cars then.

The Warholas' lot was a good deal better than many Pittsburghers'. On 16 January 1931 relief organizations warned that 47,750 were at starvation level. In June 5000 hunger strikers marched through the city. In contrast, when he was not looking for work or visiting relatives, Mr Warhola, who did not take part in demonstrations, was able to spend his time looking for a house to buy in the countryside around Lyndora where Julia had relatives. With the prices down, Andrei now considered leaving the slums for a more comfortable, safer neighbourhood, though he would not purchase a house until 1934. Julia took part-time jobs doing light housework and cleaning windows for two dollars a day. She also spent hours making flower sculptures out of tin cans, which she would sell for 25–50 cents. Andy recalled them fifty years later:

> The tin flowers she made out of those fruit tins, that's the reason why I did my first tin-can paintings. You take a tin can, the bigger the tin can the better, like the family ones that peach halves come in, and I think you cut them with scissors. It's very easy and you just make flowers out of them. My mother always had lots of cans around, including the soup cans. She was a wonderful woman and a real good and correct artist, like the primitives.

Andy's father was an unusually ambitious man whose goal was to lift his family out of the slums and give his children a chance for a better life. Andy's mother was a Mother Courage figure, strong, resilient, humorous, as well as wildly superstitious and eccentric. Mr Warhola did not gamble, drink or swear and although Mrs Warhola did have a penchant for the numbers she was in every other matter thrifty and resourceful. Julia provided a balance to Andrei's sternness and distance. She was a cheerful woman, talkative, warm-hearted, generous and wise. A large part of the mystery of Andy's personality is revealed by realizing that he inherited just as much from his father as he did from his mother.

Julia had her shortcomings as a mother. For all her sympathy and warmth, her refusal to learn English kept her at a considerable distance from the reality of being a hunkie child in the Pittsburgh ghettoes. When Paul was forced simultaneously to learn English and Old High Church Slavonic, as was traditional at six, he complained bitterly to his parents that the double task was impossible but they were unsympathetic. This drove him to turn his frustrations to some extent on John

and Andy. The crowded conditions at Moultrie Street cannot have made matters easier and John and Paul often scrapped together. Perhaps because of the hardships of being the oldest son and the abuse he was taking at school, Paul remembered these as hard, frightening years for the Warhola family.

I remember Dad sitting at the table and Mother had supper. It was usually a bowl of soup. And as kids we'd slap one another or hit one another, or if we slept in the same bed we might get into a fight and yell. 'You'd better not touch my foot with your feet!' – you know. Then there's a commotion. Dad didn't like us starting a commotion because he was so exhausted and he would get emotionally upset. Mother used to say he worked hard.

Andy was afraid of Dad. We all were. He was firm. Dad would discipline us by just looking at us. Even though he was tough and strict all he had to do was just look at you and that was enough. Sometimes he'd yell at you. Mother was very critical of anybody that would even hit a child in the head or the back. She always thought if you had to punish somebody whack them in the ass.

John's memories of the Warhola boys' upbringing generally differ significantly from Paul's, except when it came to their father.

Dad spent more time with the family during the Depression, but he was so strict that when you were a kid you'd think that he was a mean father. Father was very strict about all things in general, starting from like we didn't have no dessert. Like if I asked for cakes he would get angry with me for asking for it. I thought he was mean, but he told me, 'If you're still hungry, rye bread with butter is better for you.' We never had any pop. I drank just water and coffee. But he made sure that we had enough to eat and that it was good. It wasn't junk food.

He'd discipline me and Paul. Maybe we'd start fighting over something. You know how kids get when they both want something, and he was tired; he'd warn us once and then if we did it again he would pull off his belt, but we ran and hid under the bed. He never hit us but the threat was just like a beating.

On a Saturday I'd go down to where the hardware store was and I'd get all the cardboard boxes and bring them home and we'd stack them up and take 'em down to the junkyard and maybe get 30 or 40 cents and then you'd buy a quart of milk for seven cents and a loaf of bread for six cents. And I remember I used to go around looking for lightbulbs and I'd get the brass from the base, take a hammer, get the glass out and save the brass in a basket. Then there was Prohibition where people used to make the whisky in their homes and if you'd find little bottles you'd get a penny or two pennies. You'd know the person who made the moonshine but you wouldn't want nobody to see you taking it down there cos they would probably arrest the people so I would save about ten of those bottles. I used to look for them in the alley. I'd give the money to my mother and she used to send it to her sister in Europe.

Paul was also hustling for nickels and dimes, hawking newspapers on streetcars. When he made 25 cents he would run home and give it to his mother.

She said, 'What do you want me to do with it?'

I said, 'Save it up. When you get a dollar, send it to your sisters in Europe.' Mother used to send two or three dollars and that was a fortune. My dad was tough about money and one day when a letter was returned in the mail and he found a dollar in it he got furious.

Even this early on in their lives, the Warhola boys were competing for their mother's affection by making money for her. This is something that would later play a big role in Andy's career.

*

Andy Warhol: 'The first time I ever knew about sex was in Northside, Pittsburgh, under the stairs, and they made this funny kid suck this boy off. I never understood what it meant. I was just sitting there watching.'

Andy later described himself as 'aggressive and pushy' as a little boy, and by all accounts he was a bit wild when he lived at Moultrie Street. Paul Warhola:

When Andy was a youngster you could see he was picking up things much better than we had, but he was mischieful between the ages of three to six. Andy picked up some bad language when he was about three and this wasn't allowed in our house. He heard some of the kids swear and he was just a youngster. We'd go to a relative's place and Andy'd say some of these things and it wasn't nice. It was really embarrassing. And the more you smacked him the more he said it, the worse he got. He was real bad. Just because we didn't want him to say it he said it. Nobody swore in our house. We weren't allowed to say 'hell'.

Andy turned to his mother for protection from the rough males in the family. Julia Warhola was a very good storyteller. She loved talking to Andy in the kitchen while she cleaned and cooked or worked on her tin and paper flowers. Her favourite topics were the Bible and her life in Mikova. Julia was the first great nonstop talker in Andy's life and he would for ever afterwards be mesmerized by women who could tell good stories. Julia gathered the children around her kitchen table in the evening and told them tales about the adventures of her life and about Ruthenia.

The Carpathian Mountains are popularly known as the home of Dracula, and the peasants in Bram Stoker's description kneeling before roadside shrines, crossing themselves at the mention of Dracula's name, resemble Andy Warhol's distant relatives. The women were delicate and pretty with fine skin and high cheekbones, wearing babushkas and

long colourful dresses. The men were handsome with long hair and enormous moustaches, and wore baggy white trousers held up by large, studded belts and tucked into high boots.

As Julia explained it to her children, their father had been born in Mikova on 28 November 1889. The Warholas were devout, taciturn, serious, abstemious, hard-working and characteristically stingy. Their region had been economically blighted throughout his childhood. Andrei grew up working in the fields with his younger brother, Joseph. By the time he was seventeen he realized there was no future there and emigrated to the faraway promised land of Pittsburgh. There he worked in the mines for two years before returning to Mikova to, as she put it, 'recruit a bride'.

Julia Zavacky, who was born in Mikova on 17 November 1892, claimed that her mother, Josephine, had fifteen children. If so, six must have died for by the time she was in her teens there were only nine. Her brothers John and Andrew had already emigrated to Lyndora, Pennsylvania. Her brothers Steve and Yurko and her sisters Mary, Anna, Ella and Eva remained with her in Mikova. She wove long, dreamlike reminiscences of the village into her stories. There the water was 'so good', the soil was so good, and the potatoes were so good – for Julia nothing was so good in America. She talked of working in the fields and herding goats, being frightened of wolves, or walking barefoot in the snow.

Unlike the Warholas, the Zavackys were an expressive, emotional and imaginative family, marginally less poor than the other villagers. As a child Julia sang, laughed and talked constantly. She and Mary harmonized together. They wanted to be famous singers and toured the area around Mikova for a season, singing with a gypsy caravan. She implied that she'd had a romance with one of the gypsy men. When she was young, 'my body like a magnet, only attract good men', she said, chuckling. The Zavackys had a melodramatic streak and dwelled on the tragedies of their lives, recounting them like biblical tales. Most of the daughters eventually became alcoholics.

From the Warholas Andy would get his relentless drive, his abstemiousness, aggressiveness and tightfisted attitude towards money. From the Zavackys he inherited a tendency to cry easily, a desire to perform, a belief in destiny and magic, a penchant for death and disaster and an ability to mythologize everything that happened to him. His ancestors often suffered from these traits but Andy would learn how to put them to work.

Julia grew into the most beautiful and exuberant of the Zavacky daughters. She was a gifted folk artist who liked to make small sculptures and paint designs on household utensils. In 1909, when she was sixteen, her father declared that it was time for her to get married so that he would not have to support her any longer. That year his eldest

son, John, got married in Lyndora, Pennsylvania, and the best man at his wedding was Andrei Warhola. When Andrei met Julia in her parents' home shortly after he returned to Mikova in 1909, he was a good-looking nineteen-year-old on his way to becoming an American. He had a full head of curly blond hair, which he wore short, and was clean-shaven. He was a somewhat romantic figure in the village because he had gone to America and returned with gifts, and he had a good reputation as a hard-working, devout, kind man. According to Julia, 'He came back to the village and every girl want him. Fathers would offer him lots of money, lots of land to marry daughter. He no want. He want me.'

Julia was a small, slim girl no more than five foot three with long golden hair, high cheekbones and an alluring smile. She was a dreamer with a great sense of humour whereas Andrew was dour; she loved to talk whereas Andrew was silent.

'I knew nothing,' Julia would say. 'He wants me, but I no want him. I no think of no man. My mother and father say, "Like him, like him." I scared.' When she refused to marry Andrew, Julia's father beat her. When she still refused, he called on the village priest. 'The priest – oh, a nice priest – come. "This Andy," he says, "a very nice boy. Marry him." I cry. I no know. Andy visits again. He brings candy, wonderful candy. And for this candy, I marry him.'

Donning the traditional garb of his people once again for the wedding, with ribbons on his large hat, Andrei danced and drank for one and a half days with the Zàvackys and one and a half days with the Warholas while their relatives beamed approvingly.

The couple spent the next three years in Mikova, living with the Warhola family and working in their fields. In 1912, with the outbreak of the First Balkan War, Andrei decided to return to Pittsburgh to avoid conscription in Emperor Franz Joseph's army which would soon have forced him to fight against his own people on the Russian side of the border. Julia was pregnant and remained behind with her aging mother and two younger sisters, Ella and Eva. Her father had died, and the other children had all left for America. Andrei promised to send the money for Julia to join him as soon as he could. Their separation would last nine years.

Life with the Warholas had never been easy and once Andrei left it became harder. They resented having to support Julia and made her work twelve hours a day to pay for her keep. As she put it, 'After my husband leaves, everything bad.'

The following year came the first great grief of her life. At the beginning of 1913 she gave birth to a daughter, Justina. It was a particularly cold winter and the whole family slept on top of a large stone oven in their house. The baby contracted influenza and had convulsions, and there were no doctors in the area. The Warholas insisted that Julia still

go with them to the fields. One day she returned to the house to find her six-week-old girl was dead. It drove her mad, she said. She flung open the window and screamed into the night, 'My baby dies! My baby dead! My little girl!'

Shortly after this Julia went to the Red Cross to find out what had happened to her brother Yurko and was told that he had been killed. She came back to the village and told her mother. A month later her mother died of a broken heart and Julia became responsible for Ella and Eva, then six and nine.

That spring the harvest failed and the people of Mikova were threatened with starvation. An old widow in the village took pity on her and helped care for Ella and Eva during the day while Julia worked. They lived on potatoes and bread for months on end and nearly starved to death. In the autumn Julia received a letter from Yurko explaining that his death had been reported because he had switched uniforms with a dead soldier and left his identification in the dead soldier's pocket. He had, he said, made a mistake.

Then the First World War came. Cut off from Andrei in America, virtually unprotected in Mikova and responsible for the wellbeing of her little sisters, Julia was engulfed by conflicts.

The bitter fighting that raged in the Carpathians between 1914 and 1916 became as much a war of reprisals on the civilian population as a war between nations. Long-standing, deep hatreds based on emotionally powerful religious and class differences erupted violently and the area was laid waste. Julia's house was burned down and she lost all her possessions. She particularly grieved over the loss of an album containing photographs of her wedding. Andrei's brother George was reported killed by drowning in quicksand as his unit was crossing a river. In a nearby village the fathers of thirty-six families were lined up and shot. As far as Julia was concerned the Russians were as bad as the Germans and the Poles were worse. Her knowledge of the surrounding countryside saved her life. Every time she was warned of the approach of soldiers she would bundle her little sisters and the old widow into a horse-drawn cart and take off for the forest, where they would hide for days. These trips were often made in the middle of the night in snow or rain. By the time she reached her destination Julia's skirt was sometimes frozen stiff.

Andrei had begun working in the construction business. We have one glimpse of him just after the war, when his brother Joseph returned from service. To celebrate they went to a wedding, got drunk and engaged in a fight in which they both got badly cut by razors. This may go some way towards accounting for his later sobriety. He was now evidently eager for Julia to join him in the USA because beginning in 1919 he sent her the fare five times, or so he claimed, but none of the letters containing the money ever reached her. We don't know whether

he had tried to send her the fare previously in the seven years since he left.

In 1921, as the European flu epidemic continued to decimate the population of the Carpathians, and shortly before the United States placed an embargo on immigration from Eastern Europe, Julia Warhola borrowed $160 from her priest and made her way by horse and cart, train and ship to look for her husband in Pittsburgh.

SLAVES OF

PITTSBURGH

1932–44

I think prayer really helped him through a tough life and religion formed his character.

All three boys remember Julia as 'a wonderful mother', and there is no doubt that she nurtured them at home. She was a good cook, although they were occasionally reduced to eating tomato soup made out of Heinz tomato ketchup, water, and salt and pepper. However, she was largely out of touch with the reality of their lives outside the home and refused to learn English. Her mind was full of religion, the ghost of her dead daughter, and her memories of the war. She had very little idea of what was really happening to Andy.

When Andy was four, Andrei returned to work with the Eichleay Corporation and began to travel away on jobs again, leaving Paul to act as surrogate disciplinarian (since Julia was incapable of it) over John and especially Andy. All the brothers were frightened of Andrei, but Andy's relationship with him was characterized mainly by his absence and may partially explain Andy's lifelong feeling of vulnerability. Being the youngest and smallest of the brothers he was clearly at a disadvantage.

With 'Nonya gon na contry', as they used to say when Andrei took a job out of town, Paul, now ten, became the man of the household. He was already selling newspapers on trolley cars and hustling for change at the ball park where he parked cars and sold peanuts. The combination of his father's physical and his mother's mental absence often left Andy at the mercy of his eldest brother. Paul was a well-meaning child but he was having severe problems at school. He had never been able to overcome the embarrassment of not being able to speak English when he went into the first grade, and now whenever he had to speak in front of the class he got terribly nervous. Soon he developed a speech impediment and began to cut school when he had to speak publicly. He was too frightened to tell his father about his problems and his mother would not have understood. Instead of

dealing with his own problems he focused on disciplining his delin-
quent little brother Andy.

In Pittsburgh in the thirties children did not attend elementary school
until they were six. In September 1932 Andy was only four, but Paul
boldly decided to register Andy in the first grade at Soho Elementary.
Remembering how tough it had been for him in the first grade, he
was convinced that this step would effectively tame Andy's rebellious
nature.

> In those days you didn't need a birth certificate or anything. You'd come into
> the principal's office and say, 'I want to register him for school.' Mother
> didn't realize. At the time, I was about ten. I thought, Well, we'll just start
> Andy off in school. He's big enough. He's walking around. We were only
> two blocks away. At first he didn't want to go to school but I forced him. He
> was all right the first day when I took him along and registered him. They
> didn't ask for no records. The guy just took him right by the hand and put
> him in the principal's office. I says, 'He's starting.'

But when Paul came to collect Andy at the end of the day he found his
little brother in tears. Andy continued to cry all the way home, and
when they reached the house he told the family he was not going back.
'The first day he was in school some little black girl slapped him and
he come home crying and says he's not going back no more,' said Paul,
'so my mother said, "Well, you stay home then." ' Paul did not know
what to do. School had been hard for him too in the beginning. He
thought Andy should go back the next day. Andy clung to his mother's
skirts and begged her to keep him at home. 'So mother says, "Don't
push him, he's just too young yet." So we didn't force him.'

For the next two years while Paul and John went to school, Andy
spent most of his time at home with his mother and the family cat.
Julia liked to draw pictures. 'I drew pictures so Andy made pictures
when he was a little boy,' she later recalled. 'He liked to do that, sure,
he made very nice pictures. We made pictures together. I like to draw
cats. I'm really a cat woman.' They used to draw portraits of each other
or the cat. They went clothes shopping together.

When Julia was at home on Sundays, guests would drop in from the
neighbourhood. Sometimes relatives from Lyndora would make the trip
into town. Julia made chicken soup, *halupka* (stuffed cabbage) and
pirogi. Visitors to the Warhola home always found Andy glued to her
side if she was sitting down or holding on to her skirts if she was
standing up. He kept his head down now and when he did look up it
was furtively as if he was afraid of getting hit. If Julia could not see
him when she came into the room she would always ask, *'Deya* Andek?'
Where is Andek?

As 1933 drew to a close, the austere conditions of the Depression
began to lift. Pittsburghers voted out the 'blue laws' that forbade playing

games on Sundays. Prohibition was repealed and men filled the bars after work.

At the end of 1933 Andrei's brother Joseph took a mortgage and moved his family from Lawn Street to Dawson Street in the blue-collar residential neighbourhood Oakland. When a close friend of Andrei's, Alexander Elachko, bought the house two doors away, Andrei decided to buy the house in between them. He paid $3,200 in cash for it and in early 1934 the Warholas moved from Moultrie Street in the Soho ghetto to 3252 Dawson Street in Oakland. Andrei had always wanted his family to live close to good schools and to their church. Holmes Elementary was half a block up the street. It was a fifteen-minute walk to Schenley High School. St John Chrysostom's was only a mile away.

The house was a vast improvement over anything the Warholas had ever lived in. It was a semidetached two-storey brick house with the Elachkos on the left. A short flight of stone steps led from the pavement to the two-family duplex. A second set of steps led to the Warholas' porch. The front door opened into a narrow corridor, with a stairway to the upper floor. A door to the right opened onto a 14 by 10 foot living room. A brick fireplace stood in the middle of the wall opposite the door. To its left was a sofa covered by a sheet. A floor lamp in front of a small table covered by a white cloth stood beside the sofa. To the right of the fireplace was a rocking chair. Another small lamp was placed on a table next to a white straight-backed wooden chair. Two windows looked out onto a front porch. The walls and floors were bare and streaked with ingrained dirt. Beyond the living room was a small dining room and a kitchen. On the second floor there were two bedrooms: John and Andy shared the back one; their parents had the front room overlooking the street. There was a small bathroom with a tub. Paul converted the attic, which had a single dormer window that faced Dawson Street, into a third bedroom. This was the first house the Warholas lived in that was heated by a coal-burning furnace in the basement.

John was proud of his father who owned his own house. 'It was,' he said, 'just like going into a different world.' Andrei was proud of the house too, and immediately began trying to improve it by digging out the cellar in the evening after work. Julia grew vegetables in the small back garden, which Andy helped her dig up.

The Elachkos were almost like relatives. Andrei was also close to his brother Joseph, but Joseph's wife – Andy's aunt, whom the boys called Strina – 'was a very domineering, bossy person and she wasn't very intelligent', Paul recalled. 'We liked my uncle, he was terrific, but he was being dominated by her. My mother could never get along with her.' 'She was the only person I knew who could talk and inhale at the same time,' said John Elachko. The difference between the family fortunes was what caused the most friction. Paul said:

My uncle was always sort of jealous of my dad, because Dad had saved his money where his brother squandered money. They used to ridicule him because he had the money to fall back on. His brother always brought it up. He said, 'You're loaded and you're cheap!' My father was a good father. He was firm with the kids and he expected all of us to be doctors and lawyers. He worked his tail off so he could send us to school and when I quit high school, that disappointed him very much. If he knew how famous Andy was today he'd be very proud of him.

Andy's later claim that 'I never saw my father very much because he was always away on business trips to the coalmines' caused some consternation among the Warholas.

Marge Warhola (John's wife, whom he married in 1952):

I see all these write-ups about Andy and his mother. What about his father? It's as if he didn't have a father. It reminds you of these coloured people nowadays. They have kids and not fathers. I mean, it's not true. He worked so hard and he was really a family man. He wanted all of them to have college educations if they could, but especially Andy because he knew that he was intelligent. They said he had a lot of wisdom and he seen something in Andy. His friends all looked up to him. The neighbour used to tell me about Andy's father. He says they didn't have loan companies back then and when they came from Europe they used to borrow from one countryman to the other to buy a house. So they come up to Andy's father and they would ask him to borrow some money and he would say, 'What did you do with yours?' He knew this man drank. He says, 'Well, I spent mine.' He says, 'Oh, you spent yours. Now you want to spend mine,' and he wouldn't give it to him. But, he said, if it was a person who he really knew was watching his money he would lend them money. When they put in the books that Andy came from a really poor family I says, everybody was poor then. I mean, in the ethnic groups they all lived the same way. You didn't have birthday parties or Christmas presents. His father should be given a lot more credit.

Oakland, east of Soho, was a large neighbourhood divided into two sections by the major artery of Fifth Avenue. To its north were the massive institutional buildings built as symbols of their empire by the Pittsburgh milionaires: the Soldiers' and Sailors' Memorial Hall, the Syrian Temple and the 42–storey Cathedral of Learning at the centre of the University of Pittsburgh. On a rising slope to its south stretched row upon row of tightly packed two- or three-storey workers' houses, culminating at the top of the rise in Dawson Street, which ran parallel with Fifth. Beyond Dawson the ground fell away steeply into the beautiful green bowl of Schenley Park and Panther Hollow. Julia soon became popular for her legendary hospitality. Friends and relatives visiting the Warholas were always greeted with a hug and a bowl of chicken soup. Her humorous nature, love of conversation and constant

dispensing of wise advice made her a focal point of the block and Julia thrived on Dawson Street.

'It was about a block from the park and the homes were very nice,' said John Warhola. 'They were mostly like Jewish people, Polish, Greeks, and we all got along good.'

An anonymous Italian source who was friendly with the Warholas in the thirties and forties described it:

Andy was younger than me but he went to school with my brother at Schenley and he lived about six houses up from me on Dawson Street. We were Italians, Jewish, Polish, and further down the street at the corner they were black. When I was growing up they would use that phrase towards us; Hunkie, Guinea, Dago, Wop, I eat chicken, you eat slop. We'd call the Jews schmucks and sheenies. Mr Baier owned the candy store on the corner. He was Jewish. And down from him was Mr Katz. He was Jewish. He kept the neighbourhood together. If he would ever have collected the money that was owed to him he'd have probably been a millionaire.

It was a fairly safe neighbourhood in those days. The children played together and they were friends and more or less brought the parents together. That's what it was all about. We did everything together. There were maybe about forty, fifty young guys down there. We were tight. Maybe 7.30, eight o'clock in the morning pitchin' horseshoes. Then when enough guys came we'd start playing softball or baseball. Around 12.30, one o'clock we'd go out swimming in Schenley Park. And then we'd play craps behind the Board of Education. But Andy was so intelligent, he was more or less in a world all of his own, he kept to himself like a loner.

As soon as Andy began mixing with other kids a definite pattern emerged. He would choose to relate almost exclusively to girls. His best friend at Holmes was a little Ukrainian girl, a Byzantine Catholic like him, named Margie Girman. Margie was a year younger than Andy but they were almost the same size and build. When Andy wasn't at home he could usually be found playing in the street with Margie or sitting with her on her stoop. Friends and relatives recalled it as a case of puppy love, but in Margie Girman Andy had found the first girl he could identify with. Margie's best friend, Mina Serbin, who also attended Holmes, recalled that 'Margie was very bright and she never stopped talking, and she stimulated Andy to do well in school. She always talked about how hard she was going to study for a test. Andy liked that, and he did everything she did.'

The extent to which Andy identified with Margie is evident in a photograph of them together. In the picture her expression and stance are identical to his. It looks as if their personalities have merged. Andy's relationship with Margie Girman set up a pattern for his relationships with women throughout the rest of his life. Part of him wanted to be her.

Andy and Margie began going to the movies together on Saturday mornings. For 11 cents each child got an ice-cream bar going in, saw a double feature, and got an eight-by-ten inch signed glossy of the star on the way out. Andy soon had a box full of these publicity photographs, the same sort of photos he would use twenty years later in his silkscreen portraits of movie stars. They made up his first collection. Andy's all-time favourite film was Bill Osco's *Alice in Wonderland*.

John Warhola remembered playing with Andy on Dawson Street:

You'd put a cork from a bottle cap and try to hit that with a tennis ball and make it go towards his side and he'd try to hit it. Then we'd play softball and when Andy was out in the field he'd be playing for a while and then by the time you hit the ball out there Andy wasn't there. So when I come home he was there drawing on the porch. He did that a lot as a kid. We used to laugh. The kids would say, 'Now, don't run home, Andy!' He just loved to draw with crayons. I think he was just born with that.

Ann Elachko also remembered playing with Andy:

I thought he was a nice little kid. He was bouncy enough but he wasn't robust. Maybe it was his colouring that gave the impression that he was delicate, fragile some way. When I would go next door to visit he would always be standing at his mother's knee. She was delightful. She had a sense of humour and she saw a little beyond what an ethnic group of people could understand. Even her insight into religion was a little beyond what most of our people discussed. We all liked his father. He was a wonderful man. He was totally different than his brother Joe. Andy's father was a little bit of a step above. He seemed to be self-educated and there was nothing brash about him. He was a very nice gentleman.

About once a month Julia would visit her family in Lyndora, taking Andy, John and Paul. 'There was nobody closer than my mother and her brothers and sisters,' said Paul Warhola. 'We enjoyed it up there because it was like farmland and my uncles were like pioneers. They started the town.'

Andy's best friend in Lyndora was Lillian 'Kiki' Lanchester. Kiki was a very pretty, talented little girl who played the steel guitar and loved to play pranks on people. As soon as Andy got to Lyndora he would find Kiki, they'd run down to the corner candy store and then disappear into the surrounding countryside and giggle and talk for hours. Andy loved to listen to Kiki. She recalled:

Aunt Julia made the most beautiful crochet things you ever saw. Aunt Anna was very artistic too. From what I remember about Andy he was particularly neat all the time and very clean. We were close friends when we were younger. He talked a lot to me because we were playmates. But he was very serious and shy when we were with other people. Every picture that we took

of him he would have his head down and he would look up at you as though he was afraid or he didn't trust you.

On alternate Sundays Julia visited her sister Mary Preksta on the Northside. Andy's best friend at Aunt Mary's house was his cousin Justina, 'Tinka', who was four years older than Andy and also a great talker. There was a wooded area nearby they played in. 'He kind of followed me,' recalled Tinka. 'I would tell him stories and he always giggled a lot.' While the children played outside, Mary and Julia would read their letters from Europe. 'It was always so sad,' Tinka recalled, 'because they didn't have the money to send Ella and Eva and they would always talk about the sadness of Europe and cry.' Sometimes Julia got very bad migraine headaches and Mary would put her to bed, heat some salt in a bag and put it on Julia's head. Other times they would sing together, harmonizing beautifully as they had in Mikova.

John Warhola: 'Tinka was like a big sister to him. Her mother and my mother were very close, in fact, if you closed your eyes you wouldn't know which one was talking – both personalities were the same.'

Tinka:

> My mother and his mother would just talk and talk in a foreign language and we were together, Andy and I, and we'd maybe go to the store and get some ice cream and candy, go to the theatre or something. But I know one thing. He used to go to town with his mother and help pick her hats out. He liked to do that. And his mother loved hats. I remember her buying a black felt hat and as a very young boy he painted it gold around the edges. He was sort of an artist then, I guess. He also liked to pick his mother's clothes out and of course he was just like a mother's boy.

Margie, Kiki and Tinka all found Andy charming, sweet and kind. He found through them ways to develop his interests and became, John said, 'a happy-go-lucky kid'. However, a friend of John's, Harold Greenberger, recalled that 'Andy didn't have no buddies, I don't even remember him having a boyfriend to loaf with. The only one I remember him with was Margie Girman. He never had a buddy or a pal or anything.'

*

Andy's single day at Soho Elementary had been credited as a full year so when he entered Holmes at the age of six he went straight into the second grade. His teacher, Catherine Metz, remembered him vividly fifty years later. 'He was a towhead with light eyes, very quiet, not at all outgoing, and he was real good in drawing.' At first Andy seemed to want to pass through the halls as if he were invisible, but his pale face and white-blond hair made him stand out as something of an oddball who was, one observer recalled, 'hard to get to know'. Despite this, his first year at Holmes was a success. The classrooms were light

and airy and the children's artwork was hung in the wide hallways. Half the students were Jewish and the remainder were mostly hunkies. The school day began with a reading from the Bible and a recitation of the Lord's Prayer in each homeroom. Second-graders went home for lunch at noon – Julia gave Andy a bowl of Campbell's soup every day – and left for the day at 1.30, exiting over the fire escape in a daily drill. Andy told his mother that he liked school.

By the time he entered Holmes, Andy was able to speak some ungrammatical English. His mother continued to speak Po nasemu, but the boys were answering her increasingly in English. Andy was not required to take the arduous course in Old Slavonic at the church school.

Andy's slight form made him an obvious target for the gangs who loafed on the corner outside the candy store opposite the school. He used to come straight home after school, and Julia did not let him go out much on his own. Julia had given all three Warhola boys medals of the Virgin Mary. 'We couldn't afford chains,' said John, 'so she pinned them inside our clothes so the other children wouldn't laugh at us. I used to ask Andy if anybody was picking on him and he said no. He was well liked. I never saw him even getting angry. He was really a unique personality. He never complained.'

After school Andy stayed in and did his homework. He seemed, at least temporarily, to have got over his early rebelliousness, and no longer swore in front of the family or talked as wildly as he had. He was doing a lot of drawing. 'He just picked it up and had a natural ability from the time he was a youngster,' recalled Paul. 'In the early thirties we didn't have a radio, so you did your school work and then entertainment was drawing pictures.'

John recalled how far Julia would go to encourage Andy's interests.

Money was real hard to get and Andy wanted things that we just couldn't afford. When he was seven, for instance, he wanted a movie projector. We didn't have money to buy the screen but you could show the pictures right on the wall. It was just black and white. He'd watch Mickey Mouse or Little Orphan Annie and he got ideas and then he would draw a lot. My mother bought that without my father knowing about it.

Julia got a job doing housework for a dollar a day until she had the $20 to buy it for Andy.

At Holmes Andy gained a reputation among his teachers for being efficient and competent at any job that involved art. In the upper grades Andy was very much in demand to come into their rooms amd make a seasonal border around the blackboard or draw a picture for the monthly classroom calendars.

Julia Warhola: 'Andy no have time to loaf around. He no have time

to play. He just by my house doing homework. My Andy draw for fun neighbour boy's face. Andy was nine years old. Oh, Andy a good boy. He's smart. His school teacher, a lady, tells me he teaches himself good.'

Andy Warhol: 'I got good grades in school. The teachers liked me. They said something like I had natural talent. Or unnatural talent.'

*

'I had three nervous breakdowns when I was a child,' Andy wrote in *The Philosophy of Andy Warhol*. 'I was always sick so I was always going to summer school and trying to catch up,' he told an interviewer in the mid-seventies. 'He said he had St Vitus's dance as a child and he lost his hair and couldn't hold his hand steady,' recalled one of his acolytes from the sixties. When one reporter enquired why a little boy would have nervous breakdowns, Andy replied gravely, 'I was weak and I ate too much candy.'

Andy did have a number of physical problems as a child. According to Paul:

When Andy was two years old his eyes used to swell up. That lasted for a while and mother used to bathe them in boric acid every day. When he was four he came out of the house on Moultrie Street, fell on the streetcar tracks and broke his arm. He didn't tell mother nothing about it until a couple of days later. She says, 'How does it feel?' 'Well, it's sore.' We let it go. Then two months later somebody called to our attention that it had a pronounced curve in it. This was the arm he eventually painted with. So they had to take him up to the Fall Clinic. They only charged 25¢ to get a card and then 50¢ to see a doctor. And they had to re-break it. When he was six he had scarlet fever and when he was seven mother sent him to get his tonsils taken out at the same time I had to have mine removed. It cost eight dollars.

Then, in the autumn of 1936 when he was just eight, Andy came down with the illness that defined his childhood. Before the discovery of penicillin, rheumatic fever was common among children who lived in sometimes unsanitary, close proximity in poor neighbourhoods, and a small percentage of the victims died from it. About 10 per cent of the cases developed into chorea, popularly called St Vitus's dance (named after a third-century Christian child martyr), which is a disorder of the central nervous system. In the worst cases the victim lost coordination of the limbs and had a series of what appeared to be spastic fits. It was particularly frightening because doctors were not sure what caused it and all they could do was assure the victims and their parents that it would pass and cause no permanent damage. In fact its worst effects were psychological because children who contracted it often thought they were going insane.

By the time Andy began to get sick he had become the teacher's pet at Holmes, but now when he tried to write or draw on the blackboard

his hand began to shake and the boys laughed at him. Sensing his fear, they began pushing him around and punching him. Years later he told an associate that the other kids would beat him up, which made him afraid of socializing. As Kiki Lanchester pointed out, 'They always picked on the frail kids.' Andy had no idea what was happening to him and became, once again, terrified of going to school. He became increasingly disoriented, was easily provoked to tears, and began to find the simplest tasks, like tying his shoes or writing his name, difficult to coordinate.

At first nobody at home took any notice of these symptoms, perhaps because Andy was a timid little boy anyway and had a reputation as a crybaby. However, when the symptoms worsened they became imposs- ible to miss. He started slurring his speech, touching things nervously with shaking hands, fumbling, and had difficulty sitting still. 'Our family doctor was Slavish, Zeedick,' recalled John, 'but we never called him because we couldn't afford the two dollars. Usually you just lay in bed till you felt better, but mother did call him to the hass.' Dr Zeedick diagnosed a mild case of St Vitus's dance. Andy was confined to bed for a month. The doctor told Julia that Andy needed mental and emotional peace and constant care. Julia moved him into the dining room next to the kitchen and devoted herself to nursing him back to health. Her greatest concern was that he would go into convulsions and die, as her baby daughter Justina had because she had been unable to move her bowels. In times of sickness Julia always believed in giving her children enemas.

This was a golden time in Andy's childhood. For a month he was able to detach himself from the world – from school, from his brothers, from his father, from everyone but Julia. She made sure that he was constantly entertained by a stream of movie magazines, comic books, cut-out paper dolls and colouring books. 'I buy him comic books,' Julia recalled. 'Cut, cut, cut nice. Cut out pictures. Oh, he liked pictures from comic books.' She also moved the family radio, which Andrei had recently bought in a rare fit of generosity, from the living room to the dining room. As soon as his hands stopped shaking so much Andy made use of his time colouring book after book, cutting up and pasting magazines to make collages, and playing with his paper dolls.

A friend from the sixties:

Warhol recalled, in one of the rare moments he spoke of those trying times, that his mother would read Mickey Mouse stories to him under a lamp dimly lit with a 25-watt bulb. At other times she would draw colourful pictures of cats and other animals for him while they sat listening to programmes like *Suspense* or *One Man's Family* on the family console radio. His mother was determined that her boy would do something unique, something different in the world.

Warhol wrote in his *Philosophy*:

> My mother would read to me in her thick Czechoslovakian accent as best
> she could and I would always say, 'Thanks, Mom,' after she finished with
> Dick Tracy, even if I hadn't understood a word. She'd give me a Hershey
> bar every time I finished a page in my colouring book. I liked Walt Disney.
> I cut out Walt Disney dolls. It was actually Snow White that influenced me.
> But I couldn't do cartoons. I could never think of a good person to draw.

Andy also discovered the glamorous world of celebrity, wealth and
beauty in the movie magazines, which detailed the lives of the stars in
the 1930s even more extensively than they do today. The 'Life of
Marlene Dietrich', for example, was run as a daily cartoon in Pittsburgh
newspapers. Here Andy found not only a life that seemed like a perfect
escape for him, but two places that he could focus on: the dream cities
of Hollywood and New York.

All this information pouring in turned Andy's sickroom into his first
studio. Julia was his first assistant. She marvelled at his drawings and
collages, laughed at the radio shows ('She was a happy-go-lucky woman
and could really make you laugh,' said John) and kept him comfortable
night and day, sleeping in the same bed, sometimes sitting up all night
watching him sleep.

Both his brothers pointed out that Andy greatly exaggerated his bouts
with St Vitus's dance, that he only came down with it seriously once,
and was really too young to worry about it. According to John, 'It was
like having chickenpox or a sore throat.' Yet the attention Andy paid
to it later in life indicates how important the experience was to him.

After he had been in bed for four weeks the Warholas decided that
it was time for Andy to go back to school. However, on the appointed
morning he balked. Standing on the front porch with Julia he held on
to her skirts and started crying that he didn't want to go. Andrei was
absent and Julia was uncertain what to do. Paul came out on the porch
on his way out and found Andy throwing a tantrum just as he had
after the incident at Soho Elementary four years earlier. 'He's gotta go
back to school,' Paul declared. He presumed that Andy was scared of
being beaten up by some kids who laughed at him for being a mama's
boy, and did not consider that good enough reason for him to stay
home. Andy started screaming.

Hearing the commotion the next-door neighbour, John Elachko, an
undertaker's apprentice, came out on the porch to see what was going
on. He was used to playing surrogate father to the Warhola boys when
Andrei was away, and immediately assessed the situation. To him Andy
was just a sissy littly crybaby who didn't want to go to school. Stepping
over the wall that divided their porches he grabbed him by the shoulder
and shouted, 'You're going to school!'

Andy's knees buckled, as often happened to chorea victims, and he

fell down and refused to move. Grabbing the terrified child by the shoulders, Elachko dragged him down the front steps.

> Andy was a very mild, squeamish kid, artistic, sensitive, all of that business. He took after his mother. She was soft on everyone. She wouldn't hurt a fly and just felt sorry for everyone. But Andy was afraid of everything. I picked him up and he squealed and hollered a few times but I just took him to school.

'Andy tried to kick him,' said Paul, 'and then the neighbour grabbed him, he just held his arms and legs and forced him and Andy's crying and trying to break away. He fought us not to go and we did force him to go to school. Now that was the worst thing to do because after that he developed a worse nervous twitch.'

'We didn't know he wasn't completely cured,' John added. 'The neighbour thought he was doing us a favour when he carried him there. I remember the doctor says he got it all over again.'

Andy immediately had a relapse and had to be returned to bed for four more weeks. The incident bred in him a lifelong abhorrence of violence and a strong desire to detach himself from any kind of physical force. One way to unleash Andy's rage in later life would be to try physically to force him to do something.

Andy's second period in bed was like his first. Once again the magic incubation allowed him to spend long uninterrupted hours dreaming about being a movie star in Hollywood. This time, when he emerged from his sickroom, his position in the family had changed. Julia had been warned by Dr Zeedick that a relapse was more than likely. The illness had also left Andy with a skin condition that would plague him throughout the rest of his life. Everyone noticed that Andy suddenly had large reddish-brown blotches on his face, back, chest, arms and hands. He appeared frailer and became like a clinging vine to Julia, rarely leaving her side. She became more protective of him than ever and made sure that nobody laid a violent hand on him again. Andy was now accorded the position of an eccentric invalid who had to be treated with special care and understanding, and his brothers began to watch out for him in school. 'What I didn't understand,' recalled John Warhola, 'was when he went back to school after a couple of months, even though he had lost so much time, they put him ahead.'

In the most revealing comment he ever made about his childhood, Andy wrote in *Popism*, 'I learned when I was little that whenever I got aggressive and tried to tell someone what to do nothing happened – I just couldn't carry it off. I learned that you actually have more power when you shut up, because at least some people will start to maybe doubt themselves.' At the same time the new fantasy life he was developing in his imagination gave him an inner focus that left him more

confident and driven about his art. His two-sided character began to emerge. While continuing to be as sweet and humble as ever with his girlfriends, he began on occasion to act like an arrogant little prince at home. Freud observed that 'subconsciously you remain the same age throughout your life'. The Andy who would polarize his audience as an artist during his prime remained, at least partly, the eight-year-old who now emerged from the cocoon of his illness and convalescence.

It was a new, eager, impatient and sometimes aggressive Andy who constantly challenged Paul, saying, 'Well, whataya do now?' and ran off to the movies every Saturday morning. The movies defined life for American children of the 1930s and 1940s, and they defined Andy's life even more than most of his contemporaries'. They became his passion, a necessity, an escape. It was not always easy to get the 11–cent entrance fee but Andy pursued it with dogged determination, helping Paul or John sell peanuts at the ballgames, earning a penny a bag, taking the neighbours' baby with him in exchange for the entrance fee, or getting it from his mother.

Andy, the perfect fan, began a lifelong habit of writing stars letters asking for pictures and autographs. Just as he identified with girls rather than boys in his daily relations, he chose a female rather than a male movie star to idolize. In 1936, the year she made *Poor Little Rich Girl*, Shirley Temple became Andy's idol and role model. In the story Shirley is completely protected by her father's extraordinary wealth, but then, escaping by sheer chance, she ends up working (aged eight) with a vaudeville team. Her attitude towards everything is that it's a game. Within this plot lies the basic philosophy of Andy Warhol's life: work all the time, make it into a game, and maintain your sense of humour.

When Andy mailed off a dime to her fan club and received back a photograph with 'To Andy Warhola from Shirley Temple' written on it, it became his most cherished possession and the centrepiece of his collection. He also sent away a cereal-box top and got a blue glass with the face of Shirley Temple on it. Just as he had done everything that Margie Girman did, Andy now tried to emulate Shirley Temple. For the rest of his life he would imitate her standard gestures, folding his hands in prayer and placing them next to his cheek, or twisting them together and holding them out to the right just below his waist. He dreamed about learning to tap dance. The only thing he didn't like about the Shirley Temple films, he told a friend, was the regular appearance of her father to take her home at the end. In Andy's view, that ruined the fantasy. 'In those Shirley Temple movies, I was so disappointed whenever Shirley Temple found her father,' he said. 'It ruined everything. She had been having such a good time, tap dancing with the local Kiwanis Club or the newspaper men in the city room. I don't want to know who the father is.'

*

At the end of the 1930s the balance of power in the Warhola household shifted. For some time now Andrei's health had been slowly failing. Always the disciplinarian, he could still freeze his boys with a glance and the threat of his hand moving to his belt, but Paul, who was now seventeen and working in a steel mill, was pretty independent and Andrei was for the most part so tired when he came home from work that it was all he could do to stand in the back yard silently hosing the tiny garden. Julia begged him to slow down. He had around $15,000 in postal bonds and a savings account, a fortune for a man of his background. Paul was bringing a salary into the house, making enough to buy his mother dining-room furniture and a fridge. It was no longer necessary for Andrei to take every job that was offered him and keep up the backbreaking pace of twelve hours a day, six days a week, but he was a workaholic and Julia's pleas fell on deaf ears. Paul recalled the time Andrei left the house on what would turn out to be his last job, on his way to Wheeling, West Virginia:

He had been sick with yellow jaundice for a couple of years earlier on, after he was operated on to have his gallbladder removed, and then for so many years it was OK. And then all at once he was getting yellow. Apparently his liver was failing him. Mother says, 'Don't go on a trip, you don't have to go away.' She'd say, 'Andrei, you have money, why go? *Please* don't go!' But my dad, he wanted to push himself.

On the Wheeling job site a number of the men, including Andrei, drank some contaminated water and when he returned to Dawson Street he came down with a bad case of jaundice and was confined to bed. 'Andy was a young boy when my husband die,' Julia recalled years later. 'He go to West Virginia to work, he go to mine and drink water. The water was poison. He was sick for three years. He got stomach poisoning. Doctors, doctors no help.' She broke down weeping as she recounted the tale.

It was a confusing, depressing time in the Warhola household. According to John:

Dad was ill and housebound from 1939 to 1942. He was up and about, he just couldn't work. It was depressing because he was only fifty-five when he died and he was like a leader. We all felt bad. Dad was not a very emotional or talkative man. Particularly when we were younger, he didn't think we'd be interested in hearing about his work, and I can't remember him talking to Andy much. No more than he did to me until the year before he passed away. I was sixteen then and he figured, I'll treat you like a man, and he discussed a lot of things about his job.

In order to make up for the lost income they took in boarders but that only aggravated the situation. Paul and John started spending more

and more time away from home, John trying to lose his troubles in games, Paul in girls. Andy remained at home by Julia's side during the next few troubled, for Andy vital years. The American entry into the Second World War after the attack on Pearl Harbor in December 1941 added to Julia's fears and brought into focus her bad memories of the First World War. Many boys in the neighbourhood went off to war. Paul's turn would come soon.

Andy took a photograph of himself in a photo booth in a bus station around this time in which he looks trusting and angelic. 'He had the prettiest smile,' recalled Kiki, 'but he was real serious.' 'I remember kids used to say, "Who's that good-looking blond-haired kid?" ' recalled John, 'but he always wanted to be tall. He used to tell me when he was like thirteen, "When am I going to be as tall as you?" I said, "You'll get there." I says, "In a couple of years you'll be six foot tall." He never made it.'

As the string that had held the tightly knit family together unravelled, the dissensions between the brothers hardened. The combination of Andrei's distant strictness and Julia's embracing softness had pitched them into unspoken conflict with each other for their parents' attention. By cleaving to his mother and detaching himself from his father and because he was still too young to have to face practical responsibilities, Andy was not as affected as John and Paul, who now found themselves in the unenviable position of receiving the final judgement of their patriarch.

Andrei's greatest concern was what would happen to his hard-won savings after he died. He knew that Julia had no head for figures and that anything could happen if she was left in control. Visions of the precious college fund floating off to Mikova or being dispersed among the hungry Zavackys in Lyndora tormented him. He was equally uncertain of Paul's ability to manage his money. No sooner did he make a buck than he spent it and he had already developed a lifelong habit that Andrei abhorred – he was a gambler. 'My mother used to always say, "You know, you're never gonna have nothing!" She says, "All you like to do is gamble." ' Besides, Paul – the eldest, the crown prince – had already disappointed Andrei horribly by dropping out of high school without even telling him, for fear of being ridiculed for the speech impediment he had developed when he had to speak in front of the class. Andrei's silent displeasure rested heavily on Paul's troubled mind and was made doubly painful by a strong emotional bond. For all his brusque hustle and go, Paul took after his mother and was a soft, warm soul inside.

That left only John as a possible recipient of the responsibility of running the Warhola household. Sixteen in 1942 and taking courses at Conlee Trade School, Johnny had pleased his father with his diligence and steadiness:

He seen the way I handled money. I guess some people are born that way, they just can't take care of it. He seen that I would go out and shovel snow for 15 or 20 cents or else take the ashes out from the coal for five cents a bushel. When I was fourteen I would buy a bag of peanuts and make small bags to sell for a nickel and I made enough money to go to the dentist, because he couldn't afford to send me to the dentist.

In his last months at Dawson Street Andrei began to tell the relatives who mattered – his brother Joseph, Julia's sister Mary and, of course, Julia herself – to listen to John when it came to matters of finance. This choice to promote John over Paul as the head of the family created a rift between the brothers that never healed and set them in interminable competition with each other for their mother's affection. 'Mother always tried to say, "All my sons mean the same to me," ' Paul claimed years later, 'but I can just feel that I was her favourite.'

The use Andy made later on in life of the same devices his mother and father employed to keep their children in constant, edgy competition for their attention indicates that he was, at least intuitively, fully aware of the family dramas that surrounded his father's death.

One day before Andrei went into Montefiore Hospital for a series of tests, he called John out onto the back porch.

He talked for about two hours. He says, 'I'm going into hospital tomorrow and I'm not coming out.' He felt bad. It wasn't that he was crying or nothing, he just talked real sad. And when he told me he wasn't coming back I couldn't concentrate because I felt real close, and my mind kept going back to – he ain't coming back – and that's why the only points I can remember are the predictions, because they all came out true. He says to look after Mother and Andy because Paul is going to get married soon, and Andy, he says, 'You're going to be real proud of him, he's going to be highly educated, he's going to college.' He told me he had enough postal bonds saved up to pay for Andy's first two years in college and he said, 'Make sure you do that. Make sure the money isn't spent in any other way. Make sure the bills are paid and we don't lose the house for taxes.'

For the next five days Julia, Paul and John took turns visiting Andrei in the hospital. Paul Warhola:

The day before he died, Dad had an awful fever and he was in a lot of pain and he asked me to get him a drink of water, and the head nurse grabbed me and said, 'Don't you dare give him no water! We're running tests on him!' Dad looked at me so pitiful and he says, 'Just give me some water to wipe my lips.' And I felt so bad because I couldn't even give him a little bit of water.

The following morning Andy came down to breakfast and asked his mother, 'How come you tickled my nose with a feather?'

'And my mother says, "I wasn't even in the room," ' John recalled.

And he says, well, somebody tickled his nose and when he woke up he looked up and he says he just seen like a body going out the door into the hall. About eight hours later, my dad passed away and my mother said, 'That must have been an angel or God leaving, you know.'

'I was very much upset,' said Paul Warhola.

We thought he might be able to pull through, but as the doctor explained it to me, if you have TB in the lungs you can survive, but it ended up in his stomach and it just spread because the air couldn't get at it. This was the diagnosis of the autopsy. I was very bitter at the doctor because they run tests up until right before he died and I went and argued with the doctor afterwards. I says, "Youse didn't do anything to help him out!"

'Andy sure had an emotional reaction to his father's death,' recalled Ann Warhola (Paul's wife, whom he married the following year). 'As was traditional, his dad was laid out in the house for three days with somebody sitting up with him through the night, and his mother always told me Andy would just not go down and see him when he was laid out.'

Paul Warhola:

He just didn't wanna see Dad. When they brought the body into the house Andy was so scared he ran and hid under the bed. But we didn't push Andy too much when Dad died because we didn't want him to have a relapse. We were always fearful that his nervous condition might come back. Andy started crying. He begged Mother to let him go and stay with Tinka at Aunt Mary's house on the Northside or to have Tinka come over and keep him company.

'He was just frightened to sleep in the house with the body,' John Warhola said, 'so he stayed with my aunt for a couple of nights.'

Tinka explained, 'I was more like a sister to him and I guess he wanted to be with me, he felt better with me. We all came down for the wake and the funeral.'

John Elachko, who had brought on Andy's second attack of St Vitus's dance by forcing him to go to school, assisted at the funeral.

I helped bury him. The old country people had a singsong wailing kind of thing they did, telling a story about the dead person's life with their arms across their chests, hopping from foot to foot. Julia Warhola was one of those wailers. We took him to the church first and then to the cemetery in a regular hearse followed by a stream of cars. It was a real traditional funeral. They rented a couple of big cars for anyone who wanted to go. There were a lot of people.

It was probably the only funeral Andy went to. His fear of death would

lead to a hardcore detachment from anything concerning it. Whatever inner emotions he may have experienced were already submerged as they lowered his father's coffin into the ground on the gently sloping Pennsylvania hillside in St John Divine's Cemetery at Castel Shannon. Back at Dawson Street Tinka noted that 'Andy was playing outside in the street. He didn't take it seriously.' In a series of photographs taken outside their house after the funeral, Andy appears to be bursting forth as if both relieved of some inner burden and fuelled by new energy that will take him through his teens. John Warhola said, 'If there was any outstanding thing that affected Andy during his childhood more than anything else I think it was when my dad passed away.'

Despite the heartfelt sympathy of her relatives there was a morbid side to some of the Zavackys, a kind of feasting on disaster that tended to magnify rather than heal the wounds, and Julia had to be careful not to let herself drown in the Zavacky sadness. 'I felt really bad, like nothing material would make me happy,' recalled John.

> And it took a long time to get over. We were a close-knit family. Mother says she didn't think she would have made it without Andy. Andy really kept her company because he would stay home and paint and study more than I would stay with her. I'd go up to the corner and play ball, but Andy spent most of his time with my mother. He was very close with her.

As Julia began to cling to Andy the way he had clung to her throughout his vulnerable childhood, they became equals in a pact of mutual support.

This bond was strengthened by the events of 1942–44. Joseph's wife Strina, who had been Andrei's most outspoken critic during his lifetime for being tightfisted and cheap, announced that she thought her family should inherit a good portion of his fortune, but Julia refused. 'My husband was a good man,' she said. 'Not a drunk man. I had $11,000 in the bank. I just pay taxes. I raise my children.'

'After that,' recalled Paul, 'Mother didn't get along too well with Strina. They were distant.'

Then there was Paul's marriage. Before his father had been in the ground a year, Paul fulfilled his prediction by hooking up with an attractive young woman from nearby Greenfield. In April 1943 he asked his mother how she felt about his getting married. 'I says, "Is this gonna maybe change the situation?" She says, "I'm not gonna stand in your way. If you want to get married, that's fine." I says. "Well, we'll live here. We'll rent the second floor and I can pay you so much a month." '

Despite his protestations and Julia's attempts to make room for the new intrusion on her life, the arrangement was doomed before it began. Ann Warhola was a domineering, neurotic woman who believed that

everybody should see things the way she did and was given to religious soul searching. Everybody, she felt, must search for their inner truth and declare it openly. Nothing could have been further from the nature of the Warholas, whose intricate, multilevelled family connections were based entirely on not saying how they really felt. She never liked Andy, he thought, because she was the first person who obviously recognized that the artistic, quiet little boy was homosexual. They never got along and Andy felt mentally tortured by her presence. Paul soon became utterly disillusioned with Ann and spent as much of his time as possible out of the house, working or dating other women. Ann, whose jealousy was almost equal to her religion in its spitfire fervour, would fly into rages and the house became a war zone for the mistaken and disruptive marriage. This threw Julia into a turmoil she was unprepared for and gained Ann, who was completely unsympathetic to her mother-in-law's situation and singularly focused on her own ego, Andy's lasting hatred.

The situation deteriorated further when it was announced that Ann was pregnant and Paul, who had been called up to join the navy and fight in the war, would shortly be leaving her in Julia's care. Pregnant and, she felt, abandoned, Ann became even more of a burden for Julia.

By the time the baby, Paul Warhola Jr, was born in early 1944, it was evident that the situation simply could not be sustained. This was brought into focus by Julia's ill health. Resilient and tough though she had been throughout the hardships of her life, the pain finally started eating away at her body. For some time she had been suffering from piles. She found herself physically incapable of taking care of a recuperating, difficult mother and a baby, and, to the great relief of Julia, John and Andy, Ann moved back into her parents' house to await Paul's return from the navy.

Their relief was shortlived. Julia's piles started bleeding so badly that she was forced to call in her doctor, who prescribed a series of tests and shortly diagnosed colon cancer. Her chances of survival were at best 50/50, he informed both Julia and John, and that chance depended entirely on her agreeing to an operation which doctors were just beginning to experiment with called a colostomy.

The news came so hard on the heels of their previous troubles that the Warholas barely had time to think about how they felt. Since Julia was incapable of assuming the responsibility, Paul as the closest adult, was rushed home from training camp to sign the necessary papers to give the doctors permission to cut out Julia's entire bowel system and replace it with a bag on her stomach. The boys and Julia were simply told that the operation was essential and had to be done immediately. John Warhola:

My mother had so much faith in religion, she told me not to worry. I guess she seen the expression on my face where you'd think that I was the one

that was going for the operation. Don't worry, she says, she'll be all right. I don't think the doctors knew that much. We always felt that she didn't need that operation. I'll never forget the first day Andy come down there after she was operated on. The first thing he asked me, he says, 'Did Mumma die?' It was a sad situation to lose your father, then two years later . . . It was too close. Andy had a lot of sadness. I think that had a bearing with me and Andy getting real close. We tried to listen to my mother and we just prayed, we prayed a lot. We visited mother in the hospital every day. She was in there for about three weeks.

When Julia, who had apparently not fully understood the details of her emergency operation, discovered the results she was shocked. According to John, 'She was weak and she was very upset when she found out how she had to go to the bathroom. She always says she thinks she just had it for nothing, when the bleeding could have just been from piles.' 'It was pretty successful,' recalled Paul, 'it was just that you get into a very bad depression with an operation like that. You kind of feel, do you want to live?'

For the rest of her life she remained convinced that she had not had cancer and the operation had been unnecessary. Whether this was true or not, when Andy later tried to persuade her to have a follow-up operation to replace the colostomy bag with tubes inside her, Julia flatly refused because the operation had been too painful.

Her experience, combined with the harsh treatment his father had received in hospital, bred a fear of hospitals and surgeons in Andy that would eventually lead to his own premature death.

When Julia returned home, John changed his shift from 4 p.m. to midnight so that he could spend the day with her. Andy returned home from school around 3.30 p.m. and spent the afternoon and evenings taking care of her. John Warhola:

When she come home she had a hard time recuperating, but she come round. Andy did a lot of praying with my mother. In fact I have three prayer books of his which are worn out from prayer. Everybody talks about how important his mother was to Andy but he was equally important to her. They both worked together. Andy really kept her company. He spent most of the time with my mother. He was very close with her.

In fact Julia's recovery was so remarkable that her doctor asked her to visit patients who were going to have colostomies to show them that it was possible to have a fulfilling life afterwards.

In the opinion of John Warhola, the experience of his father's death and his mother's close call had a major effect in strengthening Andy. 'We were brought up to believe that prayers are the only thing that are going to help you and it seemed that when he had nowhere else to turn Andy got closer to God.'

THE EDUCATION OF
ANDY WARHOL
1937–45

I just went to high school, college didn't mean anything to me.

ANDY WARHOL

Although Pittsburgh was a provincial city, it was an excellent place to study art in the 1930s and 1940s. The Carnegies, Mellons and Fricks were among the leading collectors in the world. The interest of the Pittsburgh millionaires in art both as an aesthetic and a financial investment lead them to sponsor art competitions, art centres and free Saturday-morning art classes at the Carnegie Museum for talented children from all over the city. Pittsburgh boasted at least two outstanding resident artists during Andy's childhood, the folk artist John Kane, who had received an avalanche of publicity when it was revealed that he painted over photographs, and the academic painter Sam Rosenberg, whose street scenes of Oakland and Greenfield emphasized the hot pinks and reds of the city and the noble nature of its peasant population. The Pittsburgh public-school system specialized in teaching art and had a number of innovative and dedicated instructors who were responsible for giving Andy not only a solid grounding in his field but also the inspiration to see it as a way of life. Chief among them was a teacher named Joseph Fitzpatrick who taught the Saturday-morning Carnegie Museum course. Andy's art teacher at Holmes, Annie Vickermann, who gave a solid if somewhat formal course from the fifth to the eighth grade in Egyptian, Greek and Roman, medieval and modern art, recommended him for the Saturday-morning course in 1937 when he was nine.

The Carnegie Museum classes were split into two groups. The Tam O'Shanters, named in honour of the Scottish-born Andrew Carnegie, were the younger members from the fifth to seventh grades. In the eighth to tenth grades they were called the Palettes. The Tam O'Shanters class was held on the first floor of the museum in the Music Hall, a large room with high ceilings and ornate frescos that made it look like a ballroom. The approximately 300 students who had been chosen for the Tam O'Shanters would assemble there early on Saturday morn-

ings. The tall, striking, flamboyant Joseph Fitzpatrick taught these classes. A Pittsburgh character of some renown, Fitzpatrick was an extraordinary teacher who seemed to come alive, rather like a television-show host, when he was on stage teaching art. 'Look, to See, to Remember, to Enjoy!' he would bellow from the stage at the children, who listened in rapt silence. He instilled in them his beliefs about discipline, creativity and authority in art. 'Art,' he told them, 'is not just a subject. It's a way of life. It's the only subject you use from the time you open your eyes in the morning until you close them at night. Everything you look at has art or the lack of art.' He expected them to learn to observe and would ask them what their bus driver had looked like that morning. And he taught them to draw with authority, starting with an understanding of the fundamentals of drawing and painting, then looking at how they could manipulate the basic forms. He is sure that he had some influence on Andy: 'What I taught him may not have helped with the kind of thing he did later on, but it acquainted him with different styles.'

The children sat in rows and worked in crayon on masonite boards. Each student would describe what he had observed during the week that had helped him improve on the previous week's drawing. They would do a new drawing based on this knowledge. The subject was simple – a coffee pot, a table. The idea of the course was to give each child a good background so they could pursue any type of art career. Local artists sometimes visited and talked about their own work and techniques. The students learned about composition and proportions of the figure. They visited various exhibitions in the museum galleries to relate what they had heard to what they could see. Andy later told one of his superstars, Ultra Violet, that the classes

> made a particular impression on him because they gave him his first chance to meet children from the neighbourhoods beyond his ethnic ghetto and to observe how the well-to-do dress and speak. Several times he mentioned two youngsters who arrived in limousines, one in a long maroon Packard and the other in a Pierce-Arrow. He remembered the mother who wore expensively tailored clothes and sumptuous furs. In the 1930s, before television and with no glossy magazines for poor families like Andy's and few trips to the movies, the art classes opened a peephole for Andy to the world of the rich and successful. He never forgot what he saw.

According to Fitzpatrick, Andy had a unique approach. His work was not at all derivative and he was constantly experimenting with his own style:

> He must have been highly intelligent to do what he was naturally doing, because he was so individualistic and ahead of his time. I encouraged him to do whatever he wanted to do. Andy won an award at *Scholastic* magazine

– they had a show of art at Kaufman's department store and later the show became national. He was tremendously creative.

Every week ten students were selected to exhibit their drawings to the class. Each of them would come to the microphone and explain their piece. Andy was chosen to do this on several occasions. He had to go up and say, 'My name is Andrew Warhola. I go to Holmes School, and in my drawings, I tried to show . . .' Thin and pale, he held himself in check, hunched a little forward, but he seemed to enjoy the attention.

'A more talented person than Andy Warhol I never knew,' said Joseph Fitzpatrick.

> He was magnificently talented. Personally not attractive, and a little bit obnoxious. He had no consideration for other people. He lacked all the amenities. He was socially inept at the time and showed little or no appreciation for anything. He was not pleasant with the members of his class or with any of the people with whom he associated. Maybe he was withdrawn because of his lack of social background, and developed the approach to cover. But he did seem to have a goal from the very start. You weren't conscious of what it was, but he stayed right with it.

After observing Andy for a while, Fitzpatrick decided that Andy had created his repertoire of behaviour and appearance to gain attention. 'He seemed to be extemely keen on knowing people, and knew exactly what to do to get the attention he outwardly seemed to avoid.'

After class Andy could spend the afternoon looking at paintings and sculpture or reading in the library. When he was a child in Pittsburgh the museum used to have an annual international show. During the six years he attended the Saturday classes the young Warhol was exposed to a variety of artistic movements.

This was the first step in his career, the first time he was singled out and made his way into another world via his art.

*

In September 1941, Andy entered Schenley High School. Despite his claim that he did not have any friends or fun at Schenley, his high-school days were stimulating in many ways.

Schenley was a twenty-minute walk from Dawson Street. The children were a mix of black, Jewish, Greek, Polish and Czechoslovakian. It was a lower-middle-class school with lower-middle-class academic standards, but the art department was quite good. Attending high school during the Second World War was exciting. Life on the home front was marked by a sense of shared goals and values, of participating in a cause if only by collecting tin foil or buying war stamps, and of having a common enemy to hate. There was a solidarity among the students that there might not have been at other times, so it was not a threatening environment as it might have been for somebody of Andy's

disposition. They sang patriotic songs from *Your Hit Parade* or the naval battle hymn as they walked to school. On Saturdays they flocked to the cinema to watch John Wayne heroically decimate enemy soldiers. There were occasional gang fights between white and black students, but by and large the atmosphere was unusually harmonious and dedicated.

This was the period when a new group called 'teenagers' emerged in American society. At the same time as they were inundated with news of the war, the kids Andy went to school with were provided with a whole brash new world of their own with its star, Frank Sinatra, its dance, the jitterbug, and its customs and uniform. Teenagers wanted to dress and look alike, especially the girls, who all wore the same uniform, including saddle shoes, bobby sox and a string of pearls. Hair and make-up tips filled the new teen-oriented magazines they devoured. All this kitschy life style was right up Andy's street and he fitted into it perfectly. As an artist Andy would have a large following among teenagers and a great influence on and interest in the youth culture.

On the other hand, the emphasis on appearance could not have come at a worse time for him. A national survey defined the teenagers' most serious problem as acne, and Andy's complexion had erupted in blotches and pimples that spread from his face to his chest and hands. His small symmetrical nose had flared out into a bulbous red one that led his family to dub him Andy the Red-Nosed Warhola. 'His features started changing when he got serious about going to college,' recalled John. 'You can see it in pictures. His nose got bigger. He almost looks like two different people. I think he worried a lot and the worry and stress affected his appearance.'

The two words that best describe Andy during high school are 'determined' and 'serious'. By now the aim of his work was to fulfil his father's prediction and go to college. Both at home and at school he was dead serious about making it and spent most of his time drawing. 'The way he fought out of his background through his art and his talent is extremely important,' noted one friend. 'It explains him.'

Andy had become highly disciplined and self-directed in his work. His talent was gaining him approval from both the teachers and students at Schenley High School. He drew compulsively, constantly, and amazingly. Drawings piled up in stacks all over his room. It was family lore that Julia once dumped a whole cupboard full of them in the trash because she thought they were in the way. John Warhola: 'Andy was determined as a child and so serious and quiet I thought he was going to be a priest, but I think that's when he started planning on being an artist.' Lee Karageorge, who was in Andy's freshman and sophomore classes at Schenley, remembered that his talent was quite recognizable to the other students even then.

He wasn't one to show it off at all, in fact he was very close with his personal life, but when we were in Miss McKibbin's art class she would show us his drawings. He wasn't part of any of the cliques, he was sort of left out, but he wan't in the art club because his talent was so superior to the rest of us. Nobody made anything out of it or picked on him.

Andy was not bothered by other boys at school. John asked him if he was and he said no. John Warhola: 'He had a fellow there that really protected him, an Irish kid, Jimmy Newell, who later on became a policeman. He was a friend of mine and I asked him to look out for Andy. He was the toughest kid in the neighbourhood.'

In Miss McKibbin's art class Andy did not pal around with the other youngsters, but went straight to his desk, got his materials out and began to draw. Never looking up to discuss his work, he drew and drew and drew. He was intensely interested throughout the period and never created any problems but was very much a loner in those days. Mary Adeline McKibbin:

Andy was a small child. He was pale, he had a sallow complexion with high cheekbones and washed-out tannish hair that was almost the colour of his skin. The work was developmental and very simple at first, the idea being that appreciation is a great part of it as well as teaching a subject. So they went from drawing and painting into various media. They were limited in high school, they didn't have oil paints – they were too expensive – but they did have poster paints.

During this time, drawing seems to have been not only a means of gaining distinction at school but something for Andy to hide behind. Anywhere, in homeroom, at Yohe's drug store, during breaks, he could always be found with a sketchbook in his hands. The others were impressed by his skills. Boys would huddle around Andy's desk in homeroom and one of them would hold up a drawing he had done and say, 'Look at this, guys!'

Before she moved out of Dawson Street, Ann Warhola observed:

When Andy came home from school he would go straight to his room and work. Dinner would be ready and you could hear his mother yelling for him to come down and eat. Sometimes she would take food up to him. When he did come down and sit with us he never had much to say and when he did talk it was always about his work and nobody paid too much attention. He was really wrapped up in his work.

Joe Fitzpatrick, who taught the Saturday-morning art classes, was Andy's art teacher in his junior and senior year at Schenley and now became his mentor. 'Andy had a very wonderful relationship with Joe Fitzpatrick,' Mina Serbin, who had been at school with Andy since

Holmes, recalled. 'You could see them bending over Andy's drawings scrutinizing them together. It was a very warm relationship. Joe would make him sit and do things that Andy didn't think he could do. He brought all of that out of him.'

It was obvious to all that Andy was going to pursue a career as an artist and he was beginning to apply to college.

<p style="text-align:center">*</p>

From the account of other former Schenley students, Andy appears to have been a shy but normal teenager. His comment years later that 'I was't amazingly popular, although I guess I wanted to be, because when I would see the kids telling one another their problems, I felt left out. No one confided in me,' seems typically misleading.

'He was oddball-looking but not oddball as a person,' one Schenley graduate recalled.

> He didn't dress outlandishly. He often wore a favourite sweater vest with the sleeves of his shirt rolled up, and, like almost everyone else, he wore saddle shoes. But he had that white hair which he wore down in bangs or swept back. Most of the other boys wore crewcuts, and sometimes they made fun of him - they called him 'the albino'. He was more serious than most of us were, but that doesn't mean that he didn't have fun.

Andy had a number of friends, mostly girls. He developed a close friendship with a Jewish girl named Ellie Simon, which he would maintain throughout college and his early years in New York. Ellie was intelligent, artistic and a little self-critical – she thought she was ugly – but her outstanding quality was empathy. 'Ellie had a thing about helping other people, particularly if they had emotional or physical problems, and she seemed attracted to these people,' recalled a mutual friend. By now Andy had a lot of problems and Ellie was a font of sympathy. Though there was no romance involved, Andy and Ellie became so close and spent so much time together that Julia became jealous and warned Andy that they would not be able to marry because of their different religions. Ellie recalled Andy as something of an eccentric even then, with an unusual sense of humour, an independent person, not a conformist.

He remained close to Margie Girman, and her friend Mina Serbin was, like Andy, a member of the school safety patrol. Every afternoon after school, Andy and Mina would patrol the street crossings until the students had all withdrawn from the area. Then he would accompany her to Yohe's drugstore and join other high-school students in the traditional pastimes of eating ice cream, playing the jukebox and messing around. Andy always had a sketchbook and would draw while the others talked, joining in only during their more serious discussions about who was going to college and how many neighbourhood boys had been killed in the war. Mina Serbin:

Andy was different than the other boys – he wasn't tough or frightening, and he didn't want to do anything wrong with you. He was always complimenting me. I was captain of the cheerleaders, I was popular but I wasn't that pretty, but he would always say how beautiful my hair was or what nice colours I was wearing.

We didn't really have dates in those days – who could afford it? But we went bowling in Oakland together, and we went ice skating, and we'd walk to the movies holding hands. One time, when I was about fourteen, a man sat next to me at the movies and put his hand on my knee and offered me candy. I was very upset, I was crying, and I told Andy. I remember he went off looking for the man like he was going to do something to him. Andy was going to protect me.

During his junior year a student canteen called the High Spot opened, where on Friday nights for 25 cents the students could drink Cokes and dance to a jukebox. Andy played an active role as a member of the board of the High Spot, and could usually be found there with the others on Friday nights. This was during the big-band era. (There were also many concerts in Pittsburgh and Andy attended at least one by Frank Sinatra.) 'I didn't think Andy was the greatest jitterbugger, but he did slow dance very nicely,' Mina recalled.

He was successful enough with girls to stir jealousy as well from the other boys. Seeing him walking Mina or Ellie home, they would wonder how come Warhola, with his pimply face and high-pitched voice, was able to talk so easily to girls who tied their tongues in knots.

One student who remembered Andy with mixed feelings was Bill Shaffer. His parents were in the middle of getting a divorce so he was emotionally scattered and insecure. He took a lot of derision because he was the smallest boy in his class. When Andy took a sympathetic attitude to Bill Shaffer and talked with him, although their relations never went beyond the school walls, Shaffer felt flattered because by then Andy was a not unremarkable character in his class.

The acquaintance turned sour for Shaffer when Andy started taunting him. It began in the showers during the compulsory nude swimming period.

Everybody hated to go into the pool so for most of the hour everybody would just stand in the shower. Andy was always in that shower. He used to twit me because I was on a lower end of the scale as was he in terms of we were both about the shortest-hung studs in the shower. The short-hung guys would face the shower and the other guys would turn around. I very distinctly remember he always stayed in the back of the shower and never went in the swimming pool. Andy had an ugly body. He had a little dick and a kind of hunched back, a little bent. He wore his hair straight back and had this bulbous nose. I did not suspect him of being gay. It wasn't the sort of thing one thought about at that time.

In the corridors afterwards when Andy passed Bill Shaffer he would point at him and say, 'Hee hee hee hee hee hee.' It made Shaffer feel very uncomfortable. 'He used to say, "Shaffer, euuuughh . . . euuuuughh . . . eugggghhh." He used to just ridicule me. There were others who he twitted too.' Shaffer and Andy were in the same algebra class and when Shaffer was asked to drop out Andy taunted him about that as well. It was, thought Shaffer, who said they were high-school friends, part of his personality. Shaffer also had the distinct impression that Andy was anti-Semitic, which was very common among the hunkie people.

But Andy's reputation among the majority of the teenagers at Schenley was summed up in the phrase used to describe him next to his graduation picture in the yearbook: 'As genuine as a fingerprint'.

*

I tried and tried when I was young to learn something about love and since it wasn't taught in school I turned to the movies for some idea about what love is and what to do about it [Andy wrote in *The Philosophy of Andy Warhol*]. In those days you did learn something about some kind of love from the movies, but it was nothing you could apply with any reasonable results. Mom always said not to worry about love, but just to be sure to get married. But I always knew that I would never get married, because I didn't want any children. I don't want them to have the same problems I have. I don't think anybody deserves it.

And in his book *America*:

I loved going to the movies and I probably hoped that the movies showed what life was like. But what they showed was so different from anything I knew about that I'm sure I never really believed it, even though it was probably nice to think that it was all true and that it would happen to me some day. It's the movies that have really been running things in America ever since they were invented. They show you what to do, how to do it, when to do it, how to feel about it, and how to look how you feel about it. Everybody has their own America, and then they have the pieces of a fantasy America that they think is out there but they can't see.

Andy was enormously influenced by the movies, the radio and the press of the 1940s and benefited from the high standard of the American culture of the period. Entertainment was important during the war. Movies were in particular demand. The Hollywood studios worked at peak production, many of them turning out a film a week. The swing bands of Glenn Miller, the Dorsey Brothers and Artie Shaw blared out of every radio. Everything was big, dramatic, dynamic and sharp.

There were only two cinemas in Oakland during most of the time Andy lived there and they were both Warner Brothers theatres. The 1930s and 1940s were the great period of American filmmaking. The resulting classics, with their dramatic camera angles, high-contrast

lighting and underlying sexual implications, had a major influence on Andy. The studio system reigned, films were made quickly for relatively small amounts of money, and a large number of stars were manufactured to satisfy the movie-hungry public. Bing Crosby, Bob Hope, Humphrey Bogart and Abbott and Costello were the leading male stars, Judy Garland, Peggy Lee, Rita Hayworth and Betty Grable represented the women, and in 1944 Andy got a new child star to identify with when the sultry twelve-year-old Liz Taylor burst onto the scene in *National Velvet*, playing opposite Mickey Rooney. In addition to this, Warner Brothers created a revolution in animated cartoons with the introduction of the slapstick comedy of Elmer Fudd, Bugs Bunny, Sylvester, Daffy Duck, Tweety Pie, Tom and Jerry, and Popeye the Sailor Man, who Andy would later claim was his childhood hero, while Walt Disney was developing epic cartoons like *Fantasia*. Attendance was at an all-time high.

Radio had a bigger audience and better shows than ever, too. Hitler's speeches, Churchill's impassioned and defiant voice and Edward R. Murrow's broadcasts from London brought the sounds of the war into the Warholas' living room. According to Mina Serbin, all Andy ever talked about was how many people were dying. His favourite radio character was the Shadow, whose signature statement was, 'Who knows what evil lurks in the hearts of men? The Shadow knows . . .'

Magazines and newspapers proliferated and Andy read voraciously, paying particular attention to the photographs, many of which he tore out and used in collages and drawings. This is where he picked up the kind of images he would later use in paintings that would shock and dismay people with their 'bad taste'. Although the war news dominated their pages, the newspapers of the forties, rather like some of Andy's Zavacky relatives, thrived on disasters at home, too. Deaths in railroad accidents, hotel and circus fires, earthquakes, hurricanes, flu epidemics, explosions and plane crashes were grist for the mill, as were the thousands of mutilated soldiers crammed into hospitals all over the country. Photographs of people committing suicide (usually women jumping out of windows) were standard fare. One famous photo, which looks almost exactly like a Warhol disaster painting of the sixties, showed the hole produced between the seventy-eighth and seventy-ninth floors of the Empire State Building when a bomber crashed into it on 28 July 1945. The press feasted on disasters throughout the decade and Andy had the dubious honour of waking up on his seventeenth birthday to read the *Pittsburgh News* headline SECRET ATOM BOMB TO WIPE OUT JAPS accompanied by President Truman's threat, QUIT OR DIE!

When I was little, I never left Pennsylvania, and I used to have fantasies about things that I thought were happening in the Midwest, or down South, or in Texas, that I felt I was missing out on [Andy wrote in *America*]. But you

can only live life in one place at a time. And your own life while it's happening to you never has any atmosphere until it's a memory. So the fantasy corners of America seem so atmospheric because you've pieced them together from scenes in movies and lines from books. And you live in your dream America that you've custom-made from art and schmaltz and emotions just as much as you live in your real one.

CLASS BABY

1945–49

If anyone had asked me at the time who was the least likely to succeed, I would have said Andy Warhola.

ROBERT LEPPER

During his senior year at Schenley, Andy had been accepted at both the University of Pittsburgh and the Carnegie Institute of Technology, and chosen the latter because it had a better art department. 'Andy told me he had been accepted,' John recalled, 'but he wasn't very excited about it. Andy wasn't the sort of person who really showed his expression. He did tell me he was glad but that was about it. We felt proud because I didn't know any fellows going to college, it was just somebody from the wealthy families.'

Going to college was a big step in Andy's career. It held the promise of escaping from Pittsburgh, which still smelled like the inside of a tunnel, to the crystal city of New York, and it was desperately important to him.

Things had improved at home. Julia had got over the shock of her colostomy and concentrated on supporting Andy's ambitions. She moved out of the front bedroom so that he could have the best room in the house to work in, and paid the first year's tuition out of the postal savings bonds on which she was living. With Paul out of the picture John was the man of the house and he took care of the monthly bills by working as a Good Humor ice-cream vendor. Still, the transition was fraught with problems.

First it turned out that Andy had no birth certificate, because Julia had failed to register the event. As soon as this problem was remedied with a signed affidavit, John recalled:

They weren't going to accept him because he was going to just go in the evenings to save money, but my mother told him to go back and tell them that he'll go in the daytime and she gave him the money. I think it was $200 a semester. I remember before he went to talk to the people at the office he had to kneel down and say some special prayers with my mother.

Carnegie Tech, on its beautifully landscaped campus in Oakland, near the rows of mansions where the Pittsburgh elite lived, was a zone of culture distinctly separate from the workaday life of the city. The

Fine Arts building, which contained the departments of Painting and Design, Drama, Music and Architecture, was a grand rectangular building five storeys high, composed of yellow brick with a four-sided, sloping, green-tiled roof. Rows of large windows were divided by ivy-covered Doric columns. The interior had wide marble hallways where students from the various departments mixed. They were easily distinguished by their specialities. The architects were suit-and-tie types, the music students were locked away, for the most part, in practice rooms, the sculptors were like troglodytes in the basement, while the drama students rushed around calling each other 'darling' and detailing pathetic litle bits of Broadway gossip. The Painting and Design students, in their requisite paint-spattered jeans and turtlenecks, were generally regarded as the most intelligent and talented, but since Tech was primarily an engineering school, the fine-arts students were largely isolated from the remainder of the student body and even more from the real world of Pittsburgh.

The academic standards at Tech were high, the courses were competitive, and hard work was stressed. *Laborare est orare* – To labour is to pray – was the motto of the school. Andy's freshman courses were called Drawing 1, Pictorial and Decorative Design, Color, Hygiene, and Thought and Expression. In one way or another Andy had trouble with all of them, but his most glaring problem came in Thought and Expression.

The course was taught by Gladys Schmidt, a stern woman who ran the only artistic salon in Pittsburgh and bore an unfortunate resemblance to Popeye's Olive Oyl. Nevertheless, Thought and Expression, in which students attended plays staged by the drama department or read books, then discussed their reactions and wrote interpretive essays about them, was popular and fun. But Andy, with his hunkie accent and vocabulary – he would say 'ats' for 'that is', 'jeetjet' for 'did you eat yet?' and 'yunz' for 'all of you' – and his inability to write grammatically, was in trouble from the start. There were few students from ethnic minorities and being a hunkie was very outré.

'It was said that his mutilations of the English language were the despair of Gladys Schmidt,' one of Andy's teachers recalled. 'Andy was never very strong in his academics, but that had nothing to do with his intelligence – there was a language problem at home, and it was also difficult for Andy to follow directions in the beginning, because he had already developed enough to be very self-directed.'

Andy never spoke in Gladys Schmidt's class, and was incapable of forming his thoughts coherently in writing, often relying on the help of two classmates: Ellie Simon, who had come to Tech with him from Schenley High School, and Gretchen Schmertz, a slender, talkative woman whose father was a professor in the architecture department. Gretchen Schmertz described Andy's appearance at the time as 'thin,

soft-spoken and very pale, as if he never came out in the sun, and he appeared to be frail, but I don't think he really was because he always produced a lot of work, most of it at night'.

Working at night was a habit Andy had developed in high school because he was afraid of the dark and it was the only time he could be completely uninterrupted. Now that he had his own room he could work as late as he liked.

The girls helped Andy write his papers. They would get together after class and ask him what he thought about the book or play in question. Gretchen would put his thoughts, which she remembered as always interesting, into literate English, then the three of them would go over the paper to make sure it sounded as if Andy had written it. This ploy, however, could not cover up Andy's difficulties when he was called upon to speak or write exam papers, which was a serious problem, because if he did not pass Thought and Expression he would be dropped from the school.

At the same time, he was having considerable trouble with his art teachers. The faculty was led by a group of older academicians like the department director, Wilfrid Readio, and the anatomy teacher, Russell 'Papa' Hyde, who simply did not know what to make of Andy. Often his work seemed slapdash and untalented. He would, for example, tape a piece of torn construction paper over the gaps between one figure and another in a drawing, or leave the paw prints of the family cat on his work as a sign of sensitivity. On several occasions, he brought in something completely different from what the class had been told to do, as if he simply had not understood the assignment.

Robert Lepper, who was a younger, broader-minded teacher than some of his colleagues, remembers that Andy was

> a timid little boy who was often in academic difficulty. At that time the work of the students was graded by a jury system. The majority prevailed. At first, Andy was regularly proposed for 'drop' from the institution for failure to maintain standards. It is to the credit of the faculty, some ten or twelve, that the proposal to 'drop' failed by at least one vote, and that Andy was permitted to continue his studies. I am pleased to think that I always voted on the side of the angels before he was my student and certainly after. I didn't know him as a person but I knew him because of his work. I didn't even have to look at the name. I'd just say, 'Here we go again. There's going to be a fight.' He regularly split the faculty down the middle. Some of them thought he couldn't draw at all. Others recognized his talent immediately. Andy was the baby of the class; the other students all looked after him. He was a tiny, undernourished little guy.

At first Andy found himself out of his depth. However, he had learned when in trouble to find a strong woman to support him. His strategic choice was the art department chairman's secretary, the

sympathetic, strong-minded, Tallulah Bankhead look-alike Mrs Lorene Twiggs. Most people who met Andy during his first year at Tech say that he was so shy he could hardly speak. Soon, however, Andy the crybaby was pouring his heart out daily to Mrs Twiggs. Conjuring up a tale of abject woe he told her how ill his mother was in clinical detail with no embarrassment. He emphasized how poor they were and how difficult it was for him to get any work done at home. His brothers, he claimed, made fun of him for wanting to be an artist and let their children stomp all over his work. To illustrate his predicament he always wore the same pair of baggy jeans, a turtleneck, a frayed workshirt and a pair of sneakers that looked as if they had been found in a Goodwill box.

'The main threat to him was poverty,' believed Gretchen Schmertz. 'We were concerned that he was warm enough in the wintertime. Nobody did the Joe College dressing at the time – the girls wore blue jeans – but it was a case of: Does he have gloves for his hands and a decent coat or sweater? I never visited his house, it was off limits.'

The truth was that his mother served Andy delicious, piping hot meals whenever he would eat them, and chased him around the living room every morning trying to force a woollen hat onto his head because he caught cold so easily. Andy evaded these attempts, gleefully sliding out of the front door like one of the Katzenjammer Kids. He finally agreed to carry a pair of earmuffs but rarely wore them.

In the economic recession following the war, jobs were scarce and many returning soldiers began to take advantage of the opportunity of going to college on the GI Bill. Since the art department could accommodate a maximum of 100 students, it was announced that thirty to forty members of the current class would be dropped at the end of the first year to make room for the veterans. In fact, only fifteen of the forty-eight in Andy's class would survive. 'The competition was tremendous,' recalled Gretchen Schmertz. Despite her and Ellie's assistance, and the help of a new tenant at Dawson Street, a Mrs Hyatt, Andy failed Thought and Expression and his other grades were poor.

Paul Warhola: 'Mrs Hyatt helped him a lot during his first year in college. We rented her and her husband a room and they lived there for a short time. She was very instrumental in helping Andy out because she was a college graduate herself.'

As a result, at the end of his freshman year, Andy was automatically dropped from Carnegie Tech. On hearing the news he burst into tears. Andy's response to rejection in general throughout his life was that he couldn't handle it, and it was one of the few things that could reduce him to tears. One member of the faculty, the painter Sam Rosenberg, according to his wife Libby, 'hated the judgement system and his one big gripe was what they did to Andy. He said Andy was as fine a draughtsman as he knew. Sam thought he was better than some of his

teachers, and he was very upset when they almost dropped him.' John Warhola:

> When Andy came home that day he was very upset and very determined, alternating between weeping and saying that if they threw him out he would go to art college in New York. I wondered how he would be able to do that but Andy just said he would. Then Mother said, 'We'll say some prayers and everything will be all right.'

Paul Warhola had just returned from the navy:

> At that time they were very particular. His grades weren't up and he was clearing out his locker. I guess he felt kind of bad about it and he was crying and the professor came in and he said, 'Jeez, what's the trouble, Andy?' Andy said, 'I flunked out and I feel bad because I won't be able to come back.' The professor said, 'I didn't know you were so concerned about it, I thought maybe you were just coming to school because you had to. Let me give you some advice. You go to summer school and make up these credits and reapply in September.'

Russell Twiggs hung the students' work and was, along with his wife Lorene, a confidant and bridge between them and the faculty:

> At the end of his first year at the faculty meeting, a majority of the teachers felt Andy should be dropped. My wife, who was recording the meeting, took it upon herself to put up a fight for him. She knew more about him than any of the teachers.

Another teacher confirmed, 'Mrs Twiggs, who was a very sharp gal in that she was able to spot talent, said, "He just hasn't bloomed yet, he's too young. Let him come back over summer school." ' The faculty decided he should go on probation for the summer and produce work to be considered for readmission in the autumn.

This rejection so scarred Andy that later in life he would deny ever having attended college or tell people that he hadn't got anything out of the experience. 'They didn't help me out at all,' he would tell Paul, who found this hard to believe. However, there was less pressure at summer school and Andy, accompanied by the ever faithful Ellie Simon, thrived on it. He made up Thought and Expression, and took 'Papa' Hyde's course in anatomy. Russell Hyde was in his seventies. Over six feet tall with a big head of neatly swept-back silver hair, he was as formal in his appearance, always in three-piece suits, as he was keen on Nicoleydes' natural approach to drawing.

'I think Andy's relationship with "Papa" Hyde that summer was extremely important,' related one of Andy's classmates.

> In my opinion, it is the metamorphosis of Andy Warhol. He gave Andy a

lecture in summer school one day. He said, 'Andy, damn it, you just must stop drawing in a manner where you try to please me or you're trying to get a good grade. You do it the way you see it. I don't care how good it looks. How bad it looks. You've got to do it to please yourself. And if you don't do it, you'll never amount to a damn. Be goddamned what I think. Or what Wilfrid Readio thinks. You must do it to please *you*, regardless of what anybody thinks.'

*

Paul had started a new business. He had a flatbed huckster's truck and sold fruit and vegetables door to door. He gave Andy a job for the summer helping him three or four mornings a week for three dollars a day. They would load the truck early in the morning at the produce market and follow a regular route. Andy would run from door to door, yelling, 'Fresh strawberries! Fresh corn!' and delivering orders as Paul drove the truck down the street.

Soon Andy started to carry a sketchbook on the truck. He sketched everything he saw around him at the produce yard and in the streets, using a technique he had learned at school called speed sketching. He would put the pencil on the paper and draw the figure in ten seconds without taking the pen off the paper. He drew people standing in doorways or gathered around the truck. 'It was a very uninhibited style,' one witness remarked. 'He drew what he saw. You could see the nude bodies of the women through their tattered clothes, babies hanging on to their mothers' necks. In a very simple manner he really got the essence of this depressed side of life.'

Andy presented a notebook full of these social-realist drawings to the art department and was reinstated at Tech. In fact, the first thing his classmates saw when they came back for the autumn semester of 1948 were Andy's huckster drawings hanging in a group accompanied by a striking self-portrait. This display was in a sense Andy's first show and it made him into something of a figure in the department and on campus, when it was anounced in the school paper, the *Tartan*, that they had been awarded the coveted Leisser Prize for best summer work done by a sophomore. The $40 prize money was the first cash Andy ever received for drawing. The award and cash given out by Chairman Readio in front of the assembled student body of the Painting and Design department drew the kind of attention to Andy that Fitzpatrick had noted he knew how to gain while appearing to avoid.

'I think Andy was a natural groundbreaker,' recalled one of the few black students in the department, Betty Ash.

There was an ambivalence of attitude at that particular moment in history, as to what degree one should celebrate rising above one's common lower-class background, and to what degree one should stay with it and celebrate it. Like Courbet, who came from peasant stock and was on the upwardly

64

mobile road via art, Andy wore his peasant heritage like a badge of honour. His use of the working-class vernacular was part of it.

The brightest students in the department formed a group led by a middle-class Jewish intellectual aged twenty-four who had just returned from the war. Philip Pearlstein had also been taught by Fitzpatrick as a child and made a splash by having two of his paintings reproduced in *Life* magazine when he was only fifteen. Pearlstein would become Andy's closest friend at Tech. Other members of the circle were Leonard Kessler, Arthur Elias, Jack Regan, George Klauber, Pearlstein's girl-friend Dorothy Kantor, Regan's girlfriend Grace Hirt, Ellie Simon and Gretchen Schmertz. Each of these people was a striking, stimulating individual in one way or another and they had a creative rapport. They were a noisy, outspoken, argumentative, high-spirited bunch. Their seriousness about what they were doing, shaped by the war years, was unprecedented even by the already tough Tech standards. Shortly after Andy won the Leisser Prize they began to notice him. Leonard Kessler:

> Here was this cherubic little guy drawing these beautiful graceful pictures of cherubs, and we started to talk to him. He was never argumentative, never put anybody down. He was a gentle and very kind person, and he had a whimsical smile and a wide eye, as if he was always ready to make some outlandish remark. Once we were sitting on the grass and he was looking up at the sky and he said, 'Maybe there are giants out there in the universe and we're like the ants on the ground in this universe.'

His new friends liked his drawings. 'Here was this kid who just drew like an angel,' said Gretchen Schmertz. 'He had his own quality of line, this wonderful shaggy, jagged line.' According to another student, Leila Davies, 'His work stood out, because he seemed to have a different approach. His development of a project would always be a little more unique than anybody else's.' Jack Wilson, another student, remembered that 'Andy was the damnedest mixture of a six-year-old child and a well-trained artist. He put them both together totally without inhibition.' Philip Pearlstein:

> It was very apparent to all of the students that Andy was extraordinarily talented. It was not apparent to the faculty. But there was this marvellous quality. Andy was a very young person. He liked to laugh. He was very naïve and left himself open in a way. He was like an angel in the sky at the beginning of his college times. But only for then. That's what college gets rid of.

'He was very naïve and left himself open,' agreed Jack Wilson, 'but I cannot remember Andy laughing. He always had a kind of sad face. He was pleasant, but he never laughed.'

Andy greatly benefited by their association. He was able to play up the bad-little-boy side of his personality, delighting in trying to shock the not easily shocked veterans by drawing pictures of little boys masturbating and peeing. They, in turn, delighted in Andy's naïveté and talent. The women in the group all mothered him. Soon he had them all thinking of him as the class baby. This meant that without being the leader of the group, as he would be in his glory days, he was always at its centre, protected, nurtured.

*

Many of Andy's professors in the art department were commercial and industrial designers. The teachings of the Bauhaus, the German-based movement led by Walter Gropius and Laszlo Moholy-Nagy, whose basic policy was the marriage of art and technology, was particularly emphasized. The Painting and Design faculty believed that fine art and commercial art were one and the same thing and their avowed aim was to break the barriers between them. The P&Ds were taught that the important thing to learn was good design. Moholy-Nagy's *Vision and Design* and Paul Klee's *Pedagogical Sketchbook* were two of their principal texts. The Bauhaus was an example of art as business, an organization with a number of people, that Andy would not forget. His own work ethic at his New York studio, the Factory, would be based on just such a principle.

The period 1945–49, between the end of the Second World War and the onset of anticommunist hysteria, was a time of energetic intellectual curiosity on American college campuses. Different social and ethnic groups mixed together as they never had before. The seeds of the women's and gay liberation movements were sown in this period.

The writer Albert Goldman, who grew up in Pittsburgh and was a student in the drama department at Carnegie Tech at the same time as Andy, recalled the prevalent attitude:

We scorned popular culture. We were artists. The idea that anything popular could be artistically interesting unless it involved the spirit of the people and the working man would have been unthinkable then. The arts were the arts and this other garbage was in Hollywood. I remember going to *Song to Remember* about Chopin, Cornell Wilde playing his balls off and Merle Oberon walking around with tight ass-grabbing pants – all right, that was culture but the idea of popular music you never heard. It was the greatest era in the history of jazz and you never heard a note of jazz. Of course when you went to school you put away childish things like jazz, the jitterbug, Hollywood movies. You could see art movies, you could go to see a naked girl crawl down a table and take a key and put it in her mouth and look strange, that was fine, that was art, don't ask me what it means, but no, you didn't go to regular movies, you cut yourself off. When you walked into Carnegie Tech you put that world behind you and beneath you – Go fuck yourselves, you're nothing but philistines – and you moved on to this higher plane of being.

66

The faculty encouraged it. They were like German drill instructors. These were very exceptional people, these were artists and they belonged to a different world. That's why that idiot movie, *Song to Remember*, was so important, because that movie is a very campy version of the idea of the artist's superiority to the common man. We really believed that we were these chosen spirits, we were these wonderful souls, and that people around us were just such assholes that we couldn't even waste our time thinking about them. The heroes of the age were Picasso, Michelangelo and Matisse. Looking back on it I can see that we were totally out of touch with reality. We didn't have any idea of what was really going on in the arts or the theatre. Who'd ever heard of Jackson Pollock? Art was something that went on in a studio. That was a very important word – a bohemian ideal – *studios*. You always had turtlenecks, a very vital element . . .

By his second year Andy was none the less thriving in this environment and casting off some of the shyness of his freshman year, although he still needed a lot of help with his written papers. He joined a student film club, the Outlines, which screened films from the Museum of Modern Art in New York. The club also hired guest speakers and Andy heard lectures by the avant-garde filmmaker Maya Deren and the composer John Cage. Pittsburgh had a fine symphony orchestra and he attended their concerts. Andy also became interested in ballet and modern dance. José Limon was a cultural hero and Andy and Philip saw him every time he appeared. Martha Graham visited and made a big impact on the whole group. Andy was very moved by her performance of 'Appalachian Spring'. They posed for photographs parodying her style.

Andy was so interested in dance that he went one step further and began taking modern-dance classes with Kessler's sister Corkie Kaufman. He had little natural rhythm and found it agonizing to do his pliés, but twice a week he changed into a leotard and joined the girls exploring rhythm, space and movement for an hour. He also joined the woman's modern-dance class at Tech, in which he was the only male, and posed somewhat defiantly with the girls for their yearbook picture. Asked many years later if she recalled him, his teacher, Dorothy Kanrich, snorted, 'He was a nut!'

His greatest pleasure of all were the parties. In the living room of Gretchen Schmertz's family or at the Kesslers', since 'Pappy' Kessler was married and had his own place, Andy would sit at the tables with his fingers covering his mouth in a characteristic gesture he copied from his mother, and listen to the conversation swirl around him. 'He enjoyed them immensely,' said Kessler. 'He just loved parties. He glowed. You could see the litle cherubic face lighting up.'

Andy never spoke about homosexuality, never made any sexual advances and, like most of the students, did not have sexual relations with anybody while he was at Carnegie Tech. Albert Goldman:

Screwing around was something the people in charge regarded as very dangerous. Students were expelled for it. So there was little hanky-panky, and besides, the students by and large had no money – they either lived at home or in tiny rooms around campus in the apartment of some old matron, so where were they going to go? And they were working around the clock. Anyone who talked openly about homosexuality would have been considered insane.

Though there were some openly gay students in the drama department, where there was enough artificiality to enable them to get away with it, in the more straight-laced milieu of Painting and Design there was no overt suggestion of homosexuality, though some of the students, like George Klauber, and faculty members, like Perry Davis, a new, young instructor, were homosexuals.

According to the British historian John Costello in his book *Love, Sex and War*:

The military experience of homosexuality in World War II chipped away some of the old taboos. Servicemen living in close proximity to one another were made aware that men who chose a sexual relationship with other men were not suffering from a deadly disease, nor were they cowards or effeminate. Many thousands of homosexuals discovered a new consciousness of their collective identity in the subculture of bars and camaraderie which expanded to meet the wartime demand.

In the postwar reaction to the liberal morality of wartime, there was an inevitable homophobic campaign.

Betty Ash identified with Andy because, being black, she also felt like a loner among her more privileged classmates.

There were people who would avoid anyone who seemed to be gay like the plague. One of the prejudices of the day was all artists are gay and to be gay is wrong or bad. So there were people who overstrutted the macho bit in order to avoid any suggestion that they might be gay or might even be friendly towards guys who were.

To them it was quite evident that Andy was gay from some of his mannerisms and the way he dressed. He used to wear a corduroy jacket with the collar turned up and closed across his throat with one delicate hand. Walking with a dance step he whispered 'Hi!' to everyone he met in a surprised, breathless voice. When he was sitting down his hands were always artfully placed or suspended from his wrists. Betty Ash:

I think people tended to protect him and shield him from some of the other characters who definitely said some unkind things about him. I remember when one of Andy's drawings was in exhibition and I was looking at it in

admiration and there was this one guy who liked to tell dirty jokes and make fun of any fella that he thought less than fully masculine. I can remember him making a comment about how he didn't understand why everybody was always celebrating the work of this fruitcake.

Of the faculty members, Perry Davis was closest to and best understood Andy.

It wasn't that Andy was streetwise but maybe through his family he had an idea of how to get along in the neighbourhood. And I think he would avoid going to a certain street corner for fear some of the older boys might beat up on him. Homosexuality was pretty well accepted in art school. But no one really thought much about Andy and sex because he left a very sexless impression. He had a childlike duality about him. It was just that Andy always was intrigued by anything that was bizarre.

In the summer of 1947 Pearlstein, Elias, Jack Regan, Dorothy Kantor and Andy rented a studio. The Barn, as they called it, was the carriage house of an old Victorian mansion across from the Carnegie Tech campus. It cost $10 for two and a half months. They each had their own space to work in. To inaugurate it they threw a bohemian party with a chamber orchestra, then settled down to a spell of serious work. Art Elias:

That summer we had the Barn was a wonderful period. That was the summer we all decided to dedicate ourselves to painting. We didn't know exactly what painting was. We were all rather nonverbal. Andy was very influenced by Ben Shahn and Paul Klee. Jack Regan was rather protective of Andy. People bent over backwards to help Andy. He was very passive and he brought it to a high art form. We were both rather shy and we were walking over the Schenley bridge together one day, there were a few quiet moments and he said, 'Entertain me.'

They spent hours discussing and commenting on each other's work. Andy did a series of paintings of children on swings and little boys picking their noses. Even this early on he was drawn to serial imagery and intent upon reviewing periods of his childhood. They all decided to dedicate their lives to painting.

The future looked bright and dark for Andy. On the one hand, he was an artist. On the other hand, what was an artist? President Truman had expressed the opinion in a recent speech that they were goldbrickers.

Andy was already developing the habits of a workaholic. Paul had got him a job as a soda jerk for the summer and the boss was hard on him. According to John, Andy worked till 3 a.m. washing dishes at the soda fountain.

*

While Andy was at Carnegie Tech he discovered the blotted-line drawing technique that was to be the mainstay of his commercial-art career in New York during the 1950s. Just how he discovered it is unclear. Wilfried Readio taught blotting in his technical-resources course, but Andy said that he discovered the technique when he accidentally spilled some ink on paper. It seems likely that he copied it from the successful and well-known fine and commercial artist Ben Shahn. For his blotted-line drawings Andy took two pieces of paper, laid them next to each other and attached them by a piece of tape that would act as a hinge. Then he drew on the right-hand sheet. Before the ink could dry he lifted it up and folded it down on top of the left-hand sheet. The 'blotted' line was a smudged mirror image of the original line he had drawn. Andy liked the look and the implication that since his hand had not actually drawn the line onto the piece of paper that would contain the final product he had removed himself one step from the result.

Ever since he had contracted chorea Andy had been using elements from magazines in his work. At Tech he was ripping pages out of *Life* magazine. He began to use parts of them in his blotted-line drawings. If he was doing a drawing with a chair in it he might trace a chair from a photograph. If he traced another object from a photograph onto a drawing via the blotted line he was distancing himself two steps from the final result. What Andy did with the combination of the blotted line and tracing details from photographs was directly influenced by the Bauhaus approach to art, removing personal comment from the work, focusing on design and breaking down the barriers between commercial and fine art. These methods contain the seeds that would eventually blossom into his silkscreen paintings of the 1960s.

Some of his teachers afterwards agreed that Andy came to Tech with a style and developed it on his own and that what he got from the institution was what he took, not what he was given. However, many of the members of Pearlstein's group insisted that Professor Robert Lepper, who taught juniors and seniors majoring in Painting and Design, was a big influence on Andy. Lepper himself demurred, saying only that Andy did very good work in his class. Lepper taught an anthropological approach to art – that it was necessary to know how a person in a drawing felt before you drew them. Andy only drew what he knew about first-hand. Lepper assigned his students to read modern novels and short stories and draw illustrations for them. Andy excelled at the task. He began to draw and paint a series of large blotted-line pictures that showed an intelligent understanding of what the books were really about, and a sharp ability to go straight to the heart of them and chose an image that would capture their essence. A large blotted-line drawing illustrating the fictionalized character of Huey Long giving a Nazi-style salute from Robert Penn Warren's *All the King's Men* is a

memorable example, now in the Carnegie Museum Library. That is not something that Lepper would have taught him how to do.

Among the other faculty members, perhaps the most influential on all the aspiring young painters was Balcomb Greene, since he seemed most to exemplify what being an artist was all about. Tall, with a sweeping white moustache and a deep voice, Greene looked like John Carradine and was the heartthrob of many of the women students. The fact that he was an abstract painter and painted at night – in the nude – added to his legend. His wife 'Peter', a swarthy constructivist sculptor and a near-total opposite to her dashing husband, spent most of the winter in her studio in New York, making him even more of a target for the mad crushes of the girls.

The high-minded attitude towards art of Sam Rosenberg, Lepper, Balcomb Greene, Howard Worner, Perry Davis and Roger Anliker, their serious consideration of his work and their example must have encouraged Andy to think of himself as an artist and to see art as a possible profession. Certainly he learned from the environment at Tech: from the cultural activities of the Pearlstein group, the art-history slide shows of Balcomb Greene, and the open-minded conversation of Perry Davis and George Klauber.

In the spring of 1948, with one more year to go, Andy, then nineteen, began his art career. He was given a job in the display department of Pittsburgh's premier department store, Joseph Horne's, painting backdrops for windows. He thought the store was like heaven. Once again Andy entered into a refined world in which his oddball personality and behaviour branded him as an eccentric. He would paint his fingernails a different colour every day, dye one of his shoes a different colour from the other, or let his tie dip into cans of paint. Once again he charmed everybody before they could object. Larry Vollmer, his boss and the only person in Pittsburgh Andy has ever publicly acknowledged as an inspiration to him, was a suave businessman and display director who had worked in New York with some of the top artists in the world.

I had a job one summer in a department store looking through *Vogue*s and *Harper's Bazaar*s and European fashion magazines for a wonderful man named Mr Vollmer. I got something like 50 cents an hour and my job was to look for 'ideas'. I don't remember ever finding one or getting one. Mr Vollmer was an idol to me because he came from New York and that seemed so exciting. I wasn't really thinking about ever going there myself, though.

Once, Vollmer told Andy, he and Salvador Dali installed a fur-lined bathtub in the window of Bonwit Teller. There was a dispute between Dali and Vollmer and when Dali attempted to remove his work it went crashing through the plate-glass window onto Fifth Avenue. In the confusion following the incident Dali spent a brief time in jail and as a

result of the ensuing publicity his show sold out. Here was a lesson in public relations that Andy would not soon forget, and it was not lost on him that an artist as superior as Dali would stoop to doing commercial installations in a department-store window.

Vollmer was as impressed with Andy as Andy with him. Andy's commercial work was eclectic and varied. His only fault was that he worked too slowly. The most important thing he learned at Horne's was that to make it as a commercial artist he would have to work much faster.

At the store he was also exposed to the conversation of a group of colourful homosexuals. Perry Davis:

> When he worked in Joseph Horne's department store in the display department there were a number of flaming queens and he was fascinated with them and always intrigued by their conversation. They would talk about their costume parties. Some of them were very talented people, but what Andy noticed about them was the bizarre dress, mannerisms and that sort of thing . . . The students were always referring to Andy's being innocent and naïve and I felt that wasn't quite it. He just hadn't had the exposure. And then I think he still was so loyal to Mama that he had to go home at night. He might have wanted to do something else but he went home out of duty or respect, and love, I'm sure.

This was the first time Andy made any money to speak of. He bought himself an elegant cream corduroy suit that became known to his friends as his dream suit. Although it was not the most practical outfit, it defined his emerging self-image as an artist and dandy.

This first example of Andy's spending money indicated what his relationship with it would be. On the one hand he would splurge on impractical extravagances. On the other hand he would plough it back into his work. He spent the rest of the money on his first trip to New York to scout out job possibilities and look at modern art.

*

At the beginning of September 1948 Andy put his precious portfolio into a brown paper bag and took a Greyhound bus to New York with Philip Pearlstein and Art Elias on a scouting party to look over the territory they expected soon to be invading.

Andy boldly visited the two worlds that were foremost in his mind. In the offices of *Glamour* magazine he received a sympathetic reception from Tina Fredericks, who has since been given credit for discovering him. She was impressed by Andy's portfolio and said that she would give him freelance work when he graduated. At the Museum of Modern Art he saw for the first time original work by Picasso, Klee, Ben Shahn and Matisse.

Andy and his friends clowned for snapshots outside the museum and roamed the city. Joan Kramer, another Tech student, had invited

them to stay at her apartment in Greenwich Village, and George Klauber, who had left Tech the previous year and was already working as the assistant art director at *Fortune* magazine, had asked them to dinner at his parents' house in Brooklyn. George spent the evening talking about his successes, about how exciting the magazine world was and how commercial artists could make it in New York. He offered his contacts should any of his friends decide to move to the city. It seemed to Andy that George knew everybody.

Before he left New York he visited the offices of *Theater Arts* magazine, where he instantly fell in love with a blow-up of the sexually provocative photograph that appeared on the back of Truman Capote's first book, *Other Voices, Other Rooms*, which had just been published. Andy must have turned on all his charm because he left the office with the photograph of Capote.

Twenty-year-old Andy was instantly taken with the image of the 23-year-old Truman. He was everything Andy wanted to be. He lived in New York and gave dinner parties for Greta Garbo and Cecil Beaton in his boyfriend's apartment. He was young, attractive, talented, glamorous, rich and famous. Andy lived in Pittsburgh, was poor, unknown, insecure and did not have a boyfriend. However, he felt that Truman's description of himself at thirteen in the opening chapter of *Other Voices, Other Rooms* could just as well have been a description of Andy at thirteen.

Truman Capote now became Andy's idol and role model, superseding Shirley Temple and Mr Vollmer. Andy yearned to escape and join his hero in the radiant city. As soon as he got back to Pittsburgh he began to write Capote fan letters, but he did not respond. Andy also began a series of sensitive blotted-line watercolours to illustrate Capote's novel.

Andy had emerged from the shy cocoon he had been in as a seventeen-year-old freshman and in his senior year he was eagerly trying on a series of identities in his drive to become famous. By now he was a hero to many students in the art department because he symbolized the sensitive, emotional artist.

On the campus there was a large student cafeteria made out of an aircraft hangar, called the Beanery. In the centre of this building was a self-contained coffee shop with booths and a jukebox. Andy could often be found here holding court at a table surrounded by students, much in the same way he could be seen sitting in clubs and restaurants in New York surrounded by adoring admirers in later years.

He had turned his hunkie heritage into a style. In his baggy blue jeans, open-necked work shirt or T-shirt and heavy work shoes Andy became a model of the working-class hero soon to be personified by James Dean, Allen Ginsberg and Jack Kerouac. People told each other Andy stories, imitated Andy, wondered what Andy would have

thought or done in such and such a situation. He had become a leader of subculture and even had his first hardcore fan in an underclassman named Arthur Reese. Perry Davis:

> I have never known anything like the hero worship a younger student named Arthur Reese had for Andy Warhol. I worked very hard to help Arthur for a number of reasons. I always thought from the beginning he was gay and he was. He made a tremendous splash during his first year. In his second year he almost had a nervous breakdown. He tried to commit suicide and he didn't turn in his final project and we had to drop him. When his parents came to pick him up they said, 'There's nothing wrong with Art,' but he was loading his paintings into the station wagon all wrapped in black. It was just like a funeral.

Arthur's self-destructive behaviour was to repeat itself among Andy's followers in the sixties.

Andy loved the studio parties in the art department but always kept slighly apart. 'We used to have these parties when we would get costumed and have song and dance and all types of art-student activities,' recalled Betty Ash. 'One time Andy came with chartreuse-green hair combed forward. I think he was trying to look like a woman in a painting by Matisse.' (It is more likely that Andy was imitating the role Dean Stockwell played in the 1948 film *The Boy with Green Hair* about a young waif who is shunned by society when his hair mysteriously turns green.) Betty Ash continued:

> Andy would come to the parties, but he would always wind up isolating himself from them to a certain extent. One evening, during one of these parties, I had gone out to the hall and I could see a figure in the shadows on one of the little narrow stairways that led up to the studios. Andy was sitting in a characteristic pose. He had his hands clasped, his fingers entwined between his knees, and he was sitting on the steps with his head leaning against the wall. When the party got to the state where everyone thought, Well, now we're really partying, he would tend to fade away.
>
> All the conversations I had with him would be marked by a certain reticence. There was a hesitancy in his speech, he would say a few words and pause, internally reflecting on what he was saying. He seemed to always be very careful and thoughtful about what he was saying. There would always be these strange little twists, or a humorous way of seeing that somehow things that seemed to be right side up in the world could also be backwards. He seemed to be able to see things on a couple of levels simultaneously, but there'd be a wry quality, seriousness mixed with humour, that struck me as being characteristic of him. He would talk to anyone who approached him quietly. I never had any trouble talking with him on a one-on-one basis in the corner of a studio where he was working, but he never wanted to get involved with idle or shallow small talk.

Andy's work was now beginning to cause a stir. Balcomb Greene

acquired a Russian wolfhound and this inspired Andy to do a series of dog paintings. In one work, a woman was shown nursing her baby, only the baby was a little dog. Andy confided to Perry Davis that as a child he always felt like a little dog. When he was nine the Warholas had acquired a dog to replace the family cat. The mutt was half dalmatian, half chow. John, Paul and their friend Harold Greenberger used to take the dog down to the basement when it was a puppy and take out their suppressed anger by kicking it around. When the dog got bigger, it became so vicious nobody in the family could go near it except Julia. Neither John nor Paul would dare even put one foot in the backyard when the dog was there, and eventually they had to get rid of it.

The painting was hung in a small exhibition in the department but was removed on the orders of Wilfrid Readio, who thought it was disreputable. During his senior year Andy walked around campus asking all the straightest students from the engineering and women's college to stick out their tongues so he could draw them. Everyone in the art department was surprised at how many people complied. Andy was so unthreatening and comic that he could get normally conservative people to lower their guard. When Professor Lepper assigned him to build a model of an Egyptian room for his final project, Andy presented his astonished teacher with the candy-coated model of a discotheque. He received a B. His greatest coup of all was with a painting called 'Nosepicker'.

Every year an institution called the Pittsburgh Associated Artists held an exhibition of local work. Andy had shown two paintings the previous year. For their March 1949 exhibition he submitted an autobiographical painting somewhat in the manner of George Grosz, of a little boy with one finger thrust defiantly up his nose. The painting caused a sensation among the jurors, who included Grosz himself as well as several regional academic painters. Just as Andy had polarized the faculty at Tech throughout his four years there, he now polarized the jurors. Half of them thought it was a terrible insult, the other half, championed naturally by Grosz, thought it was an important work. As the upshot of their argument the painting was rejected. Such censure was almost unheard of and only served to draw more attention to the work. This was Andy's first *succès de scandale*.

Among the multifarious projects Andy took on during his final, triumphant year at Tech were several collaborations with Philip Pearlstein. These two artists, who in their maturity would become leaders of major schools of painting, were diametric opposites, Pearlstein being heavyset, intellectual, bourgeois and heterosexual. They complemented each other. Pearlstein clarified points over which Andy was confused and introduced him to a whole range of subjects. Philip Pearlstein:

Andy and I shared certain attitudes. I would say if there's any relationship between Andy Warhol's work and my own, it would be a kind of cold looking at something, not worrying about what meaning it had, but just that it is interesting as an object.

Andy used Pearlstein, as he used everything, to the hilt. He liked people who could teach him things and was always an extremely receptive person. Conversely, Andy's energy and light-hearted vision helped to keep Pearlstein afloat with his own ideas. They designed the set for a play, put on by the drama department, using a large collage of newspapers and signs. They wrote and illustrated a children's book about a Mexican jumping bean called Leroy. When Andy wrote out the title he mispelled it Leory. This accident seemed perfect to both of them so they left it that way.

It was noted by several of his friends that Andy had become aware of the value of his work. At the end of each semester, when most of the students gave away or discarded their work, Andy sold the pieces he did not need for his portfolio to other students. He drew portraits of people at the Pittsburgh Arts and Crafts Center for five dollars each, but when he was offered $75 for a painting on show in the Pittsburgh Associated Artists annual exhibition, which he had listed at $100, he refused to lower the price and the painting did not sell. This showed a remarkably uncompromising attitude towards business. Seventy-five dollars was a lot of money to Andy in 1949.

During his four years at Carnegie Tech, Andy took several large steps towards becoming Andy Warhol. He began to experiment with changing his name. As art director of the university's literary magazine, *The Cano*, he was Andrew Warhola. On the Christmas card he designed, reproduced and sent to all his friends he signed himself André, an affectation he had picked up from George Klauber, who spent some time in Paris after the war. On the painting in the Associated Artists exhibition he was credited as Andrew Warhol. To his friends he was Andy.

As graduation approached, Andy was becoming increasingly concerned about what he was going to do. Here he faced a real dilemma. He was worried about leaving his mother, and, for her part, Julia could not imagine living without Andy. But what was he going to do in Pittsburgh? For a while he seriously considered becoming a high-school art teacher.

Mina Serbin was at a graduation party Andy attended at the Schenley Hotel:

I remember talking to him to find out what he was going to do and he didn't say that he was going to go to New York. He said he was going to go into teaching and I remember saying to him, 'Better you than me,' but I knew he admired Mr Fitzpatrick and I think he felt that Mr Fitzpatrick was the kind

of teacher he would like to be and I think he fashioned himself to be a teacher because he didn't feel he was good enough to make it in New York.

In fact, according to John, Andy had sent his portfolio to a school in Indiana to get a teaching post, and 'he was really disappointed when they sent everything back and says they can't use him. He was very upset and that's when he said, "Well, I'm going to New York." ' The sophisticated people he wanted to emulate lived there. The prospect of moving to New York was frightening, but it was what you did if you wanted to make it as an artist.

Julia warned him that if he went to New York, he would end up dead in the gutter without a penny in his pocket like Bogdansky, a Ruthenian artist whom his father had once tried to help. She repeated the name Bogdansky as if it were a religious portent every time Andy brought up the subject. But his friends urged him to go. They believed in him. They knew Andy could make it.

The sober, solid Philip Pearlstein swung the balance in favour of going to New York when he said that he would go with Andy. Balcomb Greene gave them his blessing and offered to arrange a cheap summer sublet for them. Once he had made up his mind, Andy was enormously excited about going. It was all he talked about.

'I remember the day Pearlstein and Andy left for New York,' recalled Paul. 'Mother didn't want him to go but she didn't want to stand in his way.'

Just before he graduated, Andy performed in a show put on by the art department's Take It Easel Club in which several students performed skits satirizing their professors. While one of them imitated Worner lecturing on the importance of the T-square, Andy suddenly burst onto the stage waving a large piece of coloured paper in each hand and did a triumphant dance, singing a song written by Leonard Kessler, but with sentiments that were Andy's, and, in a way, predictive of what lay ahead: 'Oh, you can't scare me, I'm sticking to emotion. It's my devotion. Oh, you can't scare me, I'm sticking to emotion . . .'

KISS ME WITH
YOUR EYES

1949–52

*The ultimate dream of any Painting and Design person was
to go to New York and get a studio. That word 'studio' was
enormously charged, it was much more charged than 'sex'
or 'fuck', because it implied this whole life, I mean, this was
it! The most talented and independent people would come
to New York in the summer and sublet somebody's studio
with an outdoor toilet for $18 a month.*

ALBERT GOLDMAN

According to Truman Capote's biographer, Gerald Clarke, when Capote
took New York by storm with his first novel in 1948–49:

> Manhattan was the unchallenged centre of the planet . . . Political decisions
> were made in Washington, but most of the other decisions that counted in
> the United States – those involving the disposition of money and fame and
> the recognition of literary and artistic achievements – were made on that
> rocky island, that diamond iceberg between the rivers . . . Eight major papers
> made everything that happened in the five boroughs, no matter how trivial,
> sound grave and consequential, while a battalion of gossip columnists made
> the city seem smaller than it was with their breathless chatter about the
> famous, and those who would like to be famous.

To the English critic Cyril Connolly, writing for the British magazine
Horizon, New York was 'the supreme metropolis of the present . . .
continuously insolent and alive'. To Capote himself it was 'like living
inside an electric lightbulb'.

One week after graduating from the Carnegie Institute of Technology
in June 1949, Andy Warhola and Philip Pearlstein moved into an apart-
ment in the heart of the Lower East Side overlooking Tompkins Square
Park. It was a sweltering, roach-infested, sixth-floor walk-up cold-water
flat with a bathtub in the kitchen and a toilet in the closet on St Mark's
Place in a Slavonic tenement slum worse than Andy's hunkie neigh-
bourhood in Pittsburgh.

Provided he kept his personal expenses to a bare minimum, the $200
Andy had saved to bring with him was enough to last through the

summer in New York in those preinflation days. Beyond that, he was counting on the portfolio of drawings he had been working on for the last two years to get enough work to support him. 'When we came to New York together on the train,' recalled Pearlstein, 'he had familiarized himself with all the elegant fashion magazines of that period and prepared a portfolio which was simply dazzling.'

Pearlstein was also hoping to be able to make enough from commercial art to support his larger, distant endeavours. His inclination towards realism and portraiture was already clear, though pointedly out of synch with the direction being taken by the action painters – Jackson Pollock, Willem de Kooning and Franz Kline – who were becoming recognized as artists of heroic stature by their contemporaries. Critics had lumped together Pollock's 'all over' paintings with their lyrically coloured spatters of pigment, de Kooning's fierce 'Women', and Kline's huge black and white canvases with the work of a cooler group of abstract painters that included such important artists as Mark Rothko and Barnett Newman, who concentrated their efforts on 'colour fields', into a movement – abstract expressionism – though there was little agreement among the artists themselves as to what that meant.

The Cedar Bar where the abstract painters hung out on MacDougal Street, a short walk from Andy and Philip's apartment, was already a subterranean legend for the at times violent, chair-smashing arguments between the painters. While Pearlstein could identify with the intellectual appeal of the abstract painters, characterized by a perhaps exaggerated degree of high-mindedness summed up in Barnett Newman's often quoted statement that artists 'make cathedrals of themselves', it was unlikely that he was going to follow in their footsteps. As for Andy, while the influence of the abstract expressionists would be of critical importance to both his art and pop in general, the two-fisted world of the Cedar Bar was not for him. He was far more inspired by the dramatic art of Tennessee Williams and the largely homosexual theatrical world than he was by Jackson Pollock's anguished drips, which he did not understand, and the macho realm that the abstract expressionists inhabited.

A lack of money was the one thing Andy and Philip had in common with the abstract painters, who despite their growing fame had yet to achieve anything approaching financial success. Although the art dealer Betty Parsons thought it was 'a magic time' and that Pollock had 'released the imagination of America and freed its creative urge', Robert Rauschenberg's biographer Calvin Tompkins wrote, 'The climate in the early fifties was still extremely hostile to modern art.' While, as Pearlstein would recall, 'the chances of making it as a fine artist were nil', commercial art work was readily available, particularly in the magazine and advertising fields, which were in the midst of their own revolutions. As America became the most overproducing nation in the

world, advertising flourished to package, design and sell products that were otherwise indistinguishable from their competitors. During the first years of the 1950s, the amount of money spent on advertising rose to nearly $9 billion – $53 for every man, woman and child in the country – and the need for images that would persuade and sell was unlimited. At the same time, owing largely to increased advertising illustration revenues, magazines were proliferating.

The world of commercial art was high-powered and snobbish – 'the crowd was the smuggest, meanest, drunkest bunch of people you ever saw,' one fashion veteran recalled – but George Klauber, Andy and Philip's friend from Tech had already demonstrated that the prospects were good for someone with talent, a little flair, and a lot of hustle. Of course, Klauber was a smooth, fast-talking New Yorker. So where did that leave Andy?

*

On his second day in New York Andy went to see the art director of *Glamour* magazine, Tina Fredericks, whom he had met on his first brief visit the previous year, in the vast Condé Nast building in the heart of Madison Avenue's 'ad alley'. He held himself in a loose way, with his hands hanging limp from his wrists, and talked in a breathless whisper. Fredericks was intrigued by Andy's personality and the way his drawings blended commercial and fine art. She even bought a small drawing of an orchestra for herself for $10, but warned Andy that while he was very gifted, she saw gifted people every day. 'I need some drawings of shoes, Mr Warhola,' she said. 'I need them tomorrow morning at ten o'clock. Can you do them?'

'Little did she know the wellspring she stirred,' commented one friend. 'Andy not only loved shoes. He loved feet.'

After replying that he could draw anything, Andy returned with the drawings the next morning. Fredericks was quite surprised to see that he had drawn the shoes with a lived-in, rumpled look that had a slightly suggestive sexual edge to it. 'They were terrific, but they wouldn't sell shoes,' she recalled. She explained that *Glamour* needed something with cleaner, harder lines, and the shoes must look new. That night, with a little help from Pearlstein, Andy completed a second set of drawings which he delivered to *Glamour* in the morning. This time, Fredericks bought them for the magazine, and gave him a second assignment, without knowing what wheels she had set in motion. Andy's shoes were to become his calling card as a commercial artist. Of greater immediate importance, though, was his fortuitous entrée at Condé Nast, at a time when Condé Nast publications, which included *Vogue* and *Vanity Fair* as well as *Glamour*, were setting innovative trends in graphic design.

Andy's unorthodox appearance made as much of an impact as his idiosyncratic blotted-line drawings. 'Brush your hair! Put on a suit!'

Pearlstein would urge him as they launched their assault on New York, going out every day lugging their portfolios to a series of art directors of advertising agencies and magazines whose names Klauber had supplied. Instead, Andy wore a bohemian uniform of chino pants, cotton T-shirts and worn sneakers, which he had appropriated largely from Marlon Brando, and carried his drawings in a brown paper bag, looking, one friend remembered, 'as if he had written his own part in a play by Truman Capote'.

His friends would nickname him 'Raggedy Andy', but his image of traumatized naïveté and hipster's innocence with its, as one critic later wrote, 'implacable sweetness and ability to humiliate himself', gained the sympathy of art directors, particularly women. Sometimes he would give a cheap bouquet of flowers to each of the receptionists he saw. Asked by one embarrassed recipient, 'Have I done something special?' Andy replied, 'No, you're just a nice lady.' Other times, while sitting for hours in the offices of a magazine on the off-chance of getting to see a busy art director, he would serve as a gofer, fetching coffee and doughnuts and ingratiating himself with everyone he could at any level of the business.

These were the golden years of the fashion magazines when they were, wrote Gerald Clarke, whose subject Capote had been made a star by them, 'among the liveliest publications in America and provided a haven for the new and daring'. A handful of powerful, European-born art directors and designers developed a new, sophisticated, Bauhaus-influenced commercial art that was strikingly graphic and visually alive. In this milieu Andy's drawing ability was immediately recognized and his off-beat personality was welcome. Art directors were also struck by how much fun Andy seemed to have doing the work. Unlike most commercial artists, who felt that they were prostituting themselves, he made each job seem like a special celebration. 'The impression he left,' recalled George Klauber, who now became his most important New York contact (Andy later said Klauber 'invented' him), 'was of this eager, interested person, who drew beautifully.' Within days of Andy's arrival in the city, Klauber's boss, Will Burton, whose prestigious clients included UpJohn Pharmaceuticals, had commissioned him to design a cover for one of the drug company's pamphlets. Other assignments quickly followed from *Charm* and *Seventeen* magazines, as well as a string of album covers for Columbia records.

Although Andy later said, 'I never wanted anything. Even when I was twenty and hoped that maybe one day I would be a success and very famous, I didn't think about it,' Pearlstein recalled him as

a workaholic who sat at a table and worked all day and often late at night and did several versions of each of his assignments, showing all of them to art directors, who loved him for that . . . He was not the evil character

people have tried to make him out to be. His *talent* – that's what should be emphasized.

Whereas Andy's portfolio fitted perfectly into the magazine world, Philip's was more political and it was almost immediately apparent that he was going to get nowhere as a freelance illustrator. Instead, he settled into a full-time job with the graphic designer Ladislav Sutner, doing layouts and mechanics for plumbing and ventilator catalogues during the day, and working on his own paintings in the evenings while Andy laboured over his commercial-art assignments in the hot, dingy kitchen.

Despite Pearlstein's presence, Andy would recall that summer as lonely. 'I used to come home and be so glad to find a little roach to talk to. It was so great to have at least someone there to greet you, and then just go away.' One of the climactic moments in the Raggedy Andy saga occurred when he presented his drawings to the elegant *grande dame* of the fashion magazines, Carmel Snow at *Harper's Bazaar*, and a roach crawled out with the pictures. 'She felt so sorry for me,' Andy told everyone, 'that she gave me a job.'

Though he gave the impression to art directors that he thoroughly enjoyed his work, when his Tech classmate Jack Regan and his wife Grace stopped on their way to London, where Jack had a Fulbright scholarship, to have dinner with Philip and Andy on St Mark's Place, they got the impression that Andy was really struggling. He complained about how tough the competition was and of being rejected and disliked by art directors. Because of his Pittsburgh accent and ungrammatical speech patterns, Andy felt an outsider in the romantic, rich and elegant world he aspired to.

Despite the fact that she was hundreds of miles away in Pittsburgh, Andy's mother and the religion she had instilled in him were his most important supports in his first years in New York. Andy wrote Julia a postcard every day saying, 'I am fine and I will write again tomorrow,' and popped into church two or three times a week to pray for success.

Just as easily as he was frightened by the competition, Andy's fears were exaggerated by his superstitious and fatalistic relatives. 'What are ya gonna do?' his oldest brother Paul would ask their mother. 'They got a million artists up there in New York! He's gettin' a lot of hard knocks!'

'God, oh God, help my boy Andy,' Julia prayed. 'He no get job.' And she sent back letters, enclosing a one- or five-dollar bill when she could.

On 6 August 1949, Andy was twenty-one.

Near the end of the summer, *Glamour* published Andy's first drawing, showing girls climbing a ladder, illustrating an article titled, 'Success is

a Job in New York'. The credit listed his name as Andy Warhol, a misspelling (he claimed) which he adopted from that time on.

<div align="center">*</div>

With their sublet running out, Pearlstein recalled, 'we were able to write to our families in Pittsburgh and our friends in New York that we had moved from one roach-ridden apartment to another.' Answering an ad in the *New York Times*, they found themselves a single large room at one end of a loft over a truck garage at 323 West 21st Street in the Chelsea section of Manhattan. The loft's tenant, Francesca Boas – a dance therapist working with disturbed children – had fixed it up like a theatre with a proscenium arch towards the back and decorated it with ethnic musical instruments collected from around the world by her father, the anthropologist Franz Boas. While she lived behind the arch with a friend named Jan Gay and a huge exotic dog named Name, Andy and Philip took up residence in the front part of the loft. Klauber visited them there, and was not favourably impressed. If anything, he thought the place was an even worse dump than their apartment on St Mark's Place. To him, Philip and especially Andy seemed too timid and nervous to make it.

'Francesca took an interest in us,' Pearlstein recalled. 'I guess we were both odd enough, but Andy especially intrigued her. During the course of that winter, she actively encouraged him to "open himself up", and he slowly metamorphosed into Andy Warhol from being Andy Warhola.' Still, Andy remained for the most part anxious and divided about his directions.

Another friend from Tech, Joseph Groell, overheard him telephoning around to magazines one day. He introduced himself by saying, 'Hello. This is Andy Warhol. I planted some bird seeds in the park today. Would you like to order a bird?' Continuing in a whimsical, whining voice, he announced that it was raining, 'and I have a hole in my shoe and do you have any work for me?' When, as most often happened, whoever he was talking to said no, Andy would reply, 'Well, I'm not coming out today.' Hanging up after one of these calls, he turned to Groell and said in his normal voice, 'Isn't this ridiculous? I don't want to behave like this.'

Days at 21st Street quickly settled into a routine revolving mainly around work. Pearlstein went to his job, while Warhol hustled up new assignments which he would complete that night. Philip Pearlstein:

> He studied the printed results carefully for the effectiveness of his work and applied the results of these self-critiques to his next assignment. At the other side of the room, I worked at painting every evening after the day's work at Sutner's office. I had some records that I played – Bartók, Stravinsky, Mahler, and Walton's 'Façade', with Edith Sitwell reciting her poetry. That was Andy's

favourite. He hated Mahler. So did Francesca Boas, who would rather have had silence from our room.

One of the biggest problems was the ongoing battle with the roaches, who went after the black paint they used for lettering. Andy would leave his empty soda-pop bottle out after lunch every day and by the evening it would be full of them.

Some evenings, if they had the money, they bought standing-room-only tickets for Broadway shows like *Death of a Salesman* and *Member of the Wedding* or went to the movies, mostly reruns on 42nd Street. They did not have extended or intellectual conversations, but in years to come Pearlstein would recall one exchange. Walking home one night from the movies, Andy complained that the film they had seen was terrible. Pearlstein replied that nothing could be so bad that there was not something interesting in it. Andy made no comment, but Philip was sure the remark had made an impression, it was so much like what Andy would later say about his own films.

Whether Andy's success in commercial art and Philip's relative failure affected their relationship is unclear, but cracks appeared in it. Philip's know-it-all attitude began to get on Andy's nerves. On their Sunday museum excursions Andy reminded Philip of a reluctant child following his father around places he had no interest in at all. He would get angry when they came out of the subway at the wrong stop because Philip always insisted that he knew where they were. He thought it was the wrong stop, Andy would exclaim, in fact he knew it was – but he wasn't going to say anything.

By the autumn of 1949 the rest of their group from Tech – the Kesslers, Leila Davies and Ellie Simon – had all moved to New York, and they picked up where they'd left off, seeing each other frequently. None of them seemed sure of what they were going to do – Kessler was making a little headway as a children's-book illustrator, Leila Davies was working in a jewellery shop in Greenwich Village. While their education had supplied them with excellent tools in design, it had also confused them to some extent about what art meant beyond a means of making a living. Andy saw little difference between his commercial and fine-art drawings; the others said he shouldn't waste his talent, and should be painting more. Faint criticism floated back to friends who had remained behind in Pittsburgh. Betty Ash commented, 'I guess part of the disappointment was, well, if Andy's got a job as an ordinary commercial artist, does that mean he has sold out, that he's just like the rest of us?'

'The word "prostitution" was used,' recalled his old teacher Perry Davis.

Andy was certainly aware of these criticisms but probably had a different reaction to them from what his detractors expected. One friend

who met him around this time observed, 'Andy was unique in my experience of people in that I think he knew he was going to be in the position of having people be angry with him. He knew it quite a long time before it happened, or he was determined to make it happen.'

In March 1950, Warhol, Pearlstein, Boas and Gay were evicted from the West 21st Street loft. Although Philip and Andy had paid Francesca their sublet rent, the landlord had not been paid. With Philip about to marry his college sweetheart, the painter Dorothy Kantor, he and Andy now parted company. Andy always found it hard to maintain close relationships with people after they got married, since he needed their undivided attention, but Dorothy was a friend of his from Tech. He attended their wedding and remained friendly with the Pearlsteins for a few more years.

Through Leila Davies, Andy arranged to move uptown into a two-bedroom basement apartment at 74 West 103rd Street just off Manhattan Avenue near Central Park, which was rented by a dancer with the Ballet Theater named Victor Reilly, and inhabited by a changing roster of six tenants at a time. Word passed among his bemused, protective Pittsburgh friends that Andy had 'moved in with a bunch of dancers'. It was a transition period, introducing him into the bohemian world of dance and theatre people. He felt more affinity with them than with intellectuals like the Pearlsteins, and for the first time Andy began, tentatively, exploring the homosexual underground.

Sharing the girls' bedroom at one end of the corridor were Margery Beddows and Elaine Baumann, both dancers, and Leila Davies. Andy, Victor and another Ballet Theater dancer, Jack Beaber, shared the boys' room, where Andy arranged a small draughtsman's table with neatly aligned pens, inks and brushes under a bright light next to their permanently unmade mattresses. He thrived on working in the crowded apartment. 'It was an impossible scene,' recalled Lois Elias, Art's wife, who visited that summer. 'All I remember is Andy sitting there drawing, surrounded by this complete chaos and people doing things that would seem to be disruptive of any concentration. The food was mixed in with the clothes.'

'It was the strangest place I'd ever seen,' Klauber agreed, 'quite dark, empty, no furniture.'

The kids were playful and friendly, living the kind of existence that Andy would later say was 'just like the kind of bohemia portrayed in *My Sister Eileen*' (a musical about two sisters from Ohio, one with looks and the other with brains, who come to New York in search of fame, fortune and a man and rent a basement apartment in Greenwich Village), sharing spaghetti suppers, going to Judy Garland, Fred Astaire and Gene Kelly movies, and singing along to Carol Bruce's rendition of their theme song, 'Bewitched, Bothered and Bewildered'. They can be seen in a series of photos Leila Davies kept, munching ice-cream

cones and camping it up outside the apartment under a banner reading: WE LOVE OUR MOTHERS EVERYONE. The only thing that makes Andy stand out among them is the contorted gestures of his arms and hands.

He called Leila 'Mother' and Elaine 'little one', and they were in charge of taking care of him and making sure he ate. Since he was doing a lot of his assignments at night, Andy began a habit of sleeping late and often didn't sit down to breakfast until the afternoon, and then was usually so noncommittal about what he wanted to eat that Elaine once became frustrated enough to throw an egg at him. They both cracked up when it broke on the side of his face and ran down his neck.

Despite the camaraderie, Andy wrote twenty-five years later:

I kept living with roommates, thinking we could become good friends and share problems, but I'd always find out that they were just interested in another person sharing the rent. At one point I lived with seventeen different people in a basement apartment on 103rd and Manhattan Avenue, and not one person of the seventeen ever shared a problem with me. I worked very long hours in those days, so I guess I wouldn't have had time to listen to any of their problems even if they had told me any, but I still felt left out and hurt.

This came as a surprise to many of his roommates who recalled cooking meals for Andy, mending his clothes, taking him to parties, movies and dance recitals, listening to his problems about his work and his mother, posing for him. 'We certainly cried on each other's shoulders enough,' recalled Leila Davies.

We took a lot of long walks around Manhattan, through the park, and had picnics on the Palisades, and he appeared to be interested in everything. He was very innocent and naïve, and he clearly worked hard, and constantly took his work around to advertising agencies. He used to get discouraged a lot, but he kept going. I don't think that there was anything more important than his work.

Other friends recalled him as whimsical, fey, sweet and charming, but painfully shy. About the only thing he ever said among a group of people was a whispered 'Hi!' as he spent long hours sitting in the apartment, drawing like a robot while the talk flowed around him. According to Elaine Baumann, he 'just sat and observed as if he was removed from his body. He was an inarticulate, totally nonverbal young man. He was also star-struck. He would write fan letters to Truman Capote and Judy Garland. He would be breathless when he'd seen Somebody or Someone.' Andy was so in awe of celebrities that when one of their frequent weekend parties was attended by Hurd Hatfield, the actor who starred in the film of *Dorian Gray*, he just stared and

whispered unbelievingly to Elaine, 'Hurd Hatfield!' On another occasion, when he found himself sitting next to Marlene Dietrich in a cinema, he could barely whisper to Leila, 'Marlene Dietrich!'

Andy seemed to believe, even then, George Klauber observed, that association with celebrities had a potent magic. 'More than anybody I ever met, Andy Warhol wanted to meet celebrities. He really had a passion for success and for famous people. He had some illusion when he first came to New York that I knew a lot of people. And he always used to beg me to introduce him to someone famous.'

'Anybody whose name he'd heard was a famous person,' added Margery Beddows. 'If he heard the name of a famous dentist he wanted to go.'

*

Andy had by now fulfilled one of his early ambitions, turning out a series of powerful full-page blotted-line drawings illustrating plays by Giraudoux and William Inge and an article on Lorca for *Theater Arts* magazine. They captured the ambiguous sexual nature of the characters with a sophisticated, ethereal touch. Another commercial artist once watched fascinated as Andy did one of his illustrations. 'He would hinge two pieces of paper together with masking tape like a door, then draw on the door a little short line and blot it onto the working surface and then lift it up and draw a little more and blot it again.' While the process was far from simple and required a good deal of dexterity and choice to get it to work, it was fast enough to enable Warhol to do his commercial assignments overnight and it gave the work an individual style.

Klauber, who was operating in what Andy envisioned as a commercial-art-and-design in crowd, and whom he was continually bugging for invitations and introductions, thought of Andy as

> something of a crybaby in that sense, whining that I was doing these things and couldn't he come too? I couldn't really do much for Andy and the truth is I needed to do very little for him. He was launched and on his own. He got the impression that I was leading a much more exotic life than I was. Occasionally I would take him to a rooming house in East Hampton for the weekend. He came to visit me once on the Cape with the Eliases. He had a skin problem so he couldn't be in the sun or he would get burned fiercely. He was always eccentric, wearing khaki trousers and a white shirt, holding an enormous black umbrella over his head, cutting across the dunes. It really was a sight. But he was what he was and never made any apology about it.

Andy was spending very long hours working, honing his skills and experimenting with new ways to do things. Tina Fredericks insisted he go to an optometrist to get special glasses. His eyes were weak and they were beginning to get lazy under the strain. The new glasses had

very thick lenses and made him look even more of a geek than he usually did, but he wore them conscientiously.

Andy filled his sketchbooks with drawings of his roommates and the apartment cat. He also did a number of large paintings on canvas which have since been destroyed. One of them set a precedent for his later death-and-disaster paintings. Based on an old *Life* magazine photograph by H. S. Wong of a screaming baby, its skin charred, its clothes shredded, its mouth stretched open in a silent scream, sitting among the ruins of Shanghai's South Station after a 1937 Japanese bombing attack, the painting was horrific yet surprisingly decorative, executed with the blotted-line technique and pastel colours. The *Life* caption stating that up to 136 million people had seen the photograph reproduced in various media undoubtedly caught Andy's attention as much as the image. He was also pleased with its shock value, but it may have touched a nerve he did not want to expose, expressing too much of his own feelings of vulnerability, for he abandoned the subject in favour of more decorative images like chubby cherubs and butterflies. With these and acrobats and trapeze artists he filled a 10-foot mural on the walls of Elaine Baumann's bedroom in her parents' apartment, which they later painted over.

When the building on Manhattan Avenue was slated for demolition in the autumn of 1950, the commune broke up and Warhol was stuck with a large phone bill in his name which he could not pay. He moved in with another Tech classmate, the painter Joseph Groell, who had an apartment on East 24th Street. When Groell returned to Pittsburgh for several months that winter, Andy found himself living alone for the first time in his life.

By the beginning of 1951, he had added to his credits a series of book-jacket illustrations for New Directions and had made his first television 'appearances': *Art Director and Studio News* magazine, in a showcase article titled 'Andy: Upcoming Artist', reported that Walter Van Betten was using Warhol drawings for promotion pieces on NBC programmes, and Andy in an uncharacteristic fashion was waking up at 5 a.m. so his hand could be made up. It was featured on the morning news programme, drawing the weather map.

He had also produced a provocative drawing of a young sailor on his knees injecting heroin into his arm, which was published as a full-page advertisement in the *New York Times* on 13 September 1951 for a radio programme about crime called 'The Nation's Nightmare'. This ad, for which he earned more than anything he had done to date, gained Warhol a lot of attention. It was reproduced as an album cover for a recording of the programme and eventually, in 1953, won Andy his first Art Directors' Club gold medal – the Oscar of the advertising industry.

The 'Nation's Nightmare' illustration was more typical than Andy's

previous commercial drawings of the sensationalism of the print media and print advertising in the early 1950s, which formed an essential part of Andy's education as an artist. The dark side of commercial art – the use of advertising images to play on hidden aggression and loneliness, status seeking and sex appeal, documented by Vance Packard in his book *The Hidden Persuaders* – was to become a theme in Warhol's most famous pop-art paintings. Because the glamour business was dominated by women-haters and men-haters of dubious sex polarity, Marshall McLuhan wrote, 'Sex has been exaggerated by getting hooked to the mechanism of the market and the impersonal techniques of industrial production.' Consequently the 'dominant pattern' of pictorial reportage in the popular press was 'composed of sex and technology, surrounded by images of hectic speed, mayhem, violence and sudden death'. It was a period in which sensationalistic photos in magazines, like the one in *Life* of a woman jumping out of a window, reached their peak. These influences would not fully come to light until Warhol completed his best-known pop paintings in the early sixties.

His next major assignment was to illustrate Amy Vanderbilt's *Complete Book of Etiquette*. He was making enough money now to afford a new Brooks Brothers suit and trenchcoat, which he wore to go out in the evenings, while assiduously maintaining his poor-boy image for art directors. According to several of Andy's old Pittsburgh friends, who were becoming increasingly critical of him as he became successful, he would sometimes charge ridiculously low prices for his drawings if a magazine would, in exchange, include a brief bio of him.

*

While Andy's success gave him new confidence and steadily increasing amount of money, he was beginning to have a lot of what he would refer to for the rest of his life as 'boy problems'.

Though he never spoke directly about the subject of homosexuality with any of his friends – it was always more characteristic of Andy in conversation to be able to draw out the details of his friends' personal lives than to reveal anything about his own – his confusion, stemming from a growing conflict of wanting to have a romantic involvement with another man and his almost insurmountable incapacity to do so, was especially obvious to those friends, like Klauber, who were close to Warhol and could sympathize with what he meant by boy problems. For all Klauber's bravado, being gay in America in the 1950s, where homosexuality was against the law and homosexuals were thought to be a sick and 'unusually revolting species of pest', was painful. The predominant attitude of vilification was typified that year by a statement of findings issued by the McCarthy Senate Subcommittee, drafted ironically by the flamboyant yet closeted lawyer Roy Cohn, which declared that 'homosexuality and other sex perverts' posed 'security risks' and were 'unsuitable' for government employment. 'One homosexual,' the

statement warned, 'can pollute a government office.' Such witch-hunting was less threatening to commercial artists than it was to civil servants, but the threat of physical violence – of being beaten up on the street or shaken down by the police – was shared by the entire gay community.

For Andy, as for others, the 'lavender' social circle which flourished underground in New York, and which increasingly became part of his life during and after his stay on Manhattan Avenue, was a means of survival. Again, George Klauber was his guide. Klauber was familiar not only with the right people and places in the commercial-art world, but with the distinct homosexual enclaves, stylish bars like Regents Row and, more importantly, the salons in the homes of interior decorators and set designers at which Andy – having persistently remonstrated with Klauber to take him along – was a frequent guest. The New York gay scene in the fifties was quite different from what it has since become. One veteran recalled:

> There was still all this hate and fear of the underground, but being underground wasn't tense or fearful, it was quite relaxed. There were a lot of people in that scene and there were lots and lots of parties. It was a party decade, much more so than later, and this is where people met. It was extremely outgoing and, as long as you didn't disturb the straight world, completely nice.

The life replaced a sense of isolation with a sense of collective secrecy.

From all accounts, the glamour of this secret world was of far greater appeal to Warhol than any opportunity it provided for sexual liaisons. On this score he was extremely tentative. Like many gay men, Andy worried that he was sick, emotionally stunted – that, after all, was what the psychiatrists said – and he experienced the same repressed anger and feelings that 'normal' people (that is, heterosexuals) were happier than he was. His self-image problems were compounded by his acute sensitivity about his physical appearance. His hair was thinning rapidly, his skin would still erupt in brownish-red and white blotches when he was nervous, and his new thick-lensed glasses, with only a tiny hole to focus through, made him feel even odder than before. Although one friend recalled, 'I always thought of him as a rather good-looking chap and I don't know why people made fun of the way he looked,' and contemporary photographs support this view, Andy was, by his own estimation, 'a mess'.

Even so, George Klauber found him attractive enough to fantasize having an affair with him. Andy did not reciprocate his advances and George 'got the feeling he was inaccessible, untouchable'. 'Kiss me with your eyes' was one of his pet expressions. It seemed to Klauber that Warhol was avoiding intimate relationships completely. Instead, Andy

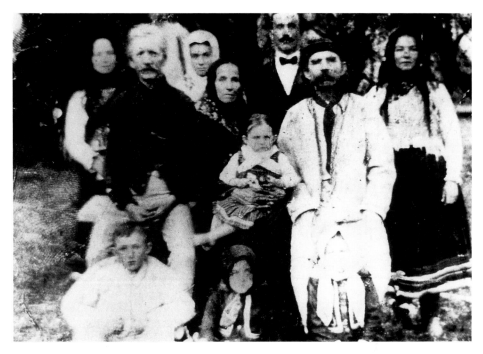

Andy Warhol's ancestors in Pittsburgh. Julia Zavacky (mother) far left, Aunt Mary Zavacky far right. Front centre, Andy's grandparents. (*Lillian Gracik collection*)

Julia Warhola with John and Andy. 1931. (*John Richardson collection*)

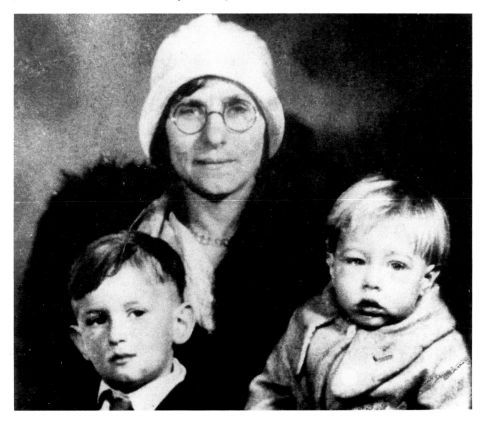

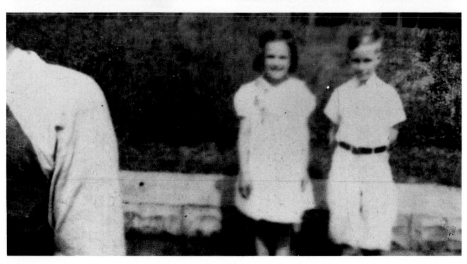

Andy, second from left, at garden party with his mother. (*Lillian Gracik collection*)

Opposite top: 55 Beelan Street, where Andy spent the first few years of his life living in the front section. (*Photo: Victor Bockris*)

Opposite centre: Andy's father, far right, on construction site in Pittsburgh late 1920s. (*John Warhola collection*)

Opposite below: Andy with his first friend Margie Girman on Dawson Street. (*Paul Warhola collection*)

Andy with sister-in-law Ann. (*Paul Warhola collection*)

Andy with family after his father's funeral, Dawson Street, May 1942. (*Justina Swindell collection*)

Andy on Dawson Street. (*Paul Warhola collection*)

The Warhola brothers on Dawson Street, John, Andy, Paul. (*Paul Warhola collection*)

Andy's high school graduation picture. (*Paul Warhola collection*)

Andy at Carnegie Tech with Leonard Kessler and Dorothy Kantor. (*Leonard Kessler collection*)

Andy at Hornes with his first boss and "idol" Mr Vollmer. (*Vollmer collection*)

Andy during his first year at Carnegie Tech. (*Lillian Gracik collection*)

Philip Pearlstein, Joan Kramer and Andy Warhol outside the Museum of Modern Art during their first visit to New York, September 1948. (*Arthur Elias collection*)

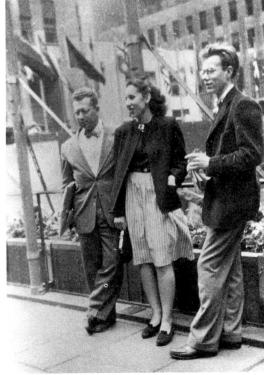

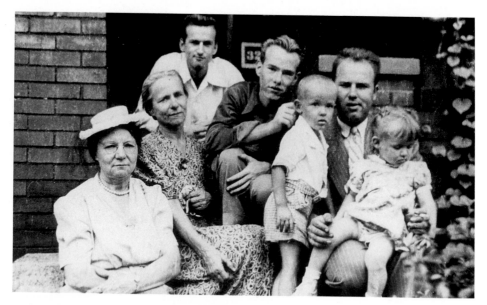

Andy with John, Paul, Julia, Aunt Mary and Paul's first two children in front of the Dawson Street house, 1948. (*Justina Swindell collection*)

Andy as art hero at Carnegie Tech during his senior year. (© *Archive Malanga*)

indulged himself in crushes on a number of attractive but quite inaccessible young men. One friend observed:

> He more or less expected to be rejected by the beautiful boys he was always falling for. His attitude was, 'Aren't they beautiful creatures?' He just wanted to look at them, to be around them, to admire them. It wasn't that he wanted to get into bed with them. He was much too self-conscious for that. He was watching a beauty pageant.

At the top of Andy's list of beauties was Truman Capote. Throughout his first year in New York, he had written Capote almost daily fan letters, announcing he was in town and asking if he might draw Truman's portrait.

'I never answer fan letters,' Capote would later recall,

> but not answering these Warhol letters didn't seem to faze him at all. I became Andy's Shirley Temple. After a while I began getting letters from him every day! Until I became terrifically conscious of this person. Also he began sending along these drawings. They certainly weren't like his later things. They were rather literally illustrations from stories of mine . . . at least that's what they were supposed to be. Not only that, but apparently Andy Warhol used to stand outside the building where I lived and hang around waiting to see me come in or go out of the building.

Months later, Warhol got up the nerve to call to see if Capote had received the drawings, and got Nina Capote, the author's mother, on the line. She invited him over to her Park Avenue apartment. Upon arriving, Andy quickly realized that Mrs Capote was more interested in acquiring a drinking companion than in looking at his work, and they repaired to a Blarney Stone bar on Third Avenue. There, they drank boilermakers and Nina talked at length about Truman's problems and what a big disappointment he had been to her. By the time they returned to her apartment, Nina Capote was drunk and listening intently to all Andy's problems.

This is how Truman found them when he entered the apartment later that afternoon. Not wishing to be unkind, he sat down and listened to Andy's story, which he found woeful. 'He seemed one of those helpless people that you just know nothing's ever going to happen to,' Capote later said. 'Just a hopeless born loser, the loneliest, most friendless person I'd ever seen in my life.' Yet, after the visit, when Andy telephoned daily, Truman took the calls, which would centre on Andy's activities. His phone relationship with Truman was shortly curtailed when Capote's mother answered the phone and told him, 'Stop bothering Truman!'

'Like all alcoholics, she had Jekyll and Hyde qualities,' Capote recalled, 'and although she was basically a sympathetic person and

thought he was very sweet, she lit into him.' Surprised and upset, but long accustomed to obeying his own mother's instructions, Andy stopped writing or calling Truman.

Warhol spoke animatedly to friends about other, equally unattainable, mad crushes – on dancers John Butler and Jacques D'Amboise, the photographer Bob Allyson, and a succession of anonymous beauties. He claimed on occasion, to the total disbelief of those listening, that someone had given him a 'sore bum' by 'fucking the ass off' him the previous night. Even in the Manhattan Avenue commune, his strange private life was characterized by a detached voyeuristic interest in sex and he began painting nude figures of men and coy, stylized drawings of genitalia, which he said he was assembling into a *Cock Book*. Sometimes he asked people if he could draw their feet. A surprisingly large number of people are said to have acquiesced to his requests and he did hundreds of cock and foot drawings, the latter to be included in a *Foot Book*. Andy was a classic foot fetishist and had what many of his friends found to be a creepily erotic relationship with his own shoes, which he would always wear scrunched down at the back and falling apart with holes in the soles and his toes sometimes sticking out at the front. Later, when he did have sexual relations, he found the ritual of kissing his lover's shoes particularly erotic.

One of those who posed for him regularly was Robert Fleischer. Fleischer, who with his bushy red moustache struck an elegant figure, was a stationery buyer at Bergdorf Goodman's department store and a part-time model. He had first been introduced to Warhol by Elaine Baumann at the Manhattan Avenue apartment. Later, Fleischer had commissioned one of Andy's butterfly drawings for a Bergdorf Goodman stationery design, a job which had proven frustratingly difficult for Warhol, who seemed incapable of accurately aligning the acetate sheets that separated each colour. While this later became a Warhol trademark, it was then an annoyance which had to be corrected at the printer's. Nevertheless, the two became friends.

At first Fleischer, like so many others who knew Andy, felt 'a tremendous sense of protecting this poor innocent waif who was going to get strangled in the big city', but came to believe that Andy was using this helpless pose to manipulate people, particularly after Andy began drawing a series of increasingly explicit portraits of Fleischer and his lover, which seemed to be testing what he could get away with as well as the limits of their friendship. 'Andy sketched us screwing a couple of times,' Fleischer told the art historian Patrick Smith.

Andy would get very excited. He wouldn't quite join in, but he loved watching. He would very often like to draw me nude and see me with an erection, but he never actually touched me, and I think that I never really put myself in a position of letting him, or leading him to think that I was

interested physically, because I wasn't. At one time he said that he got so hot when he saw men with erections that he couldn't have an orgasm himself. But he started to strip that day. 'And wasn't it all right if he sketched in his jockey shorts?' And he did.

In his weird way, Andy was opening up. While part of his image at Tech had been his delight in shocking classmates, it was nothing compared to the behaviour he displayed at a party back in Pittsburgh at Balcom Greene's. 'There were a bunch of students there,' Perry Davis recalled, 'and he came in and said, "OK, everybody take off their clothes, I brought my sketchbook." ' Robert Fleischer told Patrick Smith that when the Manhattan Avenue commune had been breaking up, Elaine Baumann's parents gave a Halloween party, which Warhol was expected to attend with several other roommates.

> It got later and later and all of a sudden at midnight – they had obviously done this on purpose to make an entrance – they rang the bell, and in they walked, hand in hand, and around each of their necks was a big cut-out daisy, and they were carrying garlands, as they do in high-school graduations. They came in as a daisy chain, and that's what they used to call orgies in those days. The whole place fell apart hysterical.

To Fleischer, their laughter was humiliating. It may have been Andy's idea of a joke, but he felt exposed.

It was while he was living alone that Andy formed his close relationship with the telephone, which he would later call his best friend. It became not only his lifeline to art directors and money, but a magical machine which enabled him to have more intimate conversations than he could handle in person. Since Andy was frightened of going to sleep alone but was not able to sleep with anyone else, it was also the perfect companion for him in bed. Klauber, who was 'going madly crazy' for a young man named Francis Hughes that winter, grew to expect the regular late-night phone call from Andy to ask about the evening's activities.

> This was Andy's big vicarious connection. The kid would leave about two o'clock in the morning, at which point I'd speak to Andy about what happened. He had to know all the details, and, naturally, I told him. Hearing stories is what made him happy – 'Tell me more, tell me more.' He was truly a voyeur and truly a person who enjoyed vicariously the experiences of other people. Then I introduced him to my second great love, Ralph Thomas (Corkie) Ward, and I think Andy fell in love with Corkie.

Ward was living on Union Square with an older man named Alan Ross McDougal (Dougie), who had been Isadora Duncan's secretary. A tall lithe, talented poet and artist with curly brown hair, who drank a

lot and was quite free-wheeling, Ward was something of a romantic ideal to his friends, but it wasn't until Christmas of 1951 that Klauber noticed Andy's growing fixation on him. On Christmas Eve the three of them, along with a young man named Charles, had gone to see a French film. Afterwards they had picked up a Christmas tree and taken it back to Klauber's apartment, where they celebrated the season by dancing round the living room. Klauber recalled the scene vividly:

> I had taken my trousers off and Ralph and I were waltzing wildly around and crashed into a table and when I got up I had this big gash in my side so we called for an ambulance, which meant the police would come too. Andy got quite sick with apprehension and flew the scene. He was just really terrified. Of course to the cops it was apparently a gay party and they thought somebody had stabbed me.

According to Ward, 'The cops were not nice, although one of them was pretty cute.' However, there were no charges to be pressed and George, Ralph and Charles got into the ambulance and police car. As the convoy took off for the hospital, Andy watched from the alcove of a building across the street. He had not dared to be involved but had to see what would happen. It indicated to George that Andy was already quite enamoured of Ralph.

Whereas he had previously been content to indulge himself in voyeuristic games, Andy became a little more forward with Ralph. In the weeks that followed, he wrote him a number of love letters, but Ralph rejected his tentative overtures. 'Andy had a love affair with me,' he recalled. 'I was never really attracted to him.' A close enough friendship did ensue, however, to make others wonder if they were lovers. It was Klauber who now felt left out.

Early in the spring of 1952 Ward and Warhol began collaborating on a series of privately printed books. It was the first of many times Andy would keep a romance going by collaborating on some work. The first – *A is an Alphabet* – consisted of twenty-six Warhol drawings, outlining heads and bodies, with doggerel captions by Corkie. *Love is a Pink Cake* was a bit more interesting, consisting of twelve Warhol illustrations to famous love stories with accompanying verses by Ward like: 'The moor of Venice pulled a boner, when he throttled Desdemona.' The third book, *there was snow in the street*, had blotted-line drawings mostly of children, and remained unprinted for years. The emotions underlying the work were obvious, and the books made excellent promotional gimmicks to send to art directors and Andy's other clients. 'The nature of Andy's promotion was so personal, so his conception and manner, that it really had an influence in making him known,' Klauber recalled. 'People began collecting them and anticipated receiving them. If you went into an ad agency you would often see an Andy Warhol thing out.'

Whatever intimacy existed between Andy and Ralph ceased over the following year. Maintaining a close friendship with Andy, Ward discovered, was difficult because Andy was so needful of attention and so easily hurt. Ralph also tended to look down on Andy's devotion to work and making money.

'Andy did everything for money,' insisted Ward. 'His main goal was to learn how to do everything faster.'

Klauber explained:

There's a resentment among people who knew Andy back then. Both Philip and Dorothy Pearlstein are a little resentful too, but Ralph was particularly disdainful of Andy's peasant mentality in terms of the PR factor and super-hype. And I think Andy did feel hurt by Ralph. There's no doubt about that.

THE ODD COUPLE

1952–54

My mother had shown up one night at the apartment where I was living with a few suitcases and shopping bags, and she announced that she'd left Pennsylvania for good 'to come live with my Andy'. I told her OK, she could stay but just until I got a burglar alarm.

ANDY WARHOL

The relationship with Ward coincided with Andy's move into his own apartment, a depressing dirty, mouse- and louse-ridden, cold-water basement flat in a building under the tracks of the since demolished Third Avenue elevated train at 216 East 75th Street.

Julia visited with Paul. Cleaning the apartment and cooking a big meal, she questioned him about his finances and did his laundry. Andy had never had to fend for himself before, and Julia was justifiably worried that he wasn't able to take care of himself. She found all his clothes dirty and falling apart and one friend noted that Andy sometimes smelled as if he had not taken a bath in days. He was subsisting largely on cake and candy. During the fourteen-hour drive back to Pittsburgh Julia recited her litany of fears and prayers for her youngest son.

In Pittsburgh, Paul Warhola was just beginning to be successful in the scrap-metal business and Julia was considering moving with John to a house in the suburb of Clairton where Paul lived. Paul Warhola:

Mother liked that section. She says, 'If you find me a house out where you're at, I'd like to move out there.' OK, we found a house, bought the house. Then my brother John decided that he was getting married. So mother felt that there was no need for her to come out to a big house. She says, 'Well, the only thing I can see, I guess, is I'd like to be with Andy in New York.'

In the early spring of 1952, Julia rode to New York with John in his ice-cream van. 'Andy had a hole in the sole of his shoe as big as a silver dollar,' John recalled, 'so I left him my best pair of shoes. I think when mother saw that she decided to move up there at once to look after Andy.'

The Dawson Street house was put up for sale, and was sold a few months later for $6,800. Julia put the money in the bank and held on

to it until her death in case something happened. John took his father's memorabilia, while all Andy's school books and student art works were carted out to Paul's. 'I asked what I was supposed to do with these things,' Paul recalled. 'Andy told me, "Just discard 'em. Just pitch 'em." ' On further consideration, Paul decided not to throw away ten paintings done on masonite board. 'I stuck 'em in the rafters and never figured much on 'em. We walked on 'em.' His children would later use them as dartboards.

On the other hand, like his father, Paul believed that Andy would be famous one day and the paintings would be worth a lot of money. On the other hand, he treated them with the disdain he would show Andy's work throughout his life, never once, for example, going to one of his shows even when Andy asked him.

In early summer, Paul drove his mother back to New York. He was not too happy about leaving Julia to live in Andy's 'terrible place', but he could see that Andy and Julia needed each other. 'She felt, why be at home by herself when she could go and be of some help to Andy? And he was fond of Mother. It was nice for him to have her around and she was happy to be there.'

The first months on East 75th Street were hard. Andy's income was still irregular and he invested as little as possible in his living quarters. Like his father, Andy was intent on saving money and he was not going to squander any of it on what most people consider basic necessities. On his last visit John had accompanied Andy to a printer to pick up one of his promotional items and was struck by a trait he was sure Andy had inherited from their father:

He told the printer, 'This isn't what I told you to do.' And he says, 'Well, I thought you wanted it this way,' and Andy says, 'Well, no, you didn't listen to me.' The way Andy stood up to him just reminded me of my father. If it was me, I would have paid him. So when we left I told Andy, I says, 'Well, aren't you going to pay him?' 'No', he says, 'he didn't do what I wanted,' and the guy says, 'Jeez, I'm going to lose money on this.' Andy says, 'Well, next time you'll listen. You didn't do what I told you. Now I'm going to have to wait and have that all done over again.' My father was that way. Even though he wasn't built like Dad, Andy was tough.

Andy and Julia shared the bedroom, sleeping on mattresses on the floor, while Andy used the kitchen table as a studio. The bathtub was usually full of paper he was marbling, leading friends to believe that he rarely used it himself. He had bought a black and white television set to keep him company during the brief period when he lived there alone, and a Siamese cat to keep the mice at bay. A second Siamese was soon adopted and the two, Hester and Sam, began multiplying.

At first, Klauber remembered,

everybody was appalled that he would allow his mother to come and live with him, but the marvellous thing about Andy was that he was very gentle with her, very nice about it. As a matter of fact I always thought Andy was very kind and gentle in his thinking. I never saw him really do anything nasty to anybody. He was always kind and considerate. So, it wasn't surprising in a sense that his mother could live with him.

Andy was clearly somewhat concerned about his mother's presence in New York just as he was starting to make it. At first, he did not think she would stay very long because in Pittsburgh she had a large, loving family, a congregation and a priest to whom she was attached, whereas in New York she knew no one. Andy was not about to include her in his social scene, which he would have to keep for the most part secret from her. However, it soon became clear that she wanted to dedicate her life to supporting his efforts.

Most of Andy's friends were kept at a distance from 75th Street. A part of him was embarrassed and ashamed of his mother. Julia in her peasant dress and babushka in no way matched up to a glamorous, wealthy mother like Nina Capote, who wore furs and jewels and entertained her friends with society anecdotes. Julia persisted in speaking Po nasemu and treated Andy with a mixture of maternal warmth and scorn. She encouraged him to 'do what is right' and 'find your ideas in dreams', but nagged him for not dressing properly and not getting married. One of the ironies implicit in her stay was that she said she was only there until Andy found a nice girl, settled down and got married.

Warhol's relationship with his mother was similar to the novelist Jack Kerouac's with his 'saintly, peasant mother', with whom he lived for most of his adult life, Allen Ginsberg's with his mother, who was the subject of his great poem *Kaddish*, and Elvis Presley's with his mother, who was the mainstay of Presley's career in the 1950s. Truman Capote and Tennessee Williams were also haunted by their mothers. Momism loomed over American culture after the Second World War.

'Julia was the source of the tenacity and gentleness and down-to-earth resilience, which were at the core of Andy's character,' commented the art historian John Richardson. 'Narrow and uneducated she may have been, but Julia struck those who met her as humorous, mischievous, and shrewd – like her son.'

Underneath her naïve peasant exterior Julia was the only person in Andy's life who was as complex, manipulative and powerful as he. As an outstanding Odd Couple Julia and Andy were to become a team but also ultimately prisoners of each other's needs and compulsions. One of the key points of Andy's character was his ability to share his life with whoever he spent time with. There was an openness towards others that let them feel as if they were doing something equally with

him and were in a sense part of him, and led many of his collaborators to say, 'I am Andy Warhol.' By the end of the decade, their personalities would become so intertwined that Julia would claim, in a bitter tirade, that *she* was Andy Warhol.

Still, for the time being Julia's arrival on the scene was more positive than negative. She was for the most part good company and could usually be counted on to make Andy laugh. With Julia to take care of him and run the household Andy was freed to focus completely on his work and inspired to make more money faster so that he could get her a better place to live. Furthermore, ever economic in the development of his legend, Andy promoted her presence as much as he kept her hidden. When the sophisticated fashion crowd heard that the strange, fey, talented boy lived with his mother, they became even more amused and intrigued.

*

In March 1952 Andy achieved another of his early goals, to publish work in *Park East* (a magazine about the rich, famous people who lived on the Upper East Side) and could feel a distant kinship with the stars Rita Hayworth, Capote and Greta Garbo, whose pictures appeared in the issue. That spring, as well, Andy had taken his first tentative steps towards acceptance as a fine artist when he had presented his illustrations of Truman Capote's writings to Iolas, whose international status as one of the major dealers in surrealist art warranted his last-name-only soubriquet, at his Hugo Gallery. David Mann, Iolas's assistant and part of the smart set Klauber knew, recalled that Iolas's initial response was uncharacteristically enthusiastic.

> Andy came in. He looked like a poor boy with a pimply face and very ordinary clothes. It was the end of the season, it was almost June and normally we closed but Iolas said to me, 'Look at this man's work!' We both thought it was amazing and he said, 'Well, we have nothing else to do, why don't we just take on another show in June?'

This kind of sympathetic support in the gay art community would play a significant role throughout the rest of Andy's career. Unfortunately, Iolas himself was in Europe along with almost everyone else of importance on the art scene when Andy Warhol's first opening took place on the afternoon of 16 June 1952.

Of Andy's close friends only Klauber came. He remembered Andy pacing nervously, apparently upset that Truman Capote failed to arrive.

Julia came to the opening and hovered in the background in her cloth coat and babushka, making Andy even more nervous. It was the first and last time she appeared at one of his public events. Among the other visitors to the gallery that day was a young commercial artist

named Nathan Gluck, who as Andy's assistant in years to come would make a vital contribution.

Before the show closed, Truman and Nina Capote did come to see it. According to David Mann, Mrs Capote was particularly vocal about how good she thought the drawings were. Andy was very happy and impressed when Truman and his mother came. They talked with him for about half an hour.

In retrospect, these ethereal drawings of boys, butterflies and cupids are almost shocking, given the existing codes of secrecy in the gay world. Delicate and pale, with splashes of magenta and violet, they expressed an obvious ambivalence.

'For various reasons one thinks of Beardsley, Lautrec, Demuth, Balthus and Cocteau,' wrote James Fitzsimmons in a brief *Art Digest* review. 'The work has an air of precocity, of carefully studied perversity.' But for the most part, 15 Drawings Based on the Writings of Truman Capote was not taken seriously except by Andy's friends and those few others who admired his talents as a draughtsman.

None of the pieces, priced around $300, sold, but Andy had made a good connection in David Mann, who would give him a number of shows later in the decade.

Andy's commercial career turned a corner in the spring of 1953. Wearing his shoes scrunched down, chino pants and a paint-spattered T-shirt under a sloppy jacket, Andy was visiting the office of Klauber's boss, Will Burton, to give the art director a hand-painted Easter egg, when Burton introduced him to an energetic, intelligent woman named Fritzie Miller, who had just become an agent for commercial artists. 'Andy,' Burton said, 'meet Fritzie. You need her.' Andy seemed to agree, though, according to Fritzie Miller, there was a brief delay when Andy called her in a panic saying that a friend of his, who had previously helped him get his work around, might beat him up if he gave the account to her. Soon after, Warhol called Miller a second time and said he wanted her to represent him, and she agreed.

Fritzie Miller's help in getting his work into *McCall's* and the *Ladies' Home Journal* and later into *Vogue* and *Harper's Bazaar* was essential in establishing Warhol as the most sought-after illustrator of women's accessories in New York. After that, wrote Calvin Tompkins,

a lot of people in the industry began to notice Andy's magazine work. Whatever he illustrated – shampoo or bras or jewellery or lipstick or perfume – there was a decorative originality about his work that made it eyecatching. It was amazing, Fritzie thought, how someone with Andy's background could hit the right note so unerringly. The childish hearts and flowers and the androgynous pink cherubs that he used were not quite what they seemed to be, there was a slight suggestiveness about them that people in the business recognized and approved. He could kid the product so subtly that he made the client feel witty.

In the next six months, his earnings from illustration work would nearly double his income that year to over $25,000. Warhol, at twenty-five, despite all outward appearances was doing well enough to have confounded the early expectations of his friends. The driving ambition behind his helpless Raggedy Andy front was now apparent.

As soon as he began to make money Andy signalled that he was to have what one friend described as an 'unhealthy' relationship with it. Either he overspent completely or he underspent completely. There was no middle road with Andy. There were certain things he wouldn't spend on even if he needed them, while going to the Plaza Hotel for breakfast and sitting in the hall outside the Palm Court Lounge afterwards hoping to be mistaken for Truman Capote was one of his favourite things to do. Andy would sometimes astonish friends by spending $50 on taking several of them to breakfast there. He'd also become a regular at the chic Café Nicholson, an expensive restaurant celebrated in *Park East* magazine as a gathering place for young writers, dancers and designers. Andy was a favoured customer there, because he always tipped so well and left the waiters a cluster of Hershey's chocolate kisses.

Andy made a daily excursion to the most expensive pastry shops, where he would buy several pastries or a whole birthday cake for himself, carry it home and often immediately devour the lot. This grossly unbalanced expenditure on food was a constant source of annoyance for Julia, who began to treat him as she had her husband, wanting him to contribute some of his earnings to their family in Pittsburgh.

These symbolic extravagances were in distinct contrast to the marginal life Andy and Julia were living beneath the rumbling El in the apartment on 75th Street. In fact, Warhol's cash flow fluctuated so radically, or else he was embarrassed to take her anywhere else, that he and Julia shared their first Thanksgiving dinner at a Woolworth's counter. 'It would make him incredibly sad,' recalled Pat Hackett, Andy's secretary in the 1970s and 1980s, to dredge up this memory from the winter of 1952. For all the strength she brought him Julia's presence was also a constant reminder of Andy's poverty-stricken childhood.

Much in need of more living space, and finally able to afford it, in the summer of 1953 Andy sublet a fourth-floor floor-through walk-up apartment at 242 Lexington Avenue near the corner of 34th Street from his Tech classmate Leonard Kessler, with the proviso that for several months, Kessler be allowed to keep one of the smaller rooms as a studio for his children's-book illustrations. Unfortunately for George Klauber, he had a car and was recruited to help Andy move. Andy was sitting helplessly at East 75th Street, totally unprepared, when he arrived. It bugged George, who 'had to go and help him pack all his boxes, *and* carry them out to the car'.

The new apartment was larger than the previous one. The door opened into a big kitchen furnished with a table and a set of straight-backed chairs and decorated with a picture of Jesus pointing to his Sacred Heart. There was a large room in front overlooking the busy street with a small one off to the side. In the back was one big room and a small bedroom. While Kessler kept the small front room as his studio, Andy and Julia shared the little back bedroom, still sleeping on mattresses on the floor. The rest of the place quickly filled with stacks of paper, magazines, photographs and art supplies until every surface was covered, and Andy was confined to doing his work on a portable desk on his lap. The shoes, gloves, scarves, hats, handbags, belts and jewellery he was assigned to draw added to the clutter. One day when Kessler was helping to shift some piles around, he turned up a $700 cheque that someone had sent Andy months earlier and that had got overlooked among his new assignments and accumulating junk.

The cat population, meanwhile, has multiplied to anywhere from eight to twenty depending on how quickly Andy could give them away. Most of his friends received at least one Warhol kitten, a number of which turned out to be unusually skittish and vicious. One day one of the cats bit his mother's hand so badly that she had to go to the hospital. At that time he figured he had too many cats and he got rid of some more, but it was a menagerie. They roamed through the paper jungle, clawing and pissing on Andy's materials and periodically storming through the unruly heaps of art work in fits of feline mania. Julia was for ever cleaning up after them with a bucket and mop. The television was on continually, as often as not accompanied by Broadway show tunes on the record player. One friend noted that walking through the apartment without knocking anything over or tripping up was like walking on a tightrope. Other friends described the place as a 'bat cave' and a set from On the Waterfront. To Klauber, the cats appeared to be 'like his surrogate children'. To most people they became part of his legend: Andy was living in a mad studio with his mother and twenty-one cats. The smell, they said, was something else.

The apartment was situated over a night club, Shirley's Pin-Up Bar, on the ground floor, and the booming beat of 'You're So Adorable' floated up through the front windows mixing with the thunder of the Lexington Avenue subway to create a New York cacophony that would have kept an out-of-towner awake all night. For the first time in his life, Andy, who could now think of himself as a New Yorker, was in his element.

That summer both Andy's brothers visited him on separate occasions now that there was enough room for them and their children to camp out in the apartment. His mother always enjoyed their visits, and the children seemed to have fun playing with 'Uncle Andy', who supplied

them with crayons to colour with so they wouldn't bother him too much, and always gave each of them a present when they arrived.

Visitors became more frequent, too, though they seldom could find a place to sit among the piles of paper and the cats. Regardless of who was there, Andy would continue working on the next day's assignments. 'He was demonic about it,' one friend remembered. 'He was constantly working.' The only time he wasn't working, said another, was when on impulse he would go to the Café Nicholson or the theatre, paying for dinners and tickets with crumpled bills extracted from various pockets and even out of his shoes.

> He was very playful, and he was making a lot of money at advertising and he just enjoyed himself quite a bit. At the last minute he'd suddenly get a whim to see the most successful show on Broadway and I would say, 'Andy, you can't get tickets for that now.' And he'd say, 'Oh yes, we can get tickets. Let's go, let's go.' And he'd go in a taxi and he'd go right up to the box office at 8. 30 and they'd only have the most expensive seats in the front row. He'd never get dressed up, necessarily, for those things. He liked to do things like that – go some place in the middle of the night suddenly, have a picnic in the park for fun.

Andy also resumed an interest in the dance now that he could afford tickets for Paul Taylor, John Butler and Martha Graham.

Julia, with her folksy manner, muddled English and perennial laughter, became a favourite among his friends as she sewed, cooked, and even, on occasion, coloured in Andy's drawings for him. 'I got to know Julia quite well,' Leonard Kessler recalled.

> She used to make *kapushta*, which is cabbage with short ribs of beef. It's marvellous if you live in Alaska or the Yukon. On the hottest day of the summer, she'd say, '*Kapushta* will keep you warm.'
> 'Mrs Warhola,' I'd say, 'I am warm.'
> 'You can be warmer,' she would reply.

Andy adored sweets and his own food faddism tended to fat-saturated mashed avocados and chocolates, which Julia would prepare for him, mumbling disconcertedly. George Klauber was a regular guest for *kapushta* and *halupka*, though he recalled, 'Dinner was just an eating thing. Andy was always impatient to be going somewhere afterwards. His mother was not much interested in conversation. She always reminded me of my mother. She was lonely. The thing is, he didn't know what to do with her.'

Other friends who visited the Lexington Avenue apartment were fascinated and charmed by the relationship between Andy and Julia, particularly their antagonistic moments when Julia would 'sit on' her eccentric son. Andy's peculiar way of dressing was a constant source

of contention. He was beginning to wear suits and ties now, but in his own way. 'He often bought expensive shoes,' one Lexington Avenue visitor recalled, 'but before wearing them, he would spill paint on them, soak them in water, let the cats pee on them. When the patina was just right, he'd wear them. He wanted to appear shabby, like a prince who could afford expensive shoes but couldn't care less and treated them as worthless.' Often he would leave his shoes untied. One friend maintained that Andy never knew how to knot a tie.

When he couldn't make the ends match up, he just cut them off. Eventually he had a whole box of tie ends. This drove his mother crazy, but of course Andy looked great, he looked exactly right. She would be crazy as he was going out of the house, going after him about why didn't he meet a nice girl and get married . . . It was just like a cliché. She didn't know what to make of New York or Andy's friends. She hardly ever went out except to go to the A & P.

For his part, Andy would cringe in embarrassment, and whine, 'Oh, Ma! Leave me alone, Ma!'

Overall, however, it was apparent that Julia was overjoyed to be with Andy. 'I like New York,' she would bubble. 'People nice. I have my church, nice big church on 15th Street and Second Avenue. And the air . . . air better than in Pennsylvania.'

Andy's life had a fairly regular pattern. He would get up around nine and his mother would make him breakfast. Then he would work briefly on finishing a job, put on his Raggedy Andy costume and leave the house by taxi to go to the magazine or ad-agency office to deliver or pick up an assignment. 'It was like being a laboratory rat and they put you through all these tests and you get rewarded when you do it right, and when you do it wrong you're kicked back,' he later wrote.

Somebody would give me an appointment at ten o'clock, so I'd beat my brains out to get there at exactly ten, and I would get there and they wouldn't see me until five minutes to one. So when you go through this a hundred times and you hear, 'Ten o'clock?' you say. 'Weeeellll, that sounds funny, I think I'll show up at five minutes to one.' So I used to show up at five minutes to one and it always worked. That's when I used to see the person.

After spending an hour with an art director, Andy might have a business lunch at an expensive East Side restaurant. After lunch he would go to another office to pick up materials for an assignment. Late in the afternoon, he usually dropped by a new favourite hot spot, Serendipity, to have coffee and pastries. Serendipity – the word could describe Andy's attitude towards life – was located in a basement on East 58th Street and specialized in serving ice cream, cakes and coffee and selling fashionable knick-knacks in a tasteful, all-white setting. It

was a mecca for celebrities like Gloria Vanderbilt, Cary Grant and Truman Capote. Andy was often joined by one or more young men who would sometimes help him fill in colours on drawings. The proprietors, Stephen Bruce, Calvin Holt and Patch Harrington, who were soon to have an important influence on Andy's life, formed an early impression of him as somebody special and spirited who held onto a rather sad, forlorn manner and sometimes seemed like a poor relative visiting from out of town. Before leaving he would often buy pastries or cakes. On the way home he would sometimes stop to buy a book, record or magazines. During the evening he was frequently invited out to parties or went to the opera, ballet or theatre with friends.

Andy was more than generous with people he liked. Apart from taking them out, he spontaneously gave them gifts of something he had bought that they might admire. His friends were playful people on the bohemian end of things, people who were attempting to write or paint. The girls he knew were rather eccentric. They were nice but slightly odd, and he seemed to be very fond of them.

After the evening's entertainment, Andy would often work for a few hours before going to bed around three or four in the morning.

Into this setting Andy brought a new friend who would briefly become his first real lover – Carl Willers.

*

Alfred Carlton Willers met Andy in 1953 in the photo collection of the New York Public Library, where Warhol frequently came to look for source materials for his illustrations. Andy would take home a number of photographs at a time. He traced a face from one, part of a chair from another, the face of a cat from a third, applied the blotted-line technique to the ensemble, and had an original drawing whose sources were unrecognizable. The most important thing, he often said, was what he left out. To make doubly sure no one could detect his sources, Andy would hold on to the photographs long after they were overdue, paying small fines rather than returning them. This way he soon built up a large source bank of photographs. He had also started collecting antiques and art. Willers, who had learned typing and shorthand in the air force, was working as a secretary to the collection's curator while waiting to begin an art-history course at Columbia University.

Carl, as he called himself (Andy teased him by calling him Alfred) was twenty years old, a native of Iowa, whose boyish good looks were accentuated by a thatch of blond hair so long some friends jokingly nicknamed him the Palm Tree. It was his first year in New York and he was, perhaps, more innocent than he cared to admit.

That autumn he became a frequent visitor to the Lexington Avenue apartment and one of Andy's companions for dinners at the Nicholson and spur-of-the-moment theatre evenings. Julia appeared to be delighted that Andy had found a close friend and treated him as if he

were another son. Carl was struck by the Warhol household: Andy, Julia and the cats, who all seemed to have emerged from a European folk tale, were distinctly different reality from the impression Willers had initially formed of Warhol. In typical fashion, Andy had at first tried to obscure the details of his private life by telling 'Alfred' he came from Hawaii. Many people remarked on how much Andy seemed to delight in making up different backgrounds for himself every time he was asked. At least one big Hollywood star, Marlon Brando, was known to do the same thing. One need often look no further than Hollywood stars for clues to Andy's conduct, since he was constantly appropriating facets of their behaviour.

'Andy literally wanted to be famous and said it,' stated Carl Willers. 'He would simply tell you how wonderful and marvellous and talented and brilliant a genius So-and-so was and, "Gee," Andy wanted to be famous too.'

In the evenings after work Carl began helping Andy colour in drawings, or served as a hand or foot model for his illustrations. Often they went out. Carl Willers:

> He loved to go to parties, and there were a lot around. In the fifties, there just seemed to be a party every night. He had many friends who had plenty of money and lived well in apartments in New York and would give these wonderful parties and Andy would go. This was his one real social outgoing thing, but also I think Andy liked parties because he didn't have to be trapped and if he wanted to leave he could. If he really didn't want to go somewhere, which happened often, he could be very adamant about it. When someone else came up with an idea, 'Andy, let's suddenly go here!' he said, 'No, no, no, no,' because he would feel that he was going to be intimidated, or he wouldn't be able to overcome his shyness, or these people would just overwhelm him with their charisma and talent. So he would balance these things out to what he would or wouldn't do.
>
> Andy was definitely gay, but he just didn't make much of it in his life. He found it very glamorous and he liked to be among very elegant gay people who had beautiful apartments or who were doing what he considered very glamorous and exciting things in the world.

Sometimes, if it got late, Carl would stay over, sleeping on a couch in the front room, while Andy worked through the night.

The Andy Warhol Willers knew 'used his shyness as a little boy, but it was a really playful thing, it was very obvious. He really felt people should be playing, but he wasn't at all boisterous, he was in fact rather quiet.' At the Nicholson, their dinner conversations were never heavy or intellectual. Andy was amused by any tidbit of gossip, or would laugh about something he'd seen on television while blissfully devouring his third chocolate soufflé. Later Carl would listen patiently while Andy indulged in remorse.

He had a lot of trouble with his skin and was for ever having eruptions of pimples almost like a teenager. He was very conscious of that and had a great deal of guilt about all this eating of sweet things because he thought that was making him fat and causing these skin eruptions. He was acutely self-conscious. He thought he was totally unattractive, too short, too pudgy. He thought he was grotesque.

Warhol's increasing baldness was a source of particular distress. At the time Willers met him, Andy had almost no hair on top of his head and had begun wearing a cap with a snap-down brim even to dinner parties, a practice Willers felt uncouth. 'Andy, this is insane,' Willers recalled telling him. 'People think it's either phony or rude. Why don't you buy a wig?' Soon after, Warhol bought a light-brown toupé, the first of several hundred hairpieces he would eventually accumulate: brown, blond, white, silver and grey. Years later Andy explained, somewhat satirically, his decision to 'go grey':

I decided to go grey so nobody would know how old I was and I would look younger to them than how old they thought I was. I would gain a lot by going grey: (1) I would have old problems, which were easier to take than young problems, (2) everyone would be impressed by how young I looked, and (3) I would be relieved of the responsibility of acting young – I could occasionally lapse into eccentricity or senility and no one would think anything of it because of my grey hair. When you've got grey hair, every move you make seems 'young' and 'spry', instead of just being normally active. It's like you're getting a new talent.

It was apparent to Willers that Warhol was attracted to him but found it very difficult to act out his feelings, especially around Julia. With the gap in her front teeth, Carl thought she looked like a witch when she laughed. Even when Andy thought he had locked her in her bedroom for the night she would suddenly emerge, grinning and laughing with a bucket and mop. Sometimes she staggered, appeared to be slightly drunk, and giggled uncontrollably at some private thought. At other times she would curl up under a pile of drawings on a chair and fall asleep, only to spring from underneath them in the middle of the night and stagger into the bedroom. She was beginning to develop the same kind of drinking problem that her poor, confused sister Mary had, and that had labelled her sister Anna the black sheep of the family. Perhaps a part of Andy delighted in this. He drank sparingly if at all, but was for the rest of his life what is called in Alcoholics Anonymous a para-alcoholic, that is, a person who thrives on relationships with alcoholics, enjoying their craziness while acting as if he is trying to get them to stop drinking. Andy's fascination with people thought crazy by a majority of society – the drug addicts, drag queens and other freaks of the sixties

– was for the time being at least partially satisfied by his mother, who was a genuine eccentric.

Though Carl was sure that Julia thought that he was only helping Andy and suspected nothing more between them, she was also an inhibiting force. One night as Carl casually bent over to kiss him good night, Warhol brushed him away and silently motioned for him to follow to the other room. He was concerned that his mother might emerge from the bedroom and catch them in an embrace. Safe from her eyes, Andy was finally able to kiss Carl goodnight. On another occasion, when one of Andy's friends asked Julia if she had slept well the night before, she replied, quite seriously and touchingly, 'Oh, no! I stayed up all night watching Andy sleep.' Ten years later Andy would make a film called *Sleep* after staying up all night watching his boyfriend sleep.

It was in Andy's art that his intimacy with Willers was best expressed. He began a series of portraits of Carl, at one point impressing him with the seriousness of his intentions by stopping work on his illustrations for several days and clearing a space in the apartment to concentrate on five large canvases of Willers posing naked. He drew him lying on his back and leaning on his side facing forward. One finished canvas depicted not one man, but two lovers.

Around this time they consummated a brief, nervous affair. Andy was twenty-five years old and it was his first consummated sexual experience.

'I think it's a truly complex subject and many people have been mystified by it and pondered it,' Willers remarked years later.

Does Andy go to bed with anyone ever? All I can tell you is that when I knew him for all intents and purposes he was already celibate, except that if somebody pushed him a little bit, or said, 'Come on, Andy, let's get in the sack,' he would maybe . . . *maybe* . . . But if he could barely get into bed with someone like me, who he knew probably as well as he did anyone at that particular point, I can't imagine who else he could ever have managed with. He was so incredibly self-conscious, he really had such a low opinion of his own looks, it was a serious psychological block with him.

This was at least partly due to his mother. Whenever she was especially angry with Andy, or threatened by his interest in somebody else, Julia would fix him with a hard look and tell him in broken English, so there could be no mistaking the message, a story of a Ruthenian peasant whose beautiful wife only married him for his money. She was capable of making Andy feel as if he was the ugliest person in the world.

Warhol's only comment on the affair with Carl came years later when he told the author that he was twenty-five when he had his first sexual experience, and twenty-six when he stopped.

Like Corkie Ward, Willers came to the conclusion that for Andy, work was more important than sex and that he was not interested in getting physically involved with anyone, although he had an ability to form long-lasting friendships. He would remain close friends with Willers for the next ten years. Unbeknown to Carl, however, Andy destroyed all the portraits he had made of him, including one he was storing for Carl as a gift.

That autumn, 1953, George Klauber recruited Warhol (along with their other Tech classmates, Art and Lois Elias and Imelda Vaughn) to join a play-reading group in an apartment on West 12th Street. Though the Theater 12 Group, as it was called by the apartment's owner – an ex-lover of Klauber's named Bert Greene – would eventually mount a successful production at the Cherry Lane Theater of Jean-Paul Sartre's *The Flies*, the company at this point was receiving little in the way of public response. 'Usually, during performances,' Klauber recalled, 'there were more people on the stage than in the audience.'

Warhol's first appearance was one Bert Greene still remembers vividly:

> Two other people came at the same time who were his friends from Pitts-burgh, Lois and Art Elias. Lois Elias, who had been in the Pittsburgh Reper-tory Theater, was a very good actress. Arthur was not so great as a reader, and Andy was impossible. The first play he read with us was *The Way of the World* by Congreve, and Andy couldn't even read the words. He was really having difficulty. Finally we stopped and said, 'Andy, do you want to read the scene over?' And he said, 'No, no, I'll stumble through.' I thought he'd never come back, because it was a big public embarrassment to not be able to read in front of all these other people, but he wasn't abashed at all.

For the next six months, Andy attended the rehearsals of the group and designed their programme and sets. Often he came with Imelda Vaughn, a Valkyrie-sized woman with a proportionate voice, who had been a friend of Andy's at Tech and in the intervening years had been in and out of several mental institutions. 'Like most people who have had long stays in mental institutions, she was supersane,' Bert Greene recalled, 'and she seemed to be Andy's lodestone when he started becoming a little off the wall.'

Warhol was an anomaly in the group, looking like a slightly gaga preppie with his granny glasses, his weirdly knotted ties and the ballet slippers he now wore. Greene noted:

> When he liked people's performances, he would give them presents. Once he gave someone a walnut with a tiny doll inside. He had opened the walnut and taken the nut out and put the doll in. Or he would give you little drawings with messages on them like 'I'm happy to be here tonight'. His spelling was atrocious, but it was endearing and he was ingenious. He was

a great admirer of physical beauty and was never abashed about it. When there was a handsome person, or even a beautiful woman, in the group, Andy would be riveted to them and instantly go to them, make them gifts.

Beneath this front, Greene could see that Warhol was attentively learning all he could. And he would make good use of these experiences when he created his own theatre in the 1960s. From an older member of the group, Aaron Fine, who was also a successful commercial artist, Warhol was introduced to the 'alienation effects' of the German playwright Bertolt Brecht, which Andy later acknowledged had helped him shape his own aesthetic. Bert Greene:

> He used to talk to Andy in a way that I couldn't. He'd say, 'Now, see here, Andy,' and sit him down and be very straight with him. They genuinely liked each other. Aaron said very original and funny things, and Andy was always a great audience for wit. Andy would sit on the floor at his feet while Aaron sat on a couch talking to him.

Andy's thespian skills also improved considerably. Greene was impressed by Warhol's portrayal of the 92-year-old Russian servant, Firs, in Chekhov's *The Cherry Orchard*. As Andy said the line, 'Life has passed me by as though I had never lived', Greene felt that he was expressing what was perhaps a real inner melancholy. Andy was still trying to learn 'how to live'.

This was the last time the Tech group and Andy would be really close as his success and lifestyle separated him from all but Klauber. In the five years since he had come to New York with his possessions in a paper bag, Andy Warhol had established himself as a commercial artist. He had an accountant, Mr Schippenburg, a stock portfolio, a small but valuable art collection, and a number of hand-tailored suits made in Hong Kong hanging in his closet. Art Elias remembers seeing him that winter at a party at the Pearlsteins' for their psychology professor Klee, who made reference to Andy's homosexuality which Warhol openly accepted.

Kessler moved to Long Island, leaving Lexington Avenue to Andy. Leila Davies, who was giving up her jewellery business and returning to Cleveland, also came over to say goodbye. With others from his old crowd, she shared a sense of pleasure at how far Andy had come (Elias was struggling, and Pearlstein had yet to hit his mark and had begun supplementing his income as a paste-up man by giving private painting lessons), but she and some of the others worried that Andy was making a mistake by neglecting his talent as a fine artist.

Strong currents were pulling him in conflicting directions. As the art critic Hilton Als wrote in an analysis of Warhol's fifties career, by juxtaposing fragility of line with a strong sexual subtext (mostly in his images of boys), Warhol was satirizing the common ad-world concept

of the 'weird' boy window-dresser or illustrator by producing images that they would expect from such a creature, but getting away with more than they realized. 'Not only were his various assignments pleasing to the eye and therefore bought, but he made a style out of his sissy preoccupations with butterflies and ladies' shoes and boys,' Als wrote. 'The style was made powerful through its reproduction in magazines and in books. It became a taste. That was Warhol's difference.' And in that difference there was a trap.

EVERYTHING WAS
WONDERFUL
1954–56

Andy didn't really know what he wanted to do with art at all. He was totally unfocused. Except he had this overwhelming creative drive to do something and never stopped going. It would have helped if he could have been a little more specific but he didn't know what it was he should be doing, or could be doing, or ought to be doing. It was very strange.

CHARLES LISANBY .

In 1954, Andy showed three times at the Loft Gallery on East 45th Street, which was run by the well-known graphic artist Jack Wolfgang Beck and his assistant Vito Giallo in the former's studio. Andy, who had been introduced to Beck and Giallo by Nathan Gluck, was included in the group show in April. The painter Fairfield Porter came to the opening and they were all very friendly towards him and thought he was going to give them a great review, but he wrote a scathing putdown saying they were all commercial artists trying to be fine artists and branding the Loft a commercial-art gallery. 'Warhol's early work exhibited during Abstract Expressionism's heyday,' wrote the German art historian Rainer Crone, 'understandably received almost no publicity and had a very small following. It was considered either as commercial art or, perhaps worse, as work done by a commercial artist during his spare time.'

Andy appeared unwilling to engage in the conflict between commercial and fine art, acting as if he thought the whole subject beyond or beneath him. His first one-man show at the Loft Gallery consisted of a series of marbled-paper sculptures with small figures drawn on them. Art Elias thought, 'This was really a genius show, because it was anti-art, the death knell of abstract expressionism,' but Vito Giallo was rather shocked by it. He had expected Andy to show some of his drawings. Andy explained that he was just trying to do something different and have fun. 'He would never analyse anything,' Giallo recalled, 'you just had to more or less guess what he was doing or why he did it, and he would never discuss other artists in depth either. I was quite surprised

112

that Andy wanted to be a fine artist because I thought all he was interested in was commercial art.'

Andy's second show, which was devoted to drawings of the dancer John Butler, received a brief review in *Art News* from Barbara Guest, who wrote, 'Andy Warhol has developed an original style of line drawing and a willingness to obligate himself to that narrow horizon on which appear attractive and demanding young men involved in the business of being as much like Truman Capote or his heroes as possible. His technique has the effect of the reverse side of a negative.'

If the work attracted little serious attention in the fine-art world, Andy had by now clearly emerged not only as a prodigy but as something of a star in the commercial-art world. All the art directors of the major agencies flocked to the opening. Vito Giallo:

Even though he was shy and withdrawn at times, they all wanted to talk to him. And he would just listen. He was always like that, he wouldn't make any comments, never had much to offer, but everybody liked him, he had tons and tons of friends, because he was different. He would never swear, for instance. He used things like 'Holy cow' and 'Wow' and 'Gee whiz', and people just thought that was so cute and different and funny, and he would always say more or less the unexpected thing. He was like an innocent child, he had this childlike quality that people were fascinated by. They just had to know this person and what made him tick, and I could never figure out why they wanted to know because he just stood there in the middle of all these people talking to him and said, 'Yes' or 'No'.

Shortly after meeting Vito Giallo at the Loft Gallery, Andy hired him as his first assistant from 1954 to 1955.

I came to New York in 1949 and when I started going out into the art world in 1951 I would see these strange blotted-line drawings. Other artists would always talk about how he achieved that blotted line and nobody knew exactly how he did it. When he came up to the gallery and Nathan introduced him I thought, Gee, he's a very shy boy, very shy, and we liked each other immediately. We became very friendly. I was thinking of freelancing and Andy was always very supportive of that and liked my drawings and said, 'You gotta freelance.' At that point he had a lot of extra work and I would go to the apartment every morning and work on some of the projects. I would trace his drawings. When I did the blotted-line technique he would do the drawings and I would trace the line with ink and then fold the paper over to get this perfect registration and it looked like he did it. You couldn't tell that someone else did it because I was just following his line.

He always, always wore chinos, white socks and loafers and an open shirt. I don't ever remember seeing him in a tie. In fact, he always said to me, 'I don't know why you wear a tie. You should never wear a tie,' but I don't ever remember him being sloppy, he was never spattered with paint.

There was practically no furniture in the apartment whatsoever. It was like a railroad flat. In the back room at the very end where the bathroom was

there was a bedroom and I noticed that there were no beds but two mattresses next to each other on the floor. The rest of the apartment was pretty much barren except for his drawing table and his lightbox and the black and white TV which was on a lot. I saw him do a lot of drawings watching TV with the pad on his knees with his legs crossed, his mother standing there holding the shoe while he drew it. And then she'd put it on, and then she'd get into both shoes and they'd laugh because she looked so funny in those shoes. She couldn't really walk in them at all, she had very wide feet, she always was barefoot. Andy laughed a lot.

I got there around ten or eleven o'clock and I'd work into the early afternoon. He would get jobs constantly. He was probably the busiest commercial artist at that point, making a tremendous top-notch salary; $100–$125 a week was a very good salary if you were working in a studio. He could have been making anywhere from $35,000 to $50,000 a year. He did say he would send money home to his brothers.

His mother liked me, and that meant a lot to him, that someone could talk to her and get along with her well. She was devoted to him and it seemed like her whole life revolved around Andy. I don't think she had any friends. She was constantly offering us sandwiches all day long while we were working, and would never understand what we were talking about. He would talk Czech to her and I don't think he respected her very much. One time I said to Andy, 'You know your mother has to go down these five flights to go to the A & P and come up the steps all by herself with all these shopping bags. Don't you think that's too much for her?' He said, 'Oh no, she loves it.' She'd be floating in and out of the rooms cooking, cleaning, picking up. He depended on her completely, which always kind of shocked me, but I think she really enjoyed it.

Andy liked gossip. I like gossip. We always had that wonderful rapport of, what's happening, what's going on? We would never talk about art, it was always about people and parties, who's going with who. He would want to know everything about me. What do you do? Who do you see? But he would never give any information about himself. I always gave him a lot of information about things he'd like to hear. That's why we got along. He would like to talk about guys, who was hot, who was sexy, he would like to know if I had seen this guy or what he was like, how he was built, he was always very interested in sex and the way he dressed was very suggestive, revealing, tight pants, he was very sexually interested in other men and we'd often talk about it. I think Andy did get an actual sexual excitement out of talking about it, 'I think you should go with this person and you could do this and that, I think you two would be great together.' He liked that, it was almost enough to satisfy his sexual appetite.

He had a friend named Valerie and Valerie's boyfriend was a sailor and on certain nights of the week he would go for lessons, they gave him sex lessons. I think he was there just to observe and take notes, but I thought that was kind of cute. I never met the boyfriend but Andy said, 'Oh yes, every week they want me to come over and they give me lessons in sex.'

He never complained about personal relationships. I think he had a good time no matter where he was all the time. He never talked about anything

that was a problem. I never saw a down side. Even if he didn't like somebody's work he would always at least see a positive side to it. He never looked at the bad side. To me he was always an up person. Never upset, never, never. That's why I liked to be around him. He was always positive about everything about life. That's what was so refreshing about Andy. Everything was wonderful.

<p style="text-align:center">*</p>

Shortly after hiring Vito, in the autumn of 1954 Andy fell head over heels in love with Charles Lisanby. Their relationship lasted for almost ten years.

Charles was the most exciting person Andy had ever been in love with. He was outstandingly good-looking, tall, elegant, aristocratic, plus he was glamorous, a good hustler and knew everyone who was cool. Some people thought he was a little snobbish, but that's precisely what Andy wanted – the upwardly mobile. Charles moved in a world that included James Dean and was dating the actress Carol Burnett and worked with the photographer Cecil Beaton. These were exactly the kind of people Andy wanted to be associated with.

Andy gave Charles the impression that

> the romance of everything just swept him away, and he had often looked for love but never found it. In my own particular way I really did love Andy because he had many lovable qualities. He radiated an extreme vulnerability, like Marilyn Monroe or Judy Garland, and you just felt, 'If I can shield this person from the problems of the world . . .' Almost anyone he met felt that and wanted him to be happy and get what he was looking for.

Early on in their relationship Andy gave Charles a photograph of himself taken when he was a boy in which, Charles thought,

> he looked like a beautiful Botticelli choirboy, the Little Prince, a child from another world. He gave it to me because inside he always still thought that's what he was, and inside he was a very beautiful person. That's what I really liked about him. But he had an enormous inferiority complex. He told me he was from another planet. He said he didn't know how he got here. Andy wanted so much to be beautiful, but he wore that terrible wig which didn't fit and only looked awful.

The year 1955 was a great time for Andy. He loved going out with Charles. Charles used to take him to chic parties. 'Neither of us ever drank more than a glass of wine. I would circulate and Andy would sit in a corner without saying a word. People thought he was dumb. He was anything but dumb. He was more brilliant than even he knew.'

Enormously turned on by each other, Andy and Charles 'never stopped chattering away'. Charles thought Andy was 'the most interesting person I ever met, the strangest little guy with an original and unique approach to everything'. Once Andy gave Charles a television

set. Another time, when they stopped outside a shop to admire a stuffed parrot, Andy bought it and gave it to Charles. His idea of heaven was having Sunday brunch at the Plaza with Charles.

As soon as he met Charles, Andy began to make a concerted effort to improve his appearance and immediately started going to the gym. He got the printer who did his promo books, like the 25 *Cats Named Sam and One Blue Pussy* he turned out at Christmas 1954, Seymour Berlin, to put him through a workout at the McBurney YMCA three nights a week. 'When he got there,' Seymour recalled, 'he could not do a push-up, but he worked out very good because I saw a big change in strength.' Seymour felt that Andy was so young he still had no façade. He never seemed relaxed, he was almost edgy, except when they worked out. Then he would talk a lot and he told Seymour about his adventures getting into the high-powered world of New York celebrities, how he would buy $500 suits but cut them with razor blades and spatter them with paint to draw attention to himself, or send Truman Capote and Cecil Beaton presents in the hope that they would want to meet him. Seymour was all ears, but he concluded that there was something seriously unbalanced about Andy's need to be with these people. 'The wrong things were always important to Andy,' he recalled.

> His relationship to money was not healthy. He would not spend on things he needed but he would spend outrageously on going somewhere like the Plaza just to say he'd been there. He was in a sense a split personality. On the one hand he was a very, very smart businessman, on the other hand he was fatalistic. He told me on several occasions that he always knew he was going to die early. But at the time I knew him, going out at night and meeting famous people was a very important part of his life. And he would get very upset if these people did not respond to his gifts and letters. He'd complain that *they* were taking advantage of *him*!

'He was always fond of celebrities,' attested Paul Warhola.

> He wanted to go to a lot of parties. I mean, he met friends and he would say, 'Well, take me to this party. So and so's going to be there.' He'd say, 'I don't care even if it cost me money. I wanna go! I wanna meet people!' And he just kept on. It kept on building up. Later on, they would pay him to come to their parties.

The idea of fame was quite different in the 1950s from what it has subsequently become, particularly in the art world. 'Warhol was the first American artist to whose career publicity was truly intrinsic,' wrote the critic Robert Hughes.

Publicity had not been an issue with artists in the Forties and Fifties. It might

come as a bolt from the philistine blue, as when *Life* made Jackson Pollock famous; but such events were rare enough to be freakish, not merely unusual. By today's standards, the art world was virginally naïve about the mass media and what they could do. Television and the press, in return, were indifferent to what could still be called the avant-garde. 'Publicity' meant a notice in the *New York Times*, a paragraph or two long, followed eventually by an article in *Art News* which perhaps five thousand people would read. Anything else was regarded as extrinsic to the work – something to view with suspicion, at best an accident, at worst a gratuitous distraction. One might woo a critic, but not a fashion correspondent, a TV producer, or the editor of *Vogue*. To be one's own PR outfit was, in the eyes of the New York artists of the Forties or Fifties, nearly unthinkable – hence the contempt they felt for Salvador Dali.

*

Andy's career took a big leap forward too in 1955 when he got his biggest account of the fifties, the one that really made him famous in the advertising world, doing a weekly ad in the society pages of the Sunday *New York Times* for the fashionable Manhattan shoe store I. Miller. The shoe market in the 1950s was vast and bought a lot of advertising. The people who brought him to I. Miller, the vice president Geraldine Stutz and the art director Peter Palazzo, had known Andy since he came to New York. They appreciated Andy's talent and thought of him as an artist, and they chose him to launch a campaign to change the store's sagging image. The subject suited Andy perfectly, he was thrilled by the development, and the small but growing, largely gay audience that was beginning to recognize each Warhol drawing opened their copies of the Sunday *Times* with anticipation and saw the new work with delight. Geraldine Stutz:

> The strength and spareness of Andy's work took people's breath away. Peter Palazzo and Andy were true artistic soul mates, and Andy always prided himself on doing exactly what we wanted, but the reality was that we presented Andy with an idea in simple form. He took it away and came back having transformed this idea into something that was universal and extraordinary and special on his own. The effect was a sensational resuscitation of the I. Miller name.

Shortly before getting the I. Miller account, Andy's relationship with Vito Giallo had broken down.

> Andy had a way of dropping people. He would constantly call me and say, 'Oh, let's go to a party tonight.' He would pick people out for me, 'I think you would like this one,' he was good at it and it was cute. But he really expected me to go with him, and one night when he wanted me to go and see Valerie and her boyfriend perform and I couldn't, he was a bit peeved, and I didn't hear from him for a long time after that.

117

In the autumn of 1955, Nathan Gluck, who had originally introduced Vito to Andy, took Giallo's place as Andy's assistant. Although somewhat self-effacing, Nathan was talented, had original ideas, good taste and a sense of humour. When he was excited or upset he would exclaim, 'Oh, Jesus Christ!' 'My mother would like it if you wouldn't say that,' Andy had to inform him. Nathan soon developed a good relationship with Julia, who regaled him with her unique, often hysterical renditions of biblical tales, in one of which 'Moses was born in the bull'.

Nathan was the first of many great assistants Andy discovered. During the next nine years his ideas and contributions would have such an influence on Warhol's career that many of their mutual friends felt that Gluck became one of Warhol's first victims, that Andy used and abused him. Gluck calmly denies the charge. In his view, he was Andy's assistant, not his collaborator.

One important contribution he made early on was getting Andy assignments to decorate windows for Gene Moore at Bonwit Teller's. Moore was another figure on the scene who was highly impressed by Andy and his work:

On the surface he always seemed so nice and uncomplicated. He had a sweet, fey, little-boy quality, which he used, but it was pleasant even so – and that was the quality of his work, too. It was light, it had great charm, yet there was always a real beauty of line and composition. There was nobody else around then who worked quite that way.

As Andy's I. Miller ads, with their freshness and strength and magnificent use of white space, began to make their impact, Andy jumped on the chance to develop the theme. Stephen Bruce remembered his coming into Serendipity with a huge portfolio of rejected I. Miller drawings and saying, 'What do I do with these?' Since the whole theme of the place was white and everything in it, including the Tiffany lamps and white china, was for sale, Stephen suggested Andy frame them and sell them in the shop for $15–$25. The next thing he knew, Andy brought in a whole portfolio of watercoloured shoe drawings called 'A la Recherche du Shoe Perdu' and sold those as well. Serendipity was one of Warhol's first factories, and he created works of art right at the tables in exchange for his meals. 'At first I thought Andy never changed his shirt,' said Stephen Bruce. 'I said, "I see you day after day in the same shirt." He said, "Oh no, I bought a hundred of them, I wear a new one every day." '

However, it was quite obvious that selling drawings in a coffee shop, even a coffee shop with the clientele Serendipity attracted, was not going to get Andy accepted as an artist. Labels were, and still are, very important in the art world. If you were known as a commercial artist

there were no serious galleries that would be interested in your work. It was all very confusing to Andy because his Carnegie Tech training had pitched the Bauhaus line that there is no difference between commercial and fine art, and the disillusionment of finding that this was not so may be another reason that for the rest of his life he would deny that he had benefited in any way from his years at Tech.

The dilemma was brought home in a particularly annoying way the same year Andy reached the peak of his commercial career, when his old fellow student and roommate, Philip Pearlstein, was accepted at the prestigious Tanager Gallery. Pearlstein's struggle had been a subject of occasional derision among Andy and his gay friends, who felt they had a more accurate view of the *Zeitgeist* than intellectuals like him, and now Andy responded with the subtle aggression that would become typical of him later. The Tanager was a co-op gallery, which meant that the artists decided whose work was to be shown there. Andy gave Philip a group of his paintings of naked men and asked him to get them shown at the Tanager. Nudes were a perfectly acceptable subject, but the way Andy did his was so overtly homosexual that Philip would have been insulting his serious, high-minded colleagues by presenting them. When he tried to explain to Andy that the paintings should perhaps be done more objectively, Andy cut him off, pretending not to understand what he meant. Pearlstein got the impression that Andy 'felt I had let him down, and we were seldom in touch after that', but it is more likely that Andy's demand had been an act of detachment and defiance.

Andy was bent on a strange course, which provides an early indication of just how defiant of the rules his art would become. You could get away with being homosexual in the sophisticated New York world of the fifties as long as you kept the homosexuality out of your work. But Andy kept looking for an art gallery that would show his overtly gay drawings and paintings. 'Other people could change their attitudes, but not me – I knew I was right,' he wrote later.

In the autumn of 1955 he showed a portfolio called 'Drawings for a Boy Book', which were mostly of cocks with bows tied around them or kisses on them and faces of beautiful young men, to David Mann, Iolas's former assistant, who now had his own Bodley Gallery next to Serendipity. David liked the work and decided to give him a show.

Hooking up with David Mann was a big move in Andy's career. Mann was a legitimate dealer, who specialized in the surrealists and was well connected. For the next few years he would play an important role in helping to get Andy's work accepted.

Charles helped hang the show, which opened on Valentine's Day, 14 February 1956. Champagne and martinis were served. Andy was dressed in an elegant custom-tailored suit. Although the gallery was packed with friends, mostly very good-looking young men, Andy

seemed to David to be terribly ill at ease. 'He was one of the shyest people I have ever seen. He would be very happy to see the people and he'd greet his friends, but his outstanding characteristic was great shyness.'

Andy was always worried and never satisfied by the acceptance of his work or their sales. He would worry that nobody was going to come, that the reviewers would tear him down and that nobody was going to buy anything. And in fact, although the drawings were only priced at $50 to $60, only two or three of them sold and he would say, 'Oh, my God, bombed again!' In years to come Andy's translation of this vulnerability into hostility would spur him to success.

Reviews were lukewarm. Critics could not be expected to take drawings of narcissistic boys by a homosexual window decorator seriously, even if they were in the style of Cocteau and Matisse. Despite this lack of critical interest, with the help of David Mann, in April some of Andy's less overtly sexual drawings were included in the Recent Drawings show at the Museum of Modern Art.

SO WHAT?

1956–59

Everything was just how you decided to think about it.

ANDY WARHOL

Julia never openly acknowledged that Andy was gay, but during the 1950s finessed the situation by accepting his boyfriends as adopted sons. Charles Lisanby had been coming to dinner at Lexington Avenue regularly and got along very well with her. When Andy went on his trip around the world with Charles from June through July 1956, Julia and Paul, who had come up from Pittsburgh to take care of her while Andy was away, followed the route closely via maps Andy drew and sent them along with numerous postcards saying he was fine and having a good time. By the middle of the trip, however, the pressure of the unconsummated relationship had begun to try Andy's patience.

After Bali they visited the ruins of Angkor Wat and travelled on to Bangkok, where Andy was particularly impressed by the black furniture with gold leaf on it, something he would soon make good use of in his own work. Charles found Andy's reactions to the orient as original as his reactions to New York, and the constant travelling kept him too busy to worry about their relationship, but Andy was less than happy with the situation. It wasn't what he had imagined. Even after his realization that everything was just how he decided to think about it, Andy still held on to the hope that Charles would give in and decide that something was going to happen between them.

His hopes were dashed once and for all when Charles got food poisoning. He was terribly sick by the time they arrived in Calcutta, one of the dirtiest, smelliest cities in India. Andy, who had eaten the same meal, was unaffected. Charles could hardly crawl to the bathroom. A doctor came to the hotel, recommended several weeks in bed and gave him some medication. That night they read in the paper of the death on the steps of the local hospital of a pregnant woman who had been administered the wrong medicine, and Charles decided he did not want to die in Calcutta. They flew from Calcutta to Rome via Cairo.

From here on the trip took on a madness of its own. When the plane landed in Cairo Andy and Charles were astonished to see the airport surrounded by soldiers and tanks. It was a few months before the Suez crisis. Everyone had their passports removed and was marched out of the plane across a runway to the sound of screaming fighter jets,

marching soldiers and shouted commands, and ushered into a Quonset hut where they were forced to watch a propaganda film, then marched back on to the plane. Andy was solicitous but still refused to take responsibility for their tickets, passports and luggage even though Charles could hardly stand up. Charles had to make sure they got their passports back. Andy just walked through the scene like a zombie. They were in Rome the next morning and at the Grand Hotel Charles gratefully collapsed and summoned an Italian doctor.

For the next two weeks he was confined to bed. Much to his dismay, Andy decided to spend the two weeks sitting in the room with Charles rather than sightseeing in Rome, drawing Charles asleep and awake, finding pleasure in this uninterrupted time with the object of his desire. Charles found it really hard to take after a while. Just having Andy in the room took energy he didn't have. It was impossible to relax with him there. He begged him at least to go and see the Pope, and Andy made a few excursions, returning forlornly with some scarves he had picked up. When Charles recovered and they went down to Florence for some sightseeing Andy seemed just to be going through the paces, mumbling 'Wow' or 'Gee' disconsolately at a Titian or a Botticelli.

By the time they got to Amsterdam he had cheered up considerably and they had a good time, taking, as Charles saw it, a little holiday from the trip, being driven around to the best restaurants and seeing the city.

Charles was absolutely shocked when Andy walked out on him the minute he got through customs at Kennedy airport, leaving him with all his bags and packages, getting into a cab and going home alone without saying a word. 'That was a whole other person emerging,' he reflected. 'I had never imagined Andy could be that decisive. It was as if the whole trip had been an act, and he really meant everything in Honolulu and was just waiting to get home. I was very angry.'

So, apparently, was Andy. His brother Paul could see that

> he wasn't too pleased with Charles Lisanby. I says, 'What happened to Charles Lisanby, you don't have no friend with him?' He says, 'Well, he was hoggish. He took a lot of things we got together.' Andy was hurt. He says, 'Gee, I made this trip there around the world and I wanted some of the pictures and he hogged up everything.'

But to another gay friend Andy complained that he had 'gone around the world with a boy and not even received one kiss'.

After waiting in a fury for him to call for a couple of days Charles realized Andy never would, so he phoned and said, 'Andy, why did you do that?'

Andy acted as if nothing had happened. 'Oh, why didn't you call?' he said. 'I thought I was supposed to go home alone.'

They continued to be friends, seeing a lot of each other for the next eight years, but it was never quite the same again. Charles felt that Andy was still in love with him but would never forgive him. He knew it was simply not in the cards between them, it would never happen. Andy still occasionally suggested that it would be so much easier if they lived together, but he never pushed it again as he had in Honolulu.

*

Lisanby's rejection may have been a blow to Andy, but there were distractions. The boys at Serendipity had persuaded him to rent the second-floor apartment at 242 Lexington Avenue Calvin Holt was moving out of, letting Julia remain on the fourth floor, and start to enjoy his money a little more. It was time to stop living in that bat cave with no furniture, they told him. They felt that Andy was always hanging back from the glamorous life he wanted, not believing he could have it, and they helped persuade him that he could.

While Andy worked upstairs in the last months of 1956, they were decorating the place downstairs. When they finished they had created a stage-set apartment that set a whole trend. Stephen and Calvin had installed a long white wicker couch in the living room and placed a white wooden column with a big bulb atop it at each end. The leaves of a large potted palm tree spread over it. Apart from a couple of rustic rockers made out of twigs and branches, the rest of the living room was empty, so that when you sat on the couch it was like being on the set of a Tennessee Williams play. They put a large round table in the front room and surrounded it with eight bentwood chairs. An enormous Tiffany glass lamp hung above the table. White curtains covered the windows and beautiful white china filled the kitchen cabinets. A friend rigged up a stereo system. A four-poster Louis XIV gold bed and Eartha Kitt-influenced tiger-skin throw rug had been installed in the bedroom.

Andy now had his own stage to operate on and he started giving parties. Guests later recalled how much fun these parties were. Andy would have Broadway show tunes playing on the stereo and everybody he invited would be, somehow, just in the bloom of their youth. The parties were full of the eccentric girls he was always trying to promote and the most beautiful boys. Andy attracted a lot of people now because on the surface he always seemed confident, shared his abundant energy and gave everybody encouragement.

Influenced by Nathan Gluck, whose own apartment was like a museum, Andy had begun collecting art. He bought watercolours by Magritte and Tchelitchev, a drawing by Steinberg, an early Klee, a coloured aquatint by Braque, a Miró, lithographs by Picasso and a sand sculpture by Constantino Nivola (which Julia tied to the bookcase with a rope when she discovered how much it had cost). Nathan was disturbed by the cavalier attitude with which Andy handled his acqui-

sitions. Most of them leaned against the wall or were tacked up without frames.

On the spur of the moment either Paul or John would frequently decide, 'Hey, let's go to New York and see Bubba!' and descend on Andy's apartment with their children. Andy appeared to enjoy their visits almost as much as Julia. George Warhola:

> He had bunk beds set up for us. Bubba used to go the market and buy vegetables and cook on a big stove. Andy would buy us presents. Once it was a real nice camera. You took the picture and a mouse shot out.

<div align="center">*</div>

Andy had a real breakthrough with his Crazy Golden Slippers show at the Bodley Gallery in December 1956. These were large blotted-line drawings of shoes painted gold, or decorated with gold metal and foil, like the lacquer furniture he had seen in Bangkok. The distanced, iconographic golden slippers were a distinct contrast to the personal, voyeuristic male portraits he had shown at the beginning of the year and – perhaps consequently - more successful. He gave each shoe a name: Elvis Presley, James Dean, Mae West, Truman Capote and Julie Andrews, among others, were given shoes that mirrored their characters. Julie Andrews and her husband Tony Walton came to the opening and so did the actress Tammy Grimes. There was less of the gay element.

The show was followed by a two-page colour spread of the Crazy Golden Slippers in *Life* magazine. Andy had been so worried his work was going to be rejected that he had taken David Mann to *Life*'s offices with him. 'Andy kept saying, "Oh God! They're not going to like these, this is going to be absolutely terrible, they're going to tear me down," ' Mann recalled. 'He was really sweating it out.'

With the help of David Mann, Andy was beginning to get some footing for himself as an artist in the chi-chi gay-fashion-celebrity world. The socialite Jerome Zipkin commissioned a shoe portrait. The cosmetics tycoon Helen Rubinstein's aide-de-camp Patrick O'Higgins approached David Mann:

> He said that Madame had seen the show and would Andy consider doing a portrait of her, and he did. Then I got this telephone call from Patrick and he said, 'About that portrait,' he said, 'Madame likes it very much but do you think you could better the price?' I said, 'Well, you know, it's only $125 and it was commissioned,' and I could hear her going on in the background. 'Tell him $100!' and he said, 'She suggests $100.' I said, 'Well, no, I don't think so,' and so he said, 'Well, all right, she'll buy it anyhow.' Andy got so upset. He said, 'Oh God! What does she think of me?' But he was moving into that smart world.

The socialite D. D. Ryan bought the gold shoe he had dedicated to

Truman Capote, and sent it to Truman as a Christmas present with an accompanying note describing Warhol. 'He's becoming very well known. Very on-coming,' she wrote.

'Even then I never had the idea he wanted to be a painter or an artist,' Capote recalled. 'I thought he was one of those people who are "interested in the arts". As far as I knew he was a window decorator . . . Let's say a window-decorator type.'

Capote's bitchy response was, unfortunately for Andy, on target. And if Andy had any doubt that his shoes were not going to put him on a par with Jackson Pollock, all he had to do was read the caption for the double-page spread in *Life* magazine. It described him as a 'commercial artist' who sketched 'imaginary footwear ornamented with candy-box decorations as a hobby'. Getting into *Life* had been one of Andy's greatest ambitions and was certainly a mark of how successful he was, but this was as high as he would go in the 1950s. This was where he would find himself stuck.

*

In the fall of 1956 Andy, who had been going to the gym for two years and was so strong he could do fifty push-ups, made another determined effort to change his appearance, this time by having his nose scraped. His doctor suggested Andy have this done or else, he told him, in later years he would look like the comic W. C. Fields. Andy, who was particularly uptight about the porous red skin on his nose, went into St Luke's hospital to have the cosmetic operation. However, after waiting for two weeks for the scars to heal, he discovered that it had not improved his appearance at all. In fact, he thought it looked worse. Charles Lisanby:

> He had a great lack of confidence about himself physically, about his physical appearance, his physical prowess and everything else. He had very definitely the idea that if he had an operation on his nose then suddenly that would change his life. He thought that he would become an Adonis, and that I and other people would suddenly think that he was as physically attractive as many of the people that he had admired because of their attractiveness. And when that didn't happen, he became rather angry.

David Mann had been listening to Andy's complaints about how Charles no longer seemed to have much time for him.

> Andy, curiously enough, was not a happy person in the fifties. He wasn't light and gay. He was very serious, and frankly I think very often unhappy in his love affairs. Andy is interesting as a personality now, but he was really a very unattractive young man. He had a bad complexion, bad hair, no shoulders. I mean, he was a mess! And then he was always falling in love with these beautiful boys. Even when they became friends and went to his

parties, the last thing in the world they were interested in was going to bed with him. That wasn't a very happy thing for him.

Friends noticed a pronounced change in the sweet, innocent Andy to whom everything had been wonderful. When Ralph Ward's long-term friend Dougie died, Andy presented no condolences but eagerly asked if his Tchelitchev paintings were for sale, earning Ralph's lasting contempt. When the fashion photographer Dick Rutledge told him, 'I can't stand America any more. I can't stand this fucking fashion world any more. I'm going to kill myself!', Andy said, 'Oh, can I have your watch?' It was a very expensive watch and Rutledge took it off and threw it at him. Andy kept the watch for the rest of his life.

The failure to improve his appearance did not seem to dampen Andy's ardour for his next lover, another great-looking young photographer, Ed Wallowitch, but perhaps it did change the way things worked out between them. Ed Wallowitch shared an apartment with his brother John, a pianist, at 8 Barrow Street in Greenwich Village. It was an 85-foot-long basement place and the Wallowitch boys had a downtown salon where guys brought jugs of wine and watched old movies at rent parties. This was the Village gay scene as opposed to the Upper East Side scene Andy had been doing with Charles, and it was a very cute scene. Andy started to spend a lot of time at Barrow Street. At first John was very excited about the Warhol–Wallowitch connection:

I thought these guys were going to do something really great together. Ed couldn't keep his hands off Andy and Andy was all over Ed. We had a lot of laughs. My brother was very witty and Andy was very sweet in those days. Adorable. *Artistique.* Once we all went up to his apartment to see Mrs Warhol and he showed us two refrigerators. He kept one filled with champagne, which he said was for her. Andy and Ed were extremely close and Andy would stay over at the apartment down in the Village a lot.

However, the writer Robert Heidie, who would work with Warhol on several films in the 1960s, saw the relationship from another angle:

There was an awful lot of drinking going on. They were heavy into the martinis, but Andy wasn't drinking. He was more like the little boy. Edward was very serious about his work and there was a kind of sensitivity, but he was very manipulated by the brother, John, who was extremely controlling and they were very competitive.

Andy, he noticed, was rather withdrawn and reserved. He had started wearing dark glasses and Heidie felt

that on some level Andy was always acting, that the real person was submerged and there was definitely a pre-oedipal thing about him. His

mother was a very important, almost spooky presence – 'My Andy can do no wrong. He's a good boy' – and Andy would retreat into that four- or five-year-old. People acting things out in a relationship to prove something to a parent often relate to other people in terms of sibling rivalry in extreme competitiveness, and I think that was the whole thing. I saw him as somebody with a little smarts but there seemed to be something icky about him at the same time. I felt he was a person to keep distanced from.

For a while Ed Wallowitch probably knew Andy better than anybody else and saw more of him. The affair with Ed was certainly the most sexually active affair he ever had and Ed took some beautiful photographs of Andy in bed in which he looks handsome and at peace – very balanced.

The American lifestyle in the Eisenhower era was based on infinite economic expansion, size and speed. Everything got bigger and faster, and New York was the hub. Andy was leading a superactive life and operating on a number of different scenes simultaneously, and he seems to have been for the most part pretty up. His income continued to increase. In 1957 Andy was doing so well financially that on the advice of his accountant, Mr Schippenburg, he established Andy Warhol Enterprises. Although he had been making good money for a few years now, Andy and his family remained paranoid and confused about the distribution of it. Every time Andy had a show at the Bodley Gallery Julia would complain that he spent $5,000 on champagne but did not sell one piece. 'He makes $100,000 a year but he spends $125,000,' she told Paul. Andy, for his part, was so afraid of the Internal Revenue Service he gave Paul the impression that somebody had tricked him.

This one guy used to come in from Connecticut to do his books and I wouldn't be surprised if he didn't fake being an IRS agent to shake Andy up a little and says, 'You're in big trouble!' I'm pretty sure he took advantage of Andy because when he incorporated he wanted to be his partner and put his name down and his wife's name down as presidents of the company. I think that was a scam. After Andy got rid of him he became very wealthy. But Mother, she had a sense of discernment. As soon as this guy walked through the door, she said, 'Andy, watch out!'

Andy was investing a good deal of his money in the stock market as well as broadening the area of his collecting. Through a new friend named Ted Carey he developed an interest in American folk art.

The year 1957 ended with another very successful show at the Bodley Gallery. Although it did not receive as much media attention as the Golden Slippers show, the Gold Pictures show sold well and *The Gold Book*, which Andy sent out as a promotional item that Christmas, was equally appreciated. Only John Wallowitch began to feel a little

uncomfortable when he realized that Andy had traced all the drawings in the book from Ed's photographs without giving Ed any credit.

<p style="text-align:center">*</p>

The bottom was just about to fall out of Andy's fifties world. The breakdown began with the opening of Jasper Johns's first show on 20 January 1958, four weeks after Andy's show closed at the Bodley. Just twenty-seven years old – two years younger than Warhol – the gloomy Johns with his *poète-maudit* features, saucer eyes and brittle image became an overnight sensation when his show of Flags, Targets and Numbers sold out. The Museum of Modern Art bought four paintings, an unprecedented reaction to such a young artist. Several important collectors and an unorthodox newcomer named Robert Scull (who wanted to buy the whole show) bought all but two of the others.

Johns had done exactly what Andy dreamed of. He appeared, seemingly from nowhere, with an exhibition so powerful, so controversial and so good (and with Andy's favourite subject, a cock, in it) that the best his critics could come up with was to call Johns unpatriotic because he had painted the American flag. Each painting contained a historical essay about art in the choice of subject matter, application of paint and individual brushstrokes, as well as the bold questions Johns was asking about how people looked at art, what they thought art essentially was. The overwhelming impact of these instant classics heralded a new movement.

The changes that would burst forth in the experimental counter-culture of the 1960s were bubbling under the surface. New artists like George Segal, Frank Stella and Roy Lichtenstein were just starting to find their métiers. The pop-art movement that had begun in England in 1956 had spread to France and was finding followers in America. The New York scene still centred on de Kooning and the abstract expressionists, but they were not moving with the same velocity as they had in the early and mid-fifties. De Kooning spent the entire year on one canvas, painting it over and over again because he didn't think it was working. 'It was an insane time,' recalled the photographer and filmmaker Robert Frank. The art world had not turned commercial yet and the majority of the painters were, in the words of one, 'a scruffy, excitable lot. It was us against the world.' 'Everybody was in everybody else's pocket,' recalled another. 'There was rivalry – egos were gargantuan – and there was a lot of competition, but the struggle was private and not corrupted by media.'

It was a scene that Andy was still definitely not allowed in because of his success as a commercial artist and his homosexuality. That is exactly why the great success of Jasper Johns's first show was tremendously significant for Andy. Johns had been a commercial artist and worked for the same man at Bonwit Teller (Gene Moore) Andy had. Johns was gay. And Johns's paintings were a major step away from

abstract expressionism in content and style. Johns was immediately taken seriously by the art world. If Jasper Johns, who was two years younger than he, could do it, Andy reasoned, that meant he could. The belief was supported two months later when Johns's lover, Robert Rauschenberg, who had also been a commercial artist and whose work also definitively broke the abstract-expressionist stranglehold, had an equally dramatic show.

Suddenly, an art world that had been completely closed to Andy appeared to be opening up. The Castelli Gallery, which had shown both Johns and Rauschenberg, was now the place to be shown and Andy started going there regularly. He was more determined than ever to get into the scene.

However, he had a big problem. The last things Jasper Johns and Robert Rauschenberg wanted anyone in the art world to know was that they were gay. In the 1950s such a revelation would have destroyed their careers. They were putting as much distance as they could between themselves and many of the gay art directors who had hired them. When Andy approached them at openings they cut him dead. 'He was very unpopular with the people he wanted to be popular with and very unhappy about it,' recalled David Mann. 'And I think that slowed him down in his work, but he was definitely already having an artistic revolt.'

It was just at this time that Andy met Emile de Antonio. The brilliant, eloquent and stylish de Antonio had already played an important role in many careers of the period and had become an important contact, since De's circle of friends included several who were rising in the art world and were gay: the composer John Cage and his companion, the choreographer Merce Cunningham, as well as Johns and Rauschenberg.

'I met Andy Warhol in 1958 through Tina Fredericks,' de Antonio wrote in *Painters Painting*. 'I realized early that he knew the answer to every question he asked. The first day I met him, he said, "Tina tells me you know everything. How did World War I begin?" He came to small dinner parties at which I served smoked salmon, Dom Perignon, and grass.' Later de Antonio explained:

> The commercial art world was a small gay world and once Rauschenberg and Johns were in Castelli their lives started to change. They were already not liking to know gay guys who were in fashion, because the mystique of the great artist was already on them. They were separating themselves from Gene Moore. A number of times I said to them, 'Why don't I invite Andy to dinner?' and they would say no.
>
> I really felt when I first knew Andy that he was the greatest voyeur I ever met. He was fascinated by the Johns–Rauschenberg relationship. He was really interested in who did what to whom. He was an incredibly intelligent person, extraordinarily incisive. Santayana once defined intelligence as the ability to see things as they are *quickly*. That's precisely what Andy had.

De was also struck by another characteristic that was interesting in terms of Warhol's later development. Andy seemed to him to be 'engrossed' by the idea of evil. 'That used to be one of his favourite subjects. "Isn't that evil?" or "Oh, De, that's absolutely evil." I sensed what he meant was someone dominating another person.'

Meanwhile things were beginning to go badly with Ed Wallowitch. Ed had finally moved away from John and had his own place. When Ed's sister Anna May decided to get married he felt deserted and began drinking like a pig and having psychotic episodes. After a while Andy distanced himself from him. Their relationship disintegrated. Ed had a nervous breakdown and had to move back into his brother's apartment, where he stayed on Thorazine for six weeks. John Wallowitch:

The analyst thought it would be better for Edward to go to a place out on Long Island that could handle this kind of thing. But it cost $250 a week. At the time, I was making three dollars an hour and there was no money coming in from Ed, or our parents. I called Andy up and asked him for $600 to help Ed out. He said, 'Oh, I'm sorry. My business manager won't let me do it.' It would be nice if Andy had come to see him or called, but no, there was nothing. I loved Andy, but there was something malevolent and evil about the way he sucked off Ed's energy. But I know Ed got his revenge because Andy took it up the ass a lot. And my brother was well equipped from what I hear.

*

Looking back at Andy's work in 1959 it is quite easy to see how he was progressing towards his pop-art paintings like the Campbell's soup cans. He was using repetition more and more. On a book jacket for New Directions he rubber-stamped a face ten times across and five times down. The show he was doing for the Bodley, Wild Raspberries, really was pop art although perhaps a bit too precious and restrained by his softer side to make it in that cool field.

Andy painted the show, which consisted of watercoloured drawings of fanciful foods, in collaboration with an important new friend, Suzi Frankfurt, who came up with the fantasy recipes that were handwritten beneath each drawing by Julia. Andy and Suzi, who thought her life was a cross between Pompeii and Coney Island, had a lot of fun writing the recipes together, but Suzi formed a negative opinion of Andy's mother:

She was very talented in some mad way, but she was so manipulative. When we were doing Wild Raspberries Andy had to chain her to the lightbox to get all the calligraphy done. She said she'd copy it over and she didn't. He gave her too much bloody credit. I mean, she was like Miss Prima Donna. She wasn't really a very nice person. I never liked her. She was too much of a force in Andy's life. He adored her too much. She was omnipresent. She was too weird for me, too ill-kempt, too much of a Czechoslovakian peasant.

David Mann liked the exhibition:

Andy was very serious about what he did. As a matter of fact, in those food things he had connotations which he discussed. The food things were very refined and that was sort of a hangover. He hadn't gotten rid of himself that completely, but then the funny recipes were hilarious. I felt he changed radically after that.

Wild Raspberries opened on 1 December 1959. The *New York Times* review effectively put the lid on Andy's 1950s career, calling them 'drawings by Andy Warhol which are clever frivolity *in excelsis*'.

They couldn't get a book of recipes and drawings published. 'We published it ourselves,' recalled Frankfurt. 'And he and I went around with shopping bags full of books and tried to sell them, and nobody wanted them, nobody was interested in them at the time.'

The end of the fifties was hard for Andy. He had bought a townhouse at 1342 Lexington Avenue between 89th and 90th streets for $67,000 but lost his I. Miller account and had to scramble to keep his income up to his needs. Although the joy had gone out of the work, he had to do more rather than less commercial art to pay his expenses and he was well aware of his dilemma. 'I got a real kick out of seeing my name listed under Fashion in a novelty book called *A Thousand New York Faces and Where to Drop Them*,' he recalled, 'but if you wanted to be considered a "serious" artist, you weren't supposed to have anything to do with commercial art.'

'Built into Andy was the fear that there was never going to be enough money,' noted de Antonio, 'there was never going to be enough of anything, things were always going to turn out badly – that seemed to me almost to be his mother's voice.'

The break-up with Ed and the break-up of Jasper Johns and Robert Rauschenberg had convinced him to be celibate for a while. He believed that 'they should have a school for love. Because so many people go through so much pain that they should tell you right off the bat what it's all about. After a while sex isn't anything . . . it isn't timeless . . . It's easier to have an affair without being in love. I learned the hard way.'

The rejection of his work by the art world and of himself by the artists he most admired combined to make him unhappy, uncomfortable and finally fearful of really not making it as a painter. After all, he had been in New York for ten years now.

*

Andy's relationship with his mother was also going through a crisis. Many people who visited the Warhol household recall Julia constantly going on about the way he dressed and spent money. Every time Seymour Berlin went to the house she asked him why he couldn't get

Andy a girl. What had been largely humorous in the first half of the fifties seemed to have turned sour as the decade neared its end. When Andy had moved into the tastefully furnished second floor of 242 Lexington Avenue, Julia had remained on the cluttered fourth floor. When they moved to 1342 Lexington Avenue she was relegated to the basement. Apart from the strain one might expect between a mother and son living in such close proximity for so long, there were several other reasons for the tension that had developed between them.

Ted Carey, who became one of Andy's closest friends after the separation from Ed Wallowitch, got the impression that Andy 'would have liked to have thought of his mother as glamorous and Mrs Warhol was not glamorous, and I think he felt a little ashamed of her. If you got to meet Andy's mother you knew that Andy liked you very much.'

Because he was busy and reluctant to include her in his social life, Julia had become lonely in New York. She returned to Pittsburgh twice a year and John and Paul visited New York regularly with their growing families, but this and her weekly visits to church provided her only social life. Otherwise Julia remained mostly alone, her daily isolation interrupted only by visits to the supermarket. This isolation had led to a steady increase in her consumption of Scotch whisky. Although most people say that Andy continued to be as sweet with her as he ever had been, more than one visitor had begun to notice signs of the conflict between them. Ted Carey:

> Mrs Warhol was very lonely. Her whole social life was at a New York Czech church. Whenever I was over she loved to talk. Andy didn't like me talking to her because I wouldn't work fast enough, and when he'd come back and felt that I hadn't accomplished enough he'd yell at his mother, 'Say, you've been talking to Ted!' But as soon as Andy would go out she would come up and we would talk. She loved television and programmes like *I Love Lucy*.

Two other factors contributed to the breakdown in their relations. The first was money. Andy's fear of poverty could only be assuaged by cash. He carried wads of it on him and kept piles of it in the house. According to Suzi Frankfurt, 'Andy was always very sweet to his family. He used to feel guilty about his brothers. He said, "I make more in two minutes than they make in a year." He was always crazy about them, he loved them, he was never ashamed of them at all.' And both John and Paul say that not only did Julia constantly send care packages to their families but Andy paid all their expenses whenever they visited and often helped them out with loans or gifts. At some point, however, Julia appears to have felt that he was not contributing enough.

The second problem was one of identity. While there is no question that Julia was Andy's muse and backbone, his biggest fan and tower of strength, her inclusion in his work as calligrapher and signer of his

name seems to have ultimately confused her to some extent as to who Andy Warhol was. Another close friend of both Andy and Julia (he called her 'Missy'), the painter and art director Joseph Giordano, related the following intriguing tale to the art historian Patrick Smith:

I always thought his mother thought of Andy as a source for money to give to her other children, to be honest with you. But, evidently, he wasn't shelling out enough – you know, what she thought was enough. So she packed her bag one day and went to Pittsburgh.

According to Suzi Frankfurt Julia stayed away for some time:

That house was totally a nightmare because they were so disorganized. It was just a disgusting mess. And when his mother was there you could never get him to do anything about it. It was much nicer when she wasn't around, because I could do it much better than she could.

According to Giordano, however:

Then he was very upset, because he just couldn't function. I think he expected me to get in there and function, but it was just too much of a household to run. So he finally called her back. She insisted that I be there that night. She came in and slammed her suitcase on the ground and turned around. She looked at him and said, 'I am Andy Warhol.' And there was a big discussion about why she was Andy Warhol. But I guess she convinced him that he was. She was exactly like Andy: she was a myth-maker. I think this is the basis of his whole character. He is a myth-maker. He knows how to perpetuate the myth.
 She saw the possibilities in him, but she resented the package. I really adored Missy. But the ambivalence used to shock me. I can remember going home and saying to my mother, 'I just can't believe it. She's so good, and then she comes out with these horrible things.' The crux of Andy Warhol is that he felt so unloved, so unloved. I know it came from his mother. I knew she was doing something wrong. She made him feel insignificant. She made him feel that he was the ugliest creature that God put on this earth.

On another occasion, Giordano observed Andy's problems with a magazine:

Andy had to do a sketch of flowers for I think it was *Harper's Bazaar*. He did several and Nathan did several. And *Harper's* would invariably pick Nathan's. That used to upset Andy greatly, greatly . . . I mean, he burst into tears. He was really disconsolate.
 Every time I met him he cried. I don't know why. He was always crying.

Andy realized that he couldn't find anybody to share his life. In 1959 and through half of 1960, he had what he called a 'nervous breakdown',

a period when he was hurting very much inside, was very confused, and did not know what to do about it. Andy made light of the situation in *The Philosophy of Andy Warhol*, blaming his confusion on 'picking up problems from the people I knew. I had never felt that I had problems, because I had never specifically defined any,' he explained, 'but now I felt that these problems of friends were spreading themselves onto me like germs.'

He sought the help of a psychiatrist to define his own problems rather than sharing vicariously in the problems of his friends. The visits were not successful, however, and Andy stopped going, concluding, 'It could help you if you don't know anything about anything.'

How near Andy actually was to breaking down – becoming incapable of getting up and getting through the day – is a matter of conjecture. Nathan Gluck, who was with him five days a week, noticed no sign of anything being wrong at all.

Seymour Berlin: 'I wouldn't say that he was a manic depressive, but at times he was very elated and very excited and then somehow if something didn't go the way he wanted he would become very depressed.'

Suzi Frankfurt: 'He had a real fear of not being successful. I always thought he was really sensitive and fragile, but that was the only time in his life when if you said, "Oh, Andy, that's terrible. How can you like that? That's ugly!" he'd get very hurt. He was supersensitive about his taste.'

Charles Lisanby, with whom he was still in love, backed off from a new round of 'bottomless' emotional demands from Andy. 'I was very concerned with everything about him, but I did not want to go and live with him and I was being trapped. Perhaps it became so intense because it was never consummated. I always knew he never forgave me for not being his lover.'

In fact, Andy was about to bring into play the 'so what?' attitude he had discovered in Bali. To de Antonio he seemed scattered:

He was also jealous and envious of Johns and Rauschenberg. Andy never expressed anger. He was always cool and understated, but in maybe two hours of conversation, in his silent, withdrawn way, he'd say, 'Why don't they like me? Why can't I see them? Why do they say no when you ask if you can invite me to dinner? Why can't I be a painter?' That tension was underlying his entire existence in New York because he surely came here with the idea of being a painter.

THE BIRTH OF ANDY

WARHOL

1959–61

He looked like a superintelligent white rabbit.

EMILE DE ANTONIO

Pop art, with its up attitude and tough celebration of American society, mirrored and recorded the early sixties more accurately than movies and television shows of the period. Warhol may well have understood this more clearly than anyone else. 'There's going to be a new movement and a new kind of person and you could be that person,' he kept repeating nervously to friends, who rightly suspected that he was really speaking about himself.

Andy's enthusiasm for the new art was boundless but he had not been able to find his own subjects and technique. 'They always say that times changes things, but you actually have to change them yourself,' he decided.

Leonard Kessler ran into Andy coming out of an art-supply store carrying paint and canvas. 'Andy! What are you doing?' he greeted him.

'He said, "I'm starting pop art," ' Kessler recalled. 'I said, "Why?" He said, "Because I hate abstract expressionism. I hate it!" '

When Ted Carey admired a Rauschenberg collage at the Museum of Modern Art, Andy snapped, 'That's nothing. That's a piece of shit!'

'I said, "Well, if you really think it's all promotion and anyone can do it, why don't *you* do it?" ' Carey remembered. 'And he said, "Well, I've got to think of something different." '

He called upon everything he had learned from advertising and television, where the dollar sign and the gun were the predominant symbols and the common denominator was to arouse sexual desires without satisfying them and to shock. He decided to paint a series of big black and white pictures of what artists were supposed to hate most, advertisements for wigs, nose jobs, television sets and cans of food. He took the simplest, crummiest, cheapest ads from the backs of magazines, made them into slides and projected them on to blank canvas. Then he painted a fractured section of the ad in black paint, letting

drips and splashes accidentally splatter. The paintings were ugly and banal but reverberated with anger and contempt. One observer said:

Basically it was an act of compulsion, he had to do it. As a person working in commercial art, which was essentially towering blandness, Andy had to apologize in his mind for being involved. To make an art of it seemed a way of getting the anxiety out, which is what much art is about: you need to confront the images which cause you distress in order to relieve the distress.

A second series depicted his childhood heroes, Dick Tracy, Popeye, Little Nancy. He painted large pictures of cartoon frames using bright colours but obliterating most of the words with messy hash marks and drips. He feared that the work would not be taken seriously without these signatures. De Antonio was coming around regularly to look at the work and encourage him, but Andy was frustrated. He still wasn't doing what he wanted. One day he pissed on some canvas to see what it would look like but, unsatisfied with the results, rolled it up and put it away. Another day he put a piece of canvas outside the front door to see what kind of picture people's footprints would make.

In the summer of 1960 a breakthrough came. De Antonio:

One night I went over and had a bunch of drinks and he put two large paintings next to each other against the wall. Usually he showed me the work more casually, so I realized this was a presentation. He had painted two pictures of Coke bottles about six feet tall. One was just a pristine black and white Coke bottle. The other had a lot of abstract expressionist marks on it. I said, 'Come on, Andy, the abstract one is a piece of shit, the other one is remarkable – it's our society, it's who we are, it's absolutely beautiful and naked, and you ought to destroy the first one and show the other.'

Andy was very excited. He wanted to paint twentieth-century folk objects like Coke bottles and adverts just the way they looked but had been worried that people would dismiss him as a commercial artist. De Antonio's encouragement was very important to him.

He started to contact some other people in the art world. The first was Leo Castelli's assistant, Ivan Karp, whom he invited over to look at the paintings. Karp was a classic early-sixties character who wore dark Brooks Brothers suits like the Kennedys plus sunglasses, smoked cigars and called people 'baby'. He would play a major role in Andy's career. He was a literate, articulate man who had a feeling something big was about to happen in the art world and that it was going to happen in America. When he knocked on the door of 1342 Lexington Avenue he knew nothing about Andy Warhol except that he was enthusiastic enough about the new art to have spent $475 on a Jasper Johns drawing he had bought from Castelli.

Karp met Andy as he was taking steps to change himself. The new

Andy had made a definite decision to draw attention to his weaknesses. He had, for example, bought some new silver-blond wigs which he wore uncombed and just slightly askew. He had also started to change the way he spoke, mumbling monosyllabic, often incoherent replies to any questions. And he had exaggerated everything else in his repertoire, like his slightly swish dancer's walk and his limp wrists. This prototype for the Andy Warhol whose image would shortly become world famous was based on a combination of Marlon Brando and Marilyn Monroe. 'He made a virtue of his vulnerability, and forestalled or neutralized any possible taunts,' wrote John Richardson. 'Nobody could ever "send him up". He had already done so himself.'

His new quarters had been just as carefully decorated to enhance his presence. Once Karp had stepped inside and negotiated his way around a sculpture of a car crash by John Chamberlain which partially blocked the entrance, he found himself following Warhol down a dimly lit corridor lined with spooky figures like a wooden Punch, a life-size Mr Peanut and a cigar-store Indian. A rock record was playing loudly in the living-room-cum-studio. As Andy stood silently in a corner and did not turn down the sound, Karp was confronted by a sombre, surreal, Victorian setting. The room had previously been a psychiatrist's office and the windows were boarded over to keep out light and noise. There were several paintings by modern masters on the walls. He noticed a large Toulouse-Lautrec print of a man on a bicycle and there was a long Empire sofa against the wall to his left. Andy's paintings were neatly stacked against another wall, but what made the biggest impression on Karp was the record playing over and over. Andy, who was drawn to falsetto songs about broken hearts, later explained that he was in the habit of playing one song a day at least a hundred times until he 'understood what it meant'.

The scene turned Karp on. He started dancing around the room shouting out comments. 'I was being quite arrogant,' he said. 'I told him that the only works I thought of any consequence were the cold, straightforward ones like the Coca-Cola bottle.' He thought the same people who were interested in a new painter Castelli was looking at, Roy Lichtenstein, might be interested in Warhol, and took some slides of his work back to the gallery. Andy was so excited that later the same afternoon he sent Karp the Little Nancy painting Ivan had also admired, tied up with a red ribbon and a note that read, 'Love from Andy.'

During the next few weeks Ivan brought several collectors of modern American art to Andy's house. They were at first confounded when Andy answered the door wearing an eighteenth-century *bal masqué* mask festooned with jewels and feathers (Karp was under the impression he wore it to conceal the pimples and blotches on his face) and offered one to each of them, and still further taken aback when the artist stood mutely in the corner behind his mask while the day's rock

single blared repeatedly from the phonograph, but each collector bought one or two paintings for a few hundred dollars each (much less than Warhol earned for a single commercial drawing). Andy was enormously grateful to Ivan, always insisting he take a commission. As Andy loosened up in his company Ivan was 'very taken with his eccentricity', and they became friends. 'He was a combination of European theatrical style and singular American eccentric,' the dealer recalled. 'I found him fascinating, gratifying, exotic and enjoyed his company a great deal. He was no question after fame and attention, but he was a very spirited man who had a great deal of emotion and enthusiasm for American art.'

Although Andy continued to work with Nathan Gluck every day, his commercial-art friends were mostly excluded from his new world. Karp accidentally discovered that Warhol was well known in the advertising community while walking with him one day on Madison Avenue. 'He knew every fifth person. I said, "My God, Andy, I thought you were a secret soul!" He said, "Oh, I know them . . . I just know them casually." '

In July Karp brought the new young assistant curator for twentieth-century American art at the Metropolitan Museum, Henry Geldzahler, to Warhol's studio. While they talked, Andy kept painting on the floor surrounded by a TV, radio and phonograph playing at the same time, stacks of teen, movie and fashion magazines and a telephone. He was trying to make his mind as empty and blank as possible, he said, so no thought or emotion could go into the work.

'I had heard all my life that Stuart Davis played jazz records when he was painting,' recalled Geldzahler, a courteous, intelligent fat man with a light, joyous presence, 'so I knew I was somewhere. Once I had gotten used to the flickering of the television set the first thing I noticed was a pair of Carmen Miranda's platform shoes far higher than they were wide. Their placement on a shelf in his wood-panelled living room made a smile-provoking introduction to a camp sensibility.'

As the new boy at the Metropolitan, Geldzahler was supposed to discover what was going on in the contemporary American art scene. Henry and Ivan had been running around town introducing each other to a string of emerging artists who were as yet largely unaware of each other – James Rosenquist, Claes Oldenburg, Tom Wesselmann and Lichtenstein. Henry was good friends with Frank Stella too, but his connection with Andy was made special by the fact that Henry was also gay. When Andy took up his invitation to come by his office at the museum to look at Florine Stettheimer's paintings the following day, Henry felt as if he had known Andy all his life and recognized with a kind of thrill that he was in the presence of 'someone who epitomized the age in a very special way', and was possibly a genius.

He agreed to take Warhol's work around to galleries and try to get him a show.

It was a period of opulence and Henry and Andy were soon having a wonderful time going to dinners and parties and gossiping about everything that was happening in the art world. 'There was a phenomenon that happened in the early sixties,' said a mutual friend, 'that came out of the fifties: everyone was a prince. Andy was a prince. Henry Geldzahler was a prince. They operated on a broad, extravagant level of endless expanse, infinite privilege and freedom. There was infinite money and everyone was really smart and naïve and sweet and grasping and powerful and brilliant.'

As their acquaintance grew into what would become a lifelong friendship, Henry enjoyed playing 'humanist scholar' to Andy's 'Renaissance painter'.

'Oh, you know so much,' Andy said. 'Teach me a fact a day and then I'll be as smart as you.'

'Cairo is the capital of Egypt,' Henry said.

'Cairo is the capital of Egypt,' repeated Andy.

'They were both like little Buddhas,' another observer commented.

Although they were never lovers, the relationship became intimate. Andy spoke to Henry on the phone every night before he went to sleep and every morning as soon as he woke up. Henry Geldzahler:

He was very much a night creature and literally afraid to go to sleep at night. He wouldn't fall asleep until dawn cracked because sleep equals death and night is fearsome, and if you fall asleep at night you're not quite sure about waking up again, but if you fall asleep in the daylight it's kind of a comfort knowing that the sun is out there. It's very primitive, it's a kind of inverted sun worship because Andy actually detested the real sunlight.

By the fall of 1960 the Castelli, Green, Judson, Tanager, Martha Jackson, Stable and Hansa galleries were putting on or planning shows by Johns, Rauschenberg, Oldenburg, Wesselmann, Lichtenstein, Rosenquist, Segal, Indiana, Stella, Red Grooms, Jim Dine, Lucas Samaras, Robert Whitman and others. As his allies stepped up their campaign to get his work shown, Andy was only too well aware that 'the new movement' had arrived and that until he got a gallery to represent him there was no way he could be 'the new person'. Unfortunately, neither his cartoon nor his advertising series was as good as most of the other work that was being sold. This was emphasized by the paintings of Roy Lichtenstein, who had also appropriated cartoons and advertisements but taken a bolder step than Warhol by copying the images as exactly as possible, with no comments by brushstrokes and drips, in not just some but all his paintings. Rosenquist was also using cartoon images with good results. Beside their work, Warhol's

looked weak and confused and the reaction to it was mostly negative. David Mann:

> Whenever he had come to me before, I had been very enthusiastic and said, 'Oh, great, let's do a show,' but when he came to me with his early pop paintings I wasn't for them. The break was not unpleasant. He said, 'If you don't think they're good and if you're not interested in them I'll take them elsewhere.' A whole group of galleries were coming up, like Elinor Ward's Stable, and Sidney Janis was starting to interest himself in the pop people.

However, when Karp and Geldzahler showed Warhol's work around they were rudely dismissed by the gallery owners Sidney Janis, Richard Bellamy, Robert Elkron and Martha Jackson, who offered him a show then cancelled the exhibition after the introduction of his paintings had bad repercussions for her gallery. Just as he had feared, a lot of people in the art world despised Andy Warhol. Not only did they think of him as 'something that had crawled out from under a rock', but they considered his work ridiculous. They laughed cruelly and predicted that he would soon return to the commercial world where they felt he belonged.

This description of Andy by the socialite Frederick Eberstadt sums up how Warhol was seen by the majority of the one hundred or so people who dominated the New York art world at the beginning of the sixties:

> You couldn't miss him, a skinny creep with his silver wig. His appearance was far more conspicuous than it would be today. To put it mildly, I was not impressed. Andy asked me if I ever thought about being famous. Andy would start off conversations like that. It often made me vaguely uncomfortable. He said he wanted to be as famous as the Queen of England. Here was this weird cooley little faggot with his impossible wig and his jeans and his sneakers and he was sitting there telling me that he wanted to be as famous as the Queen of England! It was embarrassing. Didn't he know that he was a creep? In fact he was about the most colossal creep I had ever seen in my life. I thought that Andy was lucky that anybody would talk to him.

Geldzahler was angered by their response. He believed that Andy was so obviously talented that they were being blind or, worse still, prejudiced. It was distressing to Karp too, 'because I had a little network of friends in the art business, and when I said, "Look at Warhol's work, it's terrific work, it's going to be a revelation," they said, "You're nuts. It's nothing at all, it's empty stuff, shabby, squalid, horrible." '

Even though he was trying to divorce himself from his emotions in his work and in his life, Andy constantly complained about how hard it was to be an artist, or how cruel somebody had been to him, and became terribly worried. 'He was a tender, fragile person,' recalled

Karp, 'who couldn't stand having anything bad said about him or his work. He took rejection very poorly.'

'If you think he's so great,' other gallery owners would tell Karp, 'why don't you take him yourself?' And that, of course, was the question.

*

Despite criticism by some of the old guard that he was running a public-relations concern, Leo Castelli's methods, which included selling on credit, allowing payments to be made in small instalments over a long period of time, and talking up his artists to increase their auction prices, were playing an important role in inventing the new art marketplace. Castelli often spent Saturdays visiting artists in their studios. In January 1961 Ivan Karp steered him to Andy's. Castelli could remember Warhol's pale, mottled face from numerous visits to the gallery, but they had never spoken. Karp, who knew Castelli well, was concerned about the impression the eccentric artist and his environment would make on his fastidiously civilized boss, and tried to soften the effect by assuring Leo that Andy was a 'fine and sensitive gentleman, with a good art background, who is a serious artist but has a curious way of being'. This was quite evident as soon as Warhol opened the door, wearing one of his eighteenth-century masks and holding two others. A nonplussed Leo received 'a very curious impression' from the dark, cluttered house and the blasting repetitious rock music. As they stood throughout the interview Karp thought the person most confounded and seriously affected by the scene was Leo Castelli, adding, 'He felt the exoticness presented a bohemianism that he wasn't interested in. He was as warm and sociable as he could be, but I saw him troubled and anxious during the whole interview.'

Castelli left the house without committing himself, saying they would talk in a few days. 'We didn't stay long,' he recalled, 'not more than half an hour. I just felt the paintings were not interesting. They seemed to be spoofing all kinds of things. You really weren't quite sure what he was going to do.'

According to Karp:

When we left Leo said he was not about to show Warhol's work. He said, if we were interested in Lichtenstein, could we really be legitimately interested in Warhol? He thought there might be, in the fragile beginning of an artist's career, a jeopardy to one or to the other, and if we were to commit ourselves to Lichtenstein, which we had decided to do at this point much to the chagrin and distress of the other artists in the gallery, it would be a threat to his career to have another artist working just like him that obviously.

Several days later Andy met Leo Castelli alone in his office. Castelli said he liked what Andy did but reiterated what he had told Karp. Andy appeared dejected but was unusually outspoken. 'You're mistaken,' he

insisted. 'What I'm doing will be very different from what anybody else is doing. I really belong to your gallery and you should take me, because I'm very good.' When Castelli repeated that it would be impossible for him to represent Warhol, Andy appeared quite upset, crying out, 'Well, where should I go?' but his final words were defiant. 'You will take me,' he said. 'I'll be back.'

Andy was working at what was to him great financial risk. Painting was not only costing him money, it was taking time from his commercial art work and his income had dropped. He told John Warhola he only made $60,000 in 1960 and hadn't saved a dime.

'What did you spend the money on?' John asked.

'That's what I'd like to know,' Andy replied.

Financial pressure helped to change his attitude. He became an aggressive salesman, as Robert Scull discovered when he visited Warhol after the Castelli rejection. A self-made millionaire who ran a taxi company called Scull's Angels, by bypassing the dealers and paying cold cash to artists for their works, Scull was acquiring for only thousands of dollars a pop-art collection which he would sell for $2.5 million ten years later. 'I want to sell you some paintings,' Andy told him. 'I don't care how many you take. I just need $1,400. Here, take five, will that do?' When a nonplussed Scull paused, Warhol snapped, 'OK, take six.'

He got the $1,400. Scull became one of his biggest collectors and Andy became a regular at Robert and Ethel Scull's art dinner parties. Presented with a lavish meal he would eat nothing, mumbling to concerned enquiries, 'Oh, I only eat candy.'

Despite his front Andy's mood was shaky in the spring and summer of 1961. For one week in April his paintings 'Advertisement', 'Little King', 'Superman', 'Before and After' and 'Saturday's Popeye' were shown by Gene Moore in a Bonwit Teller's window behind five mannequins in spring dresses and hats. Naturally, this display received no attention in the art world. As he lay awake at night, Andy often became so terrified that his heart would stop if he fell asleep that he grabbed the bedside phone and spent the anxious hours gossiping with one of his many acquaintances.

By the end of the year Andy was back where he had started. He had just come out of a 'nervous breakdown' and feared he might be slipping towards another. After he attended Claes Oldenburg's excellent Lower East Side exhibition, The Store, in early December with its garishly painted soft sculptures of some of his favourite subjects – underwear, ice cream and pies – he was so annoyed because he hadn't had the idea that when Ted Carey invited him to dinner Andy said he was too depressed to go out. Oldenburg's success was particularly painful because while Andy was friends with Claes and particularly with his

swinging wife, Patti, she recalled that Claes 'did not like Andy's early work so there was some confusion there'.

Later that evening Ted stopped by with an interior designer who was struggling unsuccessfully to support her own gallery, Muriel Latow. Andy usually enjoyed Muriel's overwhelming personality but on this evening she and Ted could see that he was in a funk. He was desperate, he told them. He had to *do* something. Ted Carey:

> Andy said, 'It's too late for the cartoons. I've got to do something that will have a lot of impact, that will be different from Lichtenstein and Rosenquist, that will be very personal, that won't look like I'm doing exactly what they're doing. I don't know what to do! Muriel, you've got fabulous ideas. Can't you give me an idea?'

Yes, she could, Muriel replied, but it would cost Andy some money.

'How much?' he asked.

'Fifty dollars,' she answered.

Andy promptly wrote out a cheque and said, 'OK, go ahead. Give me a fabulous idea!'

'What do you like most in the whole world?' Muriel asked.

'I don't know. What do I like most in the whole world?'

'Money,' she replied. 'You should paint pictures of money.'

'Oh, gee,' Andy gasped, 'that really is a great idea.'

In the silence that followed, Muriel elaborated. 'You should paint something that everybody sees every day, that everybody recognizes . . . like a can of soup.'

For the first time that evening, Andy smiled.

THE CAMPBELL'S
SOUP KID
1961–62

Between you and me pop art was just man made, you under-
stand, it was nothing. Andy was there at the right time when
they wanted to expose art a little. It was dead and he got in
with several different painters and a couple of promoters.
They put Andy's Campbell's soup cans up 'ere and people
said, 'Gee, whatya call this? Is this art?' And before you
knew it, it became very controversial. Time *magazine would*
ridicule him, but you know Andy didn't care. It was adver-
tising. It gave him publicity.

PAUL WARHOLA

You could not get more personal with Andy than a can of soup or the
money needed to buy it. Muriel Latow had turned a spotlight in Andy's
mind on his childhood. In a flash he realized that he had always wanted
to paint the contents of his mother's kitchen. Robert Heidie:

Andy told me that, even though he had learned to draw the required bowl
of fruit on the dining-room table at art school, what he really wanted to paint
was that can of Campbell's tomato soup (his favourite) from his mother's
pantry. 'Many an afternoon at lunchtime Mom would open a can of
Campbell's for me, because that's all we could afford,' he said. 'I love it to
this day.'

The next morning Andy told Julia to buy one of each of the thirty-
two varieties of Campbell's soup at the local A & P and he started to
work on his idea. First he did a series of drawings. Then he made
colour slides of each can, projected them on to a screen and began
experimenting with different dimensions and combinations. Meanwhile
he was doing the same thing with the dollar bills, painting them indi-
vidually, then in rows of two, then in rows of one hundred.

Finally he hit upon his format for the soup cans. A lot of pop artists
used supermarket food images in their work but they crammed their
pictures with them. Andy decided to do one portrait of each of the
thirty-two cans as exactly as possible alone against a white background.

144

'It showed the value of colour in the most minimal way,' explained James Rosenquist.

'He made us feel that in even the simplest of commodities and the most commonplace of subjects there was a great deal of poetry and meaning,' Patterson Sims of the Whitney Museum wrote in his obituary of Warhol.

During the first half of 1962 Andy worked on his commercial art in the front room of the parlour floor with Nathan Gluck and spent the rest of his time gazing at TV or magazines and blasting rock singles as he mechanically painted pictures of soup cans and dollar bills.

From the first Campbell's soup can onwards Warhol was at his purest as a conceptual artist. His talent was to recognize the right idea at the right time and know how to give it the right design. This is why he was both heavily criticized and instantly recognized. His approach to painting broke all traditions and was considered by most people on the scene not to be art. But his choice of subjects, his timeliness and his talent for design and painting overrode the decisions of the traditional critics and made his work acceptable to a mass public. 'I am a mass communicator,' Warhol would tell an interviewer.

Just ordinary people like my paintings. It took intelligent people years to appreciate the abstract-expressionist school and I suppose it's hard for intellectuals to think of me as art. I've never been touched by a painting. I don't want to think. The world outside would be easier to live in if we were all machines. It's nothing in the end anyway. It doesn't matter what anyone does. My work won't last anyway. I was using cheap paint.

As the tempo of Andy's work picked up, his studio became a nightly salon for casual visitors, among them the proto-pop artist Ray Johnson, who was an important influence on many artists of the period, particularly Warhol.

He was always very cordial. If I was uptown at an art opening I'd casually call up and he'd say, 'Sure, stop by.' He always had music playing. He'd bring out these huge glass tumblers of Scotch, and he'd throw that at you and you'd drink that, but I don't think he drank himself. He was a candy eater.

The art critic David Bourdon, who had known Warhol in the late fifties but not seen him for several years, phoned him as soon as he saw the soup can.

I first visited him uptown in March 1962 to see the soup cans. They had been illustrated in a newsletter. I was very intrigued by them, and from that moment on we became really fast friends and I was there a couple of evenings a week. It was kind of an informal sitting room. He had a hard phony Empire-

145

style sofa, floor lamps, chairs and tables and some Planter's Peanut ashtrays. He was doing all his painting in that room and as the months went by the furniture gradually disappeared as the rolled-up canvases took over. That's where everybody gathered to guzzle Scotch. These weren't social events, he invited people to drop in.

Andy encouraged his guests to talk while he drifted in and out, taking phone calls from Henry Geldzahler or checking on his mother in the basement, where the Warhola family life went on just as it had done downtown.

If Andy had wanted to distance himself somewhat from his mother as he struggled to transform himself into a new kind of person, short of expelling her from the premises he could not have done it more effectively than by confining her to the basement. For the next twelve years she lived alone in the dark, dank subterranean room where she invented a world of her own that could have been in Depression Pittsburgh or for that matter in Mikova. Along the wall under the half-window facing the street at eye level was a couch covered by a sheet. Against another wall was her bed. In the corner stood her altar with a crucifix. Apart from the simple kitchen table and chairs at the other end of the room next to the stove, that was about it for furniture. The rest of the room was covered with shopping bags, mail, a talking parrot in a cage, and cat hairs. A multitude of skittish Siamese cats were hiding underneath the kitchen cabinets between sudden forays to overturn a stack of mail or a bag full of junk.

Julia was by nature a pack rat and the habit of never discarding anything, regardless of its use or condition, extended to her own person. Her long cotton peasant dress and apron were usually covered with buttons, paper money, notes and other memorabilia affixed with safety pins. Andy spent a modicum of his time in his mother's domain, appearing regularly each morning for breakfast and before going out, when they would recite a brief prayer together and she would caution him to watch himself.

Mrs Warhola's exile to the Lexington Avenue basement became at times a bone of contention in the Warhola family and at the same time a staple of Warhol's emerging legend which he took pains to embellish, telling friends that his mother was an alcoholic whom he had to keep locked up with a case of Scotch. She arose punctually at 5 a.m. every morning and proceeded to clean the house, he said. As the years went on, Andy's quarters sunk beneath the same collection of junk as hers and she was largely reduced to mopping up the cat shit and piss that pervaded the house. The family continued to visit as often as they could (between John's and Paul's growing families, little Warholas were running around the place every couple of months) and noticed that whenever they came up Julia could not stop talking since she had had

no one to talk to in between their visits. They also complained that the basement was often damp.

However, to the best of his ability Andy treated her well, continuing to give her $500 a week, some of which she spent on sending care packages to Pittsburgh and Mikova or saved in a large glass jar in which Paul once found six or seven thousand dollars. Since the house was only eight blocks south of Harlem, she felt somewhat frightened of going further than the corner supermarket, drug store and post office on her daily sorties into the surrounding neighbourhood. But when Andy suggested she would be better off in a house on Long Island she balked, claiming that this was the best place she had ever had and she did not want to leave it.

Uncle Andy had become something of a hero to his nephews and nieces. 'We'd always wait for him to wake up,' remembered George Warhola, Paul's third son.

> Bubba used to bring his orange juice up every morning and then we'd go up and talk to him. One time we went in and pulled the covers off his head and saw him bald. He yelled, 'Get out of here!' When he was going out we'd be up there watching him shave and get dressed. He was like a movie star to us. He was our idol. And he'd have his Chanel perfume and he'd say, 'Here, you want to try it?' We always wanted to know, 'Well, gee, Uncle Andy, who'd you meet that's famous?' And he'd tell us all about the people he went out to dinner or parties with. Sometimes we'd help him stretch canvases. He'd pay us two dollars an hour and buy us things or bring us home presents.

Recalling the scene fondly, George concluded, 'It was a different world.'

As Andy relentlessly hustled the art scene, going out to an opening or party every night keeping his eyes and ears open for every development, he began finding some acceptance. A pair of young English twins, David and Sarah Dalton, finally got him together socially with Johns and Rauschenberg at small dinner parties in their flat which Henry Geldzahler would also attend. Andy was still enamoured of Jasper Johns and if he was coming over Andy got so nervous he had to run to the toilet to urinate several times. For his part Johns 'was very patronizing to Andy', David Dalton recalled, 'because Andy would always affect this dumbness. But Jasper appreciated his work.'

At one point Andy was in an artists' rock band. Patti Oldenburg:

> It was such fun. I was the lead singer because no one else could sing. Andy was great. He and Lucas Samaras were my back-up singers. It was an all-star cast. Jasper wrote the lyrics and Walter De Maria played drums, Larry Poons was on guitar and La Monte Young played saxophone. We rehearsed three or four times and then it just fell apart.

'I was singing badly,' Warhol recalled, 'and there were fights between Lucas and Patti over the music or something.'

David Bourdon:

Andy was very infatuated with the Dalton twins and Henry Geldzahler. He was always gushing and exclaiming and constantly scheming to beat the band. The ambition was very naked but the weak and vulnerable side was equally evident. Andy wasn't as adept at concealing it as he was later. He was hurt by dealers who didn't take him on or collectors who wouldn't buy things. His face would fall and he would whine. Andy's most voluble emotions were always ones of distress and disappointment, a kind of plaintive 'How could they leave me out? How could they do this?'

*

When Irving Blum, who owned the Ferus Gallery in Los Angeles, paid Andy a visit in May 1962, he found him kneeling next to the glowing television with the radio and the record player blasting opera and rock simultaneously, painting his sixteenth portrait of a soup can. 'What happened to your cartoons?' asked Blum, who had seen his paintings of Superman a year earlier.

'Oh,' replied Andy nonchalantly, 'Lichtenstein was doing them better so I'm not doing them any more. Now I'm doing these,' and he explained that his intention was to paint all thirty-two varieties.

After watching him for an hour Blum asked if he was going to show them in New York. When Andy said he didn't have a gallery, Irving offered to show the whole set in LA that July.

Andy paused. He knew from bitter experience that summer was a bad time to show art in New York, but as soon as Irving assured him that it was the best time in Los Angeles Andy whispered, 'Oh, I would adore it.'

They agreed that the paintings would sell for $100 each (the same price Warhol had charged for a painting during his junior year at Carnegie Tech, and one tenth of what he was getting for a commercial drawing) with the artist receiving 50 per cent. By the time Irving left the house Andy's face was glowing and he was trembling ecstatically.

Even before they were shown, the reaction to Warhol's Campbell's soup-can paintings was what he had hoped for – outrage and publicity. He was featured in the first mass-media article on pop art in *Time* magazine on 11 May 1962. Warhol, *Time* reported, was 'currently occupied with a series of "portraits" of Campbell's soup cans in living colour'. His quote was typical of what was to come. 'I just paint things I always thought were beautiful, things you use every day and never think about,' he told *Time*'s readers. 'I'm working on soup and I've been doing some paintings of money. I just do it because I like it.'

Considering the avalanche of publicity the paintings would soon get, their exhibition was insignificant. Blum simply placed the thirty-two

little canvases in a single line on a narrow shelf around the Ferus Gallery walls, sent out a postcard of a tomato-soup can inviting buyers, and opened for business on 9 July. There was no formal opening and Andy did not go out to Los Angeles. Irving Blum:

> People walking into the gallery were extremely mystified. The artists in California were provoked by these paintings but they tended to shrug, not really condemn. There was a lot of amusement. A gallery dealer up the road bought dozens of Campbell's soup cans, put them in the window and said, 'Buy them cheaper here – 60¢ for three cans.' That was publicized. So there was a lot of hilarity concerning them. *Not* a great deal of serious interest.

'The paintings were vividly assaulted in the press when they were shown in California,' Ivan Karp recalled. 'Very unpleasant jokes were made about them.' However, John Coplans, who edited a bright new West Coast art magazine called *Artforum*, saw the show and was impressed, and as word spread people took strong positions pro and con.

'I was a great admirer of Andy's because everyone was making fun of his Campbell's soup cans and I thought they were what the United States deserved,' said the underground movie star Taylor Mead. 'I considered him the Voltaire of the United States. I felt they were really a coup d'état.'

'He got an enormous amount of publicity around that time,' recalled David Dalton, who helped Andy file his press clippings.

The man most immediately affected by the works turned out to be Irving Blum.

> After about three weeks I rang Andy up and said, 'Andy, I'm haunted by these pictures and I want to suggest something. I'm going to attempt to keep these thirty-two paintings together as a set.' Andy said, 'Irving, I'm thrilled, because they were conceived as a series. If you could keep them together it would make me very happy.' I said that I had sold a few of the paintings, but that I could approach the various collectors and see if I could make any progress. As soon as I hung up I called the first collector I had sold one of those paintings to – the movie actor Dennis Hopper. I explained what I wanted to do, and he gracefully relinquished the picture to me. I did that six times, and when I had the complete set, I called Andy to tell him. I then asked, now that I had all the paintings together and intended to keep them, what price could he make me on the group? Andy offered me all of them for $1,000 over the course of a year, and we agreed that I would send him $100 a month.

Around this time Andy began asking friends if they thought he would become a household word.

The one hundred or so artists, dealers, critics and collectors who made up the hard core of the pop movement were as diverse and eccentric a bunch as only New York could put together in one room.

Among them were a number of dramatic women. Elinor Ward was one of the legends of the period. According to her assistant Alan Groh, 'She was a composite of all the movie stars of the thirties and forties, Joan Crawford and Bette Davis rolled into one. She was always beautifully dressed, had tremendous presence and charisma and the gallery was her life.'

That same summer, when a show scheduled at the Stable Gallery that autumn was cancelled, Elinor Ward considered giving Andy his first one-man pop show in the vital New York market.

Although not as businesslike as Castelli's, the Stable Gallery – so called because it was located in an old stable on West 58th Street – had fostered the careers of two of Andy's favourite painters, Cy Twombly and Rauschenberg, represented Joseph Cornell and had just taken on Robert Indiana and Marisol. However, said Groh, 'Elinor was completely unpredictable. You wanted to embrace her and the next moment she could say something that was unbelievably devastating.' Friends who had warned Andy about her must have been unaware that she was just like the women who had given him his start in the fashion world. When she called him on the phone to ask if she could drive in from the country to look at his work, Andy just said, 'Elinor Ward! Oh, wow!'

Elinor asked Emile de Antonio to take her over to Andy's house that night. He remembered:

Andy was incredibly nervous and agitated from the beginning. Elinor and I drank ourselves into the wall for about three hours and I could see Andy was losing his cool because he looked as if people were sticking pins into him, so I said, 'Well, come on, look here, Elinor, are you giving Andy a show or not? Because he's very good, and he should have one, and that's why we're here . . .'

She pulled out her lucky two-dollar bill and sort of waved it in his face and she said, 'Andy, it just so happens I have November, which as you know is the best month to show, and if you do a painting of this two-dollar bill for me I'll give you a show.' She was a beastly woman and she was obscene with that two-dollar bill.

According to Elinor Ward, all Andy said was 'Wow'.

<p style="text-align:center">*</p>

Warhol's summer of 1962 was enormously productive. He finished painting the contents of his mother's kitchen, doing canvases of rows of Martinson's coffee cans, Coca-Cola bottles, S & H Green Stamps and a number of large Campbell's soup-can portraits as well as '50 Campbell's Soup Cans', '100 Campbell's Soup Cans' and some 'Glass – Handle with Care' labels. Repetition, with which he would become associated, was in the air. Man Ray had written about it in his recent autobiography. John Cage thought that it was a basic concept of

twentieth-century art. But Andy's use of it was considered by many critics to be one of his most subversive moves. Many artists painted the same subject over and over from different angles, but to paint the same subject repeatedly looking the same undermined the individual preciousness of a work of art, or so many of Warhol's detractors felt, and was a banal and meaningless thing to do. Andy, who had been drawn to repetition of images when he was a child and counted the sheets hanging out to dry on his way to school, saw its real meaning (that every sheet is different) as one of the essential lessons of looking. Like everything Andy would do from now on, repetition was fuelled by a double-edged irony. On the one hand he recognized, with St Francis of Assisi, that 'there are thousands of flowers, thousands of people, thousands of animals, and each one is different, each one unique'. On the other hand, repetition was the bane of existence: Andy had come to believe that people never changed and that his problems would repeat themselves throughout his life. In July, Warhol discovered a technique that would change his career dramatically. He was trying to find a quicker way to paint rows of dollar bills. Nathan Gluck suggested he silkscreen them. Silkscreening, which Andy would make his painting medium for the rest of his life, is a sophisticated stencil process in which a photographic image transferred to a porous screen can be quickly duplicated on canvas by laying the screen on the canvas and applying paint or ink over it with a rubber squeegee. Using a silkscreen, printing an image on a canvas could be completed in a matter of minutes.

Andy quickly realized that this process was tailor-made for his talent, which was largely as a conceptualist and designer. Still foraging in his childhood for images, he went back to his first collection, the moviestar publicity pictures, and did silkscreen paintings of Elvis Presley, Troy Donahue, Warren Beatty and Natalie Wood, repeating the same picture over and over again in rows across a large coloured field, but he didn't hit his stride with the new technique until Marilyn Monroe committed suicide the same day his Soup Can show closed in LA, 4 August 1962.

'I wouldn't have stopped Monroe from killing herself,' Andy said later. 'I think everyone should do whatever they want to do and if that made her happier, then that is what she should have done.'

As soon as he heard the news Andy decided to paint a series of portraits of Marilyn. He used a publicity photograph by Gene Korman taken for the 1953 film *Niagara*. Rather than just having it silkscreened and running it off on canvas, Andy applied a good deal of paint to the canvas before silkscreening it. Outlining the shape of her head and shoulders, he painted in a background, then painted her eye shadow, lips and face before applying the silkscreened image based on the black and white publicity head shot. During the late summer and early fall

Warhol did twenty-three Marilyn portraits, ranging from 'Gold Marilyn' – a small, single image silkscreened on to an expansive Byzantine gold field – to the famous Marilyn diptych, 100 repetitions of the same face across 12 feet of canvas. The colours were garish, 'overworked Technicolor', one critic would later write: bright yellow for her hair, chartreuse for her eye shadow, her lips a smear of red – and they were frequently off register with the black and white background image. When Nathan Gluck pointed out the flaw, Andy mumbled, 'Oh, but I like it like that.' The misprints and the occasional clogging of the screen gave each face a slightly different expression, making the point that although her face is reproduced endlessly, Marilyn Monroe is not the plastic consumer good she appears to have become.

'I just see Monroe as another person,' said Warhol. 'As for whether it's symbolic to paint Monroe in such violent colours: it's beauty, and she's beautiful, and if something's beautiful, it's pretty colours, that's all. Or something.'

The elusive movie star's mask was reproduced to the point where it was impossible to say where the mask ended and the real woman began. The portraits were very much like the man who had created them. This was one of Warhol's greatest works and his supporters were quick to recognize it. The critic Peter Schjeldahl wrote:

Visually and physically the Marilyn diptych had majesty reminiscent of Pollock and Newman. The effect was like *Moby-Dick* retold, to resounding success, in street slang, with a sexy actress standing in for the fearsome white whale. With his subject matter and technique in place, Warhol suddenly let loose a pent-up profound understanding of New York school painting aesthetics.

Ron Sukenick, a New York writer:

Warhol's serial photo silk screens of Marilyn Monroe are about as sentimental as Fords coming off the assembly line, each one a different colour but each one the same as every other . . . What happens to the idea of originality with the advent of mass production, or to the idea of the unique artifact? As with the computer, there is only the abstract program and the 'hard' print-outs it can reproduce infinitely. It is perhaps because of such factors that Paul Bianchini insists that Pop Art represented America's first real break with European tradition, and, one might speculate, a final and irreversible one, as opposed to Abstract Expressionism, which can be seen as an extension of European ideas.

The silkscreen process gave Andy the perfect opportunity to develop his concept of repetition. As soon as he had finished the Marilyns he silkscreened all the paintings of coffee cans, Coke bottles, dollar bills and soup cans he had done earlier that summer. Released at last to do

exactly what he wanted, in the next three months he painted one hundred pictures. His living room looked and smelled as if it had been hit by a paint bomb.

'Andy represented a new force and I was immediately fascinated,' recalled one visitor. 'There was a tremendous amount of vitality and energy coming from him. There were many huge paintings tacked to the wall, one on top of another, glaring with hot scintillating colours, and his studio was very alive with the rock and roll going full blast. I was quite bowled over.'

'Ever since I first knew him he had this desire to get into where the stars were shining,' remembered Carl Walters. 'He just loved being at the Stable Gallery and I really believe that's when his whole life started to happen.'

Elinor Ward thought working with Andy was the most extraordinary experience she ever had. Alan Groh:

He would come by very often with Ted Carey and hang out in the office and we would yak, mostly about sex. It was very comfortable. Ted and his friend were promiscuous in the extreme and Andy enjoyed being exposed to all of this second hand. My impression was that he had no sexual relationships at all during that period, but he was aware that Elinor was sympathetic towards any subject that had to do with who was sleeping with whom. Andy was not what one would call physically attractive because of the hair and he had very bad skin, but his quality as a person overcame that so far as I was concerned, although most people didn't know what to make of him in those days.

'Look what the cat dragged in,' Andy would chortle, turning up with rolls of canvases under his arm, dressed in paint-splattered jeans, his hair askew, sneakers unlaced, chewing candy. At first Elinor openly adored him and thought he was a great artist. She was also selling a lot of paintings he was bringing in, buying several of them for herself at a 50 per cent discount. She called him 'my Andy Candy'.

With his work going well and his show at the Stable Gallery coming up, the autumn of 1962 was a heady time for Warhol. By now, *Art News* had acknowledged his soup cans for their 'quality of lofty elegance', claiming there was 'as much humanity and mystery in them as there is in a good abstract painting', and old friends could see a change in the Andy they had known. In September he attended a Labor Day weekend party at the Brooklyn Heights home of George Klauber. Bert Greene, with whom Andy had worked in Theater 12, recalled:

We were all waiting for him to arrive, because he was the one among us who had achieved a certain level of fame. He came with an entourage of very good-looking boys, I don't want to say 'call boys', but expensive boys and

certainly like acquisitions. He had more authority, an air of hauteur. He
didn't seem so little-boy fey.

'I said, "I understand you're so well known I have to have you at my
party," ' said Klauber, with an edge of condescension that hung in the
air. Bert Greene:

I was very impressed and I was equally impressed by what he said. A close
friend of ours, Aaron Fine, was dying of cancer. He had wanted to come and
see Andy but couldn't, so sent a question in his place. I said, 'Andy, Aaron
wants to know why you picked the Campbell's soup can to paint.'
 'Tell him,' he said, 'I wanted to paint nothing. I was looking for something
that was the essence of nothing, and that was it.'

*

The Cuban missile crisis began when US spy planes discovered that
Soviet nuclear missiles were being installed in Cuba. President Kennedy
insisted that they be dismantled and on 22 October 1962 ordered a
naval blockade to enforce it. The historian William O'Neil described the
popular reaction:

TV newsmen displayed maps with sweeping arcs showing every large city
but Seattle to be in the range of Cuba's missiles. Schoolchildren practised
hiding under their desks. Each day tension grew as missile-bearing Russian
ships approached the blockade line. Would they try to cross it? Would they
be stopped or sunk? Would Russia strike back then? On retiring no one knew
if he would live to see the morning. Was the country, perhaps the world, to
perish now?

The crisis broke on 28 October when it was announced that the Soviet
premier Khrushchev had backed down to all Kennedy's demands. Most
Americans were exuberant. The political commentator I. F. Stone
argued that the risks run seemed disproportionate to the threat posed.
'When a whole people is in a state of mind where it is ready to risk
extinction – its own and everybody else's – as a means of having its
own way in an international dispute,' he wrote, 'the readiness for
murder has become a way of life and a world menace.'
 Three days later, on 31 October 1962 – Halloween – pop art, which
had always taken a strong, positive attitude towards America, exploded
in the media at a group show at the Sidney Janis Gallery in New York.
To James Rosenquist the artists were 'post beat and not afraid of an
atomic bomb'. They thought fear passé. To Robert Indiana, 'Pop was a
re-enlistment in the world. It was shuck the Bomb! It was the American
dream – optimistic, generous and naïve.' The curator Walter Hopps
recalled how exuberant the opening was. 'Jean Tinguely showed an
icebox that had been stolen from an alley outside Marcel Duchamp's
secret studio. When you opened it, a very noisy siren went off and red

154

lights flashed. It set the noise and tone that was to continue all the way through the sixties.'

Andy had three paintings in the show, including '200 Campbell's Soup Cans'. People pointed and whispered his name. Warhol claimed, 'I feel very much a part of my times, of my culture, as much a part of it as rocket ships and television.' However, to at least one onlooker that night he seemed more 'like a white witch, looking at America from an alien and obtuse angle'.

The Janis Gallery opening marked a changing of the guard. The older abstract painters affiliated to the gallery – Guston, Motherwell, Gottlieb and Rothko – held a meeting and resigned in protest. On the other hand, de Kooning, who was also a member of the Janis Gallery, came to the opening. He paced back and forth in front of the paintings for two hours and left without saying a word. James Rosenquist:

> After the opening, Burton and Emily Tremaine, well-known collectors, invited me over to their house on Park Avenue. I went and was surprised to find Andy Warhol, Bob Indiana, Roy Lichtenstein and Tom Wesselmann there. Maids with little white hats were serving drinks and my painting 'Hey! Let's Go for a Ride!' and Warhol's Marilyn diptych were hanging on the wall next to fantastic Picassos and de Koonings.
>
> Right in the middle of our party, de Kooning came through the door with Larry Rivers. Burton Tremaine stopped them in their tracks and said, 'Oh, so nice to see you. But please, at any other time.'
>
> I was very surprised and so was de Kooning. He and the others with him soon left.
>
> Now Mr Tremaine had never met de Kooning, and probably didn't know him by sight, which was surprising because he had bought some of his paintings, but it was a shock to see de Kooning turned away. At that moment I thought, Something in the art world has definitely changed.

Warhol's Stable show, which opened one week later, included his best paintings, the Marilyn diptych, '100 Soup Cans', '100 Coke Bottles', '100 Dollar Bills' and many others that have since become classics. It staked out his territory as aggressively as Oldenburg's Store and Lichtensteins's cartoons had claimed theirs, and created a lot of controversy. In the view of the poet Charles Henri Ford, 'The real identity of pop art happened with Warhol and Oldenburg. I would say they were the two that registered the most.' According to Ivan Karp, 'Many artists working in different styles were resentful, and a lot of unpleasant things were said.'

Elinor Ward was so nervous she would not come upstairs from her office for the longest time, but Geldzahler, Karp and de Antonio were there to support Warhol, along with a host of other artists and critics riding the wave of exhilaration – Marisol, Indiana, David Bourdon, Ray Johnson and Gene Swenson – as well as friends from the 1950s like

Lisanby, Suzi Frankfurt, Nathan Gluck and many others. Elinor finally made an entrance and passed out soup-can buttons. Sarah Dalton modelled a dress reproducing Warhol's 'Glass – Handle with Care' painting. It was a great night. The sharp-eyed Leo Castelli, gazing at the works with his wolfish smile, realized that he had grossly under-estimated Andy Warhol.

Nervous but loving every minute of it and accompanied by a group of handsome young hustlers, Andy arrived late and hurried into Elinor's office to find out that a prominent collector, the architect Philip Johnson, had already bought the 'Gold Marilyn' for $800. Elinor Ward remembered, 'Andy was thrilled and he was happy and he was gay. His work was accepted instantly with wild enthusiasm.' However, for the rest of the evening Warhol seemed withdrawn in public, standing in a corner of the gallery and at the party afterwards with a blank expression on his face. 'His eyes were soft, expressive,' recalled one friend who saw him that night. 'They were the eyes of a fragile night creature who discovered himself living in the blaze of an alien but fascinating world.' Many people were struck by his behaviour, including Philip Johnson, who later said it was the only thing he really liked about the whole crazy show.

In the gallery's put-on publicity release, written by a Bennington student who had never met Andy, he was quoted as saying, 'I just want to give life to what is in me.' But for the most part when people tried to talk to him he mumbled indistinctly.

'At a party I gave after the show, the art critic Barbara Rose referred to Andy in conversation as an "idiot savant",' said Henry Geldzahler. 'I later reported this to Andy, who said, "What's an idiot *souvent?*" '

The show was a controversial smash. Many of those who saw it joked about how terrible it was, but it almost sold out. Typical was the reaction of William Seitz, who bought a Marilyn for the Museum of Modern Art for $250. When Seitz's colleague, Peter Selz, called him and said, 'Isn't it the most ghastly thing you've ever seen in your life?' Seitz replied, 'Yes, isn't it. I bought one.'

With his dumb blond image and what seemed to many to be dumb paintings Andy became the number-one target for anybody who wanted to attack pop art, particularly among the first- and second-generation abstract expressionists and their followers, who had fought long and hard for recognition and viewed the pop artists as upstarts. Reviewers in the abstract expressionists' camp said, among other things, that Warhol's work was 'mass produced' and a 'vacuous fraud'. 'Frank O'Hara and all of the New York school poets completely disapproved of Andy's work,' one witness reported, 'because it wasn't based on any tradition they were supporting. Frank was very cruel to Andy after that on many occasions.'

'That generation of artists had struggled for so long for the little

amount of attention they got, only to be eclipsed by pop art, that they had this tremendous amount of animosity, especially toward Andy,' said David Bourdon. 'Andy was very wary of those people.'

'Warhol's work provoked a great deal of interest in the press. *Time* magazine blasted it to smithereens, but he got very extensive attention for it,' said Karp. 'Most of it negative, but a lot of attention. And they picked it up as a new put-on.'

Among those who thought Andy was a fraud who had betrayed his talent were a number of his oldest friends. Charles Lisanby greatly upset Andy by flatly rejecting the gift of a Marilyn portrait, telling him that his apartment was too small for the work, but confessing privately that he 'really hated it'. Andy got quite worked up, his voice cracking as he told Charles, 'But it's going to be worth a lot of money one day!'

'I kept saying, "I think it's wonderful what you're doing," ' remembered Lisanby. ' "Just tell me in your heart of hearts you know it isn't art." He would never admit it, but I knew he knew it wasn't.'

Andy gave Ed Wallowitch a Campbell's soup-can painting and was furious when Ed sold it for a few hundred dollars. 'You should have held on to it,' he fumed. 'You would have made a lot of money.'

Vito Giallo thought Andy was barking up the wrong tree. 'I didn't like that pop-art school at all and I said to Nathan, "I can't believe he's doing this, I just can't see it." '

When Andy showed big Imelda Vaughn his paintings she boomed, 'These are terrible, Andy. What are you doing?'

'Oh, it's really good,' he told her. 'You'll see, you'll see.'

The art also got rough treatment from his family. Paul Warhola:

Mother used to say when I was going home, 'Paul, take a couple of paintings.' And I'd say, 'Ah, Mom, I don't want to take the paintings.' 'Oh, go ahead.' In fact she even gave paintings away. She gave one to her sister. Her sister gave it to her granddaughter and when the granddaughter sent it to New York for Andy to autograph it, Andy says, 'Hey! How did this . . . ? I was looking for this. You gave away one of my best paintings, Ma!' Mother also wanted to throw out the sculpture in the vestibule. She says, 'When Andy's gone, take this out and put it in the rubbish.' Andy overheard. He cried, 'Ma! Ma! That's from a famous sculptor. Maaaa!'

The manner in which Andy handled the uproar over his work was indicative of his developing persona. His credo was, 'Don't think about making art, just get it done. Let everyone else decide whether it's good or bad, whether they love it or hate it. While they're deciding, make even more art.' Rather than defend himself he encouraged the attacks. It was true, he purposefully lied, that anybody could do his works. In fact, he liked that idea. It was true, he said, that his subject was nothing. And it was true that his paintings would not last. By accepting all the criticism with open arms he deflated or ridiculed it.

Andy quickly became a master of the interview. One of his famous responses was a direct steal from an interview with Tallulah Bankhead. The interviewer asked, 'Do you think pop art is –'

'No,' he replied.

'What?'

'No.'

'Do you think pop art is –'

'No,' he replied. 'No, I don't.'

As the social critic Tom Wolfe wrote:

He was the person who created Attitude. Before Warhol, in artist circles, there was Ideology – you took a stance against the crassness of American life. Andy Warhol turned that on its head, and created an attitude. And the attitude was 'It's so awful, it's wonderful. It's so tacky, let's wallow in it.' That still put you *above* it, because it was so *knowing*. It placed you above the crassness of American life, but at the same time you could *enjoy* it.

The campy put-on was a vital element since the support of the gay audience was a major factor in Andy's success. The critic Kenneth Silver stated:

Warhol made blue-collar gay American art. His subjects were drawn from both the mass culture in which he grew up and the 'campy' culture which he grew into. Indeed, that second, gay culture is really a gloss on Warhol's first aesthetic experiences, the mass ones in the picture press and on the silver screen, just as his own art was in turn a focused and selective form of both popular and gay culture.

'Gene Swenson who wrote for *Art News* was a magnificent fellow in every way, a brilliant young man,' said Alan Groh, 'and he was extremely supportive. So were David Bourdon and Mario Amaya.'

'When I came back from London in 1962 people were saying, "Oh, God, guess what Andy's doing now," ' recalled the art critic Mario Amaya. ' "He's a great artist and he's actually conned somebody into giving him a show." This was a great laugh and everyone thought it was a camp joke, particularly all the faggots.' In the first book on pop art, Amaya later wrote, 'Some see Warhol as a great *faux-naïf* in the tradition of Douanier Rousseau. Others consider him a supra-intellectual, and still others think of him as a brilliant art director, organizing his images with the timeliness and insight of a window display man.'

'Warhol generated intellectual energy, always, by disregarding and hence erasing boundaries that separated what one would have supposed to be logically distinct orders of things, and allowing them to explode into one another through conceptual collapse,' stated the philosopher Arthur C. Danto.

Ron Sukenick wrote:

Warhol deflated the mystifications connected with high culture, but at the same time he devastated the adversary position of avant-garde art in relation to the middle class . . . There's also the point of view that, as a young artist who was part of his entourage says, 'everyone took Andy seriously as an artist because he sold,' a remark in itself indicative of the new criterion he promoted . . .

Warhol let the middle class know that it was culturally contemptible while he assured it that, don't worry, there's nothing about art that you don't understand. There is an element of vindictive contempt in Warhol's activities, in view of which it is fascinating to consider Schjeldahl's observation that Warhol is one of the few American artists who have ever come out of the lower working class. 'Warhol went from the bottom of the heap to the top without ever passing the middle, so it's like he was completely free of the middle-class perspective. [His art had] no anguish, no doubt, no apology, no existentialism, no expressionism, nothing except what it was.'

David Mann, who continued to see Andy on occasion, was also friends with Marcel Duchamp.

In the early days of pop there was a tendency to label it neodadaism. I spoke to Duchamp about this. He was very interested, and he liked pop art, but he said, 'No, it's a completely different thing, it has nothing to do with dadaism. What they're doing applies to today.' And he knew Andy's work very well.

'If a man takes fifty Campbell's soup cans and puts them on a canvas, it is not the retinal image that concerns us,' said Marcel Duchamp. 'What concerns us is the concept that wants to put fifty Campbell's soup cans on a canvas.'

Michael Fried wrote in *Art International*:

Of all the painters working today in the service – or thrall – of a popular iconography, Andy Warhol is probably the most single-minded and the most spectacular. At his strongest – and I take this to be in the Marilyn Monroe paintings – Warhol has a painterly competence, a sure instinct for vulgarity (as in his choice of colours) and a feeling for what is truly human and pathetic in one of the exemplary myths of our time that I for one find moving.

Tom Wolfe observed:

Pop art absolutely rejuvenated the New York art scene. It did for the galleries, the collectors, the gallery goers, the art-minded press, and the artists' incomes about what the Beatles did for the music business at about the same time. Avant-gardism, money, status, Le Chic, and even the 1960s idea of sexiness – it all buzzed around pop art.

By the end of 1962 the soup cans and other paintings had made Warhol's name a byword for bad art. 'The "Campbell's Soup Can" was

the "Nude Descending a Staircase" of pop art,' Henry Geldzahler wrote. 'Here was an image that became the overnight rallying point for the sympathetic and bane of the hostile. Warhol captured the imagination of the media and the public as had no other artist of his generation. Andy was pop and pop was Andy.'

LIKE A MACHINE

1962–64

People were always saying that Andy Warhol was over-exposed. From the very beginning he was considered passé. There were always people saying, 'Well, he's finished. What can he do now? 'Everybody was chronically tired of him. I think that 1963 was his high mark. All those silkscreen paintings of the disasters and car crashes were the greatest thing he ever did.

DAVID BOURDON

In the autumn of 1962 Andy went out to openings, dinners and parties every night. To him, going out at night was, and always would be, work. His arrival at events began to have an effect. The party or opening would, as Bourdon put it, 'snap to' when he came in. Patti Oldenburg:

> The minute Andy walked into the room you felt really good and you knew things were going to happen. He was kind of joyous and it was fun to go up and talk to him. He had the kind of strength people who are leaders have. He was terrific. He was always smiling and he always looked shiny, brushed and scrubbed and he always seemed very modest to me, also very creative. He was so open you could envision anything happening.

Andy would never go anywhere alone but made a point of gathering around him the most attractive, sexiest women on the scene. Prominent among them were Marisol and Ruth Kligman.

Marisol was a Venezuelan sculptor who was Andy's stablemate at Elinor Ward's gallery, and, like Andy, a star. In addition to being an outstanding artist – affiliated neither with expressionism nor pop art she was, in a sense, in a school of her own – Marisol was beautiful and spooky, and as silent and aloof as Andy at the four or five openings and parties they attended together each week. In fact, he picked up a lot of his new act from her. They were affectionate, recalled a mutual friend, like 'two pussycats rubbing their heads together. They were infinitely close. They had these one-liners about whatever was going on, about their emotions or where they were at, which were totally brilliant.'

Marisol said she found Andy sexually attractive because he was so

strong, and even on occasion expressed the desire to go to bed with him, but naturally nothing came of it.

Another important woman in Andy's life at this time, again for significant reasons, was Ruth Kligman. Ruth looked like Elizabeth Taylor, and she had been the muse of some of the greatest of the abstract painters. She had lived with Kline, de Kooning and Pollock, whom she had been accompanying on the night he had committed suicide by ramming his car into a tree on Long Island. Ruth Kligman:

> Andy was fascinated with de Kooning and Pollock, and through me, he wanted to be part of that lineage. And I wanted to be part of him, because I knew that he was this incredible talent and genius. He asked equally about their work and personalities. I would say that he was more fascinated by Jasper and Jackson, but he was more into me. Andy is the kind of person who when he's with you he's *with* you, and he would ask about Jackson and Bill and Jasper, and then he'd say, 'Oh, you're so wonderful, you're just like that. You're a star!' He felt I should capitalize, that I was much too nice to everybody. He used to say, 'Oh, don't talk to everyone. Be aloof, be aloof, be aloof.' He was always telling me that I should behave more like Marisol.

Shortly after Warhol's Stable Gallery show, Ruth started seeing Andy regularly. Their relationship would continue until 1964, when she got married. Andy found it impossible to have relationships with married people, he told her then. He had to come first or not at all.

During the time when she was 'dating' Andy, Ruth Kligman's defection from the abstract-expressionist camp did naturally not go unnoticed. 'I got the feeling from a lot of people that I was somehow betraying the group,' she said.

> De Kooning never liked me to mention Andy. Andy polarized the departure from abstract expressionism to pop art because he looked like pop art, and also he was very anti-painting. De Kooning represented a classical approach to art where Andy represented a more modern, revolutionary approach to anti-art. But I saw Andy more as a force like Duchamp. To me, he revolutionized modern art. First, there was Pollock and de Kooning and Kline. The next important influence was Jasper Johns. And then it was Warhol.

Many painters hated Andy because they thought he wanted to destroy art. Nothing could have been further from the truth, but in the pretentious art market of that period much was made of his methods and attitude. When Andy and Ruth ran into Mark Rothko on Sixth Avenue and 12th Street one Sunday afternoon and Ruth said, 'Mark, this is Andy Warhol,' the eminent painter turned and walked away without a word. Ruth was shocked. 'He was a great man. He shouldn't have been threatened at all, but he couldn't accept Andy's strength.' On another occasion, Marisol took Andy and Bob Indiana to a party.

When they walked in the room fell silent. Then Rothko could be heard urgently demanding of his hostess, 'How could you let *them* in?'

As Ruth saw it, she and Andy

had a terrific crush on each other and I think that it was sexual. We didn't act it out, but we spent a lot of time together, and we would hug sometimes. I remember getting a little carried away once and he said, 'Oh, Ruth,' and squirmed out of it. We'd have frivolous conversations about, 'We should get married and Oooooooohhh how wonderful it would be, and we'd just be together for ever.' It was like a really great pal-friendship-supporter thing, very intimate, very sweet. Andy was very graceful and we had instant rapport.

Andy told Ruth that he was celibate by choice.

He would talk about not wanting to invest his emotions that much. He was always curious about what other people did sexually, but he would say, 'Oh, you're better off putting all your energy into your work. Sex takes up too much time.' He was very much for not being involved emotionally.

His art had become his form of sexual expression. Ruth Kligman:

Although Andy was beginning to practise detachment from emotions and people, he always kept a feeling of understanding other people's foibles on an emotional level. Like, if someone was committing suicide over love, he completely understood it. You always got the feeling that he'd experienced it. He was never judgemental. The complexity of his personality, to me, was always his humanism juxtaposed to his desire to be detached and machine-like. He was able to do both at the same time. He could be very loving, very kind, very generous and yet cut you off if it wasn't going to be good for his career.

Marisol and Ruth, who had been close friends for years, stopped speaking as a result of jealousy over Andy.

*

'Paintings are too hard,' Warhol told *Time* in May 1963. 'The things I want to show are mechanical. Machines have less problems. I'd like to be a machine, wouldn't you?'

By June 1963 working on his paintings at home had become untenable. Canvases were spread over the living room, paint and ink from the silkscreen had splattered on the floor and furniture. Junk lay all around. Andy rented a studio in an abandoned hook-and-ladder firehouse a few blocks away on East 87th Street. The price to lease the second floor of the city-owned building was about $100 per year, but he had to hopscotch over the holes in the floor, the roof leaked, sometimes destroying paintings, and there was no heat.

In order to keep up with the demands of his own output, Warhol

decided to hire an assistant to help him to do his silkscreens the way Nathan Gluck was helping on his ongoing commercial art projects. Gerard Malanga got the job.

Gerard Malanga looked like a fashion-model Elvis Presley and came from a poor family in the Bronx where, like Andy, he lived alone with his mother. He had been rescued from poverty by some admiring poets and groomed in the homosexual literary community that floated around W. H. Auden and Charles Henri Ford. Malanga was only twenty years old and primed for action when Andy hired him.

> Andy loved all sorts of machines and gadgets, embracing new techniques and technologies, working with tape recorders, cassettes, Polaroid, Thermofax, but the heart of all this experimentation had as its central focus photography and silkscreen for making a painting. This was by extension his love for the machine because the screen process was very machinelike. Andy's reasoning was that the silkscreen would make it as easy as possible to create a painting. Ironically, the process relied directly on manual application.
>
> When the screens were very large, we worked together; otherwise, I was pretty much left to my devices. I had a first-hand knowledge of silkscreen technique, having worked for a summer as intern to a textile chemist in the manufacture of men's neckwear, so I knew what I was doing from the start.
>
> Andy and I would put the screen down on the canvas, trying to line up the registration with the marks we made where the screen would go. Then oil-based paint was poured into a corner of the frame of the screen, and I would push the paint with a squeegee across the screen. Andy would grab the squeegee still in motion and continue the process of putting pressure on pushing the paint through the screen from his end. We'd lift the screen, and I would swing it away from the painting and start cleaning it with paper towels soaked in a substance called Varnolene. If this was not done immediately, the remaining paint would dry and clog the pores.

Nathan Gluck took an instant dislike to Malanga and it is easy to see why. With his droopy eyes, his mouth constantly hanging open in a pout, and his insouciant air of being a poet, Gerard represented the new model of the gay boy peacock proud of his beauty and totally out front about it. Even though Malanga was basically a heterosexual and would later become Warhol's model male trendsetter, he had had a few homosexual affairs before he met Andy and was certainly an active bisexual during his years with Warhol. The fact that Gerard was also immediately accepted as an equal by Andy and was rapidly propelled into his social life did not sit well with Nathan either. He had never once been invited to a social affair by Warhol.

On the second day of his job Andy had taken Gerard back to his house to meet his mother and have lunch. Gerard could not have known how rarely Andy introduced his friends to Julia for her inspection. In fact, Gerard Malanga had no idea who Andy Warhol was as he walked into his living room, and was only worried that he was going

164

to try to put the make on him. That was something he wouldn't know how to deal with, he remembered thinking, because to Gerard Andy looked demonic – 'real weird, threatening and overpowering'.

Warhol left him in the room, which reminded Malanga of nothing so much as the seedy archive of a pornographer, listening to 'Sally Go Round the Roses' while he went to check in with his answering service. Malanga looked around, saw some paintings of Cambell's soup cans, and it suddenly dawned on him that his boss was one of those pop artists he had read about in a magazine. As 'Sally Go Round the Roses' repeated he felt 'in awe of the situation'. When Andy returned to the room with Julia carrying a tray of Czechoslovakian hamburgers and Seven-Ups, he began to relax. As soon as his mother was in the room, he noticed, Andy was reduced to behaving like a little boy, which put him on just about the right mental level for Malanga, who had the innocent and spontaneous intelligence of a somewhat louche eight-year-old. In fact, Gerard wrote later, they often felt like children together. In Andy's best fantasy that would have meant like two little girls playing out in the street after school.

And yet, Malanga persisted in the first weeks he knew him of having a feeling of fear when he was around Andy. 'That was the paradox,' he recalled. 'The word alien is the perfect description of his presence, because this very sweet presence was coming out of this demonic-looking person.' Malanga was the first person to be frightened of Andy, whose deathly cold glamour later frightened a lot of people.

Gerard soon discovered that he had much in common with Andy. They were both collectors of movie memorabilia and idolized stars, and they were soon going out to the movies and parties together several nights a week and calling each other Andy Pie and Gerry Pie. Gerard was struck by Andy's ability to make you feel like his best friend, even though he had only known you for five minutes without letting go of his emotions.

'If you were to meet him for the first time and Andy liked you,' he said, 'he became your instant fan, and this, in turn, would create in you a feeling of self-esteem.'

In the spring and summer of 1963, as if pausing to pay homage to some of the heroes who had informed and were going to inform his work as well as prepare himself for what would later become a major enterprise, Warhol painted a number of outstanding portraits. A series of six-foot-tall silver images of Elvis Presley holding a gun based on a film still were among the best. 'As in so many of Warhol's finest works, it is the absolute stillness and silence they generate that gives them such power,' wrote John Carlin in *The Iconography of Elvis*.

Andy had first brought Elvis into his work in 1956 in the Crazy Golden Slippers show at the Bodley Gallery in which Elvis was represented by an elaborately festooned boot. Elvis was the only subject

Andy took with him from the fifties into the sixties. A multiple 'Red Elvis' had appeared in the Stable Gallery show; one of his many experiments with the soup cans was called 'Campbell's Elvis' and superimposed the singer's face over the can's label. John Carlin:

Both came from humble backgrounds and meteorically captured their respective fields in a way that seemed to break entirely with the past. Each betrayed his initial talent as soon as it became known, and opted for a blank and apparently superficial parody of earlier styles which surprisingly expanded, rather than alienated, their audience. Both went into film as a means of exploring the mythic dimensions of their celebrity.

On the surface both men shared a scandalous lack of taste. Particularly as both took repetition and superficiality to mask an obscure but vital aspect of their work: the desire for transcendence or annihilation without compromise, setting up a profound ambivalence on the part of both artist and audience as to whether the product was trash or tragedy.

Warhol also did a series of portraits of Rauschenberg. The art critic Sam Hunter wrote:

Andy Warhol's piquant multi-frame, serial portrait of Robert Rauschenberg, capsulating selective stages of his early growth, from childhood to mature youth, is an unusual invention in its complex story-telling aspect. The interaction of biography and public life that Warhol mines from this series of modest family snapshots also suggests his general appeal as an artist and his approach in idiosyncratic aspects of their life and personality. The images are forthright, neither reworked nor touched up, and come across with a special kind of candour.

He did several paintings based on multiple reproductions of the Mona Lisa. Ivan Karp described 'Coloured Mona Lisa' as a quintessential pop painting, 'cold, mechanical, tough, alien and bland'. Robert Scull gave him the opportunity to do something different on a large scale when he commissioned Andy to do a portrait of his wife.

Ethel Scull was nervous about Andy doing her portrait because 'with Andy you never knew what to expect'. When he came to pick her up to have her photograph taken for the silkscreen, she expected to go to Richard Avedon's studio and dressed accordingly in a designer outfit, but Warhol took her to a photomat machine on 42nd Street. She protested that she would look terrible, but Andy told her not to worry and took out $100 worth of coins.

He said, 'I'll push you inside and you watch the little red light.' I froze. So Andy would come in and poke me and make me do all kinds of things and I finally relaxed. We were running from one booth to another. Pictures were drying all over the place. At the end he said, 'Now, do you want to see them?' They were sensational.

When he delivered the portrait it came in pieces and Bob said to him, 'How would you like . . . don't you want to sit down at this too?'

He said, 'Oh, no. The man who's up here to put it together [Warhol's assistant], let him do it any way he wants.'

'But Andy, this is your portrait.'

'It doesn't matter.'

So he sat in the library, and we did it. Then, of course, he did come in and give it a critical eye. 'Well, I do think this should be here and that should be there.' When it was all finished, he said, 'It really doesn't matter. It's just so marvellous. But you could change it any way you want.'

'Andy's attitude toward women was very complicated,' said Henry Geldzahler.

He admired them. He wanted to be one. He wanted to be involved in their creation. 'Ethel Scull Thirty-Six Times' was the most successful portrait of the 1960s. It was a new kind of look at a single human being from thirty-six different points of view, obviously influenced by the cinema and television. He was creating an image of a superstar out of a woman who could have been any one of a series of women.

Andy knew that he needed to come up with a new idea that would shock as much as the soup cans and dollar bills. 'He always tried recklessly to outdo himself,' recalled Roy Lichtenstein. Robert Indiana spent a lot of time with Warhol in 1963.

At one particular point everybody who was involved with the art world in New York was almost completely convinced that the next immediate movement or concern of young artists after pop was going to be pornography. I remember going around New York visiting studios with Warhol just to see all the really rather raw pornography that was being done. I had the feeling that Warhol was going to go in that direction.

Andy did two large paintings called 'Bosoms I' and 'Bosoms II' using paint that could be seen only under ultraviolet light, and was enthusiastic enough to tell Gene Swenson, who wrote for Art News:

My next series will be pornographic pictures. They will look blank; when you turn on the black lights, then you see them – big breasts. If a cop came in, you could just flick out the lights, or turn to regular lights – how could you say that was pornography? The thing I like about it is that it makes you forget about style; style isn't really important.

Andy quickly dropped this idea when he found out the paintings were impossible to sell.

*

Andy was a walking threat to a majority of the people on the scene.

His affiliation with commercial art, his strange alien appearance, that pale slab of a Slavonic face inscrutable and silent beneath its blond wig, his notoriety and the steady hint of homosexuality all confounded and embarrassed them. Stealing the beautiful young darlings of the art world away from the establishment and appropriating them, seemingly, as his girlfriends was a brilliant, threatening move. It confused people. It partially masked his homosexuality, leaving him less open to homophobia than he might have been, it associated him with the great painters they had been close to, and drew more media attention to him than he might otherwise have got. Andy knew that the photographers were more likely to take his picture if he was standing next to a beautiful woman. He had not lost his focus on fame.

'He went into it with the most deliberate manner,' stated Charles Lisanby. 'He knew exactly what he was doing. He would try to appear artless and naïve, but he really knew the effect that he was having. Always, always.'

The critic Robert Hughes wrote:

He went after publicity with the voracious singlemindedness of a feeding bluefish. And he got it in abundance, because the sixties in New York reshuffled and stacked the social deck . . . the new tyranny of the 'interesting' . . . had to do with the rapid shift of style and image, the assumption that all civilized life was discontinuous and worth only a short attention span . . . To stay drenched in the glittering spray of promotional culture, one needed other qualities. One was an air of detachment; the dandy must not look into the lens. Another was an acute sense of nuance, an eye for the eddies and trends of fashion . . . Diligent and frigid, Warhol had both to a striking degree. He understood the tough little world, not yet an 'aristocracy' but trying to become one, where the machinery of fashion, gossip, image-bending, and narcissistic chic tapped out its agile pizzicato. He knew packaging, and could teach it to others.

Within a few months of the first collective impact of pop art, the camaraderie that had seemed to characterize the group had dissipated as competitive envy. According to one observer:

Andy was not particularly the prince at first, although his rise through all of this was slightly more sublime as the days went by. At first there really was some group heroism about what took place. Everyone was relatively equal. Ultimately, Andy was the strongest because he was the most focused. But Andy had a problematic friendship with everyone. Andy had a problematic friendship with Claes Oldenburg, because Claes was a big guy. And Roy was so coy and everyone was sad and so hungry. Andy was not always in a defensive position, but a passive one, which was never combative like Claes's. Roy was tough, tight and eccentric. So Andy, with his softness, always took a deferential position – in his bearing, in his clothes, in his voice, in his passiveness. And Andy is infinitely aggressive. Other people have their other

ways of doing it, but that humble, passive approach is the most powerful and ultimately the others felt threatened by him. The only pop artist Andy really tried to befriend was Robert Indiana, but Bob was always so serious and made the wrong decisions because he was just a little bit too uptight.

Robert Indiana called Warhol 'a strange beast'.
Andy told an interviewer:

I'm not the High Priest of Pop Art, that is, popular art, I'm just one of the workers in it. There're five pop artists who are all doing the same kind of work but in different directions: I'm one, Tom Wesselmann, whose work I admire very much, is another. I don't regard myself as the leader of Pop Art or a better painter than the others.

*

As early as 4 June 1962 Henry Geldzahler had suggested that Andy start looking at the other side of American culture. 'That's enough affirmation of life,' he had said.

'What do you mean?' Andy had asked.

'It's enough affirmation of soup and Coke bottles. Maybe everything isn't always so fabulous in America. It's time for some death. This is what's really happening.' Henry had given him a copy of the *Daily News* with the heading 129 DIE IN JET emblazoned on its front page, and he had done a large, stark black and white painting of it that had been included in the Stable show and much admired.

The death portraits of Marilyn had brushed up against the theme once again. Then, in the spring of 1963, Andy had silkscreened a photograph from *Life* magazine of a police dog tearing the trousers off a black man in Alabama on a 17-foot-high yellow canvas and called it 'Mustard Race Riot'. Shortly after that, following a suggestion by the painter Wynn Chamberlain, he had started doing a series of paintings based on violence – the subjects were car crashes, suicides, funerals, the electric chair and the hydrogen bomb.

'I realized that everything I was doing must have been Death,' he told Gene Swenson.

It was Labor Day and every time you turned on the radio they said something like, 'Four million are going to die.' That started it. But when you see a gruesome picture over and over again, it doesn't really have any effect. The death series I did was divided into two parts: the first on famous deaths and the second on people nobody ever heard of and I thought that people should think about some time: the girl who jumped off the Empire State Building or the ladies who ate the poisoned tuna fish and people getting killed in car crashes. It's not that I feel sorry for them, it's just that people go by and it doesn't really matter to them that someone unknown was killed so I thought it would be nice for these unknown people to be remembered. There was no profound reason for doing a death series, no 'victims of their time'; there was no reason for doing it at all, just a surface reason.

Working with Gerard Malanga, Andy painted the series rapidly. For the first time he simply silkscreened images on to canvas painted with a single coat of garishly coloured (lavender, pink, mint-green) paint. He reproduced photographs of dead bodies torn limb from limb, wrapped around wrecked, burning cars, sixteen or twenty times on a single canvas. As a result of the silkscreen clogging or slipping out of line some pictures were clear, some blurred, some were lined up straight, some crooked. The effect was raw and hard. The paintings were given titles like 'Vertical Orange Car Crash', 'Green Disaster Twice', 'Purple Jumping Man', 'Lavender Disaster'. They perfectly mirrored the American attitude towards death in newspapers and on television. Gerard Malanga:

Each painting took about four minutes, and we worked as mechanically as we could, trying to get each image right, but we never got it right. By becoming machines we made the most imperfect works. Andy embraced his mistakes. We never rejected anything. Andy would say, 'It's part of the art.' He possessed an almost Zen-like sensibility, but to the critics Andy became an existentialist because the accidents were interpreted as being intentional statements.

The art critic John Rublowsky wrote:

These works reveal a creativity that exists close to the unconscious. In his search for artistic truth, Warhol has stripped away the layers of pretence and repression that obscure dark memories and knowledge all of us share. His imagery grips the imagination, striking a hauntingly responsive chord . . . It takes a special kind of person to venture into an entirely new dimension. Andy Warhol must be included in that rare company who recognize no boundaries, who create their own standards and values.

These were Warhol's most political statements, although in a conversation with Oldenburg and Lichtenstein on radio station WBAI he refuted all such imputations, claiming they were an expression of indifference. 'Ask somebody else something else,' he told the moderator. 'I'm too high right now.' And on another occasion:

The United States has a habit of making heroes out of anything and anybody, which is so great. You could do anything here. Or do nothing. But I always think you should do something. Fight for it, fight, fight. I feel I represent the US in my art but I'm not a social critic: I just paint those objects in my paintings because those are the things I know best. I'm not trying to criticize the US in any way, not trying to show up any ugliness at all: I'm just a pure artist.

Gerard Malanga was often amused by the intellectualization of Warhol by critics.

I was with Andy twenty-four hours a day at that time, and I know that he would never choose an image for the kinds of reasons critics dug up. He was really on a roll because every one of those images is a hot image. He really made it work for him. Andy used shocking colours in his paintings, even the silver was hot when he juxtaposed red lips on it. I think Andy put his sexual energy into his work and was conveying a sexual image throughout that period, but he never talked about it. The emphasis was on pretty. That was the word he used. It was never beautiful, it was always pretty.

'I don't think he was trying to make social statements in these paintings,' said Henry Geldzahler. 'I think that he's turned on by certain images, and those images that turn him on are loaded, supercharged images. I think the death image, the image of corruption, the image of decay, is really closer to his heart.'

'What held his work together in all media was the absolute control Andy Warhol had over his own sensibility,' Geldzahler also wrote, 'a sensibility as sweet and tough, as childish and commercial, as innocent and chic as anything in our culture.'

'There was a lot of disapproval of Andy's work,' recalled a friend, John Giorno,

but the disapproval is complex. A lot of people would completely dismiss the car-crash paintings because they thought they didn't have anything to do with a paintbrush, a brushstroke, a palette. Also, although I love the car crashes more than anything, things that are gross and offend one's good taste don't sell. The Marilyns and the Campbell's soup cans are pretty and decorative, but the car crashes don't work because you can't have them in your living room.

The death-and-disaster paintings have since become recognized as among Warhol's greatest and fetch prices upwards of a million dollars a piece, but many of his supporters found them unacceptable. Just as Lisanby had rejected a Marilyn, David Dalton refused a gift of a disaster painting, commenting that he didn't want to have to look at dead people on the living-room wall every day. Elinor Ward flatly refused to show them. Cracks began to appear in Andy's relationship with her. During 1963 he did not have a one-man show in New York. However, the paintings were soon to make him famous in Europe. In Germany, where pop art was already being collected, they were admired, the art dealer Heiner Bastian recalled, 'as the greatest things we had ever seen'.

In France the paintings were shown in January 1964 at Leo Castelli's ex-wife Ileana Sonnabend's gallery in Paris. The focal point of the show was 'Blue Electric Chair', a large painting on two panels, one of which was the same image of the death chamber, with a sign reading *Silence* in one corner, that Andy and Gerard had used in several paintings, repeated twelve times; the other panel was simply an empty blue mono-

chrome, which had been added both as an ultimate comment on death and to double the value of the painting.

They were met with rapturous praise. 'Their subjective quality is neither sadness nor melancholy, nor regret nor even bitterness,' the art critic Alain Jouffroy wrote. 'The traditional feelings attached to death are banished. In front of these pictures we are cleansed. The paintings become the holy scenes of a godless world.'

SEX

1961–63

For those to whom the sex act has come to seem mechanical and merely the meeting and manipulation of body parts, there often remains a hunger which can be called metaphysical but which is not recognized as such, and which seeks satisfaction in physical danger, or sometimes in torture, suicide, or murder.

MARSHALL McLUHAN

Everybody who knew Andy well was sure he was putting all his sexual energy into his 'scenes of a godless world', and that it made the startling, horror-filled visions so powerful. Actually, as early as 1961 Warhol had recommenced having sexual relationships. His first post-celibacy affair was with a man in the art world who wishes to remain anonymous for fear of homophobia but may be considered a reliable witness. Mr X, a promiscuous man who was particularly adept at seducing people, claims to have gone to bed with Andy on numerous occasions between 1961 and 1963. In those days, gay men were forced into being butch or femme to such an extent that when you were picked up you were asked which you were, and Andy was definitely femme. Mr X said Andy was extremely good in bed, so light-fingered in fact that Andy had brought him to greater heights of pleasure than he had ever reached.

Theirs was a purely sexual affair with no emotional ties. On one occasion when he visited Andy's house with Gene Swenson to pick him up to go somewhere, while Swenson was waiting, he went upstairs and engineered Andy into bed. It was rather quick but totally enjoyable, and Swenson never knew. When Mr X met him Andy was not famous, but during their affair he crested the wave of publicity. As soon as he became famous Andy started being very cautious, as most people did in those days, and covered his tracks.

However, Andy's attitude towards being gay had hardened and become if anything more overt rather than covered up. Although he goes largely unacknowledged in this, Andy was one of the pioneers of the gay liberation movement. One young man, who was a stockbroker on Wall Street by day and a hustler on the gay scene by night, explained:

Andy made a point of his gayness by the way he walked, talked and gestured as a kind of statement, but the reason it worked is, it was very qualified. To

173

start with, he kept it out of his work and didn't try to put the make on anybody he was involved with professionally. But since Andy was very strong and smart, he worked at it in a very subtle way and he was able to confront people with being gay.

Andy was playing on the cutting edge of the culture not only in his art but in his way of life. In fact, it was Andy's effect on people's lifestyles rather than his art that would make him the most famous of the pop artists and the only real celebrity among them. This started to happen now as he cut a swathe through the very active social scene around pop art, appearing frequently with a group of young men. Andy had acquired a taste for perverse, delinquent boys who were at least ten years younger than he.

The first in a long string of young men Andy was infatuated with during the sixties was John Giorno, a stockbroker at Fahnstock and Co. He was twenty-two, had the kind of face that hit you with its beauty, and was one of a new breed who would break down the barriers of sexual stereotypes in the 1960s. He went on to become known as a poet. Giorno, who was at one time or another also involved with Jasper Johns, Rauschenberg, William Burroughs and Brion Gysin, recalled that the art world was 'completely homophobic and that's what had always terrified Andy and Bob Rauschenberg and Jasper. Having grown up in the fifties, coming into the sixties was like punching out of a paper bag.' Giorno recalled that everything in his life was so horrible he slept as much as he could. Naturally, this intrigued Andy. Every time he called John up he said, 'What are you doing? Don't tell me. I know, sleeping.' Later he would change that to 'John slept so much he didn't know I was around'.

In April 1962 Andy and John started going out together several nights a week, but it was a frustrating relationship for Andy because John felt that it would have been 'gross and disgusting' to let Andy give him a blow job, since 'he wasn't beautiful and he was older than me'. They made out a lot and occasionally Andy would stick his face into John's crotch, but when Andy wanted to make it John thought it 'slightly undignified' and didn't want to. He did not feel as if he was rejecting Andy because Andy told him about his boy problems in the fifties and his nervous breakdown and said he thought that falling in love got in the way of work and wasn't good for you. 'In a completely cool, sublime way,' recalled Giorno, 'Andy knew that if we ever got into anything else it would completely blow the situation.'

After a while things began to break down between them. Feeling that he was losing Andy, John thought, What the hell, three people a day have sex with me. Why shouldn't I do that? On the one occasion Andy did give him a blow job, John noticed five or six tiny stripes of different coloured hair that grew out from underneath his wig at the nape of his

neck. 'It looked like a Frank Stella painting, and I said, "Andy, what in the world . . . ?" He explained that he went to a chi-chi uptown hairdresser once a month to have it dyed.' John also recalled how light-fingered Andy was.

The relationship came to a head one night in July 1963 when Andy took John up to the firehouse to look at the Elvis paintings. All those silver Elvises painted on a single roll of canvas stretching the 30-foot length of the studio were an exhilarating sight. Standing at the top of the stairs they started making out. It was around 10 p.m. John was drunk and as they walked down the steep flight of metal steps, still kissing, he slipped and fell, pulling Andy with him. They tumbled down the entire flight, body over body, landing in a stunned, silent heap, both miraculously unscratched.

'We coulda been killed!' Andy cried out, meaning, 'You tried to kill me!'

'No, Andy,' said John, grabbing him in a hug, 'if you fall right you don't get hurt.'

After that night Andy started to look at John in a different way. 'I should give you a present,' he kept saying as if looking for an exit line. 'What can I give you?'

Drunk and stoned late one night in Andy's living room John had mumbled, 'I wanna be Marilyn Monroe.'

'Oh, John,' Andy laughed.

By then Andy had already recruited the boy who would become John's rival. Although he never had a sexual relationship with Malanga, Andy was soon using him to make John feel as bad as possible, playing Gerard off against John just as he had played Marisol off against Ruth. And for the first time with a boy, it worked. Giorno gave in and would have done anything, but it was too late. The side of Andy that would torture people for the rest of his life now emerged, and John became his first victim.

By 1962 Warhol had started taking diet pills to keep him going through his standard twelve-hour workdays followed by rounds of social events that often kept him out till 3 or 4 a.m. On many occasions, as they sat up talking through the night in his apartment, Giorno would watch Andy breaking open capsules and licking the tiny pills off his fingers. Soon, it would be nothing special for him on being offered a cocktail or a plate of food to say 'No thanks!' and pop a pill in his mouth instead, chasing it with a glass of soda. He would make not sleeping or eating – like a machine – as much a part of his legend as his silver wigs and beatnik clothing.

Andy liked drugs a lot and knew what he was doing. He was also very careful to be legal about whatever he took because as he started to acquire a kind of negative fame, a notoriety, he could feel the heat closing in. At the beginning of 1963 he got a prescription for Obetrol,

175

a particularly grand diet pill that gave an exciting tingling feeling in the pit of the stomach and a confident sense of infinitely expanding time without the teeth-grinding jabbers or the awful crash of Dexedrine and many of the other amphetamine pills so easily obtainable in and so much part of the sixties. To friends who could see that he was well on his way to turning into the glamorous star he had always wanted to be, Andy said he had to be pencil thin. He started working out at the gym again, going several afternoons a week and popping the pills daily.

His path was not always as smooth as his Wow! Gee whiz! pop persona suggested. Henry Geldzahler remembered a frantic call at 1.30 a.m., only an hour after they had parted, insisting Henry meet him at the Brasserie in half an hour. When Geldzahler protested that he was already in bed, Andy said it was very important: 'We have to talk, we have to talk.' Imagining that something of creative import was coming down, and wanting to be in on its every moment, the fat man rushed to the restaurant to find a pale and trembling Andy perched on a banquette.

'Well,' Henry said, hurtling into the booth breathlessly, 'what is it? What is so important that it can't wait until tomorrow?'

Staring at him with wide-awake blank eyes, Andy replied, 'We have to talk, Henry. Say something!'

Geldzahler heard it as a cry for help from a man who had detached himself from his emotions and got stuck on the way between heaven and hell in a kind of metaphysical twilight zone where he was alone with his work.

*

Andy had been going to the movies like crazy lately. If he wasn't spending an afternoon sitting through one of Emile de Antonio's monumental hangovers in a 42nd Street cinema, watching hundreds of the worst monster and gangster movies ever made, he was squiring Malanga to the premiere of *Dr No* or to Orson Welles's version of Kafka's *The Trial*. In between he would sit with John Giorno, Charles Henri Ford and sometimes Malanga too in the Film-Makers' Co-op and watch hour after gruelling hour of some of the most boring art films ever made. 'That was the beginning of that phenomenon of the New York underground movie scene,' recalled John Giorno. 'Some of the movies were great, like Jack Smith's *Flaming Creatures*, Ron Rice's *Chumlum*, Taylor Mead's *The Queen of Sheba Meets the Atom Man* and Kenneth Anger's *Scorpio Rising*, but most of the others were truly horrible.'

'They're so terrible,' Andy whispered to John in between reels. He started to think that he could easily do better on his own. To Andy, the solution was obvious. 'There are so many beautiful things,' he said. 'Why doesn't somebody make a beautiful movie?' In July 1963 Gerard

and Charles Henri took him to Peerless Camera where he spent $1,200 on a Bolex 8-mm camera. He told anybody who would listen that he had no idea how to load or focus the camera, chortling gleefully, 'I'm going to make bad films!'

One night that summer, shortly after the fall down the firehouse stairs, John and Andy spent the weekend together on Elinor Ward's estate in Old Lyme, Connecticut, sharing a room with two separate beds. As usual John passed out in a drunken stupor around 4.30 a.m. When he woke up to go to the bathroom several hours later, he discovered Andy lying in bed next to him wide awake and staring. 'What're you doing?' Giorno mumbled.

'Watching you,' was the mechanical reply.

Several hours later, when Giorno awoke a second time, Warhol had switched angles and was on a chair at the foot of the bed, 'looking at me,' John recalled, 'with Bette Davis eyes. I said, "Andy, what are you doing?"

' "Watching you sleep," he said.'

For the longest time Andy had been wanting people to 'do things' for him while he watched. Having abandoned the naked-boy drawings and paintings of the 1950s as inappropriate subject matter and turned his attention to media subjects for his art, he had only recently begun asking friends to undress for his camera. Ruth Kligman had been insulted and thought his motives in poor taste when he had asked her to let him film her getting up, taking a shower and getting dressed. Now Andy was having a more extraordinary idea. On the train going back to New York that night he told John he wanted to make a movie and asked him if he wanted to be a movie star.

'Absolutely!' Giorno moved closer to him in the packed carriage. 'What do I have to do?'

'I want to make a movie of you sleeping,' Andy replied.

Stunned as he may have been by the odd notion, Giorno none the less agreed, and several nights later after leaving a party they took a taxi over to his flat so Andy could set up his equipment. Giorno wrote:

I was sitting on a seventeenth-century Spanish chair as he checked out where to put his tripod and lights and suddenly Andy was on the floor with his hands on my feet, and he started kissing and licking my shoes. I had always heard he was a shoe fetishist. 'It's true!' I thought with a rush. 'He's sucking my shoes!' It was hot. And I got some poppers to make it better. I jerked off while he licked my shoes with his little pink tongue and sniffed my crotch. It was great. Although Andy didn't come. When I wanted to finish him off, he said, 'I'll take care of it.'

For the next two weeks Andy shot four hours of footage per night on several different occasions. When he had the film developed he discovered that he had ruined all of it because he had not rewound the

camera properly every time he loaded it. Once he had overcome this problem he shot the whole film again. Looking at some rolls of footage on a movie viewer he exclaimed to John, 'They're so beautiful!'

The novelist and art critic Stephen Koch in his book *Stargazer* wrote that *Sleep* was a necrophiliac act of love to the body, filled with tenderness at the spectacle of a silenced vitalism, but at considerable cost to Andy, whose consciousness of his divided self, Koch felt, had been achieved in an alienation that must be underwritten by rage. 'That renunciation, the narcissistic repression, cannot survive on sweetness alone,' he wrote. 'It needs the help of hatred.'

It would take several months to have all the footage developed and then Andy would have to edit and design it. Before beginning this vital part of the task, he decided to pay a visit to Hollywood.

Pop art was rapidly taking over the West Coast scene. Irving Blum was giving Andy his second Ferus show of the Elvis Presley and Liz Taylor portraits, opening 30 September 1963. The Oldenburgs had moved out there and Claes was having an opening the day after Andy's. Furthermore, Marcel Duchamp, the spiritual godfather of pop art, was having a retrospective the following week. To make the scene even more inviting for Andy, Dennis Hopper, who had worked with James Dean in *Rebel Without a Cause* and had met Warhol in New York, offered to give him a movie-star welcoming party, and Hopper's wife, Brooke Hayward, arranged for him to stay in her father's suite at the Beverly Hills Hotel. To Andy, who had dreamed of Hollywood since he was eight, this was an invitation he could not refuse. 'Being a star was absolutely a dream of his,' Ruth Kligman recalled. 'But he didn't want to just be a movie star, he wanted to be the head of a studio. He said that was one of the reasons he came to New York.'

Dispatching the Elvises in a giant roll of silver canvas and blithely instructing the astonished Blum to cut them up and stretch them any way he liked, as long as the entire wall was covered, Warhol announced that he would be arriving in LA one day before the opening and would see Blum at the Hoppers' party that night.

As Blum prepared for the Elvis show, Andy's reputation grew on the West Coast. He was prominent among the artists included in the Pop Art USA show at the Oakland Museum, leading the California painter Larry Bell to write, 'It is my opinion that Andy Warhol is an incredibly important artist. He has been able to take painting as we know it and completely change the frame of reference, and do it successfully in his own terms.' The LA County Museum of Art showed the West Coast version of the Guggenheim's Six Painters and the Object earlier that year, which established Warhol as one of the leading pop artists. California was ripe for Andy's arrival. 'Vacant, vacuous Hollywood,' Warhol wrote, 'was everything I ever wanted to mold my life into. Plastic, white on white.' And:

I like American films best, I think they're so great, they're so clear, they're so true, their surfaces are great. I like what they have to say: they really don't have much to say, so that's why they're so good. I feel the less something has to say the more perfect it is. Who wants the truth? That's what show business is for – to prove that it's not what you are that counts, it's what you think you are. I always wanted Tab Hunter to play me in the story of my life.

*

Although he had flown around the world in 1956 without a sign of fear, after the death of Liz Taylor's husband Mike Todd in a plane crash, Julia had told Andy, 'Too many big shot die in planes,' and instilled in him a fear of flying for the rest of his life. Rather than taking a plane or train to the West Coast like the movie stars of his dreams, Andy made the then hip decision to drive across America – as in *On the Road* – even though he was right in the middle of his car-crash paintings.

As a teenager Andy had been given driving lessons by his elder brother, and one day in 1952 Paul had attempted to give him a lesson in New York. This ended in a minor accident on Park Avenue, with Andy blaming Paul for not having put on the brakes, even though Andy had been in the driver's seat. Andy never attempted to drive again.

The first thing he needed now was a car and at least two drivers, since he had to make the 3000-mile trip in four days. Characteristically, rather than choosing two responsible, sober people from among his legions of friends, he picked two of the most unlikely candidates for the job: underground film's classic clown Taylor Mead, whose ditsy childish bearing and appetite for marijuana and Quaaludes would seem to impair his ability to navigate a big automobile across the country's dangerous highways, and Wynn Chamberlain, another zany, pot-smoking artist, whose beat-up Ford station wagon would furnish their transportation. They planned to drive out as fast as possible, stopping only to eat and sleep. As a boon companion and glorified valet Gerard Malanga was persuaded to take a sabbatical from Wagner college, where he was studying poetry, to accompany Andy on the fun trip. This did not go unnoticed by Giorno, who began to feel used and abandoned.

For their comfort Wynn put down the back seat and placed a mattress in the back of the vehicle. There Warhol and Malanga lolled for the majority of the journey, listening to the tunes of the day like 'Puff the Magic Dragon', 'Dominique' and 'If I Had a Hammer'. Everybody in the car except Andy smoked pot.

Their first stop was St Louis. As soon as the boys had checked into their motel and wolfed down a big steak dinner at one of those knotty-pine restaurants where Andy insisted on eating all the time, since he was paying for everything on his Carte Blanche credit card, Taylor,

Gerard and Wynn were raring to explore the town. Not Andy. While the others rushed off into the night he returned to the room he was sharing with Gerard to commune with himself. When Malanga came in several hours later he was struck by the studied manner in which Warhol was sitting in the room doing absolutely nothing. He got the sudden impression that Andy saw the whole trip as a movie in which he was starring. Right then, he was playing a man alone in a room from a script by Samuel Beckett.

The next night they came close to getting killed in what would have been a terrible crash had Taylor not screamed out 'Wynn!', making Chamberlain accelerate as he raced through a red light at a crossroads in the middle of nowhere and narrowly escape collision with a big car thundering down the highway broadside to the Ford. After a brief silence Andy said in the small, tight voice of a complaining wife, 'Wynn, where were *you?*' After that he insisted that the radio be turned up higher and played at all times, although the songs they would have been forced to listen to, like 'All I Have to Do Is Dream' by Richard Chamberlain, 'Can't Get Used to Losing You' by Andy Williams and 'I Love You Because' by Al Martino, cannot have given any of them much pleasure.

Taylor finally freaked out on the third day and said if they didn't stop for a break he was getting out of the car and hitchhiking. Andy agreed to go into a truck stop full of teenagers and truckers. Warhol, Chamberlain, Mead and Malanga looked about as New York oddball as you could get to these innocent souls in the heart of America in the summer of 1963, just before the sixties really began. 'It was like we were from outer space,' Mead recalled. Warhol felt that all the people they were seeing were living in references to the past while they were living in the future. The kids gathered round, stared, asked questions. Andy apparently enjoyed the attention. After all, he was just about to become a star and this was one of the last occasions on which he would appear in public without people knowing who he was, but it also made him very nervous, rightly so, Mead thought, because it was frightening to be homosexual in that context.

That night in Albuquerque Andy was quite upset when Mead turned down the opportunity to make it with a bellhop. At least Andy could have heard about it the next day.

As soon as they got to Hollywood things started to happen fast. No sooner had Warhol checked into his suite at the Beverly Hills Hotel than there was a knock on the door and in walked the underground movie star and filmmaker Naomi Levine, whom he had recently met in New York and who had the same kind of crush on him as Ruth Kligman. Under the pretence of flying out on Film Co-op business she had come out to Los Angeles with no less an intention than seducing Warhol. As soon as he got there she attached herself to him like a

limpet mine. At Dennis Hopper's party that night she was already transforming herself into an Andy Warhol superstar.

Warhol wrote that Dennis Hopper's party was the most exciting thing that had ever happened to him, but this seems highly unlikely. The Hollywood Warhol visited that year was dying. You only had to look at the year's crop of films, like *Cleopatra*, *It's a Mad Mad Mad World* or *How the West Was Won*, and note that the top box-office stars were Doris Day, John Wayne, Rock Hudson and Elvis Presley, to see what the trouble was. Pop art and the world of the New York underground which Warhol and his entourage symbolized was much hipper and more in tune with the times than this slop. Furthermore, the fun young stars Hopper had gathered to fête Andy – such characters as Sal Mineo, Troy Donahue, Peter Fonda and Dean Stockwell, to mention only the better-known people there - had little to recommend them. What he was going to do in the cinema was so far removed from the mind of someone like Suzanne Pleshette, who represented the female contingent at the party, that he must have known that there was little point in pursuing the issue. Andy may have enjoyed himself that night but he made zero effort to contact any of these people, apart from Hopper, again.

Besides, art was still uppermost in his mind. The next morning he was meeting Blum to check out the installation and get down to business. With the appetite for pop art so primed in LA that season, he had high hopes of selling out the series of Presley and Liz Taylor portraits. He needed the money. This little trip was costing him several thousand dollars and taking even more time away from his commercial-art career, still being valiantly upheld single-handedly by Nathan Gluck, who must have felt more than ever deserted and replaced by Gerard Malanga.

What is the first thing an art dealer does for his artist as soon as he hits town? Introduce him to his contemporaries? Show him some new paintings? No! He gives him the phone number of the best hustler service in town so that Andy can have boys delivered to his hotel room like so many steaks sent up from room service. That was the kind of reputation Warhol had acquired by the summer of 1963, although it was far removed from the reality. Taylor Mead was greatly amused by the incident, recalling, 'We were all such nervous nellies we just sat there looking at each other. He was dying for me to call but I was scared shitless and I was begging him to call.' Nobody in Warhol's entourage, which would soon be as associated with sado-masochism and homosexuality as Hell's Angels are with motorbikes, had the balls to use the number, which languished in Warhol's pocket until it was thrown out with his used Kleenex.

The opening that night was also a big disappointment. In a last-minute decision that puzzled Mead, Andy decided to withhold the Liz

Taylor paintings and only show the Elvis Presleys. The work was coolly received by the local critics and collectors, and not one painting sold. Although Warhol was by now adept at masking his reactions, he was enraged by the bad reviews and by what he considered the flat-out stupidity of the movie stars who did not snap up his work. Andy was convinced that these paintings, which could have been purchased for a mere $1,000, payable in instalments, would soon be worth a great deal more. As far as he was concerned they were free money hanging on the wall. They were also among his best works. Stephen Koch wrote:

> It is worth noticing just how startling and suggestive pictures like 'Triple Elvis' once were and how powerful they remain. Ordinarily when we look at any given image, there is a certain passage of time – five, maybe fifteen seconds – during which the mind is simply identifying precisely what it is looking at. In Warhol's case, the time span of recognition is invariably reduced to a flash.

Despite the failure of his show, Warhol turned up in top spirits at Oldenburg's opening the following night, to support his colleague. Taylor Mead:

> He was totally pleasant to be with. You realized he was thinking all the time. There was this awareness in the air, and however crazy or bad it turned out to be, it was unique. And the people we were around in LA were very hip, successful people. Their attitude toward Andy was, 'This guy may be a phoney, but he's successful.'

Warhol certainly stood out the night of Marcel Duchamp's opening on 8 October at the Pasadena Art Museum. He was there with the Hoppers and his entourage as well as the Oldenburgs, Irving Blum and others, and spent a good deal of time at Duchamp's table talking with Marcel and Teeny. It was the first time they met. Andy was so excited and thrilled by the show and party afterwards that for the only time in his life he drank too much pink champagne and had to get out of the car and puke on the way back to their hotel in the early morning.

Andy's vomit signals the end of the first half of the California trip and ushers in the second half, during which something was disturbing him that he couldn't get out of his system.

Bored by the formality of the palatial Beverly Hills Hotel, Warhol and company had moved to the Santa Monica Beach Motel and were spending the remainder of their visit with the street people and emerging hippies Taylor knew. Andy was getting more interested in them than in the dull and stuffy art crowd.

One night when Taylor was preparing to give a poetry reading, Andy and Wynn Chamberlain mistook Mead's contemplative warm-up for a depression, Mead recalled,

and Andy said, 'Oh, you should calm down. Here!' and he pulled out this big grey cock and tried to make me blow him. Both Andy and Wynn! They said, 'Blow us! Here, it'll calm you down. Give us a blow job!' I said, 'You gotta be kidding! I have to think about my reading,' and I walked off. It was a totally evil thing to do – cold-blooded and ruthless shit. The dumbest peasant wouldn't be that cruel or misread a state so much. I couldn't handle it and it was just so bizarre, because Andy usually had a certain amount of consideration, but he was just being a dirty little kid.

Gerard, too, at nearly the same time, discovered a side of Andy that startled and upset him. Throughout the trip Gerard had shared hotel rooms with Andy, with no hints of emotional or sexual overtures, so Gerard felt he was doing nothing inappropriate when, after a party, he had brought a girl back to their room and put the chain on the door for privacy. Andy arrived back unexpectedly early.

I was only in bed with her for half an hour when, all of a sudden Andy's at the door of our hotel room, and Andy was so angry with me that I had put the chain on the door and he couldn't get in, he literally tried to break the door down. He was banging on the door, shouting, 'Why is this door locked? Who's in there? Come on! Open it! Open this door up!' We put on our clothes and I let him in. As soon as he saw the girl, that just made him more annoyed, I guess because he was jealous, and he reprimanded me. He was visibly annoyed and pissed off. He said, 'How can you put the chain on the door? Why'd you do that?'

Gerard and the girl split, leaving Andy alone. Gerard thought he was being 'babyish'.

The same week Naomi Levine, who thought that Andy's work 'was all an excuse to be with people', finally freaked out. Warhol had made a film during the California visit starring Taylor Mead and Naomi Levine and called *Tarzan and Jane, Regained Sort of*. The filmmaking had gone remarkably well, particularly several nude scenes with Naomi, who earned the dubious credit of being the first person to take her clothes off in a film for Warhol. Andy filmed her 'swimming' naked in the bathtub of their hotel suite. She felt she was making progress at winning him over, but at the same time, she said, she was beginning to see 'how he provoked people with his passiveness into becoming freaky'.

He had obviously decided he liked me and he was very sweet. One night he took a big bag of sugar and opened it and poured it down my arm. But you had to relate to him on a very simple conservative line. He used to say things like, 'Oh, I really like Tuesday Weld.' I looked at him as a very, very bright businessman. I think he was a phenomenon of America.

'Andy was putting up with Naomi,' noted Gerard. 'She was a very sensitive person and he went out of his way not to hurt her feelings.

Andy's passive state made women feel they could approach him. Women felt that Andy was almost asking them to take care of him.'

As soon as the filming was completed Andy had started to get tired of her constant needy presence. Things came to a head after a day spent at Disneyland when Naomi had really put the pressure on him during a ride through the tunnel of love. Finally, screaming with frustration at Andy's evasive responses, she snatched at his wig in an attempt to pull it off'and break down his composure. Anybody who wanted to see Andy get angry had only to try forcing him to do something. The child who had been forced to go to school when he was ill would suddenly emerge, screaming angrily. Naomi was quite taken aback, desisted in her attempts and, chagrined, flew back to New York.

It was left for Warhol and his somewhat deflated entourage to return to New York. They drove once again the gruelling 3000 miles, taking the southern route this time but without the spirit of the outward journey. Actually the trip had been a success. *Tarzan and Jane* was a good film and would be well received and Andy had got a lot of publicity even if much of it had been negative. He had also learned something important about himself. If he was going to work with groups of people, which he was about to start doing as soon as he got back to New York, he was going to have to practise an even more detached method of relating to them than he had in LA or else it would be impossible to control them.

This had not quite sunk in yet, but the next episode indicated that it was about to. Somewhere in North Carolina, when they stopped overnight at a motel, Andy finally attempted to put the make on Gerard. 'We were horsing around in the room the next morning when Andy suddenly turned around and put his hand on my crotch over the sheets. I didn't say anything but I shook it off, turning over. He suddenly turned quiet and that was the end of the incident. He didn't mention it again.' However, when they got back to New York Andy, who had usually been generous in this matter, refused to give Gerard cab fare and he had to schlep his heavy suitcase out to the distant Bronx on the subway.

*

The next day Andy and Gerard went straight back to work painting car crashes and suicides, but there was one significant change in their daily schedule. After painting in the morning, they spent the afternoon looking for a new studio. Andy had wanted to buy the firehouse when it was put up for auction but had not been able to afford it. They spent most of November looking for a new space, with conflicting desires. Gerard wanted somewhere he would have a room of his own to live in. Andy wanted a large, open space where he could paint, make movies and do everything.

In the six months they had been working together, Gerard had made

himself indispensable as Andy's assistant and sidekick, to the extent that the two had become an identifiable cultural entity known as the Gertrude Stein and Alice B. Toklas of the art world. A Sam Montana cartoon in the *Village Voice* that winter depicted Warhol commenting on a painting, saying, 'I dunno, Jerry, it's not boring enough,' and Malanga replying, 'Golly, will it hurt us, Andy?'

Gerard Malanga:

> If I wasn't going out somewhere with Andy, whether it was a movie, dinner, a party or an opening, that meant Andy was invited to some chic dinner where he couldn't take me. The Sculls would invite him to dinner, but they wouldn't invite me. Or he was at home with his mother, or I was out on a date with some chick. We used to go out to dinner a lot together. He loved the Brasserie. It was the first chic, cafeteria French restaurant. We went to Serendipity, where he knew the owners. We would talk about what we were planning to do: were we going to do two paintings or twelve paintings? Andy was always curious about what I was doing in the poetry world. We talked about people we liked.

They were seen out so often together at openings and parties that it was widely, though mistakenly, assumed that they were lovers. In fact, as Malanga points out:

> It was almost as if he was sexless. He cringed from physical contact. It was that celibacy which gave him enormous manipulative power over the magnificently beautiful people he brought together. But it was congenial. We were like two teenagers hanging out together. I don't think Andy was consciously trying to hide something about himself as much as attempting to maintain a mystique, as a cover for his own inadequacies. His shyness allowed him to be private.

As soon as Andy got back to New York the November issue of *Art News* came out. It contained Gene Swenson's brilliant series of interviews with pop artists, including one with Warhol which had been done that summer with a hidden microphone. This was the first major interview with Warhol published and it introduced the third field in which he would become predominant.

Americans have always been drawn to the common-man philosopher who dates back in folk legend to Paul Bunyan and has been carried through the twentieth century by such characters as Will Rogers, Huey Long and Carl Sandburg. Although the kind of statements that Andy began to make, like 'I want to be a machine' and 'I don't believe in love', were considered at the time shocking and negative, they played a vital role in making him famous. Just like the soup cans and *Sleep*, they were instantly clear to everybody even if people didn't like them. 'In the future everybody will be famous for fifteen minutes', for

example, was memorable, repeatable and timely. Andy's sayings would become as well known and often repeated as the lyrics of the Beatles or Bob Dylan.

'I want everybody to think alike,' Warhol declared in *Art News*. 'I think somebody should be able to do all my paintings for me. I think it would be great if more people took up silkscreens so that no one would know whether my picture was mine or not.'

GENE SWENSON: 'It would turn art upside down!'

WARHOL: 'Yes.'

*

Some of Andy's comments were brought to the fore by the assassination of President Kennedy on 23 November. Warhol had told Swenson that he believed in death and had recently realized that everything he painted was about death, that death was his grand theme. Andy claimed to have been more affected by the media's manipulation of the event than by the event itself, which, he wrote, did not bother him. 'I thought Kennedy was great but I wasn't shocked by his death,' he said. 'It was just something that happened. It isn't for me to judge.' That would, however, seem to have been as much of a pose as his expression of desire to be a machine when he was actually a passionate, emotional, religious person. John Giorno rushed over from his office to Warhol's house on hearing the news.

> We sat on the couch watching the live TV coverage from Dallas. Then we started hugging, pressing our bodies together, and trembling. I started crying and Andy started crying. Hugging each other, weeping big fat tears and kissing. It was exhilarating, like when you get kicked in the head and see stars. Andy kept saying, 'I don't know what it means!'

In fact, Warhol rose to the occasion with one of his greatest works of the early sixties, the 'That Was the Week That Was' portrait of Jackie Kennedy, based on eight newspaper head shots taken in the minutes before and hours after the assassination and at the funeral, and metamorphosed into a large sixteen-panel work. Jackie Kennedy was one of the women he admired and identified with, and his handling of her image in the blues and greys that divided America in the Civil War mirrored the dignity with which she handled herself as the heroine-widow. Stephen Koch:

> These images have a frontality that would hit us smack in the eyes were it not for Warhol's countermove: his voyeur's transformation, his aesthetizing stare. *This* distance is uniquely Warhol's own. The game here is power – the back and forth of Warhol's work is always a subtly eroticized interplay of active and passive terms. This is why soup cans can come from the same artist who shows the images of a man leaping to his death; why the duration of an entire film can sink into the voyeuristic absorption in the face of a man

asleep. In every case, the power of an image is modified, put in equipose with some response of Warhol's own creation. This response – however much work it took – is invariably, deeply passive; indeed, Warhol's entire art is based on his profound passivity as a man . . . Deep in its paradoxical distances, the frivolous art that Andy Warhol produced during this period trafficked in themes of major dimensions: what it means to see feelingly, what it means to fear what you want to see; the struggle with the visual power of fame, beauty, death and terror.

"The thing that is missing from the American evaluation of Andy Warhol's work," the American poet and art critic Frank O'Hara told the British poet and art critic Edward Lucie Smith, "is that Andy is a terribly serious artist rather than an agent to make everything lively, which he sometimes is taken for in the United States. I recently went to Boston and saw the full mounting of the picture of Mrs. Kennedy. It was never shown in New York in full scale. And it's absolutely moving and beautiful. Not sarcastic, and it's not some sort of stunt. It really is a complete compelling work when shown in the way he wanted it to be shown. When it's as big as it's supposed to be and there are that many images of her, the color somehow works from image to image. The European evaluation of him is much more exact."

VIOLENT BLISS

1963–64

The role of setting the pace, of being first, by definition meant doing things that had not been done before or that had failed in the past. It necessitated a vicious disregard for tradition and common sense. And a vicious disregard for success.

<div align="right">GERARD MALANGA</div>

At the end of November 1963 a truck containing Warhol's painting equipment from the firehouse and 1342 Lexington Avenue pulled up outside a warehouse and factory building on East 47th Street. Andy was pleased with his new location. It was just down the block from the United Nations and overshadowed by the Empire State Building, he noted – not the sort of place where an artist was expected to have a studio. The new space was on the fifth floor of 231 East 47th and could be reached by a large open freight elevator, which sometimes broke down, or a flight of stairs. It was a single room, about 100 by 40 feet, with a couple of toilets in the back and a payphone. Metal columns stood foursquare defining its central area. The floor was concrete and the brick walls were crumbling. It was dark, since the windows facing south were mostly painted over black, and the ceiling was low. It had previously been a hat factory.

Without missing a beat Andy continued painting, turning out the first 'Electric Chair' pictures and the suicide painting 'White', twenty repeated images of a young woman who jumped off the Empire State Building, spreadeagled on the dented roof of a car. Suicide would be one of his themes. In an exchange with Henry Geldzahler, which was typical of Warhol's public posture, Henry asked Andy if he knew what he was doing.

WARHOL: No.

GELDZAHLER: Do you know what a painting is going to look like before you do it?

WARHOL: Yes.

GELDZAHLER: Does it end up looking like you expect?

WARHOL: No.

GELDZAHLER: Are you surprised?

WARHOL: No.

He was at the peak of his pop-art career and he would stay there for another year. Peter Schjeldahl wrote:

> For a short while, roughly 1962–1964, Andy Warhol was a great painter, one of the best in this half of the twentieth century. Like most modern artists, the halcyon Warhol was both radical and conservative, looking both forward and backward in cultural time. He (1) inserted painting in a humiliating semiotic continuum as one medium among many of the mass culture, and (2) made great paintings. Initially appearing to ridicule the preciousness of art with a technique of mass production, Warhol and his silkscreening – actually a clumsy and messy artisan device – finally mocked mass production and exalted painting. This was possible because, for a while, he was on to something serious: chaos – systems entropy, human madness and death – as a crack in the world through which could be glimpsed a violent bliss. It was only a glimpse, but its after-image will linger for as long as Warhol's best paintings are shown and seen.

Andy's next idea may have been at least partly inspired by trying to think of something Elinor Ward would reject again, thus making it easier for him to leave her gallery. He also wanted to do something that would grasp the attention of the public. He announced that he was going to make some 400 sculptures of grocery boxes for Campbell's tomato juice, Kellogg's cornflakes, Del Monte peach halves, Brillo pads etc. out of plywood, silkscreening them to look as much like the originals as possible except that they would be nailed shut.

Mrs Ward was aghast. Andy had only just got accepted as a painter. To her this idea sounded like a disastrous departure. How much would he sell them for? she asked. He said, $300–$600 each. He was so enthusiastic about the idea that he won her over.

Andy got to work with Gerard. For three months rows of wooden boxes reached the length of the studio as they toiled over them in what one observer described as 'a production line in a surrealist sweatshop'. There was something ironic, Gerard thought, in Andy's concept of automatic assembly-line art, because making the boxes was the hardest work they ever did together. They had to hand paint six sides of each box, wait for them to dry and then silkscreen each of the six sides. In a documentary shot by the filmmaker Marie Mencken both Warhol and Malanga appear to enjoy themselves as they wrap each box in brown paper, chattering away happily.

With the art world waiting for his next statement and excitement mounting among those who heard what he was doing, Andy was turning his attention towards film. As soon as he had returned from Hollywood he had thrown himself into getting *Sleep* developed and edited while Taylor worked on *Tarzan and Jane*. All Warhol's early silent black and white films were striking because of the painterly care taken in their design and lighting (*Sleep* would often resemble an abstract

expressionist painting by Franz Kline) and because he insisted they be projected several frames per second more slowly than they were shot, like the famous Zapgruder film of the Kennedy assassination that Warhol saw over and over again that November. While not 'slow motion', this hardly noticeable shift would prove to be very effective.

Naomi Levine helped get Andy into the New York underground film scene by screening *Sleep* in Wynn Chamberlain's loft at 222 Bowery for the so-called saint of the underground cinema, Jonas Mekas, who ran the Film-Makers' Co-operative and published *Film Culture* magazine around which the scene revolved. *Sleep* immediately caused a furore since the idea of a six-hour film of a man sleeping sounded so ridiculous that people thought Warhol was trying to insult their intelligence, yet Mekas saw it as an important work. To him, the simple displacement created by running the film at sixteen instead of twenty-four frames per second was the essence of Warhol's art – the 'one little thing choice that shifts the whole to a totally new angle'. Warhol was presenting a new vision of the world, Mekas said, and 'celebrating existence by slowing down our perceptions'.

In late 1963 and early 1964 Andy filmed *Kiss*. He would get a couple like Marisol and Robert Indiana to pose in a mouth-to-mouth kiss, and hold the pose for three minutes without moving. In many cases he mated couples who were not at all compatible. They filmed several segments at Naomi Levine's apartment on the southeast corner of Avenue B and 10th Street. One day when Naomi felt uncomfortable with a partner, Gerard replaced the kisser and began his movie career as a Warhol superstar.

'I kept saying, "Why don't you have two men kissing?" ' recalled John Giorno. "It would be so beautiful." Andy was always so horrified at that idea. I said, "It would be better than Naomi Levine!" '

Haircut, *Eat*, starring Robert Indiana eating a mushroom, and *Blow Job* carried on the tradition of *Sleep* but were much shorter. Two months earlier, in January, Andy had shot a second film starring John Giorno. *Hand Job* consisted of a shorter approach to the subject of sleep. This time, Warhol would keep his Zapgruder speed film trained on his boy's face while John jerked off. He shot the film in the doorway of the toilet at the back of the Factory. It was so cold, Giorno recalled, you could see your breath. 'I said, "Well, how're we gonna do this?" and then Andy would suck my cock a little bit to get me going. Right after that he shot *Blow Job*." By then almost everybody in the underground film scene was up in arms about how much attention was being given this seemingly banal Johnny-come-lately Andy Warhol. Word also reached the esteemed experimental filmmaker Stan Brakhage in Colorado, and brought him to New York. Mekas later wrote:

He sat down at the Film-Makers' Co-operative and he said: 'Enough is

enough. I want to see the Warhols and find out what's the noise all about.' So he sat and looked through all of it. I was working by the table, and Stan stood there, suddenly, in the middle of the room, and he started raging, in his booming mountain voice. He told us that we were taken in, that we were fools for sure. Plus, he said, he was leaving New York. Something to that effect. I walked ten times across the room, listening to Stan's rage. Something shot through my mind: 'How did you project the film, 16 frames per second or 24 frames per second?' I asked. 'Twenty-four,' said Stan. 'Please, Stan,' I said, 'do us a favour. I know it's hard for you, but please sit down again and look at *Eat* and *Sleep* at 16 frames per second, because that's how they were intended to be.' Which Stan bravely did. We went across the street, to Belmore, for some coffee and left Stan alone to watch the films. When we came back, much later, we found Stan walking back and forth, all shook up, and he hardly had any words. Suddenly, he said, when viewed at 16 frames per second, suddenly an entirely new vision of the world stood clear before his eyes. Here was an artist, he said, who was taking a completely opposite aesthetic direction from his, and was achieving as great and as clear a transformation of reality as he, Stan, did in his own work.

'I like the filmmakers of the New American Underground Cinema, I think they're terrific,' Warhol said.

My first films using the stationary objects were also made to help the audience get more acquainted with themselves. Usually, when you go to the movies, you sit in a fantasy world, but when you see something that disturbs you, you get more involved with the people next to you . . . You could do more things watching my movies than with other kinds of movies; you could eat and drink and smoke and cough and look away and then look back and they'd still be there . . . I made my earliest films using, for several hours, just one actor on the screen doing the same thing; eating or sleeping or smoking; I did this because people usually just go to the movies to see only the star, to eat him up, so here at last is a chance to look only at the star for as long as you like, no matter what he does, and to eat him up all you want to. It was also easier to make.

*

While Andy was working on the Brillo boxes and making these films, a 21-year-old hairdresser and lighting man, Billy Linich, started designing his studio. Linich was an attractive, intense young man, a Buddhist and, he claimed, a black magician. Andy had met him at the apartment he shared with several other young men, including the dancer Freddie Herko, on the Lower East Side, in which everything was painted or tinfoiled silver and brightly lit. Andy had immediately been drawn to Billy and his friends, whom he recognized as the precursors of a new breed, and asked Billy to come and do the same thing to the studio that he had done in his apartment. 'It must have been the amphetamine but it was the perfect time to think silver,' Andy wrote. 'Silver was the future, it was spacey – the astronauts . . . And silver

was also the past – the Silver Screen . . . And maybe more than anything else, silver was narcissism – mirrors were backed with silver.'

Gerard Malanga:

Andy was fascinated, and he took to Billy like he took to a lot of different people who were shy. Andy would sit right next to the person and budge up to them, listen intently and maybe ask questions, but he was always like a little boy next to the person. Andy was really good at making people feel important. He always sat down with somebody who didn't have an identity for himself. He found these people because he needed them.

From January to April 1964 Linich toiled at the meticulous task, slowly transforming the dark crumbling room into a giant reflector. While he was working on it Billy became as close to Andy as Gerard, who had moved some boxes of his posssessions in, dumped them in the middle of the room, and started living there. Gerard slept on the couch, with his books and things in disarray around him. His perfect assistant, Andy quickly discovered, 'could be very slobby', and as a result, without having to be told, near the end of February, Gerard moved instead into a spare bedroom in the poet Allen Ginsberg's Lower East Side apartment.

Before Billy finished the job he too moved into the studio, building a nest for himself in a back corner next to the toilets and sleeping on the floor like an ascetic disciple. In fact, with his strong, sinewy arms, washboard stomach, handsome, serious face and close-cropped hair, Billy looked very much like a disciple in a movie.

As soon as he started working in Andy's studio a number of Billy's friends began coming by regularly. There were Rotten Rita, the Mayor, the Duchess, Freddie Herko, Mr Clean, the Sugar Plum Fairy, Ondine . . . These characters, who sound as if they had woken up in a novel by Genet or Burroughs and crept off its pages, were talented misfits, most of them gay, who shared two important characteristics: they embodied a camp sensibility, marked by a spirit of theatrical extravagance, outrage and excess; and they took amphetamine. They were called the 'amphetamine rapture group' and 'the mole people' (because they remained underground throughout the hippie times and emerged as pioneers of the gay liberation movement in 1969). Outstanding among them were Freddie Herko and Ondine.

'Life seemed to take on more importance in his meteor presence,' wrote a friend of Herko. 'Talents unknown to the possessor bloomed in the beneficial warmth of his enthusiasm.' Andy and Gerard filmed Freddie roller skating all over New York on one bleeding foot, leading Andy to write, in a definition which can be applied to almost all the people who worked with him since:

The people I love were the ones like Freddie, the leftovers of show business,

turned down at auditions all over town. They couldn't do something more than once, but their once was better than anyone else's. They had star quality but no star ego – they didn't know how to push themselves. They were too gifted to lead 'regular lives', but they were also too unsure of themselves to ever become real professionals.

Ondine was a self-described 'running, standing, jumping drug addict' and brilliant verbal acrobat. It was Ondine's intensity as a crazy rapper – as opposed to his own silence – that fascinated Andy. 'And Ondine was not just that verbalist crazy person, he was a high-powered intellect,' Linich recalled,

> but he was such an intense person, and he could be so cruel and dictative about what he thought was wrong or right, sometimes people just looked at this dragon monster and missed the whole point of the aesthetic dissertation he was giving them. Ondine was really a magnificent master. One day Ondine, Andy and I were trying to think of what to call his studio. We said, we'll call it either the Lodge or the Factory, and since it was a factory before, let's call it the Factory. And everybody just said, 'Yeah, that seems right.' We were the prime movers, the catalysts, the destroyers, taking away people's façades. Saying, 'Are you really telling me this is your true self or are you just putting on shit?'

Billy persuaded Andy to let him move his Harmon Kardon hi-fi system to the Factory from 89th Street and Billy, Ondine and friends often stayed up for several days straight taking speed, listening to opera records and constantly talking.

As traffic increased Billy became manager of the Factory. Under his watchful supervision, the paraphernalia of drug use were kept out of Andy's sight. 'He didn't know that people were shooting up because they were very discreet. They saw he was a very special person and they didn't want to offend him,' Linich said. 'I was constantly aware of Andy's security, safety and wellbeing. And Andy would have his Obetrol so he would be joyously in tune with all they were doing instead of just being amazed by it.'

Brigid Berlin was one of the few women among the mole people. Brigid's claim to fame, apart from her high-society heritage – her father ran the Hearst Corporation – was that she was said to be the person who squirted Nikita Khrushchev in the face with a water pistol when he visited the UN in 1960. She was known as the Duchess, or the Doctor because, she boasted, she would give anyone who asked for it a poke of amphetamine through the seat of their pants – her new name at the Factory soon became Brigid Polk. She shot speed several times a day, but gorged on food and was, at times, grotesquely overweight. She would often erupt in passionate tirades of demented hatred, but she seemed to evoke a protective instinct in Andy, who was entertained

by her informed gossip, delivered in a broad society accent, about everyone from J. Edgar Hoover to the Duchess of Windsor. She got rid of a lot of anger against her parents by screaming at Andy, who would listen blankly. She adored him from the moment they met and would become one of Andy's closest friends for the rest of his life.

Crystal 'meth' – methamphetamine hydrochloride – was cheap and easy to get in 1964. Injected, sniffed, taken orally or dissolved in liquid, it increased and prolonged energy, produced a feeling of euphoric wellbeing, confidence, even invincibility, made people talkative and broke down their inhibitions. Amphetamine was widely prescribed at the time as a psychic energizer and diet aid by doctors who were only partly aware that it was addictive and that if taken over a prolonged period of time it could produce anxiety, paranoia, and occasionally symptoms of full-blown psychosis, as well as physical side effects resulting when users stopped eating and taking care of their bodily needs. The rock critic Lester Bangs later wrote that it

> of all accessible tools has brought human beings within the closest twitch of machinehood, and without methamphetamine we would never have had such high plasma marks of the counterculture as Lenny Bruce, Bob Dylan, Lou Reed and the Velvet Underground, Neal Cassady, Jack Kerouac, Allen Ginsberg's *Howl*, Blue Cheer, Cream, and *Creem*, as well as all the fine performances in Andy Warhol movies not inspired by heroin.

'I used to go home and sleep for an hour and then someone would wake me up so I could go back to work,' said Warhol.

Among the amphetamine rapture group was also a coven of self-styled witches: Dorothy Podber, Orion de Winter and Diane di Prima. Their attitude, according to Linich, was 'How dare you come into my presence and not be exquisite and perfect and know exactly what you're doing because if you don't I'm going to find out and destroy you!' Naomi Levine was back, and Andy was developing a new girl named Baby Jane Holzer.

Baby Jane, who had appeared in *Kiss* and had been hanging out with Andy since then, witnessed the transformation of the Factory into a perpetual happening by the mole people with a degree of alarm, though she thought some of their drugged-out performances 'brilliant'. The beautiful young Park Avenue socialite wife of a wealthy businessman, with her leonine mane of hair, 'in' clothes and friendship with the Rolling Stones, had been thrust into the fashion spotlight by the British photographer David Bailey and that autumn was profiled by Tom Wolfe as the Girl of the Year 1964 in *New York* magazine.

Andy made her his first 'superstar' and escorted her to parties, openings and rock shows, attracting a lot more attention from the press. Andy loved the press. Some of his friends formed the opinion that

he only really felt alive when he saw a photograph of himself in a newspaper.

However, the Factory was undoubtedly a man's world and a gay man's world at that. It quickly took on a style and attitude of its own. Ondine:

> Andy was always so provocative sexually. I think he knew that everybody was really thinking about big cocks and he exposed that too. When people came to see him at the Factory, like foreign journalists or art dealers, he would say quite blandly, 'Check him out, see how big his cock is,' and these people would be horrified.

While explaining his 'theory of art' to Gerard, Andy envisioned himself as the headmaster of an all-male brothel. His idea, Malanga recalled, 'was that he would sit at a table with a cash register on it in a large dormitory with rows of beds without partitions between them. People would come in and have sex with a boy in a bed and then pay Andy the money on their way out.'

Robert Heidie:

> A lot of these people were into a particularly empty form of Zen Buddhism and Andy indulged in that very vapid kind of emptiness in which anything could happen. There was a sense of drift with these people, a kind of surliness and negativity. Nobody ever expressed anything directly. In a way Andy courted that very French idea of success and death that was in the air at the time.

Under their influence Andy started to change his own look. The new Warhol dressed in a muscle man's S & M black leather jacket, tight black jeans (under which he wore pantyhose), T-shirts, high-heeled boots, dark glasses and a silver wig to match his silver Factory. Sometimes he emphasized his pallor and Slavonic features with make-up, and wore nail polish. He looked clean, hard and arrogant and was now very thin. He hardly ever laughed. He rarely spoke in public and when he did it was in a new disembodied voice that sometimes sounded like Jackie Kennedy talking on television, was laced with several layers of sarcasm and contempt and tended to repeat single words over and over, like 'Marvellous'. The British social commentator Peter York wrote:

> The absolute flatness [of his voice], the affectlessness meant you couldn't see behind it at all. Drawing on druggie and toughie and gay styles, it forged an adoptive Manhattan occupational tone for the sixties. The drug voice meant: I'm so far away you can't touch me. The ethnic tough-bitch wisecracking voice said: No quarter given and none expected. The New York fag voice said: Oh, c'mon.

'If you want to know all about Andy Warhol,' Andy drawled, his

expression blank as stone, his fingers straying across his mouth, 'just look at the surface of my paintings and my films, and there I am. There's nothing behind it.'

'Warhol's hypnotized voyeuristic stare of smarmy whitened wormi-ness inspired much fascinated talk about what you find under rocks,' noted another writer. On the other hand, his followers told him he looked magnificent and that his looks improved all the time. Ondine:

> It was that kind of voluptuous vulnerable quality. He was kind of a beauty too. He wasn't good-looking but he was voluptuous, he was gorgeous, he would look up from painting and you would see the big lips and the big eyes and the big nose and the way he held his hand and think, Aaaahhhh, isn't he beautiful, isn't he exotic? And those visions of him would constantly keep you going.

The history of Warhol's face, the art critic Mary Josephson pointed out, had much to do with his reputation.

> For Warhol's mature physiognomy is directly appropriated from the stars of the forties – Dietrich, Crawford, Hayworth. There is the slightly open mouth, the lidded gaze, the blankness that encourages projection in a triumphant form of servitude. This blankness is much more than a device; it is an iconographic signature with a high symbolic content.

As Warhol's image changed and he surrounded himself with what almost looked like a bodyguard of flagrantly gay, shameless young men, many of his oldest friends began to back away from him. Charles Lisanby:

> I warned him to stay away from that kind of thing, but he was fascinated to be in a room where somebody was shooting drugs. I never got the idea from talking to Andy about it that he was doing any of this himself, but I thought it was terrible. I once accused him of just doing things for effect and of trying to be different, doing things that would disturb people because he thought different was better. He always denied this and insisted what he was doing was really what he wanted to be doing. But I said to him, 'Andy, if you hang around with these kind of people one of them's going to kill you!'

Suzi Frankfurt was also unsure of his motives.

> I hated the way he dressed, and I said so. He said, 'Ooooohhhh Suzi . . . you don't like it?' Then he'd have something worse on the next time. And he really got into having bad manners and he got tougher on the exterior. For example, I'd have a dinner party for somebody Andy liked because they were so rich. He would ask if he could bring ten people, and then they'd arrive two hours late.

Typical of the confused reaction caused by Andy's new approach was

Ruth Kligman's. She was running the Washington Square Gallery at which *Blow Job* was first screened in March 1964.

Perhaps the best example of Warhol's silent films, *Blow Job* is somewhat removed from what its title suggests. The camera remains fixed on the face of a good-looking young Shakespearean actor who is obviously being blown, and the entire point of the 33-minute film is to watch the sensitive twitchings of his face – nothing else is shown. The film is beautifully designed and has the sense of humour that was such an important part of Warhol's world and work. Suddenly the guy lights a cigarette and you snap to the fact that he has finally come.

Ruth was offended and scared by both the film and Andy's entourage.

I showed the film but I didn't like it. Even the word 'blow job' offended me. And there were all these strange people I couldn't relate to who were all on speed. And there was a kind of prurience I didn't like. He took his lack of sexuality and put it into his voyeurism, watching people. He would provoke people who I thought had no ego to get into their dark side, into their homosexuality, even if they weren't gay. He remained the master and he would make all sorts of promises to these people, like to Freddie Herko and all these pathetic souls who hung around, and I thought that was very negative.

Carl Willers held on to his affection for Andy but realized they were living in different worlds.

When he went into making films I think that was really the period in his life where he just decided to redo himself utterly, and he became a whole different person. There were a lot of people in his life who he knew before that didn't fit into that world very well. I certainly didn't and didn't want to. He was so different that it was as though he couldn't be his old self any more.

Many of Andy's friends from the fifties thought that he didn't recognize them when he bumped into them at parties or dinners. 'It was as if,' recalled George Klauber, 'he just looked right through me.'

*

In April 1964 Warhol had a fight with the architect Philip Johnson, who had commissioned him to do a mural for the American pavilion at that summer's World's Fair in New York. Andy had delivered a 20 by 20 foot black and white mural called 'The Thirteen Most Wanted Men' based on a series of mugshots of criminals. It had been installed beside works by Rauschenberg, Lichtenstein and Indiana. On 16 April, however, Johnson informed Warhol that he had twenty-four hours to replace or remove the piece since word had come from the governor that the painting might be insulting to some of his Italian constituents,

because most of the thirteen criminals were Italian. When Andy suggested he replace it with large pictures of the fair's head Robert Moses, Johnson 'forbade that because I didn't think it made any sense to thumb our noses at Mr Moses and I thought it was in very bad taste. Andy and I had a little battle at the time.' On 17 April Warhol went out to the fair with Malanga and Geldzahler and spitefully instructed his mural be 'painted over silver and that'll be my art'.

The following day the *New York Times* featured an article about how many people had been robbed at the Fair. 'It was so shocking a mural and mirror of the actual society,' Allen Ginsberg said, 'they refused it. When the searchlight of his mind came into that particular area, one could see how revolutionary the insight was.'

On 21 April 1964 Warhol's Boxes show opened at the Stable Gallery. Andy had said he wanted the gallery to look like the interior of a warehouse and Alan Groh had lined the boxes up in rows and stacked them in corners.

The opening became another rallying point for those for and against the new art. Lines of people a block long waited to get in. 'The most striking opening of that period was definitely Andy's Brillo Box show,' said Robert Indiana. 'You could barely get in, and it was like going through a maze. The rows of boxes were just wide enough to squeeze your way through.' Passage was made harder by a man who had passed out between a row of boxes and was left sleeping there.

It was one of the seminal events of the early sixties, and the Sculls immediately put in an order for a large number of the boxes. But the presentation of the boxes as sculpture confounded a lot of people, not least among them the abstract expressionist painter James Harvey who had actually designed the original Brillo box, which quickly became the most identifiable and popular of the boxes. 'When Andy's show happened,' said the reporter Irving Sandler, 'Harvey's dealer at the Graham Gallery came out with a press release saying that while Andy was selling these for $300, here this poor starving artist James Harvey had to support himself by making commercial things like Brillo boxes.' The press had a field day. Photos of Warhol and Harvey appeared in *Newsweek* with their respective products. Andy called Jim Harvey and offered to trade one of his sculptures for a signed original, but before the trade could be arranged Harvey died of cancer.

The night of the opening the public got its first view of the silver Factory. Andy had decided to have a party at the Factory and Billy had been up for several nights putting the finishing touches on the ceiling and lighting the room with white, red and green spotlights.

'Reynolds wrap is what hits you,' wrote a reporter who visited the Factory that night.

The whole place is Reynolds wrap, the ceiling, the pipes, the walls. The floor

has been painted silver. All the cabinets have been painted silver. The pay telephone on the wall is silver. The odd assortment of stools and chairs are silver. And the bathroom is silver lined and painted, including the toilet bowl and flushing mechanism.

Rock music played at top volume as the lights bouncing off the silver created a hall-of-mirrors effect. The reception was the first time the New York social and art worlds were at the Factory and it was a huge success. The look of the Factory, with Andy's paintings on the walls and Brillo boxes stacked up on the floor, was striking. 'It was like a crash,' recalled Billy Linich. 'It was really a smash.'

It also marked a turning point in Andy's career. It was the last time he would be photographed in a group with Oldenburg, Lichtenstein, Wesselmann and Rosenquist. From now on he would only appear surrounded by his own people. It marked a removal from the pop-art world in general, symbolized by a falling-out with the Sculls.

From the point of view of the socialite Marguerite Littman, who gave the party with the Sculls,

> the party was not a success. First of all, Bob Scull wanted detectives at the door to turn away people who weren't on the list, but, as Andy and I said, how can we keep out an artist bringing someone he'd had dinner with? What should have been frivolous and fun was for us a nightmare. We had every one from Senator Javits to the New York police, who dropped in. The detectives gave up. Bob Scull was furious because Ethel hadn't been photographed. Why were *Vogue* photographers just taking pictures of Gloria, Judy and Isabel? he asked. The next day Andy rang to ask if I wanted any Brillo boxes.

The Sculls had cancelled their entire order. According to Nathan Gluck, who was still labouring away on Warhol's commercial work at 1342 Lexington Avenue and witnessed their return, Andy was once again disappointed and dismayed by the rejection of his work.

Andy was in a curious position. His paintings had made him famous beyond the boundaries of the art world to the point that his name was synonymous with pop art. However, his paintings were not selling well. The death-and-disaster series had been a financial disaster and while the Brillo boxes were an artistic success – even Jasper Johns had to admire 'the dumbness of the relationship between the thought and the technology' – as Elinor Ward had feared, sales of the boxes were sparse. 'Andy was always crying about being broke,' Taylor Mead recalled. 'We were all saying, "Who can we call to get more paint or screen materials?" all the time. Andy tried hard not to invest his own money in the work.'

Andy's relationship with Elinor Ward had deteriorated rapidly and bitter arguments over money ensued. According to Emile de Antonio, 'They got into a huge argument when Andy insisted on doing the

boxes.' Andy had begun to make overtures to change his allegiance to Leo Castelli. Elinor Ward was extremely hurt by this defection and what she saw as ingratitude after all the time and money she had invested in giving Andy two shows. She attempted to influence him to stay, urging a go-between to tell Andy that he would get second-hand treatment at Castelli, saying it was a terrible gallery, was falling apart, and Leo was only taking him to nullify the competition. The etiquette of moving from one gallery to another was complex and made everybody nervous. 'Dealers were very competitive in those days,' said Alan Groh. 'I can't think of any dealers who were friendly.'

Castelli, whose gallery was far from falling apart, was glad to take him, once the delicate negotiations were completed by Billy Linich, who, as Andy's secretary, wrote to Mrs Ward saying Mr Warhol no longer wished to be affiliated with the Stable Gallery. 'Elinor, of course, was devastated,' said Alan Groh.

There was some bitterness over the disputed ownership of Warhol's 'Colored Mona Lisa' which Elinor Ward insisted he had given her and Andy insisted he had not. The matter was finally settled in court by a judge who ruled that they each owned 50 per cent. However, as Alan Groh pointed out, 'The monetary value of the early paintings was not something he took too seriously because the largest painting in the first show was only about $1,200. It wasn't a matter of major concern to anyone. He had paintings he would throw away. He'd say, "Oh, I don't want that one," and throw it out.'

Leo Castelli:

It's difficult to talk about Andy as a person because he's terribly spare in his emotional manifestations. He almost created a culture, but it was based on material that was handy, like the Beatles or the Rolling Stones, or whoever was around. The Supremes. He had a genius of putting all the things together and making a work of art of the whole climate here in New York . . .

Taylor Mead felt moving to Castelli ensured Andy's success.

Their grand plan was already in operation. They were taking over the art world with Henry's help. They were all wheeling and dealing like crazy, with the fine Italian hand of Castelli manoeuvring. They were all too cool to be struggling any more, and they were all on a power trip. It was in the cards that they were making it. There was no two ways about it.

*

At the Factory, the mole people started calling Warhol Drella – an amalgam of Dracula and Cinderella. Ondine used the nickname all the time, Malanga recalled. 'It was a homosexual campy fairy-tale thing like the Wicked Witch of the North. Andy was cast as the bad guy in the fairy tale.'

Around this time one of the mole people's witches, Dorothy Podber,

came to the Factory with her dog, Carmen Miranda, and asked Andy if she could shoot his Marilyn paintings. When he said he didn't mind, Dorothy put on a pair of white gloves and pulled a small German pistol out of her pocket, aimed at a stack of Marilyn Monroe paintings, and shot through the middle of the forehead. After she left, Andy went over to Ondine and said, 'Your friend just blew a hole through . . .'

Ondine said, 'But you just said she could.'

Andy and Ondine flipped through the stacks and saw that the bullet had passed cleanly through four Marilyns. He retitled them 'Shot Red Marilyn', 'Shot Light Blue Marilyn', 'Shot Orange Marilyn' and 'Shot Sage Blue Marilyn' – and later sold them. Ondine: 'Andy really was playing with a loaded pistol in everything he did, but every time I saw him witness real violence he was completely surprised. He didn't suspect violence on other people's parts and violence shocked him. He wasn't aware of it. He didn't have street smarts.'

ANDY WARHOL

UPTIGHT

1964–65

He was the most hated person of the time. Hated as a cold fish, a cold-blooded, calculating, power-hungry media figure.

<div align="right">RONNIE TAVEL</div>

As soon as the Factory opened, it became a hyperactive place. People began flocking there in droves for parties, to interview Andy, to take pictures, to make films, to become part of it. 'The Factory was a place where there'd be poetry readings and people would do plays there,' recalled Baby Jane Holzer. 'Andy used to let other artists do their thing there too. He really was a very generous person. He gave his time and of himself very much to other artists.'

Billy ran it like a theatre, vacuuming up after each performance and continually repainting the tinfoiling. He also became the Factory's official recorder when Andy gave him his 35-mm camera and Billy began taking great photographs of the action, which he developed in an impromptu darkroom converted from one of the toilets. These photographs, as collected in the 1968 Moderna Muséet catalogue of Warhol's first European retrospective in Stockholm, constitute the best visual document of the Silver Factory.

Now that he had a lot of people hanging around there, Andy started to make large-cast films like *Dracula* and *Couch* and the Factory became what he had always wanted, a film studio. Andy also loved filming in the houses and apartments of wealthy people, but most of these people had no idea what they were in for when they let the Warhol crew into their homes. One of the habits of the amphetamine addicts was to steal anything they could.

'We were pioneers in this,' Ondine wrote. 'Once we started lifting things there was a rash of it everywhere. The drug may have been responsible. It gave you courage and enabled you to commit crimes with relish.'

'They were like a fucking crowd of locusts,' recalled one observer. 'They just stripped everything. There wasn't a pill of any kind left in the bathroom.'

Baby Jane Holzer was constantly amazed by Warhol's ability to maintain control of his followers.

Andy was just standing there in the middle of it watching the whole thing happening. I don't think he believed at the time that it was happening anyway, but he had some sort of genius putting it all together. Andy Warhol had genius and talent which was totally misunderstood and underestimated. You never had to go through the tense part when you were on camera with Andy, because it just happened. Andy would do incredible things when I'd do a film. He'd say, 'Look at the camera and don't blink your eyes.'

The film of the unblinking Baby Jane Holzer was the prototype for Warhol's films of people sitting stock still for three minutes which he called screen tests and filmed hundreds of. 'The Warhol screen tests were studies in subtle sadism,' said Malanga. 'The camera was located relentlessly 15 feet away. The recorded results were often brutal.'

'The more destroyed you were,' said Taylor Mead, 'the more likely he was to use you.'

Throughout the spring and summer of 1964, Andy was also filming three-minute silent scenes with his Bolex for *Couch*, which owes a debt to psychoanalysis and the Hollywood casting couch, but goes far beyond their limits in its portrayal of sexual attitudes and encounters. It consisted of scenes of people having sex on the couch at the Factory. This was a natural set-up to explore the tensions between his followers. Naomi Levine was filmed writhing around naked on the couch trying to attract a young man who appeared more interested in tinkering with his motorcycle than her big breasts. Kate Heliczer was fucked in the ass by Gerard Malanga as she lay on top of the big black dancer Rufus Collins, while her husband, Piero, an underground filmmaker, ran out of the Factory and took a walk. Several scenes included sex between men.

'Andy would sit watching it with his legs crossed, wrapped up in himself like a little child,' one friend recalled. 'I thought I was in the presence of a Buddhist who had achieved the desired transcendent state.'

'Andy is often commented about as being a voyeur,' said Malanga. 'Andy's desire for power was initially realized through the voyeuristic tendency of distancing himself from what he was watching with the use of a movie camera.'

With *Couch* it began to emerge that Andy was going to denigrate the concept of heterosexual coupling as the be-all and end-all of sex and present homosexuality as a normal practice. Some people stirred uneasily, but for the time being there was no great outcry. These films were, after all, confined to a tiny, sophisticated underground audience. Henry Geldzahler:

Andy himself was never into drugs deeply, just as one might say Andy's never been into sex deeply. In both aspects he was a Catholic and I think he had a sense of evil and saw it as evil. His position was not a profoundly moral one, he surrounded himself with all kinds of things that society and the church disapproved of and perhaps finally he disapproved of. That was one of the fascinating and repelling aspects of his films and life at the Factory.

Just like any movie mogul Andy pitched everybody in competition with everybody else for his attention and a part. As soon as Billy moved into the Factory he had him in competition with Gerard, but when Billy drew up a list of people who were not allowed in and put Malanga's name on it, Andy forbid him to put it up. 'Warhol was a master,' said Ondine. 'Gerard was one edge of the coin. Billy and I were the other edge. Billy was a conservative experimental intelligent traditionalist. Gerard was a popular fad and fashion what's-going-on folk element. We were equally important. Warhol walked through both elements and used them beautifully.'

In his manipulation of people Andy was being a lot like his mother, who had kept her three sons in such constant competition for her affection that in their fifties the Warhol brothers were still each insisting that he was her favourite. Julia had a way of making Andy feel really bad about himself that he never completely got over but learned from her.

John Giorno was the first to be expelled from the Warhol world. 'It was really painful to be spit out, to feel exploited, ripped off. He could arouse one's worst feelings and one's worst fears. I totally loved Andy and at the same time blamed him.'

By the summer of 1964 Andy Warhol had become, in the eyes of Jonas Mekas, 'an orchestra conductor of extreme possibilities'. He had gathered around him a misfit filmmaking company, consisting, Mekas wrote, of some twenty 'sad, disappointed, frustrated, unfulfilled, per-verted, outcast, eccentric, egocentric Underground Stars on the brim of Waiting to be Used', for whom Andy was the Diaghilev of the under-ground. Rainer Crone:

Any description of Warhol's production would be incomplete if it did not take collective work into account. Working together makes work meaningful for the individual, and the fanaticism that determines the character of so much strictly individual production is eliminated in a positive way. So per-haps Warhol appears as a 'genius' after all – the genius of a time for a people whose insecurity makes the collective solution the only satisfactory one.

'The Factory was a place where you could let your problems show and nobody would hate you for it,' wrote Warhol. 'And if you worked your problems up into entertaining routines, people would like you

even more for being strong enough to say you were different and actually have fun with it.'

The object was not to blow your cool no matter what happened, like Andy, and if someone got wounded the others would rip them apart. Brigid Polk, overweight, high-strung and easily provoked into fits of violent rage, was one easy victim. Gerard Malanga was another.

'I don't think anybody ever had a studio like the Factory on 47th Street,' said Emile de Antonio. 'There were political people, radicals, people in the arts, disaffected millionaires, collectors, hustlers, hookers. It became a giant theatre. I said to him, "You're making a film of a film, aren't you?" He laughed.'

Andy's manipulative method was captured succinctly in the fictional character of Mel, based on Warhol, in Stephen Koch's novel *The Bachelor's Bride*:

If Mel felt uncertain about some aspect of himself, if he felt doubtful of himself intellectually, artistically, socially, sexually, any way – he was in the habit of adding to the Bunch somebody who reflected that anxiety in some way. Then he would play that person off their opposite number. And when the panic began, he'd feel strengthened, reassured. It was as though the two contending people somehow invalidated each other, and left him autonomous, free.

The heightened daily conflicts that resulted were unappealing to some long-term Warhol supporters. 'Andy became very royal,' Henry Geldzahler recalled. 'It was like Louis XIV getting up in the morning. The big question was whom will Andy pay attention to.' Emile de Antonio:

Andy was like the Marquis de Sade in the sense that his very presence acted as a kind of release for people so they could live out their fantasies, get undressed, or in some cases do very violent things to get Andy to watch them. He was able to bring that out in a lot of people doing weird things in his early films who wouldn't have done what they were doing for money or D. W. Griffiths or anybody else. He loved to see other people dying. This is what the Factory was about: Andy was the Angel of Death's Apprentice as these people went through their shabby lives with drugs and weird sex and group sex and mass sex. So Andy looked and Andy as voyeur *par excellence* was the devil, because he got bored just looking.

'The misconception is that Andy desired and strived for fame and money,' stated Malanga. 'What he really wanted to possess was power. Andy, like Hitler, created the illusion of strength by surrounding himself with people who would do his bidding.'

Deep vibrant hatreds often grew up between the people who competed for Andy's attention. He chose for his performers mostly

very young, beautiful, psychologically unstable people, and by lending them his approval, interest and support he drew from them their most intense presentation of themselves. Consequently many of these people became psychologically dependent on Andy and when they had passed their prime for his use, which usually took from three to six months, and he shifted his attention to somebody else, the deserted star would be in the position of a drug addict suddenly cut off by his supplier.

The only person on the payroll at the Factory during this period was Gerard. All the others 'worked' for free. This fact has often confused people who have tried to understand Andy's methods. Why would somebody not only work but work hard and expose themselves, often give themselves completely, like a disciple, to Andy? In exchange for what?

This is where the Factory is best understood as a school, with Andy as the headmaster. There was no question that people who worked for Andy could learn a lot from him. Artists could learn about the import- ance of hard work as opposed to theorizing. Actresses could learn about the importance of being aloof and creating a mystique. Everybody could learn about magic and serendipity.

'The Factory was a church,' wrote the critic Gary Indiana. 'The Church of the Unimaginable Penis. Andy was the father confessor, the kids were the sinners. The sanctity of the institution and its rituals was what was important, not personal salvation.'

Like most cult leaders, Warhol inspired a strangely powerful love in most of his followers. The girls wanted to marry him, the boys wanted to serve him.

Gerard and Billy, who always performed their jobs well, remained closest to him. Others came and went, often callously dismissed when they were no longer needed. The Factory had become a testing ground. 'You were either a predator or a victim,' said one newcomer. 'You were like a snake. You looked around and if something cropped up you lanced at it.' Billy Linich:

> If you were capable of dealing with these people who were destroyers, taking away your façade and insisting on seeing your true self, if you were capable of projecting yourself as a star and taking care of yourself you could come and have your place. It was a reality but it was so crucial and critical everyone was constantly in a crisis, constantly being destroyed.

*

That July, Andy gathered Jonas Mekas, Gerard Malanga, Henry Geld- zahler and another filmmaker, John Palmer, in an office on the forty- fourth floor of the Time-Life Building and filmed *Empire*, his eight-hour study of the Empire State Building at night. Andy originally intended it as a sound movie with Geldzahler, Malanga, Mekas and Palmer talking in the background, and Jonas had brought the Auricon newsreel

camera he had just used to film the Living Theater's production of *The Brig*. Gerard Malanga:

> It was John Palmer who came up with the idea for *Empire*. John, Jonas Mekas and I changed the reels for Andy. He barely touched the camera during the whole time it was being made. He wanted the machine to make the art for him.
>
> We started shooting around 6 p.m. – it was still daylight – and completed around 1 a.m. The first two reels are overexposed because Andy was exposing for night light, but it was all guesswork. What happens in the course of the first two reels, and partway through the third, is the building slowly emerges out of a twilight haze, balancing out the exposure for the darkness that slowly blankets the sky.

Andy looked through the lens, composed the shot and told Mekas to turn it on, while he encouraged Henry and John to 'say things intelligent'. Later, on seeing the rushes, he opted for the purity of silence in the movie.

Most people thought Andy was really crazy when they heard he had made a film of the Empire State Building from dusk till dawn, but Andy was excited. 'The Empire State Building is a star,' he announced. 'It's an eight-hour hard on. It's so beautiful. The lights come on and the stars come out and it sways. It's like Flash Gordon riding into space.' Gerard Malanga:

> I remember once – this happened so many different times and in varied contexts – we were attending the premiere screening of *Empire* at the Bridge cinema in New York. We were standing in the rear of the auditorium. Andy was observing the audience rather than film, and people were walking out or booing or throwing paper cups at the screen. Andy turned to me, and in his boyish voice said, 'Gee, you think they hate it . . . you think they don't like it?' *Empire* was a movie where nothing happened except how the audience reacted.

Like the death-and-disaster series, *Empire* was a work inspired by an amphetamine vision. 'Among the younger artists Andy was involved with alcohol got almost completely phased out by marijuana in 1964, and then three months later by LSD, which made alcohol seem gross,' recalled one observer. 'But while everyone else mixed speed and grass and LSD, which made everything softer and more confused, Andy didn't give up the speed for a second.'

Next he made a film called *Drunk*, starring Emile de Antonio drinking a quart of whisky.

> I liked the idea of the risk involved, but Andy lied to me that night, which was fairly disagreeable. I said, We do the film but I don't want anybody there except your people who are necessary. And then once it started I could see

people. The lights were obviously in my eyes but I saw the people. He had a lot of them there. I was very angry then. During the first reel I was moderately quiet because I was sober and I could hold a lot of liquor. Then he had a lot of trouble changing the reel. So by the time reel two began I'm on the floor and I can't get up.

At some point the next day I called him up and said, My lawyer is so and so and I want to see it before anybody else does. Then I told him, Well, it can never be shown. He had no reaction.

Andy had been making a number of overtures to Taylor Mead to keep him around, none of which had come to fruition since *Tarzan and Jane*. 'We respected him tremendously,' said Taylor.

If he was bored we would move on to something else, because in a way we considered him very delicate. He always seemed so fragile. He was like a tentative existence. I've seen him get terribly embarrassed but he really held it in. There was one time when he went red as a beet and that was just unheard of – that Miss Thing could get terribly upset! But I knew what contempt Andy and Gerard and everyone had for people who pushed, so it was up to Andy to call me. And apparently to him it was up to me to push in there and kowtow. No way, no way possible. I'll kowtow till I know you, but when I know you, it's a mutual understanding. No. Andy could always put the blame on anybody. That was his big card. 'Oh, why didn't they call? They should have called.' I wanted to say, 'Who are *you*?'

On 5 September 1964 Andy shot a seventy-minute picture called *Taylor Mead's Ass*. Shortly after that Taylor decided to move to Europe,

because I was going to kill Andy Warhol! He was manipulating people like crazy, lying to everybody too much and being too cold-blooded. It wasn't just Andy but it was New York. These phoneys would not tell you what the real number they were doing was. They'll kill you! They'll ruin you! They'll lie to you! They'll do anything for fucking success, from which I come so I'm not impressed. Andy made all these promises. He was bullshitting and making promises like crazy then. It was kill or be killed.

On 27 October 1964 Freddie Herko, who had seen his dreams destroyed and watched himself fall apart, went to a friend's apartment on Cornelia Street in Greenwich Village, put on Mozart's Coronation Mass and danced naked out of a fifth-floor window high on LSD. When Andy heard the news, he kept saying over and over again, 'Why didn't he tell me he was going to do it? Why didn't he tell me? We could have gone down there and filmed it!'

The remark, which spread like wildfire by word of mouth, confirmed many people's suspicions about how cold and callous they thought Andy had become since opening the Factory. Warhol's supporters were quick to spring to his defence. 'It was a complex statement,' said one.

'It was serious and he really meant it, but what it meant beyond that was: anyone can decide whether this is sheer objective detachment or whether there is a lot of pain in it. It was certainly expressed in a way that made people hate him, but it was beyond love and hate.'

'A lot of people thought Freddie was an asshole,' said Ondine, who thought of Herko as the Baryshnikov of their set.

> He wasn't an asshole. He prepared himself for that moment, and Warhol was there! Warhol was able to get from Herko, and Herko was able to get from Warhol, a sense of completion so that Herko could actually die as he wanted to do all of his life. The thing was that Warhol was allowing people to mirror himself in a way. So, these people who were saying that they were bouncing off Warhol, Warhol was also bouncing off them. It was a totality. I don't know how else to say it: working with Andy Warhol gave one a great sense of completion.

<p style="text-align:center">*</p>

Shortly before Freddie's death Andy had met a remarkably good-looking young man named Philip Fagan at a concert with Gerard. 'Somehow they latched on to each other,' recalled Malanga. 'Philip was being very helpful and endearing so he immediately became a helper – stretching and crating canvases, or shifting packages around.' It was quite obvious to Gerard that Andy was infatuated with Philip.

> He used to make a three-minute film portrait of Philip every day after work. It was Philip's idea but Andy liked it because it was a way of keeping Philip around. At one point Philip was actually staying at Andy's house. That was the first time I was aware that Andy might have some kind of relationship with somebody, but both of them were very discreet about it.

'Philip was definitely not selling sex,' recalled another observer,

> which would have worked out just fine there in 'celibate heaven', as I thought of the Factory. But Andy and Philip seemed to be very close, like two little girls in a way, and they baked cakes together, so Fagan had found a niche in which he didn't have to put out but could get supported and hang out. On the other hand he wan't an artist and he was monopolizing Andy's time and arousing the animosity of all these other people at the Factory. And he had a certain power over Andy at that point, telling him, I don't want these people around when I'm up here because they make me uncomfortable because they don't like me. I was absolutely sure they were not having sex because Philip was known as a bad boy. He would string you along but you ain't gonna get anything.

<p style="text-align:center">*</p>

Back in April 1964 Henry Geldzahler had gone out to the World's Fair with Andy to look at the 'Thirteen Most Wanted Men'. As they left the Factory, in a reversal of his previous suggestion Henry told Andy that he had painted enough death pictures, that it was time for some life.

Challenged by Warhol to explain what he meant, Geldzahler picked up a magazine, opened it to a centrefold of flowers and said, 'Like this.'

For his first Castelli show Warhol had recalled Geldzahler's advice and told Malanga to get some silkscreens made of a photograph of four poppies by Patricia Caulfield in *Modern Photography*.

During the summer of 1964, to the sounds of 'Baby Love' and 'Not Fade Away', Andy and Gerard made some fifty flower paintings, using silkscreens of the Caulfield photograph on a dark, jungle-green background. They ranged from four by four inches (a set of six in a box cost $30) to over nine by twelve feet.

Much has been made of the fact that the flowers were poppies, from which opium is derived. Critics would later say that Andy painted 'flowers of death'. (They are, in fact, not opium poppies.) Other critics read sexual connotations into the imagery of the flowers. Andy later told a *Newsweek* reporter that he liked the flowers because 'they look like cheap awning'.

'Everything is art,' Andy told *Newsweek*. 'You go to a museum and they say this is art and the little squares are hanging on the wall. But everything is art, and nothing is art. Because I think everything is beautiful – if it's right.

In November the flower paintings were displayed in Andy's first show at Castelli's. They sold out. At the opening, Malanga stood by the door receiving congratulations for a nice show, while Andy sat relaxed in a corner. Ivan Karp was thrilled that his four-year association with Warhol had culminated in a grand success. 'He's been called a voyeur,' Karp concluded a *Newsweek* profile about the artist. 'While the other pop artists depict common things, Andy is in a sense a victim of common things; he genuinely admires them. How can you describe him – he's like a saint. Saint Andrew.'

'The flower paintings are very beautiful,' wrote David Bourdon in the *Village Voice*. 'The artist is a mechanical Renaissance man, a genius.'

The critic Carter Ratcliff, who would become another long-term Warhol supporter, wrote:

What is incredible about the best of the flower paintings . . . is that they present a distillation of much of the strength of Warhol's art – the flash of beauty that suddenly becomes tragic under the viewer's gaze. No matter how much one wishes these flowers to remain beautiful they perish under one's gaze, as if haunted by death.

'He is the most popular of the Pop artists,' wrote the art critic Lucy Lippard.

Warhol is not by a long shot the best artist in conventional terms, but he is one of the most important artists working today by virtue of his leadership of the uncompromisingly conceptual branch of abstract art. Warhol is greatly

admired by many younger artists, even though he is also the centre of a fashionable cult whose extravagant homages inevitably arouse suspicion.

'The tragedy of Warhol rests in the deliberate absence of tragedy, in his denial of all emotions,' wrote the art critic Otto Hahn.

> It is here that Andy Warhol finds his only exaltation, in this frigidity and anonymity which kills the good and the bad which sadistically degrades the world where emotion proliferates, which kills human warmth, childhood. He needs to kill any sentiment within and without himself in order to achieve a clean, mechanical world. And when everything is sparse and emotionless, the world becomes pure . . . and the frozen universe, where Andy Warhol finds refuge to protect himself from the world, then becomes livable.

While pop art was approaching its zenith, the underground film scene was developing rapidly. 'The Lower East Side movie world here is really thrilling, like a poetry renaissance, excitement, parties, tragedies, masterpieces in lofts, etc. Best thing in NY,' wrote Allen Ginsberg in a letter to Lawrence Ferlinghetti.

In December 1964 Warhol was presented with the Sixth Annual Film Culture Award by Jonas Mekas for his contribution to the cinema. In his citation Mekas wrote:

> With his artist's intuition as his only guide, he records, almost obsessively, man's daily activities, the things he sees around him. A strange thing occurs. The world becomes transposed, intensified, electrified. We see it sharper than before . . . A new way of looking at things and the screen is given through the personal vision of Andy Warhol; in a sense, it is a cinema of happiness.

Warhol did not attend the awards ceremony, sending in his place a silent film of himself and several friends vapidly handing around a large basket of fruit which had been the official prize and staring into the camera with a bored, slightly surly, disdainful attitude. The steady hint of unspeakable practices continued to emanate from the Factory like a creepy enveloping fog.

Naturally, the other stars of the New York underground cinema were outraged by the attention the coveted award gave Warhol. An observer quoted one of them, Gregory Markoupolous, as saying:

> I don't know what's going on in this world! Here I spent ten years studying my craft, perfecting my craft, understanding, thinking, theorizing about movies and how they're made and what a movie really is, and this guy comes along who does absolutely nothing and knows absolutely nothing. Other people have to set his camera up, load it, focus it, and he just shoots nothing and he's the biggest thing going.

Stan Brakhage, awed as he had been by *Sleep*, could not tolerate what

the new Warhol films stood for and resigned from the Film-Makers' Co-op in a stinging letter to Mekas, which declared in part, 'I cannot in good conscience continue to accept the help of institutions which have come to propagate advertisements for forces which I recognize as among the most destructive in the world today: "dope", self-centred Love, unqualified Hatred, Nihilism, violence to self and society.'

Warhol next shot his first talking pictures, *Harlot* and *Screen Test #2*, both starring Jack Smith's notorious Roman Catholic transvestite Mario Montez, whose shtick was based on the favourite forties star among the camp set, Maria Montez, with scripts by the young novelist and playwright Ronald Tavel, who would later invent the Theatre of the Ridiculous. A skinny, sharp-looking young guy, Tavel had a humorous, tired, faggy voice that fit perfectly into the Factory. In a fit of jealousy Malanga had belittled Warhol's choice of Tavel as his scenarist, commenting, 'Your standards are sometimes so ridiculous,' but Tavel, who would play a major role in the Factory, understood what Warhol saw in him:

A person whose work is as much about escaping as mine and whose entire compulsion is exoticism and whose favourite actress is Maria Montez must have a very clear understanding of the here and now they want to get out of. It was this here and now that he was interested in and knew I had a very strong take on that he wanted out of me. Another thing he liked was I seemed calm, detached, didn't start screaming madly, just came in and did the job. I was objective enough to know this was a most unusual time in history. I kept pinching myself saying, Is this all real? And I knew it wasn't going to last.

Harlot dealt not with Jean Harlow but with the Harlow cult that sprang up in the midsixties. Tavel saw 'Jean Harlow as a transvestite as are Mae West and Marilyn Monroe in the sense that their feminineness is so exaggerated that it becomes a commentary on womanhood rather than the real thing.' Still using the stationary camera, Andy created a tableau by having Mario, dressed in imitation of Harlow, sit on a couch eating a banana while Carol Koshinskie sat next to him with a small dog on her lap, staring into the distance. Philip Fagan and Gerard Malanga, who based his character on a cross between Rudolph Valentino and George Raft, stood behind the couch staring at the camera. The 'script', in a last-minute improvisation, consisted of Tavel, the poet Harry Fainlight and Billy Linich talking off camera about great female movie stars.

An article called 'Saint Andy: Some notes on an artist who, for a large section of a younger generation, can do no wrong' appeared in the February 1965 issue of *Artforum*.

One most effective way to get under the skin of bourgeois America is by

threatening its sexual values . . . Warhol's activities in the film treat much more openly that mockery of prescriptive values which is only implicit in his paintings.

Art critics who cannot find the art in Warhol, who are mystified at the virtual idolatry with which he is regarded by a younger generation of painters, might have been even more astonished at the roar of approval which greeted the award given to Warhol's three-minute 'Banana Sequence' [in *Harlot*] at the recent Los Angeles Film Festival. For this was an audience of the young, disaffiliated filmmakers making movies on nickels and dimes, film buffs who do not, for the most part, tend to concern themselves with doings in the art galleries, an audience seeking not the chic but the subversive, not the elegant but the destructive, not satire but nihilism. 'Banana Sequence', with its blatant and hilarious assault on that world of what Allen Ginsberg has called the 'heterosexual dollar', met all the requirements.

In *Screen Test #2* Tavel acted as an off-camera interviewer coaching Mario into his role. 'I constantly deferred to his understanding of himself as a star and treated him as Miss Montez – star,' Tavel recalled.

The soundtrack was pretty dirty. That was another thing that shocked people, the things that were discussed. They would get up and walk out and scream and call the police. And there were like fifty people there watching us film. Among other things, this was a publicity stunt for Warhol. That's where I really started getting the reputation for sadism. What you saw on the screen was the genuine belief on Mario's part that this was all so, and his willingness to cooperate during it.

'The enormous, out-of-focus head of a sultry, attractive girl flashes on the screen,' recalled one viewer who saw the film at the Factory just after it was made.

She is brushing her hair. Then sound. The kind of sound you expect from a very old used-up army training film, garbled, filled with static. An occasional word filters through. An off-screen voice is telling the girl that if she wants to become a movie star, she must master the art of saying certain words with the right inflection. The voice starts drilling her on a word, over and over. The word was 'diarrhea'. 'Di-ah-rii-aaaa' and her lips form the syllables lovingly and obscenely, her eyes darkened under lowered lids.

Warhol's appreciation of Mario indicated how much more aware he was of what he was doing than he pretended to be. 'Actually he goes back to the days when Chaplin slipped into a female role. Or when Jack Benny put on a wig and dress to play Charley's Aunt in the movies. Mario is very, very good, and no one moves all the muscles in his face the way Mario does. He really knows what to do in front of a camera. He has an instinct for it.'

Once they were informed of the kind of activities Warhol was

overseeing, the police started going up to the Factory frequently. 'The police come up here all the time,' Warhol complained to an interviewer. 'They think we're doing terrible things, and we're not.'

As a witness at the Warhol Factory during yet another transformation, Ronnie Tavel had a writer's eyes and memory for detail and a distanced stance that enabled him to give an objective view of the proceedings.

I didn't judge him. I didn't feel anything. It was an artist. I do not remember him as somebody loved or well loved. I remember him in point of fact as the opposite, as somebody hated. He began to become a humanoid, which is what he was thought of as at the time. The whole direction of moving towards the twenty-first century as humanoids has no holes in it. But I could see how people could be frightened of it. People were also frightened of Andy because he was a media figure. I would never tell anybody he was likeable. Ondine once said to me, 'Drella, she's not good to her friends.' Andy was evil because he'd screw a lot of people, but I was objective about it. I was learning a great deal. He was turning me into a different kind of writer.

The dexies and the Obetrol made him so edgy he did tend to take them in the Factory when he got nervous. Once he went through a black period during which he did a lot of pacing. It was in between two big projects. He paced a great deal. And even when I would sit and talk with him he would sketch figures of little boys and girls floating in the air. I thought it was a sign of great tension to revert to something as sure as that. While he was talking to you he was knocking them off a mile a minute and dropping them on the floor. Then he would walk on them. I remember him also walking over the paintings on the floor during this period. It was just a normal interim between projects but in those days we all worked at such a feverish pitch that the pregnancy period between one big project and another would make everybody nervous. I saw him as cold and isolated, like a continuation in art of Beckett, and when I was a kid there was no arguing with Beckett. His was the last icy horrifying unarguable word. That was the tradition Andy belonged to – the icy classicist, unapproachable, air-tight, very negative and nihilistic. The uproar over his reaction to Herko's death was sentimental soap-opera bullshit. If you're talking about somebody who can take a position with Samuel Beckett you're talking about something much more serious than crying over somebody's death. This was art. In the days I knew him Andy was uncompromising, didn't give an inch, nor would an artist ask him to. When I worked with him, that was a true artistic period in which nobody would dare to ask you to be anything less than your best as an artist. When I knew him he was a pure artist and certainly a great artist. This was authentic hardcore steel icy art and that's all. It was not to be argued with.

If something can be referred to as in bad taste, it was Andy's next film, *Suicide*. It was his first experiment with colour. He had met this guy who tried to kill himself by slashing his wrists twenty-three times. So he said, Go and interview him and get the story, and I was to reproduce his life story and act out the roles of the people who provoked each suicide. So, on 6 March, a Saturday, this kind of high-class faggot came to the Factory and he cooperated completely, as suicides will. That's part of why they attempt

suicide. It was Andy's idea to just focus in on the wrists with all these slashes for each suicide and to have not blood but water spilled from a pitcher onto the wrists after each story. You never saw the guy's face and there was a bucket underneath to catch the water. Andy's last-minute inspiration was to get gorgeous flowers from a local florist since the hands would get kind of dull just being there. So you saw this wringing of his hands tearing apart the flowers and in the middle of it he freaked out and took the bucket and threw it in my face. I was drenched.

Andy came up and said, 'Oh, Ronnie, shall we stop? Oh, how awful.'

I said, 'No, go on, let's go on, I'm fine, the script is still legible. We'll discuss this afterwards.'

So we continued and finished it. Then the guy took out lawsuits against us and the film was never shown.

FEMME FATALE

1965

In my life, in everybody's life, that was the culmination of the 1960s. What a year! Oh, it was splendid! Everything was gold. It was just fabulous, it was complete freedom. Any time I went to the Factory, it was the right time. Any time I went home, it was right. Everybody was together. It was the end of an era, the end of the amphetamine scene. It was the last time amphetamine was really good. And we used it, we really played it.

ONDINE

In the second half of the sixties Warhol began to get more attention in the press for his personality than his art, but every time he gave an interview he threw in some reference to his major theme so that the images and the words continued to be one. A profile in the *New York Herald Tribune* describing Andy at the Factory was typical:

He is very relaxed, almost sagging. His mouth is sullen. His hand is loose as you shake it. He is skinny, and has an anemic look about him. A photographer is there and sets up a few lights and prepares a remote camera, the idea being to let Warhol press the button and take self-portraits. This appeals to Andy. 'Why, this is really marvellous,' he says. 'I mean, if a person were dying he could photograph his own death.'

'Food does not exist for me,' he told a reporter from *Vogue*. 'I like candies. I also like blood.'

Ronnie Tavel said, 'People asked why he was so famous. Every morning when we came to the Factory he would go to the phone and call his press agent and tell him everything he had done. In those days a press agent cost $30–$40 a week. People were so naïve about fame. It was engineered in a purely businesslike way.'

By the beginning of 1965, Andy's love affair with Philip Fagan was ending. Philip had moved out of Lexington Avenue and was living in a cheap hotel, but still spending a lot of time at the Factory. He was not really working there like Billy and Gerard, and was causing a lot of infighting. The people Andy worked with tended to get more attention than the ones he was merely attracted to, so Philip had suggested that Andy make a film of him. However, the film, *Screen Test #1*, had

been a complete failure because Fagan had clammed up and refused to reveal himself. 'Andy was very displeased with the film, and he was becoming annoyed with Philip,' recalled Tavel. 'Very shortly after that he said to me, "You know, I don't think Philip really understands what we're doing around here." Which really took me aback because it implied that everybody else knew and cared – which I doubted.'

Warhol had a Canadian show of electric chairs and Brillo boxes scheduled to open on 18 March 1965. When the director of Canada's National Gallery ruled that the grocery boxes were not art and were therefore subject to a 20 per cent import duty, a controversy arose. On 8 March the *New York Times* printed Andy's reaction. 'I really don't care,' he said. 'I think with some of the important things happening they must have more to worry about than some dumb little boxes.'

Andy was planning to take Philip and Gerard to Toronto for the Canadian show, but shortly before they were to depart Fagan presented him with an ultimatum. Gerard Malanga:

> I vividly remember Philip taking Andy aside one day and they were having some kind of heated discussion. Philip wanted Andy to get rid of me and take him to Toronto alone. Andy just said, 'I'm not going to do what you're telling me. It's going to have to be your decision what you want to do.' Philip's decision was that he packed up and split. He never came back, and I don't think he would ever have been allowed back, because once you walked out on Andy that was it.

Tavel remembered that

> the end of it was kind of ugly. Andy told me, 'I had to get rid of him, he stopped me working.' Then Fagan sent a telegram from a yacht in the South Seas where he was being held prisoner by some millionaires he had been stringing along and now he couldn't get out of it. Andy said, 'Good. Good for him. I'm not going to help him at all.' That was the first time I saw him react that cold.

<div align="center">*</div>

Andy's favourite film in 1964 had been *The Creation of the Humanoids*. 'In this film the survivors of World War III solve their labour shortage by creating humanoid robots,' David Bourdon wrote. 'The denouement comes when the heroine and the hero discover themselves to be machines. This is the happy ending of what Andy Warhol calls the best movie he has ever seen.'

On 22 March 1965 Andrew Sarris in the *Village Voice* reviewed Warhol and Tavel's film about the Cuban crisis, *The Life of Juanita Castro*, shot right after *Suicide*, as the only 'serious' political statement made about the Cuban revolution in American film.

'My philosophy is every day's a new day,' said Warhol.

I don't worry about art or life: I mean, the war and the bomb worry me but usually there's not much you can do about them. I've represented it in some of my films and I'm going to try and do more, like *The Life of Juanita Castro*, the point of which is, it depends on how you want to look at it. Money doesn't worry me either, though I sometimes wonder where is it? Somebody's got it all! I won't let my films be shown for free.

During the spring of 1965 Andy shot a film with Tavel every two weeks. They always tried out something new. After *Juanita Castro* they made *Horse*, a western, for which an enormous stallion was rented and brought to the Factory. The script was based on the theme of cowboy homosexuality implicit in the old West with no women and their love of horses. As Jonas Mekas described the film,

> a man sits on a black horse at the back of the set. In the foreground, four men drink milk. Then, to loud music, they perform operatic movements. The men play cards. They jump on one man (upon the instruction of a commentator), bind him to the horse and beat him up. 'Beat it, beat it,' they repeat. 'Get out of town.' Again they do the 'opera'. Credits on the soundtrack are interspersed throughout the movie. The lighting is dark, detail not visible; sound not good.

'What I really wanted to see,' Tavel recalled, 'was how easily and quickly a group under pressure could be moved to genuinely inhuman acts towards each other and perhaps the horse.'

Malanga and Tavel wrote out directions and held them up on cue cards. The first card read: 'Approach the horse sexually.' Under the influence of amyl nitrite, alcohol and marijuana, the nervous horse and Andy's silent presence behind the camera, the scene completely disintegrated in about four minutes. The horse kicked one of the actors in the head. When he didn't respond two of the other actors pounded his head against the cement floor. Gerard and Ronnie put up signs reading 'STOP! ENOUGH' but the actors were out of control and they had to rush onto the set to break up the brawl.

Although Tavel thought *Horse* turned out to be the best film he had made with Warhol, the incident scared him. He had an intuitive understanding of Warhol's mind and peculiar way of communicating his ideas, often by a single word, but he was beginning to feel increasingly uncomfortable about the way Andy was getting him to dehumanize people as fodder for his work and his superstar system.

After *Horse*, Warhol made *Vinyl*, based on Anthony Burgess's novel *A Clockwork Orange*, starring Gerard Malanga (in the role of the juvenile delinquent), Ondine, and several other regulars. Ronnie read half the book, got bored, and wrote the script in a day. None of the actors even attempted to learn their lines, apart from Malanga, but Andy kept him out most of the night before the shooting. Andy's relationship with

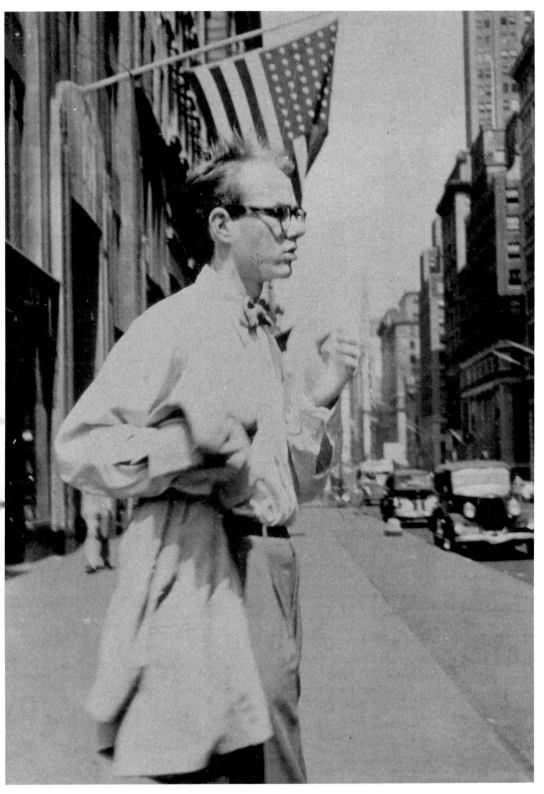

Andy in New York City, 1950. (*Arthur Elias collection*)

Andy with his first assistant, Nathan Gluck (centre). (*Photo: Edward Wallowitch. Nathan Gluck collection*)

Andy with his mother at 242 Lexington Avenue. (*Photo: Duane Michals*)

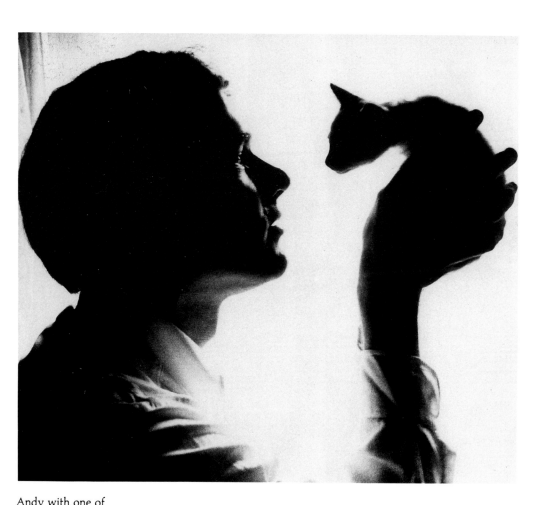

Andy with one of
his siamese cats.
(*Photo: Edward
Wallowitch. Nathan
Gluck collection*)

Andy with hands over his face. (*Photo: Duane Michals*)

Opposite: Andy lying on his side. (*All three photos by Duane Michals*)

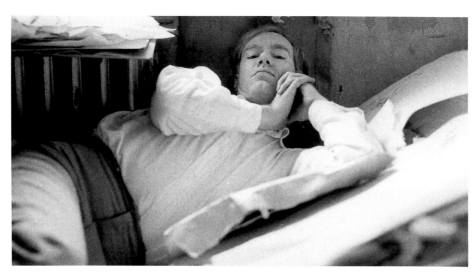

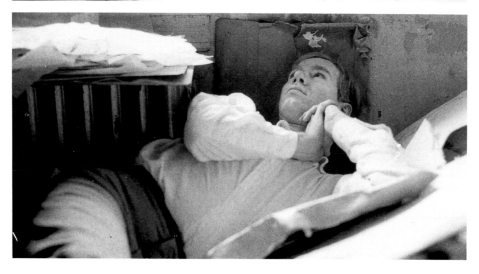

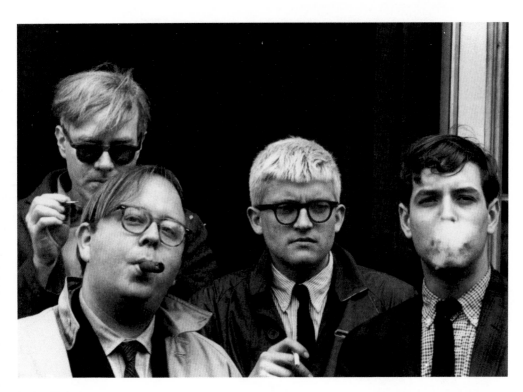

Andy Warhol,
Henry Geldzahler,
David Hockney and
Jeff Goodman.
(*Photo: Dennis
Hopper/Tony
Shafrazi Gallery*)

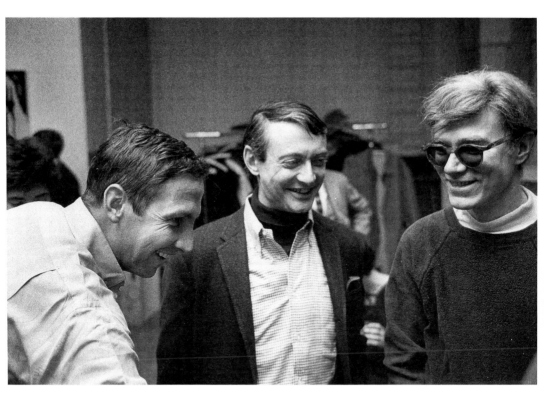

Robert Rauschenberg, Roy Lichtenstein and Andy Warhol at a New York opening 1964. (*Photo: Bob Adelman*)

Andy Warhol, Irving Blum, Billy Al Bengston, Dennis Hopper. (*Photo: Julian Wasser. Irving Blum collection*)

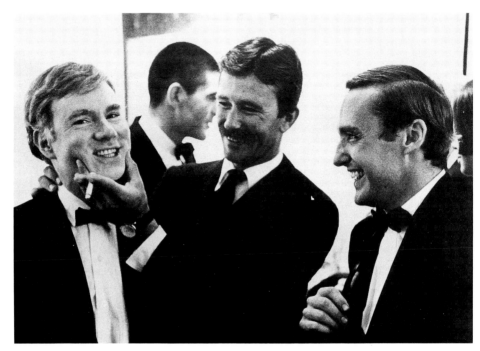

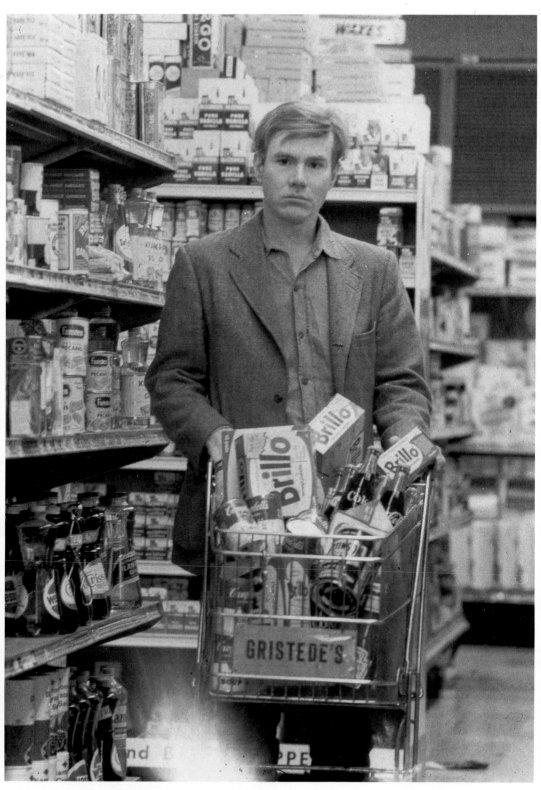

Andy with shopping cart. 1964. (*Photo: Bob Adelman*)

Gerard was going through the first of many crises that would lead to a dramatic split two years later. Gerard Malanga complained to a friend:

> Andy loses his temper a lot. About finishing a job and not doing something. But that is part of a sadistic game. It's incredible, it's a very powerful anger. Uptight for days. It's an anger that is completely passive. He doesn't say anything. He'll mention your name and say, oh, So and so, and that's it. Completely uptight.

'There was no question that he was laying into Gerard and sabotaging him,' said Tavel. 'His motivations were to prevent the film from looking like a normal movie, and to get at Gerard.' It was this sort of unorthodox tactics that made all the difference between the actors in Warhol's films and other experimental films. 'Work for no meaning,' he told them. Andy directed totally with temperaments and egos, moaning or whispering 'Marvellous' or 'Great' encouragingly behind the camera. If he almost silently laughed, his actors did more, if he looked away, they did less. His presence was everything. He detested Hollywood and its lies and was destroying plot and character. As Brigid saw it, Andy had buried painting and now he was burying film.

Filmed with most of the actors once again under the influence of poppers, pot and alcohol, *Vinyl* turned Tavel's serious script about the rage and dehumanization of sado-masochism into a farce, in which 'the monotonous and the ridiculous skitter all over the screen like the peal of a long embarrassing giggle', wrote Stephen Koch. The actors were so demented by the time they had completed their torturous tasks that most of them rushed off and had sex on the couch, on the roof, in the toilet.

The film was a great success when it was shown at Jonas Mekas's Cinémathèque on 4 June. When Malanga came out of the screening his first reaction was that the film made him look stupid.

*

What Andy conspicuously lacked at the beginning of 1965 was what he had always wanted, a female star to mould, an alter ego. Naomi Levine's temperament had limited the lengths to which he could go with her. Baby Jane Holzer looked great but she was not dependent and was too easily frightened by the boys. Andy needed a new girl.

The film producer Lester Persky promoted a young Boston Brahmin, Edith Minturn Sedgwick, for the position as early as January 1965 when he introduced her to Andy at his apartment. Andy was intrigued after taking one look at Edie because, as he said, 'I could see that she had more problems than anybody I'd ever met,' but they did not get together until March when she had begun coming by the Factory regularly with her escort Chuck Wein.

After she had had her hair cut short and dyed it silver to look like

Andy's, he put her in *Vinyl* at the last minute. She didn't say anything, just sat on a trunk in the foreground smoking cigarettes, but she had great impact in the film. Andy realized he had found somebody special, somebody he could mould into his next big thing.

Edie was a skinny 22-year-old beauty with androgynous looks, teetering on the edge of a new life. 'She was the personification of the poor little rich girl,' recalled Gerard Malanga.

> Her features, slight and symmetrical with no outstanding facial bone structure, were brightened by the vivid and penetrating eyes, full of small timidities, which recorded perhaps the shock that too great an honesty expects from life. Most of her wardrobe consisted of shirts with tails hanging out and leotards. She knew how to wear them with a style and grace unachieved by anyone else. She liked to wear large earrings. She applied a great deal of make-up before going out. When she spoke she made sense. She could not be the fool or be made to look foolish.

Another acquaintance described her as 'a schizy, modern-day Holly Golightly'.

When Andy met Edie she was in the thrall of her Harvard-grad puppet-master, confidant and nursemaid, Chuck Wein. Chuck was a sixties cosmic bullshitter with a great rap about aliens and witchcraft and he was *au courant* politically. However, there was something shady about him and his influence. As Henry Geldzahler saw it, 'He seemed to be in the process of controlling and moulding Edie, getting her involved, in the process, with deep drugs.'

'The real phenomenon of Chuck Wein and Edie Sedgwick coming to the Factory was a matter of class,' Tavel stated flatly.

> I don't think Andy was taken in by Chuck for one minute. What he liked was his blond hair and blue eyes. If he was to be seen with Edie on his right hand, then on his left hand he wanted Chuck, the little look of aristocracy, of class, which to me was silly. I thought, Andy! You're an artist, why do you care about that shit?

It soon became clear that 'that shit' was one of the things Andy did care about. Edie's family had wealth and position and she had gone to the right schools. Through her he would move up in society. According to Malanga, 'Andy believed Edie had money and so he was taken by her.'

To begin with he was right. Edie lived on Sutton Place and had a large grey Mercedes in which she started taking Andy, Gerard and the rest of the entourage to dinner, often picking up the tab (which usually ran to at least $100 a night) by signing the bill or simply paying cash. A night out on the town with Edie was life imitating art, said Gerard,

> the kind of activity you'd read about in a book by F. Scott Fitzgerald. One

would never dream it could still happen. Edie made it happen. She added something to the ambiance of every public place or private home she entered. She was an archetype.

Edie was not career-oriented at the time she met Andy. Edie was a blue blood. She had no active goals other than to enjoy herself to the fullest. She could be very easily moulded. She had the one ingredient essential to be a star – glamour. Glamour is aura. The person who possesses aura becomes beautiful. Andy was deeply fascinated with glamour on this level. He had an eye for it.

Andy saw her as the girl in his mirror. Like him, she craved love but, because of a love-hate relationship with her father and the recent suicides of her two brothers, she was unable to feel anything and acted as if she didn't care about anybody. Apart from her car, fur coats, credit cards, her husky little girl's voice that always sounded as if she had just stopped crying, and her huge eyes somebody described as being the colour of twice-frozen Hershey bars, Edie had, as Warhol wrote, 'a poignantly vacant, vulnerable quality that made her a reflection of everybody's private fantasies. Edie could be anything you wanted her to be . . . She was a wonderful, beautiful blank.'

'Vulnerability exuded from every pore of her skin,' noted another new friend of Andy's, Isabelle Collin-Dufresne, who would become Warhol's superstar Ultra Violet. 'Like a precocious preppie puppet, she rocked and rolled unconsciously to the sound of a radio station inside her head. She was always high. Andy liked high people.'

Andy started making films starring Edie right away. The first was *Poor Little Rich Girl*. He started working without scripts, explaining, 'I only wanted to find great people and let them talk about themselves and talk about what they usually liked to talk about and I'd film them.' If Edie had needed a script, he said, she wouldn't have been right for the part.

For seventy minutes she lay on her bed, talked on the phone and walked around her room, showing off her clothes and describing how she had spent her entire inheritance in six months. Gerard Malanga:

We shot two reels. When they came back from the lab, we previewed them and, to our horror, found them to be extremely out of focus – not even close to salvagaeble. After replacing the lens, we reshot the two long takes a week later and got it right. We took the first reel, from the first version, and sequenced it with the second reel, from the second version, so the film opens with an out-of-focus 35-minute take. That takes a lot of guts.

Poor Little Rich Girl quickly earned Edie a reputation as a new underground star to be taken into account when it was released at the Cinemathèque.

At the beginning of her relationship with Andy, Edie seemed to be

in good shape and happy, at least when she was around him, and Andy's appreciation of her seemed obvious. According to her roommate Genevieve Charbin, most of the day was taken up talking to Andy on the phone. 'Andy was a real blabbermouth on the phone. He told her every little thing he did from the second he woke up. He would compose exercises with Edie. Andy did one hundred pull-ups every morning – which does not surprise me because he had an incredibly strong back.' Almost every evening Edie went out with him or worked on a film.

'Andy couldn't have been nicer,' noted one Factory observer. 'He never asked her to say bad words. He never asked her to take her clothes off, or have sex, or do anything. He just said, "Now the camera's on, talk. You're great. Just be great." Most of the time it wasn't very good and he didn't care. He didn't criticize her. He gave her an identity.'

Edie's sudden rise to star status at the Factory delighted the gay boys there because Edie was the perfect fag hag. Gorgeous, campy, always up and ready to go, always fun, she basically despised and laughed at straight men. But her arrival was noted with chagrin by the other women. The tired and spooked Baby Jane beat it, blaming the faggots and their laughing gas, and the temperamental, demanding Naomi freaked out, screaming at Andy that everything was his fault, and had to be hauled out onto the stairwell by Billy Linich, slapped in the face and told to get the fuck out.

Andy and Edie quickly became the royal couple of the underground, the coolest, prettiest characters on the New York scene.

'They were both these pale, frail, glamorous people,' Henry Geldzahler explained years later to Edie's biographer Jean Stein, 'but Andy had always felt himself to be unattractive and to be with Edie was to be Edie for a season. He loved running around with her appearing in public. She was one of his ego images. And Edie thought she was Andy's. She felt possessed.'

That spring Edie became Andy's number-one superstar. When they attended the opening of Three Centuries of American Painting hosted by Lady Bird Johnson at the Metropolitan Museum of Art in April, the pop couple were photographed for the society columns with the first lady. And though the New York Times gossip columnist noted that there was something 'seamy' about Andy Warhol in paint-spattered work pants, a dinner jacket and dark glasses, with Edie Sedgwick, a fragile creature with cropped, silver-rinsed hair, on his arm, Edie's presence made Andy a more glamorous celebrity. 'Success is expressing yourself,' he told Leo Lerman in Vogue. 'It's participation-liberation.'

When he stood next to Edie Andy finally felt beautiful. There are many photographs of Andy and Edie together in which the same look-alike transference is obvious as in the photographs with Margie Girman taken when he was six.

'Andy enjoyed acting, being other than himself,' the artist James Rosenquist pointed out. 'He wanted the escape of being in another life.' He lusted after people, another friend observed, lifting enormous chunks of other people's personalities and making them his own. He was like a high-powered executive who didn't show his feelings but was seething inside. What Andy was selling, unlike traditional painters, was not art so much as milieu. The atmosphere around him was very potent and self-contained, and everyone close to Andy represented a different side of him. In most women Andy looked for mothers. In Edie he found himself.

'Andy Warhol would like to have been a charming, well-born debutante from Boston like Edie Sedgwick,' stated Truman Capote. According to Andy's nephew James Warhola, Andy was soon prancing around the house wearing black tights and a T-shirt or long-tailed striped shirt, just like Edie.

*

Andy's flower paintings were to open in Paris in May 1965. When Ileana Sonnabend offered to pay his round-trip fare to France by sea, Andy asked her to spend the money on four plane tickets instead. He was going to Europe for the first time since he had become famous and he wanted to make as much impact as possible. He decided to take Gerard, Edie and Chuck Wein. The foursome arrived in Paris in the early morning of 30 April.

Warhol's first visit to France was perfectly timed. Pop art had become a respected Franglais term in record time, noted the American writer John Ashbery: 'Reporters were always asking Brigitte Bardot and Jeanne Moreau what they thought of it; it was the theme of a strip-tease at the Crazy Horse Saloon, and there was even a pop-art dress shop in the Rue du Bac called Poppard.'

The Warhol opening at the Sonnabend Gallery broke all attendance records. The French critics glorified his work. Another American writer, Peter Schjeldahl, vividly recalled seeing the show:

> It was as if, in a dark, grey atmosphere, someone had kicked open the door of a blast furnace. The beauty, raciness and cruelty of those pictures seemed to answer a question so big I could never have hoped to ask it: something about being, as Rimbaud had declared one must be, 'absolutely modern'. The future breathed from the walls like raw ozone.

Andy went to night clubs, gave interviews, and posed with Edie for *Paris-Match* and *Vogue* photographs in which they came off like another fashionable couple, the film director Godard and his first star Jean Seberg. He thought the French were terrific because they didn't care about anything and he loved Paris because 'everything is beautiful and the food is yummy'. In fact, he was having 'so much fun in Paris' that

he decided to make a bold gesture. He told the French press that he was retiring from painting to make films.

This was not a pose but a carefully planned strategy. Andy's prices were climbing steadily but they were still low. A flower painting sold for around $2,000, depending on its size. And Andy felt the pop-art explosion was spent. Meanwhile the arrival of Edie encouraged him to try to make it big as a film director. His plan was to stop painting, make films and then go back to painting, by which time he felt sure the prices would have increased a lot.

Gerard noted in his diary that Andy was letting himself be too easily influenced by Edie and being very silly because he had started taking Seconal to go to sleep. One morning Gerard left a snappy note in their luxurious room where they were sharing one very wide bed:

> I'm not scheduling myself for a pill head. I took $6 because I had no money and I wasn't going to stay in the hotel till you decided to wake. There's no reason in the world why *you* have to take sleeping pills. This only proves my theory that you are a very impressionable person. If someone told you to jump in fire you probably would.

On many levels Andy must have enjoyed this. Gerard's position as Andy's prime minister was being threatened by the Sedgwick–Wein team. Andy was happily manipulating them against one another for his attention and Gerard's diary was full of complaints. He couldn't wait to get back to New York.

From Paris, Andy and his entourage flew to London, where they visited the art dealer Robert Fraser, went to a poetry reading by Allen Ginsberg, and were photographed by David Bailey and Michael Cooper in a series of pictures that perfectly caught their presence. They looked more like a superhip rock group than an artist and his assistants. This sort of imagery contributed to Andy's attraction for his growing young audience, who were often more impressed by his image than his work. In the States, for example, he already had five fan clubs.

From London they flew to Madrid, then travelled on to Tangiers, where Andy took his first vacation since 1956, staying for a week at the luxurious Minza Hotel. He thought the city smelled too much of piss and shit but everybody else was happy because of all the drugs. Andy was, he later recalled, particularly happy because he thought that with all the publicity he had received in Paris, Picasso (Andy's favourite artist because he was so prolific) must have heard of him by then.

In fact, according to Paul Warhola, shortly after this Andy did receive a note from Picasso saying how much he liked his work.

They spent their days having lunch by the pool and walking around the city walls while Andy dreamed up the movies he was going to make with Edie. Everything went smoothly until they boarded the

plane for the return flight. Then, as the plane sat on the tarmac, Chuck Wein yelled, 'I'll be right back!' and bolted from his seat, leaving an extremely pissed-off Edie unattended during the long flight.

In New York, Edie passed through customs without incident, but Andy and Gerard, whose long hair and clothing made them obvious targets, were taken to separate rooms to be strip searched by customs agents. As he walked off, Gerard saw Andy surreptitiously drop a stream of pills on the floor. Apparently he was either not sticking to Obetrol or his prescription had run out and he had got extra speed illegally.

A limousine took them from the airport straight to a double bill of *A Hard Day's Night* and *Goldfinger* in the Village. As he watched the pop movies unspool, with Edie at his side and his car waiting to take him to a party at Sybil Burton's disco Arthur, Andy must have felt momentarily more than content with the movie of his own life.

*

The next day Warhol astonished Ronnie Tavel with his directness. He was going to make Edie the queen of the Factory, he said, and he wanted a script for her. 'Something in a kitchen. White and clean and plastic.'

'Do you want a plot?' the writer asked.

'I want a situation,' he said.

'Yes,' said Tavel. 'I know what you want.'

A soundman, Buddy Wirtschafter, offered his pristine white studio apartment, and the film *Kitchen*, starring Edie with René Ricard and Roger Trudeau, was shot there in June. Three people sit and move around a table in a small kitchen talking about many different things. The soundtrack is largely inaudible. At the end of the film Edie is killed for no apparent reason. Andy said the film was 'illogical, without motivation or character, and completely ridiculous. Very much like real life.'

Kitchen got a lot of critical reaction. 'It was a horror to watch,' wrote Norman Mailer, who told a reporter he thought Warhol was the most perceptive man in America. 'One hundred years from now they will look at *Kitchen* and see the essence of every boring, dead day one's ever had in a city and say Yes, that's why the horror came down. *Kitchen* shows that better than any other work of that time.' Mailer would be influenced by Warhol's films when he made his own in 1967 and 1968. He was most impressed by their chaos but, not having been on a Warhol film set, did not seem to understand how Andy worked.

'Being with Andy and Edie was like running with a teenage gang,' remembered the writer Bob Heidie, who had known Andy when he was with Ed Wallowitch and now started hanging around with him again. Genevieve, Chuck or sometimes Ondine would deliver Edie to the Factory late in the afternoon, and, if there wasn't a film to be shot,

the evenings would be spent making the social rounds. For Andy these evenings were as much a part of his work as painting or giving interviews. He always took several people with him wherever he went and used the occasions to make contacts and discuss projects.

Robert Heidie:

Edie was not only very beautiful but there was a lot of sensitivity. She had a kind of Judy Garland quality with the legs, the deep penetrating childlike eyes, vaporous skin, people would stop and stare. It wasn't the real bad drug period, although she was taking drugs like everybody else. I remember one party at the Factory that summer: everybody was there, like Tennessee Williams, Nureyev, Judy Garland, and Edie was very high up on a rafter doing the twist for the longest period of time, alone. She often talked about trying to get close to Andy. She had some kind of fascination that bordered on sister-brother incest crush, but she was always frustrated that she never could get close to him on some emotional level.

After seeing *Kitchen*, Chuck Wein recognized what a powerful combination Tavel and Sedgwick were and decided to take Tavel's position for himself.

Maintaining a state of uncertainty and flux kept the wheels turning at the Factory. Andy let Ronnie and Chuck work it out. Ronnie Tavel:

I wasn't bothered that Chuck Wein insinuated himself, because I was starting to run out of ideas and I couldn't keep up that pace. And I felt uncomfortable being with Warhol so much because he was so nonverbal. I didn't understand his whole groupie thing, but I felt constantly under pressure when I was with him, particularly when we were alone, so it was all to my benefit that he could have this high-class trash to amuse himself with. What hurt, of course, was his attitude that you could just be shuffled to the side.

When Andy filmed *Beauty #2* in the bedroom of Edie's new apartment on East 63rd Street in July 1965, Chuck Wein was credited as writer and assistant director.

Beauty #2 was the core of Warhol's relationship with Edie Sedgwick. She sat on her bed in her underwear drinking vodka with a hunk in jockey shorts called Gino. He was her Beauty #2. Beauty #1, Chuck, sat several feet away, just off camera, and interrogated her. Edie came off as a shifty Hayley Mills until Wein's questions began to stab down into the nether regions of her psyche. Andy directed by the slightest body language, small sounds, moans, sighs, slight gasps, a tiny dry laugh. As Chuck took Edie apart, Andy's camera recorded her twisting and turning in its grip. Gino tried to make love to her half-heartedly, although halfway through it became obvious that he was not as interested as she seemed to want to be. By the end of the film Edie was reduced to the victim she always saw herself as.

It was a stunning piece of work and perfectly executed. The image

of Edie flickering with softness shot through the hardness of the Silver Factory in high-contrast black and white revealed the soul of Andy Warhol. By being aware of the death of Edie's every little moment, he completed her just as he had completed Freddie Herko.

Beauty #2 was released at the Cinémathèque on 17 July billed as an 'untraditional triangle (without love)'. Critics compared Edie's screen presence to Marilyn Monroe's – she was vulnerable, delicate, dynamite. As one reviewer wrote, 'She knew how to eat up a camera alive.'

'The films would have an instant audience,' said Malanga.

> Reviews would appear in the press; and Edie's career was launched, so to speak, but she wasn't getting paid. She thought Andy was making money with the films, because of all the hoopla, but he wasn't. The sales of his paintings were supporting a highly speculative venture into filmmaking. If anything, the films were a drain on him financially. Nevertheless, Edie wanted to get paid, but Andy never indicated that any payment, however small, would be forthcoming, except to say to her every so often, 'Be patient.' Andy assumed, wrongly perhaps, that if he started paying everyone for whatever the work involved, the end result would be of a lesser quality.

Edie became the envy of every hip girl in town. 'She was acting out the repression of her mother's generation by blasting out each day constantly,' said her sister. 'In a way, she was a metaphor for the young of that time who were not political.'

Andy's ambitions grew concomitantly. He told journalists that Edie could 'change the way movies looked' and that he wanted Edie to play him, 'because she does everything better than I do.'

*

After the success of *Kitchen* and *Beauty #2* Andy was at the height of his collaboration with Edie. She was, he thought, his ticket to the big time. They started thinking about how to make a hit film with her, maybe by stringing several of the shorter films together. Then, when Jonas Mekas offered Andy a week at the Cinémathèque to do anything he wanted, Andy suggested they do an Edie Sedgwick retrospective. Everyone thought that was a fabulous idea.

However, serious problems, brought on by the complex circumstances they were working under, were about to disrupt Andy's summer's work.

Although Edie was a star and people were beginning to copy the way she dressed and acted, Warhol was cast in the role of the destructive Svengali, best summed up by Tavel's view of what was going on. 'I didn't like his exploitation of human flesh,' recalled the scriptwriter, who was becoming increasingly reluctant to work with Warhol.

> It seemed immoral, ultimately, I could not come to terms with it, ethically. I don't think Warhol cared. And it was bringing out the worst in me because

who debases himself more than the person who debases someone else? I also felt part and parcel of a system that was doing something as insane as thinking of people as superstars. It was so American. What could be more American than dehumanization? And that was part of Warhol's message.

As soon as *Beauty #2* made Edie the certified queen of the New York underground, a lot of people around her started to give her conflicting advice, the sum of which was, 'Get away from Andy Warhol. He's just using you. You don't need him. He doesn't even pay you. You could go to Hollywood!' Foremost among them was Bob Dylan's right-hand man Bobby Neuwirth, who began to draw her into the Dylan enclave in Woodstock, where Dylan's manager Albert Grossman dangled offers of recording contracts and starring roles in films with Dylan on the condition she left 'that madman Warhol'.

Bob Neuwirth was one of the few men in her life with whom Edie had a satisfying sexual relationship. But there was a tug of war between the Warhol and Dylan entourages, who represented the two poles of the New York underground, the one homosexual, mostly into amphetamine, the other heterosexual, mostly into acid, amphetamine, heroin and pot. The two camps despised each other. At the Factory Dylan was known as 'the creep'.

Being twenty-two and extremely messed up anyway, Edie was confused. 'Part of the reason this whole Warhol thing worked in the sixties and was so fabulous was because of her.' said Ondine, who worked for a time as her French maid.

She was essential. But she was on drugs. She was a nonstop drug addict period. And Andy didn't force her to take drugs. That's such a crock of shit. She was on drugs long before I ever met her. She had pharmacists. One of my duties as her French maid was to go to the pharmacist and get her uppers and downers and betweeners or whatever and throw them in her face. When I got there she'd ask me if I had any amphetamine. I'd give her some and she'd be fine. She'd sniff the amphetamine or put it in her coffee. That would start her to come alive. She'd begin to talk. She would open the I Ching. We loved the I Ching. It was very serious about rulers and being truthful to the Prince. At that point, we thought Warhol was the Prince.

Other people were telling her that she should concern herself with being a very famous star – putting it in her mind that she was the greatest thing since Greta Garbo or Marilyn Monroe – she owed it to herself to be that famous. She didn't know what to do. She began getting qualms. She told me I was her guru at one point, and I said, 'I refuse the challenge. I'll be nobody's guru, darling.'

Others saw a pronounced change. Henry Geldzahler:

I went to her apartment, which I thought very grim, a couple of times. It was dark and the talk was always about how hung over she was, or how

high she was yesterday, or how high she would be tomorrow. She was very nervous, very fragile, very thin, very hysterical. You could hear her screaming, even though she wasn't screaming – this sort of supersonic whistling.

Having tasted the adoration of stardom Edie had become ambitious and the constant prodding from Dylan's entourage, along with her developing reliance on Bobby Neuwirth, soon led her to start spending more and more time with them and seriously consider switching her allegiance. 'She should have gone out of her way to be thankful to Andy,' stated one Factory regular indignantly. Edie used to come across Dylan at the discotheque Arthur. 'Andy would go there every night, if they let him in. Sometimes they wouldn't let him in, but with Edie they let him in probably, and then that creep would be there.'

In late July, just before Dylan released 'Like a Rolling Stone', which contained some acid comments about the Warhol–Sedgwick relationship (Andy is Napoleon in rags), the two contenders for the underground throne met for the first time when Dylan went to the Factory to sit for a Warhol screen test. Andy took his usual refuge in the humble position of the fan, chewing his fingernails and squealing, 'He's here! He's here!' when Dylan, foreshadowed like a presidential candidate by his advance men and accompanied by bodyguards and a film crew, swept in, in the opinion of several onlookers high on amphetamine and blotter acid. He was jiving with the Factory's poet Gerard Malanga and bouncing off the walls and there was an immediate standoff between the two opposing entourages. The hardcore amphetamine heads like Billy and Ondine wanted nothing whatsoever to do with Bob Dylan, while Dylan's people looked at the gays with cold contempt. As for Bob and Andy, it was, one observer noted, as if 'two incredible people users had come together to see who could take a bigger chunk out of whom'.

'They were like oil and water,' said Gerard. 'There was just bad friction. Dylan immediately hated Andy and Andy thought Dylan was corny.' Visibly annoyed, Dylan sat still and silent for the screen-test filming and even went so far as to share the ritual toke on a marijuana cigarette on camera with Warhol and Malanga. However, as Bob Heidie recalled the visit, 'after being filmed Dylan said, "I think I'll just take this for payment," and walked off with an Elvis painting. Andy didn't say a word, but his face could have fallen through the floor.' Shortly thereafter Warhol got paranoid when he heard Dylan was using the painting as a dart board and then traded it for a couch. 'When I'd ask, "Why would he do that?" ' Warhol wrote, 'I'd invariably get hearsay answers like, "I hear he feels you destroyed Edie." He blamed me for Edie's drugs.' Andy's anger was partially understandable since manipulative drug use was, if possible, even more pervasive among Dylan's

followers than Warhol's and it was in Woodstock, not at the Factory, that Edie got addicted to heroin.

By August problems overwhelmed Andy's association with Edie. She was, he realized, a compulsive liar and a bulimic who made herself vomit after eating. She never took a bath unless he made her, and she was heavily dependent on amphetamine and barbiturates. Andy Warhol:

> One night when the parties were over, I guess she didn't want to sleep with somebody, so she asked me to share a room with her. She always had to have her glass of hot milk and a cigarette in one hand. In her sleep her hands kept crawling; they couldn't sleep. I couldn't keep my eyes off them. She kept scratching with them. She just had nightmares. It was really sad.

In the middle of a long, scatological conversation about 'the different levels of the New York hell' Warhol tape-recorded that month, Edie wailed, 'Why do I keep hanging on about Drella? I'm probably wasting my whole life.'

Ondine replied, 'You will, but you shouldn't.'

After they dropped her off at her apartment that night Ondine told Andy, 'I really don't think Edie should take any more Nembutals. She can make an accident so easily.'

'She can?' Andy asked. 'What kind?'

'She can accidentally take an overdose with them and not know about it,' replied Ondine.

'No,' Andy said, 'she doesn't sleep, she just has nightmares; she can't get herself to sleep.'

'I didn't think of myself as evil,' he wrote, 'just realistic.'

'Warhol really fucked up a great many young people's lives,' Sedgwick later said. 'I was a good target for the scene. I bloomed into a healthy young drug addict.'

One night Edie asked Andy to meet her at the Russian Tea Room, where she finally confronted him. 'Everybody in New York is laughing at me,' she said. 'I'm too embarrassed to even leave my apartment. These movies are making a complete fool out of me! Everybody knows I just stand around in them doing nothing and you film it and what kind of talent is that? Try to imagine how I feel!' She added that she was broke and if he didn't pay her some money she would refuse to sign a release and he could not show any of the films again.

'But don't you understand,' he told her, 'these movies are art! If you wait another year or two a Hollywood person might put you in a real movie. You just have to be patient.'

'Then she attacked the idea of the Edie Retrospective specifically,' Warhol wrote, 'saying that it was just another way for us to make a fool of her. By now I was getting red in the face; she was making me

230

so upset I could hardly talk. Around midnight I was so crazy from all the dumb arguing I walked out.'

They patched it up later, but things were never the same. 'The fact that Edie couldn't understand that Warhol was her benefactor, the fact that she mistrusted him, by putting him down, was something which I don't think he got over,' said Ondine. 'He was really hurt. From that point on he got disappointed in women.'

*

As Edie lost her footing at the Factory, Chuck Wein made his move. 'Chuck was sly and slippery in his own way,' Malanga recalled. 'He realized Edie was being drawn in by the Bob Dylan group and he was losing his grip on her.' In late August 1965, Wein came up with an idea for a film about an old queen who rents a boy from Dial-a-Hustler, then has to protect his 'property' from his friends.

Andy loved this idea. He decided to shoot it in a beach house on Fire Island starring the hilarious Cambridge raconteur Ed Hood, a kind of thinking man's Taylor Mead, and a new addition at the Factory, a weirdly charismatic hunk everybody wanted to seduce named Paul America, who looked like an athletic Troy Donahue, and – just to make sure Edie got the point – Genevieve Charbin was the female lead.

At the beginning of September, without saying a word to Edie, Andy took his cast and crew, including among others Gerard, Chuck and a thin hyperactive young man with a high-pitched voice and a fast mouth called Paul Morrissey, to Fire Island. Gerard, who thought Paul looked like a cross between a New England whaling captain and Bob Dylan, had introduced him to Andy as a possible technical assistant.

Andy was so paranoid about somebody putting something in his food that he had brought his own private supply of candy bars and planned to exist on them and tap water throughout the weekend.

Andy began shooting the movie the night they arrived, with Chuck 'directing' – setting up the scene – and Morrissey on sound. When Andy insisted that the still camera was his contribution to the cinema and he did not want to move it, Chuck Wein took Morrissey aside and explained that this was his movie, his idea and his script (although there was no script) and he wanted Paul and Gerard to help him shoot the movie without Andy. 'It was a mutiny of sorts,' Morrissey recalled. 'and I said, "I'm not going to do that to Andy." ' Wein further alienated himself from Morrissey, who detested drugs, when he spiked the orange juice with LSD.

For the rest of his life Andy adamantly denied that he got dosed that night. However, Gerard maintained that Andy was quite obviously stoned when he found him picking thoughtfully through the garbage in the kitchen at 6 a.m. When Gerard asked, 'What are you doing?' Andy replied whimsically, 'Oh, I'm just looking for something.' Chuck left the next day and returned to New York.

Andy planned to shoot on the beach that afternoon, still set on using the still camera. It would be trained on Paul America lying on the beach while the voices of Ed Hood, John McDermott and Genevieve Charbin talked about him from the sun deck. Morrissey pointed out that it seemed a pity that Ed Hood, who was extremely funny to watch as well as hear, would consequently not be visible in the film. 'I never move the camera,' Andy insisted, slightly annoyed. 'I don't like to pan.' Finally Paul managed to persuade him to shoot the reel twice. The first time the camera would remain on Paul, the second time it would pan back and forth.

When *My Hustler* was screened the following month it was shown with the long pan across the sand from the beach to the house and it was sharp and funny and in focus. It was also the first Warhol film in which the sound was audible, thanks to Morrissey, and it drew a large audience and good reviews. '*My Hustler* had, despite an essentially frivolous air, a real dramatic form, and a hellish dramatic compactness,' the film critic Neal Weaver wrote.

The ugly face of rapacious sensuality was delineated with a fierce economy almost Balzacian. And the second half of the film, a long scene in a tiny bathroom, largely between the two hustlers, was rather remarkable in itself. For an unrehearsed scene, filmed in a single long take, it achieved an inordinate degree of psychological subtlety, and a good deal of dramatic tension.

Morrissey's arrival at the Factory was one of the fortuitous accidents that dominated Andy's career. He liked Warhol's films, although he had little interest in the silent epics, but thought the art world was pretentious and boring. In his opinion the only artists in America were working in film. Paul Morrissey:

Andy wasn't doing experimental photography, he was experimenting with people. From the very beginning I could see what he was doing was very interesting because it left the camera on human beings who were characters, and the basic ingredient of all dramatic fiction is character. It was very simple. Andy wanted films that weren't directed. I was able to provide the framework in which a film that was basically undirected had some direction.

Andy just said, 'Come to the Factory every day.' Andy himself was not a very exciting person. He was very quiet. But it was fun to go there because people like Brigid Polk and Ondine would come around, and in those days they were considered not well behaved. In those days they were genuinely outsiders. They'd come around a lot and just talk and they were extremely funny. Andy was there to hold open house.

Edie's exclusion from *My Hustler* was a double let-down for her by Chuck and Andy. She was angry and hurt and complained. Gerard 'thought something very cruel went down. That was a real violation on

Chuck's part, because they were very close.' Andy never said anything. He let paranoia and guilt do the talking for him. Word got back to Edie that people at the Factory were annoyed with her, that she was screwing up Andy's work, and she went out of control into a tailspin that was as swift as her rise.

Shortly after Andy came back from Fire Island he took her to the New York Film Festival on 13 September. 'Clip-coiffed Edie Sedgwick upstaged the *Vampires* on screen at the Lincoln Center film festival last night as she swept in on the arm of pop artist Andy Warhol,' noted *New York World Telegram*. 'Edie's outfit included her usual black leotard plus a trailing black ostrich-plumed cape like a camp version of Mme Dracula.'

Ironically, just as they were breaking up they received the most publicity as a pop couple. The high point came on 8 October, when they attended the opening of Andy's first American retrospective at the Institute of Contemporary Art in Philadelphia.

The show's curator, Sam Green, had painted the floors of the ICA silver, put loud rock music on in the background, and tried to turn the ambiance into something like the Factory's with remarkable success, but he was unprepared for the mob scene that followed. The space, which would normally have held 700 people, was jammed with a crowd of 2000, most of them students. When the Warhol limousine arrived outside the ICA, pent-up pandemonium reigned inside. When Andy, Edie, Chuck and Gerard walked into the room, there was an explosion of people. Two students were pushed through windows in the back room and taken to a hospital across the street with multiple cuts. Dressed from head to foot in black, wearing eight safety pins on the collar of his turtleneck sweater and a pair of wrap-around sunglasses, Andy was engulfed in waves of ecstatic young fans.

'It was,' said Leo Castelli, 'just a howling . . . like the Beatles.' Sam Green:

At that point I became concerned about the safety of all of us. I looked at Andy and he'd turned white with fear. It wasn't anger that the crowd was expressing, it was hero worship, but they wanted to touch him. It was as if Mick Jagger had been stuck on the subway and discovered by sixteen teenage girls. He was pinned against the wall. I think it was the moment that Andy knew he was a star.

The campus security police had to escort the Warhol entourage up some stairs to the safety of a small balcony overlooking the room. While the students stood below and chanted, 'We want Andy and Edie! We want Andy and Edie!', Sedgwick seized the moment to address the crowd through a microphone. 'Oh, I'm so glad you all came tonight, and aren't we all having a wonderful time?' she cried. 'And isn't Andy Warhol the most wonderful artist?'

Andy watched the proceedings 'in awe', Malanga recalled. 'He kept saying, "Look how exciting this all is." He was certainly having a lot of fun.'

Other members of the group were not so relaxed. 'It was the peak of media insanity about pop art and I thought it was quite dangerous,' remembered Henry Geldzahler, who joined Warhol on the balcony. 'My attitude was, "Let's get out of here." '

From the protected balcony they had to be taken up through a hole cut in the ceiling on to the roof and down a fire escape to the street, where they were rescued from the overenthusiastic mob by police cars. The event made the local television news for several days and added to Andy's reputation in New York, where the story of his being mobbed by screaming teenagers grew out of proportion. As Warhol commented in his memoir of the period, 'Now things were getting really interesting.'

David Bourdon:

Andy loved nothing better than being asked for his autograph. From that year on it was often difficult to be with him in a public situation. Strangers in restaurants interrupted dinner to obtain his signature on a scrap of paper, apologetically explaining that they were doing so on behalf of a child who was not with them at the moment. If we were shopping in Bloomingdale's, I'd overhear individuals stage-whispering to their companions, 'Look, over there, it's Andy Warhol,' evoking the disdainful response, 'Oh, I see him everywhere!'

Andy and Edie had become icons of their time. That Halloween, Roy Lichtenstein and his wife even went to a party dressed as Andy and Edie, because, Lichtenstein said, 'he was his art and Edie was part of his art'. But the changes in Edie were obvious in Philadelphia. Her eyes looked like hollow black sockets. She had started wearing long-sleeved, floor-length dresses to hide the scratches on her arms and legs, and to mask her face she made herself up like a death's-head. Increasingly, in public, she seemed more like Andy's zombie than his partner – he directed her every movement with whispered commands to 'stand up, move around, pose'.

The underground journalist John Wilcock, who was on the set of *Bitch*, recalled that the film ended when Edie threw a drink at the light and it blew out. Warhol's technique of just pointing the camera at somebody and turning it on would often cause this kind of explosion, because the pressure to perform was so great that people would go crazy trying to think of something to do.

To spite her, he even began to develop a new superstar. 'The Warhol people felt Edie was giving them trouble,' said René Ricard.

They were furious with her because she wasn't cooperating. So they went to

a 42nd Street bar and found Ingrid Von Scheflin. They had noticed: 'Doesn't this girl look like an ugly Edie? Let's really teach Edie a lesson. Let's make a movie with her and tell Edie she's the big new star.' They cut her hair like Edie's. They made her up like Edie. Her name became Ingrid Superstar . . . just an invention to make Edie feel horrible.

Andy's last film with Edie Sedgwick was *The Death of Lupe Velez*, based on a script written on liquid amphetamine by Robert Heidie.

The film was about the last night in the life of the Mexican spitfire movie star Lupe Velez. Edie acted out a scene in which she tries to commit a beautiful suicide by lighting a circle of candles around her bed and composing herself on it after taking a handful of barbiturates, only to have them give her nausea. The film ended with Edie sticking her head in the toilet and pretending to drown in her own vomit.

It was filmed in colour on a December afternoon in 1965 on a very tense set at the socialite Panna O'Grady's apartment in the Dakota building. Edie was not in good shape. She had been fighting with a lot of people at the Factory, particularly Tavel and Warhol, screaming at them that their films were trying to make her look like a fool. Ronnie was as upset as Andy. No one had ever called his work perverse before. Edie simply did not understand what they were doing. Urged on by Chuck and unscrewed by drugs she had been ripping up scripts and throwing tantrums like a diva.

As they began to shoot, Bobby Neuwirth arrived with a handful of LSD and took Edie into a side room. 'That was where the separation really took place,' recalled one spectator, 'when Bobby Neuwirth walked into Panna O'Grady's that night. He had a fistful of acid. Sugar cubes. That Dylan group had always been great users of drugs as manipulating agents. And Andy was fuming, because somebody had invaded his domain.' Bobby slipped Edie some acid and made a date for her to meet Dylan later that night at the Kettle of Fish.

Warhol asked Robert Heidie to be at the Kettle of Fish that night.

I knew Edie was going to be there, and she was there before anybody else arrived so I sat with her. Then Dylan's limousine pulled up outside and he came in all dressed in black. Edie said something like, 'I've tried to get close to him but I can't,' and Dylan said, 'Who?' She said, 'Andy,' and he muttered, 'Oh.'

After a long cool silence Andy was the last to arrive. It was almost as if he had been somewhere watching. It really was dramatic. These were the beautiful people, but she wanted to be a star too. I had the feeling she was on the verge of tears. She seemed estranged from Andy and he wasn't expressing anything. They were all such gifted people. Dylan was a genius.

There was a dynamic underneath the meeting, something was definitely happening in terms of people pulling one another, but everybody was playing it cool. Right after Andy came in she more or less turned around and said

goodbye. She and Dylan left together and got into his car. Andy showed no sign of reaction to this. He just said something like 'Edie's on the road down, I wonder who the next girl will be'.

He was in the drama but he would stand outside it and I think that's probably the key to the whole thing. Andy was destructive because he didn't give, he gave nothing, and that's what Edie had been complaining about: what did he want from her? Why was she together with him? And in terms of his art I think he had to betray her.

After we left the Kettle of Fish we walked up to Cornelia Street. I showed Andy the spot where Freddie Herko had jumped out of the window and he said, 'I wonder if Edie will commit suicide. I hope she lets me know so I can film it.'

ANDY WARHOL'S

EXPLODING GIRLS

1965–66

*With Andy you lived and screamed with him. You were all
in that burning hellhole of electricity and thunderbolts.*

Andy hadn't had a boyfriend since Philip Fagan had walked out and
was as desperate as ever to have relationships. 'Oh, when are we going
to find someone for AW?' (which stood for All Witch, All Woman,
Andy Warhol) he cried out to Ondine in the back of a cab one day in
August 1965. But later that day he told the Sugar Plum Fairy he did
not believe in love, happiness or feelings because they never lasted and
it was 'too sad'. Asked by a cab driver if he loved himself he mumbled,
'Uh, no.'

Danny Williams had just graduated from Harvard when he was intro-
duced to Andy by Edie's consort Chuck Wein that month. Andy was
still so shy with boys that he continually depended on his entourage
to supply them for him, and Chuck had been only too happy to comply
since being his supplier of boys was one sure way to stay in Andy's
good graces.

Danny Williams was just the sort of sexy, sweet and easily dominated
boy Andy was looking for and, like Fagan, he moved into Lexington
Avenue shortly after they met. Robert Heidie 'thought they had a sexual
relationship, because Danny was a very sexual person, interesting and
nice-looking, about five ten, a little chunky, but in a cute way.' Soon
Danny was wearing the same boatneck striped shirts Andy and Edie
were wearing and regularly accompanying Warhol on their social
rounds. However, after two months the relationship broke down.

Heidie remembered being at a restaurant on Christopher Street with
Andy and Danny that autumn. Gerard was there with Ingrid, who fell
over on drugs. Danny used to work as a soundman for the filmmaking
team of Robert Drew and Don Pennebaker and he was going to show
one of his films. Andy, who expected 100 per cent attention and loyalty
from his followers, was very upset about this. 'Danny was very angry
with Andy,' said Heidie, 'and I sensed that Andy was afraid of him.
Danny jumped up at the table and pulled off Andy's wig. Andy

screamed, "Danny! Stop it!" For a second we all saw him bald, then he popped it back on.'

By October Andy had kicked Danny out of Lexington Avenue but, unlike Fagan, Danny was allowed to stay around because he could work the lights and sound for the films. He moved into the Factory, set up a workshop for himself, and lived there through the first months of 1966. Billy had been totally against the situation because 'Danny would get into quandaries or become bewildered. He was a very soft person, not up to my velocity, and he had a tendency to have nervous breakdowns, to become soft and physically unreliable in our working space. As far as I was concerned that was *dangerous* and placed us in *jeopardy*.'

But Danny's difficult lot was not confined simply to doing a job in the pressurized atmosphere of the Factory. Though they were no longer living together, he was locked together with Andy in the psychodrama of mental torture that invariably followed when Andy got someone into this position. Danny began to take amphetamine, but did not handle it well. The handsome Harvard preppie turned into an addict, his hair matted and stringy, his skin coated by the silver dust that crumbled from the walls, his glasses broken and taped together. When Danny got into one of his deflated funks, setting himself on fire or threatening to commit suicide, Andy, who normally operated completely through passivity, would actually scream at him in front of the rest of the group to shape up or he couldn't come with them. Everyone followed suit and joined in, with the result that Danny Williams became the Factory's whipping boy. In reaction he retreated behind what one observer described as 'a gay farm-boy-exposed approach like "If you don't watch out I'll hurt myself and it'll all be your fault!" to which the typical response was, "Well, fuck you, Danny. Nobody gives a shit!" '

As Henry Geldzahler saw it:

Andy was a voyeur-sadist and he needed exhibitionist-masochists in order to fulfil both halves of his destiny. And it's obvious that an exhibitionist-masochist is not going to last very long. And then the voyeur-sadist needs another exhibitionist-masochist. There were always more people around than Andy could use in any one situation. Therefore there was constant fighting to get into the royal enclave.

'It was as if he was collecting people,' recalled Malanga. 'Andy had a hypnotic power to create a personality for someone.'

'Andy had a very magnetic personality, almost like Hitler,' said Ultra Violet. 'It was just a mass hypnosis.'

What held Warhol's followers together was the feeling they had for the importance of what they were doing artistically, and that Andy let each of them be an artist, and a near-worshipful love-addiction for

Andy, the artist who could do no wrong. While Billy Linich and Gerard Malanga continued their balanced maintenance of the Factory, the tough, practical former social worker Paul Morrissey emerged near the end of 1965 as Andy's number-one disciple. Paul had never sought to be a star at the Factory, and was a self-styled square who did not like to be around drugs. Equally divergent in this haven of experimental actors, Morrissey was determinedly anti-intellectual and (making an exception for Andy) anti-avant-garde. He adored John Wayne, Katharine Hepburn, and the films of John Ford. Consequently Morrissey was looked down on as 'not an artist' by others at the Factory.

His ability to act as a buffer between Warhol and the more volatile members of his group was for the time being his main asset. Paul became responsible for passing on Andy's orders and, significantly, handling requests for money. With the rapidly increasing number of people offering their time and energy for free in exchange for being attached to the magic of the Warhol name, Andy needed more organization than Billy was capable of.

Ondine and Gerard made the innocent mistake of actually believing they were friends of Warhol's and viewed Morrissey correctly as a threat. Ondine, in particular, was offended at what he saw as 'the callous way Andy allowed someone like Paul to take control of people who were very important to his legend in filmmaking'. Morrissey's withering sarcasm didn't win anyone in his favour. He was soon the object of general hatred among his coworkers, who constantly speculated scornfully on whether or not he had a sex life. Malanga found Morrissey's habit of constantly tugging at little bits of hair on his head or under his arms to be even more revolting than his high-pitched voice and he kept screaming at him to stop. He thought Morrissey was afraid of his sexuality.

Paul wanted to make commercial films and had, apparently, convinced Andy of the moneymaking potential of movies, although the others were doubtful. 'Gerard told me that Andy got the idea of not moving the camera from seeing Thomas Edison movies from 1896, which is why I loved Andy so much, because Edison was right,' Tavel declared. 'As soon as he started trying to be Cecil B. De Mille he was going in the wrong direction.'

Morrissey's immediate objective was to raise enough money to enable Andy to make a big film by marketing the Warhol name, an effort which at first proved less than successful. Paul Morrissey:

Basically I was Andy's manager. Anybody who wanted to deal with Andy had to talk to me. If they wanted him to endorse something, or put out a button, or go to a party, we tried to get a little money out of them. I don't think I was very good at that. It was very hard to get an income, even though Andy was very famous. He was still really considered an offbeat character.

In mid-December, they were approached by a theatre producer named Michael Myerberg, who had brought the first production of *Waiting for Godot* to the States. Myerberg told them he was opening a discotheque in an abandoned airplane hangar in Queens to compete with the popular club Arthur, and was willing to pay Andy a small fee to bring people to the club and hang out.

'I had this idea,' Morrissey recalled, 'that Andy could make money not only from underground films but from putting the movies in some sort of rock-and-roll context.' So to up the ante, Paul suggested that Andy also supply the music. Under those circumstances, Myerberg agreed to call the club Andy Warhol's Up. An informal agreement was reached around a proposed fee of $40,000 for four weekends in April, and the Factory squirrels, as Geldzahler called the young kids on amphetamine from whom Andy got so many of his ideas, went out looking for a band.

*

Just before Christmas 1965, the filmmaker and squirrel *extraordinaire* Barbara Rubin heard the Velvet Underground at the Café Bizarre. The group was: Sterling Morrison, lead guitar, a self-styled 'nasty rock-and-roll biker type' who was in fact the friendliest and funniest member of the band; Maureen Tucker, a tiny, androgynous girl who kept a metronomic machinelike backbeat on a tympani drum and cymbal; John Cale, electric viola and bass guitar, a Welsh intellectual music scholar and disciple of the avant-garde composer La Monte Young; and Lou Reed, vocalist, guitarist and songwriter, who, at twenty-one, was already a veteran rock-and-roll animal. Lou contributed the hard-edged songs. And John contributed psychedelic musical settings performed at ear-splitting volume.

The next night, Barbara Rubin took Gerard, Paul, Andy and a bunch of hangers-on, including the rapidly fading Edie, to see them. According to Morrissey, their first impressions were that you couldn't tell if the drummer was a boy or a girl, they sang songs about drugs and had the word 'underground' in their name, all of which associated the Velvets with the image of the Factory. Bob Heidie, who was also there, said that after the set Andy whispered to him, 'Gee, do you think we should, uh, buy them?'

After the show Andy hit it off with Lou and invited the Velvets to the Factory to discuss ways of working together.

The same week Gerard received a phone call from a singer he had met several years earlier. Nico had just returned to New York.

Nico had had a part in Fellini's *La Dolce Vita*. She had studied acting and singing at the Lee Strasberg studios, had a son, Ari, by the French actor Alain Delon, and had been hanging out with the Rolling Stones in London. She brought with her a test pressing of a single she had recorded on the Rolling Stones' manager Andrew Loog Oldham's

Immediate label, and had also attracted the attention of Bob Dylan, who made her a gift of his song 'I'll Keep It with Mine'.

Andy immediately proposed that she sing with 'his' band. Andy Warhol:

> Nico was a new type of female superstar. Baby Jane and Edie were both outgoing, American, social, bright, excited, chatty – whereas Nico was weird and untalkative. You'd ask her something and she'd maybe answer you five minutes later. When people described her, they used words like memento mori and macabre. She wasn't the type to get up on a table and dance, the way Edie or Jane might; in fact, she'd rather hide under the table than dance on top of it. She was mysterious and European, a real moon goddess type.

Andy's idea was to take the black-clad, scruffy young punk band with its rock-and-roll music about heroin and sado-masochism, put the icy blond white-on-white Nico up front, and have them play as loud as they could behind male and female go-go dancers while his films were projected in the background and strobe lights roamed the audience. He understood the need to express distress in the culture and he saw that rather than entertain people in the old-fashioned sense, rock and roll should be controversial and make them alienated and uptight.

When the Velvet Underground visited the Factory a few days later, they were presented by Paul and Andy with an offer they could take or leave. Andy would manage them, give them a place to rehearse, finance their equipment, support them and make them famous, in return for which Warvel Inc., the cover company, would receive 25 per cent of their earnings. But Nico was to sing with the band.

Persuading the Velvets to play with Nico was not easy. First of all she really wanted a back-up band so she could sing all the songs. The multitalented Velvets had no interest in being a back-up band. Besides, some of their best songs, like 'Heroin' and 'Waiting for My Man', weren't as well suited for Nico's voice as they were for Lou's. Still, everybody was eager to do something and Andy was in a position to offer them a chance at his upcoming discotheque, so they all agreed to Andy and Paul's proposal that Nico be allowed to sing some songs and, when she wasn't singing, just stand on the stage looking beautiful. Lou Reed:

> Andy wanted us to use Nico, and we went along with it at the time. We didn't really feel we needed a chanteuse, but Andy asked me to write a song about Edie Sedgwick, so I did and called it 'Femme Fatale', and we gave it to Nico because she could sing the high chorus. That's why at the end of the song, you get those 'oh-woa-woe's'. With all due respect to Nico, but Andy wanted her so he got her.

241

The problems were somewhat ameliorated by the fact that Nico took an instant shine to Lou and Lou was immediately captivated by Andy.

Andy told me that what we were doing with music was the same thing he was doing with painting and movies, i.e. not kidding around. To my mind nobody in music was doing anything that even approximated the real thing, with the exception of us. We were doing a specific thing that was very, very real. It wasn't slick or a lie in any conceivable way, which was the only way we could work with him. Because the first thing I liked about Andy was that he was very real.

All the Velvets seemed equally snowed. 'It was like bang!' Mary Woronov recalled. 'They were with Andy and Andy was with them and they backed him absolutely. They would have walked to the end of the earth for him. And that happened in one day!' But it was Lou Reed that was the most affected. Just like Billy and Gerard, Lou was waiting to be moulded by the master. He was cute, cuddly, sexy and vulnerable, a heterosexual who said he wanted to be a drag queen, but as a rock-and-roller Lou was around the bend, a wild man on the guitar who couldn't get pumped up enough and couldn't be mean enough. 'When the smack begins to flow / Then I really don't care anymore / About all you jim jims in this town / And everybody putting everybody else down / And all the politicians making crazy sounds / And all the dead bodies piled up in mounds,' read one verse of 'Heroin'. Most of Lou's songs were like that – sharp, cool, on target – and he delivered them with withering contempt in an edgy static-electric voice that mirrored Andy's passive, seething rage.

During the following days and weeks they worked hard together. Andy gave Lou ideas for songs and asked him how many he had written every day. He taught him that work was everything and Lou came to believe that his music was so beautiful people should be willing to die for it. That was the kind of effect Andy could have on somebody. 'It was like landing in heaven,' said Reed. 'I would hear people say the most astonishing things, the craziest things, the funniest things, the saddest things. I used to write it down.'

Reed easily acquiesced not only to Andy's request to write some new songs – like 'All Tomorrow's Parties' and 'Femme Fatale' – for Nico but even to changing the name of the act to the Velvet Underground and Nico, and splitting their upcoming concert fees evenly between members of the band and the support staff from the Factory who would light and perform in the show.

The Velvet Underground immediately became a part of Warhol's entourage. 'New York was based on parties then,' Paul Morrissey recalled. 'There were twenty parties a night, some of them given by public-relations companies, and Andy started to find his way on to

some of those lists.' And if Andy just heard about a party, he would crash it with five or ten people. By New Year's Eve 1965–66 he was famous for crashing parties. They started off the evening going to Richard Barr and Edward Albee's traditional New Year's Eve party but, as Billy recalled the incident, when they got to the top of the stairs Barr stood up, pointed at them across the room and said, 'You! Out!' and they all turned around and walked right back down the stairs, half amused by how definite the rejection had been, half musing over its cause. Bob Heidie, who was at the party, was stunned, 'because at that time Edie was the Girl of the Year and it would have seemed absolutely right that they be there along with Noël Coward and John Gielgud, but apparently they didn't want a woman there!' After that Edie, her friend from Cambridge, Donald Lyons, the Velvet Underground, Andy and Gerard went to the Apollo Theater in Harlem to see James Brown. From the Apollo they travelled in Edie's limousine over to the rock entrepreneur Danny Fields's apartment to watch Walter Cronkite's CBS TV show on Piero Heliczer's film *Venus in Furs* featuring the Velvets playing, then journeyed on to Sterling and Lou's apartment on Grand Street, where they just sat around. There was no heat and everybody had coats on. Edie was wearing her leopard-skin fur coat. Andy bit his nails and looked at a magazine. The atmosphere was very uncomfortable. Hardly a word was spoken.

In preparation for the opening of Andy Warhol's Up discotheque a test run was scheduled at the Cinemathèque, where Jonas Mekas had given Andy a free hand to do anything he liked in place of the Edie Sedgwick retrospective, which had been cancelled after she refused to sign releases for her films. For the show Billy changed his surname from Linich to Name, which Andy thought was 'so cute'. Since one of Andy's ambitions was to have an art show 'with people on the walls instead of paintings' it was decided to present the Velvets and Nico with Andy's films in the background. Barbara Rubin was going to run up and down the aisles screaming threatening questions at people while Billy photographed their reactions. Strobe lights flashed across the stage and audience. Danny Williams created the job for himself of working and designing the strobe lights at the performance, often sitting up alone at night at the Factory, staring into as many as seven pulsing strobes, experimenting to see what effect they would have on him. Morrissey, however, soon squelched even that small source of self-esteem when he became the technical adviser, and Danny was reduced to being a technician who simply did what he was told. Morrissey and Warhol really tore into that boy, recalled one observer. They were relentlessly on his case.

Gerard pulled together and prominently led a company of interpretive dancers who pretended to shoot up, whip each other and perform crucifixions in front of the band. 'It left nothing to the imagination,'

said Ronnie Cutrone, a teenage art student who was hanging out at the Factory and would soon dance with the show. 'We were on stage with bullwhips, giant flashlights, hypodermic needles and wooden crosses. It was very severe. It scared a lot of people.'

'It's ugly,' said Andy, 'a very ugly effect, when you put it all together. But it's beautiful – the Velvets playing and Gerard dancing and the films and the lights, and it's a beautiful thing. Very vinyl. Beautiful.'

The show, which was renamed Andy Warhol Uptight, was designed to provoke tensions in the performers as well as the audience. 'They were a very bitchy, competitive crowd at the Factory,' noted one observer,

and Andy tricked these people along. He was always saying, 'You're going to be a star!' and they got involved with him to the point where if they pulled out they lost everything they had put in. So Andy could just screw people over left and right. No one got paid. He was eating people! It was straight-out exploitation.

Edie Sedgwick danced with Gerard at the Cinemathèque but in February 1966 she finally left Warhol after a bitter fight at the Gingerman restaurant in front of the whole entourage. 'What am I supposed to be doing in the Velvet Underground?' she screamed. 'What's my role? When am I going to get paid?'

Pale and shaking, Andy repeated what he always said, 'I don't have any money, Edie! You'll have to be patient.'

'Edie's falling-out with Andy was definitely over money that she rightly deserved,' observed Malanga, 'and which Andy for his own petty reasons was not giving her.'

Edie stormed away from the table, made a phone call, supposedly to Dylan, came back to the table and told Andy she was leaving him for good.

According to his followers, Andy was very hurt by Edie's defection to the Dylan camp. And even more hurt when he heard that she was putting him down as a sadistic faggot and making fun of his films. 'Dylan, who had an extreme drug problem with amphetamine, was a creep,' said Paul Morrissey, 'and I think he was really doing it to spite Andy. He had some sort of dislike for Andy. Andy didn't care. He just felt very hurt that she would be so cruel as she was.' One night at Ondine's, according to Dylan's biographer Bob Spitz, 'Bob lit into Andy Warhol like a snarling pit bull. He ripped the frail artist to shreds, savaging his paintings and lifestyle. To his credit, Warhol shrugged off the attack.'

Mary Woronov, who acted in one of Warhol's best though least appreciated films, Hedy, that month and was dancing on stage and going out with Gerard, remembered that 'Andy did not show that he

was upset but everybody else got upset for him and there was a ripple effect. All everybody around him was talking about ninety-four hours a day was how this stupid cunt could go off with Bob Dylan. So that meant Andy was upset.'

As Andy later explained the incident to a friend, 'They gave her drugs . . . Uh, she, uh, said we were so old-fashioned . . . and the other group, uh . . . was, uh, hip . . . and so she, uh, left us.' Gerard Malanga:

> The people advising Dylan had this illusion that they could develop Edie into a singer and in turn capitalize on her already established reputation in the media. So it was easy for Edie to finally leave Andy. She was the product of a heterosexual milieu, whereas Andy was very much a part of a homosexual sensibility, any which way you cut it, and the Dylan group was staunchly heterosexual. Edie had assumed that being promoted as a singer was promised to her, but her talent was totally undeveloped. She thought she could further herself by being associated with Dylan, but this was merely an optimism based on hopes and dreams.

Andy may rarely have been more upset. He had been effervescent about his ability to merge with Edie. It was the kind of connection he had been looking for all his life. In photographs of them that appeared in fashion magazines the month she split, Andy looked more and more like Edie. 'I still care about people,' he reflected hesitantly, 'but it would be so much easier not to care . . . I don't want to get too involved in other people's lives . . . I don't want to get too close . . . That's why my work is so distant from myself.' Deserted by his loved star, Andy started to sculpt a living theatre of resentment out of the people around him to express his conviction that love was an illusion. He wrote:

> During the sixties I think people forgot what emotions were supposed to be. And I don't think they've ever remembered. I think that once you see emotions from a certain angle you can never think of them as real again. That's what more or less happened to me. I don't know if I was ever capable of love, but after the sixties I never thought in terms of love again. However, I became what you might call fascinated by certain people. [Edie Sedgwick] fascinated me more than anybody I had ever known. And the fascination I experienced was probably very close to a certain kind of love.

At crucial points in Andy's life nothing sharpened his focus like the threat of rejection. It was as if Edie's departure triggered a bomb in his psyche. Bereft of his mistress, betrayed, a furious Drella would show no quarter in his relentless revenge against not Edie but everyone, and the rate of attrition at the Factory would increase.

*

In March 1966, when *Andy Warhol Uptight* performed at Rutgers University, after dancing in the first show Ondine was informed by

Malanga that the stage was too crowded and his presence would not be required at the next show. Ondine threw a chair across the room and left enraged.

Paul was glad to see him go. Barbara Rubin, another heavy drug user, was getting on his nerves too. He began to torture her, making fun of everything she said, refusing to take her seriously. By now Paul was the acknowledged leader of what one observer called 'the Factory dog pack', and he would turn them loose on anybody who got in his way. Paul Morrissey:

I kept trying to press Myerberg, through our lawyer Sy Litvinoff, to sign an agreement that Andy's group would open his club and be paid a certain amount of money. However, there was let's say an Italian influence in this club and I think they had their own plans for the opening. Somehow, even Myerberg lost control of it. About a week before they were scheduled to open, this lawyer said, 'They've changed their mind, they're going to open this weekend with the Young Rascals.'

I remember going down to the Café Figaro, where Gerard had taken Andy to see Allen Ginsberg, who was about to go to Europe. I said, 'Andy, they're not going to sign the agreement, we don't have a club for the Velvets.' Andy had already invested this money in their equipment.

Sitting at the table behind me were Jackie Cassen and Rudi Stern and they heard me talking. They said, 'You're looking for a dance hall to present a rock-and-roll group? We present dance concerts and we know a wonderful place.'

I said, 'You're kidding, where?'

They said, 'On St Mark's Place.'

I said, 'You're kidding. I never knew there was a place there.'

I went over with them and I saw the Dom and I came back and arranged a rental deal. It was only signed on Friday and that afternoon the Velvets moved their equipment in. Gerard was up on the back painting the wall white. At eight o'clock that night all these people showed up. It was packed. It was an enormous success its very first night.

The advertisement in the *Village Voice* read:

COME BLOW YOUR MIND
The Silver Dream Factory Presents
The Exploding Plastic Inevitable
with
Andy Warhol
The Velvet Underground
and
Nico

There was no question of who the real star of the show was: the Velvet Underground and Nico were unknown. People were coming because

of Andy, who from his nightly perch on the left side of the balcony next to the projector, high above the deafening din, ran the film and slide projectors and changed the light filters, directing the people on stage with light; the conductor, as Jonas Mekas saw him, 'structuring with temperaments, egos and personalities, who manoeuvred it all into sound, image, and light symphonies of tremendous emotional and mental pitch . . . somewhere in the shadow, totally unnoticeable but following every second and every detail of it'. The last thing Andy wanted people to do was relax and have fun. Whenever he thought the audience was enjoying the show he immediately began saying, 'Change it, change it.'

Throughout April, the Exploding Plastic Inevitable packed the Dom with a cross-section of straights and gays, art tramps and artists (including Salvador Dali, who was advertised as a member of the group), the thrill-seeking rich, the drugged and the desperate, beautiful girls in miniskirts and beautiful boys, for all of whom Andy had created a kind of religious spectacle. This was the first time Andy combined all his different worlds under one roof. Paul Morrissey:

It was almost the first time a strobe had ever been on a dance floor. And Andy had bought the old mirrored light ball in a junk shop. That was part of his own collection of Americana, and he brought that down and pretty soon every single hippie in the world had one in their living room.

I always thought that we were reflecting what we saw about us. That was always our attitude, I think Andy's too, but because it became part of a whole movement it seemed to affect more people's lives than we realized. People looked on it as some sort of a political movement. We didn't intend it to look like we were taking a position either, because we were just dealing with it in a kind of objective way. The West Coast hippie movement was a political movement. People used to say, 'Well, aren't you hippies too?' People outside of New York don't understand that the New York sensibility doesn't take anything seriously. It's just grist for the mill. It was only provincial attitudes, like in Germany or England or California, that took this stuff seriously.

Stephen Koch, whose view of Warhol is generally considered among the most articulate:

The effort to create an exploding (more accurately, imploding) environment capable of shattering any conceivable focus on the senses was all too successful. It became virtually impossible even to dance, or for that matter do anything else but sit and be bombarded – 'stoned', as it were . . .

Seeing it made me realize for the first time how deeply the then all-admired theories attacking the 'ego' as the root of all evil and unhappiness had become for the avant-garde the grounds for a deeply engaged metaphor of sexual sadism, for 'blowing the mind', assaulting the senses; it came home to me how the 'obliteration' of the ego was not the act of liberation it was advertised to be, but an act of compulsive revenge and *resentment* wholly entangled on

the deepest levels with the knots of frustration. Liberation was turning out to be humiliation; peace was revealing itself as rage.

Nobody could have described better Andy's programme in 1966. 'We knew something revolutionary was happening,' Warhol wrote. 'We just felt it. Things couldn't look this strange and new without some barrier being broken.'

The press reactions were good. 'The sound is a savage series of thrusts and electronic feedback,' wrote the *Village Voice* critic Richard Goldstein. 'The lyrics combine sado-masochistic frenzy with free-association imagery. The whole sound seems to be the product of a secret marriage between Bob Dylan and the Marquis de Sade.'

The media pundit of that age, Marshall McLuhan, also found the Exploding Plastic Inevitable remarkable and included a photograph of their peformance in his book *The Medium is the Massage*, along with the statement, ' "Time" has ceased, "space" has vanished. We now live in a global village . . . a simultaneous happening.' 'Andy created multi-media in New York,' said Lou Reed. 'Everything was affected by it. The whole complexion of the city changed, probably of the country. Nothing remained the same after that.' Others, jealous of Warhol's publicity and angered by his indulgence towards amphetamine and homosexuality, attacked the EPI as nothing more than an untalented evening of noise and insults. Warhol, they charged, was ripping people off at six dollars a head just to make them feel uncomfortable. On more than one occasion members of the group were attacked by bottle-wielding hostiles as they left the building. Lou Reed:

> We were doing the Exploding Plastic Inevitable in New York one night, and right around the corner was Timothy Leary and some mixed-media event. He criticized us, saying, 'Those people are nothing but A-heads, speed freaks.' So the people talking for Andy Warhol said, 'Those people take acid. How can you listen to anything those people say?' It was that insane and that ridiculous.

'We really wanted to go out there and annoy people,' recalled John Cale. 'So what happened? We had Walter Cronkite and Jackie Kennedy dancing to it. We were fooling ourselves even then.'

*

During his first week at the Dom Andy opened a new show at Castelli's. There had been an eighteen-month hiatus since the Flowers show during which he'd devoted himself almost exclusively to filmmaking. The previous year, after he had made his Paris announcement publicly retiring from painting, he'd insisted to Castelli and Karp that he really had run out of ideas and did not want to repeat himself. This show had, therefore, been conceived as Andy's farewell to art.

His response to a suggestion by Karp that he paint something

'pastoral, like cows' was to wallpaper one room of the gallery with the repeated images of a cow's head, resembling the friendly Bordon ice-cream trademark Elsie. Gerard Malanga:

> Andy got most from what was around him at the time or what might have been suggested to him in conversation over the phone, or he might be flipping through a newspaper or magazine and an image would catch his eye. Sometimes I would come up with the idea or find the appropriate image to fit the idea like, for instance, the portrait of the cow for the wallpaper. He hated the cow at first. I had to force the cow on him. He didn't like it, I said, 'Andy, it's got a kind of motherly quality, there's a maternal look to that cow.'

The other room was filled with free-floating helium-filled silver pillows, originally created as the set design for Merce Cunningham's dance piece 'Rain Forest'.

As a Happening the show was powerful. One of the two little school-girls who were working at the Factory typing up Andy's tape recordings of Ondine for his forthcoming novel was so amazed when she saw Andy, silver-haired in black leather and dark glasses, standing in the middle of the silver pillows hovering around his head that she ran right down the stairs and out into the street.

The pillows quickly deflated and the wallpaper peeled. The critics were puzzled. 'These installations exemplified Warhol's outspoken disregard for conventional art contexts,' wrote Professor Charles Stuckey. 'The ways his materials were deployed demonstrated, in a single show, extremes of stability and mobility; the full implications of that show are still to be worked out,' wrote the British art historian Richard Morphet.

There were few sales for this show, but 'production at the Factory had continued full blast', Calvin Tompkins wrote. 'Then, with awesome timing, Andy declared Pop Art dead and moved on to the next phase.' Andy would not have another major show at Castelli's until 1977. Mary Woronov:

> Even if he turned out something bad, we didn't fucking care. We all thought that way and that's what we wanted to think. It was an extremely strong attitude and it was fun. Wherever we went with him, we'd all be dressed in black and we'd look like this death squad . . .
>
> You learned to lie when you were with Warhol. If somebody asked me if I was gay I would say, Sure. If somebody asked me if I was on drugs, I would say, Major. If somebody asked me if I liked roses, I would say, Never. You just gave them what they wanted and it was like this run, man, we had a run.

In April 1966 it really looked as if Warhol's ambition to branch out

into different fields was succeeding financially as well as artistically. *My Hustler* opened the same week as the Silver Pillows and Dom shows and brought in $4,000. It was the first time a Warhol film made a profit. And during the first week at the Dom the EPI took in $18,000, which they kept in brown paper bags. Meanwhile Andy started to produce the *Velvet Underground and Nico* album, which would become a rock classic.

A recording studio was rented at $2,500 for three nights, but conflicts between the performers quickly erupted. Nico did not have enough material to sing. Lou didn't want her on the album. He wrote 'Sunday Morning' for her, but wouldn't let her sing it. Then Nico kept insisting on singing 'I'll Be Your Mirror' in what Sterling Morrison described as a 'Götterdämmerung voice'. 'The whole time the album was being made,' Warhol wrote, 'nobody seemed happy with it.'

'Andy was like an umbrella,' Lou Reed recalled. 'He made it so we could do anything we wanted. But when we recorded our album, we had our sound. We made the record ourselves. Andy was just there, but he made it possible to do it the way we wanted to do it.'

Everything was going well until Warhol and Morrissey made the kind of mistake that would undercut a good deal of their work together in the coming years. They did not pay attention to the sharks in the booming rock business who would move in on a good thing as soon as they saw it making money. When a genial booking agent named Charlie Rothchild approached Morrissey and persuaded Paul to let him handle the box office and get other bookings for the band since he was a professional, Morrissey gladly agreed to hand over the burdensome financial chore.

Consequently, at the beginning of May the Exploding Plastic Inevitable, numbering some fourteen souls in all, found themselves flying out to Los Angeles for a month-long engagement at an LA club called the Trip which promised to put them over the top and get them a big record deal too.

Almost as soon as they established themselves in a large imitation-medieval stone structure in the Hollywood Hills called the Castle, where many rock stars put up their entourages at $500 a week, things began to fall apart.

Their opening act and, as it would turn out, their biggest competitors, the Mothers of Invention, set out to make fools of the Velvet Underground whenever they could, and the jealousy that exists between the East and West Coast entertainment businesses immediately broke out in the open. Lou Reed said that Frank Zappa, the leader of the Mothers, was 'probably the single most untalented person I've heard in my life', while among the local rock hierarchy Cher (who said she was afraid of Warhol) commented that the EPI would 'replace nothing except maybe suicide', and the local critics were equally dismissive. To make matters

worse the Trip was closed down on their third night by the local sheriff's department, which threw the group into a quandary.

Andy did not want to spend a month in LA supporting fourteen people doing nothing, but the Musicians' Union informed him that if they stayed in town for the duration of the engagement they would have to be paid the entire fee. Visitors to the Castle that night found the atmosphere eerie and extremely uptight. Fissures between the performers were beginning to split open. Lou Reed was already looking for a way out of his contract with Warhol. There was a lot of tension and relationships soured. However, they decided to stay and use the time to complete and sell their record.

This immediately became another source of problems. Several companies turned it down because of the subjects of the songs as well as their unorthodox sound. Finally they received a positive response from the talented producer Tom Wilson, who was about to get an executive position at MGM. But as soon as it became time to sign contracts Reed refused to sign unless all money from sales came first to the band, not Warhol as originally agreed upon. Morrissey started to think that Reed too was a creep, just like Dylan.

The moment of truth of the West Coast trip came when the band was booked to play a weekend at Bill Graham's Fillmore West in San Francisco at the end of the month. By then tempers were so frayed that the hardcore New York contingent could no longer hide their contempt for the West Coast scene, typified by Reed's description of it as a 'tedious untalented lie', and the grating sarcasm of Morrissey asking Graham why the West Coast bands didn't take heroin since 'that's what all really good musicians take'.

Paul was putting him on, but Graham exploded, screaming, 'You disgusting germs! Here we are trying to clean everything up and you come out here with your disgusting minds and whips!', which just about said it all. That night Gerard was arrested in the street for carrying the leather bullwhip he danced with, and spent a nervous night in jail. Lou Reed:

It was very funny – until there were a lot of casualties. Then it wasn't funny any more. That flower-power thing eventually crumbled as a result of drug casualties and the fact that it was a nice idea but not a very realistic one. What we, the Velvets, were talking about, though it seemed like a down, was just a realistic portrayal of certain kinds of things.

Later, the rock critic Lester Bangs wrote:

Rumblings were beginning to be heard almost simultaneously on both coasts. Ken Kesey embarked on the Acid Tests with the Grateful Dead in Frisco, and Andy Warhol left New York to tour the nation with his Exploding Plastic Inevitable rock shows (a violent, sado-masochistic barrage on the senses and

the sensibilities of which Alice Cooper is the comparatively innocuous comic-book reflection) and the Velvet Underground. Both groups on both coasts claimed to be utilizing the possibilities of feedback and distortion, and both claimed to be the avatars of the psychedelic multimedia trend. Who got the jump on who between Kesey and Warhol is insignificant . . . The Velvets, for all the seeming crudity of their music, were interested in the possibilities of noise right from the start, and had John Cale's extensive conservatory training to help share their experiments, while the Dead seemed more like a group of ex-folkies just dabbling in distortion.

After another two unappreciated shows the troupe returned to New York in disarray, split up temporarily and went off in different directions. Only Danny Williams remained behind on the West Coast, thoroughly disenchanted with life at the Factory.

THE CHELSEA GIRLS

1966

A vision of hell! The film is an image of the total degeneration of American society.

EAST VILLAGE OTHER

In June 1966, as soon as Warhol got back from San Francisco, he returned to his original goal – to make a big movie that would be a huge hit. The only problem was money. Six months' work with the Velvet Underground had rather than filling his coffers depleted them.

Warhol's constant complaint that he didn't have any money, which was always sneered at by his entourage, ranging from the self-exiled Taylor Mead to the fuming Sedgwick, was much closer to the truth than any of them, even Malanga, would allow. In fact, ever since the beginning of the decade when he had started his pop career Warhol had been earning less than he had at the height of his commercial-art career in the 1950s, while simultaneously maintaining a much more expensive lifestyle. The monthly tab for the Factory and the entourage of some fifteen to twenty whom Andy fed and transported around with him, as well as the upkeep of his house, his mother and her demands that he help support their growing family in Pittsburgh, was hardly being supported by the sale of paintings for which he might make at most $2,000 each, and apart from *My Hustler* the films had so far earned him absolutely nothing. The profits from the Velvet Underground shows at the Dom had gone into supporting the act, taking them out west and making the record which was now in the can but would not be released for almost a year. Contrary to the popular misconception of Warhol as a businessman, Andy had neglected to renew his lease on the Dom and when he returned to New York he found, much to his dismay, that none other than Charlie Rothchild and Dylan's manager Grossman had taken over the place and turned it into a lucrative rock club called the Balloon Farm. A year later, based on the concepts Warhol had pioneered, it would become one of the seminal rock clubs of the sixties, the Electric Circus, and make a ton of money, none of which, naturally, would go to Warhol.

Andy bewailed the lack of success of the Exploding Plastic Inevitable, throwing up his hands in dismay and professing not to understand why they were not making as much money as the Rolling Stones.

'Other people succeed who have no talent,' he would say. 'Here we are with all you gorgeous people and we can't make it. How come? Oh, it's so hard.' Still, he never let failures, however big or unexpected, stop him in what Malanga used to call his relentless drive for *la Gloire*. The Exploding Plastic Inevitable had spread his name to a much larger, younger audience than he had had as a pop artist and underground filmmaker. Now was the time to put out a new film which this audience could eat up. In fact, there was no time to be lost. The feelings that had erupted around the disintegration of the EPI were perfect material for his new idea.

Rather than focusing his camera on one star in films like *Poor Little Rich Girl* and *Beauty #2*, he would take his growing stable – Ingrid Superstar, Mary Woronov, Nico (whom he held on to and promoted as his Girl of the Year), a newcomer called International Velvet, the stud Malanga, the prodigal Ondine, back at the Factory and ripe for action, Brigid Polk, approaching the zenith of her role as the Doctor – and pitch them all against each other in films that would present the reverse side of the sixties, challenging the corny flower-power philosophy of the hippies and their messiah, Dylan, with the savage hardcore truths of Ondine as the Pope of Greenwich Village or Warhol's own flat, negative statements like 'I don't really believe in love' and 'Life is nothing'.

Ever since he had been commissioned to do 'Ethel Scull 36 Times' Andy had been aware that painting portraits was a quicker and surer way to make money than painting works like the death-and-disaster series that nobody might buy. After pausing briefly to knock off several commissioned portraits to finance his summer's work, in mid-June 1966 Andy began the greatest three months of his moviemaking career.

'Andy tried to film a sequence a week,' Morrissey recalled. 'To buy the film, to develop it and get a print was about $1,000–$1,500 a week, depending on whether it was black and white or colour. He wasn't making a fortune then so these experiments, which everybody except us thought were idiotic, had to prove themselves in some popular way.'

Between June and September, he shot some fifteen one- and two-reel films at the Factory, in various apartments, and at the Chelsea Hotel, where several of the performers were living, with the general idea of filming people in conflict or, if alone, exposing their innermost feelings. The aesthetic dynamic behind the films was that of the EPI: uptight and confrontational.

No one in the cast was fully aware of what Warhol was doing since he was working on intuition, but they were all primed to perform. The films had no plots and, in most cases, no scripts, except for a few sketches mailed in by Ronnie Tavel, who had finally been so shocked by Warhol's sadism and cruelty he had removed himself to California. Like previous Warhol films, they were shot in one take until the 35-

minute reels ran out. His idea was that if he aimed the camera at interesting people and kept it running, something great was bound to happen. 'This way I can catch people being themselves instead of setting up a scene and shooting it and letting people act out parts that were written,' he explained. 'Because it's better to act naturally than act like somebody else. These are experimental films which deal with human emotions and human life. Anything to do with the human person I feel is all right.'

Naturally, this put all the burden on the character of the individual performers, and this pressure was always compounded by hostile interpersonal relationships and chemical side effects. 'All these people were used again and again in his films,' Ondine pointed out, 'but in ways that would lead them to really dislike each other, because of the dialogue, also because of the drug taking – an enormous amount of drug taking: most of the people were off the wall with their own versions of what was happening.'

In addition, Andy and Paul had developed unique directorial methods for eliciting performances by priming their actors just before filming with rumours about unpleasant things the other actors had said about them, and playing their jealousies and frustrations off against one another. The films were shot under the most primitive conditions. The sound was recorded optically, which was inexpensive but often led to garbled, almost inaudible soundtracks. Warhol's attitude was to not care. When the soundman on one set protested that the sound was hopelessly unbalanced and the batteries were dying, Andy shot the film regardless. It was this reckless, driven, edgy 'Just do it!' attitude along with everything else that inspired his actors to give him everything they could.

The results were often explosive. For Ondine's scenes, for example, it was decided that the demented but inspired actor would play the Pope of Greenwich Village. In one reel, desperate to be magnificent, he began by shooting up amphetamine on camera, confessing his homosexuality and lambasting the state of the church. As his exposition became more searing, Ondine uttered what would become one of his most controversial lines: 'Approach the crucifix, lift his loincloth, and go about your business!' A girl named Rona Page – who had been sent by Jonas Mekas – came in to give confession. On camera she made the terrible mistake of calling Ondine a phoney. Flying into a murderous rage he slapped her in the face, tore into her, jumped up and slapped her again. Andy, who abhorred violence but was too fascinated to stop it, ran to the other side of the room, followed by Rona, who rushed off yelling, 'Oh, Andy!' and started reading him her poetry. Ondine stormed off after them screaming, 'Turn off the fucking camera!' but the camera stared obdurately at the empty couch and ground on. Off set Ondine could still be heard fuming, 'You phoney! You fool! You

moron! You misery! You're a disgrace, a disgrace to yourself. May God forgive you!'

Andy's methods were unconventional, Ondine conceded, 'but he pulled out of these people, including myself, some of the best performances *ever* on screen'.

In August Jonas Mekas asked Warhol for a film to show at the Cinemathèque, and Andy and Paul started looking at the footage they had shot over the summer. As they screened the twelve to fifteen reels they realized that the films related to each other in a totally unintended way. In addition to the Pope Ondine story, there were great reels of Brigid playing a drug dealer, shooting up amphetamine through her blue jeans, of Gerard lambasted for being an irresponsible hippie by Marie Mencken in the role of his mother, of Mario Montez being reduced to tears by two bitchy faggots, of Eric Emerson stripping and telling his life story, of a lesbian torture sequence, and of Nico cutting her hair and crying. They quickly assembled twelve of them into a sequence and gave it the umbrella title *Chelsea Girls*.

With a running time of six and a half hours the film was too long. To solve the problem Andy decided to show two reels next to each other simultaneously on a split screen with only one side of the screen talking at a time, cutting the running time in half. The juxtaposition of actors and action, colour and black and white, sound and silence gave *Chelsea Girls* a visually beautiful impact as well as a schizophrenic effect, particularly when the same players appeared in two reels running next to each other exposing different aspects of their personalities, and turned it into something much greater than any of the individual films alone. Ingrid Superstar, who appeared in more reels than anyone else, emerged as the comic heroine of the film. Morrissey explained:

> With us everything is acceptance. Nothing is critical. Everything is amoral. People can be whatever they are, and we record it on film. The one Andy loves is Ingrid Superstar, because Ingrid can't dissimulate. She couldn't not be Ingrid. She can do her thing for us because she thinks we're trash. We treat her like dirt and that's the way she likes to be treated.

Above all, *Chelsea Girls* stood out as a harrowing montage portrait of what Andy Warhol's world had become by the summer of 1966.

In June Henry Geldzahler had

> finally understood what Andy was doing with people and I had to get out of there to save myself. It was so unattractive I walked away. There was one tense moment. There was a blackboard in the studio and I wrote: 'Andy Warhol can't paint any more and he can't make movies yet.' That was when he was between the two. But he never forgot that.

*

By the time Andy was getting ready to show the film, the whole Factory

was shaking with negativity. Personal conflicts, ego frustrations and drugs had worn the group to the knife edge of their souls and the casualties were beginning to mount.

Danny Williams had rejoined the EPI (minus Andy, Nico and Lou) one last time for a week of shows in Chicago in June, but after an argument with Morrissey over a plug during the sound check resulted in a fist fight, he had returned to his parents' home on Cape Cod.

On 8 September, the week before *Chelsea Girls* was to open at the Cinemathèque, word arrived at the Factory that shortly after returning home, Danny had driven to the shore, undressed, left his clothes in a neat pile by the car, and swum into the sea and drowned.

Although many of them had watched Andy destroy Danny, his death was big news to the denizens of the Factory for only about ten minutes. The general attitude was, 'If that's what he wants to do, that's cool.' When Williams's parents sent Andy two doorknobs which Danny had left him with his suicide note, everyone pretended they didn't grasp the vulgar message that Andy should shove them up his ass. Ronnie Tavel:

> I was there the day the mother called and Andy's reaction was appalling. I said, 'You must speak to her.' He said, 'Oh, I don't care, what a pain in the neck, he was just an amphetamine addict!' And I was a little startled by that. I mean, all these people at the Factory were so public in their display of not caring about people.

'You couldn't have a broken heart at the Factory,' said Barbara Rose. 'That place was beyond romanticism.'

'You couldn't blow your cool ever,' said Ronnie Cutrone. 'You were not allowed to be a human being even. Everything worked through guilt and paranoia.'

Billy Name became so ill as a result of exhaustion that he was reduced to lying on the couch at the back of the Factory for several days 'urinating this black and red stuff and crying because it was so painful'. Clearly revealing his own method for dealing with such problems, Andy advised Billy to try and 'see it all as a movie so you don't have to experience all that pain'.

Barbara Rubin left the Factory screaming with frustration after losing her umpteenth fight with Paul.

Gerard Malanga's relationship with Andy was beginning to fray as Paul increasingly subverted his position as Warhol's closest associate. In early September, while dancing with the Velvets at another disastrous gig stopped by the police in Provincetown, Malanga had begun keeping a daily tally of rebuffs in a 'Trip Book', which he described as a 'chronicle of love-hate conflicts', mostly with Andy. A typical entry, dated 4 September, was an imaginary letter expressing the feelings to

which Gerard felt Andy had become oblivious. 'Dear Andy,' it began, 'it seems I'm always writing you letters to explain myself, my feelings, what's bothering me as you find it easy to say nothing . . . I feel,' the letter accurately concluded, 'that you will do nothing in your almost absolute power to correct the mess you are responsible for . . .'

When on 15 September, the day *Chelsea Girls* opened at the Cinemathèque, Warhol upbraided Malanga for not getting copies of all the film reels finished on time, Gerard noted tersely, 'Andy is sometimes beneath contempt and his contempt came out in full force today.' Despite this and other last-minute problems, *Chelsea Girls* was an immediate, stunning success and catapulted Warhol into a relevant position for a much larger audience than he had ever had. Jonas Mekas wrote in the *Village Voice*:

> It's our godless civilization approaching the zero point. It's not homosexuality, it's not lesbianism, it's not heterosexuality: the terror and hardness that we see in *Chelsea Girls* is the same terror and hardness that is burning Vietnam and it's the essence and blood of our culture, of our way of living: this is the Great Society.

'In the *Chelsea Girls* I found three of the most extraordinary sequences of the cinema I've ever seen,' said the filmmaker Shirley Clarke. 'Since seeing it, I've been continually haunted by the movie's beauty and power. Anyone seriously interested in films must see Warhol's new movie because it goes into a whole new dimension.'

Not all the reviews were positive. '*Chelsea Girls* is a three and a half hour cesspool of vulgarity and talentless confusion which is about as interesting as the inside of a toilet bowl,' wrote the film critic Rex Reed in a typical put-down.

Somehow the controversy even reached the ears of Andy's mother, who admonished, 'Don't you make no dirty movies!'

'So that's when people became aware of what was going on in the Factory world,' stated Billy Name.

Blown away by the power of the film and reduced to tears on his second viewing of it, Ondine explained:

> *Chelsea Girls* wasn't funny. It was the most horrible movie ever made. I mean, everyone's worst fears were suddenly realized and thrown up there. Yes there is sex, yes there is domination and cruelty and torture and everyone hates everyone else and let's beat them to death. It was all there. It was gripping. It was fabulous, it was a statement, it was a total work of art. It's an absolute solemn black mass.

*

Andy continued to maintain his personal aloofness from the events he'd depicted on screen, but some of the violence of *Chelsea Girls* was beginning to spill over into his private life. During a filming at Max's

Kansas City, a popular bar that stayed open late, on 2 October, Malanga noted in his diary, 'the scene was disrupted when somebody came up behind Andy and poured a bottle of beer over his head. We all jump up out of our seats. Andy splits for the rear of the restaurant. The drunken schmuck picks up a table and throws it at Paul, hits Lou.'

The initial shock of success silenced the bickering at the Factory for a while. Within two months of its release *Chelsea Girls* had broken out of the underground and was playing uptown at the Cinema Rendez-vous and the Regency. Controversy in the press raged about the movie. It was hailed as 'the *Iliad* of the Underground' and scorned as 'a grotesque menagerie of lost souls whimpering in a psychedelic moon-scape', which only attracted larger audiences to the film. *Chelsea Girls* quickly became the first underground film to capture the imagination of the mass public and it was beginning to make a lot of money very quickly.

One of the problems that had constantly afflicted Andy's relationships with his entourage was the fact that he was rich and most of them were poor. Billy lived on $10 a week. Gerard never had his own apartment and slept where he could. Ondine was always broke. And all these people were dedicating their lives to Andy. Until now he had been able to plead poverty with some justification, but with the much publicized financial success of *Chelsea Girls*, which made $300,000 in its first six months (although because of another bad business deal Andy only received half the money), the tide turned against him. Mary Woronov's mother sued him for showing the film without getting a release and he settled out of court. Finally, because he had neglected to get releases from any of the performers in the film, Andy would have to settle with everyone for $1,000. The experience of trying to extract money from Andy being humiliating and difficult, it took most of them a very long time to collect.

As some of the people in his entourage saw it, Andy was reaping all the benefits from the work they had seen as a collaboration. Andy was getting the fame, Andy was getting the money, and he was not parting with any more of it than he absolutely had to. In defence of these charges, Malanga pointed out:

> It wasn't so much that Andy was ripping off people's energy or ideas. Andy had the power of drawing people to him and making them feel that they were really the stars. So, by being manipulated to feel this way, or wanting to feel this way, they felt that they should give him something of themselves and made to feel wanted, appreciated. What they could give him they didn't much think of themselves, but Andy was a master of transforming an idea into something concrete and calling it his own.

'I was going to sue him after *Chelsea Girls* was released,' said Tavel,

'because it was obviously making money, but my lawyer said, "Did you learn something from working with Warhol?" I said, "A great deal." He said, "Then let's forget it, write it off to a learning experience." '

In November 1966 a lawsuit was levelled against Andy by Patricia Caulfield, whose photograph he had used to make his flower painting. She had been prompted to sue him when it was drawn to her attention that Andy was 'rich'. A long, costly court case resulted, out of which Andy ultimately agreed to give her several paintings and a percentage of all profits resulting from any future reproductions of the paintings as prints.

Ivy Nicholson, a fashion model who had been at the Factory since 1964, was freaking out for attention. She went so far as to believe that she might be able to secure her fame and fortune not just by working with Andy but by marrying him. Constantly rejected, she was getting violent towards other people at the Factory. On one occasion, when Ondine went over to her apartment, she opened the door and threw a cup of hot coffee in his face. Another time, after Billy ejected Ivy from the Factory, Mary Woronov found a pile of her shit steaming in the elevator as a memento for Andy.

Dismissed from the Dylan entourage after his motorcycle accident and burned in an apartment fire, Edie Sedgwick had begun coming around the Factory again asking for pills and money. Andy always gave her a few dollars and an Obetrol if he had a spare one on him. In November 1966 he put her in one last movie, to try, as he said, to 'help her out'. It was called *The Andy Warhol Story*. Paul Morrissey:

> René Ricard was supposed to be Andy and Edie was in it with him. She was in a bad way, and we thought we could help her, even though she had been so mean to do what she did. Andy really liked her and I did too. We thought it might work, but it wasn't any good. All René did was look in the camera and say nasty things about Andy, and it was really embarrassing because he thought he'd be funny. I remember very well Andy just not finding it funny at all, but anybody else in that circumstance would have turned the camera off and he wouldn't.

Both René and Edie, looking almost as tawdry as Ingrid Superstar, were so stoned and incoherent, spluttering with pent-up hatred for Warhol fuelled by speed, and the movie was such a torturous document of Edie's disintegration that the one time it was shown at the Factory, those watching begged Andy to turn it off.

Andy blamed what was happening to his superstars on drugs. 'It was drugs. On drugs everything is like a movie. Nothing hurts and you're not the way you used to be or would have been.' Even so, Andy was manipulating his performers on and off screen. That autumn he was dating his latest find, Susan Bottomly (International Velvet),

playing her off against the others while Susan, who had an allowance from her daddy, picked up the tabs at discotheques and introduced him to potential backers.

Another Malanga diary entry reveals just how bitchy the competition among Warhol's entourage had become:

> Ingrid is very unhappy because she feels that she's fading. Mary was someone I invented, put a whip in her hand and spread her name around and made her a star, but she did not really show any interest and because of her passiveness allowed herself to be eclipsed by Ingrid Superstar, Nico and Susan. Nico is the true star because she keeps her distance and is socially professional. Andy and I go to meet Susan and Edie and Mary at El Quixote Restaurant in the Hotel Chelsea. We have a lot to drink. Mary keeps her cool although she's as insecure as Susan and Edie is doing nothing to help herself. I bring up the fact that when Nico comes back from Ibiza she'll eclipse all the underlings. Susan is very stoned – gets uptight and leaves the table to go to her room.

Andy had, as the perceptive journalist Gretchen Berg, who interviewed him at the Factory on numerous occasions in 1966 and 1967, pointed out, a live and let live philosophy:

> He believed you should not alter the way things really are, they have to happen just the way they happen, even if it happened to himself. He handled people by not handling them. A lot of people became very petulant and uncontrollable as a result. And he watched as though he were watching inside of a cave. He of course manipulated their emotions and a lot of people around him became very emotional. They were all like fallen angels. The general atmosphere was conducive to corruption. Andy was a very serious guy, not a fool at all, and very shrewd. He was completely detached from the things that were going on around him.
>
> He was living in the middle of a vortex and he really put up with a lot of shit. It was a very dangerous philosophy and his own good nature could have created a very dangerous situation. It was like walking around in a gasoline-filled room holding a match, but I had a feeling he was very tough and would outlast us all.

Although a lot of people who came to the Factory had problems before they came there and Andy wasn't there to cure them, Andy was blamed, in the words of one Factory defector, for 'destroying people . . . eating their energy and labour'. Mary Woronov:

> People would invite us to their houses. They would have these gorgeous mansions and we'd all walk in looking like a death squad. And nothing entertained us. They couldn't be rich enough, they couldn't have good enough food, they couldn't do anything. And what happened is the table was turned and they would all of a sudden go, 'You're great, you're great,

you're great. Oh, you're wonderful.' We all hung together and got this sense of power and people just fell over backwards and gave it to us. It was just kind of stupid, it was funny.

None of us ever tried to be beautiful. All of us tried to look striking and powerful, including Andy. We had beauty that was tragic or marked. Like Velvet would say, 'I'm beautiful but I have too much make-up on and I fuck too much. I'm tragically torn.' They all marked themselves in certain ways. Ondine was probably the only one who was gorgeous, but he was so fierce you never paid attention to how good-looking he was.

Throughout the autumn, Malanga continued to tour with the EPI (minus Warhol), helping to stage performances in Cleveland, Detroit and Cincinnati, but his own difficulties with Andy had left him feeling 'replaceable', particularly after he met an Italian fashion model named Benedetta Barzini and fell obsessively in love. Andy did not like it when his associates fell in love because it took their attention away from him. 'I sense that Andy is going to do something chemically destructive between Benedetta and me,' read Gerard's diary. 'Andy should learn not to interfere in other people's private lives.'

Gerard felt humiliated when Andy stuck him in a minor role in an epic movie, *The Kennedy Assassination*, and refused to make a movie starring Gerard and Benedetta. Malanga was convinced that Andy was trying to 'dump' him. And when Benedetta abruptly ended their affair and refused to see him, Andy had reportedly commented, 'She was only seeing him so she could be in one of my movies.' Gerard was upset. 'I think it's very cheap of Andy to say something like that to a friend of mine. She's too good to fall under the Andy Warhol school of Toy Drama. I know all of Andy's tricks and charms. He has such good taste in bad taste.'

By the end of November 1966, the break-up with Benedetta was making Gerard useless to Andy. The growing distance between them was evident on 28 November, which Gerard noted as 'the most uptight evening' of his life, when he was left behind while Andy went by limousine with Henry Geldzahler (who had become friendly again) to the greatest social event of the decade, Truman Capote's Black and White Ball at the Plaza Hotel.

Even Julia Warhola was complaining about her famous son in public, in an *Esquire* interview about how lonely and ill she was because Andy was never there. She had been badly shaken by Paul's near death in a car crash in October and prayed for him night and day. Her own health was progressively precarious. Andy had removed her even further from his life, forbidding her to answer his phone and having a private line installed for her calls to the family. Pathetically, Brigid Polk recalled that often when she was talking on the phone to Andy he would suddenly realize Julia was listening in and cry, 'Hey, Mom, get off the phone!'

That November Andy starred Julia in a movie shot in her basement apartment as an aging peroxide movie star with a lot of husbands. 'We're trying to bring back old people,' he said.

In San Francisco in May Andy had met an attractive young man named Richard Green at a cocktail party given for a screening of his film of Michael McClure's play *The Beard* about Billy the Kid going down on Jean Harlow.

McClure had originally agreed to Andy's making the film and a contract was to be signed, but then on the advice of his lawyers and the director of the play, McClure was persuaded to withhold his permission. When Andy filmed it anyway, starring Gerard Malanga and Mary Woronov, McClure was angry. This cocktail party had been planned to mend the break in their relations. It was not successful. McClure brought the director of the play with him. The director was adamantly negative towards Andy. Andy was upset. However, he never did show the film and gave the print to McClure as a gift.

The meeting with Richard Green led to an 'erotic correspondence' and at the beginning of October Warhol had flown Green to New York and moved him into Lexington Avenue. The day he arrived Malanga had noted ominously in his diary that Richard was 'young and obvious about his feelings and will be needing much of Andy's attention'. He had quickly discovered that there was a lot of competition for it.

Green came from an upper-class well-off San Francisco family. He was tall, gangly, and slightly pudgy, still carrying his baby fat, but good-looking with it, and certainly fit the profile of the shy, egoless young man on whom Warhol could assert his will. Sometimes he took a small part in a movie but his personality did not lend itself to the kind of dramatic self-expression Andy's movies required. During the evenings when Andy was out he sometimes took Richard with him, but even then Andy was working and could not pay the kind of attention to Richard that a young man in love, particularly at the beginning of a relationship which had been based on a series of passionate, lyrical letters, requires.

In the second week of December Andy was coming home with Malanga one evening around midnight when they encountered Richard Green walking towards the Lexington Avenue house with Randy Borscheit, a youngster Andy had used in a movie starring Nico called *Closet*. Gerard recalled that Andy turned bright red when he saw Richard and Randy together and blurted out. 'What are you doing with him if you're my boyfriend?' Muttering some excuse to Malanga and dismissing Randy, he followed Richard into the house and slammed the door.

The following day Andy changed all the locks to his house and Richard had to move out.

The success of *Chelsea Girls* had other negative effects beyond the

internal conflicts in the Factory. The police raided the Factory so many times that winter that Andy asked his lawyers to post phone numbers where they could be reached in case anybody needed to be bailed out of jail. The press too had begun to stir uneasily.

The same day Andy expelled Richard Green from the house, the *New York Times* critic Bosley Crowther launched a full-scale attack. 'It has come time to wag a warning finger at Andy Warhol and his underground friends and tell them politely but firmly that they are pushing a reckless thing too far,' he wrote. 'It is time for permissive adults to stop winking at their too precocious pranks . . . It is particularly important to put a stout spoke in Mr Warhol's wheel . . .' In a second article in the *New York Times* Andy's works were said to have a quality and tone of degradation that was almost too candid and ruthless to be believed.

> More disturbing than the contagious lethargy of the movie is the deeper message: these dreamy swingers, playing their little games, clearly question the most basic assumptions of our culture – namely that heterosexual coupling, happy or unhappy, moral or immoral, is a socially significant enterprise worthy of the closest possible scrutiny. Hollywood's tinsel titillation and the art-house film's hard bedrock fornication are replaced by a new sexual mythology, a cool, low-keyed playful polymorphism. The message flashed . . . is utterly subversive.

This appealed to the writer Gore Vidal: 'To make fun of the art of the cinema by just showing boys taking their pants down just because everybody wanted to see their cocks, and doing it over and over and over again and really blowing the minds of those people who write about the movies, I thought that was really genius.'

It was one thing to make a joke out of the small, relatively inconsequential art world, it was another thing altogether to destroy the sacred American art of the movies and invade the minds of the youth through the soft underbelly of their music. In both instances the bottom line was Warhol's attack on sex and the Christian religion. Calvin Tompkins:

> In a time of confrontations and passionate role playing, the self-image that Warhol projected through all his activities – passive, voyeuristic, silver-haired and pale as death – had a prodigious negative power. Far more effectively than Duchamp, Warhol succeeded in ridiculing the very notion of art as a high and noble calling . . . The negative message that emerged from the Warhol Factory was really a memento mori, a chilling reminder of the sixties' 'dark side'.

THE ORIGINAL AMERICAN

GENIUS

1967

Andy just doesn't give a shit! He loves himself, like we all do, and he would do anything to retain the glory he is basking in.

<div align="right">RENÉ RICARD</div>

Andy's real problem was how to go beyond *Chelsea Girls*. Ondine thought that even he had not anticipated the extent of its success. 'It showed the fun of the sixties turning into the horror, and I really think dancing on the tip of an iceberg like that blew Andy's mind out.'

'I think the youth of today are terrific and kids seem to like my work,' Warhol said, 'but I'm not their leader or anything like that.' The truth is, Warhol could see that he was going to become a guru to the young and wanted someone to be the high priest for him. Ondine's performance as the Pope was the most talked-about scene in *Chelsea Girls*. Ondine:

'Why don't we do something like Leary and start a new religion?' he whispered to me, and we actually made some little films trying to establish me as a religious leader, but everything I knew told me that I was messing with the wrong thing. Lots of Andy's ideas were frightening like that, because they went over the bounds of good taste. He was just amazingly demented!

At the beginning of 1967, Warhol began working on three new films in the *Chelsea Girls* mode, using the same actors and methods of improvised dialogue and one-take filming. *Loves of Ondine* was to be a series of confrontations similar to the Pope Ondine sequence. With Ondine and Brigid Polk Warhol was also shooting scenes for *Imitation of Christ*, portraying a married couple up against a host of problems centring on their son who, among other things, wanted to wear a dress to school. The third movie, *Vibrations*, was again about the Kennedy assassination, black magic, and 'love situations', as Andy described them, in which actors like René Ricard and Ivy Nicholson were thrown together to insult and hit one another. *Loves of Ondine* and *Imitation of Christ* were each to be eight hours long and *Vibrations* was to be *the* Warhol mara-

thon endurance test – forty-eight hours of film that would run for twenty-four hours on a split screen.

The Factory was still attracting an ever expanding company of actors, and the new movies presented several fresh faces for the audience to eat up: Patrick Tilden, known for his imitations of Dylan; Andrea Feldman, who would become a superstar and another Warhol suicide; the raven-haired heiress Ultra Violet, who abandoned Salvador Dali's entourage at the St Regis Hotel to 'find' herself by acting in Warhol films; and a striking young visionary named Allen Midgette, who had made some early films with Bertolucci.

Despite Andy's determination to push on with these ambitious new projects, 1967 would be a year of unending problems, beginning that March when MGM released the long-delayed *Velvet Underground and Nico* album. The record was clearly billed as an Andy Warhol production in both its packaging (the sleeve had a banana that could be peeled) and advertising. One ad in *Evergreen Review* read: 'What happens when the Daddy of Pop Art goes Pop Music? The most underground album of all! It's Andy Warhol's new hip trip to the subterranean scene.' But the popularity of Warhol's art and film efforts could not guarantee airplay for the Velvets. Though the Beatles had just released their LSD-inspired hit 'Strawberry Fields Forever', songs like 'Heroin' were still too controversial for the radio. The album quickly fizzled; it has sold steadily ever since, but Warhol never saw a cent of his royalties.

'Back then we were surprised at how vast the reaction against us was,' recalled Lou Reed. 'I thought we were doing something very ambitious and I was very taken aback by it. I used to hear people say we were doing porn rock.'

Andy genuinely tried to push the record by opening a new club called the Gymnasium in the gymnasium of a rented Czechoslovakian meeting hall on the Upper East Side, but this time the magic did not happen, the crowds were sparse, and Andy quickly dropped the expensive project. Eric Emerson, one of the EPI dancers and a star of *Chelsea Girls*, put the final nail in the album's coffin when, in need of money to go to London, he sued MGM for including a photograph of him on the album's back cover without a signed release. Curiously, Andy remained completely passive and refused to lift a finger to stop Eric, with the result that MGM withdrew the record from the stores, and the Velvets began seriously looking for new management.

A few months into the start of shooting, problems were also becoming apparent on the set of the 24-hour movie. 'Things weren't working,' recalled Allen Midgette. 'It wasn't that it was worse than anything else Andy did, but it just didn't work. People were not being themselves, the way it was supposed to be.' As Midgette saw it, the aggressive, amphetamine-fed histrionics of people like Ondine and Brigid had become a 'cheap trick'. Midgette himself was taking LSD before his

scenes, and practising a discipline of calmness in the face of on- and off-screen chaos.

Billy Name, who also thought the 24-hour movie was 'tacky', a favourite Factory put-down, had talked Orion – one of the three self-described witches who had shown up at the Factory with the mole people – into costarring with Midgette in one sequence, filmed on a couch beneath a magnificent crystal chandelier in the classical guitarist Andrés Segovia's elegant apartment. This was typical of the film's overall content. Allen Midgette:

> Andy had been after Orion for years to get her on film and she had always refused because she didn't really like Andy very much at all, but she agreed to do it for Billy as long as it was just with me. When I arrived she was already on pretty strong acid and then I took acid. I knew that this was one of those scenes that was going to be heavy duty. Orion was a very strong woman and I knew how she felt, so I just sat there. Orion was sitting on a couch and I was sitting on a chair and there was a huge bouquet of flowers and we were just staring at each other through the flowers and we weren't saying a word. And she insisted on playing Maria Callas at full volume. Paul kept whining, 'Well, you know, ah, we don't have the rights to that music and, uh, you know, at least turn it down.'
>
> Orion said, 'Darling, the stipulation was that I could do anything I wanted to do and that I didn't have to do anything I didn't want to do so just shut up and listen to the music.' And we just continued to look into each other's eyes.
>
> The soundman was lying on the floor and he said, 'It's like you're in heaven and these people are on earth,' and it was. Then Paul fell asleep and started snoring. We didn't care. We were really not trying to impress him or Andy.
>
> Finally Paul started saying to Orion, 'It's very boring. We gotta do something. You gotta have sex or something or fight with each other.'
>
> Orion just looked at him and she said, 'Oh, really?' There was a machete on the wall and she picked it up and hit the chandelier and the glass went flying. I will never forget the image of Andy standing behind the camera, whiter than he normally is, frozen behind the camera with little pieces of glass on his shoulders and he could not even speak, he was so terrified.

<p style="text-align:center">*</p>

The day after Andy threw Richard Green out of his house and changed the locks, he started going out with a gawky, nineteen-year-old, kingsize Texan named Rod La Rod who was, he told everyone, going to be his next big thing. According to Ultra Violet, Rod La Rod claimed to have two gods, the governor of his home state, Alabama, George Wallace, and Warhol, whom he called 'the Great White Father'. It was an established rule that nobody touched Drella, yet part of Rod's attraction to Andy was regularly displayed in bizarre fights, in which he and Andy would slap and punch each other. 'It appeared to be a physically violent relationship,' said Gerard, 'but Rodney was always

very corny about his physical overtures towards Andy. It wasn't like he slugged him, they were always love taps, or Andy pushing him away or trying to block the punches.'

'They'd have these fist fights right on the set,' said Ondine. 'They'd smash each other to ribbons. Then they'd make up. It was just wonderful. They'd found each other.' Ondine had never seen Andy so completely in love, so sensitive and mature towards his love object at the same time as being so wild and histrionic about him. 'He was just absolutely unashamedly in love with him and he would act accordingly. Andy was so giving and so generous and so understanding to Rod I was amazed. They were divine.'

Billy was jealous of the attention Andy paid to Rod La Rod. He would pace up and down so frenetically whenever Rod came to the Factory that Andy would finally have to ask him, 'Billy, what's wrong?' By then Billy was so upset he refused to answer. Normally he was totally supportive of whomever Andy wanted to be around, but seeing Andy physically threatened by Rod made him very uncomfortable.

Rod was neither one of Andy's impossible-to-attain beauties nor one of his quiet, easily dominated houseboys. He was not much to look at, an ungainly hippie hick in his bell-bottom trousers which were always too short, and shirts with clashing stripes. Paul, Gerard and most of the others in Andy's inner circle found Rod La Rod corny and oafish. 'It was like the king taking the cow girl, the shepherdess into the royal chambers,' commented one of Warhol's friends acerbically. Andy specialized in drawing out the worst in people so they were used to assholes at the Factory, but most of the people had something to recommend their fallen-angel act, like a tragic rap or torn beauty. Rod had neither, but Andy took him everywhere with him. It was 'really exciting' to have Rod around, he said, 'lots of action'.

That May, Andy was planning to attend a screening of *Chelsea Girls* at the Cannes Film Festival along with a large entourage of his super-stars, for whom the three-week trip was to be their payment for working on his films. The entourage was to include Rod La Rod, Gerard Malanga, International Velvet and her boyfriend David Croland, Paul Morrissey, Lester Persky – who had persuaded Morrissey that they needed him to 'make the deal' – and, surprisingly, Eric Emerson. It was typical of Andy that, rather than getting rid of Eric, he would encourage him to greater heights of eccentricity. Allen Midgette was invited to come with the others but, bored of 'Andy's playpen', he asked for a ticket to San Francisco. 'Not only did I not want to make movies with Andy,' he said, 'but I was not interested in being involved with him.'

The French still saw Warhol in epic terms. 'He reigns over a sunless palace,' wrote Jean Clay in *Realité*, 'the Caligula of the underground movement . . . Warhol emerges as a kind of Hamlet of the consumer

society, a rat in the ship of affluence. He could be a character from a Genet play. At the same time he is perhaps also, in his own way, a prime witness of our era.' Andy in turn found the French and their cinema boring. He particularly disliked Godard's new work.

Cannes was a fiasco. Word of mouth had labelled *Chelsea Girls* a perverse celebration of madness, homosexuality and hard drugs, and without even seeing it Louis Marquerelle, the official in charge of screening the Critics' Choice films, who was already nervous about the dirty language in that year's English production of James Joyce's *Ulysses*, opted not to show the Warhol film after leading them on for a week to believe he would. 'Andy was definitely annoyed and upset,' Gerard Malanga recalled. 'He felt snubbed.'

Warhol and his entourage got a lot of publicity but spent a boring week at Cannes, enlivened only by a dinner at Brigitte Bardot's villa, which Andy particularly enjoyed, and parties honouring Antonioni's *Blow-Up* which premiered at Cannes, and seeing Brian Jones and his girlfriend Anita Pallenberg, who was appearing in one of the German film entries, for which Jones had composed the soundtrack.

By the end of the week the Warhol entourage had begun to thin out. Eric Emerson left for London, and Malanga, bored out of his mind after spending a few days water skiing and several evenings on a yacht with Bardot's ex-husband, Gunter Sachs, flew to Rome in failed pursuit of Benedetta Barzini. He rejoined Andy and company for the rather unsuccessful premiere of *Chelsea Girls* in Paris, which was memorable largely because the French critic Jean-Jacques Lebel led a walkout in the middle of the screening.

Taylor Mead, who had been living in Europe, showed up at the Paris Cinemathèque and was awed. At a reception after the premiere, Andy asked Taylor to work with him again on films at the Factory, and Mead accepted, ending what had been a three-year self-imposed exile.

Before returning to New York, a final stop was scheduled in London so that Warhol and Morrissey could meet with the Beatles' manager Brian Epstein and Paul McCartney to explore the possibility of gaining their backing for a British tour by the Velvet Underground, and future film projects. The meeting was arranged by and held at the apartment of Robert Fraser, Warhol's British art connection, a hip, good-looking member of London's growing underground, who had been arrested with the Rolling Stones in a much publicized drug bust several months earlier and was about to go on trial. His connections to London's beautiful people were of natural interest to Andy, who had yet to mount an exhibition of paintings or show his films in the UK, and Fraser was close enough to one member of Warhol's entourage to have given him the clap.

Epstein and McCartney, while interested in the Velvets' banana album, were much more involved at that time with the imminent release

of *Sgt Pepper's Lonely Hearts Club Band*. McCartney brought along the album's pop-art cover by Peter Blake to show Warhol, but seemed otherwise mainly concerned about soliciting their help in getting Nico out of his house, where she had been staying that spring, before his future wife, the photographer Linda Eastman, arrived for a visit from America. Little else of substance was discussed at the meeting and Warhol and Morrissey came away empty-handed. To McCartney's relief, though, Nico left with them for the return trip to New York, where new disappointments waited.

On the night of their arrival, Andy, Paul and Nico flew up to a Velvet Underground concert in Boston, but by then Lou Reed had hired a new manager, Steve Sesnick, and the band refused to let Nico join them on stage. The aftermath was bitter. Warhol told Reed over the telephone that he was 'a rat' for breaking their agreement, and Morrissey accused him of stealing the Factory's share of the banana album's profits and called him 'a creep'. Reed, for his part, told reporters that he 'was never a great friend of Andy's' and 'I fired Warhol!' Thus the collaboration that had sparked the firestorm of the Exploding Plastic Inevitable ended in recriminations.

And by the end of May, the bloom was also off Andy's unbounded but bizarre love affair with Rod La Rod. When Taylor Mead returned to the Factory to begin working with Andy again, he was astounded by Rod's behaviour. 'I almost punched out Rod La Rod because he came on to Andy, who I considered rather frail, in such a terribly rough way,' he said. 'No one else handled Andy like Rod. He would grab him and hug him and Andy would look pleadingly and I'd scream at Rod. Then Brigid would say, "Oh, they love each other." '

Ondine, too, had begun to counsel Andy to 'get rid of this trick. Andy would cry. Finally, he actually approached us and said, "Do you think I should?" And we said, "Yeah, plain dump him because he's a monster." Andy was the only person I've ever met who took his friends' advice about love, and he dumped him.' To another friend Andy confided that he had been hurt so often he didn't even care any more. 'It's too sad to feel,' he said. 'I'm really afraid to feel happy because it never lasts.'

*

The Factory was more than ever a gathering place for hangers-on with pretensions to underground movie stardom. The place was a mess, equipment was getting lost, expenses for the growing entourage were running high, and the would-be superstars were freaking out and blaming Andy for their frustrations. Even so he routinely ignored Morrissey's appeals to run a tighter ship, professing an inability to understand why they were running into so many difficulties.

One night, shortly after Andy returned from Europe, Ivy Nicholson, who had appeared in fifteen hours of the 24-hour movie, started

screaming and throwing food at Max's. She was a tough, violent and hysterical woman who could easily have beaten him up. Turning on his heels, Andy ran out of the restaurant, hopped into a cab and told the driver to take him home. The cabbie was the art critic Ted Castle, who, at Andy's suggestion but without telling him, had installed a tape recorder in the front of his cab and caught a rare unguarded monologue:

So Ivy was, you know, she called me up and said, uh, you know, uh, I'm going to Mexico right now and, you know, can you give me some money? I'm getting a divorce and I'm coming back and marrying you, and I said, What? You know, and I decided that, you know, everything is wrong and I decided that we're going to get organized and really do things right and try to, you know . . . and nobody can sit around the Factory, they have to sweep or clean up or if they don't they have to leave. And so, you know, everything goes wrong . . .

As he left the cab, Andy was worried that Ivy might be waiting for him outside his house. 'I can't figure out what she really, really wants,' he told Castle.

Andy's method at the Factory had always been to do whatever was offered, so in July 1967 when Paul Morrissey got a phone call from the owner of the Hudson Theater, Maury Maura, asking if they had any exploitation films he could run, they gave him *My Hustler*.

By then, almost a year after *Chelsea Girls* had made its impact, the New York press were beginning to treat Warhol as a serious filmmaker. 'The sound is not good enough for you to distinguish all that's said, but it's enough to give you most of the ideas, which are specific and practical,' wrote Archer Winston in the *New York Post*. 'Warhol is adept at using non-actors whose lack of theatrical skill makes the realism of their being wholly convincing.' That same week the *New York Times* reviewed highlights of the *24 Hour Movie* screened at the Factory:

The method is superimposition: three projectors are focused simultaneously on a single screen. As one projector reels off a far-out party scene, for example, another projects the oversized face of a man eating. On those two images may be superimposed a third scene involving an amorous couple. The sound track has superimposition, too, so that electronic squawks can be mingled with murmured dialogue.

In this interested atmosphere *My Hustler* drew large audiences.

Three weeks later Maura was back on the phone. 'Ask him what he wants,' Andy told Paul.

'Give us something like *I, a Woman*,' Maura replied.

'OK,' said Andy, 'we'll do *I, a Man*.'

Thus began a trilogy of feature-length Warhol–Morrissey comedies,

I, a Man, *Bikeboy* and *Nude Restaurant*, which would lead Andy towards what would be his ultimate success in 1970 with *Trash*.

I, a Man is not a particularly good or funny film, but it stands out historically because the best performance in it was given by a young lesbian and women's-liberation pioneer, Valerie Solanas, who had a small reputation on the scene as the leader of an organization called the Society for Cutting up Men and the author of a mimeographed rant of a pamphlet called 'The SCUM Manifesto', which she sold on the streets. A self-described man hater, she declared in her manifesto that 'males can't love and all the evils of the world emanate from this male incapacity to love', and advocated the elimination of the male sex as a means to world peace.

Earlier that year Solanas had come by the Factory and given Warhol a script called *Up Your Ass* which she hoped he would film. 'I thought the title was so wonderful and I'm so friendly that I invited her to come up with it, but it was so dirty that I think she must have been a lady cop,' Andy told Gretchen Berg. 'We haven't seen her since and I'm not surprised. I guess she thought that was the perfect thing for Andy Warhol.'

By the time he returned from Cannes, Solanas had become impatient and wanted her script back. When Andy told her that he had 'lost' it she started calling regularly asking him for money. Finally he said she could come over and earn $25 by being in one of his movies.

Many people who knew or worked with Andy over the years said that he was almost incapable of saying no. He had never had any intention of doing anything with Valerie Solanas's script, but his purpose in holding on to it was not so much an attempt to deceive her as to encourage her by showing interest. People gave him proposals every day. Most of them ended up in the slush pile of unanswered mail and other papers that lay around the Factory like a teenager's forgotten homework. Valerie's script had joined them.

Since 1964, when Warhol began collaborating with large numbers of 'crazy' people, he seeemd to know that he was blessed. By 1967, he had grown hardened by the success of his callousness. Less aware of the people he was manipulating, he could misjudge their reactions.

Tom Baker, who played the male lead in *I, a Man*, recalled the atmosphere on the set:

The first time I sensed impending danger was during a scene with Ivy Nicholson. She had stipulated that she would not appear on camera with me in the nude. Shortly after the scene began I walked out of the frame and removed the towel I was wearing in order to put on my pants. Clad only in unlaundered bikini underwear, Ivy exploded in an emotional fury and stormed out of the room in tears, claiming she had been betrayed. I was

talking with Warhol, who was very much perplexed by Ivy's behaviour, since, as he casually pointed out, 'Ivy'll cut her wrists for me . . .'

My third scene was with Valerie Solanas. I felt no personal threat from Valerie. Just the opposite. I found her intelligent, funny, almost charming, and very, very frightened.

Frightened or not, Valerie was good in *I, a Man* and Andy liked her performance because she was honest and funny. Valerie, too, had seemed pleased. When she took the publisher Maurice Girodias to the Factory to see a rough cut of her scene several days later, he noted that 'she seemed very relaxed and friendly with Warhol, whose conversation consisted of protracted silences'. However, Valerie had soon started complaining bitterly about Andy again. He was a vulture and a thief, she told Girodias, adding, 'Talking to him is like talking to a chair.'

Andy had been spending a lot of time with Nico, who also appeared in *I, a Man*, pushing her as a solo act and doing publicity stunts with her. She recorded a solo album called *Chelsea Girl*, and sung solo now in the basement of the Dom.

'Andy likes other people to become Andy for him,' Nico said. 'He doesn't want to be always in charge of everything. He would rather be me or someone else sometimes. It's part of pop art, that everybody can impersonate somebody else. That you don't always have to be you to be you.'

Andy never developed the kind of rapport with Nico that he had with Edie. For all his talk of beauty and glamour, Andy had always admitted that he liked good talkers best. Nico had a wonderful presence. She was mysterious, intuitive and fascinating to be with, but she was no Brigid Polk in the rap department. She was on different drugs. Edie and Andy had been able to communicate on the speed that made them look so alike. Nico's use of LSD and heroin tended to distance her from Andy's mentality. Worse, Nico was a star in her own right and was not completely dependent on Andy, although she was somewhat identified with him. She spent a lot of time with Jim Morrison, Bob Dylan and Brian Jones. She was beginning to get sidetracked by drugs and was not as dedicated to her career and ambitions as Andy wanted her to be. Even Paul Morrissey, who thought Nico was the most beautiful woman in the world, was becoming impatient. It was time, once again, for Andy to find a new girl.

That summer, Susan Hoffman, whom they renamed Viva, entered the Factory spotlight as Andy Warhol's latest superstar in *Bikeboy* and *Nude Restaurant*. A painter who gave up painting for acting when she met Andy, and a talented writer who began collaborating with Paul on scripts, Viva was strikingly beautiful. Her face was delicate, aquiline and aristocratic and her hair was worn in an individual frizzed-out style. But best of all, as far as Andy was concerned, she complained

endlessly about personal things that no respectable woman talked about in public, with an upper-class langour which Andy began to imitate in his own speech. According to Ultra Violet, 'she complained about having no sex, she complained about restaurants and lousy food, she complained about being depressed, she complained about the word "artist", she complained about people hanging up on her, she complained about male chauvinism, she complained about getting phone calls from weirdos, she complained about Andy's way of stirring people up to fight, she complained about being called a brainless nincompoop.'

Viva was a natural and, more self-possessed than Edie, she had, at least for a while, some idea of how to handle her new-found fame. She also had a better understanding of what Andy was doing:

> The Warhol films were about sexual disappointment and frustration. The way Andy saw the world, the way the world *is*, and the way nine tenths of the population sees it, yet pretends they don't. In Andy's movies women are always the strong ones, the beautiful ones and the ones who control everything. Men turn out to be these empty animals. Maybe the homosexuals are the only ones who haven't really copped out.
>
> The feeling that we were on to something good led us to approach this seemingly random improvisational method with a contagious enthusiasm and a deadly seriousness that we tried hard to hide. In actuality the whole scene, including Andy's direction, was extremely stiff. Andy's role was like that of all directors, to play God.

<p style="text-align:center">*</p>

By August the mood of the Factory was changing. Paul Morrissey was having cubicles installed to encourage a business approach. Andy was looking for new directions. Gerard Malanga, who had been there since the beginning, was feeling burned out by the Warhol machine. Andy told him his problem was that he did not have enough to do to keep busy. Gerard resented Andy's inquisitiveness about everything he did. He was also finding Andy's constant search for publicity increasingly contemptible. 'Gerard had this tremendous ego,' said one observer. 'He thought he was so wonderful and all these girls liked him and he really played it to the hilt. He was always after women constantly.'

Gerard was making a move to become a star himself, filming his own underground movies, publishing a book of poems, and demanding the rights to certain materials. This made Andy nervous. As Mary Woronov saw it, 'Gerard was frustrated by his lack of power and got aggressive, but when he wanted too much he was thoroughly tortured by everyone. They'd just blow him up. Especially Warhol. He'd have him crying.'

Gerard wrote in a letter to Allen Ginsberg:

> It seems the only way I can have Andy come to terms of respect and equality with me is if I alienate myself from the entire Factory scene which has been

the snake pit of too much dishonesty, paranoia, competition, personal profit – the scene of too many throats being cut I have witnessed, walking away, always saying to myself: 'Do Andy and Paul know what they're doing?' I've come to the conclusion that they know too well what they're doing.

One of the people who began to suffer the most from Andy's lack of attention was Billy Name. After four years of devoted hard work, for which he had been paid an average of $10 a week and given a place to live, Billy could see that Paul Morrissey was usurping his position as manager and easing him out by convincing Andy that Billy was a lunatic. Billy's habit of spraying everything silver – including the dust and dirt – was beginning to drive Paul crazy. 'It was hideous,' Morrissey recalled, 'because after a very short time all this silver paint would become powder and there was silver powder in your hair and in your lungs and you couldn't clean.'

Billy became concerned enough about his position to tell both Andy and Paul that he wanted to be legally and technically included in whatever corporate structure they were developing. 'The next time you take a step, please include me in it,' he said, 'because I feel that what I have done is significant enough I can request that.' Andy said OK, but the subject never came up again. Billy's closest friend, Orion, constantly attacked Andy, but Billy replied vehemently, 'I'm surprised at you, Orion! You're wrong! Andy is *not* cruel to me. He is my benefactor. He is kind to me and loving and he gives me a home.'

The flak that Andy was catching was not just coming at him. The mood of the country changed drastically in 1967, partly through the advent of the professional drug dealer. As the mixed-media pioneer Stewart Brand recalled, 'In a very few months it went from disorganized crime to highly organized crime, and a lot of freelance dealers who were part of the community ended up dead. Suddenly things got ugly.'

'There was a lot of violence going on all over the place,' said Ondine. 'It wasn't just at the Factory. It was a whole change. The sixties had lost their edge and their bloom. It was beginning to get very decadent very, very quickly, and it became very grim.'

The truth was that rather than heralding in a new era, the famous Summer of Love marked the end of the innocence of the sixties. Riots killed forty people in Detroit. The Vietnam War raged unabated. The government became increasingly unpopular. The economy suffered through a recession. A lot of people began to take advantage of the thousands of young people walking around in a haze who were very easy to take advantage of.

At the end of August, *Chelsea Girls* was to open in San Francisco and Los Angeles. Andy planned to attend both premieres with a number of his superstars. When Malanga discovered that he was not to be included on the trip he asked himself, 'What the fuck is going on here?'

This was after all their biggest film and he was one of its stars. He was pissed off, hurt and confused. However, he had received an invitation from the Bergamo Film Festival in Italy to show one of his own films there. Seeing a neat way out of his dilemma he accepted the invitation, which included a one-way plane ticket. On hearing this Andy, who did not like to see his stars succeeding on their own, said, 'Oh, come to San Francisco with us!' Gerard refused. Andy said, 'Well, if you have any problems I'll send you the money for the plane trip back.' Billy Name, who admitted that he had 'never been really openly supportive of Gerard', called him over to his magic desk just before he left and gave him a kiss on the forehead, because he wanted him to 'know that I cared for him, and Andy loved him too'.

Paul Morrissey's influence continued to have a divisive effect on the exploding Warhol entourage that flew west, which included Ondine, Ultra Violet and Joe Spencer, who was starring in *Bikeboy*. Allen Midgette, Nico, Orion, Patrick Tilden and Rod La Rod were already out there. The film was a success and the swaggering Warhol gang cut a swathe through the scene wherever they went, but a conflict quickly emerged between the film team, who were looking for locations to shoot the 24-hour movie, and the hippies, to whom Warhol and Morrissey were just another group of New York hustlers trying to rip off or mess up the peaceful scene. 'These are things that people do not like to hear,' said Midgette, 'but when people were not interested in Andy there was no way he could film them, because people were not just being themselves in his movies.'

Andy's observation on the hippies was, 'Somebody could take over and begin telling these people what to do. And that's probably what they want.' This is, of course, exactly what Timothy Leary, Abbie Hoffman and Allen Ginsberg were doing.

Despite Warhol and Morrissey's view of the hippie philosophy at least half the entourage, Midgette, Orion and Ondine, were deeply involved with their alternative lifestyle. This led to a crisis when Midgette showed up for a press lunch at the elegant Trader Vic's without any shoes and Morrissey told him that he could not come in.

The next day, when Andy and Paul went to pick up Ondine to go to the airport, he turned on Andy and let him have a dose of his Pope's rage. 'Don't you realize who you are?' he screamed. 'Don't you realize that you can't do anything wrong? That everything you do at this point is touched with magic, that you could have people eating shit on the stage and people would applaud it? What's the big deal about someone not wearing shoes? You make your own rules! You're the original American genius.'

THE MOST HATED ARTIST
IN AMERICA
1967

Andy was born with an innocence and humility that was impregnable – his Slavic spirituality again – and in this respect was a throwback to that Russian phenomenon the yurodivyi *(the holy fool): the simpleton whose quasi-divine naïveté protects him against an inimical world.*

JOHN RICHARDSON

Some time in the autumn of 1966 Warhol had been asked to screen a film and give a talk for the film society of Columbia University in New York. He chose to show them *Blow Job*. As a result of the film's title and the success *Chelsea Girls* was then having, the screening drew an enthusiastic, standing-room-only crowd. The film critic Rex Reed, who attended the event, described what happened:

> Warhol himself was in the audience and had promised to speak at the end of the film. The audience sat attentively during the first few minutes of the film, which showed a boy's face. That's all. Just a face. But something was obviously happening down below, out of camera range. The audience got restless. The put-on was putting them down and they didn't like it. (Some of them began to sing 'We Shall Never Come'.) They finally began to yell things at the screen, most of them unprintable. Total chaos finally broke out when one voice (a girl's) screamed: 'We came to see a blow job, and we stayed to get screwed!' Tomatoes and eggs were thrown at the screen; Warhol was whisked away to safety through the raging, jeering, angry mob and rushed to a waiting car.

Malanga's response could just as well have been Warhol's. 'It was certainly an aggressive audience,' he said. 'It was also a condescending audience. I had a ball!'

Thus it was that Warhol, who knew better than anyone the value of negative publicity, agreed to tour college campuses around the country in the fall of 1967. By then he had worked out a programme that would annoy the students even more.

The controversy over the war in Vietnam was at its height. Although the vast majority of American students were in favour of the war, the

universities had become the biggest supporters of radicals like Abbie Hoffman, Timothy Leary and Allen Ginsberg, who regularly resupplied their campaign chests with lecture tours at $1,000–$2,000 per engagement. Just as most students had never read a line of Ginsberg's poetry or taken the dread LSD that Leary was promoting, hardly any of them had ever seen a Warhol film or painting, but they all knew who he was, and they went to his 'lecture' to see him and hear him speak. Hence their disgust when they were presented with a completely mute, noncommunicative Andy Warhol.

The Warhol road show typically included a segment of his most boring and worst film, *The 24 Hour Movie*, after which Paul Morrissey gave a brief speech and Viva answered questions. Andy stood on stage, togged out in his uniform of leather jacket and dark glasses, totally passive, saying nothing even when questions were insistently screamed at him. In Viva's view, they were like Spanky and Our Gang, with Andy as Alfalfa.

Andy stood on the stage, blushing and silent, while Paul Morrissey, the professor, delivered a totally intellectual anti-intellectual rapid-paced fifteen-minute minilecture putting down art films, hippies and marijuana, saying things like 'At least heroin doesn't change your personality'. Then I, as Darla the smart ass, answered questions – 'The reason we make these movies is because it's fun, especially the dirty parts' – and advised them to drop out of school. Then I would rant about everybody in authority.

The put-ons and put-downs of the Warhol lectures did not score well with the students, who often responded by hissing and booing.

They really hated all of us, but they especially hated Andy. They were always hostile. But afterwards there would usually be a little clique who would come up and say, 'Come to our house.' Once, on the way to one of these parties, students on the roof of a college dorm picked up huge chunks of ice and threw them down at us. Andy was totally blasé. I think he liked it. He always said, 'Everything is magic!' That was his favourite *explication de texte*. I think Andy was totally in the clouds. Totally on a different plane, didn't really give a shit and just let things happen to him.

Back in New York, Billy Name was getting the same sort of flak at the Factory:

People from the peace movement would come up to me and say, 'You're not for peace and harmony, fuck you, man. You're doing this pop hustler stuff.' They considered us to be totally antithetical to what they were doing. We were exposing the culture, what the mass of America was devoted to. So they thought we were the dregs of humanity, the end of western civilization.

Around this time Warhol was going to Max's Kansas City every night,

'the only prominent quasi-assfuck/pudsuck bar in town also to serve decent food,' wrote the rock critic Richard Meltzer. Andy always occupied the corner table in the back room – 'the captain's table' Malanga called it. Warhol, who hardly ever talked in public, held silent court among the faithful in a grouping that one photographer with an eye for composition thought of as 'The Last Supper'. 'I used to see him every night in Max's,' the artist Richard Serra recalled.

> Warhol was already a historical figure. His people were making up their own tradition – and it freed all of us. He gave us a larger permission, a greater freedom to look at a larger reference in American culture. Everybody understood that he was right on the edge, completely awake. He was a strange and wonderful presence.

By now even the back room of Max's had been politicized into two camps, with a popular New York disc jockey named Terry Noel on the right side of the room and Andy's crowd on the left. There were frequent chick-pea fights between the two contingents. Noel, as the self-appointed leader of the anti-Warhol forces, had visited the Factory several times with urgent appeals to change, imploring Andy, as he recalled:

> 'Don't you know what you're doing is wrong? Don't you think there's such a thing as right and wrong? Why are you letting all this negativity be your driving force?'
> Andy wore tight black pants and always sat with his legs crossed and black boots and the wig on crooked. He was not at all elegant. He was a scrubby beatnik, he might as well have had a little bongo drum around his neck. But he was constantly being criticized for doing absolutely nothing and getting away with it, for doing garbage and getting away with it.

Andy would listen impassively, but the Factory dog pack didn't take kindly to the sermons, and Terry had finally given up on his effort to save Andy after Paul America crashed a party at Noel's apartment and systematically slashed all the guests' coats with a hunting knife.

> I'd had it up to here telling Andy how I felt. It was all over by then. We were on opposite sides of the line. Everybody I knew thought he had no talent whatsoever. He had acquired this unbelievable mystique by letting insanity go on around him, but he absolutely destroyed everybody around him and the hatred for Andy got real serious.

In Italy, after sending numerous unanswered telegrams and letters to Andy asking for a return ticket to New York, Gerard Malanga received a somewhat alarmist letter of warning from his old friend Willard Maas:

> I hope you stay there and do not come back for a long time, as the cops are

after Andy, or should be. Edie Sedgwick, superstar like you, is in the hospital having shock treatments from taking drugs which she says came through Andy! I think the jig is up for all your crowd. Keep away from New York!

One night Andy saw Valerie Solanas huddled at another table at Max's and encouraged Viva to go over and talk to her. 'You dyke!' Viva said. 'You're disgusting!' Valerie immediately told Viva her life story about how her father had gone down on her when she was eight and how good it was. 'No wonder you're a lesbian,' Viva responded. 'No man could ever be better than your father.'

Many of the girls at Max's looked up to Andy as father or father confessor. Viva saw Rona Page (who had been in *Chelsea Girls*) kneeling at his feet one night begging him to marry her. Later on Viva received an urgent call from Andy asking her to come over to his house and get Rona out of his back yard where she was kneeling in prayer to him.

'There were so many crazy little girls who were in love with me and I never even talked to them,' Warhol recalled. 'They were all on acid trips and it damaged their brains and they never came back.'

'Andy really had a terrible time for a while with kids crawling over that back fence trying to get in to see him,' said John Warhola, 'and he had to get a burglar alarm and a security system put in.'

The gossip at Max's was often laced with threat. One night the poet Gregory Corso, who was friendly with Edie, came up to Andy's table and ranted:

I know you, mister, and I don't like you. I know all about how you use people. How you make them superstars of New York and then drop them. You're evil. And you know what else? You never give anything away. You know what's wrong with you? Too many lonely women are in love with you. You use them. You give them dope and then you leave them. I'm glad I'm not in your faggoty scene. It's all show. I see that beautiful blond, angelic face of yours and it's got a snarl on it. It's an ugly face.

Andy sat staring straight ahead as if he hadn't heard a word, but according to the journalist Jane Kramer, Allen Ginsberg, who was sitting next to him, noticed 'a trace of a sad expression had settled on his face. Flinging his arms around Warhol and enveloping him in a long, happy hug, Ginsberg shouted, "You've got feelings!" '

*

Andy Warhol's career owed a lot to the number of occasions on which he met the right person at the right time or was in the right place at the right time. In the fall of 1967 when things were not going so well for Andy Warhol Enterprises, he became involved with the man who would play the biggest role in his career for the rest of his life.

Frederick W. Hughes was utterly different from most of the characters who hung around Andy at the Factory. In fact, if you wanted to find

the opposite of Ondine you would have to look no further than Hughes. A Rudolph Valentino look-alike, elegant, dapper, charming and worldly, he had been born and brought up in the most ordinary of circumstances in Houston, Texas, until the powerful de Menil family – the greatest art collectors in the United States – had taken him under their wing as a teenager, recognizing his natural talents, good taste and sharp eye for a good picture. By the time he met Andy Warhol, Hughes, twenty-two, the son of a travelling salesman, had transformed himself into a patrician snob who claimed to be related to Howard Hughes and to be descended from aristocracy. Warhol – who said, 'I prefer to remain a mystery, I never like to give my background and anyway, I make it all up different every time I'm asked' – must have recognized something in Hughes, for shortly after meeting him he drew Fred into his world with the suction of an octopus. Before long, Fred Hughes was running 'the business'.

Andy must have breathed a sigh of relief as he climbed aboard Mr de Menil's Lear jet that fall for a fast trip to Montreal to see his new self-portraits hanging in the American pavilion at Expo, for this way lay his future and at last he had somebody selling his art who knew what he was doing. For although Andy said he was glad to be at Castelli's, Elinor Ward had been right in warning him that Leo would not treat him with the same attention he fostered on Jasper Johns. During 1967, when Warhol's fame was at its height, Castelli only sold $20,000 worth of Warhol paintings, less than what artists like Johns and Rauschenberg were making for one canvas. Fred Hughes got there just in time.

'Castelli never sold a lot of Warhol paintings,' explained Fred Hughes, 'that's where *I* came in. What I did is *do*. It wasn't like a normal corporation, taking over the reins and that kind of rubbish. I came in and I was doing. I had a very interesting job with the de Menils' art foundation and I continued to work with that foundation.'

Furthermore, Hughes seemed to understand Warhol better than anyone else who ever worked for him. Whereas Billy Name, Ondine and Gerard Malanga were absolutely devoted to Warhol (and would have died for him under the right circumstances), their understanding was limited by their own needs as artists. To them he was a film director who had made Ondine and Malanga superstars and promoted Billy Name as one of the sharpest photographers of the decade as well as a name to be reckoned with in any account of the New York scene as a black magician. Fred saw a much deeper and broader picture.

The first thing Fred did was sell a lot of Andy's early works which had been ignored – the hand-painted pictures of advertisements and cartoons and the death-and-disaster series – to the de Menils, as well as getting a commission from them for Warhol to film a sunset. Next he started getting Warhol portrait commissions at $25,000 a shot. 'The

first portraits that got going were through the de Menils or through a particular friend of mine, Doris Brynner, Yul Brynner's ex-wife,' Fred recalled. 'She was a social friend and she got a lot of great people for us to do just for the fun of it.' Warhol's career shifted into a new gear. With Hughes at the helm, painting could pay the bills.

As a mark of his esteem for Fred, Andy immediately introduced him to his mother. Julia was so taken with the well-groomed, polite young man, quite different from anybody else Andy had brought around recently, that she dubbed Fred 'the Priest'. This was her highest accolade and showed that her judgement and intuition were as sharp as ever. Fred Hughes was going to help her Andy.

<center>*</center>

Many of Andy's friends were struck by the fact that he never seemed afraid of the explosive, demented people he hung around with. Back in 1964 when Dorothy Podber had stalked into the Factory, pulled out a pistol from her black leather jacket and shot a bullet through the stack of Marilyn portraits, it had been the kind of 'event' people accepted in those days and Andy had hardly reacted. In 1967, however, there were several instances of people coming into the Factory and shooting off guns in a threatening fashion. Ronnie Tavel:

> He asked me back after he got rid of Edie and Chuck and I wrote the whole script of *Jane Eyre Bear*, which was a three-hour film that never got produced because Huntington Hartford III, who was supposed to put up the money, came in throwing around guns and shooting at the ceiling at ten o'clock in the morning. I knew he was drunk because I had had breakfast with him and he had been drinking. I thought, Well, he likes me but don't bullets bounce off the ceiling? Something's going on here that's too weird.

Early one evening in November, a friend of Ondine's whom nobody else at the factory knew, called Sammy the Italian, ran in waving a gun and made Andy, Paul, Fred, Billy, Taylor, Nico, and Patrick Tilden sit in a line on the couch. Telling them he was going to play Russian roulette, he put the gun to Paul Morrissey's head and pulled the trigger. When nothing happened, they all thought he was just auditioning for a film role. 'You're just so absurd, you're not even good,' Taylor told him, but when Nico got up to leave, Sammy fired the gun at the ceiling, and this time it went off.

Andy was sitting silently on the couch staring at the gunman as if he was watching a movie. 'It was so awful,' recalled Taylor, 'he was such a fucking schizophrenic I just don't think he believed it.'

Sammy then demanded money and started to cry. He said, 'I don't want to do this, Andy. Here, someone take the gun,' and he handed it to Patrick Tilden, who said he didn't want it and handed it back.

The most frightening moment came when Sammy put a woman's

plastic rainhat on Andy's head, made him kneel, and said he was going to take a hostage. At that point Taylor 'got so offended that this little punk had Andy, whom I loved and considered a genius, kneeling on the floor with a gun pointed at his head that I jumped him from behind'. After a brief struggle the gunman ran down the stairway to the street, while Taylor broke the window and screamed, 'Call the police!'

The police arrived several minutes later. They didn't really seem to believe their story of what had happened. 'Why didn't you film it?' one of them wisecracked.

Billy Name:

We made a decision to call the *New York Times* because we wanted it to be known that this had happend to us. The *New York Times* said, 'No, we don't necessarily believe you. It wouldn't be an important story anyway.' The occurrence itself was very disturbing but the real thud was that no one cared about us. The *New York Times* was constantly saying, 'Andy Warhol, get off the stage, you have had your time, you're not really art.' Andy was very hurt by it. We despised the *New York Times* because it was so cruel to us. It said to many people, This guy is just a joke, go play with him, fuck around, do whatever you want. So people started tending to do that. And Andy didn't like that reputation, he was seriously disturbed by it. He was constantly not understanding why people would treat him that way, giving him that negative image, and why he had to carry it around with him wherever he went: What's wrong with Andy Warhol? Why is everybody taking advantage of this trend to down Andy? He didn't want people to do that to him, and he was hurt and angry that they did it to him for so long.

Warhol was the perfect target for the press that season. Rex Reed described an appearance by Andy on TV:

full of pimples and sores chewing gum in a disgusting close-up while Evil Viva says the trouble with all those boys in prep school is that they talk about sex without getting any. When asked by an idealistic young interviewer what he'd do if a studio suddenly gave him $2 million, he says, 'I'd spend $2,000 and keep the rest.' 'He'd build another church for his muh-thuh,' squeals Viva.

The image Warhol's superstars had in the press is best summed up by Robert Hughes, who wrote:

They were all cultural space-debris, drifting fragments from a variety of sixties subcultures (transvestite, drug, S & M, rock, Poor Little Rich, criminal, street, and all the permutations) orbiting in smeary ellipses around their unmoved mover.

If Warhol's superstars as he called them had possessed talent, discipline, or stamina, they would not have needed him. But then, he would not have needed them. They gave him his ghostly aura of power . . . He offered them

absolution, the gaze of the blank mirror that refuses all judgement. In this, the camera (when he made films) deputized for him, collecting hour upon hour of tantrum, misery, sexual spasm, campery, and nose-picking trivia. In this way the Factory resembled a sect, a parody of Catholicism enacted (not accidentally) by people who were or had been Catholic, from Warhol and Gerard Malanga on down. In it, the rituals of dandyism could speed up to gibberish and show what they had become – a hunger for approval and forgiveness. These came in a familiar form, perhaps the only form American capitalism knows how to offer: publicity.

Imitation of Christ was released in November 1967. Jonas Mekas proclaimed, 'The protagonist and the feeling and the content of the *Imitation of Christ* is pure Warhol . . . Andy Warhol is the Victor Hugo of cinema!' But Warhol withdrew the film from circulation after one performance, and did exactly the same thing to the *24 Hour Movie* after it was shown once in mid-December.

Many of the superstars were outraged that a year's work, for which they had been promised stardom beyond their wildest dreams, had been dismantled so arbitrarily. 'It was unforgivable what Andy did to people!' screamed Taylor Mead. 'Patrick Tilden could have been a superstar! He was the James Dean of the underground. But just on a whim Andy decided not to pursue it. Fassbinder's blood is on his hands too because he did work he needn't have done if Andy had shown his films.'

'When he made the move to work with Morrissey I knew he was no longer interested in making movies,' added Tavel. 'Not art any more. It was a deliberate step out of being serious.'

Warhol's attitude was best expressed by his first book, *Andy Warhol's Index Book*, published by Random House and fêted by its director Bennett Cerf at a big publicity party that December. The *Index Book*, a collector's item today, was a pop-art presentation of the Factory lifestyle. It was mostly made up of high-contrast black and white photographs. There was also a tape recording of Nico and Andy talking about the Velvet Underground album. A desultory, totally noncommunicative interview with Warhol ran through the book.

Two images stood out. One, a two-page spread of a pop-up medieval castle in whose windows you can spot Brigid, Andy, International Velvet and others. Underneath this structure, running across the full spread, screamed the words: WE ARE CONSTANTLY UNDER ATTACK! Two, a large photograph of Andy sitting inside the castle with a woman who looks like one of Charles Manson's followers standing ten paces behind him, pointing a silver pistol at the back of his head.

According to a Factory newcomer, Louis Waldon, 'Andy was getting threatened all the time. It was like people wanted to get rid of him.'

YOU CAN'T LIVE IF YOU DON'T TAKE RISKS

1968

Sometimes when I think about Andy, I think he's just like Satan. He just gets you and you can't get away. I used to go everywhere by myself. Now I can't seem to go anywhere or make the simplest decision without Andy. He has such a hold on us all.

<div align="right">VIVA</div>

In the autumn of 1967, while lecturing in Tucson, Arizona, Warhol and Morrissey had been struck by the peaceful desert ambiance and conceived of a western with Viva as a bareback rider. So enamoured were they of the idea that Paul had jabbered to the local press that their next project would be a western filmed on location in Tucson, called *The Unwanted Cowboy*.

By the time Andy was ready to shoot his western in the last week of January 1968 the title had been changed to *Lonesome Cowboys* and the storyline had Viva playing a rich rancher who runs into trouble with a local gang of cowboys. The rest of the cast was Taylor Mead in one of his best roles as her nurse, Eric Emerson, Allen Midgette and the newcomers Joe Dallesandro, Julian Burroughs Jr (who claimed to be related to the novelist William Burroughs), Tom Hompertz and, as the gang's leader, Louis Waldon. To play the Sheriff Warhol chose the drag queen Francis Francine. The picture was to be shot on location in Old Tucson and at the Rancho Linda Vista dude ranch 20 miles outside the city where John Wayne had made pictures. It was to be in colour, follow a storyline and be edited.

Just before Andy left for Arizona, Gerard Malanga, who had almost been arrested in Italy for forging and attempting to sell a Warhol portrait of Che Guevara, returned to the Factory. Andy was surprised to see him. 'Gee, how was Rome?' he asked. Cutting straight to the point, Malanga apologized for the forgery and tried to explain why he had done it, but Andy's eyes turned to slits of stone as he looked directly into Gerard's eyes and said with a hard, flat finality, 'You should have known better!' Feeling psychically dismissed, Gerard turned on his

heels without a word and walked out. He would stay away for six months.

Transporting the Factory to Arizona at the beginning of 1968 signalled that Warhol was losing his touch with reality. This was after all the *Easy Rider* period. The rednecks of the Southwest would not look kindly on their lifestyles being kidded by the likes of Andy Warhol and his gang of pervert hustlers – which is certainly how they perceived the Warhol invasion of Tucson. By now wherever Andy went it was with not so much an entourage as an army. As well as the actors there were Morrissey, Fred Hughes as producer and soundman, and a gaggle of extras like David Bourdon, who was covering the event for *Life* magazine, and the sculptor John Chamberlain, who showed up for the hell of it with a car thief named Vera Cruise who always toted a gun. And a thickset young stud from San Diego known as Joey had been flown in to stay with Andy. All in all there were some twenty people.

The local press, television and radio had made sure everyone within 50 miles was aware of the presence of this ragtag army of cultural terrorists. On the first day of shooting in Old Tucson a crowd of some 150 people was in attendance to make sure the proceedings did not cross the line of good taste. The sight of Francis Francine as the Sheriff and Eric Emerson teaching Joe Dallesandro ballet steps 'to tighten the buns' can have done little to enhance their faith in the project.

That night after leaving a restaurant where Taylor had made a scene screaming at some local bluestocking that he was a big queen, they were followed by several cars. David Bourdon:

I can't tell you how scared I was. Andy was in the front seat, he wasn't saying anything, but somebody else and I in the back were getting more and more agitated. We tried all kinds of things to shake them. We lost one of them, the other one stayed behind us, and I was just so convinced that they meant harm. As it turned out they were just school kids who had recognized us at an intersection and started following us.

Warhol's simple idea of focusing a camera on a group of people, turning it on and keeping it going until the film ran out was no longer viable. Forced to come up with a new method he began to abdicate his role as director, slowly transferring it in this pivotal movie to Paul Morrissey.

On *Lonesome Cowboys* Paul was doing most of the directing. David Bourdon:

Andy was at the camera doing the actual shooting, filming all the crazy zooms and missing all the action, and Fred was holding the microphone, but it was always Paul on the sidelines saying, now do this, now do that, too much. A lot of the actors objected and I thought they had a good point. Paul was too heavy-handed in not letting them improvise freely.

With Warhol in charge his actors had felt completely safe to let themselves fall into whatever transpired. With Paul giving directions like 'You gotta fight!' or 'Take your pants down!' they were subject to losing faith in themselves, with the result, as Viva saw it, that nobody was reacting or relating to anybody else personally in the film. In his defence Morrissey explained, 'The audience wants to see sex! I thought *Lonesome Cowboys* was comedy comparable to the British Carry On movies – only a very American type of comedy.'

On the second morning Warhol awoke to the acrid stench of gas in his cabin and sprang out of bed to discover that Joey, who only the previous afternoon had lain tranquilly next to him in bed holding hands over the covers as Viva drew their portrait, had tried to commit suicide. Fred Hughes:

> He was a funny kid and he was sort of in the way, but there he was. Andy was disconcerted by it, he didn't like it one bit, but judging how upset Andy was was always difficult. He would get very upset about little things and stamp his foot and have rages, but he did not show that he was terribly upset about big things.

Bourdon remembered Warhol being embarrassed by the incident: 'The kid was just a little groupie and Fred was responsible for putting him on the plane and getting rid of him right away.'

That evening the whole gang were sitting watching television in the main cabin when the door swung open and two real cowboys strode in. Expecting them to whip out shotguns and execute the entire cast on the spot, Bourdon froze again, but it turned out that they just wanted to see what was going on and had been hoping to catch Viva in the act. Asked who would have defended them in the case of such an attack, Bourdon paused before answering quite seriously, 'Taylor Mead.'

Viva's reputation as a nymphomaniac was not unearned on the *Lonesome Cowboys* location. According to Bourdon, who shared the main cabin with her and could hear everything that went on in her room, she slept with every available male in the company, causing even Andy to remind her that she was supposed to 'save it for the film'. So far as Viva was concerned the conflict between Andy, who wanted to maintain an esoteric approach to his films, and Paul, who wanted to commercialize them with what she thought were vulgar pedestrian scenes, was causing the tension between the actors on the set. The characters they were playing in the film seeped over into their real lives, causing at least one instance of real rape, when Eric Emerson got carried away while going over his lines, and in the film an unplanned scene of simulated gang rape. The scene was a complete surprise for Viva who

was, according to one observer, 'being punished by her fellow actors for being too "temperamental" '.

After the rape she stormed off the set screaming, 'Get Ultra Violet for the part. I quit!' There was a simmering competitiveness between Ultra and Viva for Andy's attention and Ultra was having an affair with John Chamberlain, who was also sleeping with Viva during the making of the film.

It was the gang rape that drove the locals around the bend. Ever since the first day of shooting in Old Tucson the Warhol crew had been under surveillance by the local police and a self-elected viligante group who had warned them on several occasions to 'leave town', only to be told by Viva, 'Fuck you!' Almost every day the local sheriff screeched to a halt in front of the main cabin, hauled himself out of his cruiser and proceeded to 'check out' the situation. Amazingly, in all the times Warhol attracted the attention of the police they never bothered to simply bust him for drugs, which would have been dead easy since almost everybody smoked so much marijuana Bourdon had to sweep the seeds and stems off his porch every morning. However, after the 'rape' the surveillance became so disruptive that Warhol decided to return to New York and finish the film there.

The rape scene also prompted some nut to make an official complaint to the FBI. This led to the local office of the agency contacting their New York office to see if they might be able to arrest Warhol on grounds of interstate transportation of obscene material, that is, if he had transported film of a rape from Arizona to New York. Andy Warhol was put under surveillance by the FBI on 23 February 1968.

Andy had a more immediate problem on his hands in Viva (described in the FBI's Warhol file as the White Female), who was beginning to believe her own publicity and demanded more attention from Andy. When she threw a fit at Tucson airport, storming out of the bar screaming for a policeman after the barkeep refused to serve her, Warhol turned to Waldon and moaned, 'Oh, Louis, please do something about Viva, I just can't take it any more!'

In fact, Viva was going through the same experience Edie Sedgwick had, only in a magnified fashion because of the amount of publicity she was getting as part of the 'Viva and Andy' team the press loved to hate. 'I have Andy to think ahead and make decisions,' she told the writer Barbara Goldsmith on returning to New York. 'I just do what he tells me to do. Andy has a certain mystique that makes you want to do things for him. He's completely mastered the art of being egoless. But I love it when they talk about Viva and Andy.'

The problem was magnified by the level of success they expected. Ever since appearing in *Nude Restaurant* virtually naked and complaining in her tired, comic voice about the problems of being a woman in America, Viva had grabbed the media by their balls. In the four fast

months she had worked with Andy Warhol she had become almost as famous as her mentor. She appeared on TV shows and gave interviews to the press as Andy's spokesperson; she travelled with him on lecture tours and even made a lightning visit to Sweden, immediately after returning from Tucson, for his first European retrospective at the prestigious Moderna Muséet in Stockholm. In the view of the media, which mostly turned a blind eye on homosexuality in those days, Viva was Andy's 'woman' just as Edie had been. Indeed, her parents were convinced they were having an affair. In reality, of course, although he was her father-brother-god-fan, Andy was no more Viva's man than Elvis Presley was a health freak. And there lay the problem: she was in love with him. He was in love with *being through her*. On top of that, Viva had never been paid a penny for all the work she had done.

The main difference between Viva and Edie Sedgwick was that Viva did not take drugs and was therefore less susceptible. She was also smarter and tougher than Edie and collared the problem directly. According to Louis Waldon, after Andy and Viva returned from Stockholm Viva proposed to Andy Warhol that they get married. When he turned her down she collapsed in a three-day crying jag and had to be taken care of by Brigid and Louis.

Then, one cold morning in mid-February standing outside the Factory in the pouring rain and unable to get in because she did not have a key, Viva flipped out. Grabbing the nearest telephone and almost pulling it out of its socket in her rage, she called up the Factory and started screaming, 'Get down here right now, you fag bastard, and open the door or – ' at which point the 'fag bastard' in question (Paul Morrissey) hung up. Viva had crossed her Rubicon. You did not call anybody at the Factory a fag bastard without becoming subject to instant excommunication. But she hadn't finished yet. Spotting Warhol himself climbing out of a cab outside the building Viva ran down the street screaming, 'Why don't I have a key to this place? I'm not treated with any respect around here because I'm a woman!' According to Barbara Goldsmith, 'Warhol regarded her, bland as farina, whereupon she flung her handbag at him catching him across the side of the face. "You're crazy, Viva," he said dispassionately. "What do you think you're doing?" '

Two things that were guaranteed to awaken a deeply buried rage in Andy Warhol were to scream at him, 'You're a fag!', or physically attack him in however mild a manner. Andy ducked into the building, slammed the door behind him and rode up in the elevator, shaking with a barely contained rage. It upset him a lot to see Viva lose control, Warhol wrote, because 'after a scene like that, you can never trust the person in the same way again, because from that point on, you have to look at them with the idea that they might do a repeat and freak out again'.

*

By then Andy Warhol Enterprises had shifted its location. At the beginning of 1968 Andy found a new space to move the Factory to just above 14th Street on the fifth floor of 33 Union Square West.

The new place looked more like an office than an artist's studio. It consisted of two large rooms. The front one had clean white walls, polished wooden floors and was furnished by identical high-tech glasstop desks on which stood white telephones and IBM typewriters. The back room, which was slightly less formal, was reserved for painting and screening films.

The new Factory was the creation of Hughes and Morrissey as opposed to Name and Malanga. Paul hired a new full-time employee from Sacramento named Jed Johnson to replace Gerard. Jed and his twin brother Jay were the epitome of what the new Factory was about. Very young, quiet-spoken, sweet and elegant, they looked more like European fashion models than cultural revolutionaries.

The only person from the beginning of the Silver Factory who made the move to Union Square was Billy Name, who had been reduced to a kind of spectral janitor and spent most of his time alone in a small darkroom he built for himself in the back of the screening room. Andy was still playing the latest rock songs on his stereo, screening films constantly, and people flowed through, but some of the old hands found themselves suddenly feeling very uncomfortable when they dropped by uninvited.

The move had been brought on by the Russian-roulette incident. Andy, Paul and Fred, who had some idea of where their future lay, wanted to remove themselves from the druggies and crazies who were spinning out of control as the sixties moved into the final phase. However, Andy could not so easily escape the shadows of his recent past. Valerie Solanas started calling the Factory again, making all kinds of outrageous charges and demands, turning some of them into barbed threats. Nothing ruffled Warhol so much as an ultimatum or a threat. He would shoot his persecutor the kind of look his father used to freeze his three sons with if they laughed on Sunday; 'Andy could *slice* you with a glance,' Malanga wrote. As soon as Valerie started to threaten Warhol he no longer took her phone calls, which he had previously been amused by (Valerie could be hilarious when she got into her 'I want a piece of a groovy world myself' bag).

We know what went through the paranoid schizophrenic mind of Valerie Solanas as she peddled her pamphlets on the pavements of Greenwich Village that bitterly cold winter, because a smart reporter from the *Village Voice* (Robert Marmorstein) interviewed her then. Warhol, she told him, was a son of a bitch. A snake couldn't eat a meal on what he paid out. By then, even she had admitted that there was no SCUM organization, that she had no followers, that she was operating completely on her own without a friend in the world. In short, she was

desperately in need of attention. Every word that came out of his mouth was a lie, she said, but then pathetically concluded that he was still planning to produce her lost script, *Up Your Ass*.

The media had a new dish to feast on that February when a startling revelation was simultaneously printed in *Time* and *Newsweek*. It turned out, they said, that back in 1967, Andy had (and this really got people tied up in knots of resentment) sent out an actor to pretend he was Andy Warhol and five colleges had swallowed the bait, paid the fees and never known the difference. Then some professor's friend had seen a photograph of Allen Midgette in white pancake make-up, a black leather jacket and dark glasses playing the role and flashed on what had gone down. The smouldering outrage at Andy Warhol and all his works flared up. What an insult! How dare this creep put on great institutions of learning like the University of Rochester and Salt Lake City College? Who did he think he was? Scribes across the country reached for phrases like 'the pooped artist' and 'puke's bad boy'. Not only that, but there was the suggestion that Warhol might be liable to several lawsuits for fraud.

The upshot of this prank which had turned into another scandal was that Andy had to trundle back out on the lecture circuit in his Warhol drag and get booed and hissed by mobs of even more hostile students than he had faced before, as well as deal with the hostility of the university authorities, whose general attitude had been summed up by the one who had screamed at him over the phone, 'How do I even know if I'm talking to you right now?' On one occasion, according to Viva, he was held in a locked room for half an hour while the authorities determined that he really was Andy Warhol.

This sort of thing was right up the old Andy's street. He still ridiculed any form of authority with the inimical put-on humour revealed in the following conversation with Billy Name, recorded around this time:

WARHOL: Oh, you know the FBI man is still calling us about . . . they think Viva was really raped in the cowboy movie.

NAME: That FBI man said, you know, you know what it was, he told me that someone had complained that guys were going down on her and she was going down on the guys. That's the thing that upset . . . that got some people to get the FBI on us. It's not the rape thing, it's that supposedly people saw her going down on guys.

WARHOL: We don't have that in the movie, do we?

NAME: No, she didn't do it.

WARHOL: Oh . . .

NAME: But the FBI wants to see, uh . . .

WARHOL: They just called again. He came here but he said he doesn't care . . . but people just keep complaining.

NAME: He's the perfect FBI man, you know. He's so agreeable.

WARHOL: Oh, I know he's very nice to Paul.

NAME: I've never known a nicer person in the world.

WARHOL: But . . . he got mad at George when he was here because he got . . .

NAME: Sure, because George is a little fairy and all the FBI men are closet queens.

WARHOL: Oh . . .

NAME: But he's really a good guy.

WARHOL: Yes, I know he was really nice to Paul.

NAME: I can talk to him for half an hour.

WARHOL: Oh yeah, he talked to Paul for half an hour too, he asked about how he was feeling . . .

NAME: He really knows how to get you on the perfect train of thought.

WARHOL: He said, there's no rush, or anything, he really was so nice.

<div align="center">*</div>

Presented with the fact that Warhol neither made nor presented any new work in the first half of 1968 (except for the little-known but timely portfolio of prints on the Kennedy assassination, 'Flash – November 23, 1968'), his surviving associates bristle. 'We were busy people, we were always doing something.' Fred Hughes:

> The focus was on film, but you have to face the fact that it wasn't really clear rather than trying to figure out some kind of scheme. Life was not lived that way. Andy was very against real strategizing. It was day by day, but it was so much fun. *There was no strain.* It wasn't real business to begin with. You're dealing with a great artist. That's why Andy was so great, because it was bohemia. It was a different point of view.

This is true, but whatever they were doing did not add up to much. While most artists have pregnancy periods between projects, since 1962 Warhol had not stopped once. Now *Lonesome Cowboys* lay fallow, undeveloped and unedited. The attitude at the Factory was, according to Louis Waldon, 'we'd made a good start with this new approach and now we'd do another one'. But Warhol was abdicating his power and letting the films drift into Morrissey's hands. The *Surfing Movie*, or *San Diego Surf*, as it was alternatively called, was almost completely Morrissey's idea and doing.

In May, going out once again on an expensive location which can only have been funded by Hughes's practical management of whatever funds were coming in, Andy took his cast and crew of fifteen to twenty people out to the exquisite little town of La Jolla, on the edge of the ocean just below San Diego in California, where he rented a large luxurious mansion for the three-week shoot.

The police were all over them as soon as they arrived. It seemed that every time Viva went out the door she got stopped by a cop. 'The police came to the house and everything,' said Taylor, 'and Andy of course

got a kick out of it.' Eric Emerson was burned out and Andy kept saying, 'Somebody get rid of Eric, he's just crashing all the time.' Emerson, who was having an affair with Ingrid Superstar, remained but was reduced to sleeping on the living-room couch.

Despite the fact that *San Diego Surf* had little of the questionable nature of *Lonesome Cowboys*, Warhol's mere presence had become a threat to red-blooded middle-class America. On one occasion Taylor Mead recalled Andy dropping a handful of pills into the dirt as a police car screamed up the hill to check out what they were doing there. One day their car was pulled over as they were scouting for locations and all six passengers were spread-eagled against it and interrogated. 'So you're Andy Warhol, huh?' snarled the cop. Louis Waldon:

> I felt very sorry for Andy. I thought it was very undignified to see Andy spread-eagled. I thought it was just hostile. But Andy sat back down and they interrogated each of us. They were looking for drugs and nobody had anything. They must have asked each of us twenty or thirty questions over and over again and I happened to hear Andy's questioning. Andy was so brilliant at saying nothing it was absolutely fabulous. Finally he would say, 'Oh . . . I don't . . . uh . . . yeah . . . uh . . . yeah . . . uh . . .'
>
> 'Well, were you born there? Is this your age?'
>
> 'Oh, uh, yes, uh, no . . .' until finally the whole idea of questioning got turned around and the cop ended up answering the questions for him.

Asked if the combination of surveillance by the FBI, who had visited the Factory on several occasions that winter, and the harassment of the police in La Jolla concerned Warhol, Fred Hughes replied nonchalantly, 'I felt very secure about that sort of thing because one knew one wasn't doing anything dodgy and one had friends in high places. One called the lawyers. It just wasn't an important thing.'

The real problem lay in the relations between Warhol and his cast. If Andy had begun to remove himself in Tucson, his detachment was marked in La Jolla.

As Taylor, Louis and Viva saw it, Andy was at the height of his powers as a filmmaker. When Andy was there the atmosphere on the set was tranquil and confident. They had all played a part in changing the way movies were made and seen and they knew it. They felt they were just on the verge of reaping the real benefits of their work and so they were intensely serious about making a good film. Their attitude towards Hollywood was best summed up by a comment Andy made one night when they were watching a Barbara Stanwyck special on TV. Taylor Mead:

> Stanwyck was saying, 'Oh, we get up early in the morning and we really get together and go over the scene and shoot it together.' We watched the whole thing and we were all kind of stunned because we never worked in that

fashion. When it was over there was a wonderful pause, Andy was really such a magnificent actor, and then he calmly said, 'Oh, tomorrow, instead of beginning to shoot at noon let's, uh, start at three.' It was *the end* of Hollywood, and the next day we did start at three. We worked for an hour, then Paul said, 'Well, the sun's going down . . .' Andy was *much, much* stronger then, his presence was everything.

But Andy's detachment soon resulted in an all-out revolt on the set when the whole cast stormed off the beach and ran into the house, and Viva started screaming at Andy to take control of the movie. When he ran into his room she turned on Paul, who was cringing on the couch, and yelled at Louis, 'If you're a real man you'll beat the shit out of him and save this film from his cheap commercial tricks.'

Once again the shoot was aborted before schedule and the troupe returned to New York feeling as if the film had just fallen apart on them (*San Diego Surf* was never released). Andy himself, though, seemed perfectly indifferent to the results and acted as if everything was wonderful, according to Mead who returned with him.

On the way to the airport in the taxi Ingrid was crying like crazy because she was in love with Eric Emerson, who had left her.

Andy said, 'Oh, Ingrid, stop crying, you're with friends,' or some strange remark. It was like he was dropping Ingrid. Then we got on the plane. Often when we travelled we'd sit separately and Andy would be very quiet, but that time he really spent hours sitting with me talking.

As they flew across America over cities that still smouldered in the aftermath of Martin Luther King's assassination, Valerie Solanas was buying two guns in New York.

'The conversation was quite serious,' said Taylor.

This was to be my year. He described how we were going to use the Factory equipment to make my own film, TV appearances, publish my book, make a record, everything. It went on for a long time. I was snowed. Andy had the power to do it and in a way I felt that he really meant what he was saying. Although he would probably have cancelled it anyway on a whim. He was just a liar, a terrible liar, he'd say anything that was convenient and you cannot be that cool with people as Andy was being. You can't pull that shit of kings for ever.

That weekend, on the Saturday, they filmed a scene for *San Diego Surf* at the Factory. Henry Geldzahler was there for the filming and they all thought it was a riotous scene.

At the end of the movie Taylor Mead is having an exchange with a married couple. They say, 'Please, we're just ordinary middle-class people, we're just home owners, we go to the country club and play

golf, we lead a dull life. Would you do us a great favour and piss on us?' And the film ends with Taylor saying, 'Thank God! Thank God!'

THE ASSASSINATION OF

ANDY WARHOL

1968

Though the thought will shock many, Kennedy and Warhol are not unrelated in these out of joint times. Each in his own way is what is called a culture hero – a force that defines reality for masses of people, whether they love or hate that reality.

<div align="right">NEWSWEEK 17 JUNE 1968</div>

On Monday 3 June 1968, Andy spent the morning sitting on the edge of his canopied bed in a dark room on the second floor of his townhouse talking on the telephone to Fred Hughes, who reported that he had been mugged the previous night in front of his own apartment on East 16th Street directly across Union Square from the Factory. Fred's wallet had been taken, and a watch he'd inherited from his grandmother, and he complained bitterly about the way the neighbourhood was going. Andy was mildly sympathetic. Before leaving home he said a prayer with his mother in her basement sitting room, then made a few stops in his immediate area to check in with his lawyer, Sy Litvinoff, renew a prescription from his doctor for Obetrol, and do a little shopping at Bloomingdale's.

Meanwhile Valerie Solanas went up to the Factory looking for Andy. Morrissey told her that he wasn't there and wasn't expected that day and she could not hang around. Valerie left and took up a position down the block leaning against a wall. When Fred went out for lunch an hour later he noticed she was still there.

Before finally heading downtown Andy knocked on the door of a good friend of some years' standing, the interior designer Miles White; receiving no reply he decided to go to the Factory. He had a couple of appointments to keep there if he felt like it, so he hailed a Checker.

It was 4.15 when the cab pulled up outside 33 Union Square West and Andy – wearing a brown leather jacket over a black T-shirt, pressed black jeans and black Beatle boots – emerged. Calmly he gazed around as if he had nothing important to do. The park was jammed with the usual crowd of mavericks: assorted merchants juggled for space on the sidewalk, drug dealers milled around the statues of Washington and

Lincoln and stood in groups around the monument to Jefferson inscribed with words from the Declaration of Independence: 'How little do my countrymen know what precious blessings they are in possession of and which no other people on earth enjoy.' It was a landscape in which Warhol, whose main interest was now commerce, felt at home.

Andy's boyfriend Jed Johnson glided down the block from the corner of 17th and Broadway carrying a bundle of fluorescent lights. Valerie strode up from her position near 16th Street and joined Andy on the sidewalk as Jed arrived, and the three of them walked into the building.

As they waited for the elevator Andy noticed that Valerie was wearing a thick turtleneck sweater beneath her coat and it crossed his mind that she must be hot. When they got into the elevator he couldn't help noticing something else as she stood beside him, bouncing slightly on the balls of her feet, twisting a brown paper bag in her hands: Valerie, who had always presented herself as a radical feminist, had combed her hair and was wearing lipstick and make-up.

Upstairs, across the polished wooden floor of the front room of the Factory, Fred sat at his black glass-topped desk next to an open window that overlooked the park, punctiliously writing a memo in a black leather notebook. Opposite him at an identical desk Paul Morrissey was listening into a telephone and tugging at his big mane of curly hair. Viva was on the other end of the line, uptown at Kenneth's Hair Salon, telling him about her part in *Midnight Cowboy* as she prepared to get her hair dyed for the role. Between the two desks paced the art critic and curator Mario Amaya, who had admired Warhol and his work for a long time. He had been waiting for an hour, and had some important matters to discuss about an upcoming retrospective in London. Mario had removed his jacket and was in shirtsleeves, smoking a cigarette, reflecting on the décor of the new Factory with satisfaction. He had been leery of the leather freaks with their sex and drugs who had hung around the Silver Factory. He couldn't understand what a man with Warhol's tasteful sensibility was doing with such a damaged crowd, and was relieved to note that there were no such people, nor any signs of their presence, in these austere, businesslike quarters.

The elevator door opened and Andy wandered into the room, followed by Jed and Valerie, chatting. Jed crossed to Andy's private office in the rear corner of the room. Andy acknowledged Mario's presence and nodded to Fred, who came out from behind his desk to remind his boss of that appointment to discuss the retrospective. Paul told Valerie she looked awfully well; she said something witty and mean in reply; he said something mean to her and everybody laughed. Then Paul left the office to go to the bathroom. As Andy crossed to Morrissey's desk to talk to Viva on the phone, Fred turned to Valerie and asked her if she was still writing dirty books.

Mario's heart sank when he saw her, for here in his opinion was one

of the very specimens of that type he thought Andy had discarded with the move. Even with make-up on, Valerie looked dirty and shaky to him, and he sensed that she might burst into tears at any moment as she stared defensively at Hughes. He walked to the back of the room to get a cigarette from his jacket that was lying on the Art Deco couch.

Sitting in Paul's chair behind his desk, half listening while Viva rattled on cataloguing the various dyes they were going to apply to her frizzy filaments, Andy leaned forward and looked down into the black glass desktop, inspecting his own coiffure in its reflection. He saw an ethereal, almost ghostly visage looking back at him, and smiled like Donald Duck.

Andy signalled Fred to cut in on his line and continue the conversation with Viva. It bored him. Valerie reached slowly into her paper bag and withdrew her .32 automatic. She pointed it at Warhol. Still nobody paid any attention. She raised the gun slightly. Fred leaned forward to pick up his phone. Andy leaned forward to cradle his. She fired.

Amaya, who thought a sniper was shooting at them from another building, yelled, 'Hit the floor!' Equally startled, Fred thought a small bomb had gone off in the office of the Communist Party two floors above them. At the other end of the telephone, Viva thought someone was cracking a whip left over from the Velvet Underground days. In that frozen second only Andy saw what was really happening. Surprised, he dropped the phone, jumped from the desk and started to move, looking directly into the woman's pinched face.

'No! No! Valerie!' he screamed. 'Don't do it!'

Solanas fired a second time. Andy fell to the floor and tried to crawl underneath the desk, but she moved in, placed the paper bag on the desk and, taking aim more carefully, fired again. Her third bullet entered Andy's right side and exited the left side of his back. He felt 'a horrible, horrible pain, as if a firecracker had exploded inside me', and started screaming and writhing. Blood pumped from his chest, soaking through his T-shirt and splattering the white telephone cord. 'It hurt so much,' he told friends later, 'I wished I was dead.'

Believing she had killed Warhol, Valerie walked rapidly towards the crouching figure of Mario Amaya. Their eyes met as she stood over him, fired a fourth time, and missed. He watched her aim again and whispered a rapid prayer. Her fifth shot hit him in the flank, just above the hip; it passed through the flesh without damaging any organs, and exited his back. Stunned, he scrambled to his feet and crashed through the double doors leading into the back room. Once inside, he turned quickly and tried to lock them against her, but found that he'd broken the latch, so he held them closed with the weight of his bleeding body. It was in this position that Paul and Billy Name, who had been

developing prints in the darkroom, found him as they rushed up to find out what the 'firecrackers' were all about.

'Valerie shot Andy,' Mario gasped. 'She shot Andy!'

They could hear her trying to open the door. Billy threw himself against it, while Paul slipped into the glass projection booth that overlooked the front room.

Believing that the door was locked, Valerie turned away to find another victim. Up front she could see Andy's legs protruding from under the desk. Paralysed with fear, Fred stood behind his desk, staring. Less than half a minute had passed since the first shot, and he had just become aware of his own pitiful position. Paul watched in horror as Valerie crossed to Andy's office and tried to open the door to shoot Jed. Jed was standing inside the tiny office desperately clutching the doorknob with both hands. She turned towards the front of the room and focused on Fred. The thin, dapper businessman epitomized the kind of people who laughed at her poverty and revolution. She strode towards him. There was nowhere to hide. As she stopped several feet in front of him and raised the gun, Fred begged her not to fire. 'I have to shoot you,' she replied coldly, aiming the pistol at his chest.

He fell to his knees, pleading, 'Please don't shoot me, Valerie. You can't. I'm innocent. I didn't do anything to you. Please, just leave.'

Whether it was the urgency in his voice, the uselessness of shooting him, or the loss of confidence in her plan, the words 'just leave' made contact. Valerie backed away from her kneeling victim and pressed the elevator button, but then stalked back to Fred. At the bottom of his throat, he choked back a sob as she aimed at his forehead and pulled the trigger. The .32 jammed. Valerie whirled towards the paper bag, grabbing the back-up .22, but her concentration was broken by the elevator doors opening and the desperate voice of Fred: 'There's the elevator, Valerie. Just take it.' She bolted into it and escaped.

As soon as the elevator doors shut, pandemonium broke out. Billy, Paul, Mario and Jed rushed up to Andy screaming and shouting orders and suggestions. Mario saw blood all over Andy. 'It was just awful, just horrible.' Fred crawled across the floor to give him mouth-to-mouth resuscitation, but because of the holes in Andy's lungs it was an impossible task and unbearably painful. 'It hurts, Fred, it hurts,' Andy croaked. He felt he could not take in a deep breath no matter how much he tried to expand his chest cavity because every time he did, air would enter through the wound as well as through his mouth, and escape through his lungs. He turned away. Fred desisted and picked up the telephone to call for an ambulance and the police.

They were all uncertain what to do. Blood was spreading to the floor around Andy. 'I can't . . .' he kept gasping, 'I can't . . . breathe.' In fact, Andy was dying, and Billy started to cry, which made Andy laugh.

'Oh, please don't make me laugh, Billy,' he whispered. 'Please. It hurts too much.'

'I'm not laughing, Andy,' Billy replied, cradling the silver head in his lap, 'I'm crying.'

Jed stood over them, choking audibly on his tears. Paul paced the room screaming, 'Call an ambulance! Call the police!' Fred was already off the phone. In shock Mario hadn't yet even realized he had been shot.

Then the telephone rang. Thinking they were playing a trick on her, Viva was calling from Kenneth's to find out what was going on. She had heard Andy screaming and thought he had been kidding. When Fred said, 'Valerie Solanas just shot Andy. There's blood all over the place. I've got to hang up. Goodbye,' she thought it was a Factory prank and decided to have her hair trimmed before she had it dyed. She told the hairdresser to charge it to United Artists.

Paul was terrified that Valerie would return and tried to jam the elevator door closed but could not. When it opened a few minutes later, everybody spun in horror: but it was Gerard Malanga who had come, accompanied by the Velvet Underground's first drummer, Angus MacLise, and his wife Hettie, to borrow $40. As Malanga recalled, 'There was chaos – telephones ringing, people running back and forth. Andy lay in Billy Name's lap, gasping, "I can't . . . I can't . . .", losing consciousness.' Gerard believed he meant 'I can't die' and thought of Julia hearing on TV that her son had died. Turning aside, he told Paul, 'I'm going to get his mother.'

'That's a good idea,' Paul replied, and pushed some bills into Gerard's hands for cab fare.

At Kenneth's the hairdresser was asking Viva if she wasn't going to call back and find out if it was true or not. Viva hesitated, but then did. This time Jed answered the phone. He could hardly speak but when she asked him if it was true, he cried out, 'Yes, it's true and there's blood all over the place.' Viva hung up. Still she couldn't believe it. A friend who was with her called back and asked for Andy. 'Andy isn't here,' a terse voice replied, 'and he may never be back.'

It was 4.35. Warhol was conscious again. He had been lying on the floor for fifteen agonizing minutes. As Gerard waited for the elevator to take him down, voices drifted up the shaft and he realized help was arriving. Two members of the Emergency Medical Service stepped out with a wheeled stretcher and ran across the room. They would not administer a painkiller, saying that pain was a valuable sign of what was going on in the abdomen. They picked Andy up, placed him on the stretcher in a semirecumbent position, and wheeled him off. But the stretcher would not fit in the elevator with him lying on it. They decided they would have to carry him down the stairs.

Lit by bare bulbs suspended from the ceiling, the stairs were steep,

narrow and smooth with age, and the climb seemed interminable – particularly as they came down the second floor, where it was suddenly dark and there was a sharp corner of the narrow staircase past which it was difficult to manoeuvre. The last flight was the steepest, but it was somewhat wider than the rest of the stairs. They pushed through a broad steel door, past the elevator, the mail boxes, out of two sets of glass doors and into the sunny street where a curious crowd had already gathered. As he was lifted from the stretcher and placed beside Mario in the ambulance, Andy lost consciousness. The ambulance sped away from the kerb, up Broadway to 18th Street, and made a right.

Viva came out of the 14th Street subway and ran across the park towards the Factory. Before she was halfway there, she saw the police cars and the crowd. Then she bumped into Jed on the sidewalk, saw the empty stretcher, and started screaming.

She went up in the elevator; she burst into the Factory. The rooms were being searched by eight plainclothesmen, who had stopped to pore through stills from *Lonesome Cowboys*. One of them looked up. 'OK, lady,' he said, 'tell us what you know.'

Viva saw Billy and finally realized that this was not a movie. Andy really had been shot. She saw the tape marking the bullet holes. She threw herself into Billy's arms, crying hysterically. Fred crossed the room and slapped her, saying, 'Stop it! Now stop it!' She saw the blood on the telephone cord, and then she fainted.

In the ambulance, the driver said that for an extra $15 he could turn on the siren, and Mario told him that would be OK. Leo Castelli would gladly pay the bill. He was afraid to look at Andy because he could not tell if he was still alive. The ambulance sped from Broadway to Park, across Irving Place, passing Pete's Tavern on the left, its siren wailing, and made a left across Third, then a right on 19th.

Warhol was wheeled into the emergency room at 4.45 – twenty-three minutes after he had been shot. A call had been placed from the ambulance to announce his estimated time of arrival and critical condition. An emergency operating room had been prepared; three nurses and a team of doctors headed by Dr Giuseppe Rossi, a crack surgeon who had been on his way home when the report had come through, were standing by. They had no idea who their patient was. The stretcher was wheeled straight through to the operating room.

The doctors clustered around the body and began to take its vital signs. The pulse was faint. They attached an EKG and inserted a catheter in Andy's penis to determine the state of his kidneys, then began to examine his wounds. During these first few moments in the operating room Andy was semiconscious again and heard voices muttering, 'Forget it,' and 'No chance.'

Mario Amaya, who was lying on an operating table across the room, sat up screaming, 'Don't you know who this is? It's Andy Warhol. He's

famous. And he's rich. He can afford to pay for an operation. For Christ's sake, do something!'

As Paul Morrissey and Viva made for the hospital, Valerie Solanas wandered through Times Square in a daze. Uptown, Gerard hammered on the door of Andy's house, trying to reach his mother before she heard the news. He could hear a phone already ringing in the front room.

At 4.51 p.m. Andy was pronounced clinically dead, but spurred on by the urgency in Amaya's voice, Dr Rossi determined to try to save him. He began to cut open Andy's chest. The first step was to massage the heart.

*

As Andy Warhol lay on the operating table, detectives from New York's thirteenth precinct continued to ransack the Factory, peering cynically through stills of naked men, slides of death-and-disaster paintings and files of receipts, looking, they said, for 'evidence'. Fred Hughes insisted that they should be out looking for Valerie Solanas instead, but the police were suspicious of everyone at the Factory. They took the distraught Hughes and a weeping Jed Johnson to the station house and held them as suspects in the shooting. They would not even let Fred call the hospital to check on Andy's condition: as far as Hughes knew, his boss was dead.

By the time Andy reached Columbus Hospital the shooting had been announced on the radio and hysteria had begun to spread; reporters, photographers and members of Warhol's entourage converged on the small emergency waiting room. Leo Castelli and a cigar-smoking Ivan Karp were standing with a reporter in one corner looking gloomy. Ingrid Superstar was dictating her thoughts to another: 'Andy's shooting was definitely a blow against the cultural revolution. We're constantly being attacked.'

Ultra Violet stood in the middle of the room, in a Chanel suit, wearing three layers of make-up, talking to two younger reporters. 'Violence,' she declared, 'is everywhere in the air today. He got hurt in the big game of reality.' Louis Waldon, star of *Lonesome Cowboys*, leaned against a wall, shaking. The photographers snapped.

Viva arrived in the waiting room to find Louis Waldon talking on the phone to a hysterical Ivy Nicholson, who was screaming that she was going to kill herself the minute Andy died. Taylor Mead, who had had his own quarrels with Andy (later, he once said that if Valerie had not shot him he might have), wept openly. Minutes later, Gerard Malanga escorted Julia Warhola into the room. Viva thought she looked 'like an old peasant woman, stooped over and grey, wearing a threadbare black coat, black stockings with runs in them, and a babushka'.

'Why did someone harm me Andy?' she lamented. 'Why did they

shoot me Andy?' Breaking down, Julia, who had a serious heart condition, was taken away in a wheelchair to be sedated.

The press had cornered the art dealers and the superstars on the far side of the room. 'How do you feel, Viva?' barked a radio reporter, shoving a microphone in her teeth.

'How would you feel,' she snapped, 'if somebody you love was shot?'

Ultra Violet closeted herself in a cubicle with one reporter after another. As the hospital's public-relations officer escorted Viva and Gerard to the upstairs waiting room so that they could stay with Julia, Ultra was saying to a reporter, 'Well, I always thought that he was a great artist . . . I have made three movies for him, the first was called . . .'

Upstairs the PR man blankly asked Viva if she was Valerie Solanas. At 8 p.m. on Times Square, Valerie Solanas walked up to a 22-year-old rookie traffic cop named William Shemalix and said, 'The police are looking for me and want me.' She reached into both pockets of her trench coat, drew a .32 automatic from one and the back-up revolver from the other. She handed them to Shemalix, stating that she had shot Andy Warhol, 'because he had too much control of my life'. Shemalix placed her under arrest and called in a report, requesting further instructions. Hughes and Johnson were released and Solanas was taken to the thirteenth precinct for questioning.

Brought into the booking room with her hands cuffed behind her back, Solanas grinned broadly at the crowd of reporters and photographers. Asked what her motives were, she said, 'I have a lot of reasons. Read my manifesto and it will tell you what I am.' The photographers jumped on to the booking desk, pushing cops out of the way, yelling at her to look at them. The noise of cameras and questions was so loud that the booking officer could not hear Valerie's voice. The police hustled the journalists out of the station house, and took her to be fingerprinted. She was charged with felonious assault and possession of a deadly weapon. As they waited to see if the charges would be upgraded to murder, the police said they knew of no motive.

In the operating room, the surgical team had been surprised to discover the amount of damage the bullet had done to the interior of Andy's chest. It had entered his right side, passed through his lung and ricocheted through his oesophagus, gall bladder, liver, spleen, and intestines before exiting his left side, leaving a large gaping hole. Andy had been clinically dead for one and a half minutes but, as he wrote later, 'they brought me back from the dead'. The doctors removed the ruptured spleen and shortly after 10 p.m. – five and a half hours after they had started – had to sprinkle some antibiotics into his wounds to ward off infection. They needed to know if he was allergic to penicillin. Julia could not remember the name of his private physician, but Gerard did. They located him and discovered that Andy was allergic to peni-

cillin; they would have to use some other kind of antibiotic. They poured it into the open cavity and sewed the wound closed.

The emergency waiting room was now jammed with people eating sandwiches and giving out exclusives under a picture of the Sacred Heart. Viva described the scene as 'a cross between a box-lunch picnic and an Irish wake', adding, 'All that was missing was the booze.'

Deciding to take Julia home, Gerard and Viva pushed her in a wheel-chair through the crowd of photographers to the street where they hustled her, still weeping hysterically, into a cab. Soon after she left, Andy's brothers arrived at the hospital. Paul Warhola:

> I saw Andy in the recovery room. It didn't look like the same person. His head was as big as a watermelon! The doctor says, 'Andy was lucky. I thought he was a goner.'
> I says to him, 'What's the chances?'
> He says, 'You gotta figure fifty-fifty.'

'He couldn't talk,' said John Warhola. He wrote it down:

> 'Who shot me?'
> I says, 'A girl.'
> 'Did she say why?'
> I says, 'No. I don't know. Do you know?' I thought maybe he was dating her. No, he don't know why she shot him.

As news of the shooting was broadcast on the radio and television, Nico went over to David Croland and International Velvet's apartment. They discussed going to the hospital, but Nico said they should light candles, sit on the floor and pray.

From her apartment, Ivy Nicholson was calling the hospital every ten minutes asking if Andy had died yet so she could jump out of the window, as Louis Waldon tried to restrain her.

At Andy's house, Julia clutched his blood-stained T-shirt and muttered distractedly to Viva and Gerard, 'My Andy, they hurt my little Andy. Please God, don't let me Andy die!' By the time John and Paul arrived she had calmed down. 'She knew he was going to pull through,' Paul recalled. 'All she did was pray for hours and hours and hours in front of her altar.' Viva and Gerard left the house for Viva's apartment, where they made love for the first time.

At 2.30 a.m., a hospital spokesperson informed a *New York Times* reporter that they did not know if Andy would live through the night. At 6 a.m., word came that he had and his chances of survival had improved.

*

'It was just nick and tuck for a couple of days,' recalled Paul.

'I never even knew Andy was so famous until he was shot,' said John, 'and he got all those headlines and stories.'

The early editions of the *New York Post* and the *Daily News* carried the headlines: ANDY WARHOL FIGHTS FOR LIFE and ACTRESS SHOOTS ANDY WARHOL, CRIES, HE CONTROLLED MY LIFE.

On a plane from Montreal to New York, Solanas's publisher Maurice Girodias read the news in stunned disbelief. She could have chosen a more representative male oppressor than Andy Warhol, he thought. In Los Angeles, Lou Reed and his manager were shocked to read the headlines on the floor of an elevator in the Beverly Wilshire Hotel, and wondered if the same thing could happen to Lou.

At the Factory, Paul Morrissey, Fred Hughes and Billy Name quietly went through the motions of answering the phones and fielding enquiries.

While Warhol remained in a critical condition, Valerie Solanas, wearing tan jeans, a yellow jumper, black turtleneck sweater and torn blue sneakers without socks, ranted before a nonplussed Judge Getzoff in Manhattan Criminal Court. 'It's not often that I shoot somebody,' she shouted. 'I didn't do it for nothing. Warhol had me tied up, lock, stock and barrel. He was going to do something to me which would have ruined me.'

Judge Getzoff asked her if she could afford an attorney. 'No, I can't,' she replied. 'I want to defend myself.' When the judge tried to explain that she was entitled to a lawyer, she interrupted him, saying, 'This is going to stay in my own competent hands.'

'I was right in what I did!' she yelled. 'I have nothing to regret!' Realizing that this was a confession that could be used against her, Getzoff ordered the court stenographer to strike the entire outburst from the court record. Solanas was remanded to Bellevue Hospital overnight.

Gretchen Berg:

> I realized instantly that Valerie shot Andy out of love, and I understand her perfectly, because I had felt the same thing. It was an intense reaction: you had a great emotion about Andy and for some reason you couldn't get close to him. He wasn't going to give you what you wanted. So I went away. She shot him.

That night, the first reports that Robert Kennedy had been shot after winning the California primary came through from Los Angeles, replacing the attempt on Andy's life as headline news. Barbara Rose's husband, Frank Stella, came home that night with the papers. 'Kennedy was critical and Andy was critical,' she recalled. 'Frank said, "Bobby's going to die and Andy's going to live. That's the way the world is." He saw the whole thing as an American parable.'

Warhol remembered those first days in intensive care as 'just cycles of pain', interrupted only by the surprise appearance of Vera Cruise disguised as a nurse. The painkillers made him feel as if he was flying through the room – a sensation he did not enjoy. Andy Warhol:

I couldn't figure out why, of all the people Valerie must have known, I had to be the one to get shot. I guess it was just being in the wrong place at the right time. That's what assassination is all about.

I realized that it was just timing that nothing terrible had ever happened to any of us before now. Crazy people had always fascinated me because they were so creative – they were incapable of doing things normally. Usually they would never hurt anybody, they were just disturbed themselves; but how would I ever know again which was which?

Early in the second week, Gerard and Viva were grudgingly allowed a ten-minute visit with Andy by the hospital authorities, who treated them as if they were lepers. Brigid Polk was afraid and stayed in the waiting room.

A white cloth was tied in four small knots at the corners of his head, an electrocardiogram machine monitored his heartbeat, intravenous tubes dripped solutions into his forearms, and in the next bed a drug overdose patient was deliriously raving.

'Hi,' Andy whispered.

His voice was so weak that Viva had to bend down to hear him.

'Look at that guy next to me. Don't tell anybody, but the nurse is in love with him. They kiss and hug when they think that nobody can see them. Look at that cabinet full of drugs. I'm afraid if Brigid gets in here she'll steal all the drugs. Don't tell her about them.'

Billy Name had begun a daily vigil outside the hospital staring up at Andy's window, praying for his 'own wizard'.

While Andy was in hospital a revolving door of relatives were in and out of Lexington Avenue taking care of Julia. Viva and Brigid (who was amazed at the incongruity of the religious statues in the house and Andy's four-poster bed beneath a crucifix) visited Julia several times the first week, and she talked their ears off. Between handwringing lamentations for Andy, often mixed with hysterical flashbacks to the death of her infant daughter in Ruthenia, Julia told Viva, 'You are an angel and I pray to the good Jesus that he will save me Andy so he can marry you,' adding, 'Work for other people. Me Andy don't pay you enough. You need money for the wedding.'

Sixteen-year-old George was startled to see her throwing Andy's leather jacket into the trash.

I said, 'Gee, could I have it? Cos it's a nice leather jacket,' and it wasn't ruined.

I took it up to the hospital and Andy says, 'Hey! I want that, you can't have it!'

I said, 'Gee, Bubba was throwing it out.'

'After Andy got shot then he don't trust nobody,' said Paul Warhola. His son Paul Jr, whom Andy was supporting in his studies for the priesthood, stayed at Lexington Avenue and spent his days at Andy's bedside throughout the six-week hospital convalescence. When gifts of rich foods from the best restaurants, cakes and candies arrived, Andy insisted Paulie or George sample each dish first. He thought that some-body might try to poison him. 'He said, "Oh, you want a candy? Here, try one," ' recalled George. 'I said, "Yeah, yeah, sure!" '

There was a minor family contretemps when Julia discovered Paulie had started taking Viva out for beers. Julia threatened to tell his mother, and later the student priest had to be sent home.

Although Warhol was still in intensive care and on the critical list, on 13 June his doctors reported that he was 'much better and on his way to complete recovery'.

On the same day Valerie Solanas appeared in the state supreme court with two representatives of NOW (the National Organization for Women): the New York chapter president, Ti-Grace Atkinson, who stated at the time that Solanas would surely go down in history as the first outstanding champion of women's rights, and Florynce Kennedy, a lawyer who had represented the black militant H. Rap Brown after the Newark riots the previous spring. Characterizing Solanas as 'one of the most important spokeswomen of the feminist movement' and maintaining that her client was being prejudicially treated because she was a woman, Kennedy moved for a writ of habeas corpus on the ground that Solanas was being improperly detained in the Elmhurst City Hospital psychiatric ward. State Supreme Court Justice Thomas Dickens denied the motion and sent Solanas back to the hospital for further tests. On 28 June she was indicted on charges of attempted murder, assault and illegal possession of a gun.

'Andy and I always used to say that we were the first feminist casualties,' Mario Amaya commented later.

In the heady atmosphere of 1968, with America in the middle of violent internal struggle over the Black Power movement, the Vietnam War and the women's liberation movement, all of which charged people up with an enormous amount of purpose and very little direction, people's widely different interpretations of the Warhol shooting mirrored their own convictions. Some saw it as his greatest art work, others thought it served him right. In the minds of many who did not know him it strengthened their view of Warhol as a political artist. For others he became a Christ or Antichrist figure. The Up Against the Wall Motherfuckers, an extremist group, some of whom were in the

entertainment business, brought out a pamphlet called 'Valerie Lives' denouncing Warhol as a 'plastic fascist' (and describing Solanas as 'a chick with balls').

On 16 June the State Department received a classified cable from their embassy in Warsaw announcing that Warhol had won first prize at the Warsaw Poster Biennale on the insistence of the Soviet judge. 'Wierjeski's action, to say the least, does not square with the more normal practice of not awarding top prizes to Americans in block cultural competitions,' it said.

Julia pitched in with her addition to the legend. Soon she was telling Paul and John that somebody had been after Andy for a while and he was going to meet a tragic death. As with any theme she got into her head, Julia was soon repeating every time she saw them, 'Somebody's jealous and they're going to kill him!'

Barbara Rose:

Without exaggerating, one might call Warhol the inventor of the lifestyle of the sixties. An artist of real seriousness, Warhol stands in a line with the bitterest challengers of society's hypocrisies and conventions. A great theatrical figure, he is related to those outré precursors of the Parisian avant-garde, Antonin Artaud and Alfred Jarry, whose life was theatre . . . Warhol appears not only as our greatest realist, but our greatest moralist as well. He has the courage to live out in fact the clichés of the avant-garde. He exposes our sores instead of glossing them over or patching them with pretty decorations. I realize this interpretation does not tally with that of critics who see Warhol as a Mephistophelian anti-Christ, tempting society into further tawdriness. Yet others have seen him as Saint Andy, a lacerated hero, like Genet martyred by a vile society. To me his pageant has always seemed a Passion, his Catholicism a living matter and not a camp. It is possible future ages will see Andy in the image of Mary Magdalene; the holy whore of art history who sold himself, passively accepting the attention of an exploitative public which buys the artist rather than his art, which it is perfectly willing to admit is trash.

When Andy was moved into a private room and given a telephone, he started talking to a lot of people. He seemed to be most interested in the press reactions to his shooting. Many of the follow-up articles took the form of unsympathetic attacks. He thought the cruellest review he ever received was *Time*'s 'Felled by Scum'. 'Americans who deplore crime and disorder might consider the case of Andy Warhol, who for years celebrated every form of licentiousness,' it began. 'The pop art king was the blond guru of a nightmare world, photographing depravity and calling it truth.'

As soon as Andy was off the critical list and in a private room, Paul Morrissey and Fred Hughes began visiting him daily to discuss what was happening at the Factory, where a lot of bitter infighting between

the Viva and Morrissey contingents was already developing, and what to do.

Morrissey brought Andy regular progress reports on John Schlesinger's *Midnight Cowboy*, which was being filmed in New York that summer. The influence of Warhol films on *Midnight Cowboy* was obvious not only in the choice of forbidden subject matter (male hustlers), but in the casting of Viva and other Warhol stars, who had been rounded up by Morrissey as extras for a party scene that was supposed to represent life at the Factory. Before being shot, Andy had been asked to play himself in the scene, but had declined; instead, Viva played the role of the Underground Filmmaker. For added authenticity, Morrissey had been commissioned to make a short, silent underground movie of Ultra Violet that was projected in the background during the party scene. Their involvement enraged Ondine. 'I said, "How dare you accept the $25 a day in blood money to go and make fun of Andy? He's the reason why you're even here! Don't you have any feelings?" '

Though Andy was curious about the filming, he also admitted feeling jealous about the encroachment of Hollywood into his 'territory', and the money that was being poured into Schlesinger's project. 'Why didn't they give us the money?' he complained. 'We would have done it so *real* for them.'

At the same time, he was flattered that his ideas were entering the mainstream. Perhaps they should make a new hustler movie, he suggested to Morrissey at one point, this time in colour.

Morrissey liked the perverse idea of using the Warhol extras in *Midnight Cowboy* to do a Warhol version of the story. He drafted an outline about a day in the life of a male prostitute, and assembled a cast featuring two teenage girls – Geraldine Smith and Patti D'Arbanville – and Joe Dallesandro. Morrissey shot *Flesh* on two weekends in July at a cost of $4,000 and later described it as his tribute to John Ford.

Warhol's participation in the filming was naturally minimal, consisting of daily chats with Morrissey at the hospital and telephone gossip with some of the performers about what they were doing on the set. He was particularly amused when Geraldine told him Joe had got an erection on camera and she had tied a bow around it. This charming image must have reminded Andy of his 1955 Drawings for a Boy Book.

While Andy spent June and July in Columbus Hospital, Edie Sedgwick was in Manhattan State Hospital suffering the effects of a drug overdose.

*

On 28 July Warhol went home. He spent the first ten days – including his fortieth birthday on 6 August – in his four-poster bed, watching television, reading magazines and telephoning friends, many of whom cried at the sound of his voice.

'My husband John went up and bathed his wounds and put clean

bandages on him after he came out of the hospital,' recalled Marge Warhola, 'because his mother was too upset with all the stress.' Andy said he was afraid to look at the taped bandages which criss-crossed his belly and hated to take a shower, since that meant taking off the bandages and having to see the purplish red and brown scars underneath.

Andy spent August at home, painting a multiple commissioned portrait of 100 faces of Happy Rockefeller, the New York governor's wife, as he watched Soviet tanks invading Czechoslovakia and street fighting at the Democratic convention in Chicago on television. Ondine:

One afternoon Billy and I went up to see him after he was released from the hospital and he was painting little pink canvases in a line from his living-room window right into the other room. He was very weak and frail. As we left that day Billy just leaned against the side of the building and said, 'I would give up my life for that man.' And I understood him because at that point you really felt, yeah, he's worthy of it. I mean we were ready to scream – scream!

Jed Johnson also visited:

Andy couldn't really do too much. He was still sick. He never talked about how he felt physically, or how he could cope, he just didn't. He was very weak and fragile but Andy had a very strong drive, he was just very strong. I saw what kind of situation he was in. His mother spent a lot of time in bed. She was really senile. I used to have to take her to the doctor once a week. Then I used to stay and I'd help him get dinner and do some shopping.

Andy was a pack rat – he'd saved everything, every bit of junk mail, every empty box and tin can. I sorted things out, put paintings with paintings and cans with cans. I ended up being there all the time so I just stayed.

According to Gerard Malanga, Jed Johnson

really fixed up Andy's house nicely, really did a beautiful job decorating it and cleaning it up and painting it and putting rugs on the floors, making it look like, you know, somebody was not just scrounging around in it but living there.

Paul Warhola resented Jed's influence.

Jed didn't have a pot to piss in when he came over and Andy helped him. He didn't really take care of Andy after he was shot. I mean, he might have been around, but, like I say, Mother put him back together. Jed may have helped care for Andy later on, because they had to drain the wound for several years.

Warhol went out in public for the first time on 4 September for dinner

at the fashionable restaurant Casey's with Viva, Paul Morrissey and a reporter from the *Village Voice* named Leticia Kent, who asked him if he had rethought his lifestyle since the shooting.

'I've been thinking about it,' he replied. 'I'm trying to decide whether I should pretend to be real or fake it. We were serious before so now we might have to fake a little just to make ourselves look serious.'

'Do you think that you had any complicity in the shooting,' Kent asked, 'in the sense of encouraging those around you to act out their fantasies?'

'I don't know,' Warhol replied. 'I guess I really don't know what people do. I just always think they're kidding. I don't think Valerie Solanas was responsible for what she did. It was just one of those things.'

'We are constantly under attack,' stated Viva. 'Andy's shooting was part of a conspiracy against the cultural revolution.'

'Well, it's our year for crazy people.' Andy winced. 'But I can't feel anything against Valerie Solanas. When you hurt another person you never know how much it pains.'

Asked if he was in pain, he said:

> It slows you up some. I can't do the things I want to do, and I'm so scarred I look like a Dior dress. It's sort of awful, looking into the mirror and seeing all the scars. But it doesn't look that bad. The scars look pretty in a funny way. It's just that they are a reminder that I'm still sick and I don't know if I will ever be well again.

(Later he posed for the photographer Richard Avedon with scars bared – 'the Ecce Homo of modern exhibitionism,' wrote Stephen Spender – and sat for an Alice Neel portrait in the surgical corset he was forced to wear for the remainder of his life, his hanging breasts making him look half man, half woman, back from the dead.)

> Before I was shot, I always suspected I was watching TV instead of living life. Right when I was being shot I knew I was watching television. Since I was shot everything is such a dream to me. I don't know whether or not I'm really alive – whether I died. It's sad. Like I can't say hello or goodbye to people. Life is like a dream.

'Are you afraid?' asked Kent.

'That's so funny.' Warhol laughed. 'I wasn't afraid before. And having died once, I shouldn't feel fear. But I'm afraid. I don't understand why. I am afraid of God alone, and I wasn't before.'

*

In September, Andy began coming into the Factory for a few hours each afternoon. Psychologically he was clearly shaken up, and physically he did not look well. He moved stiffly and was much slowed down, not

311

only by his injuries but because, on doctor's orders, he had stopped taking Obetrol. A night creature before the shooting, Andy was now home each evening by eight.

FROM FUCK TO

TRASH

1968–72

*Andy over the years never changed much. Andy's been the
same ever since he's been a youngster.*

PAUL WARHOLA

The obvious question was, What was Andy going to do now? Once at
the Factory, he would seclude himself in a tiny office off the main room,
as far away as possible from arriving visitors. He would briefly emerge
when 'harmless-looking' friends dropped by, to tape and photograph
them with his new Uher-400 tape recorder and Polaroid instant camera,
then hide himself away again until someone else came by. Andy would
still visibly start at the sound of the elevator doors opening. Noticing
his nervous reaction, Morrissey sought to issue an across-the-board ban
on people who, in his view, operated on 'tenuous mental health', but
Andy was ambivalent. Morrissey's suggestion would have excluded
almost everyone Andy truly enjoyed. Warhol later wrote, 'I was afraid
that without the crazy, druggy people around jabbering away and doing
their insane things, I would lose my creativity. They'd been my total
inspiration since 1964 . . . I didn't know if I could make it without
them.'

The most pressing need in Andy's mind after the shooting, apart
from guarding his personal safety, was the necessity to make more
money. Andy's $11,000 hospital bill had wiped out most of the profits
of 1968, he told friends, and the rest had gone into upkeep of the
Factory and making *Flesh*. There had also been a surprise lawsuit from
one of his previous actors, Foo Foo Smith, based on contributions to
earlier movies.

Andy had ignored the subpoena since it had been presented to him
at Max's Kansas City on April Fool's Day and he thought it was a joke.
'Foo Foo Smith was around the Factory a lot,' recalled Bob Heidie. 'He
was a very idiotic man, a heavy amphetamine addict. He sued Andy
because he felt he'd put money into some of his films.'

'Foo Foo Smith of the Smithtown Smiths claimed he had a word-of-
mouth agreement with Andy that he owned all of Andy's films,'
explained Fred Hughes, 'and I had to go to court in Smithtown. It was

a pain in the ass at the time, but he didn't freeze our accounts and we got through it fairly easily.'

Andy gave his brother John the impression that he was broke at the time he was shot. 'He said his insurance agent had pocketed the money rather than bought him a policy and he couldn't afford to pay his hospital bills. He said he paid the doctor with paintings.' According to Hughes, Andy had a lot of money in 1968 and was doing fine.

One positive outcome of the publicity surrounding the shooting was that the value of Warhol's paintings had shot up – works that originally sold for $200 were now worth $15,000 or more. 'People were willing to buy them at any price,' commented one art dealer. 'It was like holding on to IBM stock. People didn't even like them.' Of course, none of the money from the resales went to Andy, but he still had a lot of his early work and Fred Hughes was able to continue selling it at these increased prices. However, for the time being Warhol was clearly more interested in pursuing his goals as a filmmaker than returning to painting.

In October 1968, when *Flesh* opened for what would turn into a smash seven-month run at the Garrick Theater on Bleecker Street, his expectations of success seemed to be confirmed. While *Flesh* lacked the artistic brilliance of Warhol's early films, its comparatively formal editing and story-shaping avoided many of the pitfalls that had limited the popularity of Andy's own movies. Despite a generally atrocious sound-track, the reviews of *Flesh* were good, and the film along with its star, Joe Dallesandro, whose strong, silent screen presence reminded Morrissey of John Wayne, gained a cult following in New York.

Even Rex Reed, one of Warhol's most vitriolic critics, found merit in the film: 'In the way it showed how film can be opened up to expand our way of thinking outside conventional film barriers, *Flesh* was a wildly funny and highly innovational movie.'

A lot of people at the Factory criticized Morrissey for taking advantage of the situation and trying to promote himself as a filmmaker on his own. When the film was released, however, Paul chose to play down his own role and listed Andy's name as director on the credits. A Warhol film was comparable in his mind to a Walt Disney production. Besides, he thought, the idea of a 'director's cinema' was 'snobbish and trashy'. Paul was, he said, 'just doing a job for Andy'.

'Viva called me at the end of August,' Louis Waldon recalled,

and said Andy wanted to meet with us on Sunday morning at the Central Park Café. He had a scarf wrapped around him and he had aged a lot. He looked ashen and wan. It was a shock to see him, but he could talk and he said he very badly wanted to make a movie of Viva and me together and asked us to think of something.

Both Louis and Viva independently came up with the story of a couple who meet in a borrowed apartment to make love for the last time.

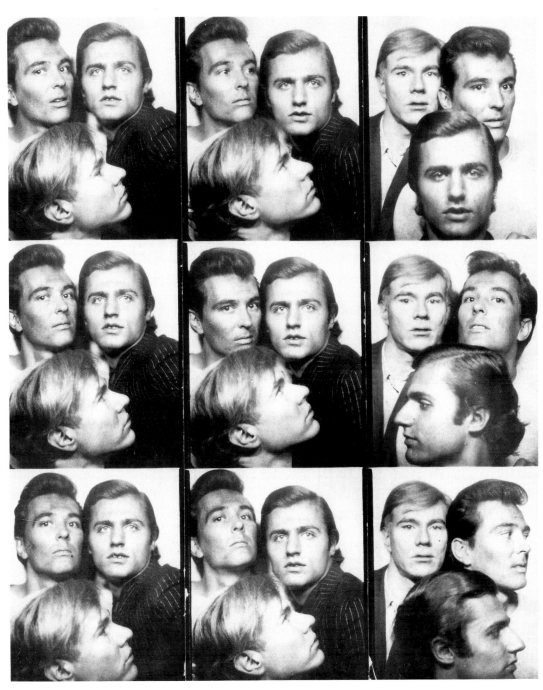

Andy Warhol, Philip Fagan and Gerard Malanga. Photomaton Assembly by Gerard Malanga. 1964. (*Photo: Archive Malanga*)

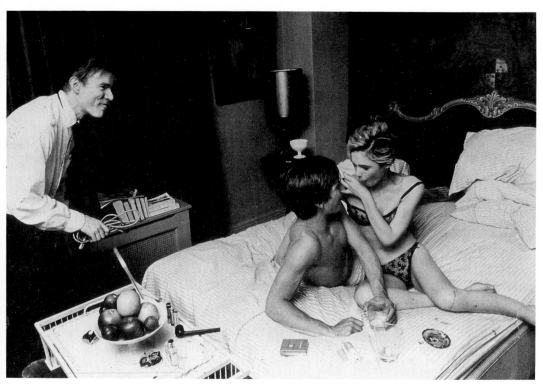

Andy Warhol filming *Beauty #2* with Edie Sedgwick and Gino Persicho. 1965. (*Photo: Bob Adelman*)

Andy lying on the Factory couch. 1965. (*Photo: Bob Adelman*)

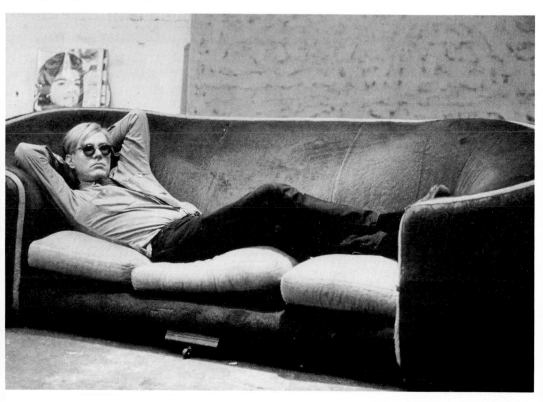

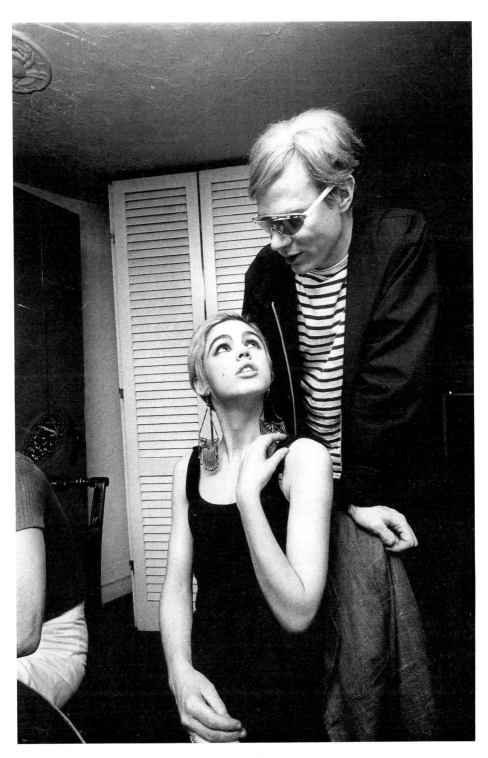

Andy and Edie Sedgwick. 1965. (*Photo: Bob Adelman*)

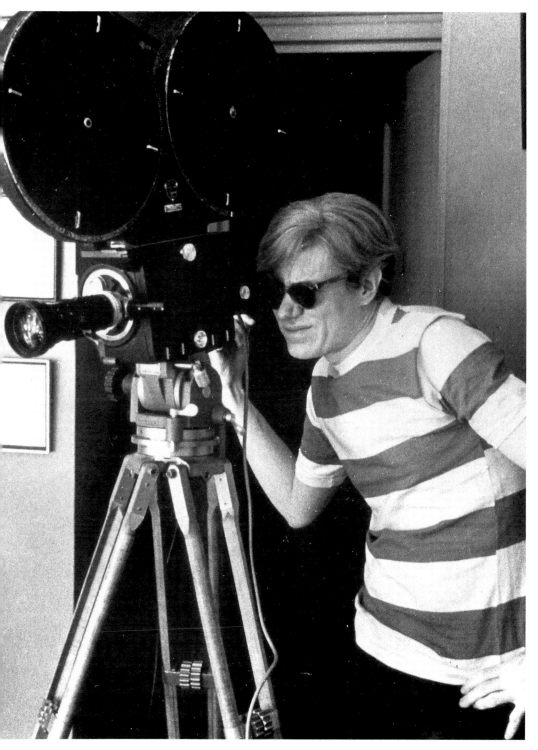

Opposite: Andy Warhol smokes a joint in the midst of Bob Dylan's screentest filming at the Factory in 1965. Dylan's head, lower left hand corner. Gerard Malanga, with his hair dyed silver to match Warhol's, to Andy's left. (*Photo: Film still, Archive Malanga*)

Andy filming *Chelsea Girls*, summer 1966. (*Photo: Santi Visalli*)

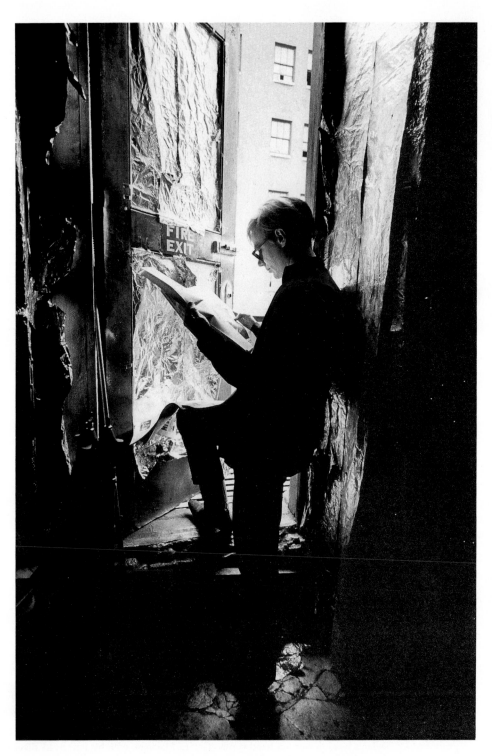

Andy reading his press clippings at the Factory. 1966. (*Photo: Bob Adelman*)

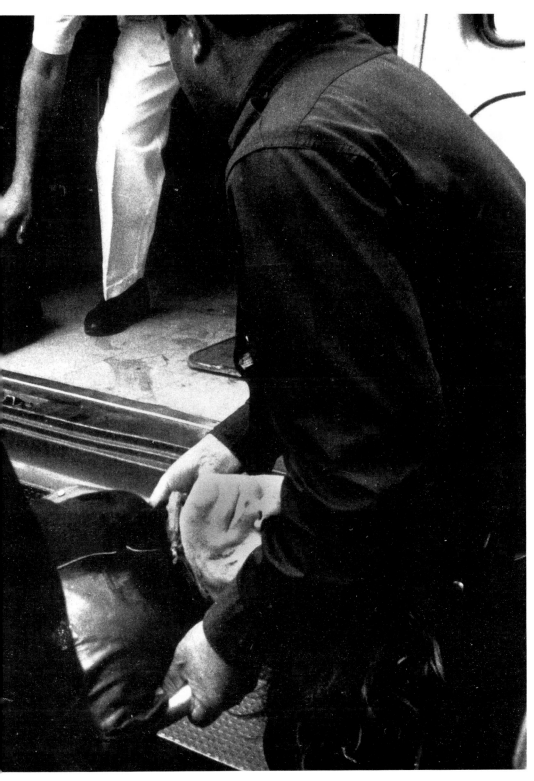

Andy Warhol being carried into ambulance outside the Factory after being shot by Valerie Solanas, 3 June 1968. (*Photo: Jack Smith/The Daily News*)

WEATHER

Mostly Sunny, 80.

Tomorrow:
Sunny, 80-85.

SUNSET: 8:22 PM
SUNRISE
TOMORROW: 5:24 AM

New York Post

© 1968 New York Post Corporation

Vol. 167
No. 169

NEW YORK, TUESDAY, JUNE 4, 1968

10 Cents
15c Beyond 50-mile Zone

LATE CITY

HOME EDITION

ANDY WARHOL FIGHTS FOR LIFE

Marcus Taking Stand

By MARVIN SMILON and BARRY CUNNINGHAM

Ex-Water Commissioner James Marcus was expected to be the government's first witness today in the bribery conspiracy trial that has wrecked his career and saddled the Lindsay Administration with its only major scandal.

His opening testimony follows a dramatic scene in U. S. District Court yesterday when Marcus, 37, changed his plea to guilty in a surprise switch which visibly jolted four of the five other defendants in the alleged $40,000 kickback plot.

The dapper former aide and confidante of the Mayor said he was in no way coerced or promised anything to change his original plea of

Continued on Page 8

Post Photos by Bozar and Enger
Pop artist-film maker Andy Warhol makes the scene at a recent Long Island discotheque party. Valeria Solanis, who surrendered to police after he was shot and critically wounded, is shown as she was booked last night.

By JOSEPH MANCINI
With JOSEPH FEUREY and JAY LEVIN

Pop artist Andy Warhol fought for his life today, after being gunned down in his own studio by a woman who had acted in one of his underground films.

The artist - sculptor - filmmaker underwent 5½ hours of surgery performed by a four-man team of doctors at Columbus Hospital late last

Andy Warhol: Life and Times. By Jerry Tallmer. Page 3.

night and was given a "50-50 chance to live."

He remained in critical condition today and his chances for life had not improved.

At 7:30 last night, just three hours and 10 minutes after the shooting, Valeria Solanis, 28, a would-be writer-actress, walked up to a rookie policeman directing traffic in Times Sq. and surrendered.

She reached into her trench coat and handed Patrolman William Schmalix, 22, a .32 automatic and a .22 revolver. The .32 had been fired recently, police

Continued on Page 3

Front page of *New York Post*

Andy liked the idea. He had always wanted to make a movie about two people fucking and decided to call it *Fuck*. According to Viva,

> Because Andy was so shy and complexed about his looks, he had no private life. In filming as in "hanging out" he merely wanted to find out how 'normal people' acted with each other. And I think my own idea about *Blue Movie* [as *Fuck* would be called] wasn't, as I believed at the time, to teach the world about 'real love' or 'real sex' but to teach Andy.

The ninety-minute film was shot in a single day at David Bourdon's apartment, characteristically shot in long takes with a fixed camera, which Andy left running in the hallway during the shower scene and walked away. Paul was standing uncomfortably on the sidelines. He finally walked out during the climactic love-making scene. Viva attributed Paul's uptightness to 'embarrassment', but according to Malanga, Paul was unhappy at having failed to 'sanitize' Andy.

After shooting the film they decided to have dinner at Casey's, but as they were approaching the restaurant Andy stopped all of a sudden, turned to the others and said, 'Oh no, we can't go in there, there's only two women and there's eight men. It won't look good. They'll think we're gay!' When everybody assured him that it would be all right and urged him to go in, he said, 'Oh, OK.' He was very quiet during dinner, Waldon remembered. 'He just kept saying over and over that he thought the film went really well and was beautiful.'

A week later Andy and Billy Name gave an interview to the authors of *The Complete Book of Erotic Art*. Andy said he did not think his films were erotic because 'we show everything the way we show it, it doesn't look sexy'. Then he took off on a long rap about pornography, typical Warhol although quite different from his silent image. 'The people who used to do girlie movies copy our movies now and they're really good,' he said. 'Oh, it's real dirty, I mean I've never seen anything so dirty. They copy our technique.'

'I think it should be noted,' said Billy Name, 'that Andy's sort of beyond sophistication.'

With *Blue Movie*, Warhol had used outdoor film to shoot indoors, which greatly enhanced the colours. The film was really pretty, he insisted, but he did not find it erotic. He told another interviewer that *Blue Movie* was about the war in Vietnam.

Blue Movie would be Viva's swan song. When she saw the rushes, she was appalled, particularly by the sex scene, which she felt was flat, perfunctory and quite unlike the beautifully choreographed balletic mystical love scene she had envisioned. Andy had to plead with her to sign a release ('so I can show it once at the Whitney').

Finding herself no longer an adored sidekick, Viva hadn't been coming to the Factory as much. 'After Andy was shot he became really

terrified of women,' Viva recalled, 'he was very much changed towards me, much cooler. He was sexually afraid of women before, I mean you couldn't touch him, he would cringe. That could have been an act, but afterwards he seemed to be deeply afraid.' She received a number of postcards from the actor Pierre Clementi inviting her to Paris, and at the end of November she left New York.

Andy had originally encouraged the match, but when Viva finally decided that she'd OD'd on the Factory and wanted to go, he tried to persuade her to stay. In the end, he accompanied her forlornly to buy her ticket for Paris, paying for it and adding $700, Viva recalled, 'for my Clementi dowry'.

Though her romance with Pierre Clementi soon fizzled, Viva's career away from the Factory prospered. She married a French filmmaker, Michel Auder, and starred in *Lion's Love*, a film by Agnes Varda. When it opened in New York, Andy wrote to tell her, 'You were great . . . you looked beautiful. We can't wait till you come back to us. If you need money just ask for it.' She did, on several occasions, and Andy sent it to her. Yet frequently during this period, Viva made bitter remarks about Warhol and the Factory, and once sent a letter stating that if he did not send more money, she would work as effectively against him as she had worked for him.

In March 1969 she announced that she had begun work on an autobiographical novel called *Superstar* which would be an exposé of the underground. Andy correctly interpreted this to mean of him. She also threatened to sue Andy for having allowed Grove Press to publish the text of *Blue Movie*, complete with photographs. 'We compromised on a $2,000 payoff. I was always a cheap date,' she said.

> But I guess I learned from Andy that if you consider yourself an artist everything you do is equally valuable. I used to get depressed over some men – my relationships with men – and he's always telling me, 'Forget about them,' to wait until I was famous and I could buy them. He'd say, 'You're crazy, what do you want him for? He's an old freak. He's too old, he's too old-fashioned for you. He's stupid, you know what to do, what do you want him for? *Get up there, get up there and you can have anybody you want.*' Andy to my knowledge didn't have any sexual relations with anybody. No one ever talked about it, and in those days everybody talked about everybody.

<div align="center">*</div>

Since Andy was shot, the hierarchical structure of the Factory had become if anything more rigid. Paul Morrissey increasingly assumed the role of spokesperson for the Warhol film works, expounding to reporters on the role of the artist as 'supervisor' in an age of mass communication and on the influence of television and home movies on his cinematic style. He also assumed the role of anti-drug propagandist, trying to tone down Andy's image as he told the press that drugs were

'obvious, boring, and old hat' and that 'the drug types had their time, but it's all gone now. Now it's stupid.'

In the uncertainty of what was to come, tensions ran high among the staff. 'Andy encouraged rivalry among us,' explained Gerard Malanga, who had returned as a trusted friend in the aftermath of the shooting. 'It kept things from getting dull.' In his *Secret Diaries*, Malanga saw the Factory rivalries as a struggle to see 'who will be chosen to be part of the future the second time around'.

Typical banter consisted of Brigid calling Paul a 'power-mad puritan faggot' or someone else saying of Brigid, 'She's an evil pig, but Andy likes to have her around. I don't know why.' Little had changed in that regard beneath the plastic mirrored surfaces of the new Factory. And for many of those who were still there, despite everything, the Factory remained the most stable element in their lives – home.

The poet Jim Carrol, who was living in Brigid Polk's hotel room and working part time for Andy that fall, described the Factory in his journals as a 'medieval monastery' with Andy as the 'Pope in Exile' and Paul as 'the abbot and Grand Inquisitor'. Jed Johnson found himself in the role of favoured choirboy. Gerard Malanga:

> I never knew Andy to be satisfied in a love relationship until he met Jed Johnson. Somehow I felt that Andy might have actually got somebody that he could love in Jed. Whatever boyfriends Andy had prior to Jed were distractions to his art, they didn't really contribute anything to enchancing or helping him, but Jed was very helpful. He would set up the projectors, put the film in the projectors, sweep the floor. I got along famously with him. Jed was a real sweetheart.

Brigid Polk became much closer to Andy after he was shot. Viva commented, 'How could she have gotten any closer? I would say it was the longest running marriage in New York. She was the wife figure in his life.'

At the Factory, perhaps because he was afraid of women, he replaced Viva in the spotlight with two transvestites: Jackie Curtis and Candy Darling, who had made a cameo appearance in *Flesh*. Jackie Curtis was a talented playwright who had, in the words of a colleague, Penny Arcade, 'taken to the streets and stage in ripped stockings, old Thirties dresses, an explosion of red hair, false eyelashes, no falsies and glitter everywhere'.

Jackie and Candy fascinated Andy. 'Among other things,' he explained,

> drag queens are ambulatory archives of ideal movie star womanhood. I'm fascinated by boys who spend their lives trying to be complete girls, because they have to work so hard – double time – getting rid of all the telltale male signs and drawing in all the female signs. I'm not saying it's not self-defeating

and self-destructive, and I'm not saying it's not possibly the single most absurd thing a man can do with his life. What I'm saying is, it is very hard work to look like the complete opposite of what nature made you and then to be an imitation woman of what was only a fantasy woman in the first place.

Since *Flesh* opened, Jackie and Candy had been renting a room together at the Hotel Albert, where a lot of Warhol people stayed. Andy felt that Jackie played the role of a woman 'with total comedy'. 'His eyebrows were all plucked and he wore pancake make-up but his beard was coming through in stubble,' Warhol described it. Jackie would periodically 'go back to being a boy', while Candy Darling was surprisingly femme and became a favourite at the Factory with reporters.

A third transvestite superstar, Holly Woodlawn, was introduced to Warhol in 1969. 'I was expecting one of those loud, boisterous, imposing, assuming big shots,' Holly recalled. 'He was a quiet little nothing, but I thought he was cute.'

The drag queens made an intriguing trio: Holly Woodlawn was the sultry Hedy Lamarr figure – what Ultra Violet would have been as a drag queen – Candy Darling was the Kim Novak Hollywood blond type, and Jackie Curtis was the Joan Crawford, vicious and strong. Andy developed the amusing routine when visitors arrived of introducing everyone on the staff, regardless of sex, as a 'transvestite'.

Warhol's stable also included a group of rambunctious, sexy teenage girls: the green-eyed honey-blond Patti D'Arbanville, who would actually go on to make it in Hollywood, and her friend the Garboesque Geraldine Smith, the costars with Dallesandro in *Flesh*; Andrea Feldman, who had briefly appeared in *Imitation of Christ* and was destined for greater things; and, later, Jane Forth. 'We all had a big crush on Paul even though he seemed so asexual,' recalled Geraldine, 'because he was the director, he had the power. And Andy really represented New York to us. Every time we went to a party and Andy showed up it was *the* party. It was great being part of that scene.' They were all so much younger than Andy, 'they were post-pop', he wrote. In the movie-lot tradition, Andy fondly called them his 'kids'.

Throughout the summer of 1968, there had been a frenzy of typing going on at the Factory. Warhol's twenty-four hours of tape recordings with Ondine done in 1965 and 1967 were to be rushed into print by Grove Press to pick up on his new notoriety. Billy supervised the typesetting at the publishers', making sure it was presented with every spelling mistake and typo intact so that Andy's intention to make a 'bad' book would be fulfilled. Andy had always wanted to call it *Cock*, but it was published as *a* in a smart hardback edition at the relatively high price of $10 in November 1968. Paul Carrol, writing in *Playboy*, praised the book as 'a genuine microcosm of the world of words,

fractured sentences, grunts, giggles and blablabla that surrounds us', but most of the other reviews were predictably bad. The *New York Review of Books* put it down at great length, calling Warhol a *haute vulgarian* and the book 'a bacchanalian coffee klatsch'. The review concluded that *a* 'is about the degradation of sex, the degradation of feeling, the degradation of values, and the super-degradation of language; that in its errant pages can be heard the death knell of American literature'. It said, 'Ondine is a little didactic, a little operatic, and rather cloacal, an East Village prima donna, both anal and oral, a hoarder of gossip and finery and orgies and drugs . . . Ondine is filthy, but he is funny.' It quoted the following passage:

> He said, 'Please try it.' I said, 'Well, I'll try, but I'll feel silly.' And I couldn't do it. I could not do it. I said to him, 'I know what we'll do, let's get a can of baked beans, open it up, you take the pork out and put them up one by one would you try, and then I'll squat over you, and I will shit them out.' And I did. And he was in seventh heaven . . .

It called the mole people 'ghouls',

> spook-hour hysterics smothered in sedatives, non-stop gabbers on a Transylvanian talk show. If Warhol were a genius, they would be devastating. As it is, the characters of *a*, like many of the other characters of Warhol films, suggest the final touch, or the final solution – they represent the bizarre new class, *Untermenschen* prefigurations of the technological millennium, as insulated from the past, from pleasure and pain, from humanism and the heroic tradition, as were pygmies and dwarfs from knights in armour. Sterile and insentient and instantly dated, void and verbose, yet they instantly proliferate themselves and each other.

As for the 'ghouls' themselves, they thought it was a very important book simply because there had never been one like it before. Andy delighted in his 'novel', reading it over, he estimated, at least forty times.

After finishing the galleys of *a*, Billy Name withdrew from the Factory scene, retiring into his darkroom at the back of the studio.

> After Andy was shot, it became obvious to me that Paul was almost completely taking over the management position. Whenever anyone came from the media Paul would tell people that he was in charge up there. I did, at one point, point out to those people and to Paul that I was also one of the people in charge there, and for them to not overlook that, but that was the only time I said that. And then I felt, since Fred had come in and assumed a masterful position as the ambassador who could do both inside and out, that Andy didn't really need me any more.

With a stack of books on white magic by Alice Bailey, a disciple of a

Tibetan lama and Madame Blavatsky, he remained secluded, refusing to come out of the little back room, letting his hair and beard grow and practising concentrated meditation, trying to 'clear the air of all the hecticness that had gone on. I never bothered to tell anyone because they would just have made something silly out of it, but I took the opportunity to go into seclusion for a year and clear the air.'

'Everybody expected me to try to somehow get Billy to come out, but I didn't,' Andy later wrote. 'I had no idea what made him go in, so how could I get him to come out?' Ondine:

> Billy was so loyal to that man, for a year he waited in the back room for somebody. And nobody was there. Andy Warhol was no longer there. He had gone somewhere else. There was some kind of fire going on in Billy's brain. Andy Warhol's lack of interest in Billy triggered it off to such an extent that Billy couldn't come out of the back room . . . I wouldn't say he was exactly crazy, but he was in touch with something so spiritual that most people would be frightened by it. He couldn't come out with those mediocrities.

During that winter, the only evidence of Billy's existence was the empty yogurt cartons and take-out containers he had left in the trash overnight.

<p style="text-align:center">*</p>

At the end of 1968, Maurice Girodias's Olympia Press rushed Valerie Solanas's 'scum Manifesto' into print. In August she had been declared incompetent to stand trial and committed to a mental institution. As far as everyone at the Factory knew she was still safely locked away, until that Christmas Eve, when Andy answered the telephone and heard her voice demanding that he drop all criminal charges, pay $20,000 for her manuscripts, put her in more movies, *and* get her booked on the Johnny Carson show. If he didn't, she threatened, she 'could always do it again'.

On 9 January 1969 she was rearrested for threatening several people.

Another painful incident was witnessed by the young editor of *Esquire*, Tom Hedley, at a party.

> Warhol saw de Kooning, made a pilgrimage to him, said 'Hi, Bill,' and offered his hand. De Kooning was drunk and he suddenly turned to Warhol and said, 'You're a killer of art, you're a killer of beauty, and you're even a killer of laughter. I can't bear your work!' It was a very dramatic, ugly moment, face to face, and became the talk of the party. Andy smiled, turned away and said to Morrissey, 'Oh, well, I always loved his work.'

In the first half of 1969, Andy appeared to be searching for a new direction. He was always thinking up new projects, many of which didn't really go anywhere. He was insisting, for example, that he

wanted to do a television show called 'Nothing Special', consisting of six hours of people walking past a hidden camera, like that which had been installed at the Factory, a film called *Orgy* – a large-cast version of *Blue Movie* – and a film shot during a journey around the world in Japan, India and Paris. Artistically, he seemed mainly interested – at Brigid Polk's instigation – in taking Polaroid pictures of the penises of any Factory visitor he could persuade to take his pants off. During this period, he recalled, 'whenever somebody came up to the Factory, no matter how straight-looking he was, I'd ask him to take his pants off so I could photograph his cock and balls. It was surprising who'd let me and who wouldn't.' Andy later estimated that he had taken thousands of Polaroids of genitals. Warhol's other nutty projects included 'figuring out a way to make a ten-foot mural that will turn brown in three days, like a Polaroid print', asking a bewildered Jasper Johns if he could play with his cock 'as a work of art', and a Systems art take-off called Rent-a-Friend (in which Andy would rent out his superstars, who would do anything for $1,000 a day or $5,000 a week).

The art critic John Perrault wrote a profile of Warhol in *Vogue*:

Andy Warhol's name is a household word like Ringo, Ultra Brite, or Racquel Welch. Andy Warhol is the most famous artist in America. For millions, Warhol is the artist personified. The ghostly complexion, the silver-white hair, the dark glasses, and the leather jacket combine to make a memorable image, especially in conjunction with sensational headlines . . . Some would maintain that Warhol's greatest art work is 'Andy Warhol'.

Perrault's profile also focused on Andy's unusual new habit of taping everyone.

Warhol records everything. His portable tape recorder, housed in a black briefcase, is his latest self-protection device. The microphone is pointed at anyone who approaches, turning the situation into a theatre work. He records hours of tape every day but just files the reels away and never listens to them.

In May 1969 *Esquire* did a story called 'The Final Decline and Total Collapse of the American Avant-Garde' with Warhol on its cover drowning in a can of Campbell's soup. Tom Hedley:

I was a very aggressive, egocentric editor, I imposed my ideas on everybody and Andy was someone I could use. He was like a hooker or a stripper for me. I could get him to pose naked, I could do anything, because he was so giving and so open. He had a world-weary, rather elegant point of view that always has been very attractive, even though it must have been enormously painful to him . . . At the time he was getting not much attention from artists but an awful lot of attention from people outside the country.

'Almost everything Andy did was of a comic nature,' said Paul Morrissey.

Andy always avoided taking any serious position or taking himself seriously. He went along with anything that seemed silly or frivolous. Anything that was serious he avoided like the plague. But being comical is one of the most serious things. It requires an enormous amount of purpose, and determination.

On 5 May *Lonesome Cowboys* opened in New York at the 55th Street Playhouse and the Garrick Theater in the Village. At a press conference after the opening, the film critic Parker Tyler noted that Morrissey

even 'translated' some of Warhol's laconic, undertoned answers to questions from the largely collegiate press . . . Morrissey underlined Warhol's admission that his own painting was 'junk', a form of 'decoration' at best, and that in any case his films bear no conscious relationship to his painting. His films seek to be 'entertaining', Morrissey declared, and entertaining only. 'No art please,' is the tacit gimmick.

Variety also quoted Morrissey, on the subject of pornography – 'Sex is the stuff of comedy. The big commercial sex pictures are just like the underground newspapers, they take the whole thing absolutely seriously' – and characterization in Warhol's films – 'When they leave the theatre people don't say, that was a great movie, they say, those were great people.'

'*Lonesome Cowboys* walked away with the San Francisco Film Festival Award,' recalled Taylor Mead, who attended the West Coast screening along with Morrissey but without Warhol. FBI agents also came to see the film and reported to the agency that the 'White Female' (Viva) was not in fact raped. This ended the one-and-a-half-year surveillance of Andy Warhol.

'If only someone would give us a million dollars . . .' had become Andy's daily litany. 'Why can't Andy get someone to back a big movie deal?' John Wilcock asked Lou Reed, who replied accurately, from experience of doing business with Warhol, 'Because he's sticking to his own terms. He has to cut out certain shit and take a more professional approach.' Andy's eccentricities made most Hollywood executives uncomfortable.

However, Gerald Ayers, an assistant to the president of Columbia Pictures, was encouraging Morrissey to submit something in writing, and Paul had hit upon an idea with a *Los Angeles Times* reporter named John Hallowell. He had originally visited the Factory to do research for a novelized account of the life of a celebrity interviewer he was writing called *The Truth Game*. With a few adaptations, Paul transformed Hallowell's story into a screen treatment which was intended to feature

a mix of Warhol superstars and Hollywood stars Hallowell was instructed to recruit in LA.

Paul finished the screen treatment and sent it to Ayers and in late May, Columbia flew Warhol, Morrissey, Joe Dallesandro, Geraldine Smith and Jed Johnson to Los Angeles to discuss the project and put them up at the Beverly Wilshire Hotel.

According to Hallowell, Warhol arrived for his studio conference with the top executives of the company half· an hour late and with his entourage in tow.

Somehow Andy, Morrissey and I got ourselves into the inner sanctum where the studio head himself greeted us from behind an enormous desk with various executives assembled. Oscars shimmered from one wall and, instinctively, Andy placed himself in a chair below Hollywood's beloved gold statues. Morrissey did the talking. So much so, that at one point the studio head called Paul Morrissey 'Andy'. That produced a Warhol smile. Otherwise, throughout the entire madly inconclusive meeting Andy simply sat there below the Oscars swathed in black leather and uttered not a word. Beneath all the money talk the studio was petrified. How could they explain all this to the stock holders? Where was the script? But on they went, through days of talks and telephones and meetings.

'Andy loved it all,' said Jed. 'He loved Hollywood so it was really exciting that people from Hollywood were talking about movie deals.' During a four-day stay they were fêted at a discotheque called the Factory where Jane Fonda took them under her wing, and went to a screening of *Easy Rider* attended, Geraldine Smith recalled, 'by everybody in Hollywood'. However, after four days of waiting for a call 'Andy stopped it', Hallowell wrote, adding, 'unaccustomed as he was to waiting he simply collected his Superstars and went back to New York.'

'Andy's thing was they brought him out to Hollywood just to put him down,' explained a new staff member, the nineteen-year-old Vincent Fremont, who would eventually become vice president of Andy Warhol Enterprises and had taken over Billy Name's duties as Factory foreman.

You don't do that to somebody like Andy. He was so shy and he was very sensitive and he didn't like it. Andy had very strong feelings about those kinds of things.

Andy's idea of finding the right people and ad libbing influenced Hollywood a lot in the early seventies, but Hollywood did not want Andy in there at all. He was too weird, and the underground image with the drugs was not bankable. I'm sure he was disappointed. It's not interesting to be flown out to be put down.

Fremont was a restaurant worker who had never been to college. He had long hair and was, like his contemporaries, looking for a new

direction. Andy and Paul soon realized that he was reliable, drug-free and had a good sense of humour. Somewhat bland in appearance, but slim and soberly dressed, he soon came to resemble the model of a yuppie accountant.

In June Valerie Solanas was sentenced to three years (of which she had already served one). John Warhola:

> Andy says that the police says that if he would appear against her she would go to jail for a long time. If he doesn't appear they'll just put her away for three years. And Andy didn't even want to bother to appear because it took him a whole year to recuperate. He was real thin and weak. He just thought he would never get better.

Among other Warhol friends, Lou Reed was appalled by the short sentence. 'You get more for stealing a car,' he complained. 'But the point is the hatred directed towards him by society was obviously reflected in the judgment.'

As the first anniversary of the shooting approached, Andy was still in pain from one wound that would not heal properly and often needed to be drained. He was less energetic and his natural pallor was even ghostlier. Zipped tightly in his surgical corset and black leather jacket as he went about his business, he had struck Cecil Beaton, who took some photographs at the Factory for a show, as a 'zombie, more dead than alive since he was shot'. When Taylor Mead looked at him now, he saw 'the ghost of a genius . . . a walking ghost'.

'At the moment,' wrote Calvin Tompkins, 'what we seem to see reflected in that strange face is a sickness for which there may be no cure. Andy, in what one fervently hopes is just another put-on, begins to look more and more like the angel of death.'

Doubtless he had changed a lot, but how was unclear. 'Up until the time of the shooting he lived a life of extreme risk,' Barbara Rose observed. 'After the shooting, he didn't take another risk.' But this was not obvious to those closest to him. His friends' responses were typically polarized. Emile de Antonio thought he was a very different person, that the shooting really made him think and a sadness came on him, whereas Leo Castelli thought he had become more relaxed and sweeter, and Baby Jane Holzer said that since the shooting, 'I think Andy is one of the happiest people I know'.

'He's as badly off as Marilyn Monroe,' snapped Sam Green.

Asked how he felt by a reporter, Andy replied, 'It's different . . . maybe it would have been better if I had died. I mean, it's so-o-o awful. Everything is such a mess. I don't know. It's too hard.'

'But you seem so cheerful and active,' the reporter commented.

'Yes, I know,' Andy said. 'But you have to . . . you know, you have to pretend.'

324

Andy said he had been thinking a lot about 'the philosophy of the fragile'.

On 4 June 1969, to celebrate the anniversary of the near death of Andy Warhol, a health-food lunch was ordered up to the Factory from Brownies. Andy had told Brigid it was going to be a hard day for him to take and she did her best to make him not think about the shooting. She thought he was just the same now that he was back in his black leather jacket. Brigid thought he'd gone through hell but looked fantastic. Usually when anybody asked Andy if the shooting had changed him he replied, 'Have you ever seen anyone change?'

Ultra Violet identified with Andy. 'I think actually he doesn't care about people and nor do I. My friend can drop dead next to me, and frankly I couldn't care less, yet I want to do things, I want to express myself, and I think he feels the same way too.'

Daniella Morera, who would become a friend and coworker, recalled Warhol's spooky presence. 'Andy always sat in a corner of Max's Kansas City in a cage of human bodies, surrounded by all the kids from the Factory,' she said. 'He was absolutely not coming one step forward. I must say for me it was the sublime discovery of an entire new world.'

In an attempt to generate some fast money, from 25 June to 5 August 1969 Andy rented the Fortune Theater on the second floor of 62 East Fourth Street and put on a series of male porno films. Gerard Malanga was in charge of the operation and the paperwork was done under his name and company, Poetry on Film. The hardcore house was called Andy Warhol's Theater: Boys to Adore Galore. Renting the dilapidated cinema was Morrissey's idea, as was the admission of five dollars, more than double the price of watching the same ten-minute loops on Times Square. Gerard Malanga managed the theatre and ran the music behind the silent reels; comanaging the venture and taking tickets was Jim Carrol, who wasn't sure if his new job 'was a promotion or a demotion from Studio della Warhol'.

'Little Joe' Dallesandro, in addition to running the projector for several weeks, replacing his brother who was in Bellevue, according to Carrol, was also 'making a nice piece of change for himself by taking the wealthy swills of our clientele into a small sofa-filled room beside the projection booth and packing their fudge for them for prices only a true superstar could demand'. Jim briefly considered reporting Joe to Paul, but quickly realized that he too could make a nice piece of change by taking a percentage off the door.

In spite of the inflated price of tickets and the complaints of a few customers who attended expecting to see Andy Warhol's films, the porn-movie house was a success, particularly on Tuesdays and Thursdays, when the features were changed and the 150-seat cinema was packed. On a good night they could take in $1,500, though Morrissey, who dropped by punctually after the last show each night

to collect the bag of money, quickly began to suspect that Carrol's uncharacteristic possession of pocket money and Gerard's fancy new wardrobe were being skimmed off the proceeds. Malanga pocketed $2,000 for his six-week stint, a considerable improvement over the $40 a week he was getting at the Factory. Carrol was taking out $200–$300 on a good night. His justification: Andy and Paul were 'making out like bandits on this layer of obscenity'. In fact, after the $4,800 in rent Andy had to put out for the theatre and the various hands in the till, he realized little profit. When plainclothesmen started sniffing around, he closed the venture.

Meanwhile *Easy Rider* had opened and been an instant hit, so when *Blue Movie* premiered at the Garrick Theater on 21 July Andy was hopeful that this film would ensure his success.

At Max's on the opening night of *Blue Movie*, Andy gave away the bride at the wedding of Jackie Curtis, in a white taffeta gown, and his 'groom' Stuart Lichtenstein. During the bridal feast early the next morning, after Andy had left, one of his 'kids', Andrea Feldman, her eyes wild with pain, jumped up on a banquette and, shoving a fork into herself, shouted at Jackie, 'This is what a real woman looks like!'

In Paris, Viva heard that *Blue Movie* was getting a lot of response. 'Timothy Leary loved it. Gene Youngblood [an LA film critic] did too. He said I was better than Vanessa Redgrave and it was the first time a real movie star had made love on the screen. It was a *real breakthrough*.'

'Love and sexuality in Warhol's art are basically tragic. No joy. No consummation. No lasting love. Only a deeply ingrained sadness that communicates the pathos of being unable to find in the present some Eden of infancy or early adolescence,' Paul Carrol wrote.

However, all their hopes of success were dashed the following week when *Blue Movie* was seized by the police on the grounds of obscenity.

'They came all the way down to the Village,' Warhol wrote in one of his few public protests,

> sat through Viva's speeches about General MacArthur and the Vietnam War, through Louis calling her tits dried apricots and through her story about the police harassing her in the Hamptons for not wearing a bra, and then they seized the print of our movie. Why, I wondered, hadn't they gone over to Eighth Avenue and seized things like *Inside Judy's Box* or *Tina's Tongue?* Were they more socially redeemable maybe? It all came down to what they wanted to seize and what they didn't basically. It was ridiculous.

The following diatribe by Rex Reed is representative of the kind of reaction Warhol films were getting at the time that *Easy Rider* was successful:

> I can't imagine any serious critic giving more than, say, ten minutes of consideration to the films of Andy Warhol . . . Warhol is merely a joke now.

He has contributed nothing of any real significance to the contemporary cinema . . . Warhol was just a trend, a phase of our self-corruption. Like the Beatles, he has almost become respectable . . . The films of Warhol lack beauty, expressiveness, meaning, relevance to anything but a certain group of social rejects who find in them, perhaps, temporary escape from narcotics and film music. For the rest of us, his films have become, as Pauline Kael says, 'Time killers on the way to the grave'.

Asked by Leticia Kent in a long interview in *Vogue* what he thought about the film being called hardcore pornography, Andy replied:

I think movies should appeal to prurient interests. I mean the way things are going now – people are alienated from one another. Hollywood films are just planned-out commercials. *Blue Movie* was real. But it wasn't done as pornography – it was an exercise, an experiment. But I really do think movies *should* arouse you, should get you excited about people, should be prurient. Prurience is part of the machine. It keeps you happy. It keeps you running.

Asked if he thought it was irresponsible to put out films that were experiements, Andy replied, with the barest hint of a smile, that the paying customers were the experiemnt.

In a final defence of his methods, which were used in *Blue Movie* for the last time, Andy told Leticia Kent,

Scripts bore me. It's much more exciting not to know what's going to happen. I don't think plot is important. If you see a movie of two people talking you can watch it over and over again without being bored. You get involved – you miss things – you come back to it . . . But you can't see the same movie over again if it has a plot because you already know the ending . . . Everyone is rich. Everyone is interesting. Years ago, people used to sit looking out of their windows at the street. Or on a park bench. They would stay for hours without being bored although nothing much was going on. *This is my favourite theme in movie making* – just watching something happening for two hours or so . . . I still think it's nice to care about people. And Hollywood movies are uncaring. We're pop people. We took a tour of Universal Studios in Los Angeles and inside or outside the place, it was very difficult to tell what was real. They're not-real people trying to say something. And we're real people not trying to say anything.

I just like everybody and I believe in everything.

*

By November, Billy Name had been living in his darkroom for nearly a year, and Paul was beginning to complain worriedly, 'Andy, he's going to die in there and the papers are going to say, ANDY WARHOL LOCKS MAN IN TOILET.' Andy claimed that he had 'gotten used' to the weird situation and that Billy 'would work it out for himself'. Among the rest of the Factory staff – hardly any of whom had actually seen Billy in months – he had become more legendary than real. Stories

abounded that he had shaved his head and was caked with scabs from lack of light, or that his eyes had turned yellow and he had grown clawlike fingernails. The only person who visited him was Lou Reed. Eventually Lou freed Billy by arranging for a payment of $200 for a photograph of Billy's to appear on the cover of an upcoming Velvet Underground album. Or, as Name recalled it, 'I said, "Well, I've done this for about a year now and I've accomplished what I wanted to and Andy doesn't need me any more, especially since Fred does a nice job of managing things, I think I will just go out into the world." '

One morning Warhol found Billy's door open with a note tacked to it reading, 'Andy – I am not here anymore but I am fine. Love Billy.'

The walls of the little room were painted white and a newly leased Xerox machine was installed.

Others were leaving the fold. Ondine had settled down with a steady boyfriend, was off speed, and was working as a mailman in Brooklyn. Being with him now, Andy noted, was like being with a 'normal person and talking to him was like talking to your Aunt Tillie, the brilliance was gone'.

By the end of 1969, Andy and Paul, anxious to start a new film project, had decided to forgo outside financing and, once again, work on their own. Excited by the success of *Easy Rider*, Warhol had been urging Morrissey to make a film about drugs. 'I thought drugs were bad and at first I didn't want to do it,' Morrissey remembered, 'but then Andy said, "You know, it hasn't been done. Nobody's really made a movie about drugs," and I thought, That's true, well, I'll show how silly it is.' The result, *Trash*, would be the most expensive Warhol movie so far (budgeted at $20,000–$30,000) and the most successful. Geraldine Smith:

> In those days Andy's reputation was such that if you mentioned that you were involved with him everybody would get freaked out. You got kind of ostracized. It became a negative thing. Everybody told us – 'Don't be in a movie called *Trash*. It'll ruin you!' So Patti, Andrea and I told Paul, 'We don't want to be in *Trash*! We want more money! We want to be big movie stars!'

Trash, shot during the first two weeks of December, starred Joe Dallesandro, essentially repeating the role of hunk he had played in *Flesh*, with the crucial difference that this time his character was unable to get an erection because of a heroin habit. The critic John Russell Taylor later summed it up:

> The true subject of *Trash* is presented neatly, as a sort of formal statement of theme, in the opening sequence, during which Geri Miller (the girl who was considering having her breasts inflated with silicone in *Flesh*, and has now apparently done so) tries everything she can think of to excite Joe Dallesandro, who remains resolutely, and not too concernedly, as unaroused by her

manipulation as by her elaborate go-go dance. Geri is worried in an almost maternal fashion about Joe; the trouble, she says, is the drugs he takes. Why can't he trip on sex instead? It's cheaper, nicer, and a lot healthier. Can you trip on sex? asks Joe. Of course, says Geri; isn't it great when you come? No, says Joe; it's over.

'Joe Dallesandro – superstar and superstud on film – lived a quiet life with his wife and child,' noted Malanga, who had often stayed at Paul's apartment, 'but in an atmosphere weirdly and powerfully controlled and manipulated by Paul Morrissey, who occupied the middle flat, under Dallesandro, of the three-floor building.'

Geri Miller, a self-described supergroupie, had previously appeared in *Flesh*, giving Joe Dallesandro a blow job. Andy and Paul cast the female impersonator Holly Woodlawn as Joe's wife, who spends her time cruising the Fillmore East and hunting for home furnishing in garbage cans while he 'works' as a bungling housebreaker. With her buck teeth and wild-looking long black hair, Holly emoted such a stunning, hilarious ferocity in the role that Morrissey enlarged her part.

The film costarred a cast of Andy's 'kids', including Jane Forth, a tall, severe-looking sixteen-year-old with shaved eyebrows and hair slicked back with Wesson oil. Fred Hughes had suggested she should test for the film. Jane Forth:

> I was fifteen when they brought me to the Factory. The very first time I saw Andy I went with someone over to his house to borrow a black leather jacket for some photographs, and everyone said, 'Andy Warhol' and 'Andy Warhol', but I had never heard of him before, I didn't know who he was. And I went up there and I kept thinking this Andy Warhol must be very handsome with dark hair and everything else. So I went up there and there was this skinny little man sitting on the end of the bed with white hair and I said, 'This is Andy Warhol?'

She was 'scared to death of him' at first but when she got to know him she felt he was like a sister – 'someone you can call up on the phone and gossip with . . . Andy plays a great big game, and it's so much fun to watch him play it. You never know when he's telling the truth or lying. He's a very good actor.'

Morrissey thought Jane was 'brilliant' playing a young socialite who attempts to seduce Dallesandro when she catches him robbing her apartment. Andrea Feldman, who changed her mind because she loved Andy so much, played an LSD-crazed teeny-bopper. Geraldine Smith:

> Andrea loved being in *Trash*, but she didn't like the part where Joe threw her on the bed and ripped off her clothes. That wasn't supposed to be in, but Joe was very sadistic. He sort of raped her in that scene and she didn't like it because she wanted her parents to see the movie. So she hated Joe for that and she despised Paul for letting Joe do it.

They all put in star-quality performances for $25 a day and free meals at Max's. John Warhola:

> Andy wouldn't give his performers much money, because he knew they were on drugs and he didn't want them to buy more so he'd send them to Max's to get something to eat, but he didn't want anybody to know. People were confused. They said he was tight with money, but it was that he didn't want to waste it because he grew up in the Depression.

Jed Johnson began to work the camera on this film. He observed:

> The atmosphere on the set was definitely very focused. Andy and Paul were serious at that time. They wanted these movies to be successful. Everything was ad libbed but ad libbed with some framework and direction for them to work in. Andy was occasionally on the set but not much, but even when Andy was away you felt a real strong influence of the presence of Andy. You thought, Well, how would Andy do this? I still feel him today. When I do something I think, Well, gee, how would Andy do it?

Though in the years that followed, a critical debate would flourish over the question of who made Andy's films, for Jonas Mekas there was never any doubt:

> The mystery of it all remains how it all holds together. It's like the United States – the idea, the concept, the essentials ('the Revolution') come from Warhol, and the particulars, the materials, the people come from everywhere and they are held together by the central spirit, Andy Warhol – Andy Warhol who has become almost the symbol of the noncommittal, of laissez-faire, of coolness, of passivity – almost the Nothingness Himself.

Trash opened in New York at the prestigious Cinema II on 6 October 1979 and was an immediate hit. Andy developed the concept of consumer feedback in advertising by having people interviewed about the film as they left the cinema and using their responses in an advertisement. Vincent Canby, writing in the *New York Times*, said, '*Trash* could simply not have been made in any time or place but Spiro Agnew's America, which, in effect, the movie celebrates . . . its heart is counterrevolutionary.' He applauded Holly Woodlawn as a 'comic-book Mother Courage'.

Trash, which would become the biggest public success of any Warhol film and eventually gross $1.5 million, marked the turning point for the enterprising Paul Morrissey and the Warhol film studio. The establishment critic John Russell Taylor wrote an essay on Morrissey and Warhol, commenting:

> One is driven to the surprising conclusion that Warhol's cinema, which seems at first glance to be built entirely on camp, finally works best when it is not

camp at all, and fails to the degree that the self-indulgence of camp is allowed to creep in. It accepts things as they are, entirely seriously, but mercifully without sociological solemnity. The methods of the Warhol Factory may be deliberately hit-or-miss, but when things fall out right, the results can stand comparison with anything else the cinema of today has to offer.

Despite the lavish attention paid the film, Paul Carrol thought Andy remained 'enigmatic and mostly in the background; as one of his friends says, 'He's the Cheshire Cat. Just when you're sure he'll be somewhere, he vanishes.'

After the financial success of *Trash*, Andy had similar problems with some of his stars to those he had had after *Chelsea Girls* four years earlier. Holly Woodlawn told Patrick Smith in an interview in 1978:

I adore Andy now, but at one point I hated him. Because after I was in the movie and it was a success, he made money and I was still poor . . . Suddenly overnight I was a star and I just didn't take advantage of it. I was too dumb and I wasn't really serious about it. I was having too much fun running around with Jackie and Candy and Andy. And whenever I needed money I went up to the Factory, 'Andy, I need money. Oh, God! Money! Money! Money!' And he'd give me a cheque. A lot of people who were his superstars had bad endings. They just felt that he had to take care of them. He doesn't owe anything to anybody.

Of all the different ideas Warhol had for films, his next effort, *Women in Revolt*, was perhaps closest to his heart. Made sporadically over a period of two and a half years with Jed Johnson behind the camera, this topical comedy starred Candy Darling, Jackie Curtis and Holly Woodlawn, all playing women in different stages of 'liberation'.

Morrissey was dubious about the project at first, thinking it dangerous because of Valerie Solanas's connection to the women's movement. 'I was very much aware that it was a bad idea and that Andy was deliberately doing it,' he recalled. 'It was one of the few things he ever did as a deliberate challenge, a show of defiance, but as soon as I realized that he really wanted to do it, I was very much behind it.'

The movie was not an attack on women's liberation, Fred Hughes told one reporter. 'We are for equal pay, day-care centres, free abortions . . .'

'And lipstick for both men and women,' Andy added.

In the plot, largely inspired by Jackie Curtis, Jackie played a virgin school teacher from Bayonne, New Jersey; Holly Woodlawn played a struggling bohemian; and Candy Darling a Long Island socialite who longs to be a movie star. The comic high point was undoubtedly the scene in which Curtis pays a former Mr America to have sex with her so that she can 'find out what we're fighting against' and, after gagging through an awkward blow job, comments quizzically, 'This can't be

what millions of girls commit suicide over when their boyfriends leave them . . .' Andy loved that line.

There were lots of arguments on the set which led to the breakdown of Andy's relationships with the drag queens. Jackie Curtis kept telling Andy it would be 'better if Morrissey had left his two fucking cents out!'

'Andy complained about drag queens calling him up in the middle of the night, but they were very aggressive and that's how they are,' said Bob Heidie. 'I think you can look at both Candy and Jackie as victims because so many promises of stardom were made.'

According to another drag queen who was a close friend of Jackie Curtis, Margo Howard-Howard:

Andy was a cocksucker, a venal man. He was not a nice person. Andy robbed Jackie Curtis. He never paid anyone. A little pocket money and all the drugs they wanted he acquired for them. Heroin. Amphetamines. For *Women in Revolt*, Jackie Curtis got $163. At the most. All the drugs and booze they wanted, and boys. He would acquire young men. For that purpose only, to fuck 'em or suck 'em, whatever, from sixteen to twenty-two, young and foolish and impressed by Andy Warhol. Andy Warhol, when you come down to the bottom line, was an unscrupulous bastard, and when you come down to it, he was a charlatan.

Women in Revolt was finally released in February 1972. Vincent Canby hailed the film as a madcap soap opera in the *New York Times*, stating, 'Probably no man, not even Norman Mailer, will ever have the last word on women's liberation, but until one does, perhaps the Andy Warhol–Paul Morrissey *Women in Revolt* will do.' Despite some of the best reviews ever received by a Warhol film, it achieved none of the success of *Trash*, largely because of a bad distribution deal.

The actor Frank Cavestani, who had met Warhol through Wynn Chamberlain and played a small role in the film, was particularly struck by the way Warhol managed the Factory and made the films.

1969 to 1972 was the heaviest drug time in New York and at the Factory. That was when Andy said, 'Oh, really?' to almost everything you said. People would bring up all sorts of foreign actors and tell Andy this is the person who can do this or that and he would say 'Oh, really?' Before you knew it these people would be taking their clothes off and doing some number because he wouldn't respond. Brigid Polk told me one time, 'Andy really likes you a lot but he thinks you should be a homosexual.' I said, 'Oh, really?'

I thought he was a wonderful man. I never heard him say a disparaging word and he was always helpful, interested, friendly and generous. You could call him at home on the phone and he would take your call. Paul was the organizer. Completely. There was a constant tension at the Factory, a kind of receiving line where everybody only has so much time to talk to Andy and then you had to move on to let the next person come in.

Cavestani played a construction worker in the film.

We started shooting in the street not far from the Factory, down from Max's. Andy was there. I said, 'What's supposed to happen in the scene?' and Andy said, 'Gee, I don't know. Ask Paul.' So I said, 'Paul, what's supposed to happen in the scene?' He said, 'Gee, I don't know. Ask Jackie.' So Jackie and I made up this scene.

At one point Jackie, whom I knew quite well, took off my helmet and smashed me in the face. I said, 'Jackie, you son of a bitch!' and started chasing her. She pulled up her dress and ran down the street. By the time I got to the end of the block I realized it was hysterical and I came back and Andy said, 'Oh, that was just wonderful.' Meanwhile, this cop comes over and he says, 'Do you guys have a permit?' I turned around and Andy was scooting up the street with Paul and they took off.

We went back to the Factory and did the second scene, where Jackie was, for some reason, supposed to give me an enema though it was completely out of context. I told Wynn Chamberlain about it later and he said, 'Oh, Andy has a whole collection of asses being given enemas. He's not going to put that in the movie at all!'

I got paid a few hundred dollars. Andy wrote the cheque himself in his office. He said, 'How much do you want?' I said, '$150.' He said, 'I think I'll make it $200.'

AN INTERNATIONAL

SUPERSTAR

1970–72

A prophet in his own land is without honour.
<div style="text-align: right">PAUL MORRISSEY</div>

In January 1970, while Andy, Paul Morrissey and Jed Johnson were editing *Trash*, a showing of *Flesh* was raided in London by the police, who in addition to confiscating the film took the unprecedented action of arresting the entire audience of two hundred people. The raid caused a scandal and was the subject of a debate in the House of Commons before Britain's official film censor, John Trevelyan, ruled that *Flesh* was not objectionable and that the cinema could resume showing it. 'This is an intellectual film for a specialized audience,' he said. 'I have seen it, and while it is not my cup of tea there is nothing at all corrupting about it.'

As Paul worked on a distribution deal for *Trash*, plans were finalized with the curator John Coplans for an international travelling Warhol retrospective to open at the Pasadena Museum in California in May. From there it would move to Chicago, Eindhoven in Holland, Paris and London, before being exhibited at the Whitney Museum in New York in the spring of 1971.

Coplans asked Warhol if he had any special recommendations. Andy was insistent that his early hand-painted works be excluded and that the exhibition be restricted to his series – soup cans, disasters, Brillo boxes, portraits and flowers – the representative works of the closed oeuvre, completed when he 'retired' from painting after the Cow Wallpaper show at Castelli's in 1966. 'I said, "Anything else?" He said, "No." It was the briefest conversation I've ever had with an artist on his retrospective.'

'Andy thought it was so old-fashioned, so ridiculous, so conventional,' said Leo Castelli. He felt sad, Andy told Leo over lunch one day; maybe he was being left behind by the younger artists. He did not feel comfortable about where he was.

To another acquaintance Warhol complained that he would 'rather have done something new and up to date' for the retrospective show, yet, asked what sorts of things he might paint, Andy's typical response

was, 'Well, I like empty walls. As soon as you put something on them they look terrible.'

Warhol truly seemed less interested in painting than in maintaining a Duchampian distance from painting. He had been working on a film about a day in the life of Duchamp in 1968, curtailed by Warhol's shooting and Duchamp's death some months later. His ambition now, he told Gerard, was 'to do nothing'.

'The critics are the real artists, the dealers are the new artists too,' he told Emile de Antonio. 'I don't paint any more. Painting is dead.' But to David Bailey he said, 'I haven't stopped painting. I paint my nails. I paint my eyes every day.'

During this period Andy led people to believe that Brigid Polk did all his work for him. All this posturing was purely in jest. Warhol had had a long-term plan to return to painting when the price was right and now that he had a manager with the acumen and panache of Fred Hughes he would be able to clean up in the new market. However, most people believed what Warhol said, and outraged collectors would call, fuming once again about fraud. Fred Hughes would have to cool them out with the quiet, firm assertion that Warhol had indeed done all his own work.

Andy attended the opening of the Warhol Retrospective in Pasadena along with a bevy of superstars, one of whom cooed earnestly when she saw the show, 'Gee, Andy, you really are an artist!' This was dramatically underscored the following day, 13 May 1970, when one of Andy's soup-can paintings was auctioned at the Parke Bernet Gallery for $60,000, the highest price ever paid at an auction for a work by a living American artist. 'At first there was quite a scandal,' recalled Leo Castelli, 'people suspected that there had been some sort of foul play and the auction had been rigged, but the price turned out to be quite correct.'

'Andy is the first real art celebrity since Picasso and Dali,' explained Calvin Tompkins.

The word, I think, is resonance. From time to time an individual appears, often but not necessarily an artist, who seems to be in phase with certain vibrations – signals not yet receivable by standard equipment. The clairvoyance with which Andy touched the nerve of fashion and commercial art, the energy emanating from God knows where, the inarticulateness and naïveté, the very mystery and emptiness of his persona – all this suggests the presence of an uncanny intuition. Always somewhat unearthly, Warhol became in the 1960s a speechless and rather terrifying oracle. He made visible what was happening in some part of us all . . .

A great deal of what took place in America during the last decade is missing of course from Warhol's house of mirrors. He had nothing whatsoever to say to the young militants, the activists on either side of our contemporary conflicts. Participation, confrontation, martyrdom do not interest him; nobody

at the Factory today would dream of going on a peace march, and if Andy contributes a painting to a liberal benefit it is only because a refusal would be awkward and un-cool. And no one in the history of cool has ever been cooler than Andy.

Andy told John Perrault he thought the Tompkins profile was 'so-o-o strange. It's like "This is Your Life", except everything is just slightly wrong. But I like it because I guess it's interesting and different. People remember things differently than the way they actually happened.'

Overnight the value of Andy Warhol's paintings increased exponentially and the worldwide trade in Warhols boomed. The soup cans naturally fetched the highest prices, closely followed by the disasters, many of which had been acquired by European museums and private collectors after their initial lack of success in America.

Shortly after the Parke Bernet auction, John Giorno sold a suicide painting which Andy had given him to a German collector for $30,000 in cash, money he used to set up a spoken-word recording company called Giorno Poetry Systems. Soon after, Philip Johnson, who had bought his first Warhol, 'Gold Marilyn', for $800 in 1962, purchased a disaster painting privately from Andy for $35,000, feeling reasonably sure that it was still a bargain. 'Painting isn't dead,' commented Johnson, good-naturedly, 'not with the prices artists are getting.'

The sudden increase in his prices and the travelling retrospective pulled Andy Warhol back into the art world, somewhat against his wishes. A part of him wanted to focus on making films, but making money was still uppermost in his mind and he could not ignore the obvious financial lure.

The New York art scene, like much of the rest of the country during the summer of 1970, was growing more politicized. The Fluxus group was in full operation. A typical example of Fluxus art was the Japanese conceptualist Ay-O's 'Kill Paper, Not People', which consisted of a bow-and-arrow attack on a theatrical paper curtain, or Yoko Ono's book *Grapefruit*. An Artists' Coalition, demanding participation in the control of the Museum of Modern Art, and an artist's strike had been organized. One member of the Coalition, Tony Shafrazi, who would later open a successful Manhattan gallery, sprayed Picasso's 'Guernica' in protest against MOMA. In the midst of this ferment – and accompanied by predictably negative responses from other artists – Andy Warhol and company were directing their efforts, if not succeeding, at making the Factory profitable. 'The new art is really a business,' Andy said. 'We want to sell shares in our company on Wall Street.'

In fact, his lawyers and accountants were establishing Andy Warhol Enterprises, Inc., as a bona fide corporation. Lest Andy Warhol Enterprises, Inc., be perceived by the Internal Revenue Service as a 'personal holding company', one of their stipulations to Leo Castelli was that

nowhere in future contracts should it be called for 'a painting to be executed by Andy Warhol the individual'.

'What he was doing was making a lot of people, including myself, uptight,' recalled John Giorno, 'because it was the time of great consciousness about the Vietnam War and everybody was trying to get together to do something and Andy was concentrating on making money.

'Ten years later,' Giorno added, 'it looked like a very good idea.'

Vincent Fremont, who was learning on the job, thought:

Andy was a very practical business person and treated business with an intuitive approach. All our lawyers and business advisers were always amazed at how good Andy was at really understanding the basic concepts of a deal and getting it across, and Andy *was* very good. There was no question he knew what he wanted. Also more than anything else he was the driving force because it was his energy that kept the whole thing going. The relationship between him and Fred was a collaboration. Fred was business manager of the overall thing because it was still the art that was taking care of paying the bills – absolutely. And that was the case pretty much all along. Andy was first and foremost an artist. I don't think he was ever inclined to walk away from being an artist.

Fred Hughes recalled, 'I was always thinking about what had to be done and what kind of strategy as far as art was concerned. There was always one thing after the next. Everything intermeshed.'

Fred Hughes, whom Malanga dubbed 'Factory Fred' because of his punctilious concern for the practical operation of the office, took an organic approach to business endeavours. It was perfectly likely that Andy might move into theatre, television, other kinds of art, he thought, it depended on what happened day by day, 'the people you meet who take you one place or another'. Fred understood that Andy was an instinctive, intuitive person, that his habit was to go into his office every day and wait for things to happen. Nonetheless Fred daydreamed of being able to 'splurge on limousines and nice restaurants instead of waiting around for taxis', and encouraged Warhol to start painting again. Andy responded by doing a new portfolio of flower prints, commissioned by the art dealer David Whitney and to be sold through the Castelli Gallery. He had also completed a portrait commission, arranged by Hughes, of Dominique de Menil. As a result of Hughes's efforts, the de Menils had become the biggest collectors of Warhols in America.

Fred and Andy also discovered other ways to generate money than the art business. In 1969 Warhol appeared in an advertisement for Braniff Airlines with Sonny Liston. 'When you got it – flaunt it,' read the caption. 'It happened on a Braniff plane: world's heavyweight champ meets pop guru. Big ugly bear meets short chic painter. Silent

spade meets honkie bullshitter. Meanest man alive meets strangest artist alive.' He would tap this source of income again later.

After he met Fred Andy started seriously collecting antiques again, soon turning collecting into an obsession. By the end of the decade he was investing a million dollars a year. Fred Hughes:

> We visited the Museum of the American Indian, one of our first outings together, and I soon realized that Andy himself was an avid collector. One of the chief sources of our friendship and collaboration was that he enjoyed sharing the little bit of expertise that I had in various fields. Indeed, when he discovered a new area of interest, he would become extremely eager and covetous, forcing us to intercede in an attempt to dampen his frenzy. Then again, Andy had no pretensions to connoisseurship, and if American Indian baskets attracted him, he suddenly wanted lots of them. To him it was all so much fun, and he would act like an excited child. Andy's bedroom was always stacked with his shopping. He didn't talk about his collection much – he did it by instinct. He disdained the show of emotion, so he was passionate about his collecting only in the sense that he was a consistent shopper. He had collected since he was a child but was always getting into something new.
>
> There was two sides to him. One side of him loved modern American things but in his everyday life he was turning to older, more classical art. He thought that classical antiques were too expensive but he loved Egyptian jars, American classical furniture and silver and got these things at bargain prices. He loved Alma-Tadema, Bouguereau, and the Vienna Secession. At the same time, grandeur made him nervous. He was nervous too that his whole life was a bubble that would burst.
>
> He was very pro-American, though he was accepted earlier in Europe. He always wanted revenge for that. He didn't show it, though. Wherever he went, Andy would be the nice guy and I had to be the sonofabitch.

In fact, Andy still had some of his childhood collection. After he was shot, John and Marge Warhola made a point of bringing from Pittsburgh the Shirley Temple blue glass he'd had since he was eight, and Andy had been overjoyed to see it.

In 1969–70 Warhol specialized in Art Deco, anticipating correctly that it would go up in value, and bought American Indian art and craft. Andy was also aware that real estate was at an all-time low in Manhattan and he was looking around for buildings to buy. In 1970 he picked up two on the Lower East Side for $15,000, a real bargain – they would be worth a million dollars by the time he died.

Collecting also got Warhol involved with different types of people, like Peter and Sandy Brant, who would be important business partners in the seventies and influenced Andy's style as he started to furnish the Factory with Art Deco desks. 'On a trip to Paris in 1969, we indulged in a rather well-orchestrated treasure hunt for Art Deco pieces,' Fred recalled. 'We were travelling with Mr and Mrs Peter Brant, friends who

led the way in finding the names of collectors from old exhibition catalogues and calling them up out of the blue.'

Warhol made Paris almost a second home for himself, largely under the influence of Fred Hughes, who had worked there for Andy's old dealer Iolas in the mid-sixties. September 1970 found Warhol and company there, shooting a film called *L'Amour*. Hughes has used his connections to arrange to make part of the film in the fashion designer Karl Lagerfeld's apartment, and another apartment was borrowed from a friend of Brigid Polk's. 'I guess we went over there because we had a lot of apartments,' Morrissey quipped. 'That's the most important ingredient. We had run out of New York apartments.'

Jed Johnson, who accompanied Warhol, recalled, 'Andy really liked Paris. He was more accepted in society there than he was in New York, and he loved that. It was glamorous. An artist was more important to the Europeans and he was very well liked by everyone.'

Hughes bought an apartment in Paris after the filming of *L'Amour* and developed a Warhol coterie there that included Paloma Picasso, Eric de Rothschild, the designer Yves St Laurent, his partner Pierre Bergé and assistant LouLou de la Falaise, who had been one of the Warhol girls in the late sixties. It was a world of Mercedes limousines, titles, nightlife, glamour and gossip. 'Fred really was the one who made Andy an international superstar because he wanted that so much,' said Suzi Frankfurt. 'Without Fred guiding Andy through French society it would never have worked.'

L'Amour was conceived as a vehicle for Jane Forth, who played an American innocent abroad, complaining, in one memorable scene in front of the Eiffel Tower, 'I miss New York. I miss Channel 5. I miss WPIX. I miss Channel 7. I miss Channel 11. I miss Channel 4.' Completed in three weeks, the film costarred Patti D'Arbanville, Michael Sklar and Donna Jordan, a Jane Forth look-alike, whose 1940s outfits, accentuated by padded shoulders, wedgies and bright red lipstick, were to have impact in the fashion world when Yves St Laurent made them his 1971 look.

Jed Johnson started operating the camera during *L'Amour*. He and Fred were now playing the important roles of art directors in Andy's life, designing the look of *L'Amour* as well as influencing him to dress in St Laurent rather than black leather. Warhol had created a fashion in the sixties which would soon become the uniform of punk rock. Now he started to create the dandy he would become in the seventies, returning in a sense to his fifties style and becoming friendly again with people like Suzi Frankfurt. But whatever Andy wore he made his own.

Gerard Malanga was an unexpected addition to the group when he arrived on the set from Germany, where he had been attending the Frankfurt Book Fair and touring with Anita Pallenberg and Keith Richards in the entourage of the Rolling Stones. The problem was that

Malanga was supposed to be looking after the Factory while Andy and the others were away. Fred Hughes turned green when he saw Gerard, who was obviously not welcome. Malanga sensed a competitive jealousy between them, largely over fashion trends and girlfriends, and distanced himself from the Warhol entourage while they were all in Paris.

When he returned to New York on a cold Irish airlines freight plane on 10 November 1970, Gerard called the Factory and was passed to Paul, who informed him that the college film-rental project he had been running had been discontinued because Morrissey wanted to get the early Warhol films out of circulation. Gerard Malanga, the last of the Factory old guard, was once again out of a job.

The year ended with the opening of the Warhol retrospective in Paris – 'the only great event', according to one French critic, in an otherwise 'bleak period'.

<div align="center">*</div>

The retrospective was due to open at the Tate Gallery in London on 17 February 1971. This was the first time a large show of Warhol's paintings had been exhibited in England, and the UK press geared up for the event months in advance. Richard Morphet, who wrote the Tate's catalogue, told them:

> I'm sure that everyone will be amazed when they see the pictures in the flesh. They have a grandeur which will come as a surprise to a public accustomed to seeing small reproductions in the press, where he is normally written up as an artist who deals with banal subjects. Some of the pictures are huge – about twelve feet square in size . . . I think he will come across as a lyrical and complex colourist. There is a tenderness and great passion in his pictures as well as an astonishingly wide variety of ways of applying paint.

Three other Warhol shows were to run in London simultaneously. Andy arrived several days before the opening with Morrissey, Hughes, Johnson, Jane Forth and Joe Dallesandro. They stayed at the Ritz. He screened *Trash* for John Trevelyan and gave a number of interviews. He visited David Hockney, had lunch with Germaine Greer at the Notting Hill Pizza where the lack of privacy made him decidedly uncomfortable, and contributed a signed poster to the *Oz* defence fund. All in all, the British press, known for making much out of little, was bemused. Geoffrey Matthews of the *Evening News* wrote, 'He looks like a corpse which has somehow raised itself up off a cold stone slab and walked out of the mortuary. He really ought to go back to the mortuary.'

Andy's private and press reception at the Tate on 16 February was a grand success, but his nonappearance at the public opening the following day upset many people who had hoped to see him. He had flown with his entourage to Cologne, en route to Munich where he

was to attend the German premiere of *Trash* on the 19th. It was his first visit to Germany. They were joined in Munich by a Factory newcomer, Bob Colacello, who would become one of Warhol's closest associates. 'We were part of the seventies generation,' he explained, referring to himself, Jed Johnson and Hughes. 'Unlike the sixties generation of "superstars", who were mostly rich kids gone bad or street kids gone public, we were mostly college-educated children of the suburban middle class – romantically avant-garde, out for adventure, even wild at times, but basically bourgeois.'

In West Germany, Warhol's art works were coveted by both collectors and museums (the Darmstadt Museum possessed the largest pop-art collection in the world). The Germans in the postwar boom delighted not only in the humour of Andy's serial supermarket images, but in the horror of his disasters, 'and even if Andy wasn't an intellectual they always saw him there in an intellectual way,' one writer said. The art dealer Heiner Bastian:

> There were several major collections of Warhol's paintings in Germany. In Germany Warhol had two distinct audiences: the art audience and those who admired him as an underground filmmaker. When his movies were first shown in Germany in the sixties they were considered *the* underground films. Through the movies he became a cult figure and since he never appeared before 1971 there was some sort of myth. And it became even more of a myth because of all those pictures of him and his stars printed in magazines and newspapers. At that time America still seemed far away from Germany.

Germany became the country showing the most works of contemporary American art. 'For us it was gripping, this art of the Americans who were also exactly our generation,' said the eminent collector Peter Ludwig. 'That was unique, because even the Americans had not yet come to the point where this art was regarded as really important. Thus German collectors played an important role in the success of American art.'

The first important book on Warhol had just appeared, written by the German art historian Rainer Crone. And *Flesh* had enjoyed an unprecedented success, thanks to a professional yet sensational publicity campaign launched by Consul Barthel, the president of Constantin Film, the German distributor. Three million moviegoing Germans had made it one of the year's top ten films, and it had made more money than either Paul or Andy cared to acknowledge. Warhol would no sooner let you know how much money they made on it, Fred Hughes observed, 'than he would go to a party in his underwear'. For Paul, it proved that Warhol films didn't have to be treated as art, but could get a mass audience if a mass distributor handled them.

During their stay, the Munich newspaper *Abendzeitung* presented

Morrissey and Dallesandro with awards for the best film and best actor of the year, but the greatest attention was, naturally, on Andy.

'Andy was greeted in Germany with an enthusiasm bordering on adoration,' Bob Colacello recorded in 'King Andy's German Conquest', an article about the trip published in the *Village Voice*:

> more like a popular monarch than a pop artist. Not only did Frankfurt boys of fifteen or sixteen chase after us in the street clutching Rainer Crone's Warhol book, beaming ecstatically as Andy signed each and every one, 'To Mary – Andy Warhol' . . . Everywhere we went we were made to feel more like visiting royalty than visiting film workers. Indeed, in the castle at Neuschwanstein the photograpers from *Stern*, Germany's leading magazine, were granted special permission to have Andy pose within the golden alcove intended for the throne of Ludwig II, King of Bavaria.

To use one of Andy's characteristic expressions, they were all 'really up there'.

Warhol's Jiminy Cricket, Robert Hughes:

> The idea that Warhol could be the most interesting artist in modern history has regularly been echoed on the left – especially in Germany, where Warhol's status as a blue chip was largely underwritten by Marxists praising his 'radical' and 'subversive' credentials. Thus the critic Rainer Crone in 1970 claimed that by mass producing his images of mass production, to the point where the question of who actually made most of his output in the sixties has had to be diplomatically skirted by dealers ever since, the pallid maestro had entered a permanent state of 'anaesthetic revolutionary practice' – delicious phrase! Here apparently was something akin to the 'art of five kopeks' Lunacharsky had called on the Russian avant-garde to produce after 1917.

On a stopover in London on the way back to New York, the Warhol entourage met polarized responses. The English acted as if they had been invaded. 'Andy Warhol is that parasitical type of activist who in the process of destroying the body of the host, be it art or politics, puts into effect a series of emotionally disturbing dead-end reactions that through their sheer nihilist excitement demand and destroy the talents of all its victims,' wrote one critic in *Private Eye*. 'The man is clearly an enemy of the people,' grumbled another. Yet many of the reviews were good and Warhol was fêted at a House of Commons reception, hosted by the Conservative MP Sir Norman St John Stevas, who had been one of the staunchest parliamentary defenders of *Flesh* when it was raided the previous year.

'Gee, maybe we can take *L'Amour* to the White House,' Warhol told Colacello as they left the reception.

'Andy at the White House?' Colacello noted in his diary. 'Well, why not?'

On 26 April 1971, after what a press release described as 'a triumphal

four-star tour of world art capitals', the Whitney Museum in New York opened its version of the Andy Warhol retrospective and drew the biggest crowd since Andrew Wyeth. At Warhol's insistence the huge fourth-floor space was covered from floor to ceiling with magenta and green cow wallpaper. His mammoth serial paintings of soup cans, car crashes, electric chairs, Marilyn, Jackie and flowers were hung against it in billboard size. The play of colour and form reflected in the lights and polished floors was confusing and beautiful. It had been Andy's intention to create a show that 'anyone could just get a flash of in a second as the elevator doors opened and then split'.

When the elevator doors opened that night and Andy stepped into the room, looking, in the words of one guest, 'like an Andy Warhol doll in his corduroy jeans, DeNoyer jacket and straw hair', surrounded by his ragtag transvestite harem of sexy boys and girls, spontaneous applause broke out accompanied by a few hisses. The opening turned into a Happening. Thronged by the press and gaping public, he was, wrote another observer, 'the centre of attention at his own canonization'.

The reviews were for the first time unequivocal. 'The plain inescapable fact, which will give pain to his enemies, is that Andy looks better than he has ever looked before,' wrote John Canady in the *New York Times*. John Perrault described it in the *Village Voice* as 'the splashiest, most dazzling, craziest, most beautiful, most outrageous museum installation I have ever seen'.

Art in America put out a special issue on Andy Warhol that coincided with the retrospective. Like the Coplans and Crone volumes it laid down a series of statements that all but enshrined him among the pantheon of international thinkers. Mary Josephson wrote:

> He has constructed a body of ideas which in themselves make a literary contribution . . . of the same order as Rousseau, Jarry and Duchamp. Its rawness (a dispensing with taste that becomes almost a form of American taste for the raw) obscures Warhol's miraculous nature. If he were French our universities would have embraced him in innumerable theses. As it is, his apotheosis is taking place in Germany . . . Just as Wilde's epigrams were repeated by his contemporaries in drawing rooms, Warhol's are retold in gossip columns, the drawing rooms of the masses.

John Canady called him 'one of the strongest influences across the land' and suggested that in the future he would not be seen as 'the pixie of the sixties' so much as 'a master of horror'. John Perrault pointed out that most people did not realize how much Andy was respected by younger artists,

> often totally different in their outward style. He is, like a cow, whatever you need. To minimal people, he is minimal. To publicity art people, he is

publicity. To boring people, he is camp. To lyrical abstractionists, he is lyricism. To decorators, he is decoration. To poets, he is poetry. To art critics, he is criticism. To filmmakers, he is film. To junkies, he is junk. To motherlovers, he is mother . . .

The same week Andy's first play, *Pork*, opened at La Mama Theater on the Lower East Side.

Andy summed up his emotions about all the attention by saying he was changing his name to John Doe and answering a friend who asked him how he was feeling at the Whitney by opening his coat, pointing to his chest and saying, 'Here. Wanna feel my scar?'

*

In August *Pork*, which had only a brief run at La Mama, was a scandalous hit in London at the Roundhouse, where David Bowie, who was just making a name for himself as the leader of the new androgynous glitter-rock movement, had seen it. The director of *Pork*, Anthony Ingrassia, a talented giant from the Theatre of the Ridiculous, had developed the idea of basing a play on Brigid Polk's tape-recorded conversations with Andy. Its two acts revolved around the character of B. Marlowe, a studiously styled duplicate of Warhol, taping and snapping photos of Amanda Pork (Brigid Polk, played by Kathy Dorritie), Vulva (Viva, played by the transvestite Wayne County), and the Pepsodent Twins (based on Jed and Jay Johnson), two nude boys with pastel-powdered genitals. The cautionary notices advertising that the play had 'explicit' sexual content and 'offensive' language helped attract audiences.

Since 1966, when his first manager, David Pitt, had been involved in a project to promote the Velvet Underground in Britain, David Bowie had idolized Andy Warhol for his ability to create human theatre around himself and his genius for publicity and myth-making. When he saw *Pork*, Bowie was impressed by the sequins, netting, tiaras and glitter of the costuming and by its gender-bender attitudes. But what impressed him most was the enormous amount of attention, generally unfavourable, the play received in the British press.

Bowie immediately befriended Anthony Zanetta, the young actor who portrayed B. Marlowe in both London and New York, and during several meetings at David's house and in the house in Earl's Court where the cast was staying (dubbed 'Pig Mansion' in the English press), Bowie quizzed Zanetta about Warhol. What was he like? What went on at the Factory?

In September, two weeks after *Pork* closed, while Bowie was in New York signing an RCA contract, Zanetta arranged for him to visit the Factory. Nothing of substance was discussed. In fact the meeting was tense and uncomfortable, with Warhol saying little except that he liked Bowie's shoes, seemingly confounded by Bowie's song 'Andy Warhol',

which the rock star made a point of playing for him. 'That was great – thank you very much,' said Andy.

'He was very upset,' said one observer. 'David Bowie said it was meant to be nice. Andy thought it was horrible. "Andy Warhol looks a scream" – he wouldn't like that because he was very sensitive about what he looked like.'

The majority of people who visited Andy in this period were made to feel uncomfortable, and Zanetta noted that Bowie threw his manager Tony de Fries a series of 'pained' looks during the interview. Going down in the elevator Bowie burst into laughter, reflecting on how much he had looked forward to meeting his hero and how nothing an experience it had been. By then Andy had become a piece of art alternatively arresting and confusing viewers.

Lou Reed, who had dinner with Bowie at Max's that night, was immensely amused by Bowie's account of how 'fascinating' the meeting with Andy had been because Warhol 'had nothing to say at all, absolutely nothing'. The Velvet Underground had once considered producing an Andy Warhol doll, he told David; when you wound it up it did nothing at all. However, Reed was as enamoured as ever of Warhol, telling an interviewer he thought Andy was the greatest artist not just of the twentieth 'but of any century'. After Lou Reed, David Bowie was the rocker to make the most of the association. Indeed, by the autumn of 1972 Bowie had transformed the Warhol mystique into his Ziggy Stardust stage show, and was in the process of hiring several members of the *Pork* cast to staff his New York office, Mainman, which would attempt a Warholian coup in the rapidly expanding international rock market.

'In the beginning, what David Bowie did was, he saw our play group in London, hired them all for his entourage, dyed his hair, wore dresses, and became the biggest star,' Warhol – who was always underneath his mask somewhat jealous of people who made more money than he did out of his ideas – told Truman Capote.

'Glitter rock' became an enormously popular musical trend. One rock critic dubbed 1972 'the year of the transsexual tramp' when 'all of a sudden almost everyone in rock 'n' roll wanted to be – or at least suggest the possibility of being – a raging queen'. Lou Reed's song 'Andy's Chest' credited Warhol as an inspiration, and his hit single 'Walk on the Wild Side' (produced by Bowie) with its caustic verses about Holly (Woodlawn), Little Joe (Dallesandro), the Sugar Plum Fairy and Jackie (Curtis) would soon be broadcasting the Factory legend over top-ten radio stations internationally.

Warhol had been wanting to make money out of rock and roll ever since he stopped working with the Velvets, but it had continually eluded him. Gerard Malanga recalled one dark moment in 1969 when they had been walking together and Warhol had spotted in a shop

window a new Rolling Stones album (*Through a Glass Darkly*) that made use of an idea Andy had contributed but the Stones had rejected. Flying into a rare fit of anger, he turned to Gerard and snapped, 'First thing tomorrow morning, send them a bill for $4,000!'

In 1971 he designed the zipper cover for the Stones' classic *Sticky Fingers* as well as the lapping-tongue logo for their record company and Exile on Main Street 1972 summer tour. Andy used Jed Johnson as the model for the cover of *Sticky Fingers* and a Factory newcomer, Glenn O' Brien, for the jockey shorts underneath the jeans. Glenn was posing with his pants down around his ankles while Andy knelt in front of him with his Polaroid and Fred said, 'Oh, can't you make it a little bit harder? It's not big enough,' when three businessmen, mistaking the Factory for an architect's office in the building, suddenly walked in. For a frozen moment they stared dumbfounded at the great artist at work before turning on their heels and hurrying out without a word.

Though Mick Jagger described Warhol as 'a fucking voyeur' in Robert Frank's film of the tour, *Cocksucker Blues*, Andy became Bianca Jagger's favourite artist and a close friend. According to the Stones' drug dealer Spanish Tony, members of the Stones' entourage accepted Andy because he was considered 'slightly mad'. Indirectly, the Rolling Stones were the catalyst for the beginning of another important friendship that fall, when Warhol was assigned to interview Truman Capote about the tour by *Rolling Stone* magazine because Capote, suffering from an acute writer's block, was unable to complete an article about it.

Andy was well enough by now to stay out late again, although he was still in considerable pain from the shooting and dependent on the care shown him by Jed. He was seen everywhere; at the Stones' Madison Square Garden concert on 26 July – Mick Jagger's twenty-ninth birthday; at Bowie's sold-out Carnegie Hall concert in September with Jackie Onassis's sister Lee Radziwill, who was, along with Bianca Jagger, an indication of the Hughes-inspired trend towards society people as opposed to the underground types Andy had been associated with.

Andy was also making the scene again at a number of clubs which, like glitter rock, seemed to be part of an Andy Warhol movie. At Sanctuary, an abandoned church on 10th Avenue, Warhol recalled, 'The altar was the sound booth, the DJ was the priest, and the nuns were the transvestite hookers standing at the bar. . . . It was the first fashionable club where boys could dance with boys and not necessarily be gay.' Another of Andy's haunts, Tambourlaine, a Latin night club in the East 50s, reached its height of fame when Truman Capote showed up one night with Lee Radziwill and Jacqueline Onassis, trying to look anonymous in kerchiefs. The club was shut down soon after when a Cuban transvestite was castrated in the ladies' room by a drug dealer.

Capote also introduced Warhol to Stage 54, a black gay bar near the United Nations.

In New York many of the barriers between gay and straight faded in the early 1970s; a great openness combined with economic success and upward mobility had increased the power and visibility of the gay community considerably. While not a standard bearer for the gay liberation movement – in fact, some of its more doctrinaire leaders felt he did more harm than good for the image of gays – Warhol, the trendsetter, was an undeniable part of this cultural trend. Tom Hedley:

> You have to look at culture heroes to really understand America. Andy understood that. He was very aware of who you had to replace to make an impact. And it was the homosexual time, the faggots were our new niggers. Homosexuality was chic. There was a kind of angry gayness going on and we were very open to making faggots and lesbians our brothers . . . They were the most stylish people in town, they ran the galleries, they had the best clubs, they had the best dinners and Andy was very involved with and very supportive of all that. He loved to show little skinny guys with huge dicks and we would always be amazed because he would say, 'Look at this!', the guy would pull his pants down for us and an enormous dork would fall out . . . He was a very lonely man who needed a romantic attachment and he was obsessive. He was like the classic lonely gay boy who loves Greta Garbo. He was full of pain and I don't think he really cared about movies or about painting, he just cared about getting himself right.

Andy was crossing over from the art world into the world of fashion. The change was reflected by a new look. Gone were his black leather jackets, replaced by velvet jackets, chic European-designed shirts, ties and expensive high-heeled boots, though always worn with blue jeans. 'Everyone's back to beautiful clothes,' he told Truman Capote. 'The hippie look is really gone.' He had bought a miniature dachshund – Archie – which he carried around with him as part of his new ensemble and said he was falling in love with. Andy was convinced that Archie could talk and was always begging him to speak so that they could make a fortune together.

Brigid for one did not like the change. 'I don't know anything about Andy Warhol,' she told David Bailey in his 1971 television documentary on Warhol.

> I don't know a thing of what he is about, because since Fred Hughes came along about five years ago Andy completely changed. Now I believe Andy to be a businessman, perhaps beginning an empire, and he is a man who goes to Grenouille for lunch every day . . . He doesn't believe in art, yet he sneaks away to Switzerland to do prints, and he will say to you, 'Oh, can't you find somebody to get me a $40,000 portrait commission? I'll give you a good chunk, dear.'

John Cage told David Bailey, 'In the art world Andy is loved by practically as many people who love people from a distance as, say, John Lennon.'

Lennon in turn told his biographer Ray Coleman that he thought Andy Warhol was 'the biggest publicity man in the world'. On a visit to New York in 1970 he had told Jann Wenner:

> I admire Andy Warhol's work. Because he is an original great and he is in so much pain. I don't dig that junkie faggot scene he lives in; I dig Heinz soup cans [sic]. That was something! That wasn't just some stupid art. Warhol said it, nobody else had said it – Heinz soup – he's said that to us, and I thanked him for it.

David Bourdon recalled the 1970–71 period at the Factory as being the intensely social year that everybody was living at Max's 'and the year that Andy and I were running around with John and Yoko'. Bourdon had known Yoko Ono in the sixties, liked her work and written about her, so when John and Yoko came to New York, as Albert Goldman wrote, 'charged with a sense of special purpose – becoming the new leaders of the New York avant-garde', one of the first people Yoko called upon for assistance in this great task was David Bourdon, now one of America's leading art critics. 'They called and they wanted to meet Andy and I thought to set up a meeting between the two great pop figures of the period would be amusing,' Bourdon remembered ruefully. As for Andy, he was keen to meet John but not so keen on seeing Yoko.

Louis Waldon, who very seldom saw Andy reveal any of his feelings, recalled how 'really upset' he had been when Yoko Ono married John Lennon. 'He despised Yoko because she had been very pushy and demanding wanting to get into the Factory and then she had said Andy was full of shit. He said, "Oh, my God, Louis, it's so horrible. It's just awful, that awful Yoko with John Lennon! Oh . . . oh . . ." '

Bourdon took John and Yoko shopping for antiques with Andy.

> That was in the period when the dealers would leave their stalls and go running halfway across the antique centre, crying, 'Oh, Mr Warhol! Mr Warhol! I have something I would like to show you!' So John was trying to show that he was a connoisseur of sorts and he was buying shopping bags full of atrocious stuff. And Yoko was putting them both down by saying that as an artist she didn't like to live with art, she liked to be surrounded by her own things. The great thing about being with John and Yoko was that you could walk along the sidewalk feeling that you were free, all because this limousine was inching along the kerb. Any time John wanted a few hundred dollars he would go to the driver and the driver would take this enormous roll and peel off the bills. We had a great time, but then Andy called me as soon as he got home and put the pressure on me to help sell the Lennons a portrait, because John had mentioned during the afternoon that, gee, he

would love to have one of those silver Elvis paintings. And Andy, not missing a thing, said, 'Well, yes, I think I have some left,' and then called me up first thing and said, 'Tell them that those paintings are $35,000. And see if we can talk them into a portrait!' But nothing came of the relationship. There was too much animosity and rivalry involved and it was partly Yoko's doing. She had said a number of extremely poisonous things in the sixties about how the New York art world was manipulated by a gay mafia, and about Andy, at the time that she left New York to go to London. When she came back she had the opportunity to make up. They were trying to get me to tell Andy that it would bring him a lot of fame if he did their portrait because there would be a lot of buyers for posters and it would open up a mass market for Andy, but Andy was being very hard-nosed about it and really wanted to make a sale. And of course they were supersensitive to anybody trying to con anything out of them, so it just didn't click.

Glenn O'Brien accompanied Paul and Andy to visit the Lennons at their Bank Street apartment. He recalled that after they sat down, Yoko said, 'You want coke, Andy? You want coke, Paul?' at which point Morrissey wanted to call the police. After they left Andy said, 'Oh, she's so great!' but Paul called them both 'drug trash'. David Bourdon:

John and Yoko were giving more interviews and she went back to this same old song about about New York's famous faggot pop artists who are controlling and manipulating the whole scene. If she had tried to make it more offensive she could not. And so for the longest time she and Andy didn't speak. Then there was a taxi strike one day and Andy, who never ever took the subway, had to go in order to get home. He got into the subway and he was standing up, holding on to the strap, and who should be sitting there but Yoko in her big dark glasses trying not to be recognized? He was trying to look away, and so the two of them didn't even acknowledge each other.

THE DEATH OF JULIA

WARHOLA

1971–72

I just thought that things were magic and that it would never happen.

ANDY WARHOL

Julia Warhola's health had deteriorated greatly since Andy got shot. Gerard Malanga had been struck by what a 'spunky' character Julia was when he met her in 1963.

> She wasn't an old lady slogging along, she was very crisp. Don't forget she supported Andy through times of doubt. Of all the people who spent any time with him over a period of years, Julia was the only one who was there every day regardless of what happened. Andy was always the little boy with Julia. She was not nasty but she would nag him the way mothers do. Andy would go, 'Oh, come on, Ma, leave me alone,' like a little boy. There was a lot of the little boy in Andy.

By 1971, however, when Paul or John came up to take care of Julia they found her a different person. Paul Warhola:

> On one occasion she says to me out of the clear blue sky, 'Take me down to the other place. I don't wanna stay here. Take me to the other place.' She put her coat on. We went outside and I walked her around the corner maybe fifty feet, because she sort of shuffled, then came back to the house. She said, 'We're here. Oh!' she says, 'Thank you! It's so good to be back here.' She was beginning to be forgetful. She was having hardening of the arteries and getting Alzheimer's disease. Andy told me Mother had to take fifteen pills at three different times a day. Andy took good care of her. It wasn't that easy. She was the type that wouldn't take the pills. She hid 'em and pretended she had. You had to say, 'No, you take it right now,' and even then she'd try not to swallow 'em.

Paul also noticed how much Julia talked, hardly stopping to take a breath. 'I wanted to tell her, "Ma, can't you be quiet for a little while so I can watch TV?" ' Paul said, 'but Mother was the sweetest person in the world and I had the utmost respect for her.'

Andy and his mother had been semi-invalids together for a couple

of years after the shooting, looked after by the tireless, sweet-tempered Jed. It had not been an easy task. In March 1969 Andy had a follow-up operation to remove part of the bullet the doctors had left inside him. It was apparently a bad experience because ever after that, according to John, Andy had a phobia about hospitals. He said, 'I never want to go in again because I'll never come out alive.' Perhaps the fear was partly caused by the results of the second operation: the doctors sewed his stomach muscles back together incorrectly, which was why he had to wear a surgical corset for the rest of his life so that his stomach would not blow up like a balloon when he ate. It may also have been caused by the difficult times his mother had had in hospital on several occasions. After one visit to see Julia in hospital Andy had arrived at the Factory outfitted in a black fur coat and a tall olive-coloured hat and clutching a shopping bag, looking, one observer wrote, 'like an aging European woman'.

'Mother didn't care too much for Jed,' according to Paul. 'Jed sort of moved in there and Mother used to tell me a lot of incidents. She was critical of him bringing his brother Jay around. Mother didn't like him because it seemed like that was her house and she didn't want nobody to take over.'

'She got really senile and she would just go out and leave the door open, forget where she went,' Jed recalled. 'We were just afraid that she would get lost. Once the police came.' As Marge Warhola remembered it:

The police called me up from New York one time. They found her wandering on the street and knew who she was by her pills in her pocket purse. Andy was at work and here they found our name next to the phone so they called us. I called Andy at the Factory but he wasn't there so they sent somebody up, but Andy had come home before they got there and he didn't like the idea of the police wandering all over his home. It was getting to be hard for Andy. We talked to him about it and said, 'Maybe it would be better if you got a full-time nurse in just to watch her.' He didn't like having anybody in the house all the time and his mother was getting fussy too. She didn't like the maid that Andy had. She'd really get very angry with her, saying, 'She's not doing this right!' And then there were all those kids climbing over that high fence in the back yard trying to get in to see Andy, so they really had a difficult time.

According to Jed, 'She really needed full-time attention and Andy couldn't do that.'

'If Andy ever wants you to take me to Pittsburgh, don't do it,' Julia told Marge Warhola, 'because I want to stay here and some day Andy's going to come home and he'll find me and I'll just fall asleep and die in my sleep. This is the way I want to die.' Jed Johnson:

She was really difficult. She needed medication which she didn't remember to take, and then she made a lot of demands but she didn't know what she was doing. I mean, she was like a bag lady. She had things stuffed in shopping bags and her whole bed was surrounded by shopping bags and she had things safety-pinned to her clothing. It was unbelievable. Little notes, money and lost buttons. And she didn't sleep, she'd be up and she had a hard time walking around the house. She didn't make sense. Sometimes she'd get emotional but you didn't really know what she wanted. It was hard.

'Andy didn't really do a hell of a lot for her,' said Suzi Frankfurt. 'I'm sure she hated Jed.'

Jed defended Andy. 'He was travelling, there were a lot of things he was doing, it was just impossible. She probably should have gone some place earlier than she did, but he didn't want to let her go.'

In February 1971 Julia suffered a stroke and was hospitalized in New York.

MARGE WARHOLA: They found a black mark on her lung and she had pneumonia at the time. She didn't want no operation. She says, 'There's nothing wrong with me! I'm not gonna operate!' She pleaded with Andy and she told him and she told me not to take her from New York, and that's why my husband didn't.

JOHN WARHOLA: Andy wanted me a lot of times to take her, I said, 'She don't want to go. You might as well leave her here.'

PAUL WARHOLA: Finally, Andy wanted her to come to Pittsburgh because she was getting pretty bad.

JOHN WARHOLA: Paul and Ann brought her to Pittsburgh. They should have never did that. Well, Andy thought he was doing her good because Paul had the place out in the country and he did bring her, but she stayed at our place for a while. Then she started to get up at night. I guess she was getting senile but she wanted to leave the house and we just couldn't watch her.

MARGE WARHOLA: She could have fallen down the steps! And I told Andy and he said, 'Well, get a nurse for her.'

JOHN WARHOLA: Well, the worst thing to do is take an older person like that from the environment that she knew.

PAUL WARHOLA: So my wife Ann and I, we decided we'll take her. Well, Mother, you had to watch her, but we took good care of her.

GEORGE WARHOLA: I remember that Bubba always used to like to take a drink. I'd be in the kitchen with her, she'd take a drink, wipe her mouth and go, 'Sshhhhh.'

PAUL WARHOLA: She'd get up every morning. 'Hey! I'm going back to New York!' And she had her bags packed and all. I said, 'The bus ain't gonna be here today. It's not running,' and we got her back in.

JOHN WARHOLA: She stayed with Paul for about a month. By then she

was in a state of confusion where she didn't know where she was at.

PAUL WARHOLA: It was several weeks later when she had this second stroke. We got her down to Mercy Hospital and she was in a coma for several weeks.

ANN WARHOLA: While she was in the coma I used to pour whisky and ginger ale down her throat every morning.

GEORGE WARHOLA: She was in the hospital for about a month. After a while she wouldn't talk to anybody but when they'd leave the room she'd say, 'George, come on, get me out of here.'

PAUL WARHOLA: So the doctor says, 'We can't do much for her, you'll have to take her. I advise you to take her home.'

JOHN WARHOLA: Then Ann, that's his wife, she put her into the Wightman Manor nursing home.

MARGE WARHOLA: She promised Andy that she wouldn't, and that's what hurt Andy. It hurt Andy very much.

PAUL WARHOLA: We had a hard time finding a home for her. Well, John called Andy up and says Andy was mad because we put her in a home, that he thought we should keep her, but we couldn't keep her, she was wandering too much and her mind was gone and she had that bag, she had that problem, and, uh, here John builds up a story that it was me shut her up in the home, that we didn't want her!

Andy called her every day from New York or wherever he was on his travels, but never visited.

JOHN WARHOLA: I visited her about every other day. Marge washed her clothes. She was in a state of confusion off and on. Her mind would go back. She would ask me if I milked the cows. She'd go back to Europe. And they tell you to go along and say everything's taken care of.

PAUL WARHOLA: We fell out again, John and I, because John used to go up on Sunday and stay all Sunday and then when he went to New York or called Andy, Andy says, 'Well, does Paul go up?' He says, 'I don't see him,' but he didn't say that I went up three times a week. Going to a nursing home, as nice as the place was, is very depressing. The odour isn't very good. She was pleasant but her mind went back fifty years ago. She says, 'Didya come up with the horse and cart? I'm going back with you!' I had to tell her, 'No, you can't come today.'

When Julia spoke of Andy now Paul noticed it was often as if he were still a small child, her little Andek, as she had continued to call him throughout her life. She would sometimes mistake Paul for her husband. On several occasions she tried to escape. Once she wandered off the premises of the home and had to be fetched back by attendants.

Ann Warhola remembered whenever she went to visit Julia she would find the tiny old lady pacing the corridors, 'looking for Andek'.

GEORGE WARHOLA: We used to go up there all the time and see Bubba in the hospital. She'd talk to me but when someone would come in she wouldn't say anything. It was sad because it got to the point where she was wandering off and they had to strap her in.

<center>*</center>

One of the reasons Andy had found it so difficult to take care of Julia was his constant travelling in America and Europe. In June 1971 he and Morrissey went back and forth to LA several times and shot a new film, *Heat*, a comic take-off of *Sunset Boulevard* with Sylvia Miles (who had starred in *Midnight Cowboy*) as an aging screen beauty and Joe Dallesandro as the former child star of *Mousetime USA* in the leading roles. The film also included a brilliant performance by Andrea Feldman. During August Andy rented a house in the Hamptons, where Paul and Jed edited *Heat*, and Andy and Paul ended up buying an estate with five small buildings on several acres of ground on prominent cliffs overlooking the sea in Montauk, which would prove to be an excellent investment. Warhol wrote:

Montauk is a little town at the end of Long Island. The next stop is Lisbon, Portugal. Montauk is about one hour past Southampton, where I should have bought a house. At least there are people to go to lunch with. There's nothing in Montauk but a bunch of motels where the locals play pool all night long. Between Montauk Village and Montauk Point is Ditch Plains, Long Island's leading trailer park. All the people there look like they've taken too many hamburgers.

My house is near Montauk Point, between the ocean and the swamps. It's really private. The driveway is a mile long – all dirt – which means we need a mile of pipes and a mile of wires. In the winter the pipes crack, the wires snap, and the roof falls in. There are constant expenses.

I never go there except as a guest. I rent it to friends every summer and wait to be invited. Actually I hope I'm never invited. I dread going there. I hate the sun. I hate the sea. I hate slipping between those damp wet sticky sheets.

In November 1971, Edie Sedgwick died. Brigid phoned Andy to tell him the news and tape-recorded the conversation. When Brigid told him that Edie had died not from a drug overdose but from suffocation, he asked how she could do that. Brigid didn't know. Andy then asked whether 'he' would inherit Edie's money – 'he' meaning her young husband Michael Post. Brigid replied that Edie didn't have any money. There was a static pause after which Andy asked, 'Well, what have you been doing?' and Brigid went on to describe a visit to the dentist.

Andy's sixties policy of using people and discarding them when he was through without bothering even to pay them what he had promised was still catching up with him. When Andy had started working with

<center>354</center>

Ronnie Tavel in 1965 he proposed that they split any profits from the films three ways, between himself, Tavel and the cast. Naturally he never expected to make any money on films like *Screen Test #2* or *Kitchen*, but Tavel, who had never been paid anything and was broke, had also contributed to *Chelsea Girls*. In 1971 he sued Warhol in an attempt to recover the money he believed he was owed. The complex emotions Tavel felt in the process show how Warhol was able to get so many people to work for him so well.

I think Warhol felt hurt when I brought lawsuits against him because he knew I knew why he wasn't paying me. He was shocked that I would betray him as an artist. He assumed that I should excuse all faults and all shortcomings. Instead of paying me a couple of thousand dollars the man plonked down $25,000 to get the lawyers of Princess Radziwill to represent him because he would rather beat me out of this than give me what I deserved.

One morning he said, 'Ronnie, can't we settle this another way? I can give you a painting or something if you don't want a thousand dollars. Let's go to Hollywood and make a movie – you know I like your work – or do you want a painting?'

I said, 'Andy, it's too late to talk about that.' The hurt in his face! I can't describe the sense of betrayal that was in his face. It was like saying to me, I know I've screwed you left and right, but you ought to understand this as another artist. This is the way I am and this is the way it has to be. And I felt very guilty about it. In absolute honesty, even though he promised a third of the take, I knew what was going to happen, and what he was accusing me of was betraying that knowledge. There were so many people who didn't understand and attacked him, but the least he could expect from me was to understand and not say anything, be exploited, be shit upon, be used for my talent. His face said, I was hurt because you have gotten benefits out of this, you have been privileged to move in a charmed circle and rub shoulders, plus you got fourteen of your scripts done and learned enormously from it, and you are saying that you didn't understand that's what it was going to be about because lawyers have told you you can get money out of this! It was a sense of one artist saying, If there is anything we can hold on to it is that another artist will not betray us in this world! And now you are doing that.

The hearings just drained me. I dropped the suit because I couldn't take it, it was destroying my life, the hatred was making me into a hateful person. I also saw it wasn't going to work.

Some time afterwards I was walking up Park Avenue in the snow, a bitter cold night, and something told me to stop in the middle of the night and just let the snow come down, and there he was just standing in a doorway absolutely alone. I moved a few steps towards him. He must have been waiting for some people but there wasn't another person around, and we stood for a while and said nothing. Then I went on. That was the last time I ever saw him.

*

Andy had almost fainted the time he'd picked up the phone and heard Valerie Solanas's voice. He was more careful about whom he talked to now and he became less arrogant, more talkative and easier to be with, but he still took no practical precautions against another attack. The Factory door was unguarded, except by an uptight receptionist and a stuffed dog.

Mario Amaya was flabbergasted when he went back to the Factory. 'What really shocked me when I walked back into the studio, the elevator was still exactly the way it was. No lock on the thing. You'd think after an experience like that . . . ' Any determined person could easily have walked into the Factory and shot him again. In fact, in 1972 two big black guys went up to the Factory and stuck it up. No one was hurt, and only personal effects were stolen, but after that there was much more security. A receptionist's nook, where visitors could be screened, and dutch double doors, making entry more difficult, were built near the elevator; later, a system of closed-circuit television monitors was added. The John Chamberlain crushed car sculpture had been brought from Andy's house to block the way 'in case girls come in and want to shoot Andy', Morrissey said, though another Factory acolyte saw it instead as 'a marvellous place to stash drugs'.

The success of the travelling retrospective, the enormous increase in the price for his early works (now averaging $30,000 apiece), the acclaim he was receiving in Europe, and the acumen of Fred Hughes combined to make 1972 the year of Andy Warhol's well-timed and well-publicized return to painting. In hopes of reviving the original shock of his art, and since it was also the year of Richard Nixon's trip to China, the first subject Andy turned to was the then chic revolutionary image of Chairman Mao.

Working from a frontispiece of the famous Little Red Book – *The Quotations of Chairman Mao* – that spring and summer, Warhol executed enough Mao paintings (over 2000 in all) to fill a small museum. They ranged in size from 17 by 13 feet to six by six inches (and included a number of rolls of purple and white Mao wallpaper).

As always, the colour combinations of the silkscreened images were striking – transforming the Chairman's inscrutable mask into an attractive, at times comic caricature – but to give the paintings more 'style' Warhol was now adding hand-painted squiggles and free-form brushstrokes reminiscent of the mock action painting in his earliest cartoon and advertising canvases.

Quickly and seemingly haphazardly adding these touches to rows of Mao portraits on the floor at the Factory, he explained to visitors that 'it's easier to be sloppy than to be neat'. The 'handpainted look', Warhol declared, was now 'in fashion'.

Henry Geldzahler, for one, was as delighted by Warhol's naïve declaration that these new (in Geldzahler's view) 'magnificent' brushstrokes

were 'easy' as he was by the choice of subject matter: 'The irony that is obvious and front row centre in these images is the fact that they are produced cheaply to be sold dearly by an artist in the capitalistic capital of the world.'

Fred Hughes had played a key role as a middleman between Warhol and Bruno Bischofberger, a Zurich-based art dealer and Warhol collector who had commissioned the Maos and arranged for the first exhibition of the new paintings in Basel, Switzerland, that fall, and at Hughes's instigation, Warhol's return to painting would be characterized by two important changes: from this point on, all new Warhol art works would also be reproduced as prints to be sold in signed portfolios, and he would work mostly on commission. Fred Hughes:

> Andy was definitely not threatened or pulled by financial interest ever. That's very important to clarify. He did like the idea of making money but he had a rather sweet childish idea of how that's done. So it was one's job, and I was about the only person who could say, 'Andy, you're full of shit on this one!' But then I was so careful because some of the craziest ideas when they first hit you were the best ideas.

Fred Hughes was one of the major characters on the New York cultural stage in the 1970s and 1980s, the sort Tom Wolfe could write a good book about. He spent his career almost completely in the shadow of his famous boss and friend, which is one of the reasons he lasted longer than anyone else, except Brigid, who took several leaves of absence and was never under the kind of daily pressure Fred was all the time. At one point Fred emerged as a fashion-plate star, appearing on the 'best dressed' list and squiring some of the chicest women around town, but soon ducked back into his hole where he laboured, invisible to the public, as chief architect and producer of Warhol's career. The kind of subtle humiliation he had to go through over those years was bound to take its toll on anyone. Fred held up well, maintaining an equitable balance between everybody at the Factory through the seventies, by 1974 putting together the best team Warhol ever had. The only drawback was that Fred got drunk easily and under the influence of a few drinks, his polite mask would dissolve to reveal the soul of an English public-school boy boasting of his lineage, in his case fictitious. His disclosures and rants often puzzled visiting art dealers and prospective clients, although they did not seem to send them away.

Warhol, who always enjoyed watching people's reactions to his eccentric entourage, embraced his partner's idiosyncrasies. They did not sit so well with New York's social elite, who quickly got bugs up their asses when they heard Fred claiming to have gone to the right schools. Brigid Polk, the only real socialite at the Factory, was particularly contemptuous of his phony accent. And Suzi Frankfurt:

Fred sounded like such a jerk most of the time with the art dealers but Andy must have liked it because there was never any criticism. He used to say how cute Fred was; 'Oh, Fred gets so drunk!' Maybe Andy thought that was the aristocratic thing to do. It was real convenient for Andy to believe that Fred was such an aristocrat and he was so rich because then Andy didn't have to pay him very much.

Fred always exaggerated the importance of his role, but that was his role – to exaggerate the importance of his role.

Another painting and print series was finished simultaneously with Mao, commissioned by supporters of George McGovern in the upcoming presidential election.

'Vote McGovern', as the set was called, was, in fact, a portrait of Richard Nixon painted in such pointedly repellent colours (yellow mouth, blue jowls, green upper face) that Henry Geldzahler declared the work 'loathsome . . . a latter-day disaster painting. The anger and horror Warhol feels for Richard Nixon is sharp and unrelenting.' One writer noted, however, that 'although the poster raised $40,000 for the McGovern campaign, it actually garnered votes for both of the candidates'.

After Nixon's landslide victory that fall, Warhol – like Norman Mailer, Terry Southern, Robert Rauschenberg and several other writers and artists who in one way or another had criticized the president – was audited by the Internal Revenue Service. As Rauschenberg remembered,

Andy Warhol and I were on the IRS list because we were politically involved. It nearly made me bankrupt. The guy from the IRS said that if I didn't just sign the agreement, he would go and do the same thing to all the artists and friends that I had ever paid or known.

'Andy was hit with a gift tax,' said Vincent Fremont.

So although he gave the poster as a gift to the McGovern campaign we ended up actually having to pay money on top of it. After that we looked into the legal ramifications of whatever contributions we made and made much tighter contracts. The audit started after that. Whether Andy was on Nixon's hit list or not we didn't know. It was really a nightmare. Then he was audited up until the time he died.

Andy told David Bailey the previous year:

Everyone's always asking me how much I get paid for this and that and thinking I'm a millionaire, I never have any money . . . Oh, my God, it's all the dealers that get all the bread. I'm just sick of it. I'm constantly attacked by the Internal Revenue Service. It's so silly.

As a result, Andy began dictating a daily diary to his secretary Pat

Hackett. She had been with him since 1969 and would stay until he died. Pat was not a glamorous Warhol superstar but became a trusted and reliable friend. She was also a good writer. She would record his diary every morning on the phone for the next fifteen years, and come to know more about his personal life and opinions than anyone else. In addition to keeping a running account of the celebrities he was meeting, she documented all his allowable tax deductions. 'As we were talking every morning anyway, Andy decided I should write things down as a way of keeping track of his expenses.' The writer Jesse Kornbluth:

> Five mornings a week, Hackett and Warhol began their day with a phone call that lasted at least an hour. Warhol talked about all the subjects that second-tier friends believed he always avoided. And Warhol, who was invariably polite in public, said what he really thought about people such as Truman Capote. 'Truman was condescending to Andy and called him a "Sphinx with no secret",' Hackett says. 'But when Andy came back from the afternoons with Truman, he was hilarious.' That Warhol was a brilliant and witty conversationalist with a childlike ability to read people was a secret only his closest friends knew.

<div align="center">*</div>

In September 1972 the new Warhol–Morrissey film, *Heat*, was included in the programme of the Venice Film Festival, and Andy, together with Paul, Fred Hughes, Joe Dallesandro and Sylvia Miles, flew over for the premiere on a plane loaded with other celebrities, including Rex Reed and Tennessee Williams.

In early October the film was scheduled for a splashy debut as part of the New York Film Festival, but the occasion was marred by the macabre suicide, three weeks earlier, of one of the film's stars, Andrea Feldman. In *Heat*, the 25-year-old actress played a borderline psychotic who kept her baby quiet with sleeping pills and couldn't remember if she was a sadist or a masochist, but Andrea's suicidal mood in the film had proven all too real.

She had been showing signs of being disturbed throughout the summer. She was calling herself Andrea Warhola in the hope that Andy would get the idea and marry her. The success of *Trash* had gone to her head and she began screeching, 'They come to see meeee! Not you, Andy Warhool!' and on another occasion, 'You fag! You asshole, you Warhole!' until finally Andy erupted in one of his rare rages and screamed back, 'Get out of here! Get out of here! And never come back!'

On one occasion she had come to the Factory, hysterical, her face covered with scabs and small round festering sores. According to one account, someone said to Warhol, 'She's very sick. Andrea should go to a hospital. Did you see her face?'

Warhol matter-of-factly replied, 'Well, she's putting cigarettes out on her face. She always does that.' In what had become an almost clichéd

way of seeing things, Andy said she was going through a 'phase' and would get over it. Everybody at the Factory blamed Andrea's problems on her mother, including Feldman's best friend Geraldine Smith.

I don't think Andy ever destroyed anybody, that's such a crock of shit. She was fucked up in her childhood. Her mother left her alone when she was two years old and she never got over that. She was obsessed about getting her mother's love. She was hospitalized a couple of times. She always planned to commit suicide. But she would blame Andy and say terrible things about him. And then she went up to the Factory and threw the typewriter on the floor and turned everything upside down. She wanted more money and to be in more movies. Paul was very nasty to her when she did that.

Vincent Fremont felt that Warhol was unfairly blamed.

Just before she jumped out of the window she was really gone. She was coming up stealing things and I'd steal them back out of her purse. Her thing was from hot to cold, she'd just flip-flop flip-flop. Paul was able to handle her, she was very good in the movie, but she was really a desperate sad person. Andy was always concerned about people. He always tried to help people, he'd give them advice and he was always very kind but they don't listen. I don't think people realize he really had that compassion, they just thought he was a cold stone. But with someone like that I don't think you could do anything with it.

One night in September, after writing a number of letters to people whom she had been arguing with (one to her mother said, 'I'm going for the big time. Heaven'), Andrea made dates with a number of Max's regulars, including Jim Carrol, promising him that he'd 'see something special'. According to Geraldine, 'She left tons of notes in her apartment saying goodbye to everyone, writing, "I was unique as an antique, you're going to miss me, farewell." '

Police cars and an ambulance had already converged at the building where her uncle lived on Fifth Avenue and 12th Street by the time Carrol arrived. She had jumped out of a top-floor window, clutching a can of Coca-Cola and a rosary.

In several of the letters left behind for her friends, she criticized Warhol for neglecting her and – though the underlying reasons for her suicide appear to have been difficulties with her family – newspaper and magazine stories about her death tended to pin the blame squarely on Andy.

Andy did not respond, although he later told Truman Capote, 'She seemed so strong and if I'd thought she was really going to do something like that I would have really tried to help.' 'Andy didn't say much about her death,' recalled Geraldine.

'Andrea was a casualty left over from Max's,' explained Vincent Fremont.

Every time somebody that was around Andy died, the same reaction would occur – because of hanging around the Factory you run into this problem – people didn't realize that these people were really screwed up. Andy was always being attacked but then it also kept him controversial, which is what he always wanted to be. He always stuck his neck out that way. He turned a lot of the negative reactions into a useful thing for him. He was the most adept person at that and he had no choice.

Andrea's death provided more ammunition for those who liked to blame Andy for the problems of all his superstars, although Morrissey attempted to shrug off any significance:

I've read a lot of nonsense about my characters, are they freaks or not, but seeing *Heat* or any of my films in 'political' terms is gibberish. The volatile parts go to the women because you can't have a hysterical man – unless he's George C. Scott. Volatile females with passive men is the great story of today, it's great material for comedy. Men aren't dramatic unless they're beating someone up.

The American social commentator Dotson Rader wrote in *Esquire*:

It is appropriate that Andrea died clinging to two symbols of Western Culture, and leaving behind letters addressed to a third. Because Andy Warhol is nothing if not a symbol to the young. He represents limitless tolerance, deliverance from loneliness and alienation. He is a parental figure, a father to the young, to this present generation which cannot connect with its parents or with the world in which it grew up.

Peter Schjeldahl wrote in the *New York Times*, 'Miss Feldman, with her twisted little face and frightening laugh, was clearly in a bad way, and the pitiless exposure of her suicidal mood makes *Heat* a repellent document.'

'If Andy gets a lot of publicity,' commented Morrissey, 'it's because he's more fascinating to write about than I am.'

<p style="text-align:center">*</p>

While Andy was in Los Angeles for the opening of *Heat*, out of touch with his family, his mother was dying. When John said to her, 'Gee, I wonder if Andy will keep in touch after you pass away,' she snapped out of her trance and replied, 'You keep it going.' Her final words to Paul were just as direct. 'Promise me you'll take care of Andy,' she begged him. 'I want you to look after him because sometimes I wonder if he don't have a childish mind.' On 22 November 1972 Julia Warhola finally died, believing fervently to the last minute in the good Lord and the blessed Virgin. John Warhola:

When mother died I couldn't find Andy. He was away. When he came back I talked to him on the phone. I told him, 'I have some bad news.' I guess I

was broken up. As close as he was he took death pretty good. He says, 'Uh,' he says, 'Aaahhh,' he says, 'Well, don't cry', he says. Still, you know, maybe he was the type he didn't want to let me know how bad he felt.

Julia left $9,000 to be divided equally between her three sons, and a $500 life-insurance policy. Andy paid the funeral expenses. She was buried under the same tombstone as her husband in St John the Baptist Byzantine Rites Cemetery in a suburb of Pittsburgh, on a grassy sloping hill overlooking a highway. All the relatives were waiting for Andy to appear but he did not attend the funeral. Paul Warhola:

I covered up for him a lot. I told relatives he happened to be out of the country. Andy didn't want to see nobody dead. He was deathly afraid. He explained to me one time, he says, 'You know what, Paul,' he says, 'I don't want you to feel bad that I didn't come in, but, uh, you know, I want to remember Mother as she was.'

Although he was with Andy every day during this period, Jed had no idea that Julia had died. 'I knew Andy for twelve years. He never talked about anything personal to me *ever*.'

Years passed before Andy divulged the fact to anyone at the Factory, according to Vincent Fremont. 'I was first aware that Andy's mother had died a couple of years after she died. It was something he never mentioned. Andy never talked about his family.' When Brigid Polk asked Andy about his mother, he said, 'I switch to another channel in my mind, like on TV. I say, "She's gone to Bloomingdale's." '

'I was aware of it,' said Fred Hughes, 'but it was a big thing and Andy was very very private about that. One *suspected* it had a particularly strong effect on him but Andy couldn't or wouldn't show it.'

When his mother died, Andy told a friend many years later, he forgot to feed her parrot, which consequently starved to death in its cage in the dark, dank, silent basement.

George Warhola stayed with him for a month.

After his mother passed away it was just a very bad time. He almost had a nervous breakdown. He started saying, 'Why's everybody bothering me? I'm tired of everybody calling me.' He was real nervous for like a week and a half. It was like he was tired of all this crap and just wanted to escape it all. I remember my uncle used to always keep that handkerchief of hers. He didn't want anybody to see him but he'd take off his wig and put the handkerchief on his head. And he liked his old movies. When he watched his old movies on TV at home he'd lose himself in the movie.

Writing about Andy earlier that year, Tennessee Williams described him as 'a lost little boy, lost in time'.

George Warhola felt sorry for his uncle.

One of Bubba's relatives from Butler likes to take pictures of people in a coffin. She took a picture of my grandmother in her coffin and mailed the pictures of her to Andy, and Jed said, 'Your uncle was very upset about that.' A lot of time when I was up there and Uncle Andy was by himself he was very unhappy, *very unhappy*. It seemed like when he was by himself he was like lost, he always had to be around people to lift him up.

Marge Warhola: 'Every time we went up there since his mother passed away he always says, "It's always on my mind." He was so upset about his mother's death. "I should never have sent her to Pittsburgh. I feel so guilty." '

Jed Johnson: 'I think he always felt guilty that he hadn't taken care of her until the end but he couldn't have.'

Andy's anger towards Paul and his family simmered uncomfortably close to the surface, until Paul Warhola Jr left the priesthood to marry a Roman Catholic. Andy had helped support him through his studies to fulfil Julia's wish that one of her descendants be a priest in order to repay the priest in Mikova who had lent her money to come to America. In the family all hell broke loose. 'Paulie decided he wasn't happy with the Byzantine faith and decided to switch over,' said George. 'She was an ex-nun, a real nice person, but it was a *real big deal*, it was the big boy oh boy in our family. All the relatives talked about it.'

'I knew Andy loved that nephew,' said Suzi Frankfurt, 'and when the nephew ran away and married the Mexican nun Andy was just hysterical. God! She's a quarter Mexican! He was absolutely freaked out.'

'I got very angry at Andy,' said Paul Warhola,

> because there was a piece that my son cut out of the paper where he lived in Denver in which it said that Andy said, 'I have a brother who works on a garbage dump and he had a son that married a Mexican nun.' The kids were offended. When I read the article I says, 'Why would Andy tell that?' I was livid at the time.

Shortly after Julia died Ann Warhola noticed a number of photographs of Andy bald pasted on the wall in his bedroom. Two years later Andy painted a portrait of Julia bespectacled, wearing a kerchief, and surrounded by agitated brushstrokes. The painting struck one observer as 'a haunting memory, at once closed and distant', but it also looked strikingly like Andy as an old woman. In January 1975 it appeared on the cover of *Art in America*. Driving up from Florida and temporarily lost, Paul Warhola stumbled into a magazine store looking for directions and recognized his mother on the cover of the journal. Although Andy made several copies of the painting, he would not give one to either Paul or John, who both wanted the portrait.

*

In the winter of 1972, in an attempt, perhaps, to replace his mother with an appropriately glamorous stand-in, Andy cultivated friendships with Paulette Goddard, whom he had admired for being 'one of the smartest of all the Hollywood stars because she didn't end up broke', and Diana Vreeland, the director of the Metropolitan Museum of Art's Costume Institute, whom he described as 'the most copied woman in the world . . . like a Campbell's soup can'. Daniella Morera:

> Andy loved only the VIP. And he was always saying that the new stars in the world were the fashion designers. He told me he loved Paulette Goddard because she had the most beautiful jewellery. He said, 'My God! She's so rich. She has these incredible rubies.' He was really fascinated.
>
> She loved Andy very much because for her he was the discovery of a different world. She was an older lady living in New York visiting her mother every day and going to formal parties. Being around Andy was like a fourth or fifth youth for her so she was very happy. And Andy was so sweet with people, he made you feel like you were a big star.

Diana Vreeland was one of the great ladies on the New York social scene from the 1960s through the 1980s. Described in her memoirs as a brilliant, funny, charming, imperial woman whose passion and style for genius energized and inspired the world of fashion for half a century, she was a major acquisition for the Factory, a token of how far Warhol had climbed. For her part Vreeland, who had specialized in recognizing and encouraging young talent in her days as editor of *Harper's Bazaar* and *Vogue* and who had met Andy many times in his earlier incarnations in the fifties and sixties, embraced the Factory spirit and enjoyed Warhol's conversation as she had enjoyed Cocteau's, Noël Coward's and other well-known wits'.

'It was the end of the underground,' one Warhol associate noted. 'The people at the Factory were becoming yuppies, but nobody knew what a yuppie was yet.'

Tom Hedley of *Esquire* saw the switch coming in December 1971.

> I was filming a documentary, *Remember the War*, with Norman Mailer and Tennessee Williams, and this annoying gossip whore Bob Colacello sat at our table and started laughing at Tennessee Williams, who was by this time destroyed drunk, and I went fucking berserk. I said, 'Get the fuck out of my sight!' and I physically threw him out of the door. I saw Colacello as a symbol of the dinner faggots who were about to take over the culture. He also struck me as the kind of guy who was sucking Andy dry. There was a moment when Andy created interesting reflections of his own vanity and confusion and moral ambiguity, but then he created parasites on his own energy, which is very deadening and boring for an artist to do.

*

At the end of 1972 Warhol left with Jed Johnson, Fred Hughes, and

Sandy and Peter Brant to spend the holidays in St Moritz. Suzi Frankfurt was there too.

> He was supposed to meet everybody. Andy and I spent the whole time in the lobby of the Palace Hotel. He kept making me do all the interviews. What do you like about this hotel? I'd say, 'Oh, the blue stationery.' What do you and Andy do all day? 'Oh, we watch the clock.' They loved it.

'There were so many people there,' Jed recalled. 'The Agnellis were there and the Niarchoses. So it was a vacation but it was also sort of work, because Andy saw that he was more accepted by society than he ever was in New York.'

'When you get people of a certain ilk like Johnny Agnelli and Mrs Agnelli and Niarchos and those sort of people, then you generate more portraits,' noted Fred Hughes.

'Switzerland is my favourite place now, because it's so nothing,' Warhol remarked. 'And everybody's rich.'

TO APPRECIATE LIFE YOU MUST FIRST FUCK DEATH IN THE GALLBLADDER

1973–74

Violence is what people want, so we're giving it to them. That's the secret of my success – just give people what they want.

<div align="right">ANDY WARHOL</div>

In the summer of 1973 Andy was in Rome working at Cinecittà with Paul, Fred and Jed on two films, *Flesh for Frankenstein* and *Blood for Dracula*, which he was coproducing with the Italian movie mogul and husband of Sophia Loren, Carlo Ponti. Andrew Braunsberg, the London producer who had set up the deal, had raised $700,000 from Ponti, Cinerama in Germany and Jean-Pierre Rassam in France. Roman Polanski was a silent partner.

Whereas Hollywood had been scared by Warhol and Morrissey's direct approach, Ponti had welcomed the hard-working, efficient team to his studio. When Morrissey had met with Braunsberg and Ponti earlier that year to discuss making a 3-D version of *Frankenstein*, they quickly reached an agreement for Morrissey to make the film on a $300,000 budget. He and Warhol would receive a fee in advance and have a share in the profits, but Ponti would control all distribution. Ponti then asked Paul how long the film would take to shoot.

'Three weeks,' said Morrissey.

Sensing an easy mark, Ponti suggested, 'Why don't you take six weeks and make two films? What could the second one be?'

'*Dracula*,' suggested Braunsberg.

The Warhol entourage included Joe Dalessandro, who was to star in both films, Jed Johnson, who had been there for several months doing the complex preproduction work, and Fred Hughes, who was to be the art director of both movies (which may account for why Dracula, played by Udo Kier, was the spitting image of Fred). They moved into Roman Polanski's house, the Villa Mandorli on the Via Appia Antica, which is Rome's Hollywood Boulevard, where they were soon joined by Bob

Colacello. Polanski was so repulsed by their taste in friends,'which was snobbishly confined to the ultrachic and aristocratic upper crust of Rome society', that he got himself another place and abandoned the Villa Mandorli to the Roman version of the Factory.

Soon Andy and his crew were hard at work cranking out the two pictures. 'It was an up experience,' remembered Jed Johnson, 'but it was really different working with an Italian crew and mostly European actors, and I think it was hard for Paul doing two films back to back.' Paul was also having trouble with Joe Dallasandro, who had become an integral part of the moneymaking film deals. Joe Dallesandro:

> I had them put that [the money] up front because it was like it was over. We weren't going the way I wanted to go, and it was like I was trapped. Me and Morrissey fought constantly. At this point, we were fighting about how I was ripped off one more time. Everybody knew that me and Paul Morrissey were a combination and that our films would sell. Andy was doing films at the time, and everything he did was *not* selling. So they put this package deal together using my name, pretending they were taking me along to do me a favour.

The first film they tackled was *Frankenstein*.

Besides Joe Dalessandro, the films starred Monique Van Vooren, Udo Kier, Maxine McKendry, Vittorio de Sica, and Roman Polanski in a cameo appearance. Because for many of the cast English was a second language, improvised dialogue wouldn't work and Morrissey, in addition to coping with the technical problems of directing his first 35-mm film in 3-D, found himself typing scripts into the early hours of the morning until Andy sent Pat Hackett over as a typist and script collaborator. She wrote a good deal of dialogue for *Dracula*, which is the wittier of the two films.

The new Warhol lifestyle crystallized that summer in Italy. 'In Rome I discovered a new Andy,' Daniella Morera recalled.

> He was happy and gloriously enthusiastic about everything. He was saying, 'Oh, my God! It's really beautiful!' with an almost Italian passion. He was social, he was glamorous, and Bob Colacello was there with all the socialites. Andy said, 'This is the real Hollywood, Cinecittà in Rome, *La Dolce Vita*, everybody fantastic!' He had this big house in the Appia Antica and all the stars were there, Paulette Goddard and Anita Loos and Franco Rossellini and Gina Lollobrigida and the fashion designer Valentino, and he went to all the big parties. Andy was there another person. In New York he was still more in the underground.

Jetting back and forth from Rome to New York, where he had a number of portrait commissions lined up that summer, Warhol was excitedly telling everyone how great it was to do a film 'with a crew, a

whole forty people and lunch in a truck', and that they'd done publicity shots with Sophia Loren, and that Jed's sixteen-year-old sister Susan had been out with Paul Getty the night he was kidnapped.

The French actress Anna Karina stayed at the villa for a while. Typical of Warhol's mood that summer was a dinner conversation with Karina in which Andy suddenly burst out, 'Look! Is that the Pope? He's wearing a turtleneck . . . The Pope has been spotted by the paparazzi reporters in discotheques in a turtleneck with a friend!' Andy was funny and provocative throughout his time in Italy, Daniella recalled.

One day walking on the beach at Frigena he said, 'My God, look at all these gorgeous people! Do you have to spread your legs for all of them, Daniella?'

Jed was a weird personality. If Andy was untalkative, Jed was more shy and untalkative, but Jed added a very conservative, nice, clean look instead of Andy's eccentric look. I think that Jed was good for Andy with his refined taste. I'm sure that he gave a lot of his notions to Andy. Jed was very influential and it was a positive relationship. I thought they were really *intime*, like a couple. I saw them in a very sentimental and sweet way many times.

Andy started to become publicly well known with the films in Rome because they were putting his photograph in the gossip magazines. Every major intellectual artist in Italy had an incredible respect for Andy. I always heard very high-level people in Europe, especially in Italy, talking about Andy in a way I never heard in America.

Frankenstein, featuring scenes of 3-D gore spraying out at the audience, was not just a parody of blood, guts and vomit movies like the popular *Exorcist*: the close-up shots of purple scars, disfigured naked torsos, surgical stitches spilling beet-soup blood, and Udo Kier caressing human spare parts were a defiance of Warhol's death demons. 'Andy once told me that he felt as if he would pop open some day,' Morrissey recalled. 'When I finished *Frankenstein*, I thought it might be a kind of exorcism for Andy and all the people who are crippled and haunted by some nutcase. And then I added laughter, because that's the only way we survive.'

Another line in the film which reflected Andy's personal problems was 'To appreciate life, you must first learn to fuck death in the gallbladder!' Just like his father, in 1973 Andy developed a gallbladder problem. His doctor strongly advised him to have it taken out, but Andy's fear of hospitals had become as strong as his mother's, and he refused.

There was also enough of Andy in *Dracula* – the pale, lifeless Carpathian vampire, embarrassed by his roots, lost in the modern world – to draw intriguing conclusions. Franco Moretti wrote in an essay called *The Dialectic of Fear*:

Dracula is an ascetic of terror: in him is celebrated the victory of the desire

for possession over that of enjoyment and possession as such, indifferent to consumption, is by its very nature insatiable and unlimited. Dracula also lacks the aristocrat's conspicuous consumption: he does not eat, he does not drink, he does not make love, he does not like showy clothes . . . Seward describes Dracula as 'the father or furtherer of a new order of beings'.

After the sets were broken, Andy, Paul, Jed and Susan with Mick and Bianca Jagger and their daughter Jade travelled to Positano, a little mountain village, to visit Gore Vidal and Howard Austin. During the social weekend there was a good deal of circular conversation about culture and whether rock lyrics were poetry. By Sunday, Andy thought he had Mick and Bianca convinced to make a movie with him in Egypt.

While Paul and Jed returned to edit *Frankenstein* and *Dracula* at Cinecittà, Warhol flew back to New York.

In early August, Andy returned to Rome to film a cameo appearance in a movie called *The Driver's Seat*, which starred Elizabeth Taylor, who had broken up with Richard Burton just one week earlier. Warhol celebrated his forty-fifth birthday on 6 August, trying to memorize the lines of his first scene with Liz the next day. 'Let's go. Let's go. I fear I am already dangerously late' sounded nothing like Andy, but the scene went smoothly enough after a few takes, and Liz invited him for a drink in her trailer.

Assured that he wasn't carrying his tape recorder, she seemed to latch on to Andy as a confidant.

They met again for lunch a few days later. 'The whole time Liz was talking she was pulling leaves off a bush next to the table,' Bob Colacello recalled.

One by one she plucked every leaf off that tree and then stacked them all in the middle of the glass table. It was such bizarre behaviour. She kept telling Andy how much Richard meant to her and how important it was to her to be married to him and how destroyed she was by the break-up. When she started getting really agitated, Andy looked nervous. So I went over to him, but Liz screamed at me, 'Get out of here! Just get the hell out of here!'

Later Warhol was able to say, 'I always call Elizabeth Taylor "Elizabeth" because she hates to be called "Liz". I like nicknames. In fact I would freak out if Elizabeth called me "Andrew".'

Back in New York Andy told Truman Capote, 'I always think that people who're creative go through these hard love affairs so they can write a book or do a movie or write a poem to get "material". . . . Franco Rossellini really said the best line. He really hit it. He said, "People who are frigid can really make out." '

*

Back in the fall of 1969, frustrated over not being able to get free tickets to the New York Film Festival and looking for something to give Gerard

to do, Andy had casually started an underground movie magazine called *Andy Warhol's Interview*, edited by Malanga. For its first few years the monthly publication had crept along as underground papers do, acquiring a small loyal audience of Warhol people in the cultural void of the early seventies, but it had not established a firm style or voice for itself until 1973. By then the magazine had had twelve editors, caused a lot of friction among its staff, and was losing enough money to make Andy consider dropping it.

'Andy didn't give a shit about people,' complained Taylor Mead, who had sent several articles to the magazine from Europe but had a lot of trouble collecting his $25 fees. 'He was out of it as a human. His word meant nothing!' Meanwhile Andy, who was openly taping all his conversations while Richard Nixon secretly recorded all of his at the White House, told a reporter, 'I think everyone should be bugged all the time: bugged and photographed.'

Fred suggested an alternative plan that would play a big role in the Factory in the seventies. 'Let's get rid of the idea of doing an underground film magazine written by poets and artists and make a whole different magazine,' he said. 'Let's make it a magazine for people like us!'

At first they brought in an outside professional, Rosemary Kent, to edit it but quickly realized what a mistake they had made and fired her when she and Andy were no longer talking to each other. After this short, confused period, *Interview* began a new era under the directorship of Warhol and Hughes with Bob Colacello in the editor's chair. It soon became a major arm of Andy Warhol Enterprises.

'We're trying to reach high-spending people,' Colacello said shortly after the transaction. 'The trend in our society is towards self-indulgence and we encourage that. We don't want to give the whole picture. We leave out the things we don't like. We're not interested in journalism so much as taste setting. We're the *Vogue* of entertainment.'

Hughes rounded up investors, including Bruno Bischofberger, Warhol's Swiss art dealer; Peter Brant, the real-estate developer and owner of *Art in America* and *Antiques* magazines; and Joe Allen, Brant's partner in the paper company that sold *Interview* its newsprint.

The magazine, which now featured interviews with actors like Michael York and Marissa Berenson, was a vehicle for Warhol to meet people and an advertisement for everything he was doing. Soon its circulation and advertising revenue rose considerably as a whole new generation who would shape the seventies emerged. Once it found its voice and style *Interview* was influential in the changing magazine industry. *People* magazine had started up in 1972. Soon *Time* and *Newsweek* were picking up tips for their people sections from *Interview*'s gossipy, chic style of reportage and its contemporary look with emphasis on good photography.

The magazine's outstanding features were Bob Colacello's diary column 'Out', which chronicled Warhol's social activities, and the humorist Fran Lebowitz's classic 'I Cover the Waterfront'. Most issues also contained an interview by Warhol, which was always entertaining. Andy's idea of how to do an interview was to go completely unprepared with no questions at all so that you would have no preconceptions and could just meet the person and see what they were like. The resultant tape-recorded transcript was a Warhol voice-portrait. They were usually very good, particularly when Andy would let loose with some nutty rap. The years 1973–76 were Andy's most creative period in the seventies. He was opening up in a lot of ways and rapidly metamorphosing from 'the blond guru of a nightmare world' in people's imaginations to a popular character like, as one friend described him, 'the rich uncle of Donald Duck'. When *Interview* presented its vision of how people should be - rich, beautiful, young and hard-working – it broadcast the Factory's new image to a large audience tired of the sixties hangover. 'If I have to sit on another pillow on the floor,' Fred Hughes snapped to a *Vogue* interviewer, 'I'm going to shoot somebody!'

Fred felt that 'Andy was one of the epitomizing fashionable dandies of all time. Time and styles were changing . . .' Warhol used *Interview* very cleverly to broadcast his new style; his own staff is pictured at dinner in Pearls restaurant, 9 November 1973, in Bob Colacello's diary column:

Bob Colacello in his emerald green corduroy suit by Polidori of Rome, Yves St Laurent silk shirt, Givenchy cologne; Vincent Fremont in his dark brown custom tailored gaberdine jacket, tan pants, white Brooks Brothers shirt; Jed Johnson in blue Yves St Laurent blazer, light blue Brooks Brothers shirt, striped tie from Tipler's, New Man pants; Andy Warhol in his chestnut DeNoyer velveteen jacket, Levis, boots by Berlutti di Parigi, Brooks Brothers shirt, red and grey Brooks Brothers tie, brown wool V-neck Yves St Laurent pullover.

Daniella Morera, who commuted between Milan and New York and became the magazine's European correspondent, thought that 'Andy brought the life he discovered in Europe back to New York. He was making more money and the Factory became more glamorous and luxurious.' It also became, in the opinion of many of its earlier denizens, obnoxiously snobbish. Ronnie Tavel observed, 'There was an underbelly to Andy that was very ugly – bigotry, racism, class.'

*

The Mao paintings were an international statement that was once again better received in Europe than America, where they were exhibited not in New York but Cleveland. The show in Paris at the Musée Galliera, which opened in February 1974, was very successful and fabulous-looking. The art critic Charles Stuckey:

Warhol fabricated a Mao Wallpaper which served as a background for his Mao silkscreen paintings. Installed edge to edge in uninterrupted horizontal rows, the paintings rivalled the decorative role of the wallpaper pattern. The wallpaper portraits dwarfed the smaller paintings and were themselves dwarfed by the larger ones. Altogether, 1951 images of Mao loomed and receded as painting and decoration in tandem orchestrated the gallery space.

Hughes's sense of humour as much as his sense of style was a key to his relationship with Andy. Arriving at the Musée Galliera to inspect the installation Andy commented to Fred, 'Gee, these paintings are great.'

'Now don't forget that you painted them,' Hughes advised.

The art critic Carter Ratcliff:

Having arrived at the upper levels of the consumer world – those haunts of celebrities where every other face is familiar from the nightly news and the pages of *People* magazine – Warhol opened his art to an icon from China, a nation dedicated to eradicating whatever vestiges of bourgeois consumerism might linger in its citizenry. Idealistic and uncompromising, at least in his public pronouncements, Mao seemed very different from the economic and political leaders of what he called the 'decadent' West. Warhol showed uncanny acuteness in introducing the Mao image into his art at a time when the artist himself was just coming to enjoy, full-scale, the benefits of Western 'decadence'.

Mario Amaya continued to be a champion of Andy's.

I don't think he's changed the look of art so much as he's changed the way we look at things. I'd say he has had the farthest-reaching effect of all the pop artists, and that's because he's such a kind of social phenomenon as well as an artist. He always chooses the image that is going to be like the image of the year. This is what makes him a great artist, the intention is so clear and right and precise, perfect each time.

The London *Times* revived at length a March 1974 exhibition of eight preparatory drawings for the Mao paintings at the Mayor Gallery, noting that with Warhol's show at the Tate three years earlier

it became clear that here was the most serious artist to have emerged anywhere since the war, and the most important American artist . . . Warhol is in some ways like Oscar Wilde. He hides a deep seriousness and commitment behind a front of frivolity. Compared with that of other American artists Warhol's view of America is bleak and uncomforting . . .

On 19 May 1974 *Frankenstein* was given a lavish champagne and caviar opening in New York at the Trans Lux East Theater. Among the guests who watched the flying gore through 3-D glasses were the actor Elliott

Gould, the socialites Patricia Lawford Kennedy, Mrs William F. Buckley, and Diane and Egon von and zu Furstenberg, who arrived separately; Monique Van Vooren, star of the film; Yasmin, Princess Aga Khan (the daughter of Rita Hayworth); and John Phillips of the Mamas and the Papas, with his second wife, the actress Michelle Phillips, and his third wife, the singer Genevieve Waite. It did not go unnoticed in the press that two days later, fitting neatly into the Warhol saga, Candy Darling died at twenty-five of leukemia.

The film was a box-office hit, grossing over $1 million during its first two months, despite generally unflattering reviews. By the summer, with bookings scheduled in an additional 150 cinemas, *Frankenstein* was projected to earn a minimum of $10 million in the months ahead. 'Audiences are laughing at *Frankenstein*, his sexually repressed bug-eyed assistant and the doctor's sister wife who makes the fatal mistake of seducing a zombie,' noted Paul Gardner in the *New York Times*. 'When asked what he does, since Morrissey receives credit as writer director on their films, Warhol says, "I go to the parties." '

Andy, Paul, Jed and Fred's euphoria over the grand success of their Roman summer was shortlived. Since Carlo Ponti controlled all distribution of both *Frankenstein* and *Dracula* they had to look to him for an accounting of sums due A. W. Enterprises and it soon became clear that none would be forthcoming. 'First,' Vincent Fremont recalled, 'Ponti claimed that *Frankenstein* did not make any money in North America.' The astonished Factory team could not believe the Italian producer's gall. According to the movie trade's bible, *Variety*, *Frankenstein* grossed $4 million (for an investment of $300,000). Furthermore the American distributor personally informed Morrissey that he collected a rental of $20 million on the film. Over the next four years the problems this created were to sever Morrissey's relationship with Warhol, teach Andy a hard lesson about the realities of the movie industry, convince Fred that Ponti was 'the thief of all time', give Vincent a perennial headache, and get them no money at all.

As the details unravelled it turned out that when *Frankenstein* had proved hard to sell to an American distributor because of its gross, sickly violence, the coproducer Andrew Braunsberg had made a deal with the leading distributors of pornographic films in the US, the Purino brothers, who had recently made a killing with *Deep Throat*. Shortly after making their second killing on *Frankenstein* they were publicly charged (by the BBC and *New York Post*) with being a Mafia company and soon, to use the vernacular, took a powder. The upshot of this crisis was that *Dracula*, a far superior film to *Frankenstein* and as good as any film Warhol had ever made, was unceremoniously dumped – released with no fanfare and quickly disappeared, Then, when Hughes and Fremont turned their attention to collecting money they believed was rightfully theirs from Ponti, they discovered 'he was a very clever

man and very difficult to get any money back out of'. Anybody who has tried to sue internationally for collection of unspecified sums due as royalties will know that it is a fool's game conducted around constantly evaporating lawyers and sundry subjects who 'cannot be reached'.

'Andy,' recalled Fremont, 'was very irritated, he was not a person to lose money. He didn't understand subtraction, he only understood addition.'

'Things were pretty weird between Paul and Andy,' remembered Geraldine Smith. 'I don't think they were speaking for a while around the *Frankenstein* period.'

Finally A. W. Enterprises managed to get an injunction against the movie doing any business in America and Ponti's son appeared out of the blue and made a deal to return the rights of both films to Warhol. However, as an indication of just how inexperienced the Factory was in the movie business, no sooner had they regained the rights to *Frankenstein* than American distribution rights were resold to Landmark Films for 'next to peanuts' in a deal that still had Fremont grabbing his head ten years later, and Landmark made another million dollars on the picture, none of which went to Andy. 'It became,' said Fremont in his characteristically dry tone, 'a sore point.'

It was typical of Andy to respond by boldly expanding rather than contracting his business. For some time now he had been bursting out of his Union Square offices, renting other rooms in the building to house *Interview* and even an extra space on the tenth floor to paint in. At one point he considered buying the whole building. When this didn't pan out he decided the time had come to move again. Clearly, a new period was about to begin.

One day, gazing across the hustler's landscape of Union Square, Fremont and Hughes noticed a large FOR RENT sign on the corner building at 860 Broadway, half a block up and across the street to their left. At first the building's agent sloughed them off when they called enquiring about terms. He had no interest in renting the valuable offices to a spacey artist like Andy Warhol. However, when Hughes and Fremont showed up at the office of the owner, Edward Gordon, it turned out that he was married to the sister of the painter Larry Rivers. The ice broke and a deal was made.

The third floor of 860 Broadway consisted of a suite of offices that had been renovated by S & H Green Stamps in the 1920s. It featured a corporate wood-panelled boardroom or dining room equipped with a small kitchen, a large kidney-shaped reception room and two broad galleries running towards the back of the space where there were a number of smaller rooms that could be used as offices, storage spaces or painting studios. The 12,500-square-foot rental was a perfect fit for the expanding Andy Warhol Enterprises and in August 1974 they started to move across the street. Ever economical, Andy made it a

condition of visiting at the end of the summer that you agreed to carry at least one item, – a chair, a lamp, a box of papers – across the street from the old Factory to the new one.

Fremont recalled that 'we sweated through the move to get the bills paid. Fred and I were on the phone constantly trying to make deals. Andy rose to the occasion doing more prints, and appearing in a series of advertisements for Pioneer stereo equipment.' Still, it was a stretch. His overheads more than doubled and as ever Andy seethed with inner conflicts about the direction he was going in.

The new offices were still empty and bleak-looking when the first crates were unpacked in early September. 'It was cold inside,' Warhol's new silkscreen assistant Ronnie Cutrone recalled.

Andy, Bob Colacello and a few other people were walking around with coats on; we were all shivering, and we unrolled a giant old flower canvas – I remember it was a big bright yellow flower – and we all sat around this flower. It was like a campfire, we were rubbing our hands, and Andy was really morbid and he said, 'What . . . whu . . . whatever happened to the sixties?' It was like, Whatever happened to the sixties, the bright yellow flowers?

ANDY WARHOL

ENTERPRISES TAKES OFF

1974–75

The speed freaks and the transvestites gave way to High Bohemia: collectors and dealers and people in 'show biz' or café society who were lured to the Factory by sociable Fred Hughes. Hughes was determined to project a reasonably respectable image and to establish the Factory, socially as well as artistically, on the international map.

<div align="right">JOHN RICHARDSON</div>

As the seventies shifted into gear, the scene at the new Factory snapped neatly into place and Andy Warhol Enterprises developed into the best team Andy ever had.

Fred Hughes worked in a large screened-off space to the right of the reception room. 'Andy started this whole thing and could make everything work toward what he wanted to do,' stated Vincent Fremont, 'but it was Fred who had a genius to find people to work around him who could get things done.' By then Fred had so much of Andy in him, noted one observer, Fred was Andy at times.

Bob Colacello ruled over *Interview* in a small, elegantly furnished office of his own at the end of a long gallery where the magazine's staff toiled. 'Bob was the ultimate diplomat,' noted one observer, 'and that rubbed off on Andy. I don't know when he first started saying, "Great", but I think that habit had a lot to do with the influence of Bob.'

'Sometimes Andy wouldn't ask me about the magazine for days,' Bob Colacello recalled, 'and then he would say, "How many subscribers do we have in Ohio, and how much do we make on each one?" ' When Bob answered, Andy would often correct him with the exact figure.

Andy had two rooms beyond Bob's. The small one he turned instantly into a garbage dump, the other was his painting space. In a cubbyhole between the reception room and the dining room Vincent Fremont, the vice president, bookkeeper and office manager, kept watch. Ronnie Cutrone would be Andy's full-time painting assistant for the next ten years. He was another of the angelic-looking hustler types, like Malanga and Giorno, that Andy favoured. A lady killer, short and skinny with a muscular build and a dancer's balance, he resembled the Silver Factory

<div align="center">376</div>

pioneers more than the middle-of-the-road kids who were taking over. His experimental spirit would be a vital arrow in Andy's quiver throughout the seventies. Andy also hired Rupert Smith as his silk-screen printer and art director. Smith would become another lifer.

As his personal secretary and diarist he had Pat Hackett. She was rarely seen at the Factory or in Andy's presence in public but she was as supportive a player in the seventies and eighties as Hughes or Colacello. Intelligent, steady and enthusiastic, Pat was just the sort of empathetic woman, like Ellie Simon and Gretchen Schmertz, Andy had always been able to confide in.

Jed Johnson was spending his time trying to find a new house for Andy. For the first time every different aspect of Andy's needs was taken care of by a competent person without any outside interference. It was a very self-contained world at 860 Broadway. As Andy's ventures had developed, several corporations had been constructed – Andy Warhol Films, Lonesome Cowboys Inc. Now all the different Warhol businesses were consolidated under the umbrella of Andy Warhol Enterprises and the Factory was primed for growth. At 'the office', as this generation called it, Warhol was no longer Drella; now he was the Boss.

Upon arriving, after quickly riffling through a stack of telephone messages and mail, Boss would check in with Hughes, Colacello and Fremont. Most often their conversations, laced with humour and bitchy gossip, revolved around what happened last night and who was coming to the day's business lunch, which became a ritual in the wood-panelled dining room, where Hughes had installed a large oval French Art Deco Ruhlman table. The room was dominated by an enormous Pre-Raphaelite painting, and for added effect, a corporate-looking moose-head above several Swahili ancestor-worship poles gazed down at the diners.

Arranging the lunches was one of Colacello's responsibilities and under his supervision the midday gatherings soon took on a stylized format consisting, he recalled, of 'two socialites, one Hollywood starlet, one European title and the victim', who was either a prospective portrait commission or *Interview* advertiser. Bob had a special talent, which Warhol did not possess, for remembering who was in town, deciding who would make compatible tablemates, and making the seemingly endless phone calls necessary to get them all to come.

Andy paid all his staff pretty basic salaries, but each was given the incentive to make some extra money by getting portrait commissions for him or selling advertising for *Interview*. Fred made out like a bandit on this aspect of the deal and Bob Colacello did pretty well too.

After concluding that watercress, smoked salmon and caviar sandwiches (like those Diana Vreeland served at the Metropolitan Museum of Art) were too expensive, the menus also were formalized – pasta salads from the Greenwich Village specialty store Balducci's for portrait

clients, and quiche and pâtés from the Three Little Pigs for advertisers. The bar was stocked with Stolichnaya vodka, Cuervo Gold tequila and the other fashionable drinks advertised in *Interview*. Throughout lunch, Andy poured wine for his guests while remaining abstemious himself. He had become careful about what he ate, but would often get on eccentric eating jags like having a bean sandwich every day for two weeks and then suddenly wondering out loud why he was eating that every day and switch to something else, like the Filet o' Fish from the McDonald's across the street. He was obsessional about everything.

If the snow job did not initially produce results, clients were typically invited back for an even more celebrity-packed lunch, or flattered into a responsive position by a big tape-recorded story on them in *Interview*.

Like everything Andy did, these lunches had a distinctly Warholian flavour. On the surface, they represented the model of sophistication, an elegant artist's salon, but beneath the glamorous façade, the guests were nervous and on guard, as was Andy, who often as not would sit speechless while Colacello or Hughes kept the conversation going. Before the guests arrived, Andy, anxiously adjusting his wig and putting on make-up, sometimes started to shake all over. Ronnie Cutrone, who always feigned complete lack of interest in the famous guests, recalled these lunches as 'awkward, brittle and stiff. Most of the people genuinely bored me to tears and they were so nervous. Andy was nervous too and I would just sit there drinking bloody Marys watching two sets of people being nervous.' This was the seventies version of the screen test, and could be just as brutal.

After lunch Andy would spend the afternoon painting, assisted by Cutrone, a talented artist in his own right who had first joined the Warhol circle years earlier as a dancer with the Exploding Plastic Inevitable. The portrait business was booming now that Andy had scored such international movers as Johnny Agnelli and his wife Marcella (the pied pipers of the jet set), as well as Yves St Laurent, Brigitte Bardot, the fashion designer Diane von Furstenberg, Bianca Jagger, Brooke Hopper and the designer Halston, whose career in fashion (in parallel with Warhol's) was reaching a peak in the 1970s. Commissioned portraits had become the bread and butter of the Warhol Enterprises. By the fall of 1974, it was well on the way to becoming a million-dollar-a-year operation.

Anybody could have their portrait painted by Warhol for $25,000 – the price of a 40 by 40 inch canvas. A nonrefundable $10,000 deposit was all that was required in most cases. Andy usually painted more than one canvas of his clients if he thought there was a chance he could sell them more than one. The second canvas cost $15,000, the third, $10,000, the fourth, $5,000. Additional panels held a special incentive for art collectors – where else could you get a comparable Warhol for the price? – and Iolas, Irving Blum, Ivan Karp, Ileana Sonnabend, Lita

Hornick and Yoyo Bischofberger, the wife of Warhol's Swiss art dealer, had all commissioned portraits.

The process began with an afternoon photo session in which Andy snapped off Polaroids as Fred or one of his other aides leaped about advising the client on their hair and make-up, or telling them how great they looked, a style borrowed, in part, from Halston's reassuring dressing-room manner. David Bourdon wrote:

> As if he were a combination hairdresser, make-up man and studio photographer, Warhol transforms his 'sitters' into glamorous apparitions, presenting their faces as he thinks they should be seen and remembered. His portraits are not so much documents of the present as they are icons awaiting a future.

Additional photo sessions were often required before Andy got a shot he liked, generally a three-quarter profile in the style of TV-screen talking heads and the mugshots he had used in his 'Thirteen Most Wanted Men' series, since he thought these were the most informative. He was not interested in the detailed 'warts and all' approach to portrait painting, choosing instead images with strong contrast. Alexander Heintici, the vice president of Chromacomp, a fine-arts printer in the flower district, personally converted the snapshots into positive proofs the size of the final painting. 'In a face,' Heintici recalled, 'he wanted the middle tones to drop out and wanted to keep the very dark and light ones. He got very upset if it was not what he wanted. You had to listen not only to what he said but be sensitive enough to understand what he really wanted.'

Andy used the positive proofs to trace the image on canvas. He then painted in the background colour, the eyes, lips and other facial features, and returned the painted canvases to Heintici, who silk-screened the black and white image of the subject on top of each. Finally, Andy embellished the silkscreened canvas with more brushwork.

The method was no shortcut; the impression Andy liked to give that he knocked off the portraits was entirely misleading. In fact, as one critic pointed out, the 'quasi-mechanical' process actually took more time than a conventional portraitist. And Andy often spent a lot of time thinking over which colour to use before starting the painting. At times it seemed to David Bourdon that Andy was not so much enlivening the rich and famous as 'embalming' them, and another critic remarked that some day the portraits might appear 'as grotesque as Goya's portraits of the Spanish court'. David Bourdon:

> The faces are as flattened out as a psychedelically coloured map. Warhol does not aspire to be an accurate cartographer of anyone's physiognomy, so he emphasizes the features he considers important. These are the eyes and the mouth. The eyes are large, lustrous and luridly embellished with expressionist

eyeshadow. The lips are sensuous and full, because the underlying colour usually exceeds the actual contours of the lips – like the 1940s Joan Crawford whose lipstick extended halfway to her ears.

Warhol's intention, of course, is to make the portraits intensely flattering – and to give as much satisfaction to his clients as Sargent, Boldini and Kees van Dongen gave to theirs. Warhol, who a few years ago feigned embarrassment at doing commissioned portraits, now exults, 'I'm becoming another Vertes.'

'His seven-days-a-week work ethic was part of his working-class Eastern European background, and it was contagious – everyone around him adapted to it,' said the photographer Christopher Makos. 'Andy used to paint from three in the afternoon until seven in the evening every day, even on Christmas Eve.'

'For years we painted on Saturdays and Sundays but would tell people that we were out of town,' Rupert Smith recalled.

Everything that Andy did was controversial. Now that he was making money hand over fist in such a conspicuous fashion, people started criticizing him for debasing his art and selling out. Warhol in his typical manner complained to Bourdon, 'I haven't gotten paid by anybody.'

Andy was getting rich. And so was Fred. 'Fred made a lot of money, darling,' said Daniella Morera.

Don't tell me he didn't! He was getting 20 per cent of everything he sold. Plus there must be a lot of money in the bank in Switzerland. I was bringing in rolls of portraits of the Italian fashion people under my arm on the plane to Milano rolled up like posters and going through customs without paying any duty. They say, 'What are these?' 'Posters!' And I know that the clients were putting the money in Switzerland. And all the paintings that Bruno Bischofberger and his partner Thomas Amman sold in Zurich, I'm sure that money stays in Switzerland. And if you go to Paris and sell paintings you don't ask the Rothschilds to send you the money in America. It goes to Switzerland. You don't pay any taxes and nobody knows anything. Every good American businessman was doing that. And I'm sure he must have had a double signature with Fred.

'I asked Fred how about his business overseas,' recalled Paul Warhola. ' "Oh, Andy always derived that money into the States. He was afraid of the IRS." But you know that's a lot of baloney.'

Asked if Warhol had Swiss bank accounts, Fremont replied, 'He brought all his money back to the States because we needed it here. We were expanding all the time. I was never aware of a Swiss bank account.' Hughes, who insisted that Warhol was not motivated by financial pressures but was painting the decade as it passed by, said, 'Andy liked to think that there was some kind of overall scheme, that the world was ruled by four people . . .'

'Andy was always afraid he would lose his money or that his cheque

book would be overdrawn,' Rupert Smith said. So attached was Andy to money that he did not have credit cards, perferring to carry his wad of crisp $100 bills in a brown envelope. Although he was rarely ostentatious in his show of wealth, that year he purchased a brand-new green Rolls-Royce.

Andy usually remained at work until seven, while Colacello and Fremont waited for him – a process often prolonged by Andy's habit of answering the telephone and casually getting involved in a long conversation, or deciding to reread all his mail before he left. This always drove Fremont crazy. If Andy wanted to be particularly torturing, he might assign whoever he was picking on that week annoying last-minute tasks like double-checking to see that there were no burning cigarettes in the ashtrays. Andy had a profound fear of fire. Anyone leaving a burner going in the kitchen, letting a kettle boil unattended, or leaving a lit cigarette lying around risked Andy's red-in-the-face ire. Most of these people were eager to get home, largely because they would be expected to reappear shortly at dinners and parties where they were supposed to continue working, pushing Warhol and his product.

Andy would taxi home, often sharing a cab with Bob, where he would eat his 'first' dinner of the evening. The gallbladder problems kept him on a restricted diet, but since the shooting he had also continued to express anxiety about the food away from home or the office not being 'clean'. Andy's favourite foods were the simplest things like turkey and mashed potatoes. He also still loved to rush into a pastry store and buy a birthday cake just because it made him feel good.

From 1974 to 1979 the Factory was heavily influenced by Fred Hughes's anglophilia and many of Andy's leading ladies, or 'gals' as he liked to call them, were English aristocrats, starting with ladies Ann, Rose and Isabella Lambton and ending with Catherine Guinness. The best thing about English women was that they could be haughty or rude while maintaining a fixed smile and their eccentricities often unsettled while also charming visitors or dinner guests. Even though Andy had replaced court jesters like Ondine with titled names, he still liked to have at least one joker in his deck of assistants. In the mid- to late seventies they were often beautiful English aristocrats.

Another of Andy's companions was Lee Radziwill, who had rented his Montauk estate that summer, leading to rumours in the British press of their marriage.

'The best dates,' Andy liked to say, 'are when you take the office with you.' The avuncular, somewhat toady-looking Colacello, with his horn-rimmed glasses and fastidious button-down appearance, seemed the least likely, at first, of Andy's inner circle to become his most identifiable social companion, but Bob's aggressive verbosity endeared

him to Andy. Colacello's outspokenness, particularly on the subject of politics, was occasionally reminiscent of Paul Morrissey. It was typical of Colacello to comment that he liked Pat Nixon because she had a 'nice throat', or, when asked how he liked a light show in one fashionable apartment, to reply that it was 'nice but Albert Speer was nicer'. But in Andy's presence, Bob dwelled less openly on his own thoughts and opinions and functioned, instead, as Warhol's mouthpiece and straight man.

'Andy could be very verbal within his inner circle, dishing away like a decadent fishwife,' Colacello recalled,

> but at dinner parties he would go mute, partially out of shyness but also because he preferred watching to being watched. Often he would give me the cue to tell an amusing anecdote about Truman Capote, Paulette Goddard or Diana Vreeland, and I would launch into a long, densely detailed story complete with mimicked dialogue right up until the punch line, which Andy was primed to deliver. 'Gee,' he would say the next morning on the phone, 'they really liked us last night. Maybe we should go on TV and tell funny stories. You could be the straight guy and I could be the nut.'

Over the past years Colacello had emerged as not only Andy's escort on social occasions, but his front man.

> What I did best for Andy, I think, was sell him, I don't mean his paintings, but him. I explained him to the clients and the ladies, to the press and my parents' friends. When they said he got Edie Sedgwick on drugs, I told them how he got Brigid Berlin off them. If they said he was evil, I said he went to church every Sunday. He became my cause.

Andy became publicly associated with a pack that included Halston, Truman Capote and Bianca Jagger, to whom Colacello gave the titles His Highness, the Count and Queen Bee. He called Andy the Pope.

Others in this group were Liza Minnelli, the socialite Barbara Allen and Victor Hugo. A Venezuelan who had come to New York in 1974 and been working ever since with Halston, Victor was a model of the period, outspokenly gay, outstandingly good-looking. He became the Ondine of the seventies and was given to long, incomprehensible and sometimes downright rude raps which sent Andy into tailspins of silent laughter while visiting dignitaries shifted uneasily in their seats. Victor was instrumental in bonding a relationship between Halston and Warhol which formed the core of the pack. Victor Hugo:

> They were the only contemporaries on the same level of human quality, business and genius. They had known each other for years but they were both so shy they shied away from each other. I said, 'Men, you have such a great tender love for each other I cannot be in between you,' and I put them together, but they had their doubts. It was just so painful.

Victor's best friend, Benjamin Liu:

They were two queens at the heights of their careers who made it to the top of their industries at the same time so there was a lot of the queendom: who could do a little more, own a little more, make a little bit more money. There was a lot of ego, a lot of competition. I thought it was a peculiarly American, almost healthy kind of business competition. And Victor had the best of both worlds in many senses, but he also created tremendous energy and creativity for both of them.

Daniella Morera was spending more and more time in New York.

After Andy made the films in Rome we were going to a lot of parties at Halston's house with Liza Minnelli and Bianca Jagger. It was very social, very glamorous. Bianca told me that for her Andy was the best chaperone because he never complained and was happy to go anywhere and Andy was always enthusiastic, telling her you should do this or that, so she got a lot of inspiration, but it was not always very good advice. He could really put you on the wrong track.

They appeared to be having a wonderful time. However, behind their masks they were all suffering from the effects of wealth and snobbery that Lewis Lapham describes in his book *Money and Class in America*:

In New York the masks of opulence conceal a genuinely terrifying listlessness of spirit. Behind the screens of publicity, the mode of feeling is as trivial and cruel as the equivalent modes of feeling prevalent in the ranks of Edith Wharton's plutocracy or F. Scott Fitzgerald's troupe of dancers in the Jazz Age.

The social life, which became a major part of Andy's world in the seventies – recorded in portraits, photographs and in the increasingly chic pages of *Interview* – drew flak from his critics. Robert Hughes:

To see Warhol entering a drawing room, pale eyes blinking in that pocked bun of a face, surrounded by his Praetorian Guard of chittering ingénues, is to realize that things do turn out well after all. The right level has been found. New York – not to speak of Rome, Lugano, ·Paris, Tehran and Skorpios – needed a society portraitist . . . The alienation of the artist, of which one heard so much talk a few years ago, no longer exists for Warhol: his ideal society has crystallized round him and learned to love his entropy.

Spreading his net as wide as possible, and not content with the worlds of fashion and entertainment which he had quickly infiltrated, Warhol now turned to world leaders as potential portrait victims.

To his roles as social secretary, luncheon arranger, *Interview* editor, and Andy's Boswell, Bob Colacello added the function of AWE diplomat

to the Peacock Throne in Iran and the Marcos regime in the Philippines, a job Colacello – who had wanted to be a diplomat while in college – relished to sometimes pompous extremes. In defence of his often criticized right-wing leanings, Bob insisted that all heads of state were interesting, but art business was the clear focus of his diplomatic efforts.

The Shah's wife Farah Diba had begun to spend what in time would amount to millions of dollars exercising the fantasy of filling a contemporary-arts museum, to be completed in 1976 in celebration of the golden anniversary of the Pahlavi regime in Tehran with works by Rauschenberg, Johns, Lichtenstein, Oldenburg, Stella and Warhol.

The first invitation to the Iranian embassy came in late September 1974. Dinner was in honour of the Italian ambassador to Russia, and Andy's best girls, Diana Vreeland, Paulette Goddard and Lee Radziwill, were also guests of Ambassador Fereydoun Hoyveda. Gisela Hoyveda, his young German wife, seemed most aware of Warhol, and Colacello made her the target of his follow-up phone calls. By December, 'caviar' had become a buzzword in Bob's *Interview* column and he had pestered Andy's way up the protocol chain to an embassy dinner for the premier of Iran and Princess Ashraf Pahlavi, the Shah's twin sister. 'All this happened through Ambassador Hoyveda, who was a friend of many people,' stated Fred Hughes. 'We met him because he was a friend of John de Menil. And the most amazing people passed through Fereydoun Hoyveda's house, including very, very far left people.'

'Every artist in town was running to Iran because they were giving out money for the arts and there were lucrative deals to be made,' added Vincent Fremont.

Nothing drew so much negative criticism towards Warhol in the 1970s as what the social critic Susan Sontag called his lack of political compassion.

Warhol – or Andy as we sometimes called him – was so ironic, he said all those smart things in this totally ironic way, so that finally the most important thing about what Andy did was his irony. But I think that his idea of things and the kinds of things that he said and the kind of perceptions that he had, excluded one enormous emotion that people do have and that's indignation. I mean it wasn't possible for him to say, 'That's terrible and I'm really against that and that shouldn't be.' It's called capitalism. That saying it's OK. He said, I just love rich people so much. That's a political statement. Don't tell me that Andy Warhol thought the Shah of Iran was a good guy. He couldn't. He thought he was charming. He thought he was amusing. He thought it was interesting to know a head of state. He thought it was glamorous. But he could not think he was a good guy. What he did think was, 'I don't have to worry about that question. That question is a boring question.' And it was not a boring question if you had feelings.

People associated with the Factory were looked upon by left-wing

elements as the dregs of humanity and a fortress mentality emerged. You were either with or against Warhol, as his name once again polarized conversations.

Ten years after the Shah's fall it is easy to forget what all the fuss was about. Many of the Iranians Warhol and his entourage dined with in New York and later in Tehran were members of Savak, the Shah's secret police, whose methods of torture (which were known at the time) included, according to the investigative journalist William Shawcross, 'whipping and beating, electric shocks, pulling out nails and teeth, pumping boiling water into the rectum, hanging heavy weights on the testicles, tying the prisoner to a bed frame that was slowly heated, inserting broken bottles into the anus, and rape'.

*

In mid-October 1974, Warhol began to spread the gospel of his new lifestyle internationally when he departed on a three-week trip to Paris, Milan and Tokyo with Fred Hughes, Bob Colacello and Jed Johnson. Andy hated travelling but was a relentless tourist once he arrived, usually wearing out whoever travelled with him with his restless need to always be doing something into the wee hours. At the end of each gruelling day and night of work and play he would ritually order a box of chocolates and a cognac, then say, 'Well, what're we going to do now?' When his exhausted aides suggested going to sleep, he would exclaim, 'Well, what did we come here for?' If he couldn't get his chocolates he might get quite moody and keep someone up extra late just to torment them.

In Paris they checked out the fashion houses and perfume shops, attended a party for Warhol's long-time friend, the British painter David Hockney, had dinner with Eric de Rothschild and hopped around night clubs. Then they flew to Milan, where Jed's twin brother Jay joined them. They went to art openings with Paulette Goddard and nightclubbing with Daniella Morera. Back in Paris they dined with Nureyev before flying via Anchorage to Tokyo. Andy spent most of the twenty-hour flight in silence, listening to opera tapes and reading movie-star biographies.

At Tokyo airport they were greeted by hundreds of reporters and photographers. Asked what his message for the people of Japan was, Andy replied, 'Be happy!' They lunched with Japanese businessmen sitting on opposite sides of the table, 'like teams at diplomatic negotiations,' noted Colacello. The trip was sponsored by the Daimuru department store, the Macy's of Japan, to inaugurate an art boutique with a show of Warhols. Andy Warhol:

By the time we got to Kyoto we had really had it with Japan and the Japanese. So after dinner in a Chinese restaurant I sent Bob to the hotel drugstore to buy me a dirty novel. As he was knocking on my door, holding *Truckstop*

Jockey Shorts under his arm, he felt a tap on his shoulder. He turned around and saw two beautiful blonde girls. Just then I answered the door. I was wearing my usual bedtime outfit: a Brooks Brothers blue oxford shirt, jockey shorts, and Supp-hose.

One of the beautiful blonde girls said to Bob, 'We're travelling with Mrs Trudeau. We saw you in the lobby with Andy Warhol. We're sorry to bother you now but Mrs Trudeau has been calling Mr Warhol in Tokyo and she can never get through.'

I grabbed *Truckstop Jockey Shorts* from Bob, slammed the door in his face, threw the book under the bed, and jumped into my jeans . . .

On the way to Mrs Trudeau's suite I knocked on Fred's door and shouted 'Fred! Hurry up and get dressed. We have to go to tea with Mrs Trudeau.'

Fred shouted back, 'I know you hate to travel but I'm sick and tired of your practical jokes.'

Margaret Trudeau was in Japan to christen a ship for the Japanese shipping magnate Y. K. Pao. She was a 'breathtakingly beautiful woman', Warhol noted, but did not fit the image of a head of state's wife. When they were introduced, she was sitting on the floor of her hotel room, sucking on a big joint of marijuana and blowing smoke rings into a little rock garden while playing with a novelty-store 'laughing' machine. She said, 'Hi, Andy. You're the hardest person to reach in the world.'

This kind of international trip, which Andy would make frequently for the rest of his life, had a lot to do with changes in his image. Always travelling with at least two suit-and-tie aides gave him the aura of an important visiting dignitary abroad while the diligently recorded reports of these trips appearing in Colacello's 'Out' column gave him an almost presidential aura at home. As long ago as 1968 Bob Colacello had written in Andy Warhol for president the first time he was old enough to vote. As early as 1970 David Bourdon had said that Andy would 'eventually tire of show business too; then what? He'll still be left the same plain, love-starved little boy that he always was. I think he may have to go into politics. He might run for president.'

In his 1974 book on Marilyn Norman Mailer wrote:

Marilyn Monroe's death was covered over with ambiguity even as Hemingway's was exploded into horror, and as the deaths and spiritual disasters of the decade of the sixties came one by one to American Kings and Queens, as Jack Kennedy was killed, and Bobby, and Martin Luther King, as Jackie Kennedy married Aristotle Onassis and Teddy Kennedy went off the bridge at Chappaquiddick, so the decade that began with Hemingway as the monarch of American arts ended with Andy Warhol as its regent.

The courting of Imelda Marcos, the wife of the corrupt right-wing ruler of the Philippines, who was buying art, shoes, jewellery and property in New York that fall, began a week after Warhol's returning

from Japan, with a tea on 16 November at the Carlyle Hotel attended by Andy and Bob. 'Artists bring people together,' Mrs Marcos told them, and extended a special invitation to Andy's dachshund Archie to come and meet her thirty dogs at the palace in Manila.

Two days later, they accompanied her to tea at the Chinese embassy, where they watched propaganda films of Mrs Marcos talking to Mao and Mrs Mao. Next they attended the opening of the Filipino Cultural Center on Fifth Avenue, while demonstrators outside chanted, 'Imelda, go home!'

Colacello gushed over Mrs Marcos in his column, describing her as 'always polite, articulate, politic, and, underneath it all, extremely intelligent'. Bob loved the name Imelda, it reminded him of Evita and Diana. He was so impressed by the number of security guards accompanying Mrs Marcos that he began to include a bodyguard count – along with the details of what any powerful person was wearing and eating – in his column. Andy was most impressed by Mrs Marcos's claim that she only needed to sleep two hours a night.

On 30 December 1974 Andy received a Modern Language Association award from the Popular Culture Association for his contribution to the understanding of homosexuality. 'Mr Warhol carried a tape recorder, which led many persons in the audience to suppose that he was fearful lest his words be lost to posterity,' reported the *New York Times*. Instead, he gave a lesson in concision.

'Thank you,' he said in a tiny Jackie Kennedy voice.

*

While Andy was trotting around the world and pressing the flesh with Imelda, Farah Diba and Maggie Trudeau, Paul Morrissey had been trying to turn Andy's fantasy of producing a Broadway musical into reality. He was working with John Phillips, the former musical leader of the Mamas and the Papas. Charmed by Phillips and his wife Genevieve Waite, who was to star in the show, Warhol, who was always keen to collaborate with anybody doing something wacky, agreed to produce the musical but in name only. He did not put up any money.

As so often happens with these expensive, time-consuming productions, almost everybody involved, including Morrissey this time, broke down under the strain of doing something they did not know anything about. By Christmas, Phillips had begun snorting cocaine and skinpopping heroin to numb himself to the coming debacle, and Genevieve Waite was close to nervous collapse. Finally, Morrissey was banned from the theatre, which amused Warhol no end.

Two nights before the opening, Genevieve Waite overdosed on pills and had to be rushed to Lenox Hill Hospital. She rallied for the opening on 29 January 1975, but the show was a total flop and closed three days later. Morrissey fled to Hollywood and never worked with Warhol again.

In May Eric Emerson, who had starred in *Chelsea Girls* and *Heat*, was found dead on a downtown street of a heroin overdose. Lately he had been attaching 30-pound weights to his legs and bicycling furiously up to the Factory in between drinking his own piss at Max's, but become morose when no one picked up on his antics any more.

That month Mick and Bianca Jagger rented Andy's Montauk estate for the summer and the Rolling Stones used it as a rehearsal space for the upcoming US tour. Andy flew out to visit.

> My favourite Jagger is Jade. I love Mick and Bianca, but Jade's more my speed. I taught her how to colour and she taught me how to play Monopoly. She was four and I forty-four. Mick got jealous. He said I was a bad influence because I gave her champagne.

The presence of the Stones in the little coastal town transformed it into a tourist attraction, mostly for groupies who were jamming the local motels and, at times, would have to be rousted from the bushes by the caretaker Mr Winters.

'It was nutty,' Vincent Fremont recalled. 'Mick had the big cottage and then John Phillips had the smaller one next to it. There was all sorts of fun out there that summer.' In one lurid moment someone snapped a photograph of Warhol holding Mick Jagger's gun and staring at it intently. Later on he would do a series of gun paintings.

Warhol accepted a commission from a London-based group to do a portfolio of Mick Jagger portraits to be signed by both Warhol and Jagger. At the same time, he was engaged in another portrait series – 'Ladies and Gentlemen' – of drag queens recruited as paid models by Cutrone and Colacello. Warhol was now employing a new technique, using torn paper patches to give the surface of the paintings a collagelike effect. The new method complicated his portrait-making process, requiring up to ten silkscreens to complete the final product.

As a regular *Interview* contributor, Bianca Jagger had taped Leni Riefenstahl, helped to interview Martha Graham and Halston, and was to be the subject of a long taped portrait by Andy in the September 1975 issue. Bianca adored Andy and thought he was a magic person and the best date to go out with but she also noted the other side of his personality, telling Daniella Morera,

> Andy always loved to make intrigues between couples. He was always pushing me, 'You should get that man,' making gossip. 'Oh, that's much better for you, Bianca. Leave this one, go with this one.' Making intrigues between me and Mick. He would say. 'Oh, Mick is a dirty man, you know he goes with other girls . . .'

While Colacello's diplomatic efforts had yet to pay off in big political commissions, they did finally gain Warhol an invitation to the White

House for dinner with the Shah of Iran on 15 May. Taking the Metroliner train to Washington, Andy, Jed and Bob checked into a five-bathroom suite at the Watergate Hotel. Only Andy was invited to the dinner. In white tie and tails, he was escorted to the White House gate by Johnson and Colacello, who repeatedly had to reassure him – as they always did – that he didn't look a mess, while Andy just as strenuously objected – as he always did – 'Oh, why can't I dress right? What's wrong with me? I mean, why can't I look good?'

Andy returned to their suite at two in the morning, reporting that he had sat with Nancy Kissinger, wife of the secretary of state, and Ambassador Zahedi of Iran. A number of show-business people also attended, and Fred Astaire had danced with Betty Ford. Andy had stayed hidden in a corner during the dancing for fear that the First Lady or the Empress, who he said was extremely beautiful and kind, would ask him to dance.

Bianca Jagger had developed a White House connection in the person of Jack Ford, the president's 23-year-old son. She introduced him to Andy one night at the El Morocco, where Warhol was dining in the company of the Marquesa de Portago and the gaga Duchess of Windsor, who thought she was on the *QE II*, when Bianca arrived with Ford and the White House photographer, David Kennerly, in tow. After dinner everyone except the Duchess went dancing at the discotheque Le Jardin where, Warhol recalled, 'some boy came up to Jack and asked him to dance. Jack had no idea what to do.' Shirley Temple Black, the president's chief of protocol, Andy mused, 'never told him the proper way for a president's son to behave in a gay bar'.

Afterwards Andy asked Bianca if she could arrange an interview with Jack Ford for *Interview*. Betty Ford expressed her doubts about the interview to her press secretary, who pointedly suggested that Jack wait to present himself in a less unconventional publication. But he wanted to go through with it, and, she thought, who reads *Interview* anyway? Andy Warhol:

I was very surprised when I arrived at my office and found a message: 'The White House called' – which is really the most glamorous message you can get in the world. I immediately had the editor of *Interview*, Bob Colacello, call right back, because I was too nervous to call myself. When I'm really impressed I get so nervous I can't talk.

This time Andy managed to visit the White House with Bianca Jagger and Bob Colacello and made out of the visit one of the most successful publicity coups of his career. In the interview, which was largely conducted by Bianca, Jack Ford was surprisingly candid – suggesting at one point that his life in the White House was so 'stifling' that he would trade places with anyone 'for a penny' – but the photographs of

him in the Lincoln bedroom with his hands on Bianca Jagger's waist, which looked like stills from a Warhol film, were suggestive enough to give rise to international rumours of a romance when they were leaked through a 'misunderstanding' with *Photoplay* magazine, which had a photo reproduction arrangement with *Interview*.

Naturally the White House and particularly Betty Ford, who felt she had been taken advantage of, were outraged when they realized what had happened, but there was absolutely nothing they could do about it. Andy on the other hand was in a position to reap the benefits of all this free publicity when his book *The Philosophy of Andy Warhol* was published in September, the same month the long interview between Jack Ford and Bianca Jagger appeared in *Interview* and the scandal was at its height.

Culled from Warhol's telephone tapes with Brigid Polk and Pat Hackett, transcribed by Pat and shaped into final form by Bob over the previous year, the book was an assemblage of Andy's anecdotal observations on themes such as love, fame, beauty and money. It was, he told one reporter, a 'negative philosophy', the central theme of which was 'Everything is nothing.' From making love to making art, he noted repeatedly, 'the most exciting thing is not doing it'.

His approach was more light-hearted than existential, ranging from the personal – 'If someone asked me, 'What's your problem? I'd have to say skin' – to the political – 'The rich have many advantages over the poor but the most important one is knowing how to talk and eat at the same time.'

'I never think positive, I always think the opposite,' Warhol reflected to a reporter as the book was being completed. 'But I don't think many people are going to believe in my philosophy, because the other ones are better.'

The fact that Andy was conveying the style of the times was recognized by Barbara Goldsmith, when she remarked in the *New York Times Book Review*, 'Some people say California is the bellwether of America. I'd say Andy Warhol.' Warhol's philosophy, like his other work during this period, was a cultural portrait and artefact of what was coming to be called the 'me' generation, and a decade without trust, ideals or love.

A tour promoting the *Philosophy* had been arranged by Warhol's staff and the publishers, Harcourt Brace Jovanovich, and in September Andy, together with Bob, Fred, Jed and with Lady Ann Lambton as his 'body-guard', was on the road on a nine-city book-signing junket.

The stopover in Baltimore coincided with the opening of a museum retrospective exhibition of forty of Warhol's representative images – soup cans, car crashes, race riots, suicides, electric chairs, flowers, Marilyns and Maos. In Chicago, Colacello noted in his diary, 'one boy asked AW to sign the casts on his arm because he had tried to commit

suicide the day before and flopped'. In Houston, Texas, Andy and Ann Lambton sat in a Fabler department-store window like mannequins, gathering crowds as the Velvet Underground song 'Heroin' blasted on to the street.

This was a turning point in Andy's reputation. For the rest of the decade he would be seen by the mass public in America as more of a comedian than an artist, therefore more famous, acceptable and palatable to middle-class America.

'My mind is like a tape recorder with one button – Erase,' *Newsweek* quoted Warhol as saying, and the book review by Jack Kroll went on:

> When you look at Warhol's art you see how much has indeed been erased from both art and reality in modern times. Rembrandt looked at a human face and used the most exquisite skills to body forth its meaning and his compassion. Warhol looks – not at the face itself, but at the innumerable images of that face which clutter up our eyes and minds – and uses the most 'banal' of mechanical means to body forth its meaning – and his compassion. He has sinned; he has created chic icons for empty people to decorate their emptiness. But at his best he captures the pathos, the garish beauty, and something of the terror, of a society that lusts after such strange gauds.
>
> In his book Warhol often comes on as a perversely funny sage – a pop La Rochefoucauld . . .
>
> 'I never fall apart because I never fall together,' says Warhol. In his art and his life, both flights from emotional commitment, you hear the laughter and the cry wrenched from a man who heard something go pop in America.

After the American book tour Warhol went to France, Italy and the UK for fashion shows, art openings and book publications. Ferrara in Italy had an exhibition of his 'Black Transvestites' paintings at the Palazzo di Diamente. Daniella Morera was there and observed:

> Andy was involved with this schizo dealer Luciano Anselmino. He was a crazy person who was involved with Iolas in a homosexual relationship. The show was incredible. There were many people and they were spending a lot of money and Andy loved that. He said, 'Daniella, these Italians, they are so rich! They are so rich!'

In Rome Andy was 'kidnapped' from an opening of his 'Drag Queen' paintings by Liza Minnelli, who was there costarring in a movie with Ingrid Bergman and produced by her father Vincente Minnelli. 'She kept talking nonstop about how her mother alternated between strong men and weak men,' Warhol later recalled. 'I thought she was talking about herself.' After a one-hour tour of the Art Deco murals in the lobby and ballroom of her hotel, they went to her suite, where she ignored the increasingly frantic phone calls from Warhol's Italian art dealer, while she acted out her lines for him.

In London, a crowd of fans rioted during Andy's appearance at the

Arts Council bookshop. Society columns in the London tabloids now rumoured the imminent engagement of Andy and Lady Ann Lambton, whose parents, Lord and Lady Lambton, gave a party at their home in honour of the book. Prominent among the social-register crowd who danced until dawn were the teenage Caroline Kennedy, who was attending school in London, and her beau, Mark Shand, a real-estate heir. Their presence among the early-morning crowd at the Lambtons' was duly noted in all the London tabloids.

Some weeks later, Warhol ran into Jacqueline Onassis in New York. 'She said, "Thank you for taking such good care of Caroline in London," ' he recalled. 'I wasn't sure what she meant.'

Despite all this relentless pitching the *Philosophy* book did not do well. In fact, Andy bought back a lot of them to give away as gifts.

*

At the end of 1975 Andy moved into a new house that would become his Xanadu. He had been wanting to move out of his 'candy box' house on Lexington Avenue for some time. Julia's death and the attendant memories were one contributing factor in his decision to move. The house was too small and lacked sunlight. 'Isn't sunlight wonderful?' Andy had remarked to Truman Capote when he first visited the author's brightly lit apartment at United Nations Plaza. 'I live in a dark dump.'

This was the first time in his life that Andy would be getting a place on his own. Jed Johnson had looked at some ninety houses before finding the right one for Andy to buy. The house Jed chose tells us a lot about Andy's state of mind in 1975. For $310,000 in a depressed market Warhol got himself a six-storey 1911 Georgian-style mansion at 57 East 66th Street near the corner of Madison Avenue and in the heart of the Upper East Side. With its wide stairways and large, light, open rooms, it was a grand house with, according to one visitor, 'the traditional old money look' that Andy wanted.

Andy had made it to the top of the heap. He was living within blocks of the Kissingers, the Rockefellers and most of New York's 'beautiful people', among whom he could now be firmly included. He had Fred Hughes and Jed Johnson, playing the important role of art directors, decide what to do with the house. Hughes pronounced it perfect. Throw out the wall-to-wall carpets, he said, and replace them with a few good rugs. Otherwise repaint everything the original colour and leave the house the way it is. Andy put Jed in charge of decorating the house and overseeing the move. Jed Johnson:

It took months to sort through everything he's collected up until that point (and this was when he'd only just begun to shop) and pack it away in cartons. We began by going into the flat files where he kept all his early illustrations from his commercial art days. He tore the old work up and we threw it into

jumbo plastic trash bags. We hauled these outside and left them in front of other people's houses down the block and around the corner because he was afraid someone would be curious to know what Andy Warhol was getting rid of in bulk and decide to retrieve it. This was the one and only time I ever saw him throw anything away, and from a few comments he made, I think he did it because he was sorry or embarrassed that he'd ever started out as a commercial artist. Then we packed up the Indian collection, the tin boxes, spatterware, American product packaging and crockery and put them all in cartons. We moved them up to the fifth floor of the new house where they were simply never unpacked. When he saw that the few pieces of furniture he'd bought (primitive country furniture) now looked out of place in these new surroundings where the spaces were high and classical, he encouraged me to shop for appropriate furniture to fill up those spaces. By this time he'd visited enough rich people's houses to know what they looked like when they were done well.

Jed had a memory for décor and wanted to add stylish touches influenced by the elite homes he had visited with Andy on their travels together – St Laurent's townhouse in Paris, Hélène Rochas's home on the Riviera, and Eric de Rothschild's estate at Château Lafite. He stencilled the same wall patterns in Andy's bedroom as they had seen in Mad King Ludwig's castle in Neuschwanstein. 'Andy let Jed do everything,' recalled one associate. 'He knew that Jed could give him a 'look'. He surrendered to a combination of Jed's idea of grandeur and his own notion that he might be ready to begin behaving grandly himself – remember he was in his Shah of Iran phase then,'

New pieces appeared almost daily to supplement Andy's collections of furniture, tureens, serving dishes and tea sets. Jed's approach was a combination of neoclassical, Art Deco and Victorian styles. Notably absent among the chintz curtains, Joseph Barry cabinets, Sheraton tables, and Dunand and Legrain furniture were any traces of pop art culture, apart from some Lichtensteins and a Jasper Johns which Warhol had purchased early in his career. He kept one of his own small Maos on a dresser in the bedroom.

Andy's collecting mania had been given freer rein by his increasing wealth and his association with Fred and Jed. 'Andy and Jed were running around in 1974 looking for American furniture down in Philadelphia or whatever, going on side trips in the Rolls,' Vincent remembered. 'Andy was very active. He had gotten quietly out of Art Deco and he had started looking with Jed at American Empire.' Jed Johnson:

He shopped for two or three hours a day for as many years as I can remember . . . Andy had the peasant's wisdom that if people (either the very rich or the very poor) knew that you had anything good, they'd probably try to take it away from you. So he hid what he had. It was inconspicuous consumption. He'd wear a diamond necklace, but only under a black cotton turtleneck. I walked into the room once as he was looking over the top of

his glasses at a sparkling piece of jewellery. I asked, 'What's that?' 'Nothing. It's nothing,' he said, nervous, and he shoved it into his pocket. Of course I never saw it again.

'The word "collector" doesn't begin to describe Andy's obsessive – what Freud called anal – hoarding,' said John Richardson.

Since virtually everything that came through the mail box was carefully conserved, the principal task faced by the executors of Andy's estate was the logistical one of sifting through rooms in the Factory as well as the house, crammed with shopping bags and cartons (neatly taped and dated), which in turn were crammed with everything from valuable documents to fan-letters, junk mail, back numbers of *Hola!* and Heaven knows what else. To Andy in his role of recording angel, every last scrap of rubbish had validity by virtue of being memorabilia – *Zeitgeist* minutiae.

'He told me,' Jed Johnson recalled, 'that the antiques made him feel rich.' So did the wads of money that Jed noticed Andy hoarded under the special straw mattress on his bed. 'You only feel as rich as the money you have in your pocket,' he confided to Jed, 'or under your mattress.'

When Andy moved to East 66th Street he got two Filipino maids, Nena and Aurora Bugarin, plus a tight security system which sealed him off from the outside world far more securely than his burglar alarm at 1342 Lexington. Fred Hughes moved into Andy's Lexington Avenue house and Vincent Fremont took Fred's East 16th Street apartment.

Working full time Jed completed several of the rooms that autumn and winter. When they were ready Andy invited Diana Vreeland and Truman Capote to dinner parties: however, within a few months of moving in, Andy began to complain to Jed that entertaining in the house made him feel uncomfortable. 'I pushed it a couple of times,' Johnson remembered.

It was always a disaster, so it just wasn't fair. He didn't enjoy it, I think he was embarrassed by it. Andy saw so many people all day long, and the Factory was so accessible and pretty much of an open house, and then he was out so much . . . he did lunches at the Factory, he entertained in restaurants. I think he just needed a place to be alone.

Suzi Frankfurt was friends with both Jed and Andy, but:

I couldn't understand his relationship with Jed, it was so convoluted. I thought Andy was just crazy about Jed but it was so in the closet. I just think that Andy was very difficult like that. He wasn't ever generous. He wouldn't let Jed have anybody in the house. He was crazy! Andy was completely difficult. I don't see how anybody could live with Andy Warhol!

From then on the 66th Street house became a private treasure trove –

off limits to all but Andy's closest associates. The elegant staterooms increasingly became used for storage. The long Sheraton table in the dining room gradually turned into a haphazard heap of crystals, cigarette cases, antique watches and Indian rugs. Meals were eaten in the kitchen – Andy's favourite room. Jed Johnson:

> He kept most of the rooms locked. He had a routine. He'd walk through the house every morning before he left, open the door of each room with a key, peer in, then relock it. Then at night when he came home he would unlock each door, turn the light on, peer in, lock up, and go to bed.

BAD

1976–77

*Andy told me he lost money on his movies, he even gave
up on it. Too much competition. I remember one time he
told me he had to sell a lot of his paintings to get him out
of the hole. That's when he was going to Iran and then the
next trip he was going to go over and he told me, well, they
wrote and they called and they told him not to come over,
they're having trouble. That's when the Shah was there and
they just had the civil war . . .*

<div align="right">JOHN WARHOLA</div>

Warhol's last movie, *Bad*, was filmed in New York in the spring of 1976.
A year of dealmaking had gone into getting it off the ground. Initially
it had been planned as a low-budget film. However, after Robert
Stigwood, who was at the height of his career as a rock-and-roll entre-
preneur, had become involved in the financing, the scale of the pro-
duction gradually expanded into the costliest Warhol movie to date,
with a production budget of $1.2 million.

When Stigwood dropped out of the project, Warhol, with Fred
Hughes and Vincent Fremont handling the paperwork, decided to pro-
duce the film himself, funnelling much if not all the money he had
made during the previous six months of portrait painting into the
project. Fred put some of his own money into it. Additional capital was
raised by Hughes. It was a difficult job even though Warhol's reputation
as a movie producer now seemed to guarantee a return. His films were
'good BO', Andy liked to say, 'good box office'.

Pat Hackett had already completed a script. Jed Johnson, who had
acted as Morrissey's right-hand man on seven previous films, was
chosen to direct the new film.

Carroll Baker returned from a seven-year self-imposed exile in Europe
to play the role, scripted specifically for her, of a Queens housewife
who worked as an electrolysis beautician by day and head of a punk-
girl hit squad by night, who specialized in killing children and cutting
off people's fingers. The all-American delinquent-looking Perry King, a
rising film actor, was Andy's choice for the male lead. The film costarred
the brilliant Susan Tyrell and the usual assortment of Warhol kids –
Bridgid Polk happily back in the fold after a two-year absence, Geraldine
Smith and her equally beautiful sister Maria, Cyrinda Foxe, and the

comic Susan Blond, who, in the film's most notorious scene, drops her baby out of a high-rise window.

The production crew included between thirty and forty people, all of whom were Screen Actors' Guild members (even the kids had to join SAG) and received union-scale wages. The production was totally uncharacteristic of the Warhol business art strategy as it had been carried out until then. Even Fremont, the AWE bookkeeper, accustomed to coping with at times grandiose expenditure, was dismayed at the way *Bad* 'chewed up money'.

Andy was on the set nearly every day working with Jed, Pat and the actors, and making use of the film as a publicity stunt, taking people he wanted to impress to 'visit the set'. Vincent Fremont:

> Andy would go to dailies and then complain to Pat about certain things. He was very active in giving critiques. And very enthusiastic. We raised all the money ourselves, bringing in Peter Brant and Joe Allen, and we inherited a producer named Jeffrey Tornberg from Robert Stigwood. He was the type of producer who only caused problems rather than solving problems. He did bring the movie in on budget and then took an ad out in *Variety* saying On Time On Budget. Unfortunately he was only working for himself. And there was a lot of tension and trouble. We were really sticking our necks out.

While pumping enthusiasm and energy into *Bad*, Andy was simultaneously engaging in a collaboration with the artist Jamie Wyeth, son of America's most famous painter, Andrew Wyeth. Warhol and Wyeth had been commissioned to paint each other's portraits and show the results along with preparatory drawings at Manhattan's prestigious Coe-Kerr Gallery.

This was a clever move by Warhol. Jamie Wyeth's reputation was largely based on his portraits of people like John Kennedy and the American movie mogul Joseph E. Levine, so realistic and detailed that their subjects, shocked by the results, often hid them in their closets. Still, Wyeth's name was a trump card, and it was a constructive move for Andy to associate with him at a time when Warhol wanted to make a strong re-entry into the New York art world. It was also a daring move since Wyeth's approach was the reverse of Warhol's and comparisons might well have reflected badly on Andy's approach to portrait painting.

The results displayed at the Coe-Kerr Gallery in June 1976 were a solid success for Andy. While Wyeth's portrait showed Warhol as an aging, fragile, shaky, shell-shocked and pockmarked victim of his life, and Warhol's portrait showed Wyeth as a glamorous if reflective all-American art star, the combination of the two and the revealing preparatory drawings presented Andy as the serious, thoughtful and painterly artist that he was. The reviews were good and Andy and Jamie continued to see each other. Warhol even went down to Chadds Ford,

where the Wyeth clan lived, and made a pilgrimage to Andrew Wyeth, who received him gladly.

The collaboration with Jamie Wyeth was a good example of Warhol's conflicting nature at work. Here he was associating with one of the most conventional names in America while simultaneously working on one of the most unconventional films being made in the United States that year.

While Andy was chatting up the cast of *Bad* and hobnobbing with the Wyeths, Bob was pumping the hands of as many rich ladies as he could. Bob was a good conversationalist and very bright, able to get Andy back and forth from Washington and in and out of the embassies of that period's chic dictators, but Bob had to clear everything with Fred. 'You'd talk to Andy,' recalled Fremont, 'and Andy would talk to Fred. That was the way it was done.' Colacello's efforts to court the Iranians paid off when Andy was commissioned by the Shah to do a portrait of the Empress.

Unable to rent the Montauk compound that summer, Warhol stayed there for two weeks in June with Jed, who was beginning to edit *Bad*, then turned it over to his staff and friends as a retreat from the summer heat. Elizabeth Taylor brought her hairdresser and Firooz Zahedi, the cousin of the Iranian ambassador, along with her for a weekend later that month.

While Liz played Frisbee with the kids on Montauk, Andy, Fred and Bob were beginning a two-week stay in London on their way to Iran. At a party at the poet Stephen Spender's Colacello was cornered by a *New Statesman* reporter who demanded to know, 'How could you go to a police state like Iran?'

'By airplane,' was Bob's tart reply.

On 5 July the Warhol team arrived in Iran to a welcoming committee of young girls and limoed to the Hilton. After several days of eating caviar and having dinner with Prime Minister Bhutto of Pakistan, Andy went to Polaroid the Empress. After a tour next day of the crown jewels and a final dinner party, Andy and his aides headed triumphantly for home, with a commission to do the Shah's sister in the works. 'Painting Imelda Marcos or Stalin, it doesn't really make much difference as long as they pay their bills,' one observer commented.

Andy thought he was well on his way to being the court painter of real courts. A week after he left, however, the Shah's ambassador to London, Parviz Radgi, had lunch with the Shah and the kings of Jordan and Greece. What did these monarchs talk about? Did they mull over world affairs or ponder the fates of their ancestors? Certainly not. They spent the entire time discussing the physical unattractiveness of Andy Warhol.

Andy's appearance was one of the big bugaboos of his life. He could never stop looking in the mirror like the witch in 'Snow White'

wondering who was the most beautiful of them all. His appearance could change dramatically from day to day. One morning he would arrive at the Factory with his face glowing, enveloped by the aura of a star. The next day he might be ashen and wan, his face grey, pimpled and pockmarked. The change was so radical his staff sometimes wondered if he was on drugs. He was taking a variety of pills every day on prescription for gallbladder and skin problems, but the extreme changes in his appearance were due more to his mood swings than extraneous influences. All his life Andy swung back and forth from being ruggedly good-looking to radically ugly.

Warhol's visit to Iran drew hostile criticism from the left, also directed, in the words of the social critic Alexander Cockburn, at '*Interview* and its exaltation of "Fascist chic" style and its moral indifference to its heroes and heroines'.

'The *Village Voice* and the anti-Iran group liked to blow this up as a kind of decadent thing,' recalled Hughes.

> It wasn't. *She* couldn't have been kinder. There were some very interesting people involved around them, very complicated, and it was hard to make the kind of judgement one would normally make. We got paid for Farah Diba's portraits and the one we did of the Shah's sister. This was shortly before the fall of the Shah.

Back in New York that August, Warhol was commissioned by the *New York Times* magazine to do a cover protrait of Jimmy Carter, the Democratic presidential candidate. Since Bob Colacello, a staunch Republican with whom Andy did not see eye to eye politically, was still nostalgically attached to Richard Nixon, Andy took Fred Hughes with him to Plains, Georgia, where they met the Carters and Andy took Polaroids of the former governor. He was fascinated by the men in peanut costumes advertising the Carter peanut enterprise. As a memento, Carter gave Warhol two signed bags of peanuts, which according to Andy made the whole trip worthwhile. 'Politicians always want something for nothing,' he commented, 'and so do I!'

A few weeks later he was asked by the Carter campaign staff – who were already making use of music stars like Bob Dylan and the Allman Brothers to spark up the campaign – to do an edition of 100 prints of the portrait for sale at $1,000 each to raise money for the campaign. Despite his bad luck with the McGovern campaign and the fact that the IRS were still auditing him, Andy agreed. He liked Carter's smile and made it the prominent feature in the portrait. 'Politicians have 24-hour smiles,' he told an interviewer, adding, 'so do dogs.' Vincent Fremont:

> Andy wouldn't take a political stand because he really wanted to document everything. Basically he was a Democrat, he was really for the people. He loved to go into the world of the rich and wealthy, but he also could be

accessible, walking down the street and talking to people. He wanted to be in every place and see everything and the only way to do that was to set up a very passive front in his political viewpoints.

'There were always a number of portraits to do,' Ronnie Cutrone recalled. 'That was work. But then there were other times when Andy would say, "OK, now what are we going to do for art?" '

Warhol's selection of the hammer and sickle as a subject in the autumn of 1976 was in sharp contrast to the Empress of Iran or Jimmy Carter, but Andy claimed the images had no significance. He had noticed the Communist Party symbol graffitied on walls all over Rome on a visit to Italy and he liked the look, he said.

Warhol began with real objects – a sickle and a mallet purchased at a local hardware store and photographed by Cutrone with their True Temper labels clearly visible. In the party symbol the hammer and sickle are crossed to signify solidarity of industrial and farm workers. Warhol chose to display the objects in disarray. The photographs that most emphasized the shape and shadows were converted into silkscreens and the painting process began in the back-room studio at 860 Broadway. The paintings in the series, which Andy would later title 'Still Lives', were among the largest he had done since the Maos, and he developed a new technique to accommodate them – 'mopping'. He applied sweeping strokes of paint using a sponge mop.

A second series of paintings of skulls – based on a particularly beautiful skull Warhol had bought in Europe – was also underway by the winter. The skulls, among his best work of the decade, were not shown in New York, but the de Menil's DIA foundation acquired a set of them.

The Hammer and Sickles show, Warhol's first major show in New York since the Silver Pillows in 1966, opened at Leo Castelli's big Soho space in January 1977. 'The show was cancelled in Italy,' Vincent Fremont explained, 'because the hammer and sickles represented commies and the skulls fascism. They were afraid of bombs and trouble.'

David Bourdon wrote:

Warhol's hammer and sickle works are probably calculated to titillate certain capitalists, who would rejoice at hanging such trophies in their living and board rooms. But Warhol, being a shrewd strategist, certainly considered the possibility that these works might also appeal to those who lean left. Warhol's hammer and sickle series is strong and brims with wit.

*

By the midseventies Andy had recovered from the shooting physically and psychologically as fully as he ever would. At the Factory his strength was all pervasive and inspired everybody who worked for him to try extra hard to create the atmosphere he wanted. The rooms became

increasingly glamorous. The highly polished floors shone, sunlight sparkled on the spotless windows, large bunches of beautifully arranged flowers mixed with cologne and perfume to create a pleasing, slightly aphrodisiacal odour. Slowly, as the staff that had coalesced around 1974 grew surer and more successful, a whole new style emerged.

Everyone copied some aspect of Andy. The men wore suits and ties or elegant jackets and jeans and imitated the hesitant, enthusiastic, questioning, funny way Andy talked. Everybody found themselves saying 'Uh, whu . . . whu . . . oh, really? Oh. Well, see, that's what you should do . . .' and walking with that curiously choreographed little dancer's step with one hand carefully placed at waist level jutting out to the side. Nobody would have dreamed of going to the Factory unshaven or dressed in a slovenly fashion unless they were already a big star. It was very much like a British boarding school, with Andy as the headmaster, Fred as the head prefect and Brigid as the matron.

Brigid Berlin had the longest relationship with Andy of anyone in his life outside his family. Underneath her tough dragon image Brigid was a sweetheart who adored Andy and would never have left him despite the constant subtle tortures he inflicted on her. She was also the one person he had really saved from the hell of terminal drug addiction. Brigid was able to connect with Andy on a different wavelength from most other people. With her he was neither a little boy nor a vampire, but more of a space cadet, calling her in the middle of the night and whispering, 'Wasted space, wasted space, what's in your mind, wasted space?' Brigid loved that. Andy in turn loved her attitude towards art. She would take Polaroids and then photograph them being flushed down the toilet or make ink impressions of people's scars. Andy once compared himself and Brigid to Marcel and Teeny Duchamp.

The English aristocrats whom Fred imported had a definite influence on the atmosphere of the Factory in the second half of the seventies and none more than the Irish-Norwegian offspring of the Mitford family, Catherine Guinness, who personified the upper-class English girl. She was beautiful but not in an artificial or threatening way. She could be so scornful with one or two words of disdain that one wanted to evaporate, but more often than not she could be, by example, an encouragement to live. For a while she was certainly Andy's best girl and her sense of humour and fresh view of everything in New York that was new to her kept him fresh too.

Catherine played a big role in the development of *Interview* magazine's style. She had just the right balance of haughtiness to impress Americans, refusing for example to be kept waiting on the phone and just hanging up, which people tended to be charmed by because she was English. Hence she was able to pull in a good deal of advertising. She was also the perfect foil to acompany Andy on interview assignments when Bob was busy doing something else. From 1976 to 1979

she was Andy's nightly date at every dinner, opening and show. 'Andy was incredibly generous, not only with money but with himself too,' she recalled. 'I never knew anybody else pay when we went out to dinner unless it was a client. He'd always take me and all my friends out to dinner.'

With his new-found fame, position, success, status and wealth Andy was able to move in and out of more different worlds than ever before and he made this his forte in the second half of the seventies, shuttling back and forth between them.

First there was the art world, consisting of other artists, dealers, critics and collectors, from which he still derived the majority of his income. Then there was the entertainment world, extending from Hollywood and Broadway to rock and roll. While he was never accepted by the movie industry, Andy met and, if only briefly, befriended a large number of Hollywood stars by interviewing them for cover stories in *Interview*. The only one he really liked was Jack Nicholson. Before the debacle of *Bad* forced Warhol out of the movie business he had been on the verge of buying the rights to Ruth Kligman's memoir about her affair with Pollock and filming it starring Nicholson as Jackson and his girlfriend Anjelica Houston as Ruth. Roman Polanski's vice bust in Anjelica Houston's house in 1977 and the subsequent discovery of cocaine on the premises put the kibosh on that deal.

Andy was more respected than ever in the rock world of the seventies and frequently attended rock concerts. Whenever Lou Reed played New York Warhol and a number of his guests were given the front row. Reed continued to idolize Andy and, although the relationship was not always comfortable, they stayed in touch until Lou got married in 1980 and neglected to invite Andy to his wedding, for which Warhol never forgave him. David Bowie also visited the Factory occasionally, but his sense of stardom was so great that he knew he and Warhol could never see eye to eye. The Rolling Stones remained Andy's favourite group and the ones he had most contact with, doing the cover of their 1977 *Love You Live* album, and becoming as friendly with Mick Jagger's girlfriend Jerry Hall as he had been with Bianca after the Jaggers separated. New-wave groups like Talking Heads, Blondie and later the Clash all came to the Factory to pay homage and were publicized in *Interview*.

In April 1977 a new club called Studio 54 opened and instantly transformed New York's gaudy disorganized night life. Studio 54 was the high-glitz brainchild of Steve Rubell and his business partner Ian Schraeger, typical denizens of the world Andy was endorsing. Within weeks of opening the club had become a playground of the beautiful, rich, powerful and famous to socialize beneath the man-in-the-moon neon sign which dropped from the ceiling and whiffed cocaine, in the form of little twinkling lights, up its nose. The party was fuelled by real

cocaine sniffed not so discreetly in the bathrooms, amyl nitrite poppers, and hundreds of gallons of alcohol sold at four dollars a drink to those without one of Rubell's complimentary drink tickets.

Drugs had developed organically along with the new society. Stinky marijuana and dopey Quaaludes had been traded for sharp-edged cocaine which turned imbeciles into geniuses with a single snort. Naturally this was the perfect drug for Andy's squirrels, who all needed to be in tip-top form at all times just like the a-heads of the sixties. Andy himself was never seen to take drugs, although they were thrust upon him. Catherine Guinness remembered that people would 'give him little packets. He'd sort of feel he had to accept them and throw it away, probably. He didn't say anything. He expressed an attitude by not taking it.'

Rubell personally supervised the door to keep the crowd as beautiful, rich, powerful and famous as possible, with the result that just getting into Studio 54 became the status hallmark of what was described as the 'New Society' by Warhol. He became a regular there, using the club almost as a second office to recruit volunteers for work at the Factory and entertain potential portrait and *Interview* 'victims' like Liza Minnelli and Truman Capote, whose portraits he painted that year.

Andy was fascinated by the fact that Studio 54 was more than a watering hole for the rich and famous, it was a place where people danced, drank, made friends, made love, broke up, did their business, and even slept. The club's equalizing effect was in many ways similar to that of the Factory. 'The key to the success of Studio 54,' wrote Warhol, 'is that it's a dictatorship at the door and a democracy on the floor. It's hard to get in but once you're in you could end up dancing with Liza Minnelli . . . At 54, the stars are nobody because everybody is a star.'

It was also a place to observe what Andy called the 'social disease' of celebrity in the 1970s, characterized as he saw it by an obsessive need to go out, a preference for exhilaration over conversation unless the subject was gossip, and judging a party by how many celebrities were there. He called it 'the bubonic plague of our times'.

Detached, aloof, watching the crowd which on any particular night might include Mick, Bianca, Halston, Truman, Diana or Liz, he tape-recorded his conversations and took photographs. The fact that he rarely drank and was never out of control enabled Warhol to take advantage of the many intoxicated people he met who would pour out their deepest secrets.

What was Andy most interested in hearing? According to Cutrone, who was among the most active partygoers of the decade, he liked women who would tell him all about their sex lives. A typical example of a Warhol tape was the night Elizabeth Taylor discussed her love life in graphic detail. You couldn't entertain Andy much better than that.

As soon as she heard he had died, Taylor was on the phone to Hughes making sure that the tape never saw the light of day. Since almost everything on this kind of recording was libellous there was absolutely nothing Andy could do with them, but he stored away his daily tapes with the care of a true archivist.

Studio 54 and its cult of personality contributed to the success of *Interview*, by defining its audience and by celebrating the same lifestyle. It seemed, at times, that the thousands of pretty blank faces and pages of empty chatter that filled *Interview* in all their glamorous mindlessness supported the contention of René Richard, in a poem printed in an advertisement for a book in one issue, that 'the rich are the worst and the very rich are the very worst'. Colacello provocatively began noting, apropos of social events, 'only Mussolini was missing'. Even so, advertisements for perfumes, designer clothes, discos and restaurants poured into the office. Advertising rates began climbing to $1,000 for a full black and white page and $1,600 for colour.

By 1978 the magazine was breaking even and showing so much promise that Warhol would buy out the remaining 25 per cent of the shares of *Interview*. 'Andy's business grew in a very cautious, relatively slow manner,' said Vincent Fremont. 'He didn't overextend immediately and then all of a sudden have debts. Andy didn't like to have a lot of debts.'

*

Like so many of Warhol's films, *Bad* was ahead of its time. The story by Pat Hackett about a gang of sexy hoodlum girls who would do anything for the right price portrayed everything about heterosexual family life as horrible, and pictured a world in which men were totally ineffectual and women ran the entire show. Pat Hackett, Warhol's only scenarist since Tavel, displayed a terrific talent for writing sharp, real dialogue, and the film was well made. If it had been released at the height of the punk-rock craze in America two years later it might well have taken off, but in the disco haze of 1977, when everything seemed just fine, *Bad* flopped. It was released in April, the same month Studio 54 opened, and ran for only three weeks in New York before it was clear that, despite Carroll Baker's star performance, the movie was going to fail.

Once again a bad distribution deal was the final nail in the film's coffin. Vincent Fremont:

New World Pictures picked it up in the States. Fred and I wrote them a letter saying, 'Please cut the one scene where the baby's thrown out the window, it's too graphic, it breaks the black humour.' They didn't cut it out, so the only place you can advertise the film is on the porn page. They spent no money on promotion. It was a disaster. The movie got trashed.

In the months that followed, Fred Hughes and Vincent Fremont were

able to make up some of the losses from European rentals. Vincent Fremont:

> It was show business. It was so difficult to get a film made. There were so many people out to try and stab you in the back. Italy stiffed us for their second payment. They said, 'You want the last payment, you come and get it.' And you try to go through the Italian courts. By this time *Bad* was giving us grief on all fronts.

It would be several years before all the investors were paid back. With unintended irony, Andy described the film to one reporter as a 'serious comedy'. Vincent Fremont:

> Andy never made another movie. That was it. He lost a lot of money. It caused problems with our friends Peter and Joe, they lost money. It hurt a lot. Andy probably lost about $400,000. It was hard on Fred, it was hard on me, it was hard on Andy. It was the first time he ever lost out of pocket money and the last time. We had a lot of bills and to pay that money off at that time was a lot of stress, though it didn't shut us down or anything. Andy was still fascinated with movies, still loved Hollywood, still loved the whole thing, it's just that he personally would not put another nickel into movies after that.
> *Bad* was confiscated in Germany, the first film to be confiscated in years: physically taken out of the theatres because of excessive violence – the scene where the baby is thrown out of the window and the finger that was cut by a Volkswagen. It was banned in Germany and it was a criminal case. So we said, Andy's not going to Germany for a couple of months till we figure out if it's OK. Later we cut out certain sections and it was shown but we had lost all momentum.

The *Bad* disaster marked the beginning of the slow, stressful end of Andy's relationship with Jed Johnson, who took the film's failure personally. He retreated into the 66th Street house, collecting new pieces and decorating rooms. He had developed something of a reputation as an interior designer among others close to Warhol, and he was soon also at work decorating an apartment which Pierre Bergé had just bought for himself and Yves St Laurent in the Pierre Hotel.

Jed's divided loyalties would eventually contribute to the rift with Andy. Jed Johnson:

> It was always difficult because he didn't know what he wanted from other people. He wanted you to be successful but, on the other hand, he wanted you to be dependent. Success would have meant independence, so there were always contradictions. He was hard to please.

Catherine Guinness witnessed the gradual breakup.

> They'd been getting on very badly for a long time before. Andy'd say, 'Jed's

coming with us tonight' or 'Jed's complaining that I never go out with him so I've got to go out with him.' But in fact Jed hated going out with Andy because of being in his shade, his little puppet. And Andy could be very nasty, and people who are nasty are nastiest to their lovers. He was probably vile to Jed.

There were no recriminations from Andy about the film, but Jed noticed that Andy was different:

When Studio 54 opened things changed with Andy. That was New York when it was at the height of its most decadent period, and I didn't take part. I never liked that scene, I was never comfortable. I was always really shy and really had a hard time socially anyway, and I didn't like the people. Andy was just wasting his time, and it was really upsetting. I'd try to get something going and he just wasn't supportive of it. He just spent his time with the most ridiculous people. So things changed.

DANCING UNDER

FIRE

1977–78

Rape is high across the country. Prostitution. Homosexuality
– they marchin'. You shocked to see so many of them, the
gay people of all kind you got . . . everything just goin' wild.
There's no moral upliftrnent.

MUHAMMAD ALI

On 24 May Andy flew to Paris with Fred, Bob and Warhol's Girl of the
Year, Barbara Allen, for the publication of the *Philosophie* and the
opening of his hammer-and-sickle paintings. The summer of 1977 was
the peak of the punk-rock craze in Europe. The French had fallen head
over heels in love with the torn T-shirts, skunk hair and safety-pin
jewellery of the skinny young boys in the Sex Pistols. Although Warhol
was heavily criticized in America for amoral support of right-wing
dictatorships, greed and snobbery, to the French he was the inventor
of punk. Now here was the prophet putting out his negative *Philosophie*
and showing what they saw as communist paintings. The French punks
couldn't get enough of Andy Warhol. Within hours of his arrival they
mobbed his book signing, proffering breasts and cocks for Andy to
sign.

The French critics gave Warhol's *Philosophie* their usual thoughtful
if bombastic attention. 'The Warhol oeuvre,' one of them observed,
'transforms itself into destiny. The Warhol personage transforms itself
into the Warhol oeuvre, he commands it, he dominates it, and he is
the parameter of reference.'

The following day Andy went to Brussels with Paloma Picasso to
attend a Warhol opening at Gallerie D, which was also attended by
hundreds of punk photographers. Back in Paris on Saturday he had
dinner al fresco at Monsieur Boeuf's with Barbara Allen, Philip Niarchos
and Bianca Jagger. They were just commenting on how nice it was to
dine outside when 'a punk off the street came up to our table and
screamed at us that she was a necrophiliac fresh out of a mental insti-
tution and madly in love with AW!' recorded Bob Colacello. 'She was
a very real punk and the very real police had to come and take her
away.'

407

Despite Andy's attempts to stay in high society, whether attending tennis matches with Bianca or dining with Princess Firyal of Jordan at Maxim's, the punks continued to claim him for their own. On 31 May the Hammer and Sickle opening drew 300 of them. 'Some punks wrote HATE and WAR on the walls in sorbet. Some punks vomited white wine,' Colacello wrote in his diary. 'One punk knocked another punk's tooth out. One punk peed. Sao Schlumberger said, "I think I better get going to my dinner at Versailles," clutching her purse, as she tried to run past the swine.'

'It's just fashion,' Andy told Bianca. 'I don't understand it. It's not big in New York at all.'

Andy was more interested in visiting the perfume shops. 'Andy was wild about perfume,' recalled one observer,

and he would wind up in these Paris perfumeries two or three times during every visit because they looked like spreads in a 1940s *Vogue* magazine. His interest was as much in the bottles and the way they wrapped the boxes as in the scent itself. His favourite perfumes were Chanel No. 5, all the Guerlain scents (because they came in Lalique crystal) and mixtures of essence that he'd either have concocted professionally or mix himself.

Back in New York Andy was fast being seen by his enemies once again as a corrupter of youth while the young people flocked around him hopefully. Many young, wealthy Europeans gravitated to the city, escaping communism and taxes and looking for excitement. New York had not rocked as hard as it did in 1977–80 since the peak of the sixties when Warhol ran the Dom. It had become the cultural capital of the world.

Andy had been in the vanguard of all this, and once again he was the most controversial artist in America. 'He was attacked every time he walked out the door,' recalled Vincent Fremont, 'but that kept him fresh.' Some felt like the critic Gary Indiana: 'Andy Warhol became a much less convincing work of art after the demimonde clasped him to its jewelled bosom.' Others like the photographer Peter Hujar: 'Andy influenced everybody. He changed everything whether people know he changed them or not. He was a fine tuning fork. It's hard to see the beauty in our time. It was a very spiritual thing he was doing, letting it happen.'

'What do you want?' Ivan Karp asked Warhol. 'You've got everything: you have crowds, hordes, young people, beautiful people, charming people, rich people, lovely people. Nobody seems to touch you. What do you want?'

'I want more fame,' Andy said.

Disco was punk's hated twin. Andy was more associated with the disco crowd who spun around Studio 54. It too called for excess of

every kind but behind a wall of suave insouciance. At discos people danced in suits and ties, sprawled on couches and drank champagne. The music was completely different but punk and disco were really the same thing: a means to release, sex and boundary-breaking expeditions in and out of body and mind, space and time. Both were fuelled by drugs. Serious partygoers were soon 'on the dawn patrol' all over town. A party had begun in New York that was going to last for several years and find no more ecstatic a cheerleader than Andy Warhol and no better a score sheet or guidebook than *Interview*. On its pages appeared the faces of the famous-for-fifteen-minutes generation.

It was getting increasingly difficult for Bob and Fred to support Andy's strange habit of offering everyone he liked gifts of art or the cover of *Interview*, then telling them to talk to Fred or Bob, who would have to deny the request, making themselves look mean when Andy had never intended to fulfil his offer from the outset. However, 1978 was a great growth year for *Interview* and Colacello was at the height of his game. According to Daniella Morera:

Bob was a little bit taking advantage of his power. He wanted to overpower with his persona, he wanted to play the boss, which many people working there every day didn't like at all. He was there with his sister, he planted a Colacello kingdom. These people at the Factory were really very into money. All the greediness was blamed on Andy, but it came just as much from Bob and Fred. Bob was taking the commissions that I was supposed to get for portraits and the advertisements in *Interview*.

Not one to ignore new cultural trends, shortly after returning from Paris Warhol began managing his own punk-rock act – Walter Steding, an electric violinist who performed in a 'bug suit' rigged with blinking lights and electronic gadgetry that modulated his music with his own alpha waves into a bizarre barrage of squawks and squeaks. Like Ronnie Cutrone, with whom he was sharing an apartment, Steding also worked as a painting assistant to Warhol. 'Right away he was saying, "You can take over Ronnie's job 'cos he's on his way out," ' Steding recalled.

They were always arguing, but at the same time he never did anything. He had all these problems with Ronnie, but he would never speak to Ronnie about them, he would come to me. As much as he didn't like what was happening, he was able to understand because he was going through the same thing with Jed. He couldn't condemn anything because, he said, 'Well, we all have our problems.'

Steding sometimes received the brunt of Andy's temper – 'He yelled,' Steding recalled, 'but he yelled like a mouse' – but mostly his encouragement, generally in the form of nagging questions about how many

songs Walter had written, what he was doing, and why wasn't he working?

When Steding began playing at the New York punk club CBGB's, Andy, after hearing him perform, would typically comment that it was good but not good enough.

Andy was supportive and enthusiastic enough to put out a record by Steding on his own Earhol label. As usual, Andy had picked a talented misfit. Whereas Laurie Anderson, doing a similar act, would go on to be an international success by dint of hard work and determination, Steding sank, despite the social advantage being managed by Warhol gave him.

Warhol was never more open to the conventional and unconventional aspects of American culture than he was in the second half of the 1970s when he was as strongly involved in the left as the right, uptown as downtown, the straight as the twisted. Jamie Wyeth was back at the Factory, where Andy had offered him a space to work on his portrait of Arnold Schwarzenegger. Andy loved having the body-builder-cum-movie-actor sitting around the Factory with his shirt off flexing his muscles, which impressed and startled visitors, and was equally turned on by Wyeth's daily industry, but after a while the presence of another artist working independently became an irritant.

Throughout the years, much as Andy might gush about how great everybody around him was, it was always noted that there was really only one star at the Factory. That was, after all, the point of the whole setup. Everybody was there to cater to some aspect of Andy's needs, they were there *for* him. Anybody who wasn't soon found themselves running into blank, dismissive behaviour that was bound to make them feel extremely uncomfortable, a sort of psychic dismissal as powerful as anything the disciples of the sixties had served up.

Andy was never able to maintain a relationship with anybody who was his equal. The stars who parade in his memoirs were never around very long unless they were having a nervous breakdown, in which case they would find Andy a constant attendant. Since Wyeth was the model of a balanced and successful person, his relationship with Warhol shortly came to an abrupt end. Catherine Guinness:

> It was not perhaps that anything went wrong; I think it was like people who are in a play together, you get very close and you swear eternal friendship and then you diverge. Jamie Wyeth was probably fascinated by Andy and everything and so poured all his energies into Andy, and then once he was doing something else his energy just went elsewhere.

With the election of Jimmy Carter in 1976, cordial relations with the White House had been restored and on 14 June 1977, Warhol was invited to a special reception honouring 'the Inaugural Artists' – Jacob

Lawrence, Robert Rauschenberg, Roy Lichtenstein, Jamie Wyeth, and Warhol – who had contributed prints to the Carter campaign. Wyeth brought along Arnold Schwarzenegger; Andy brought Bob Colacello.

'My favourite thing to do at the White House is look at the furniture,' Warhol commented. 'I think it's just great to go to the White House, no matter who the president is.'

Andy latched on to the whole nutty Carter family, becoming particularly friendly with the president's mother, Miss Lillian, who together with Andy and the actress Lucie Arnaz made up a trio of lost celebrities one night at Studio 54 during a promotion party for India, where Lillian Carter had been stationed as a Peace Corps volunteer. The other celebrities had cancelled along with the guest of honour, the Maharani of Jaipur.

Later Miss Lillian told Andy that she hadn't known 'if I was in heaven or hell, but I enjoyed it'. She couldn't understand why all the boys danced together with so many pretty girls around. Later that year Andy painted her portrait.

Bob Colacello was continuing to court the Pahlavi regime. Empress Farah was in New York in July to be honoured at a luncheon given by a group calling itself the Appeal to Conscience Foundation. Warhol and Colacello were there, of course, and shook hands with the Empress, 'who impressed me a lot,' reported Bob. 'Shaking her hand was a lot more thrilling than shaking President Carter's hand.'

David Bourdon spoke for many people when he said:

I disapproved of Andy's involvement with the Shah and the Marcoses and I didn't like Bob Colacello. I thought Bob was one of the most reactionary right-wing people, and I really resented the way he manipulated Andy into those situations where might and money was right, so I just plain dropped out, as a lot of people did.

To recoup some of the losses on *Bad*, Fred Hughes concocted a series of business art projects, beginning with the 'Athletes' series that summer in partnership with Richard Wiseman, a businessman and sports enthusiast. Ten famous athletes – Kareem Abdul Jabar, Muhammad Ali, Chris Evert, Dorothy Hamill, Jack Nicklaus, Pele, Tom Seaver, Willi Shoemaker and O. J. Simpson – agreed to pose for Warhol's Polaroid Big Shot. In exchange, they were to receive one of the six canvases Andy would paint of each of them and a payment of $15,000 once all the paintings had been sold. A print series was also planned, turning the 'Athletes' into a million-dollar project. 'Publishing prints was a way of bringing home the bacon,' Fremont commented. 'He had to pay some bills. He had to get out there and work.'

'He loved it because athletes are very glamorous, particularly the

411

ones he painted,' said Catherine Guinness, 'so it was very exciting, much nicer than painting Bob's rich old ladies.'

Warhol's most entertaining assignment was Muhammad Ali, who was photographed in August 1977 at Fighter's Heaven, Ali's training camp in rural Pennsylvania. Ali found it remarkable that anyone would pay $25,000 for a picture unless it was 'real fancy', then launched into a series of Alilogues, capped off with a forty-minute lecture, delivered from notecards, about rape, prostitution, gravity, meteorites, Israel, Egypt, South Africa, angel-food cake, Muslim morality, Jesus, boxing, the Koran and Elvis.

Women with their legs wide open, two men screwing each other right on a magazine stand! You can walk down the street and duck in a movie and watch them screwing. Little children sixteen years old go in, can watch them screwing and he's too young to get his own sex so he gotta rape somebody, he gotta watch the movies. You go to New York City and see everything in the movies, every act, oral sex, you sit there and watch it. And the magazine stands are so filthy you can't even walk by with your children. Right? Walk down the street and look at it – you got children! Women are screwing women! No faith. Man has lost faith in man.

Warhol later commented that he had had no idea what Ali had been talking about.

I don't know why he picked up on that all of a sudden. I mean, how can he preach like that? It's so crazy. I think he's a male chauvinist pig, right? But he was the perfect talker, because I didn't get one word in. The whole time I was there Muhammad was just talking. I think he was torturing us.

In the end, the amount of money involved was the most interesting aspect of the 'Athletes' project.

*

Although Andy's work may not have been as titillating or on target as it had been in the sixties, the atmosphere around him at the Factory was as potent as ever. When he arrived for the day's work around noon the reception room resembled the waiting room of a court. Standing strategically singly or in clusters would be various people waiting for his attention. Seeming to be completely casual but acutely aware of everybody's needs and each minute as it ticked by, Warhol would move from group to group murmuring a few words of assent, giving each person the fuel to continue what they were doing with a small smile or whispered comment, just as he had previously directed his films. As if injected by a powerful stimulant, each petitioner would move off towards his assignment, trying to adopt Andy's casual manner but as often as not falling all over themselves in an attempt to outdo each other.

Soon a steady stream of visitors would arrive. Unaware of the carefully timed and often conflicting appointments Warhol had made with each of them, they would one by one be escorted to their stations. If it was a rich lady coming to lunch, Colacello would slide out of the *Interview* offices extending a plump hand, and the victim would be wrapped in an aroma of laughter and compliments as she was escorted to the dining room. If it was an art dealer or a museum curator come to discuss a Warhol exhibition in some far-off country or maybe even in America, Fred Hughes would bounce out from his space immaculately tailored, his hair pasted to his head like some 1930s gigolo, his hand extended elegantly, always ready with some stage British phrase about a mutual acquaintance that would set the air buzzing with the big-time international grandeur of the Pahlavis or the Jaggers. Meanwhile a new rock star like Debbie Harry, bursting with excitement about her first visit to the Factory and dressed to the nines to have her picture taken with Warhol for publicity purposes, would be glad-handed by some lower minion, Christopher Makos or Vincent Fremont, and quickly led into the kitchen where lights were already set up. As soon as she was ready for the shoot Andy would appear as if from nowhere and murmur a few words about how great she looked. As soon as the flash bulbs had popped, he disappeared again in a flurry of aides, limp handshakes and half-completed sentences, and Debbie would be escorted out the door before a rival rock star arrived for a similar purpose.

Throughout this rapidly coalescing collage of arrivals and departures Warhol would be discussing the day's work with his painting assistants, signing cheques for Fremont to disperse, taking ten or twenty phone calls, checking on the evening's schedule with his receptionist, joking with his court jesters, and drifting in and out of the dining room where Bob and Fred would now have their victims pinned down.

There was never a lull in the activity. The phone rang constantly. Sitting in a row at the main desk in the reception room one assistant would spend all his time answering them, singing out names like 'Caroline Kennedy on 3' or 'David Whitney on 1', while two others would incessantly be typing up Warhol's tape-recorded interviews of the previous week's dinners.

As soon as lunch was over and the day's guests, who had by now had a brief opportunity of seeing Warhol as he poured them a glass of wine or sat down for five minutes, had been escorted out, an enormous commotion would take place around the bulletproof door as the day's subject would enter with his or her entourage. If it was somebody who seemed completely out of place at the headquarters of chic, like the baseball player Tom Seaver carrying a bundle of bats and some mitts or the soccer player Pele grinning his broad smile, it would be a particularly festive occasion, but none the less well oiled and smooth as Warhol would once again glide out from his back room murmuring a delighted

413

hello and instantly get to work, snapping off up to 100 Polaroids in less than forty-five minutes.

During the session he might continue to take phone calls if they were from someone famous or important but could be surprisingly curt to somebody he wanted to get rid of. For example, he might listen to Jamie Wyeth for a minute before saying urgently, 'I'm very busy now, I'm photographing Tom Seaver. Yeah. Goodbye,' and hang up, leaving his caller stunned and emptied, and pirouette back to his subject.

If it was somebody like King Gustaf of Sweden the Factory would have been sealed off by FBI agents an hour before he arrived and the atmosphere would be completely different: serious, formal and riding on a sea of subservience and propriety, although regardless of who it was Warhol would always keep them waiting just a little bit, hunkered down in his garbage dump in the back meticulously counting 1000 sheets of paper or just joking with Cutrone or Steding.

The balance of the day would be spent on concentrated painting – as fast as possible. Warhol turned out an enormous amount of product during this period, more than anybody is aware. Apart from the portraits, many of which were never seen after they left the Factory, he was doing commissions for several shows in different countries as well as a good deal of his own work, which was rarely shown these days until several years later when it might make a surprise appearance at some museum in Italy or department store in Japan.

While painting he would never stop taking phone calls or talking with Bob, Fred, Vincent and other members of his inner circle about deals, parties, bank accounts, travel plans, and gossip. A tireless worker who had schooled himself in drive and pacing since he was a teenager, like some great performer Warhol gained rather than lost energy during the day, managing to fuel himself with the adoration of his collaborators and the inspiration of the work itself as well as the numerous offers and money that flowed into the Factory.

Although he usually left the Factory around 7 p.m., his workday was only half over. After a quick pit stop to swallow a carefully prepared plate of turkey and mashed potatoes, or whatever his meal of the month was, he would turn around, change into the evening's outfit, laid out by Nena and Aurora, who were as important to his daily maintenance as his mainstays at the Factory, and take the small elevator down from his third-floor bedroom to the foyer where the evening's escort, usually Bob Colacello, would be waiting to take him to the first event of the evening, a cocktail party, art opening or reception of some kind. On the way they might pick up a second escort like Catherine Guinness before meeting more of his attendants at their other stops.

Every step on the evening's agenda was planned to maximize profit. Warhol rarely went anywhere just for fun, there was usually an angle to be explored. If it wasn't to meet portrait or advertising victims it was

to meet somebody with some other kind of deal, do a cover of a record, endorse a product, or simply to be seen with the right people at the right time so his picture would appear in the right paper. After dinner at the apartment of some wealthy and powerful person or in a restaurant with friends and prospective clients, Warhol would invariably go to a night club like Studio 54. And the night would not always end there. With unlimited enthusiasm and energy he might well be persuaded to return to somebody's apartment or hotel suite – never alone, mind you – to carry on the festivities in a more private setting, or go to an after-hours club from which he might emerge at 6 a.m., hurrying home like Dracula to jump into bed just as the sun rose.

As soon as he got up he would go shopping. Unbeknown to most of his friends, Andy's collecting had turned into an obsessive daily search for a five-dollar item that would turn out to be worth a million. One day that year, walking up Madison Avenue, he saw the name of his first assistant, Vito Giallo, above an antique shop, walked in and said, 'Oh, Vito, wow, you must be on easy street.' Thus began another collaboration. Vito Giallo:

For Andy, starting a new day meant buying something. He would come in on most mornings around 11 o'clock all through the next ten years and stay in the shop for about an hour. He was interested in everything and I was just floored by the amount of things that he bought and the diversity of his interests. Andy's mania for collecting was an extension of his painting. He would buy rows and rows of mercury-glass vases, copper lustre pitchers, Victorian card cases. One couldn't help being reminded of his paintings of multiple images. He bought thousands of rare books twenty or thirty at a time, dozens of eighteenth- and nineteenth-century Spanish Colonial cruci-fixes and santos three or four at a time, and sixty boxes of semiprecious stones, all in one gulp. He was very canny once you got past the 'Oh, this is fabulous' routine, but he always had to appear as though he were an imbecile because that would give him the edge.

I didn't think he had changed much since the fifties. There was nothing unpredictable about him. Except once, the only time I ever saw him be harsh with anyone. One day he was in the shop and a friend of his who was obviously on drugs rushed into the shop and said, 'Oh, Andy, Andy,' and he turned to the person and said in a very stern voice, 'I want you to get out of this shop immediately and if you don't I'll never talk to you again,' and the poor guy just ran out of the shop.

If he didn't come to the shop he would call and we would talk at length about auctions and galleries. Auctions had a fascination for Andy, but what was more fascinating for him was not being there to bid. We would compare notes before a sale and I would do the bidding for both of us. Then when the lots arrived at my shop Andy would rush up, buy what he wanted, and then rush back home with his purchases only to put them in a closet.

According to Fred Hughes, Warhol spent at least a million dollars every year in this way.

> Andy loved auctions. He wasn't an academic. He didn't read art books. What he liked about auctions was that you saw things without pretensions. You saw bad things as well as good. You saw things at their best and their worst. You saw things without their frames or upside down.

Another friend recalled that Warhol found 'a lot of absurdity in the auction rooms. He loved the absurdity of the art world just as he loved the absurdity of life in general.'

That fall Andy's folk-art collection was put on display at the Museum of American Folk Art in September, with Sandra Brant as guest curator. In the catalogue, David Bourdon said,

> It seems odd that such a relentlessly 'now' personality, who never talks about his own past, and can seldom remember what he did yesterday, should have such a keen appreciation for nostalgic artifacts, but that is only one of the many inconsistencies in his character.

Asked what he would collect in the future, Andy replied, 'Buildings are great . . . I think that's a really great thing to collect . . . just the façade. Uh, it's too much trouble inside . . . Gee, to be able to own the Empire State Building.'

He also did a lot of strong personal painting that year but hardly any of it was shown in the United States, leaving Americans with the impression that his career was stranded somewhere between Studio 54 and the bank. In October Warhol flew to Paris on the Concorde, and from there to Geneva for the opening of his American Indian Painting – a portrait of Russell Means, the leader of the recent Indian uprising at Wounded Knee.

'Andy always used to tell us when he was going abroad, specially if he was going to fly that Concorde,' Marge Warhola remembered. 'He was afraid to fly. John would say, "Well, don't worry, I'll light a candle." He always lit a candle for Andy while he was away.'

Andy seemed to Cutrone and Steding increasingly bored with the majority of the rich people whose portraits he had to paint in order to, as he always put it, bring home the bacon. By this time Andy had pretty much accepted the fact that whatever he wanted to do, the only thing he could count on to bring in the money he needed to support his expanding enterprises was going to come from the art business. 'Bob was always introducing him to minor rich people who had their portraits done,' Catherine Guinness recalled. 'There was a lot of going out to dinner with Bob with all those sort of rich, rather boring people.' Steding recalled several occasions on which he would go to tell Andy that a client had arrived to be Polaroided only to find Warhol meticu-

lously counting his garbage bags and refusing to be disturbed. Sitting with him for a while Steding would be amused by Andy's sharp sense of humour, which could often be hilariously cutting. Ronnie Cutrone:

He'd crunch up his face and go, 'Oooohhhh, nooo, she's going to make me cut her double chin off . . .' On the outside he was, like, oh, great, great, everything's great. But alone he would criticize art, he would criticize people, he would criticize night clubs and places, he had very definite opinions that he would publicly hide.

Walter Steding, who came from Pittsburgh and resembled Andy more than a little in both appearance and demeanour, was constantly surprised by his boss's attitude.

The thing that Andy used to like to do on Union Square was read the newspaper right in front of the window so that anybody walking down the street could look up and see Andy Warhol. When you walked into the Factory the first thing you would see was there he is, right there in front of you. He was always willing to talk to the messenger just as much as the Shah of Iran, in fact more so. The industrialists would come by and I'd say, 'Well, you really like those people, don't you?' thinking that he would be able to just talk with them, and he'd say, 'I *hate* them.' That threw me because I thought he would enjoy it, but I guess he'd had so much of it that actually it was a job to come out and say hello to these people and be nice to them. He'd say, 'Well, do you think I should go out yet? Is it time yet?'

Warhol would finally drift into the big reception room, making his entrance like a model on a runway, flanked by two or three assistants, and blow the client away with his balletic photo session. Leaving the Factory an hour or so later Mrs Düsseldorf or Mr Seattle would feel as if the Warhol aura had rubbed off on them. For days afterwards their conversations would be full of 'As Andy said to me . . .' Warhol now had this effect on almost everybody he met.

Andy gave expression to his boredom that summer, fall and winter in a series of rebellious works and gestures: the piss paintings, the torsos and the sex parts.

Jed was rarely seen with Andy in public now, and at home their relationship had grown silent and stiff; in the great empty house, they avoided each other. In Jed's place that fall was Victor Hugo, who designed Halston's shop windows and shared his townhouse, and who was on loan to cheer Andy up that season. With his irrepressible, cocaine-fuelled energy, Victor Hugo, like Ondine ten years earlier, had a gift for live theatre, especially for entrances. It was like Victor to arrive by seaplane at a Montauk dinner party in a sequined jockstrap, or to show up at Studio 54 in an ambulance, jump off a stretcher and begin to dance. He was also a voluble talker in a thick Venezuelan accent which most people – including Andy – found almost incomprehensible.

Victor Hugo's main role was as the court painter's jester. In the manner of all royal fools, he mocked Andy, calling him 'the Queen of the Shallow'. But he was impressed by Andy's attitude towards life and particularly stuck by his admonition 'There is no why' whenever Victor asked Andy why somebody had done something. He was never Andy's lover, though he was both procurer and model for his 'Torso' and 'Sex Parts' paintings, a series of explicit, verging on the pornographic, canvases depicting male backs, buttocks, penises and thighs, which Warhol began in the autumn of 1977 and continued to work on for nearly a year. Ultra Violet:

> Andy was fascinated by the naked body. He had an extensive collection of photographs of naked people. He delighted in the fact that every organ of the body varies in shape, form and colour from one individual to the next. Just as one torso or one face tells a different story from another, so to Andy one penis or one ass told a different story from another.

Although not gay himself, Steding often assisted Andy in his voyeuristic works.

> Someone came by saying they had a really big dick. Andy said 'Well, let's take a picture of it,' and then the pictures came to me as the person who had to put them somewhere. I wrote on the box 'Sex Parts'. Then Andy did a whole series of prints called 'Sex Parts' because he saw it written on the box. He would take pictures over a period of a couple of hours of two men screwing. He had a 35-mm as well as a Polaroid. I was just sort of there. I found it difficult. What am I supposed to do? I realized my position was to be there but at the same time, you know, I was looking around at the walls. But I don't think these situations turned him on. In order for Andy to have sex it had to be totally separated from his art, because with art he was only allowed to be a spectator, and with all those other activities he could only be the documenter. The people that he was attracted to definitely weren't faggots, but a sensitive quiet individual who was doing something totally removed from whatever Andy was doing.

Victor Hugo became Warhol's sexual anthropologist, pulling in the young men whom Andy photographed giving blow jobs and fucking each other for his 'Sex Parts' paintings, which were never shown. According to Victor, 'Andy was jerkin' off in the bathroom in between taking the pictures.' Rupert Smith:

> He was just so scared of physical contact. There were nights in Studio 54 when these humpy well-built numbers jumped all over Andy, like 'I'll do anything for you . . . possibly' and he just wouldn't know what to do; he'd just get freaked out. So this was his way. Victor Hugo would pick up some hot number in a bar or on the street, and Andy, the voyeur, would click click click away and see how big his cock was and how far he could spread his ass . . .

Hundreds of photographs were taken over the following months, from which Warhol selected several of the least openly sexual shots of Victor Hugo and his friend Ken Harrison for the 'Torso' silkscreens; six of the more explicit photos became the 'Sex Parts' series the following year.

Victor Hugo fawned over Andy's creations, while at the same time joking with Halston that Andy 'need to get off'. For Ronnie Cutrone, 'it was just another approach to the academic problem of the nude . . . only with a little more flair to it'.

The 'Oxidation' series was also started during the same period of bizarre activity that summer and fall, when Victor, Ronnie, Walter and Andy revived a 1961 idea of Warhol's and took turns urinating on canvases coated with wet copper paint, which would oxidize and turn orange and green where the spatters hit it. 'Andy was taking a lot of B vitamins,' Vincent Fremont recalled, 'and during that whole period the back room stank of piss.'

The 'Piss Paintings', as they were originally called, were surprisingly well received when they were displayed in Europe the following year. One critic hailed them as 'Warhol at his purest', drawing historical references to Jackson Pollock's legendary emission into Peggy Guggenheim's fireplace. Another commented that 'anyone who thinks Andy Warhol's society portraits of the seventies verge on piss-elegance will find something more literal in the so-called piss paintings'.

Unfortunately the 'Oxidation' paintings retained the lingering odour of their main ingredient.

*

Christmas was a special time for Andy. Making up in abundance for the poverty of his early childhood, he would spend weeks Christmas shopping for his vast number of friends, often up to half the day every day during the last couple of weeks, and arrive at the Factory laden down with treasures. He actively took part in all the surrounding festivities, attending Christmas parties, even on several occasions posing as Santa Claus for the cover of magazines, drinking champagne and enjoying all the trappings of the holiday.

All this *joie de vivre* climaxed with the yearly Factory Christmas party at which all his friends would gather and even the lowliest member of staff would receive a gift. At times he was surprisingly generous, giving everyone a print worth at least $1,000. In the early days of *Interview* he gave everyone tape recorders or Polaroid cameras. At the very least they received a bottle of champagne.

Of course, for Andy there was always a conflict inherent in all this celebration. Andy actually hated holidays because, having cut himself off from his family for all practical purposes, he keenly felt the solitude of a time at which the majority of people tend to visit their closest relatives. All his life Andy tried to construct some kind of surrogate

family around him to stave off the isolation he felt at the core of his soul. After his mother died he adopted the Johnson twins, Jed and Jay, and their pretty little sister Susan, inviting Jay and Susan over for every holiday dinner, but this did not pan out when Jay's drug and alcohol problems and Susan's overindulgence ruined the evenings. According to Catherine Guinness, 'Jay was one of those people who get aggressive and horrible when they're drunk. He was just nasty, verbally abusive and rude.'

The party season that began just before Christmas 1977 did not end as usual with the New Year. Instead with 'Studio Rubell', as Bob Colacello had started calling it, reaching the height of its fame as the epicentre, nights in New York were turning into a continuous party which would rock on well into the next year. By March Colacello and the other revellers were beginning to experience a backlash of 'Saturday Night Fever' caused by overindulgence in alcohol and drugs. At the Factory, only Andy and the abstemious bookkeeper Vincent Fremont seemed immune. Colacello duly reported his blackouts in *Interview*:

WEDNESDAY, MARCH 15: Pope (Warhol) and I passed by the House of HALSTON to pick up HIS HIGHNESS, QUEEN BEE BIANCA and DR GILLER. Limoed across town to STUDIO RUBELL. Danced with COUNT CAPOTE . . . PETER BEARD arrived around 3 a.m. I don't remember what happened after that, but a lot did.

'Diana, it gets more like pagan Rome every night,' Bob screamed into his partner's ear at Studio 54.

'I should hope so, Bob!' 'Empress' Vreeland replied.

'When it's really fun here,' Andy said, 'you expect someone to be murdered.'

A Warhol-Capote-hosted party for the Oscars was held at Studio Rubell on 3 April 1978. Despite the fact that half the invitations were not delivered and that Andy missed a plane to New York from Houston, the night was one of the social events of the year. Also in April 1978, the first anniversary of Studio 54 saw a giant cyclone-fenced cage in the basement to enclose the guests of honour. Halston's birthday party for Bianca Jagger featured an elaborate charade of a naked black man leading a naked black girl on a white pony through a curtain of gold streamers. Elizabeth Taylor's birthday cake was baked in her image and wheeled out by the Rockettes dancing in choreographed precision.

Although Andy was popularly associated with Studio 54 and the Capote-Halston-Bianca-Diana set Colacello touted in *Interview*, Warhol was active in a much broader social world than the disco scene. The Mudd Club, which opened in 1978, played just as important a role as Studio 54 in shaping Manhattan's lifestyles in the late seventies and early eighties. The Mudd, which was the brainchild of Steve Mass, promoted the punk life and instantly became the headquarters of the

downtown set and the mating ground for a whole generation who had been inspired by Warhol's Silver Factory and the music of the Velvet Underground. Although Warhol may not have been as intimate with these people as he was with the uptown fashion crowd, he often visited, particularly for surreal parties like the Rock Stars' Funeral, and was always welcomed at the Mudd, where many of his workers, like Ronnie Cutrone, Walter Steding and Glenn O'Brien, who was writing the rock column for *Interview*, could regularly be found.

Warhol, who announced that he would go to the opening of anything including a toilet seat, made great use of his night-time excursions not only to meet people, make business connections, and keep an eye on new talent and trends, but also to advertise himself, to keep his name and his face in people's minds. If he wasn't deep in animated conversation, taping some celebrity's darkest secrets, or snapping pictures of people in various stages of undress, he was capable of turning himself into a piece of living sculpture. Staring across a crowded room at Studio 54, Xenon, the Mudd Club or any other of the numerous watering holes of the period, you would suddenly be shocked to see Andy Warhol, his long white-blond hair hanging in slabs, his lips slightly parted, his hands folded in front of him clutching a small black cassette tape recorder, standing stock still and staring into space with a blank expression on his ravaged face like an oracle out of some mythological tragedy while the party raged around him. At such times he appeared to be as powerful an image as he had been in the sixties and once again afraid of nothing.

Ivan Karp told Patrick Smith that year:

My sensibilities are troubled and sometimes grieved at the kinds of happiness that Andy gets from people who are fashionable. See, I know that he is a person of greater depth than he would reveal in these situations when he says, 'You know so and so? Oh, aren't they simply marvellous people?' I say, 'No, I find them rather vulgar.' 'Oh, no! Oh, when you get to know them, they're so wonderful!'

And often in testing him, he will confess that he likes them because they're famous. He's like a teenager that way. He needs these people who think they're more famous than they are, and who he can think are more famous than he is. He's an observer. He's outside of himself. He is able to see himself and the world, and that's what you might call utter proof of high consciousness: is when you can see yourself in a situation and how you behave, and be able to sort out the implications of behaviour. I think Andy is still capable of that . . . and his ability to do it is remarkable, almost heroic in a way. If he can maintain the physical sameness that I knew of him, as a young formative artist, then he has been able to create for himself a personality type to function within – shyness, reticence, the role of the observer as a legitimate character for himself, and that is quite usable in the context of his present fame.

SCREECH TO A

HALT

1978–80

I really can't kill big roaches any more, I feel like they're really people. I just try to push them aside.

ANDY WARHOL

In the summer of 1978 Warhol rented Montauk to a drug smuggler named Tom Sullivan. Sullivan had blown into town several months earlier with $2 million in cash to have some fun. Young, naïve and uneducated but good-looking and romantic, he was perfect fodder for the New York hustlers who moved in on him like sharks in a feeding frenzy. Soon Sullivan found himself renting three connecting suites at the tony Westbury Hotel on Madison Avenue (a brief walk from Warhol's townhouse) shared with the anthropologist Peter Beard and the actress Carol Bosquet.

In the heady atmosphere of 1978 Sullivan was bound to meet Warhol. According to Catherine Guinness, 'We met Tom in Studio 54. We were there one night and he just sort of picked me up and carried me off.' Andy introduced Tom to Margaret Trudeau, who had recently left her husband to have some fun herself. Swept off her feet by the charismatic Tommy, whose pirate-king image was topped off by pockets over-flowing with wads of cash and a black-leather-gloved hand disfigured in a fiery plane crash, Margaret Trudeau soon found herself at the centre of the Factory's night life. Andy felt sorry for Catherine, who continued to see Sullivan on the side, but naturally he enjoyed contemplating the idea of his Girl of the Year and the prime minister's wife fucking the cocaine cowboy.

Sullivan soon attracted a coterie of onlookers, who included the writer Albert Goldman hot on the trail of a good story.

Tommy would have these dinners at the Polo lounge in the Westbury and Andy would come with his Polaroid and sit there at the table. Everybody was carrying on and he'd say nothing, but periodically he goes *brrr* with the machine and then this long thing comes out *eeeee*. I always thought it was just like sticking his tongue out at the company. Puking on them in a way. Now I ogle you . . . Now I puke on you. The sense I always got out of

Andy was incredible arrogance, contempt, derogation. I thought he was a disgusting human being. Cold and creepy and calculating and manipulative and exploitive and hiding behind all these little-boy little-girl la-la masks that he had contrived.

That spring Tom Sullivan rented Warhol's Montauk estate. Shortly thereafter a team of two German geeks, an actor turned director, Ulli Lommel, and a borderline producer named Christopher Gierke, proposed they make a movie with Sullivan's bank roll, starring Tommy himself of course and, they eagerly suggested, somebody like Bianca Jagger.

Sullivan and Lommel cooked up a story about a drug smuggler who tries to get out of the business by turning himself into a rock star. A band was rounded up and, in imitation of the Rolling Stones, Montauk was used as a base for their rehearsals. The veteran actor Jack Palance was made a cash-in-advance offer he could not refuse to star as the band's manager, and shooting commenced in June. Albert Goldman:

> The spring the movie was conceived was the climax of his long career as a drug smuggler. That spring was a disastrous season. First he broke up with Margaret Trudeau in London. Then there was a horrible plane crash in Florida in which his closest friend was incinerated, and then hard on the heels of that a great big shrimp boat full of contraband came in but Tommy cracked up and couldn't handle it. But he owed for the merchandise.

'We were never told they were going to make a movie,' claimed Vincent Fremont. 'Mr Winters [the caretaker] called me and said, "There are all these cars parked all around." There were unmarked police cars and the East Hampton police did a high-speed chase and they were arrested for gun possession.'

The film was to be called *Cocaine Cowboys* and as an added incentive Warhol would be hired to play a cameo role for an extra $4,000 on top of the three-month rental. Vincent Fremont:

> We really got very disenchanted rather quickly. Andy was very sweet about it but Sullivan really abused the house. He was a very charming guy but he was trying to be a rock-and-roll star and his band stank and we never had a tenant who caused more trouble. We got very nervous and I really think they helped drive Mr Winters to his grave of anxiety.

'When the police came up to the house, they grabbed $25,000 in cash,' Goldman reported, 'but that wasn't anything because the night before the Colombians had shown up and threatened to kill him and he gave them a million in cash.'

Warhol's appearance in *Cocaine Cowboys* was the nadir of his film career in more ways than one. Playing himself, Andy interviewed Tom,

asking him the most banal questions in the most uninterested voice he could muster up for the occasion. The truth was he despised the uptight director who, although he had worked with Fassbinder, had clearly learned nothing about inspiring his actors to cut loose. Warhol knew that Sullivan was being ripped off. To make matters worse, when Fremont went to collect Warhol's fee for his performance the film's ersatz producer pulled a gun on him.

Shortly after the film came out Sullivan was on his way down. 'He was a real sad case,' Fremont recalled. 'He bought himself into the highlife of New York and Studio 54 and he spun out bad. His drug problem became more and more apparent and by the end of the summer he fell on hard times. He said he didn't have any money. He paid his rent but we couldn't wait to get rid of him.'

'Andy was a kingmaker and Tom thought he would make him a king,' said Goldman. 'When he was on his way down he was ashamed of showing himself before Andy without his gaudy feathers, but he'd been plucked clean and couldn't grow any more feathers.'

Andy's involvement with Tom Sullivan was not his only excursion into the drug world of the seventies. He had also become friendly with the art director of *High Times* magazine, a powerful woman named Toni Brown whose overt, humorous personality fitted his needs. Soon a lot of people at the Factory were throwing up their hands in dismay over the amount of time Andy was spending with Toni. Actually, unbeknown to many of them, Andy was once again engaged in one of his many fruitless attempts to tape-record somebody's life story as the basis for a book or Broadway show and had discovered in Toni a font of amusing stories about lesbian life that might perfectly have suited the interests of that permissive period. Many a night, as she recalled the relationship, Toni would pick up Andy and Victor Hugo or whomever else he cared to bring along in a limousine and they would pass the evening at one of New York's expensive watering holes, like Trader Vic's in the Plaza Hotel, where they could cop a good view of the goings-on. Warhol and his party would divide the evening between discussing how tacky or corny everyone else in the restaurant was, guessing what they did in bed together, or figuring out the value of their jewels, listening to Toni's long, hilarious tales, and drawing pictures of cocks on their napkins. Andy would often spin off into such hysterical if silent laughter that Toni feared he wouldn't be able to stop and would go into convulsions.

Andy's openness to the world of *High Times*, populated by a variety of drug zealots with fierce political convictions as well as several members of his own *Interview* staff, was another good example of his democratic approach towards the culture. Although he was regularly trounced by fashionable liberals for associating with the most extreme right-wing elements of high society, he could just as well be found on

any night hanging out in the girls' room of a downtown club or ensconced in the loft of some aging hippie. There were certain limits, though, to what he would put up with. John Wilcock recalled taking Andy to a *High Times* party where Warhol was met with a series of withering political attacks which culminated in his being pied by Aaron Kay, a notorious figure of the period who specialized in bashing a cream pie into the faces of celebrities considered offensive to the drug culture. Although Andy continued to associate with Toni Brown until her stories and unbalanced behaviour bored him, this incident put something of a pall on his future dealings with *High Times* magazine.

Meanwhile at the Factory, like the Marx Brothers or characters out of a Jacques Tati film, Ronnie and Walter would spend most of the day setting themselves up on a series of drugs and drinks. In fact, it took them so long to 'get it together' that by 4.30 in the afternoon when they were ready to begin work everybody else would be about to wind down. Andy just couldn't fire somebody. He would get everybody else to try and tell them to leave but he couldn't do it himself. His patience with Ronnie was phenomenal, but he finally got fed up with Walter, telling him not to bother to come over one day when he was several hours late.

'You mean I'm fired?' asked the astonished Steding at the other end of the line.

Yes, he meant it, Andy replied.

'The reason people had such a protective feeling towards Andy was because he gave so much,' Walter explained.

A good example of that was when he fired me. He needed me there but he really wanted me to do my own art and he pushed me into doing it by firing me. Everyone else would have just used me. There was something about him that was really caring and you couldn't help but feel a deep sense of, 'God, please don't let anything happen to him.'

The façade of good times was cracking. The nonstop night-time revelry began to take a toll not only on Bob Colacello but Fred Hughes and others on the Factory staff for whom the open bar in the dining room had become a daytime refuge against hangovers and boredom. All the major players in Andy's life except Vincent Fremont suffered from drug and liquor problems and started breaking down around him. Closest to home, his relationship with Jed splintered further when Jed's twin brother Jay, who was an extreme substance abuser, moved to New York. 'I was always close with Jay,' remembered Jed, 'although Jay was impossible in those years. It was just a nightmare, but Andy was very nice to sort of tolerate him.'

'It wasn't hard to take advantage of Andy,' said Paul Warhola. 'Jed

made a man of himself through Andy and then he started bringing his brother around and so forth, and Jed got fat.'

Meanwhile, after ten years of building Andy Warhol Enterprises into an international multimillion-dollar business, Fred Hughes was showing signs of the strain of always living in Andy's shadow and dealing with the snobbish, uptight customers and dealers who bought the art. 'Fred was getting very drunk,' recalled Daniella,

> really getting absurd, and really getting vulgar. When he was drunk he forgot all about the snobbery. He was telling the dirtiest things I ever heard like 'Sit on my face! Why don't you sit on my face?' to girls. I don't really think he loves girls as much as he wants to say in interviews. He was really getting very vulgar and asking for drugs.

'When I first met Bob I just couldn't stand him,' recalled Suzi Frankfurt, 'because all he did was drink vodka and do coke and he was really uncivilized.'

'Bob – he was crazy,' Daniella asserted.

> He was doing a lot of coke and getting cottonmouthed and very slobby. 'Baaa baaa buuu that could be a good fuck, don't you think, that could be a good fuck, fuck, fuck,' and asking me for more coke, and Fred wasn't that different. Andy was a little worried but I don't think he was shocked because Andy accepted everything and he had seen that before.

Andy's responses now to those around him was characteristic: confused and contradictory, a mixture of genuine concern and tacit encouragement. 'The thread goes through so many of Andy's relationships,' Ronnie Cutrone commented.

> You have someone taking massive amounts of drugs or alcohol, and then there's Andy trying to save them, trying to fix them, and failing. Vincent didn't have a problem, nor did the accountants, so the people who handled the money didn't have any problems, but almost everybody else did so that made them need Andy more. Andy was what they call in AA a para-alcoholic. Para-alcoholics are just attracted unconsciously to people with compulsive problems.

He tried to help Truman Capote – who had been unable to produce any work since the opening chapters of his aborted novel *Answered Prayers* – by giving him a tape recorder and encouraging him to work. And indeed it seemed to go well for a while. Capote got back on the wagon and produced several *Interview* pieces. Yet, at the same time, Warhol wanted to hear about Truman's problems – his writer's block and how disastrous love affairs drive you to drink.

'Andy was always fascinated with other people's soap operas,' Ronnie Cutrone said. 'It was a way for him to avoid his own problems.'

For a while it seemed that Truman Capote, who had joined the staff of *Interview* as a regular contributor and was determinedly trying to stay straight, might have a good influence on the kids, but Truman's sobriety did not last long. By Christmas 1978, when Andy and Capote were supposed to tape-record a conversation for *High Times*, Capote was too drunk to speak on the phone for days at a time.

Andy joked to a reporter that the key to success was to 'drink a lot' and his Christmas present that year was a painting duplicating the Studio 54 complimentary drink ticket, executed in several sizes – the bigger the friend, the bigger the painting.

It was unlike Andy to respond emotionally and, for the most part, he disguised whatever distress the problems of his associates were causing him behind his 'nonfeeling persona', as one of them labelled it, until something went wrong and Andy exploded with anger and resentment. Ronnie Cutrone was always shocked when this happened. 'He would turn beet red and get furious. It was so strange, like a man from Mars.'

Andy didn't want to lose any of the big deals he was getting through the alcohol or drug-induced inertia of his staff. He had been wanting to work abstractly for some time, Cutrone recalled.

Andy was always saying how much he liked the corners of his paintings where the screen falls off and it becomes just broken dots, and he'd say, 'Oh, that looks so pretty. Why can't we do something that's all like that?' The 'Shadows' were a way of doing something abstract that was still really something.

The 'Shadows' series was a group of massive canvases based on an idea of Cutrone's to photograph and silkscreen shadows.

In November 1978 Warhol painted a portrait of the Shah of Iran's sister, Princess Ashraf, whom he had been assiduously courting at dinner parties for the past year. She must have appealed to him much more than the stolid, indecisive Shah (who would flee Tehran for his life two months later) for Ashraf was Andy's favourite kind of woman. A Dragon Lady, the most feared, hated and admired woman in Iran, Ashraf had, according to the CIA, 'a near legendary reputation for financial corruption and for successfully pursuing young men . . .' Her business dealings, the agency noted, were 'often verging on if not completely illegal'.

In a double live record album, *Take No Prisoners*, released the same month, Lou Reed commented to the audience, 'Andy has taken himself away from us.'

*

The 'Shadows' opened at the Heiner Friedrich Gallery in New York on 29 January 1979. They were generally well received and sold out before

the show opened, though critics tended to focus more attention on the celebrity-packed champagne reception than on the paintings, which Andy himself deprecatingly labelled 'disco décor'.

In March his 'Skulls' were shown in Milan. In April the 'Torsos' were exhibited in Vancouver. Simultaneously the Saatchi brothers, owners of an ad agency in Britain, were making a major collection of Warhols that had the same effect as investment in blue-chip stock. 'Warhol was a bit in the dumps before Saatchi intervened,' testified Leo Castelli. 'He wanted certain pieces, rare pieces that were very expensive. When he next found a painting he wanted, well, we were perfectly aware of the price that he had paid for certain paintings, and the prices would go up.' Soon the Saatchis had a collection of Warhols that rivalled Dr Marx's and Britain became a regular stop on Andy's European visits.

In May Andy, Bob and Fred were in Madrid, Barcelona and Monte Carlo on their way to Deauville, France, for the 'wedding of the year', a simple little $700,000 affair between a Niarchos and a Chevassus. In June they were poolside at Steve Rubell's oceanfront house on Fire Island for a hand-picked gathering of New York aristocracy.

The jet-set summer was not without its disasters. The fall of the Shah brought all Colacello's portrait diplomacy to a crashing halt. While Bob lamented cynically in his *Interview* column, 'You remember the Pahlavis? Uncle Sam's best friends?', Andy's concerns were more practical when it became obvious that he was not going to get all the money he had been expecting from the Shafrazi-run museum in Tehran.

In July, Warhol was in London, where after dinner one night with Halston, Steve Rubell, Bianca Jagger and Victor Hugo, Liza Minnelli proposed a toast to 'the fact that this group of people could have a fabulous time wherever in the world they chose to go'.

'Except Iran,' Andy blankly countered.

Andy celebrated his birthday on 6 August 1979 at a Studio 54 party hosted by Halston, who gave him a pair of roller skates. His other gifts included 5000 free drink tickets and a garbage pail full of one-dollar bills from Steve Rubell.

A few days later it was announced that, in conjunction with Grosset and Dunlap publishers, Warhol was to be given his own imprint – Andy Warhol Books. *Andy Warhol's Exposures* – a collection of his celebrity photographs with an accompanying gossipy text – was slotted for fall publication, to be followed later by *Popism*, a memoir of the sixties that Pat Hackett was completing.

'Andy Warhol, Prince of Pop,' announced the *New York Times*, 'has decided now that he has painted pictures, made movies, taken photographs and written books, that he would like to be a publisher too. With Mr Warhol, no sooner said than done.'

True to the Warhol style the photographs in *Exposures* were often less than flattering. Bianca Jagger was presented shaving her armpit, and

Halston shown candidly holding falsies to his chest. Overall, however, the approach was again light-hearted, stirring little controversy or excitement when the book appeared in October 1979. Despite a 25-city American and European tour, and a *20/20* news documentary on Warhol coinciding with publication, sales of the coffee-table-size book (estimated at 25,000 copies) were disappointing. A gold-embossed $500 collector's edition of *Exposures* – accompanied by a signed lithograph – fared somewhat better, selling 150 of 200 copies printed, but not well enough to salvage Warhol's publishing agreement with Grosset and Dunlap, which collapsed a few months later.

His one-time champion Peter Schjeldahl wrote:

> His once hypnotically succinct way with words has gone from oracular to almost orotund. Even his aphorisms are lame, as when he proposed to supplant his most quoted quip with 'In 15 minutes everyone will be famous'. One realizes with a start how crucially Warhol's sixties hothouse of social nomads and street people, the laboratory of his social creativity, contributed to his cultural authority. That strange authority is long gone now, consumed by the anxiety of the rich to think well of themselves. For Warhol, it seems anything but a bad bargain. He's happy as a clam.

Andy was bigger than ever in Britain when the book was published there at the beginning of 1980. 'His three-day trip to London is riddled with interviews, bugged with TV cameras and tape-recorders and beset with people just longing to give parties for him,' wrote Emma Soames. 'Andy Warhol checked into the Ritz yesterday flanked by a couple of sharp, pinstriped businessmen – and a frisson ran down the spine of SW3.' Part of it had to do with a 'razor-tongued row' that had broken out between David Bailey and Fred Hughes.

'He adopts the style of a rather wet writer who is wide-eyed at all the glamorous people in New York,' wrote a reporter in the *Sunday Times*.

'He usually speaks in the first person plural which is apt because he behaves like royalty and is treated like royalty,' wrote another reporter. 'Accompanying him were his friends and employees Bob and Fred. Bob is the editor of *Interview* and also of the new Warhol book. He seemed like a right pain in the neck . . .'

Despite all the press interest, the sales of *Exposures* were even more disappointing in the UK than in the US.

One of Andy's most revealing tendencies was to throw a spanner in the works just when everything seemed to be going fine. He appeared to enjoy fucking things up. He would for example put some visiting European princess who could hardly speak English to work collecting advertisements for *Interview* over the phone, knowing full well that she was totally incapable of handling the job successfully, or back out of what looked like a perfect deal at the very last moment.

This was part of his aesthetic. Andy always said the best art was good business and he did have the ability to focus on the essential parts of a business deal, but he was not a classically good businessman because in order to achieve his unique results he needed to work against the grain, to create negativity, to pull the rug out from under someone just before they reached the goal he had been promising them, to refuse to accept what was offered him unless it was done 100 per cent on his own terms. This was why so many people resented him and also why he was at times such a powerful artist. He was never afraid of failure, never afraid of what people thought of him and always knew just what he wanted. If he didn't always get it, that may have been because part of his strategy involved betraying himself as well as everybody else.

To the vast majority of people Andy appeared to be a negative, destructive, vampiric character. While it is true that he could sometimes be all those things, that was because his work, which was his life, needed those qualities. He could also be positive, constructive, kind and generous. He was, as everybody who knew him well concluded, a creature of contradictions who could never be pinned down from any single point of view. It was his ability to live with these contradictions that made him the powerful and timely artist he was.

*

Andy hated to travel, refusing to go anywhere unless there were several free first-class round-trip tickets and money-making propositions at his destination. More in demand than ever, he did continue to travel quite a lot, but was a prima donna on the road. He liked hotel rooms, ordering a lot of room service as soon as he arrived and flicking on the television, but he expected a full agenda of activities to entertain him. On one occasion he flew down to Las Vegas to deliver a portrait to the singer Paul Anka, only be be kept waiting in his room for two days without a word from the singer and with nothing to do. That really got on Andy's nerves and the man who caught all the flak of his bad mood was, as usual, Fred Hughes. Yet Andy could be mollified quite easily. When Anka finally called and took them out to dinner with a television actor in a popular detective series named Telly Savalas, recalled a member of Warhol's entourage, 'Andy had a lovely time.'

Andy had been fascinated by television since the early fifties and constantly kept an eye on its development. He had instantly recognized the power it was to have and learned a lot from watching it. The colours and style of the Marilyn prints he had done in 1967 had for example been influenced by an out-of-focus colour television set. As early as 1969 he had talked of having his own TV show, *Nothing Special*, and in 1972 he had begun, with Vincent Fremont, a series of video experiments called *Vivian's Girls* which, following the *Chelsea Girls* motif, had focused on people arguing. Ironically, however, success in the medium had always eluded him.

430

This was largely because, just like the movie executives who had flown him out to Hollywood in 1969, the people who controlled television productions found Warhol's ideas and particularly his presence too unsettling for the mass audience. A good example of this was what happened when Warhol tried to get the young producer of the popular if avant-garde satirical television programme *Saturday Night Live*, Lorne Michaels, to produce *Nothing Special* in 1978.

Vincent Fremont, Brigid Polk and several other Factory squirrels had worked up a series of ideas for the show that met Andy's approval and a meeting at the Factory with Michaels was arranged. Michaels was apparently keen to give Warhol a slot and Fremont and his coworkers looked forward to the meeting with great expectations.

On the big day Michaels arrived in his limousine with a hip young assistant and sat down opposite Warhol and his team at the big Ruhlman table in the dining room, smiling and expectant. As Fremont and the others delivered their pitch, his expression became even more positive. Halfway through the presentation he broke in excitedly to announce that he was prepared to give them $100,000 in development money right away, a prime time 10 p.m. Saturday-night slot and complete cooperation. He emphasized that he would let them do whatever they wanted and protect them from the censorship or intrusion of the network bosses who might frown upon some of the show's more experimental ideas.

Convinced he had a deal on his hands after six years of trying, Fremont turned to Warhol to get his go-ahead. As soon as he saw the expression on Andy's face he knew that the meeting had been a disaster and they would never work with Lorne Michaels. Andy's pale Slavonic features had metamorphosed into a slab of stone as he stared dispassionately across the table slightly to the left of Michaels and beyond him out of the room, his lips compressed into a hard line. He had not said one word during the 45-minute spiel, not even hello, and now it was obvious that he was completely turned off. But why? As he scrambled to keep up appearances in a situation that was fast becoming intolerably embarrassing, Fremont knew only too well. Andy could not stand paternalism in any form. A control freak in every aspect of his life, the last thing he wanted was somebody who promised to take care of him. He completely distrusted such an approach, believing that what it really meant was 'I promise to take advantage of you'.

Smashing up against the moonscape of Warhol's face, the meeting faltered and broke down in embarrassed silence. As Andy left the room without speaking, handshakes and goodbyes were perfunctory.

Between 1978 and 1980 Warhol produced his own television programme and put it on cable television. Following closely the format of *Interview* magazine, *Andy Warhol's TV* was a weekly half-hour show consisting of conversations between, for example, Henry Geldzahler

and Diana Vreeland, fashion shows, and informal at-home visits with up-and-coming rock stars like Debbie Harry of Blondie. With his art director's eye Andy made sure it was always visually appealing, going back in a sense to the concept of his earliest films, painting on the television screen. It was, like so many things he essayed outside of painting, well done, but just a little bit ahead of its time.

His attitude towards its failure was characteristic. Rather than drop the increasingly costly project Andy doggedly pursued it, trying again and again to find a new way to do the show that would finally catch on. In the end, as had been the case with his film work of the seventies, its failure probably came more from his inability to work within the medium's business structure than from the show's form or content. It remains an accurate and perceptive social record of the period.

Even so, Andy was fantasizing about Warhol perfumes, hotels and restaurants. But it took the Portraits of the Seventies exhibition to really wrap up the decade.

The exhibition of fifty-six pairs of portraits covering the glossy brown walls of the entire fourth floor of the Whitney Museum opened on 19 November 1979 with a $50-a-ticket champagne reception. Many of the guests, like Lord Snowdon, Sylvester Stallone and Truman Capote, were also among the portraits on display. Warhol's other faces of the seventies included Mao Zedong, Mick Jagger, Jimmy Carter, Golda Meier, Yves St Laurent, Brooke Hayward, Liza Minnelli and Julia Warhola.

Looking remarkably like Paulette Goddard, whom he escorted to the Whitney opening, Andy never appeared stronger in the seventies than he did that night.

While reviews of the show certified Warhol's importance as a portrait artist, emphasizing his use of the photographic image, and the painterly qualities – the variety of colour and texture – of the works, the focus of most of the critical response was not on the paintings but on how the progression of Warhol's images, from the working-class austerity of soup cans and Brillo boxes to the portraits of the seventies, seemed to chronicle Andy's own upward mobility. Robert Hughes raged that Andy was 'climbing from face to face in a silent delirium of snobbery', but it seemed just as apparent to others who saw the show that Warhol was capturing an era when glitter was important and the superficial paramount, and exposing its pretensions.

'The faces are ugly and a shade stoned,' the *New York Times* reviewer noted, 'if not actually repulsive and grotesque. It is probably idle to complain that the work itself is shallow and boring. What may be worth noting, however, is the debased and brutalized feeling that characterizes every element of this style. That this, too, may be deliberate does not alter the offence.'

Asked by a television reporter what he thought of one critic's remark

that his paintings were terrible, Warhol replied laconically, chewing on his gum, 'He's right.'

However, in an interview with Lita Hornick, whose portrait he had painted in 1966, Warhol

> insisted that his subjects, like the soup cans, were just objects for making paintings; no comment on the psychology, personality or character of his subjects was intended. Lastly, I asked him about his colour; since he was little appreciated as a great colourist. He replied his use of colour was totally spontaneous and never planned out in advance. Repetition of image and colours, he said, was the unifying element in his painting.
>
> In all his work, Warhol both glamorized and satirized his subject. The key to the mystification he always evoked, is that Warhol was always a double agent. His polarized point of view often seemed like no point of view at all, emptiness or vapidness. Nothing could be further from the truth. Warhol saw our fractured world in double focus.

Peter Schjeldahl sprang to his defence, pointing out that the portraits 'are a solid, typically Warholian coup, an unexpected use of painting that is right on the pulse of certain changes in culture . . . Warhol has, once again, hit some kind of nerve.'

Just as Andy was presenting his parade of seventies faces they started one by one to fall over.

As the portraits show was opening, the eighteen-month-long party at Studio 54 was ending, with Rubell and Ian Schrager pleading guilty in Manhattan Federal Court to cheating the government out of more than $350,000 in taxes. The case came in the wake of newspaper stories that the White House Chief of Staff Hamilton Jordan had used cocaine at Studio 54. A cocaine possession charge against Schrager was later dropped.

Truman was in bad shape again. He had managed to stay straight for several months earlier that year, joined a gym and got a face lift and looked rejuvenated, and Andy had liked to brag how 'we' had got Truman to stop drinking and return to work. But without outside help Capote had quickly slipped off the wagon.

'Brigid visited him in hospital,' recalled Ronnie Cutrone. 'Andy was fascinated by people's problems but he was terrified of death and hospitals so he couldn't get too close because it was too scary. Andy would go to a certain point with somebody and then realize that he was powerless over what they were doing.'

'Andy was very concerned about people, but if someone was really self-destructive, like Truman, in a way he was more interested in that than concerned,' Catherine Guinness observed.

Capote's association with *Interview* abruptly ended after Andy let Bob Colacello edit one of his pieces. Warhol claimed he never heard from Capote again.

Liza Minnelli was cracking under the pressure of performing, trying unsuccessfully to have a family and running with the princes of the night.

Andy's relationships with Bob and Fred were breaking down too. Catherine Guinness:

> Bob was quite irritated by Andy and he will tell you how mean Andy could be, making things difficult for him, frustrating him. Andy knew Fred was totally trustworthy and was a nice person but he tortured Fred too. Maybe he resented Fred's hold on him and said to himself that he didn't need Fred, but I expect he was frightened of what would happen if Fred did leave. They would fight, Fred would lose his temper, and they would scream at each other.

Catherine Guinness got a job elsewhere. Although she would continue to go out with Andy on occasion and maintained contact with him in the 1980s, her time as his Girl of the Year ended. Just like Viva and all her predecessors, she realized that although she had had a lot of fun with Andy and loved him she couldn't really make anything constructive for her life out of staying at the Factory. She certainly wasn't going to meet anybody she could marry there and she didn't have time to do anything else except work for *Interview* and go out with Andy. And so, like every woman in that position before her, she eventually left, giving Andy the opportunity to act out his drama of disappointment, hurt and resentment once again.

'In the seventies his favourite playmate was Catherine Guinness,' wrote John Richardson, 'but after several years glued to Andy's side she defected to England, married Lord Neidpath, and left the supposedly cool artist more bereft than he liked to admit.' According to Walter Steding, 'When Catherine left he said, "Well, at least I never paid her." '

Ronnie Cutrone was in the worst shape of all. His marriage was breaking up and he was drinking heavily day and night. In blackouts he was falling down and biting people. Andy was trying to fix Ronnie. 'I would confide in him and he would genuinely try to care,' Cutrone recalled.

> I think everyone, with the exception of Fred and Andy, always knew that they'd have to leave the Factory. But, see, Andy hated people to leave. There was a fear of abandonment. He could never be alone. Andy and Bob always fought, that was the nature of their relationship. The nature of everybody's relationship to Andy was that they were supposed in some way to take care of him. And that's what made working for him different than being his lover. Because all his workers genuinely loved him, but they were also being paid so they couldn't go anywhere. And I think when you control someone on any level, either emotionally or with money, the other person eventually has to rebel and resent you because you can't buy love unless you get a dog.

A BOURGEOIS

MANIAC

1980–83

One aspect of Andy's paradoxical nature was this constant conflict between convention and unconventionality; it was hard to predict when one would rise above the other. This was successfully resolved only in his paintings.

FRED HUGHES

In 1980 the language of Warhol's art, as in his 'Shadows' the year before, seemed to mirror the self-destruction of those around him. That winter he painted a series of large canvases called 'Reversals' of his best-known works of the 1960s and early seventies – the Marilyns, Mona Lisas, flowers, electric chairs and Maos – silkscreened in negative so that the surface was largely black. The gesture was poignant: it was as if Andy was throwing a shroud over his art.

A subsequent series of paintings titled 'Retrospectives', based on an idea of Larry Rivers, combined an assortment of his most famous images from the sixties on his largest canvases to date, some of them measuring up to 30 feet in length. The impact of the huge paintings was dramatic, but the repetition of old images was bound to generate criticism. To Cutrone it seemed that Andy's paintings, which before had made an art out of boredom, were now falling victim to it.

Ever since 1975, when the eminent Dr Marx established his contemporary-art collection in Germany and asked the dealer Heiner Bastian to advise him, Bastian, who considered Warhol one of the great artists of the century, had been buying paintings from the Factory. Heiner Bastian:

We considered him very generous to Marx because he pulled out all his old paintings. In the end he even pulled out his 'Advertisement' because I said it would be wonderful to have this first painting in the collection. I don't think we are yet capable of understanding how radical what Andy did really was. He has probably drawn a picture of our times that reflects more about our time than any other art. It seems as if he had some sort of instinctual understanding of where our civilization is going to.

From 1975 to 1980 Warhol visited Germany regularly to do commissioned portraits. Heiner Bastian:

> In Germany he saw very few people, serious collectors. There weren't really fashionable people to see. Mostly the people he met were the people who commissioned portraits. And these people would invite him for dinner and a party at their house, which he did not enjoy at all.

By 1980, Warhol was completing a commissioned portrait of the renowned German artist Joseph Beuys, whom he had met in 1979. Heiner Bastian:

> We came to the United States to do the Guggenheim retrospective, and I knew Andy then already quite well so I asked him to invite Beuys, which he did, and we went to the Guggenheim the next day and then to the Factory and lunch. I asked Andy to take some Polaroids of Beuys – 'Maybe you could do some paintings or something' – which he did, and that developed into a real industry.
> Beuys admired Andy a lot. He thought he was a real revolutionary artist without probably understanding it in the correct way; he had this kind of intuitive feeling that he was saying more about society in a political sense than many other artists who made direct political statements. But Andy never understood what Beuys was doing.

The Beuys portraits, glittering with diamond dust, were a sharp contrast to the 'fat and flannel' materials the openly political Beuys used in his works to confront the issue of fascism.

In 1980 this show toured Europe, beginning in Naples, Italy, in April, going to Munich in May and Geneva in June. Both Warhol and Beuys attended each opening and together they received an enormous amount of publicity.

'I like his politics,' Warhol told one West German daily newspaper.

> He should come to the United States and be politically active there. That would be really great. I think an artist should be in the ruling government. I want to support the political effort of Joseph Beuys because one day he could go to the street with it. He should become president.

Ronnie Cutrone, who was still working for Andy during this period, remembered the situation with Beuys somewhat differently.

> In 1972 when I started working for Andy I mentioned to him that Joseph Beuys was my favourite artist and he just looked at me and said, 'Oh, God! That stuff is so terrible. Euuuuggghhh, how could you like it?' Joseph Beuys got more and more and more famous and they wound up working together and being seen together and he painted his portrait. Now maybe he changed his mind, but maybe he never did. See, Andy was very democratic when it

came to fame and money. Beuys came to the Factory. I wasn't there that day. Andy told me he was also very boring. I think Joseph Beuys helped Andy's image in being taken seriously all through Europe. He was considered a very serious artist whereas Andy never was, by some people anyway. I think it was mutual exploitation.

As far as his reputation in Germany and Europe in general was concerned, Andy was a great artist and I think all great artists are accepted more by Europe. It's just the way it is. Europeans are more open to ideas. They're smarter . . . But Germans are attracted to violent things usually, or gutsy things like the car disasters. Germans have a morbid fantasy and attraction which often great art has itself, so they're much more open to that. In America they wanna know what to put behind the couch.

'Andy would never talk about his art,' Catherine Guinness recalled. 'I did once say to him, "Why did you paint a Campbell's soup can?" and he said in a tired voice, "Oh, Catherine, I thought you of all people wouldn't ask me that." '

Warhol's art – apart from portrait commissions – continued to be focused on the past. Together with Pat Hackett he was completing work on *Popism*, his memoir of the 1960s, which was published in April 1980 to dismissive reviews.

'Who or why or what is Andy Warhol?' asked the British critic Auberon Waugh during Andy's obligatory UK publicity tour. 'The heroine of the book is undoubtedly Ms Solanas.'

Peter Conrad in the *Observer*:

Popism is a necrotic book, in which the bloodless, undead, silver-maned Warhol broods over the demise of the decade and of his own talent. *Popism* reads like a report from beyond the grave. It recalls the Sixties as a zombified hell, fuelled by speed and acid, fed by junk food, populated by hermaphroditic sadists like Warhol's pop group the Velvet Underground or by cybernetic girls frugging in electric dresses with batteries at the waist and hair slicked down with frying oil – a long and demented binge which at this distance, for all its revolutionary ambition, seems as frivolous as the Twenties. Warhol is welcome to his fond mortuary reflections.

*

Near the end of 1980 Jed Johnson finally moved out of Andy's house. Andy's reaction to a close companion's departure was always wildly polarized. Outwardly he expressed a hard, cynical, withdrawn attitude. When Ronnie Cutrone told him he had bumped into Jed on the street, Andy replied, 'Jed who?'

'It was just horrible,' Suzi Frankfurt recalled. 'I said, "Oh, Andy, Jed left, you must feel terrible, is there anything I can do for you?" He said, "What do you mean? He was just a kid who worked at the Factory." It was like being slapped across the face. He was so weird.'

But no matter how hard Andy tried to deny and baffle his feelings and fears over the break-up with Jed, there was no denying its impact

on him. Late one night that fall, a friend, Raymond Foye, remembered, Andy called up to say he had just found one of Jed's socks in a drawer. 'Do you know how sad it is to find one sock?' he moaned. 'I guess the relationship is really over.'

Raymond recalled it as a 'sick, dirty' period. Warhol had started going out with a degenerate British aristocrat whom he would take to the back room of the Factory and watch as he masturbated. 'Entertainment sex is going to be the style of the eighties . . . the S & M thing where you go down to the S & M bars where they shit and piss and it entertains you,' Andy remarked to the author William Burroughs (who pointed out that it entertained *some* people). During the same conversation, Andy expressed the contrary view that sex was 'too dirty, too dirty'. Ronnie Cutrone:

> He was terrified of feeling, but he would tell me in an indirect way that he was hurt. He would say, 'God, isn't life so strange?' And I'd say, 'Well, what do you mean by strange?' And he'd say, 'Well, you know, people do this and people do that . . .' It's like a person who says, 'I have a friend who's in trouble,' and you never let on that you know they're talking about themselves.

At times Cutrone wanted to grab Andy and scream at him, 'Why can't you drop the act and show me that you're feeling something?' but that was impossible for Ronnie or anyone in Andy's life. Instead, Andy began acting out his feelings over the break-up with Jed in a totally uncharacteristic way. He started drinking. According to stories at the Factory Andy had even surrounded his bed with empty vodka bottles. He drank vodka at lunch and champagne in the evenings, getting tipsy, but unable to lose control and really get drunk. In bars and restaurants, he complained that drinks were not strong enough and ordered doubles. 'I don't give a shit any more,' he told Walter Steding.

'He did start drinking,' said Suzi Frankfurt, 'but that didn't last too long because even Andy had a hangover and he hated the feeling the next morning.'

According to Daniella Morera,

> He was drinking champagne almost every night. One night at Area he was drunk and he was really talking a lot and kissing a blond boy right in front of me. I say, 'Andy! You are so funny tonight. You are talking too much,' and he was saying, 'Touch him! Touch him!' pushing me to touch the boy he was kissing.

The situation was not funny. Jed's departure put a lot of pressure on people around Andy, particularly Fred. Andy seemed at times to be facing some kind of despair. He was fifty-two years old and frightened

of spending the rest of his life alone. 'What am I going to do?' he cried to Raymond Foye late one night in a bar. 'What am I going to do?'

He was as sympathetic as ever to others suffering from the same plight. He took up that year with Maura Moynihan, daughter of the senator from New York. 'In my cover-girl incarnation he skilfully got me to recount my life history into his tape recorder,' she recalled,

> winning my trust with his empathy and enthusiasm. He was especially fascinated by love affairs and pried me for details of every infatuation and heartbreak. 'Oh no, he really broke your heart that badly?' he'd say, his hands flying to his own heart in a spontaneous gesture of sympathy, which would prompt me to tell more. Andy had his own attachments; he liked to hold hands with boys and sometimes he'd try to kiss one of my male friends in the back of a taxi, but I always felt that he preferred to have his affairs vicariously through the girls he knew. Whenever one of his friends showed a particular interest in me, he was alternately wildly excited and envious. He loved putting people together, but often he didn't like them to establish autonomous relationships that would exclude him.

Andy was worried about his future alone in the big house. One sign of this was the frantic way in which, as soon as Jed had left, he began cramming the place with acquisitions – as if *things* would fill up the hole in his heart. While Jed had been at East 66th Andy had stuck to his promise to confine his shopping bags full of assorted junk to one or two upstairs rooms. As soon as Jed left, the house overflowed with the detritus of his collecting mania. According to the British journalist Peter Watson, 'Stuart Pivar (himself a collector of everything from teapots to Victorian paintings) knew Warhol for the last ten years of his life and was a regular companion on shopping expeditions.' Pivar told Watson:

> Every Sunday I would pick him up at the local Catholic church and we would head downtown to the flea market. Andy had an ironical way of looking at things, virtually everything he said was ironical, everything was a joke. He had a refined sense of absurdity – even art collecting was an absurdity to him. He would walk into a gallery, offer people a copy of *Interview* magazine and say, 'Have you any masterpieces?' He also wanted masterpieces in junky things. He had 100, maybe 150, cookie jars. He would say, 'I have my money in cookie jars,' and he was always pricing them.
>
> He liked to collect the best of things, the worst of things, and the mediocre. He loved the concept of trashiness, the very idea that there could be an advanced form of mediocrity. He thought it was a sociological phenomenon of our times. He always handled his own transactions. He usually paid cash or by cheque. Andy had a very fine sense of right and wrong and was very proper in all business transactions.
>
> He collected as an investment. He believed there was order in the art market even though he wasn't sure what it was. He looked upon spotting

trends as an industry. What you have to understand about Andy is that he was always working. He never switched off. While we were shopping, he would be looking at people to see if they wanted him to paint their portraits. He charged $35,000–$50,000 for a pair. It sometimes seemed as if he picked up three or four commissions a week in this way.

He didn't like compartments in his life and he didn't like compartments in his collecting. He just responded to things individually, not because they belonged to this or that category. He didn't collect like an interior decorator either, because he had a niche or a shelf that was empty. He never collected Chinese art. 'Once I start,' he said, 'I'll never be able to stop.'

Andy definintely looked upon himself as a great artist. And he found aesthetic interest in everything. He therefore felt entitled to invent a new aesthetic, a new fine art. That's what he was doing, as much in his collecting as in his painting.

By the time he died 57 East 66th Street would be so crammed with his collections that, just like at Lexington Avenue in 1962, there would hardly be room to move around and no place to sit. There was a definite sense of sadness in this. Although Andy's feverish hoarding would prove profitable, like so many things he was laughed at and criticized for, when the contents were unloaded at auction for $25 million, it would also be noted by the Sotheby's staff who catalogued his hoard that the majority of things he bought had never been unpacked. The house reverberated with a mournful silence. 'There was no life, no laughter in it,' said the head of Sotheby's Art Deco department, Barbara Deisroth, 'it was slightly spooky.'

Andy turned at first to Christopher Makos. Makos, who had become increasingly important to Andy in 1979–80 after working on the gruelling production of *Exposures*, had a personality that drew people around him. He was a good example of the kind of exuberant, ambitious, good-looking guy who made the gay scene so attractive and influential in the late seventies. He loved to travel, go to parties, make money, meet new people, get high and laugh. Above all he was audacious, intelligent but unintellectual and primitive. He was also strikingly uninhibited. Andy loved taking photographs of Christopher having sex. Ronnie Cutrone:

> The influence on Andy from Chris Makos was during the flaky period, because Chris was trying to imitate Andy so much they both just went around going, 'Oh, great, great, great.' Meanwhile everybody else knew that a lot of stuff wasn't great. It was like finding a clone. Also Andy could watch Chris's relationships, because, see, Andy always wanted to believe in love.

Andy began spending more and more time with Chris, going out with him in the evening, hanging out in his circle.

Acceptance of homosexuality had become widespread in the USA in the late seventies. As more and more homosexuals came out of the closets in the church, the army and the government, it became evident

that gay men were having a greater influence on lifestyle in America than any other minority group. It was around this time that David Hockney made the remark, 'Three hundred homosexuals rule the world. And I know every one of them.' Upwardly mobile young guys came to New York to make it as actors, photographers, dancers, businessmen. 'There are 2,556,596 faggots in the New York City area,' begins Larry Kramer's 1978 novel *Faggots*. Bonded together in couples they represented a powerful economic force. From fashion and interior decorating their influence spread into every area. From 1977 to 1980 they were a positive presence – bright, constructive, fun-loving, hard-working, healthy – and, like any minority, were very supportive of each other so that a number of them flourished.

Many of them first found success by working for Andy in some capacity and through him meeting many others. He was fascinated by the hardcore sado-masochists, black-leather gays into bondage and discipline, who flourished in the infamous sex clubs of the period. Andy, of course, didn't take part in any of their activities, but he loved the theatre of sex and found it all terribly funny to look at and talk about. Permanently locked up in his own lonely heart he clearly had a number of reasons to champion the most extreme practices, ranging from a desire to force conventional people to accept that anything could happen to a need to see people destroying themselves. For a voyeur little could beat the whips and chains and fist fucking and golden-shower performances that went on at the Mine Shaft, the Toilet and the Anvil. Andy was probably the only person in America who had access to these sex pits as well as to the White House. Daniella Morera:

> With Chris they had a lot of fun, the dirty fun of New York. Chris was a vehicle for Andy to go to discover all these cubicles, he needed somebody to take him there. It was another side of his life, separated from the Bob Colacello jet-set society. Chris was cute, he was a very good-looking boy and I'm sure that he was very sexual, he was always talking about these cute kids and sex.

Andy stopped drinking and began eating macrobiotic food. He employed an exercise instructor to come to the Factory and work out with him every day, and changed his body from that of a somewhat frail middle-aged man into a muscleman's. Andy Warhol:

> Muscles are great, everybody should have at least one that they can show off. I work out every day, and for a while at the beginning I tried to get 'definition', but it didn't come off that way on me. Now I do have one muscle that appears, and then it seems to go away, but it comes back after a while.

Andy had to make several trips to West Germany in 1981, and he took Christopher along. On one occasion the art dealer Herman Wunsche

arranged for Warhol to do a series of paintings of German national monuments like Cologne Cathedral and the Holsten Tor in Lübeck and Andy asked Chris to take the photos to base the prints on, so that both of them could make some money. Christopher Makos:

Basically Andy wanted somebody to go around with who might have been a little precocious, who wasn't afraid of being aggressive and just getting around so he would ask me to go on these ten-day trips with him to help him out a bit. We would go from Bonn to Cologne, then from Cologne to Paris and then from Paris back to New York on the Concorde. They were really mind-expanding trips and they taught me how to behave. I learned a lot from Andy and I think Andy learned some things from me . . .

Andy had a retrospective travelling through Germany starting 23 October 1981 in Hanover. On 8 October a long interview with him by Eva Windmüller appeared in *Stern*. The headline for the interview read: 'At fifty he is still a workaholic and full of vanity. He is greedy and always on the road.'

STERN: You are considered a court painter of the jet-set era. Do you have any criteria of how you choose your celebrities? And how many have you done?
WARHOL: First of all I'm not looking for them, they're looking for me. I started with it at the end of the sixties and the number I did goes into the hundreds. To be exact, I never did anything else in my life. It doesn't make any difference if I'm going to portray my own shoes or a Coke bottle or in interview or in film or in cable TV I'm going to portray a new face. Every time I do something the end effect is a portrait. Maybe this has something to do with the fact that I always find other people much more interesting than myself . . . Originally I wanted to use one colour . . .
STERN: What was the idea?
WARHOL: That everything looks the same . . .

It was an unusually open interview of a kind he never gave in the States but was consciously giving to his German audience.

WARHOL: Well, today I really talk much more than ever, it's because I'm afraid. I'm nervous. Somebody I know is writing me letters claiming that I stole his songs and sold them to the Rolling Stones. Me? Who can't even hum a melody? But just by chance I opened a letter in which it said, 'Live or die,' and yesterday the letter writer called me. We called the police but they can't do anything until you're killed. The other possibility was I take him to court but that would cause too much publicity.
STERN: How do you feel now?
WARHOL: Like in a plane. You never know until you arrive and when you arrive it's wonderful.
STERN: Do you have real friends?
WARHOL: My friend is the telephone. Everybody is my friend.

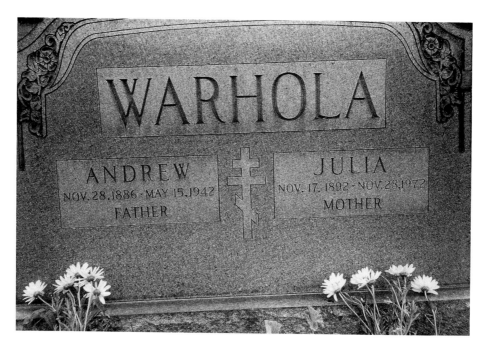

Warhola family gravestone. (*Photo: Victor Bockris*)

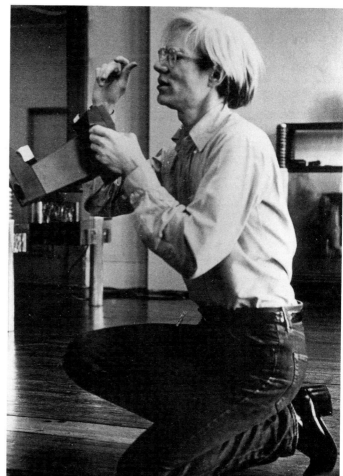

Andy Warhol at 33 Union Square in midst of doing a commissioned portrait. 1973. (*Photo: Victor Bockris*)

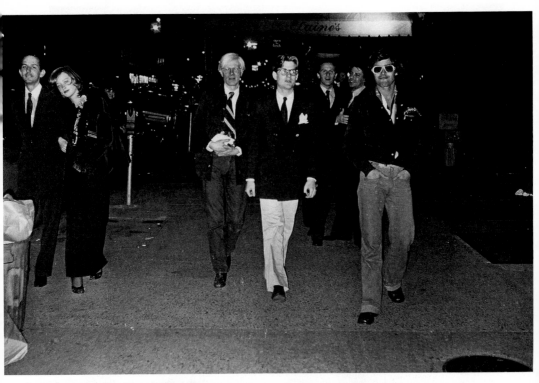

The Warhol team outside Elaine's restaurant, New York City. 1974. From left: Fred Hughes with Nickey Weymouth, Warhol, Vincent Fremont, Bob Colacello (right background) with Thomas Amman. (*Photo: Anton Perich*)

Bianca Jagger and Andy Warhol, Studio 54. 1977. (*Photo: Anton Perich*)

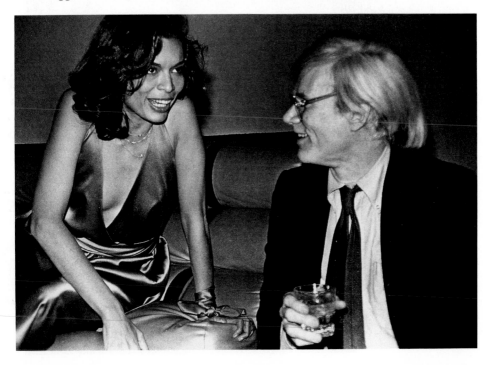

Victor Hugo and Andy Warhol. From *Punk Magazine*'s Mutant Monster Beach Party. 1978.

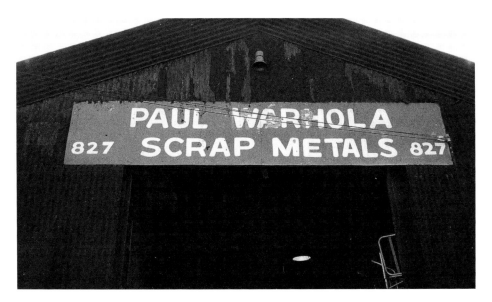

Paul Warhola Scrap Metals. 1983. (*Photo: Victor Bockris*)

Opposite, top: William Burroughs and Andy Warhol at dinner in New York, 1980. It was the first time they had ever sat down and talked to each other. A friendship, which lasted until Warhol's death, grew out of the meetings. (*Photo: Victor Bockris*)

Opposite, centre: Andy Warhol photographs Muhammad Ali for the champ's portrait at his training camp, Fighter's Heaven, in Pennsylvania. Standing between them is the man who arranged the commission, Fred Hughes. (*Photo: Victor Bockris*)

Opposite below: From left: Lorna Luft, Jerry Hall, Warhol, Debbie Harry, Truman Capote and Paloma Picasso, Studio 54. 1979. (*Photo: Anton Perich*)

Paul Warhola in his office in Pittsburgh. 1983. (*Photo: Victor Bockris*)

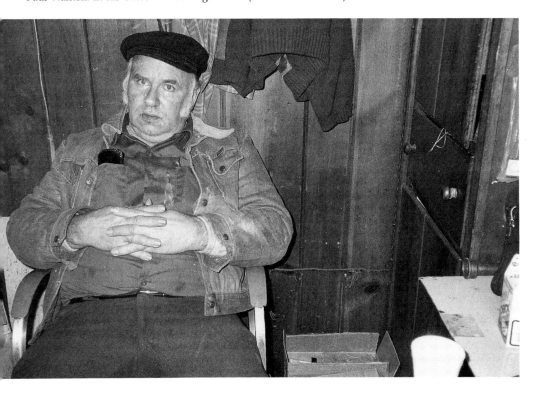

Poster announcing Warhol–Basquiat party after joint show. (*Tony Shafrazi Gallery*)

From left: Victor
Bockris, Warhol,
Winnie and Tom
Sullivan on the
set of *Cocaine
Cowboys*. (*Photo:
Elizabeth Lennard.
Victor Bockris
collection*)

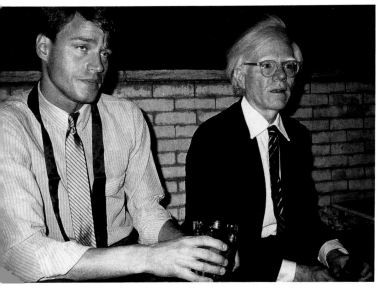

Jed Johnson and
Andy Warhol on
Debbie Harry's
terrace, New York.
1980. (*Photo: Victor
Bockris*)

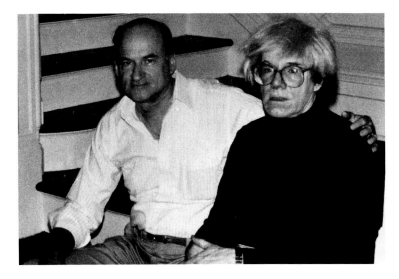

John Warhola on
stairs with Andy
during his last visit,
November 1986.
(*John Warhola
collection*)

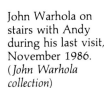

NEW YORK POST

METRO | SPORTS FINAL

TODAY: Snow, mid 30s.
TONIGHT: Clear mid 20s.
TOMORROW: Sunny, mid 30s. Details: Page 2.

TV listings: P. 75

ANDY WARHOL
DEAD
AT 58

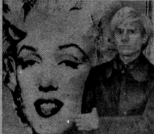

Prince of pop art who turned a soup can into museum treasure

● LIFE & TIMES OF A MEDIA GENIUS — SEE PAGES 4, 5 & 15

EXCLUSIVE

Jubilant Jagger 'n Jerry set the date — at last!

Mick's joyous gesture says it all as the couple leave Manhattan's Cafe Des Artistes yesterday after a brunch celebrating Jerry's acquittal in Barbados on drug charges. Her story of jail ordeal AND their wedding plans on PAGE 3

EXCLUSIVE photo: Geoffrey Croft

HEART ATTACK KILLS DAVID SUSSKIND: PAGE 9

Front page of *New York Post* announcing Warhol's death.

As the interview continues, Andy goes to a shop called Body Armour Special on West 11th Street to buy a bulletproof jacket. Christopher Makos joins them.

> STERN: He is an arrogant blond boy with a sports car. Warhol is trying on every jacket. The man in the shop says, 'No .357 magnum is going through this one. And the protection is Keflar from du Pont. You can even clean it. The day when Reagan was shot I had more assignments than ever. Now this one here is called the Executive for managers, diplomats, detectives. It's not very heavy, it's very light and it costs $270.'
>
> WARHOL: Why doesn't the president have a bulletproof jacket? I'll take this. My God! I feel so secure today . . .

<div align="center">*</div>

In the summer of 1981 Makos introduced Andy to a handsome, dashing thirty-year-old named Jon Gould.

Tall, with long streaky blond hair balding on top, not a fashion-model beauty but handsome, with a lean, athletic build, Jon was a flashy if gauche dresser and a party boy, aggressive in a friendly way, who used poppers and cocaine and was a wild, erratic dancer. He reminded Ronnie Cutrone of Rod La Rod, except that at least at first, Jon was not violent. In fact he was capable of being a loving, caring person, described by one friend as 'trustworthy, generous, sincere, seeking for growth and looking for meaning in life'.

It soon became obvious that Andy had fallen in love with Jon. He began showering him with presents and talking to him for hours each day on the telephone. According to Cutrone, 'He was obsessed and it was funny to see because Andy would make fun of anyone who got obsessed, and he would try to hide it, but he couldn't.'

The pace of activity in Warhol's backroom studio at 860 Broadway dropped off. 'The guy was totally out of his mind,' said Cutrone.

> There would be a very important project and he'd be on the phone bullshitting with Jon for an hour and a half. I'd go, 'Andy, the clients are going to be here in forty-five minutes,' and he'd go, 'Yeah, yeah, OK, OK . . .' We'd make the deadline but, during the Jon Gould period, often only by seconds. So things changed a lot there. Everybody noticed it and would say, 'Oh, my God, what's he doing? Oh, he's making presents.'

On one occasion, instead of working on a stack of uncompleted portraits, Warhol's assistants found themselves stretching silkscreened hearts which Andy had made as a Valentine's Day gift for Jon. 'He was intensely absorbed in his work,' explained Christopher Makos, 'except when he was having a relationship, and then the relationship became his work.'

Andy's friends had mixed feelings about the relationship. Vito Giallo thought, 'Jon was such a wonderful guy. He liked Andy a lot and

<div align="center">443</div>

would always give him the most expensive gift I had in the shop.' Benjamin Liu recalled first meeting Gould at Andy's Montauk estate, which Halston was renting with Victor Hugo that summer:

I always thought the attraction was physical because when they came out we were always admiring Jon dancing on the beach and Andy would get excited looking at that body twirling. It was the beginning of the relationship and he was always trying to please Jon, like by making him a little breakfast. I think Andy's biggest mistake was that he never gave himself enough time between the relationships with Jed and Jon, because they soon developed 'household problems', it was like Tennessee Williams's *The Roman Spring of Mrs Stone*, there was a lot of Tennessee in there. Jon was such a preppie yuppie and his main influences were material. It sometimes made Andy wonder – why does that Bulgari gold chain have to be longer? Are these the primary aesthetics that one has to deal with?

Suzi Frankfurt disapproved of the relationship.

I hated the things Andy used to buy him, like a Barry Kisselstein cord belt. Jon was a fashion victim and it was gross. I didn't like him at all. He was such a hussy, the consummate hustler, and I'm sure Andy was attracted to that. Also Jon was yelling that he was straight and was a vice president for Paramount and had girls.

To Daniella Morera, 'Jon was very weird and I was surprised because he was a different type from the shy boys I had associated Andy with. This guy was like a giant and he was doing a lot of drugs.'

Despite these dissenting views, the relationship flourished. For Christmas and New Year Warhol took Gould, along with Christopher Makos and Christopher's roommate Peter Wise, to Aspen, Colorado, where Baby Jane Holzer arranged for them to rent a house. During the holidays, Aspen had become a party scene for celebrities, and that year famous faces included the *Miami Vice* TV star Don Johnson, who was living with Warhol's discovery Patti D'Arbanville, and the show's producer Anthony Yerkovich. 'It was,' according to Makos, 'a wild period.' Andy spent the day shopping with Christopher in town and taking drives along the steep snowswept roads on the outlaying mountainsides. At Christopher's insistence he even tried skiing. Makos recalled the incident in his photo-memoir, *Warhol*:

It was the first time he ever skied. He absolutely loved it, until the last hill, when he became exhausted and gave up. So he just sat down and slid the rest of the way down the mountain – except that somehow he caught his Rolex watch on a branch. Then he started complaining in a big way. I said, 'Just get up and stop complaining. We're going to make it down this hill. Now shut up.' And he said, 'It really hurts, it really hurts, Chris.' We finally got off the hill, and he really was hurt. We went to the hospital, and they

announced that he had sprained his wrist. So Andy had a skiing injury, and his bandaged hand was like a badge. Everyone back in New York was thoroughly fascinated.

At a time when Andy was increasingly distrustful of people, Jon Gould was someone he trusted, yet their relationship was not sexually intimate. 'Though there was a tremendous amount of love between them, they were not lovers,' one mutual friend disclosed, 'just close companions.' The fact that Jon worked for Paramount was not irrelevant. They made at least one trip to Hollywood together where Jon introduced Andy to some important people in the business, and they discussed making a movie together. Soon Andy was urging Jon to move into his house. 'At first,' recalled Benjamin Liu, whom Warhol was now employing as his right-hand man, 'it was more like a chore because he still had a loft downtown, so it was like a special thing: "Oh, are you staying over tonight?" '

By the end of 1983 Jon had moved into East 66th Street and Andy was very happy about the arrangement. He was also very private about it. Jon rarely visited the Factory and many people who knew Andy were not aware of the relationship. While Peter and Christopher were holiday guests for lavish champagne and Beluga caviar suppers with Andy and Jon, in public Gould was disguised in Warhol's entourage and not seen as his companion. Instead, Andy was sharing the spotlight that season with Cornelia Guest, the 'Deb of the Year' daughter of the Manhattan socialite C. Z. Guest. However, there was no question among his friends that Andy's relationship with Jon Gould raised his spirits and helped him move out of the hole he had been in. As one friend put it, 'Jon was a light inside his life.'

*

As Andy became immersed in his relationship with Jon and began to turn away from the older group he had been associated with in the second half of the seventies, his relationship with Bob Colacello, which had been explosive for some time, began to collapse. To be sure, Colacello had played a vital role in Andy's career throughout the seventies and his work at *Interview* in 1980–82 was strong, but Andy was becoming bored with the direction he was going in as Colacello's conservatism, in the wake of Ronald Reagan's presidential victory, turned increasingly into self-parody. 'Isn't it a small world,' he sighed in one of his 1980 *Interview* columns, 'a small rich world.'

Together, Andy and Bob attended the Reagan inauguration in January 1981, where, according to Colacello, 'New Money, Old Hollywood, and the Georgetown Set united into one big party high on both power and style.' He breathlessly noted that almost three hundred private planes flew out of Washington the following morning, and described the subsequent state dinner for Ferdinand and Imelda

Marcos, which they also attended, as a 'dinner of dinners', at which 'Nancy never looked lovelier, Imelda never looked smarter, the President was as rosy-cheeked as ever, and Marcos impressed guests with his fifteen-minute toast calling for a strong America.

'Suffice to say,' he concluded, 'that as a party critic I was impressed; as a Republican, I was thrilled; and as an American, I was very very proud.'

Within months after the inauguration, Colacello hired Doria Reagan, the president's daughter-in-law, as a contributing editor to *Interview*, and through her he was able to arrange for Andy to tape Nancy Reagan for a cover story. The interview took place in October. Mrs Reagan's soporific monologue on how fascinating it was to be in the White House seemed to daze Andy, who remained silent during almost the entire taping. Even Bob admitted she had stopped him in his tracks at one point because it was 'just so exciting' to be sitting there talking to her.

Though Colacello felt the Nancy Reagan interview was his most important contribution to the magazine, when it appeared two months later it drew heavy criticism. Alexander Cockburn wrote a parody of it, substituting Hitler for the first lady, which was published in the *Village Voice*. It ended:

BOB: Is there still pressure for you? Do you think of your image and act a certain way?
HITLER: I don't think of image any more, I really don't, Bob.
BOB: Well . . .
HITLER: Have I stopped you cold?
ANDY: Well, no. It's just that it's interesting to be here, that's all. This is very exciting for us.

Warhol's toughest critic, Robert Hughes, took the occasion to draw acerbic comparisons between Reagan – 'the shrewd old movie actor, void of ideas but expert at manipulation, projected into high office by the unsuperable power of mass imagery and secondhand perception' – and Warhol – 'the shallow painter whose entire sense of reality was shaped, like Reagan's sense of power, by the television tube'.

Colacello's snobbishness and increasingly bad temper were wearing thin among many of the *Interview* staffers as well, particularly his vituperative yelling at deadline time. Under Bob's wing, the atmosphere at the magazine, according to the receptionist Dona Peltin, had become 'as congenial as being at the South Pole in your underwear. The people,' she recalled, 'weren't particularly nice to anybody, including each other. And the screamfests were harsh and humiliating.' Before quitting, Peltin came to the conclusion that the people who worked under Bob all hated themselves.

But the working relationship between Warhol and Colacello seemed

to deteriorate for reasons other than politics. On the one hand, Colacello seemed to be trying to stake a claim to an inordinate share of control over Andy Warhol Enterprises. Andy told one associate that Bob was trying 'to take over everything'.

'He came here to work on the magazine and that's what he's being paid to do,' Andy complained. 'He's not my partner.'

'Bob was a never ending fight,' Walter Steding recalled. 'Constantly talking about each other back and forth. If I'd be with Bob alone he would say, "Andy wouldn't do this, he won't do that . . ." '

On the other hand, Colacello had by now become well enough known in his own right to begin working outside the Warhol sphere, even telling one reporter that he was thinking of running for political office, and claiming to have three or four unnamed but 'wealthy' supporters. Such independence was anathema to any relationship with Warhol, who often mocked Colacello's pretensions, to the delight of the assistant editor Robert Hayes, by imitating how out of it Colacello had been the previous night on cocaine. Arguments between them became increasingly frequent with Bob screaming bug-eyed at Andy in front of a number of associates, 'You think you're cute!' and Victor Hugo exploding in rages at Bob, while Andy sat by, innocently asking, 'What's wrong with Bob?' and enjoying the action.

'Andy encouraged everyone to do everything, which led to a lot of confusion and conflict,' Colacello recalled.

> He adored having three right-hand men, arm wrestling behind his back or, better yet, in front of him. Like a peasant mother, he was expert at keeping his 'kids' in a state of constant competition. I once spent hours selling the great art dealer Iolas, only to have Andy throw the commission to Fred Hughes, because I had been in the bathroom at the moment Iolas decided between the two canvases I had shown him. Finally, I tired of selling Andy. I wanted to sell myself.

Bob would not officially leave the Factory until February 1983 but after putting Nancy Reagan on the cover he was not around as much, spending a good deal of time on lengthy all-expenses-paid trips for the magazine. The final showdown came when he made his demand for a share of *Interview*. Vincent Fremont:

> Bob made an ultimatum. Andy had the right to say yes or no and said no. Andy felt very strongly about things like that. He was the kind of person who would be very decisive if you challenged him. It was his empire and there wasn't going to be any kind of compromise. Bob wrote an official letter of resignation to Fred and myself.

Andy was never happy when a close associate left and always complained. 'How could Bob do this?' he whined to everyone, but by

then he was already moving towards a significant new development as a painter which would soon overshadow anything Colacello could have contributed.

TOO MUCH WORK

1980–84

Isn't life a series of images that change as they repeat themselves?

ANDY WARHOL

Since the pop-art explosion twenty years earlier, there had been nothing like the excitement being generated by the work of a new group of painters from 1979 to 1983. The artists – Francesco Clemente, Sandro Chia, Julian Schnabel, David Salle, Keith Haring, Kenny Scharf and Jean-Michel Basquiat among others – were all young, in their twenties and early thirties, and they shared a passion for richly painted canvases, flamboyant colour and disturbing imagery, a style that critics had dubbed 'neoexpressionism'. While some reviewers played down the impact of the new painting, calling the work 'generalized Angst' and predicting that it would be short-lived, the enthusiastic attention of the public, the media and an expanding market of energetic young dealers and collectors, not only in the US but in Europe and Japan, willing to pay unprecedented prices for the work of newcomers, was turning the neoexpressionists into highly renowned and very wealthy young men.

The market for art was booming in the early 1980s. Numbers alone told the story. Whereas there had only been seventy-three listed galleries in New York in 1970, there were now nearly five hundred and the number was growing. With prices for works by old contemporary masters like Jasper Johns passing the million-dollar mark, the demand for work by these more affordable new painters was rising. David Salle's billboard-sized multipanelled works were being sold for $40,000 and the prices for large canvases by Schnabel were approaching $100,000.

The highly publicized success of Julian Schnabel's 'smashed plate' paintings owed as much to the enthusiastic efforts of Leo Castelli's young protégée Mary Boone, whose SoHo gallery had become one of the hot spots of the new avant-garde, as it did to the size and energy of the works. In the spring of 1981, Schnabel's 'double show' at the Castelli and Mary Boone galleries had established him as the first art star of the 1980s.

Graffiti was the inspiration for Keith Haring's 'Radiant Child' and the iconographic images of crawling babies and howling dogs with which he postered New York subway stations. But while Haring's paintings, his hot colours and his sartorial style of porkpie hats, loud shirts and

449

hightop sneakers were derived from the street, his images had actually evolved out of years of experimentation with abstract painting. The 22-year-old Haring, together with another graffiti-inspired artist, Kenny Scharf, and Ronnie Cutrone, who was breaking away from Andy and painting his own works, were all showing successfully at another SoHo gallery, run by Tony Shafrazi, who was turning his experience as both a graffiti commando and an art businessman to advantage.

A trio of Italians known as the three Cs – Sandro Chia, Francesco Clemente and Enzo Cucchi – were more traditional in their approach to painting, though the often disturbing erotic content of the epic-sized canvases they were displaying at the Sperone Westwater Gallery was as provocative as the work by any of the other new painters.

Twenty-three, black and fiercely energetic, Jean-Michel Basquiat was the wild boy and darling of the group. His paintings – raw, frenzied assemblages of crudely drawn figures, symbols like arrows, grids and crowns, and recurring words such as THREAT and EXIT in bold, vibrant colours – were both childlike and menacing, qualities which, at times, also seemed to describe the shy, temperamental artist himself. His heroes were Picasso, Charlie Parker and Jimi Hendrix, and he aspired to a vision of himself as artist and rock-and-roll star. Asked what his subject matter was, Basquiat once replied, 'Heroism, royalty and the streets.'

Like Keith Haring, Basquiat was influenced by graffiti. With a friend named Al Diaz, he had first surfaced in New York as the anonymous SAMO (which Jean-Michel said stood for 'same old . . .') who scrawled cynical magic-marker messages, such as 'Riding around in Daddy's limousine with trust fund money', on SoHo walls. Always broke, sleeping on friends' couches, earning whatever money he could by doing odd jobs and selling junk jewellery and hand-painted T-shirts on the street, he had done his first paintings on salvaged sheet metal and other materials foraged from garbage cans.

He achieved his first recognition in 1981, at a New York/New Wave group show at the Long Island City gallery PS 1. Both Warhol's old friend Henry Geldzahler and his Swiss art dealer, Bruno Bischofberger, attended the show and were impressed with Basquiat's work. Back in 1979, during lunch one Saturday with Geldzahler in a SoHo restaurant, Andy had met Jean-Michel and bought a one-dollar postcard reproduction of one of his paintings from him, but even after Basquiat's career began to take off in the years that followed, Warhol remained aloof to Basquiat's efforts to gain entry to the Factory.

After Basquiat had left a graffiti message on the floor of the Great Jones Street loft, which Warhol owned and where Walter Steding was living, Andy told Walter, 'Don't let Jean-Michel in.' And when Basquiat had later shown up at the Factory Andy told an assistant to say he was not there. While Basquiat's temperamental outbursts added to his

reputation as an astonishingly precious painter (in one fit of rage he had destroyed all the work intended for a show at the Mazzoli Gallery in Modena, Italy), such behaviour had not been a key to acceptance at the Factory for some time. The fact that Jean-Michel was a drug user – who Andy was warned was heavily into heroin and chain-smoked marijuana – also spelled trouble to Warhol's aides, who thought he was a lunatic and continued to keep the door closed to him. 'Jean-Michel was not allowed in the Factory,' stated Ronnie Cutrone.

I don't even know why. Maybe because he was black and maybe because he was a street kid and maybe because he took too many drugs. People used to have to go to the door and say, 'Oh, Andy's not here right now.' And Andy would be hiding in the back. He did that with lots of people, but Jean-Michel wasn't allowed in for quite a while.

In 1980 Andy put me in charge of his art collection. He didn't know who anybody was at that point. He was totally out there in the social scene with Bob. And he said, 'Ronnie, I'd like to get some art and would you go out and maybe set up a trade?' So I started to build up, I set up trades with Keith Sonnier, I tried with Robert Morris, I liked Francesco Clemente's work. He didn't even know who Clemente was, he didn't know who Keith Haring was. I was the guy who went to all the shows and the night clubs and every day he would find out what was new. He didn't like Clemente, didn't like his work – and what could you like about Clemente? He's a total bore – they had nothing in common except that Clemente was getting famous. Andy was so impressed by fame that that dominated his taste sometimes.

While these painters had been having exciting, sometimes brilliant sell-out shows, Andy continued to plough through his modus operandi, producing a painting and print series, 'Ten Portraits of Jews of the Twentieth Century', commissioned by the art dealer Ronald Feldman, which included in each de luxe $300,000 edition portraits of Sigmund Freud, Albert Einstein, Martin Buber, Sarah Bernhardt, George Gershwin, Gertrude Stein, Golda Meier, Louis Brandeis, Franz Kafka and the Marx Brothers. Warhol had wanted to include Bob Dylan in the series but it was pointed out that Dylan had recently become a born-again Christian. Warhol and Dylan had been seeing each other socially in the late seventies and Bob had made several favourable statements about Andy.

Warhol was important to me. He was before his time. He busted through new territory. Andy Warhol did a lot for American cinema. He was more than just a director. I think his *Empire State Building* is more exciting than Bergman. I liked Warhol a lot.

'Andy was a marvellous receiver of ideas,' Ronald Feldman said, recalling their plans for the series.

He listened carefully to everything, he had an amazing energy level, and he was a shrewd business negotiator. When I was negotiating my print commissions with him, they were difficult negotiations. If he was travelling, he called his staff, woke them up in the middle of the night.

A second Feldman-coordinated series, to portray American myths such as Superman, Mickey Mouse and Uncle Sam, was arranged the following year. Included in the myths series was a poignant reference to his childhood – 'The Shadow' – a self-portrait, looking in the eyes of one reviewer, 'ravaged' beside his large, distorted shadow.

Andy's work suffered.

A low point came in November 1981 at a *Playboy*-sponsored exhibition of Andy's 'Athletes' in tandem with the sports illustrator Leroy Neiman at the Los Angeles Institute of Contemporary Art, which, at best, according to one critic, 'indicated just how convoluted the post-Duchampian, post-Pop, allegedly post-Modern situation has become'.

Neiman recalled the experience fondly.

Hugh Hefner acting as a host at the opening suggested we do mutual portraits for *Playboy*. Andy readily answered void of expression, 'If we do them nude.' Conversations with Andy would wind up with us exchanging anecdotes about our mothers, as my mother too was staying with me during this time. A special memory I do share with Andy is a beautiful one. That of Andy and I riding in the rear of a limo flanking Miss Lillian, the then President Carter's lovable mother. Everybody at every turn or light recognized her like we weren't there and we were delighted. Later in her suite at the Sheraton I sketched her while we all exchanged stories and reflections plus a few racey jokes.

However, the art critic Peter Plagens wrote:

Andy looks like he doesn't have his heart in lugging around that Polaroid any more. He does it because it is expected . . . The Master of Pseudo Equality is Andy Warhol . . . de Tocqueville on thorazine . . . His gambit had been to parody the grudging acceptance of the avant-garde by art patrons; when they have criticized his mockeries, he has co-opted them. When they said he has no taste, he answered, 'Yes, you're right. I love everything.' When they said his loving everything for so long had demoted him from a radical artist into a mere commodity, he answered, 'Yes, and I'm even more available to you this way.'

Around the factory, Ronnie had started thinking of him as 'a toothless lion' and others nicknamed him 'Grandma', while Taylor Mead, who had once called him America's Voltaire, thought he had become 'a bourgeois maniac'. To Emile de Antonio, art seemed to be giving Andy no pleasure. 'I just came back from Germany,' Warhol told his old friend. 'It was so boring. I had to paint industrialists.' Only when de

Antonio asked him how much he charged for the portraits did Andy brighten. 'Fifty thousand dollars,' he said, 'unless they have wives and children. Then it's seventy-five thousand.'

Despite his own problems Cutrone had tried hard to push Andy into doing some creative work:

We started to fight. I sensed a whole new direction in the art world and I was trying to get Andy to paint, to cut loose. Andy hadn't done anything really important since 1977 – frivolous prints that would sell in Miami and Palm Beach. I wanted to have the same respect for Andy that I'd always had and I wanted to see him really generate something once again. So I started to muscle him. I said, 'Fuck this, let's just go and do it. Come on, let's just paint it, let's just go and hit it!' And he'd go, 'Ronnie, I can't do that.' And I'd go, 'Whatya mean you can't? You can do anything you want. Let's go! Let's hit it!'

He did one painting, 'The Wicked Witch of the West', loose and it was great. Only he couldn't do it, he couldn't break out. An artist gets trapped by his own image, and the risk of losing money and clients and getting bad reviews. So our relationship started getting real testy but I thought it was healthy. I think he did to some degree too. I was trying to encourage him. I always wanted the best for Andy. I wanted him to break new ground. Even if I had to be in the shadow I didn't care.

He showed me these lobster paintings. I said, 'Andy, what the hell are you painting? You're going out to have dinner with Chris Makos in a lobster joint, you take the bib and silkscreen a lobster. So what? That's shit!' I said. 'Come on!' In response to that he'd either shut down and walk away, or he'd give me an order and say, 'Look, this is what we gotta do, let's just do it.' Or he'd say, 'No, no, nnnnnnoooooo, no, I don't like that idea.' So I could never get him to cut loose.

Continuing to rely on old images, Andy and Ronnie had completed a set of dollar-sign paintings based on a hand-drawn image by Warhol. In January 1982, a show of dollar signs was scheduled at Castelli's. Warhol was not pleased when Castelli relegated him to the basement of his Greene Street space, the least prestigious of his various locations. Cutrone was sent to do the installation. 'In a way he hit rock bottom with the Dollar Sign show,' recalled Ronnie.

That could have been a beautiful show. What happened was, he had done these paintings of knives and guns at the same time [the gun he painted was the same .32 snub-nosed pistol that Valerie Solanas had shot him with], so I set up big butcher knives, dollar signs and maybe one gun. Then I set up four more dollar signs, two giant butcher knives, and another gun, so when you walked into the gallery it looked like you were being mugged. Richard Serra came in while I was setting it up and said, 'God, this is brilliant.'

Then Fred Hughes came in, hung over, and said, 'This is too European. Let's just go with the dollar signs.'

So I called up Andy, I started screaming, I said, 'Andy, I've been here all

fucking morning installing this show. If you care anything about your own art you'll come in and take a look.'

But he assumed that Fred knew more about business, so he said, 'No, Ronnie, look, I'm sorry that you had to go through all that work, but just let Fred take over.'

So I walked out.

The Dollar Sign show was a singular disaster for Warhol. While one reviewer noted the significance of the series, appearing as it did at the beginning of the American financial crisis, and another characterized Warhol as 'the moralist of our day' and the dollar signs as 'the hand-writing on the wall of the American Temple', overall the critical response was summed up by one reviewer who wrote, 'Warhol's work has always been empty but now it seems empty-headed.' Worse still, not one of the paintings sold. Naturally, this had a chilling effect on Warhol's relationship with Castelli. Andy angrily told one associate that he was never going to show in New York again.

As the paintings were being removed a month later, Leo Castelli noticed a sign graffitied in luminous pink on the walls of his Greene Street gallery. It read:

ART$
WHAT
SELL$

'See that it's removed,' he told an aide, frowning.

*

Ronnie was by then on the wagon.

I had gotten sober and I was reading and studying the Bible. Other people were making fun of me or staying away. One night I was going to be late for my biblical research class and Andy got a silver limousine and personally took me to the class himself.

Andy presented himself as somebody who wasn't tormented. He had a stainless-steel denial. The thing that was so sad is that there was a cynical side to Andy. Andy stopped believing in love at the end of the fifties and yet was always trying for it. Andy would always be optimistic about the next project, but when it would come to actually loving or trusting another human being, that was severed with the cynicism. Now that's very sad. I know how Andy balanced his personal and professional life. He told me this. It's common knowledge, but people usually ignore it. Andy believed in God.

Andy liked to pretend that he never got angry, never got lonely, never got sad, and if he did admit to those things it was always with a sense of humour as a defence. But this French woman came and did this interview and she said to him, 'You once said that if you want to see me, just look at the surface of my paintings, so that probably means you don't believe in anything.'

Andy got furious and the lady didn't know what the hell she'd said. He just turned beet red and said, 'I didn't say that. I didn't say that I don't

believe in anything.' I've never seen Andy freak out like this with a total stranger.

And the lady drew back and recouped and said, 'Well then, what do you believe in?'

And again he turned beet red, got infuriated and said, 'Well, I believe in God.'

And then he realized that he had freaked out and, half cool and half meaning it, he said to the lady, 'And I believe in Ronnie.'

Shortly thereafter, sober and going to daily AA meetings, and spurred on by his own work, which was about to be shown at Tony Shafrazi's, Cutrone left the Factory to pursue a career as a painter.

Andy had always known that I would leave and he encouraged me. He would say, 'God, you've done stuff before any of these new guys knew how to walk, you're so much better than Clemente, why don't you just go out and do it?' But when I did leave it was like a major divorce, because I had been his left-hand man for ten years and I felt abandoned and naturally Andy would have to feel abandoned.

*

The time and effort invested in Europe paid off in 1982. On 2 March Andy appeared in a four-man show at the National Gallery in Berlin with Beuys, Rauschenberg and Cy Twombly. It had been some time since he had been in such prestigious company. Heiner Bastian:

When we first showed the Marx collection in the National Gallery in Berlin, I asked Andy to come over, and Marx had written him a long letter that the mayor of the city wants to give you a reception and the senator for cultural affairs. Andy called and said, 'We don't want to see the fucking mayor, we come to see you.' Rauschenberg and Beuys were there and the opening had to be closed by the police because too many young people wanted to come in, we are afraid the glass windows will break. Andy signed everything – passports and dollar bills – everything that was possible to sign. He enjoyed this very much, I think. Later on it was very pleasant for him because he went to some night clubs and he saw young people. Even before he came he said, 'Make sure there are some nice young people and not all those . . .'

I liked Andy tremendously as a person. I have a picture of a very tragic person, it's something that interests me most, what Andy really was, and, um . . . I personally think he was instinctively trying to survive somehow. He must have looked for substitutes every second, I mean to fill out his life. He must have had some sense of humour because he made remarks like 'Heiner, what you can do is an exhibition called The Worst of Andy Warhol.'

On 6 March his ill-fated Dollar Signs opened in Paris at Daniel Tamplon, where they were far better received than they had been in New York. On 15 October his German monuments – some people referred to them as Nazi monuments – were shown at the Zeitgeist in Berlin, where they were well received internationally. On 20 November

455

a show of Andy's replications of some of the surrealist master Giorgio de Chirico's most famous works opened in Rome. Andy Warhol:

> I met him in Venice so many times and I thought I loved his work so much. Every time I saw de Chirico's paintings I felt close to him. Every time I saw him I felt I had known him for ever. I think he felt the same way.
>
> He repeated the same paintings over and over again. I like the idea a lot, so I thought it would be great to do it. I believe he viewed repetition as a way of expressing himself. This is probably what we have in common. The difference? What he repeated regularly, year after year, I repeat the same day in the same painting. All my images are the same, but very different at the same time. They change with the light or colours, with the times and moods. Isn't life a series of images that change as they repeat themselves?

Everything was work to Andy. 'He would pick me up in a taxi to go out at night and say, "OK, this is work," ' recalled Maura Moynihan. 'Then he'd pull out his camera and tape recorder and put on his blank personality. Banality was one of his subjects and themes.' But he was showing signs of tiring. When Debbie Harry broke up her rock group Blondie after a disastrous summer tour, he asked a friend why she had stopped being Blondie.

'Because Debbie's too intelligent to remain in the role of a cartoon character every day,' the friend replied.

'What do you think I've been doing for the last twenty-five years?' Warhol snapped.

'Sometimes,' he said, 'it's so great to get home and take off my Andy suit.'

In between visits to Europe and constant travels in the States, Andy managed to fit in a ten-day trip to Hong Kong for the opening of a discotheque. He went on to Peking, accompanied again by Makos, Fred Hughes and a friend of Hughes's named Natasha Grenfeldt. Christopher Makos:

> When we got to the Great Wall, Andy looked up and said, 'Oh my God, I can't walk up that hill. It's too much work.' When I reminded him of the unique photo opportunity, he regained his strength. Besides, there was a film crew waiting at the Wall to photograph him.
>
> The whole Chinese trip was a kind of Warholian experience. Andy loved seeing the masses of organized, clean, similar-looking people. Everywhere we went there were droves of blue or green outfits coming at us. All the bicycles the people rode were the same make. Andy didn't appreciate Chinese beauty, but he did appreciate the people's simplicity and their ant-like organization.

On 16 December 1982 the Guns, Knives and Crosses show that Ronnie Cutrone had conceived of as going with the dollar bills at Castelli's at the beginning of the year opened in Madrid at the Galeria

Fernando Vijande. Makos, who accompanied Warhol on the trip to Spain, reflected:

> The kind of money that Andy required as an artist meant that he was often dealing with a lot of older, more established people, so I think in some cases that's why I was along – to attract some of the young set.
>
> The Spanish were very confused by Andy. You must remember Spain comes from a heritage of people like Goya, Velázquez, Dali and Miró, and although Andy is up in that category with them he is in such a completely different area than these people, they think of him as almost too modern for them, and so he had a very controversial reception.

The show sold out. It was all bought by one wealthy woman, whose husband was very angry with her.

*

As he shed himself of Johnson, Colacello and Cutrone, Warhol was simultaneously plotting a move. Space at 860 Broadway had been a problem for some time. Vincent had been in negotiation with the land-lord to rent a second floor in the building, but when the offered rental was too high, Andy decided to move. This time, he said, he wanted to buy rather than lease, and Fred went looking for an appropriate building. In 1981 he found a five-storey disused Con Edison generator station that stretched for a block from 32nd to 33rd streets between Madison and Fifth avenues. It was just around the corner from where Andy had lived from 1953 to 1959. The price was $2 million. Although it would have to be completely renovated to suit their purposes, Fred thought the building had great possibilities and urged Andy to buy it.

For a while there was some uncertainty about whether he could afford it. The Chemical Bank waffled about lending an artist $3 million, even though Andy had been with them for many years, and his income had increased yearly since 1970. There was some talk of buying it in partnership with the de Menils' DIA Foundation but that did not pan out, and anyway Fred pushed hard to buy it on their own. Finally the bank granted Warhol a loan. A company of builders, HQZ Enterprises, was hired to renovate the place. On 31 December 1981 Andy put down a deposit on the building. The deal was closed in 1982.

This was a doubly significant step. Not only would such a move signal a new period, but Andy Warhol Enterprises would be put under severe financial strain. The move from Union Square to 860 Broadway in 1974 had already doubled their overhead. The expense of renovation would skyrocket way past the original estimate from $1 million to $3 million. Vincent Fremont:

> Andy was sticking his neck out again. Because it was an enormous under-taking to go and buy the place and made everybody nervous. We all took a deep breath. But it worked out because of careful planning, with Andy

talking about it with some of his business advisers and myself reading every construction contract and realizing when they were going to take us for a big ride and screaming and yelling.

Andy always had the philosophy that every year was the last year. Every Christmas he would have the low low lows, like, The bottom's going to fall out, can we pay all the bills next year? Andy was such a hard worker and he ingrained that in me and in Fred. But it was a big risk. It was a raw space and it was like taking a shovel of money and sticking it into a black hole endlessly.

By October 1984, when the influential business magazine *Manhattan Inc.* published a profile, 'Andy Warhol: Portrait of the Artist as a Middle-Aged Businessman' by George Rush, Warhol had buried the doldrums of 1982 and was approaching a new pinnacle in his career. As a result, in part, of the booming 1980s market, the prices of his early works were soaring: a record $145,000 at auction paid for 'Triple Elvis' in 1983 was overshadowed when his 1961 'Dick Tracy' was sold by Blum Hellman for slightly more than $1 million, and Rauschenberg sold Warhol's 'Saturday's Popeye' of the same year for a million too. At the end of 1983 he had been listed at number two after Beuys and before Rauschenberg in Dr Bongard's authoritative yearly list of top 100 artists, based on the value of their work as investments. (By now Warhol had come to believe, at least he told the actress Jodie Foster, that 'paintings are like stocks and a dealer is like a broker. Art is an investment. You can't just love it. You have to love it if it goes up.')

Although he was not fully re-established in the eyes of the critics, the appreciation of his influence and relevance by the up-and-coming younger generation led others to reassess him positively. A series of paintings and prints of ten animals threatened by extinction, 'Endangered Species', which had been shown at the Museum of Natural History in 1983, earned him not only over a million dollars but a number of good reviews for touching on his death theme again. 'The king of pop art may have something to say after all,' began *People* magazine's laudatory piece.

Andy pushed forward on a number of fronts. He was still looking for an idea for a movie. His television show looked as if it was making progress. Post-Colacello *Interview* continued to make a profit and Andy was marketing his celebrity as well, working as first a Zoli, then a Ford model, earning $2,000 to $10,000 per shoot, and appearing in advertisements for, among others, the rums of Puerto Rico, Barney's Clothing, Sony, TDK, New York Air, Quality Markets, Coca-Cola and Golden Oak furniture. He loved modelling now that his new appearance and physique gave him the confidence he had previously lacked. The artist who had launched his career by saying he wanted to be a machine was even being cloned as a robot by AVG Productions, who

were building a $400,000 computerized automaton capable of making fifty-four of Andy's characteristic movements and statements, for use in a planned theatre production.

The *Manhattan Inc.* profile, which estimated his wealth at a conservative $20 million, made it abundantly clear that Andy Warhol was not just a celebrity geek. Warhol was generating between $3 million and $5 million a year, two thirds of it from art, one third from other sources. As always, he ploughed the considerable sums he earned back into his empire, buying 40 acres of land in Carbondale, Arizona, and paying for the costly renovations to the new Factory as well as the interest on the bank loan. The strain was evident to his friends. 'The last few times I saw him,' said Paul Morrissey, 'he always seemed a little more serious or more worried. He didn't seem to be enjoying himself as much as he did. He had too many responsibilities.'

'As Andy seemed to get richer,' recalled Emile de Antonio, 'he seemed to be more troubled by money. You sensed that the whole empire was shaky.'

ANDY WARHOL'S LAST

LOVES

1982–85

I think I influenced him more than he influenced me.
JEAN-MICHEL BASQUIAT

In 1982–84 Andy became closely involved with another young man who would have as big an influence on him as Jon Gould, although in quite a different and perhaps more significant way, the artist Jean-Michel Basquiat. When Henry Geldzahler bought the first of three Basquiats – a half door painted with layers of torn posters and scribblings – Warhol consented to let him tape Jean-Michel for *Interview*. Bischofberger also persisted in his support for Basquiat, becoming his European representative and introducing him to Mary Boone, under whose guidance his paintings would sell for between $10,000 and $20,000. When Bischofberger offered to provide money up front for a set of three-way collaborations between Warhol, Basquiat and Francesco Clemente, Andy agreed and the ban against Jean-Michel at the Factory was lifted.

The resulting works fulfilled Leo Castelli's 1970 prediction that Warhol would be 'cross-influenced by what will come later', though the reception given to the completed canvases was not as enthusiastic as Bischofberger had hoped, owing largely to the difficulty in assigning the collaborative efforts a value. To Clemente, Warhol had been a person he had grown up imagining, a prophetic hero, an art god, but once the project was over, he returned to his own painting. Basquiat, however, stayed on to work with Warhol on a series of larger canvases. Several of them were based on a *New York Post* headline, PLUG PULLED ON COMA MOM, and the Paramount Studios mountaintop logo, but in the end they looked like a succession of brilliant defacements of each other's work.

'Andy was very ripe to do something,' recalled Fremont,

and Andy and Jean hit it off. Andy could handle Jean-Michel, who could be very tough, where no one else could, and then Andy, through Jean-Michel, got back into using a paintbrush and doing things reminiscent of 1962–63. And the paintings were very good for Jean Michel's pocket as well as Andy's.

Jean-Michel was a stark contrast to Andy's other associates. In defiance of Factory protocol, he smoked enormous spliffs of marijuana as he worked and Warhol's aides found themselves at a loss when dealing with what Geldzahler described as Jean-Michel's 'charming but disdainful' attitude. He would look right through people with whom he had previously been friendly or maintain an uncomfortable silence in the face of such simple questions as 'How are you doing?'

'Andy did get a little nervous when Jean started smoking big spliffs of ganja,' said Fremont. 'That was something which would normally have driven Andy absolutely crazy, but they got along that way and Andy would give him some fatherly lectures about health and try to tell him to stop.' At first, among the Factory regulars only Victor Hugo, who thought he was the best artist 'of all those little people in SoHo', expressed outright admiration for Basquiat. The other staff members accepted him with superficial enthusiasm because of the beneficial effect the association was having on Andy, who said it was the first time he had enjoyed himself painting for years. According to Benjamin Liu:

He found some sort of affinity with Jean that went beyond the colour and the Rasta hair. It had more to do with raw talent, because above all Andy was a very primitive artist. Also Jean-Michel was a very funny person and Andy claimed that supposedly Jean once had a homosexual experience when he was real young. Andy always liked to know that deep down . . .

'I think I helped Andy more then he helped me, to tell the truth,' Jean-Michael Basquiat said.

Andy hadn't painted for years when we met. He was very disillusioned, and I understand that. You break your ass, and people just say bad things about you. And he was very sensitive. He used to complain and say, 'Oh, I'm just a commercial artist.' I don't know whether he really meant that, but I don't think he enjoyed doing all those prints and things that his stooges set up for him. There *is* work of Andy's that is definitely more Andy than other things that have his name on them.

While he was working with Basquiat, Andy's image underwent a retransformation from Brooks Brothers shirts and ties back to black leather jackets, sunglasses and black jeans; he looked younger, thinner, no longer like an old woman. 'He wasn't a person to stay in one place and say, "Gee, why isn't everything the same?" ' said Fremont. 'He was changing as things were changing and he was always trying to change. He started hanging out with a lot of young people again.'

'It was like some crazy art-world marriage and they were the odd couple,' Cutrone commented.

The relationship was symbiotic. Jean-Michel thought he needed Andy's fame,

and Andy thought he needed Jean-Michel's new blood. Jean-Michel gave Andy a rebellious image again. Plus they had the endorsement of Bruno and Henry. If Henry hadn't said, 'Look, this kid has talent,' I don't think Jean-Michel would have ever gotten near the Factory because he was a young black kid on drugs who was obnoxious most of the time. Andy could never figure out, why do these people have to act this way? Why do they have to stick needles in their arms? Why do they have to take cocaine? His thing with Jean-Michel was he tried to save him from himself.

Walter Steding, whose management contract with Warhol had been terminated, was told he would have to move out of 56 Great Jones Street, where he had been living rent-free. When he left, Warhol rented the loft to Basquiat. He negotiated the deal himself, telling Hughes and Fremont, 'You guys can't rent it out? I'm going to rent it.' Vincent Fremont:

Andy knew what he wanted for the place and wasn't going to rent it for anything less. He gave Jean a price of $5,000 a month. Jean-Michel baulked, but Andy got $4,000 a month. Andy made a very good deal, but it wasn't a bad deal for Jean-Michel either. Everything caused problems with Jean-Michel, he was very temperamental, but it worked out very well for him. We bought new appliances for him and he got a long lease.

Basquiat's first show at Mary Boone's gallery was in May 1984. The night before the opening he threw Andy out of his house, but the show, which Andy attended the following day unperturbed, included the homage 'Brown Spots', a portrait of Warhol as a banana. That same spring, in the New Portraits show at PS 1, Warhol displayed a portrait of Basquiat in a jockstrap, posed as Michelangelo's 'David'.

Their painting collaborations continued through the summer. By then, most of Andy Warhol Enterprises, including *Interview* and the management staff, had relocated to the new Factory, while Andy remained behind at 860 Broadway – with Brigid Polk, Benjamin Liu and a trusted bodyguard, Augusto Bugarin, who was a brother of his maids – painting with Basquiat for the next several months.

Andy's relationship with Jean-Michel, like his relationship with Jon Gould, was never intimate, but while teasing Jean-Michel about his girlfriends, Warhol continued to give him exposure both in *Interview* and as his 'date' at parties, restaurants and openings, telling reporters that Basquiat was 'the best' and had 'so much energy'.

Asked how Warhol had influenced him, Jean-Michel replied, 'I wear clean pants all the time now.' But to some of Andy's friends, it appeared that he was in love with Jean-Michel as well as Jon Gould, and they worried whether that was such a good thing. Daniella Morera:

Andy was in love with Jean-Michel but he would push me to have an affair

with Jean because he couldn't do it himself, so in his mind I was imper-
sonating him. He wanted to live through the experiences of Jean as a reflection
of his own life. And Andy represented everything to Jean, especially since
he was a very lonely boy, and so he had a leader. Also Andy was always
sweet about his problems with drugs and supported him on a human level,
so I'm sure Jean-Michel loved Andy too, but with a different kind of love.

Emile de Antonio thought Andy was acting 'like an old man in love
with a tough young woman who was obviously going to be thrown
away at some point, if he didn't destroy Jean-Michel first'.

He was making Jean exercise with him, trying to urge healthful habits
on him, trying to help him break his heroin habit. In fact, it seemed to
Cutrone that Andy was 'happy to be around young drug addicts again'.
To another observer, Jean-Michel was just a 'sacrificial child' to enliven
Andy's dead art.

Warhol's affinity for the new avant-garde was genuine as was their
regard for him, if characterized, as one young artist put it, by the 'ritual
of exorcism and homage involved in freeing yourself from your father'.
During the winter and spring of 1984, the homage and exorcism took
the form of *The Andy and Edie Show* staged by the performance artists
Ann Magnuson and Joey Arias, and Mike Bidlo's 'Factory' installation
at PS 1, in which Bidlo, an artist who specialized in making copies of
great art works, created a working model of the Silver Factory, turning
out 'Marilyn' silkscreens while actors portrayed Gerard Malanga, Viva,
Lou Reed and the other superstars. Bidlo himself played Warhol.

'There are so many artists that are so good now,' Warhol said in a
lengthy interview, 'but it's hard for me to go to galleries because the
kids stop me all the time.' Christopher Makos:

> Andy was a great supporter of other artists' work. He was very fond of Jean-
> Michel Basquiat, Keith Haring and all the younger artists. The only thing he
> didn't like was to see someone doing something that he'd already seen done
> to death. They had to be clever and make their work fresh. He himself loved
> the Goyas and the Renaissance paintings in the Prado as much as he loved
> anything current.

'Andy was always interested in what younger people were doing,'
said Fremont. 'He had been creating for years and years and years and
he needed to go and see what was happening. He didn't go to a lot of
shows, but he was pretty up on the whole thing. Artists were being
taken around by their dealers and he met a lot of them at dinners.'

'He was so keen and aware,' Benjamin remembered. 'When the *New
York Times* magazine came out with its cover story about the new kids,
Andy was called the Pop Myth/the Pope. He was very well aware of
his role and approached it that way. He willed himself towards them.'

Keith Haring often joined Basquiat and Warhol on evenings out. Haring was 'scared to death' of Warhol at first, but soon discovered:

He was so sweet and nice and lived a very simple life. Of all the people I've met, Andy made the greatest impression on me. He was the one who opened up the situation enough for my situation as an artist to be possible – the first artist to open the possibility of being a public or popular artist in the real sense of the word, a people's artist, *really*. He was the validation and most active supporter of what I do. He had an incredible sense of timing. He left people with their mouths hanging open.

Andy was very clever, He wanted to be part of the newest thing that was happening. He had a way of having his own fresh outlook, but he also got it through other people's eyes. He knew more about the coolest things to do than people I know who are eighteen.

Part of the way to know these things is to have younger friends. He needed fresh blood all the time – and inspiration. You never knew how serious to take it, but he would complain on the phone, 'Oh, I need some ideas.'

With complete respect I would say that we kept him on his toes. There were times when you would catch a little something in his conversation and you knew he was jealous. But it was the kind of jealousy I long for, I want to be around other artists who provoke you so that you think they are doing something better. Usually he was too nice and would compliment you on your work. But the important times were when you felt it was really bothering him. Then you knew you were good.

I only knew Andy in the last five years, and I don't know how much he had changed. If there was one word for the feeling I got from him, it was generosity. I never saw any other side of him.

Another thing I learned from Andy was my relationship to the art market. In terms of the market, Andy suffered by going into films and making multiples. Only now, after his death, are the prices starting to go back up.

'He was my hero, the reason I came to New York in the first place,' said Kenny Scharf. 'When I was younger I was involved in the club scene – Club 57 in particular. He was everything to us. Total emulation and adoration. We all wanted him so bad just to walk into that club. I see him as the granddaddy of everything. He was the father, and we're the children.'

Julian Schnabel's favourite young artist, he said, was 'Andy Warhol. His contribution is as great as Jackson Pollock's – maybe even greater. I loved him and I love his work.'

Not all the young artists were so unequivocal in their praise. 'When Andy's work was great, it was great because of its feeling,' said David Salle. 'But its feeling alone was not enough to make a convincing work of art, and while his later work had that feeling, it's not as interesting. It had a feeling that was merely depressing.'

Perhaps the Warhol influence had less to do with the surface imagery of any one of their canvases than it had to do with, as one critic wrote,

'Warhol's open acknowledgement of the marketability of an alluring avant-garde pose'.

*

On 1 August 1984, at Jon Gould's suggestion, Andy began making weekly visits to Dr Andrew Bernsohn, a chiropractor who specialized in treating stress and who had a nonprofessional interest in the use of crystals to tap into the healing energy and vibrations of the brain. Soon Andy started wearing a crystal pendant around his neck to tune him into the cosmos, he said, and because crystals were 'full of life force'. The reason women live longer than men is that they wear crystal earrings and jewellery, he explained. Diamonds worked just as well, but they didn't look right on men. 'He got hooked on crystals,' Makos recalled, 'and he wore them, carried them and put them in the pot when he boiled water for his herbal teas. He was searching for spirituality.' He was also exercising at the Factory several times a week, doing jumping jacks and aerobics, wearing a leotard.

The visits to Bernsohn became part of a new routine of obsessive health consciousness on Andy's part. On Mondays he went to another chiropractor, Linda Li, for counselling on nutrition. According to Makos,

> She got him interested in eating raw garlic, which, besides being a health fad, also reminded him of his Czechoslovakian ancestors, who used garlic to cure everything. The smell got pretty unbearable at times, and if it hadn't been for the heavy perfumes he wore, even Andy couldn't have got away with it.

On Tuesdays he visited a dermatologist, Karen Burke, for collagen shots to keep his face wrinkle-free; on Wednesdays, Bernsohn adjusted his spine; on Thursdays, he went for shiatsu massage; and on Fridays, to his internist Dr Denton Cox. Naturally, Andy involved all his doctors with each other and was soon chaperoning Bernsohn on dates with Burke and Li, as well as setting up conflicting relationships between them.

'He loved doctors,' Bernsohn recalled, 'and he told me he wanted to stay youthful and live for ever in his body. He loved life and he loved people. He really was quite different than the image that he projected. He was seeking the fountain of youth.'

As a result of the new regime, his appearance changed dramatically. He became thinner than he ever had been, his skin glowed with reinvigorated health and the new Rasta-style wigs he was wearing with the Stephen Sprouse clothes and the bulletproof Alain Mikli glasses combined to create a strikingly youthful appearance that was in the opinion of many his best ever look. Christopher Makos:

> He wore black Levi 501s or Verri Uomo, a black Brooks Brothers turtleneck

sweater, an L. L. Bean red down vest, a black leather car coat by Stephen Sprouse, white or black Reeboks, a big crystal around his neck and big black-framed glasses, and his hair was huge, jutting out wildly. He was like a cross between Stephen Sprouse and Tina Turner. Andy's look always made a statement, and it was usually about not looking perfect. His last look was as chic as ever, although the overall effect had a lot to do with his general aura: it was as though he'd accomplished everything imaginable in his lifetime.

It was with this new look that Andy would make his biggest ever public appearance when he starred as himself in a segment of the popular television programme *The Love Boat* which was aired on 12 October 1985. According to Vincent Fremont, 'The show's producer Doug Cramer, who was one of the biggest art collectors in LA, came to lunch and asked Andy if he wanted to be on *The Love Boat*. Andy got very nervous and said yes, but then it was up to Mr Cramer to come up with some work out there on the side.' Andy fretted over his debut on the popular series, telling friends that he was sure 'when they see how terrible I am, my whole career will fall over'. But he needn't have worried. During the taping of the show in Hollywood, according to the pianist Peter Duchin who also appeared in the episode, 'Andy Warhol was a bigger star than any of the Hollywood stars. When we went into Beverly Hills he received the most requests for autographs.'

'In the ten days he was out there he did Doug Cramer's portrait, he did a friend of Doug Cramer's and he also did Lana Turner's portrait,' reported Fremont.

And on the one day he had off he did a Diet Coke commercial, so it was a very lucrative week. They were very nice to him and, again, it opened Andy up to middle America where they thought he was such a weirdo. At the end of the story one of the actors says, 'I just want to say how honoured I am that you chose my wife to be the subject of your portrait.'

And yet it was revealing the degree to which Warhol's opinion of Hollywood stardom had changed, when, after the *Love Boat* episode was aired, he complained to a friend that people in Hollywood were 'idiots'. They didn't buy art, he said. They stank.

According to Vincent Fremont, Andy's reputation in America was changing as radically as his appearance.

Between 1983 and 1986 people were re-evaluating the sixties. Andy started coming out as a very important part of that whole movement in art. The critics had been trying to get rid of him for twenty years and now people were starting to realize that what he did for art was extremely important. His influence in America was enormous and it was just starting to gel in the legitimate art world and in people's minds. Especially when the younger

artists were talking about Andy in a way that no one else had – understanding him better than his peer group. That really helped propel things.

<p style="text-align:center">*</p>

By the time Andy finally moved into the new Factory, where his painting studio was situated on the third floor in the grand ballroom, a number of pressures came to bear on him and all at the same time, which made it a much less rewarding period than the public image would have us believe.

In late 1984 Jon Gould was diagnosed as having AIDS, the wasting disease which had already claimed one member of the Warhol entourage, the *Interview* editor Robert Hayes, as well as a number of Andy's personal friends, and was by now ravaging the gay community. Suddenly, the humour had gone out of Warhol's old adage about the most exciting thing being 'not doing it'.

As Gould's condition deteriorated, so did his relationship with Warhol. According to Bernsohn, whom they were both consulting about the relationship,

> Jon was trying to get more in touch with his inner soul and he wanted Andy to do the same, but Andy wouldn't let go of the ego, the glitter, and the fame. He got frightened and Jon would get mad because he didn't have the balls to let go. He felt stifled and choked by Andy, who he felt was holding him back.

Their relationship changed dramatically. 'Every time I met Jon he was becoming crazier and drunker,' said Daniella Morera. 'I saw him fighting with Andy, becoming very wild, jumping and screaming and running and answering Andy in violent ways. To see Andy associated with this electricity was too much.'

To Suzi Frankfurt, 'Jon Gould was a really unsettling influence on Andy, very demanding, and Andy wasn't used to people being so demanding. I think he was very disappointed by that because he was madly in love with Jon.'

'Jon was such a yuppie I was shocked,' recalled Benjamin Liu, 'I said, "My God, Andy!" but I found Andy hilarious in that sense. But Jon was a big influence on Andy's life, so was Christopher Makos, and since Christopher introduced them, whenever difficult situations arose he brought them to Christopher.'

'Sometimes we would share a taxi because we lived near each other,' said the Factory staffer Jennifer Chaitman, 'and riding uptown he'd always say, "So, you have any boy trouble?" And he'd always hear your set of boy problems and then he'd whine, "Oh, I have so many boy problems." '

'Andy's life always had to have a buffer in it,' Benjamin explained,

> whether it was a tape recorder or a camera, even in the relationship with Jon

<p style="text-align:center">467</p>

Gould. I was invited out to be the buffer or Christopher was. It made him able to judge and think, and not be emotionally involved. Because whenever he described sex he would say, 'Oh, sex, it's just one body on top of another and they're sweating, it's so dirty.' And I always thought maybe he was that standoffish about everything.

In early 1985, Gould had a medical crisis and nearly died. He was in New York Hospital for several weeks. Despite Andy's aversion to hospitals he visited Jon daily, often staying for hours, drinking tea and drawing. He gave a number of drawings to Jon's nurse Janice, in the hope that she would take special care of Jon, but having no idea who Andy was she threw them all away.

When Gould was released, feeling he did not want to waste any more time waiting for Andy to move on, he left East 66th Street and moved to Los Angeles, where he was hoping to produce some films with spiritually positive themes. It was evident to his intimates that Andy was very hurt by Jon's departure and particularly by the way in which he left. He told Andy he was going to California for a week, then called to say he was staying for two weeks and then never returned. While sympathetic to Jon's plight, Andy felt terribly betrayed. 'When is he coming back?' he would woefully ask Bernsohn, who didn't want to tell Andy that Jon was travelling back and forth between LA and New York regularly and simply did not want to see him. 'Why doesn't he call?' Andy would plead. 'Andy was very, very hurt by Jon,' Bernsohn recalled.

Soon Warhol returned to his old method of wiping the person out of his life and progressively dropped Jon's name from his vocabulary. Those in the know around him were careful not to mention it because they knew it would only hurt his feelings. The end of this affair was a blow from which Andy never fully recovered. When Gould died in September 1986 Bernsohn, who broke the news to Andy, found his reaction 'quite neutral'. However, in an interview he gave that year Andy admitted to being a romantic. 'My heart's been broken several times,' he said.

*

In 1985 Warhol's relationship with Basquiat was levelling out. Andy had grown increasingly cynical of Jean-Michel's response to his sudden success. Basquiat had become a flagrant spendthrift, wearing expensive Armani suits to paint in, travelling in limousines from which he once threw bums $100 bills, dining in the most expensive restaurants, and drinking $500 bottles of wine, while continuing to take a lot of drugs and be arrogant and rude to everybody around him. According to Liu, 'He had fallen asleep at dinners or on their social outings and also Andy, being a manipulator, always knew when a person's time frame was up.'

Andy had begun to torture Jean, on one occasion making him order dinner for six people in Basquiat's suite at the Ritz Carlton Hotel for $1,000. In March 1985, during a lavish dinner party at the Great Jones Street loft on the eve of Basquiat's second Mary Boone show, Andy had commented with syrupy irony how much nicer this scene was than the old Silver Factory, and how much Jean-Michel had learned about wine. For his part, Basquiat had started to express anger and confusion, stemming from his own cultural and inner turmoils about being 'used' by the rich, as thinly veiled resentment about being used by Andy. And he was continuing to blunt his rage with drugs, giving a basis to whispered rumours that he would soon die of an overdose, or ennui.

Emile de Antonio: 'To most people Jean-Michel had dominated Andy and Andy had been victimized, but I saw it quite the other way. I came to the conclusion that Andy was the prime mover of a fairly evil thing in relationship to Jean-Michel.'

According to Paige Powell, after Jean-Michel read something in the *New York Times* by the critic John Russell about his second Mary Boone show saying that he had become too obviously influenced by Warhol, he stopped talking to Warhol and never really talked to him again. During this time he tried to do whatever he could to get back at Andy and the only thing he could think of was not paying his rent, so until Andy's death in 1987 Jean was always tardy and made it very difficult to collect. Andy's reaction to this was ambivalent. On the one hand he was, as always, hurt and upset, on the other hand he was somewhat relieved. He told Paige that it was better not to have Jean around the Factory too much. There was a sense that he still had a certain fear of Jean because he was black and because he was on drugs all the time. There was always the possibility that he might become violent.

By September, when their show of collaborations opened at Tony Shafrazi's gallery, the Warhol–Basquiat relationship had disintegrated to the extent that neither man spoke to the other at the opening and Basquiat did not even bother to attend that night's dinner party at Mr Chow's. The following day, he called the Factory wanting to know exactly how many square feet the Great Jones Street loft was to make sure he was not being overcharged. Soon Jean started complaining about Andy a lot to anybody who would listen.

The Warhol–Basquiat show was drubbed by the critics, who turned their rancour on Warhol for another of his 'manipulations' and on Basquiat for allowing himself to become an 'art-world mascot'. Andy, complaining that Jean-Michel was 'just too peculiar' to work with any more, returned to his own projects, and Basquiat's career fell into a long, nearly disastrous hiatus.

Andy was putting a lot of artists down. Cy Twombly was rich because he married a rich woman, he told a friend. Andrew Wyeth married rich too. And Kenny Scharf was doing just as many bad works as Jean-

Michel. He thought several painters whose names were big would not be around the following year, pointing out that you didn't hear very much about Jean-Michel or Schnabel any more. He said Jim Dine stank and all those people at the Blum Hellman Gallery stank because they were so Jewish.

Andy kept busy. The week after the opening at Shafrazi's, Warhol's exhibition Reigning Queens opened at Castelli's small uptown gallery where he had first exhibited Flowers in 1964, but Andy seemed to have little regard for the paintings of the queens of England, Denmark, the Netherlands and Swaziland, which had been executed entirely by his assistants following his instructions and are among the dullest of his portraits. Standing at the opening in a ripped Stephen Sprouse tuxedo, white sneakers, black jeans and a turtleneck sweater spattered with paint, Warhol told an acquaintance, 'I got a terrible review in the *New York Times*. They're trying to say I was a bad influence on Jean-Michel, but the paintings were good. Better than this junk. This is just trash for Europeans.'

To a British reporter, Adam Edwards, who got the impression that 'the artist doesn't give a tuppeny jot if her Majesty likes it or not', Andy commented he'd done the four paintings because 'I did drag queens before so why not real ones?'

'Shaking hands was like grasping a dead sprat and his pale emotion-less eyes peered from behind horn-rimmed spectacles,' Edwards recalled. 'Warhol whispered in a mid-Atlantic monotone . . . and at one point he became so bored with his royal portraits that he forgot who they were supposed to be.'

To another reporter, who asked if he was one, Warhol replied, 'Every-body knows that I'm a queen.'

EVERYTHING IS

BORING

1985–86

Andy's not angry inside, he's just lonely and he's bored. That's the worst fate there is. It happened with Andy because he cut his feelings, his intelligence.

VICTOR HUGO

At the same time Andy was losing Jon Gould and torturing Jean-Michel, his relationship with Fred Hughes hit a bad period. Benjamin thought it was mainly caused by the burden of financing the new Factory. 'Fred had a lot to do with finding the place and planning it and Andy was not as pleased with it as people hoped he would be. It wasn't an artist's loft, it was more like an office, so that was a gripe he had.' He made no secret of how much he hated the renovators and was often in a complaining, angry mood. It seemed to Benjamin that he was 'bogged down by finance. He would say "Oh, no, I've got to do so many prints because I have to pay for this. I just wish I could do less." There were lots of print projects and shitty portraits and he was feeling stifled.'

According to Makos, 'He was tormented by being unable to come up with new sculpture that was as original and important as his Brillo boxes of the early 1960s.' He even complained to his brother Paul the last time they met about his $60,000-a-month mortgage. Paul felt so sorry for him he offered to lend him money.

'Getting rich isn't as much fun as it used to be,' Andy reflected. 'You spend all your time thinking about making the payroll and moving the cash flow and knowing everything about tax laws which seem to change every year.' However, on another occasion, after complaining to a reporter from *Stern* magazine, 'I give most of my money to the government,' he burst out, 'But what am I saying? This is a wonderful, magnificent country. They should take all my money! Really, they should take everything, considering how beautiful and gorgeous America is!'

The chief target of all this complaining was of course the man responsible for his financial situation, Fred Hughes. Andy's nephew George Warhola, who worked at the Factory as a maintenance man in 1985, recalled asking Augusto, ' "How come Fred's never around?" All the

471

time I was up there he was never around. And Augusto told me Andy was fed up with Fred's drug problem. He says, "He's disgusted with Fred, Fred's no good," he says. "Your uncle is planning on getting rid of him." ' (In all fairness, Augusto had by this time developed a drug problem of his own and was becoming unreliable.) 'Fred was pretty heavy into both drugs and drinks,' according to Emile de Antonio, because they kept him going. And Fred's behaviour had become erratic. 'Fred often disappeared,' Heiner Bastian recalled. 'After one night in Berlin Andy called in the morning from the hotel and said, "Can you come? Fred disappeared in the night to some other place and we don't even know where we're going." '

Michelle Loud, who worked on one of Warhol's photo projects that year, recalled that Andy was driving Fred crazy because he was becoming so forgetful as he got older that Fred had to act more and more as a buffer for him. 'Fred had to have drinks with the most horrible, crazy people all the time,' she said, 'who laughed loudly in a totally false way and obviously really only wanted to see Andy.'

'After Jed left it got particularly hard for Fred,' said Suzi Frankfurt.

Because Jed had some semblance of civilized behaviour and could get Andy organized, but after Jed left, Fred had to handle the whole break-up and everything else. He was put in a very hard position and I don't know how he did it. Andy owed so much to Fred. It was such a fantastic partnership, but Fred blew it because he was drunk and stupid and I think Andy probably did get fed up with him.

According to Daniella Morera, 'Fred had no more respect for Andy. It was like an old marriage. "Oh, Andy, yuch! What is he doing? Oh, don't listen to him!" It was really disrespectful. Fred was completely not listening. His attitude was, "He's an old, pathetic creature." '

What most people did not know was that both men were seriously ill. Fred had a minor attack of multiple sclerosis in 1983 but hadn't told anyone about it, had little idea of what to expect from his future and was very depressed. And Andy's gallstones, which had bothered him on and off since 1973, were acting up so badly that on at least one occasion he had to cancel a series of interviews because he was not feeling well. Both men tried to ignore their physical problems as if that would make them disappear. But perhaps in a way, they drew them closer together. Benjamin Liu:

Andy would always say that if anybody deserved anything that he had made through his career it was Fred. 'Fred made the business.' And he didn't say it once, he said it many times, and I know he meant it and that's the bottom line. He would also say to me, 'Oh, you know, when I got shot, it was Fred who gave me mouth-to-mouth resuscitation.' He might have criticized Fred for not being prompt or because he was bombed at the party the night before,

but these things are common when people are married to each other for so long and behind closed doors those two could sit down and not even have to mend their bridges, they could get down to business.

Still, the tension that always existed at the Factory spread through the staff. Vincent Fremont, married with two children, was the only really solid person there. Andy relied on him heavily. The others were an unpleasant bunch of misfits who made everyone and each other uncomfortable. Brigid Polk, reduced to the position of receptionist, was fondly known as the Dragon at the Gate and still had one of the nastiest mouths in New York City even though she wasn't drinking. Christopher Makos was a mainstay although everybody else at the Factory despised him for his rude, arrogant manner; even Andy had become somewhat disenchanted with him after he discovered that Christopher had been overcharging for printing his photographs. They maintained the relationship of brothers who fought constantly and hard but seemed to thrive on it. Gael Love, who had been working in minor capacities for Warhol since 1972, was the new editor of *Interview*. Short, overweight, married to a cheese manufacturer, she was, in some ways, a fire-breathing monster in the Bob Colacello image, but the magazine was flourishing under her direction, making more money than ever before, even as it took itself less seriously, turning what one observer described as the 'ditsy, fun, distracted kind of semi-attention' it gave its story subjects into an entertaining magazine style. Everyone who worked for her hated her. Andy hated a number of his employees, particularly *Interview*'s fashion editor Kate Harrington, who made a practice of taking home expensive designer outfits and wearing them to parties. When she was raped one night Andy wondered out loud if the rapist had liked her Armani gown. George Warhola summed up the scene like this:

> I was observing what was going on and the more I watched the less I liked. They didn't take Andy for himself, they always wanted something from him. *Interview* was a mess. There was no control whatsoever. A package would come and nobody knew who ordered it and I said, 'Well, send it back.' They said, 'Naaa, it's OK. Just leave it.' Andy has a lot of money, that was their attitude. Those girls on the *Interview* side were careless. They used to leave anybody in. In fact one time I found the door open with a stick in it and I found a box of prints outside the door with the rubbish. It was an inside job and I had an idea who did it, but you can't accuse anybody, you have to catch them. It was ridiculous. I said to my uncle, 'Get rid of that new kid, the kid's no good.' Everybody was grabbing. He couldn't trust anybody up there. They oughta give the Factory a big enema, blow it out, clean it out, it was getting worse in the eighties and I didn't see it getting any better.

Of the new staff members Andy became friendliest with Wilfredo

Rosado, Harrington's 22-year-old assistant, who became another surrogate companion to Andy after Jon Gould died. Andy would take him along as his date to art openings and evenings at the new clubs like Area and Limelight which had opened in the vacuum left by Studio 54. Wilfredo enjoyed the attention if not all Andy's antics. Phoning Wilfredo and finding him upset over something his boyfried had done, Andy would typically call the boyfriend, find out exactly what happened, then call Wilfredo back to stir up more trouble.

On one occasion, Wilfredo felt Andy intentionally embarrassed him by inviting him to a cocktail party at Yves St Laurent's apartment at the Hotel Pierre without telling him that the dress was black tie. Wilfredo, who arrived in jeans and a leather jacket, spent an uncomfortable evening watching the leaders of fashion drunkenly gorging themselves on caviar while Andy teased him about what beautiful lips and eyes he had.

Another night Wilfredo expressed concern over a problem. Andy, very sympathetic, took him to dinner that night, and Wilfredo explained that he had not told his parents he was gay and did not know what to do. 'Tell them you don't like women,' Andy suggested. 'You don't have to say you're gay, just say you don't like women because they smell.'

Paige Powell, the attractive *Interview* advertising representative, who also became a regular social companion of Andy's during this period, commemorated Andy's meddling ways by naming her pet dog Andy Trouble.

Andy did not live in a pleasant world. Most of the people he saw would have killed each other for money, glamour and fame if it had not been against the law. They were sarcastic, scornful and contemptuous. The most hated were the most successful and the cleverest put-downs the most applauded.

Still, Andy made the best of it. Benjamin, who had been going out with him almost every night for the past two years, recalled:

One thing he taught me was to accept all possibilities and what I liked about it was you jumped from one situation to the next. We could be attending a party for dogs and the next thing we'd wind up at some fancy restaurant, and the next thing we were on a one-to-one basis with some porno star, and so on. It just went on and on and that vision was more valuable to me than anything else.

But even Benjamin came to the end of his tether with the repetition that filled Andy's life. 'There was not much experimentation. The public cycle got very repetitious and after a couple of years it became a yawn.'

Despite the problems, the constant turnover, his approaching illness and financial worries, Andy kept up the relentless pace through 1985 and 1986 and gathered around him a whole new group of people, like

the writer Tama Janowitz, the fashion designer Stephen Sprouse and the pop star Nick Rhodes of Duran Duran. 'I love him, I worship him,' Andy told a reporter. 'I masturbate to Duran Duran videos.'

In actuality, Andy pressured Nick Rhodes into staying at Steve Rubell's posh new hotel Mortimer's, conveniently located around the corner from Factory IV, to hire the biggest limousines and to take Andy with several friends out to expensive restaurants for dinners during one of the band's New York engagements. Rhodes had a good time with Warhol and learned a lot (Andy advised him to weigh rather than read his press clippings), but it cost the British rocker several thousand dollars.

'Andy's really sweet,' said the pop star Boy George during one of his New York visits when he was a heroin addict.

> He's one of the few ones who just kinda is what he is. Andy's clever. It's like you're in the court of King Andy. When you're with Andy Warhol, he lets you use him. It's the thing he's been doing for years, and it benefits him, which I really admire. And I'm sure he wouldn't be offended by my saying that.

Andy loved hanging around with rock stars. He attended the secret wedding of Madonna in Los Angeles and flew up to the wedding of Maria Shriver and Arnold Schwarzenegger with Grace Jones, who told him she intended to fuck all the Kennedys. He was still astounded by celebrity. Sitting at Nell's one night with Bob Dylan and Sting he turned to Paige Powell and whispered, 'Do you believe who you're sitting with?'

Despite this eager, supportive scene, Andy's health-conscious attitude, great look and the renewed interest in his work, with commissions for shows in Britain, Italy, Germany, Japan and Australia as well as the United States, his intimates could tell that, in the wake of his break-up with Jon and the break-up of his collaboration with Jean-Michel, Andy was suffering from some kind of terminal melancholia. For all the frantic activity around him, he was increasingly alone. Evenings often ended early as he returned to his bedroom to watch television, play with his make-up or try on one of his four hundred wigs in the large oval mirror of his dressing table, cared for now only by the two well-paid Filipino maids, Nena and Aurora, to whom he rarely spoke. And how unlike the popular notion of Andy Warhol that bedroom was, as John Richardson described it:

> The room abounds in late-eighteenth and early nineteenth-century furniture of museum quality. Apart from a nymph-embellished chimneypiece after Canova, most of it is American. There is a grandiose chest and desk by Joseph Berry, the Philadelphia cabinetmaker; a megalomaniac's cheval mirror that would overpower anyone who wasn't wearing a full dress uniform or

ball gown; a vast armoire for Andy's vast collection of blue jeans, leather jackets, and sneakers (some of them dyed black for evening wear); and not least a large Sheratonish four-poster bed with a painted cornice and fringed hangings of cocoa-coloured stuff.

When Richardson first saw the room he could, he recalled,

more easily have imagined a *dix-huitième* dowager in a mobcap ensconced in this formidable bed than the maker of films like *Blow Job* . . . One last detail: the basket by the fireplace overflowing with dog's toys – rubber mice and squeaky bones – belonging to Archie and Amos, the two miniature dachshunds that were regularly shuttled between Andy and Jed Johnson after the latter moved out. The dogs were his boon companions – poignant relics of Andy's private life, and the only living things to share his bed.

'He loved routines,' Dr Bernsohn commented, 'but there was a part of him that was depressed and tired of routines, and he couldn't break the pattern.' In the eyes of Victor Hugo Andy was facing

the worst pain of all – the pain of boredom. Andy hung around alone. There was no one that came close to his level. His mother was dead. There was no one. He was the most interesting human being I ever knew and the only thing I can say about him is, Andy was afraid of people. A year before he died I said to him, 'Listen, I love you and check it out, I don't want to know your private life but you are making a great mistake. You can be more happy.'

In the end it seemed that the overriding emotion of Andy's self-penned script was the same one he had keenly felt as a child when he had started out by cursing everybody around him – disappointment in people.

The extent to which his belief in God comforted him in his isolation is of course impossible to say. He confided in no priests and was only rarely known to make as extreme a statement of belief as he did to Ronnie Cutrone in 1982. Yet in his own way Andy may have passed through life without being disappointed by God. Catherine Guinness remembered that 'if one talked to him on Sunday evening after he'd been to church he was a lot nicer and less cynical'.

'One thing I miss is the time when America had big dreams about the future,' Andy wrote in his book of photographs, *America*. 'Now it seems like nobody has big hopes for the future. We all seem to think that it's going to be just like it is now, only worse.'

When acquaintances asked how he was feeling, the typical reply was, 'Oh, everything's boring.' When they asked about his painting, Andy would say it was 'terrible'. When he went to private screenings he would usually fall asleep and snore so loudly that Wilfredo, or whoever was with him, would be torn between the embarrassment of waking

him up and that of everybody else in the room knowing he was asleep. 'He kept saying he had to pay the interest on the loan,' said Liu, who kept in touch with Warhol after he left the Factory. 'Money was always on his mind. Money was his mind.'

He also appeared to be thinking of the past a good deal. One day they were walking past an apartment building on 15th Street close to Park Avenue and he said to Benjamin, 'I used to come here. It was one of my first boyfriends.' He brought up his mother's death a couple of times too. He still felt bad about that. He no longer saw many of his friends from the seventies and was confused by the whole concept of what a friend was. Bianca Jagger, who used to think that Andy was magic, beautiful and charming, now thought he was only attracted to glitter and was a vampire. His aides found it increasingly hard to be around him. Christopher Makos was annoyed that though he and Andy were not lovers, Andy treated him like a lover with jealousies and demands. He complained that he had to reassure Andy that he loved him so often he 'just couldn't do it any more'. Wilfredo Rosado, too, was feeling trapped, as everyone finally came to feel, in his fantasy relationship with Andy.

Asked by a reporter who his best friend was, Warhol replied, 'I don't have a best friend.'

'Do you have a close friend?' the journalist persisted.

'No, I don't really have a close friend,' Andy said.

He seemed to be making overtures to get closer to his family. Apart from a brief weekly phone call from John, he had had little contact with them since Julia died. George Warhola, who left the Factory at the end of 1985, noticed:

When I was last up there he was asking, 'How's everyone?' I think he felt since he was getting older he wanted to know how everybody was. He said, 'I'll pay you to stay. I'll take care of you, whatever.' I said, 'Oh, Uncle Andy, it's not the money,' I says, 'I'd do anything to help you out if I could.' I felt bad for him because the crew he had up there were out for themselves. To be honest, I don't think Uncle Andy was very happy at all. All that money and fame didn't make him happy.

He offered me anything if I wanted to stay. When I told him I was going he says, 'Aw,' he says, 'once you go back,' he says, 'you'll stay home.' The truth is, I didn't feel very comfortable with a lot of those people, they kind of didn't want you there.

After George left Andy employed another nephew, John's son Donald. He too left. 'Andy felt so bad Don didn't want to stay,' recalled John. 'Four Sundays in a row he says, "Didya ask Don why he went back home?" He says, "Maybe he thinks I didn't give him enough money. Gee, if Don hadda stayed there I was going to put the *Interview*

business over in his name." ' John thought Andy was moving more and more towards the family in his last couple of years.

He was lackadaisical about the publicity tour for his new book at the end of 1985, *America*. Disappointed by its layout, he told Makos, who accompanied him on the four-city junket, that he thought it was 'ugly', and commented to a reporter in Washington DC that 'my editor is making me do this'.

'The inanities had ceased to charm, having reached a brutal apotheosis with the picture book, *America*,' wrote the critic Gary Indiana. 'Lately, Andy had resorted to flirtation.' Criticism of Andy took a more threatening form when a girl rushed into a book signing he was holding at Rizzoli's in New York, ripped off his wig and made a clean getaway in a waiting car. According to Fremont,

> Andy was very cool. When they pulled the wig off he just put his Calvin Klein hood up, didn't move, and kept writing. I thought that was just the most terrible cheap shot. It must really have upset him. He didn't like strangers getting too close to him anyway. We found out it was two Spanish waitresses and one guy. They mailed us letters from Spain trying to apologize, but it was such crap we never acknowledged it.

A trip to Paris was scheduled in March 1986 with Makos and Fred Hughes, for the opening of a show of Statue of Liberty paintings Warhol had made to commemorate the 100th anniversary of the gift of the statue from France to America. Christopher Makos:

> Towards the end, Andy used to pack only black clothes, but since everything black tends to look the same, he'd end up packing clothes that were dirty or torn . . . The first thing Andy would do at a hotel was order room service. Andy really was a princess. He'd order tea, and sandwiches that he could pick apart. During the last trips he'd order only camomile and rosehip tea until you were ready to drop.

The trip seemed to lift his spirits, though Makos returned with added complaints about Andy's insecurities and demands, referring to him as 'that mad old queen'. A week after his return Andy was depressed again. It was snowing, wet and cold, the kind of weather he hated, and he told a friend this was the last trip he would take Makos on because he had been so unpleasant. He didn't care about him any more, he said. 'More than anyone else I ever knew, Andy talked about being let down by someone, or being disappointed by someone,' recalled Heiner Bastian, 'and in the last two years of his life I thought he was more miserable.'

Knowing how much he hated holidays, Paige Powell arranged for him to visit the Church of Heavenly Rest on Thanksgiving, Christmas and Easter to serve the homeless dinners with Wilfredo and Stephen

Sprouse. 'Andy dragged around garbage cans and poured coffee,' she recalled. 'And he did something that wasn't on the programme – he found Saran Wrap so people could take food home.'

'He just loved doing it,' said Wilfredo.

A group of little black kids came in late and he ran into the kitchen and took aluminium foil and wrapped up all the extra cupcakes and stuff and gave it to the mother for them to take home. That was the first time I ever saw him in an environment where no one else knew who he was, and he just loved it.

Andy especially liked the little old ladies who hung around the soup kitchen, another friend recalled, because they reminded him of his mother.

GOODBYE

1986–87

In Warhol's face you see the horrifying price he has to pay.
To exist as a shell. Destroyed by one's own work.
<div align="right">RAINER WERNER FASSBINDER</div>

Andy's state of mind surfaced in the themes of his last works. Apart from the obvious connotations of 'The Last Supper' and the other religious paintings he worked on in 1986, the most striking example was in his last series of self-portraits completed that summer, some of them printed on a camouflage background, based on a photograph in which his hair was teased into a halo of dishevelled-looking Rasta peaks. When Ronnie Cutrone saw the painting he commented that Andy had succeeded in 'getting his wildness back', but others thought the image looked like a death mask. 'The new painting is like Warhol's great self-portraits of the sixties, candid and disturbing,' wrote John Caldwell, who purchased one for the Carnegie Museum in Warhol's birthplace, Pittsburgh.

> It is, in a sense, too self-revealing; he looks simultaneously ravaged and demonic, blank and full of too many years and too much experience . . . Warhol's face seems over-lit, almost dissolving in light, like a photograph on a sheet of newspaper held over a fire and about to burst into flames. Along with the obvious coldness and matter of factness of the image there is about it a kind of poignance and we feel that Warhol himself, like his self-portrait, is immanently perishable.

According to George Warhola, Andy looked a lot like his mother Julia in the pictures. 'I paint pictures of myself to remind myself that I'm still around,' Andy said.

The self-portraits were shown at the Anthony d'Offay Gallery in London from 8 July and Andy, Fred Hughes and Christopher Makos attended the opening, which was widely publicized in the British press. Warhol's arrival in the UK was greeted by the standard scandal the British had come to expect from the pop king. This time he was facing a lawsuit from the city of Oslo in Norway over an appropriation he had painted of Edvard Munch's 'The Scream' in 1984.

'Andy Warhol is the world's most famous artist,' said Anthony d'Offay. 'He's also an art hero. An art hero is someone in whose life

you perceive something extraordinary and brave. When Andy walked into the opening reception lots of people burst into tears, because he was a living legend.'

'I don't like looking at myself,' Warhol said. 'It's hard to look at yourself. This is just weird stuff. If it wasn't me in the pictures the exhibition would be great.'

'Warhol has always been much more than a magnet,' wrote Polly Devlin in the *International Herald Tribune*. 'He is like a terrible prophet of doom, like that rock which the ancients thought an oracle, and through which the perpetual wind boomed the sound "endure".'

During the days surrounding the opening Andy was the toast of London at parties at d'Offay's home, the Café Royal and Mr Chows, where a dinner for forty was arranged to celebrate the show and the completion of Andy's portrait of the restaurateur's wife Tina.

When Andy returned from England he seemed to have found some kind of serenity. It was the first time he had made a statement as a painter since the hammer-and-sickle paintings of 1977 and the first time he had done a whole show of himself (one of his favourite subjects since he was a child). '1985 and 1986 were really big years for Andy,' recalled Vincent Fremont.

> Things were going better and better. Paying the mortgage every month was becoming less of a strain. Things were really moving on lots of fronts. He wanted to put money into making movies again. We bought the rights to Tama Janowitz's bestseller *Slaves of New York*. Andy got very keen on that and wanted to get the rights to some other books. The producer Erica Spelling took Andy, Tama, Fred, me and our agents to lunch at the Russian Tea Room. We were being courted and Andy loved that. He was interested in television. The producer Fred Friendly wanted to do a big daily TV show on Andy and Andy was really intrigued.

'The great unfulfilled ambition of my life is to have my own regular TV show,' Warhol had said repeatedly for the last ten years. *Andy Warhol's TV* had been on cable since 1980, but it had never taken off commercially. For a person as ambitious as Warhol, who was saying he wanted his own satellite, that made it a failure. Now the project was showing promise once again under the supervision of Vincent Fremont. 'Andy was very involved in that,' Vincent remembered. 'He was very critical, analytical and correct.' Although the shows were never picked up by a network, Vincent felt that Andy's investment in them was well placed, because 'being on cable TV opened up a whole new audience of twelve- to fifteen-year-old fans. We got tons of letters from high-school teachers saying one of the first names that came up in art class was always Andy Warhol.'

Meanwhile, the Whitney Museum's John Hahnhardt was busy organizing a retrospective of the Warhol films of the sixties. With the enor-

mous success of MTV, Warhol television projects now also included making videos for popular rock bands like the Cars. Andy's cameo appearances in some of these videos kept his name and face in the minds of the young rock audience.

Interview magazine continued to expand and popularize his world. And, as Carter Ratcliff wrote about the journal in *Artforum*, it was still a controversial publication:

> Now *Interview* is his greatest triumph: the vehicle of his constant presence in the media, the sign that he is part of the machinery generating the *now* that absorbs and degrades so much of our energy and our history.
>
> The *now* is the region of scarcity, hyped demand, and inflation . . . It is a place of fear – not fear of death but of non-being, of surviving unnoticed in a deprived and diminished state. Inflation induces this fear in each of us. It doesn't simply devalue our currency. It devalues us. *Interview* is an example of how this works . . .
>
> Warhol is a leveller but not an egalitarian. From cover to cover, *Interview* is an exercise in refusing to acknowledge the full existence of anyone or anything . . . Nothing is noticed, save to diminish it.

Despite the attention he was paying to the entertainment business, Warhol's main direction was undoubtedly painting. During the last half of 1986 he finished his series of 'Last Supper' paintings, to be shown in Milan early in 1987, and did, among other works, a set of Lenin portraits which were to be shown in Munich a month later. He was also making his first serious foray into photography with an upcoming show at the prestigious Robert Miller Gallery in New York. Meanwhile the DIA Foundation had just closed a show of his 1963 disaster paintings and were planning a show of his called Hand Painted Images (1960–62) to open on 5 November. His auction prices reached a new high when '200 One Dollar Bills' sold for $385,000. As Fremont said, '1987 would have been a huge year.'

In November, John and Marge Warhola came to visit him for the last time. 'We never went up there in the wintertime,' Marge recalled, 'because John never liked to fly during bad weather, but that particular winter right before Christmas the stores were all decorated and we went up and he was sitting on the steps as he usually did, he always sat on the steps when we talked, and he says, "Are you enjoying yourself?" ' Marge told him stories about their dog and made him laugh. She thought he was looking very well.

'About six months before he left Andy found the balance he had been looking for and he wanted to look at the world for a while,' said Dr Andrew Bernsohn. 'I think he was very happy. He really enjoyed himself that last six months. He was much more centred and strong, he became like a ballerina, and that's why he was able to move again.'

The photographs for his show at the Robert Miller Gallery were being

hand-sewn together in multiples of four to twelve by Michelle Loud, who had been recruited as a seamstress by Makos. Noticing that most of Andy's clothes appeared to be ripped and torn she offered to sew them up for him too and Andy said he would bring some in soon. Outstanding among these works were another self-portrait and a photograph of skeletons.

'His talent to catalogue in paint, in print, or in film, all that went on around him still surged,' noted an old friend, Nicholas Haslam.

> Leaving a restaurant after our last lunch together we saw in Manhattan two nuns in elaborate habits, shovelling snow off the sidewalk. Andy levelled his camera. 'No, no,' shrieked the nuns, covering their faces with wimples. Andy shrugged. 'Gee, if I was a nun I'd *love* to be photographed.'

In January 1987 the photographs opened to the best New York reviews Warhol had received in years. 'Warhol's art had an aesthetic distance "just beyond the reach of either passion or resolution",' wrote Andy Grundberg in the *New York Times*. 'If this essential quality has seemed diminished by repetition since the sixties, with these photographs he has found a way to restore its contemporaneity.'

'The sewn or stitched photographs are brilliant because they transcend in the most magical way possible the literal, mundane accuracies they convey,' wrote Gerard Malanga in the *Village Voice*.

> I was envious when I saw that exhibition because I wasn't prepared for what I saw. Those dangling threads have an eroticism and sexual nuance about them, as if they were symbolic pubic hair. He took some of the most boring, mundane photographs imaginable and by multiplying the images it was like the old Andy coming back, pulling it off with great flair. Again, what you have here is a commentary on the genre of photography and art. The way he put these images together left me ecstatic.

Not everybody was as enthusiastic. Vito Giallo recalled the strange jealousy that existed between Warhol and the photographer Robert Mapplethorpe:

> I had bought Mapplethorpe's portrait of Patti Smith from Babe Paley's daughter Amanda and Andy didn't like it. He said, 'That photograph isn't any good.' I said, 'It's Robert Mapplethorpe.' He said, 'Oh, that artist doesn't bring anything. Nobody wants his work. I don't like his work, it's just nothing, it's not worth anything.' And then Robert Mapplethorpe would say the same thing about Andy. When Andy had his show at Robert Miller Robert said, 'Well, Andy's not really a photographer. He's an artist, but he's not a photographer.'

However, in an interview after Warhol's death Mapplethorpe concluded, 'I think the art is finally the best of his generation. I think

in the end it is going to hold up in a way that people didn't think it would. I have always hated to admit it because he was such a stinker.'

The opening was packed. Andy stood behind the counter autographing catalogues and smiling at the crowd. It was the last time David Bourdon saw him. 'The place was jammed, and the shoulder-to-shoulder crowd extended all the way to the elevator bank. He was thinner than I had ever seen him, but he looked terrifically healthy, and that nervous little smile still darted about his lips.' The show sold very well and Andy was impressed by how hard the people at the Robert Miller Gallery worked and enthusiastic about doing more photo shows with them.

Two weeks later, on 22 January, Warhol was in Milan for the opening of his Last Supper paintings at the Alexandre Iolas/Credito Valtalinese Gallery. It was fitting that his last show was organized by the same dealer who had given him his first. 'As Christ said to all those priests, "Suffer the little children to come unto me," and Warhol is a horrible child,' said Iolas. 'He has helped America to get rid of its puritanism. He's an amazing person, and probably some day he will be considered a saint.'

Daniella Morera visited him in his suite at the Principe e Savoia Hotel.

> He didn't have the usual enthusiasm. I mean, as much as he could keep his beautiful, childish enthusiasm, Andy was really getting old and he was in pain from his gallbladder. We had a press conference in the morning before the show. The journalists said, 'Why are you doing Leonardo da Vinci, are you very much in touch with Italian culture?' And he said, 'Oh, Italian culture – I only know really the spaghetti but they are fantastic!'

Accompanied by Fred Hughes, who was, according to Morera, 'totally bored and annoyed and had had enough of being with Andy', and Christopher Makos, Andy received relays of well-wishers who came to sit by him, pay compliments and trade gossip. 'Very moving in his platinum state wig with a mauve sheen, making him look as if he were in half-mourning, Warhol seemed to be imbued with the importance of the moment,' wrote his old friend Pierre Restany. 'He greatly surprised me by saying: "Do you believe, Pierre, that the Italians are conscious of the respect I have for Leonardo?" '

'He hadn't been in Milano in more than ten years,' recalled Daniella, 'and three thousand people came. He was so sweet he was an angel, because he was in pain but he signed everything people gave him for four hours.'

John Richardson wrote after Warhol's death:

> Though ever in his thoughts Andy's religion did not surface in his work until he embarked on a series of Last Suppers inspired by a plaster mock-up of Leonardo's masterpiece that he found in Times Square. Andy's use of a

pop conceit to energize sacred subjects constituted a major breakthrough in religious art. Andy even managed to give a slogan like Jesus Saves an uncanny ring of urgency. And how awesomely prophetic is the painting, one of his very last paintings, which simply announces HEAVEN AND HELL ARE JUST ONE BREATH AWAY. In his impregnable innocence and humility Andy always struck me as a *urodso*, one of those saintly simpletons who haunt Slavic literature and Slavic villages such as Mikova in Ruthenia from which the Warhols stem.

As the lights from TV cameras shone on his face and played over the mob that thronged the Palazzo della Stellina as much to see Andy Warhol as his version of La Cena, he seemed in good spirits. There were no traces of the cynicism of the previous year. 'I think an artist is anybody who does something well, like if you cook well,' he told an interviewer. But it was noted that, especially for late-dining Milan, Warhol made a very early evening of it, returning before midnight to his hotel.

'The last two days Andy was in Milan he didn't go out of the hotel,' said Daniella. 'He was very much in pain, he was in bed.'

From Milan Warhol's party flew to Zurich. During a series of social visits Andy became so frightened of one woman, who he claimed was trying to kill him, that he cut short his stay and returned to New York two days earlier than planned.

*

As much as Andy became more humanized in the eighties, he could never escape the pervasive relationship with death. Reviewing his television show in June 1983, *New York* magazine noted that 'looking like death's ventriloquist, Andy Warhol has become his own macabre mascot, earning with his legend the right to do a little camera time. He uses Death, Death uses him.' And Andy certainly did not play down the image. In his 1985 interview with Fiona Powell in *The Face* he remarked that he was attracted to a certain kind of Italian lip stain because 'it's the stuff morticians use on dead people'.

When she asked him what was going to happen to his art collection when he died, Andy replied, 'I'm dead already.'

'No, you're not,' responded Powell. 'You're a living legend.'

'I'm not,' insisted Warhol. 'I don't think that's so.'

And he continued to maintain his noncommittal attitude towards those who died around him. When the popular editor of *Interview*, Robert Hayes, had died of AIDS in 1984, Andy was the only person from the Factory who had not attended the memorial service. He had also not attended Truman Capote's memorial service the same year. He had had no comment when Jackie Curtis died of a drug overdose in May 1985, when Ted Carey died of AIDS on Long Island that summer, when Mario Amaya died of AIDS in 1986, when Joseph Beuys died in

1986, or when Ingrid Superstar disappeared and was presumed dead in February 1987. But the truth was, death was closing in on him.

Andy's gallstones had worsened considerably by the beginning of 1987 and during January the pain began to slow him down. He had been warned that if he did not have an operation soon they could become life threatening, but he remained so terrified of hospitals that he constantly put it off. This lifelong fear, exacerbated by the operations he had suffered through after being shot, had become so strong that whenever he passed New York Hospital on his way to an auction at Sotheby's he would turn his head aside to avoid seeing it.

During the first week of February, the illness stopped him in his tracks. For the first time anybody could remember, Andy abandoned friends in the middle of a long evening of activities and hurried home in pain to his canopied bed.

On Friday afternoon, 13 February, he watched Brigid Polk wolf down a box of chocolates. 'I'm dying for one,' he confessed, 'but I can't. I have a pain.' The next day (Valentine's Day), Wilfredo called him at home to say he didn't want to go out that night as planned. He was amazed when Andy replied, 'I don't want to go out either.' Andy went out every night.

On Saturday, he complained of abdominal pain to his dermatologist, Karen Burke, who made a sonogram that showed his gallbladder was enlarged but not infected. He spent much of that weekend in bed, refusing to acknowledge his increasing discomfort to friends. When Victor Hugo called to complain of a three-week cold, Andy was all solicitation. Asked by Victor how he was feeling, Andy changed the subject.

On Monday, an aide recalled, as Andy came down the stairs of his home he said, 'I feel funny.' Asked what was wrong he replied, 'It's my stomach.' He cancelled all his appointments that day and did not go to work. Instead, that afternoon at the Chiropractic Healing Arts Clinic, Linda Li gave him a shiatsu massage that (Andy reportedly later told Karen Burke) sent one of the gallstones into the wrong pipe, causing him even more pain.

He was able to keep a Tuesday appointment to appear along with Miles Davis as a model in a fashion show for Aarston Valaja and Koshnin Satoh at a new club called the Tunnel. According to one of Warhol's studio assistants, Ken Leland, Andy's main concern was getting batteries for his camera so he could photograph the rehearsal, but his friend Stuart Pivar recalled that he was kept waiting for an hour in a cold dressing room 'in terrible pain. You could see it on his face.' While his imported cheering section clapped, Andy clowned his way down the runway, carrying Miles Davis's coattails like a bridesmaid as the great musician played his horn. When he came off, however, he almost collapsed in Pivar's arms, gasping, 'Get me out of here, Stuart, I feel like I'm gonna die!'

Despite the pain, Andy's sense of humour remained intact. On Wednesday, he stopped in at the Mel Davis dog-grooming salon on East 49th Street to have his dachshund's paws clipped. 'You look familiar to me,' Davis said.

'Yeah,' Andy replied. 'I'm the undertaker.'

The same day, he went to Denton Cox's office, complaining of having felt ill for four weeks. After a thorough examination, Cox had diagnosed Warhol as having an acutely infected gallbladder in danger of becoming gangrenous. Cox advised him to have the gallbladder removed as soon as possible, but Andy still chose to wait for several more days.

On Thursday he caught a chill, which aggravated his condition. A second sonogram taken that day by Cox found the gallbladder to be severely infected, inflamed, filled with fluid. They couldn't wait any longer.

Andy was scheduled to model for students at the New York Academy of Art on Friday as a favour for its director, his friend Stuart Pivar. Instead, reluctantly and in sworn secrecy, he had made arrangements to go into New York Hospital. It was scheduled that he would have the operation on Saturday and be out by Sunday. Apart from his closest aides, no one, not even his family, was to know.

'They're coming for me with handcuffs,' he told Andrew Bernsohn. According to Ken Leland, 'He told all of his doctors, "Oh, I'm not going to make it." When they tried to reassure him he just said, "Oh, no, I'm not coming out of hospital." ' He locked many of his valuables in the safe in his house before checking into the hospital on Friday afternoon. Yet he did not really seem to take this fatalism seriously. He told Paige Powell not to cancel their ballet tickets for Sunday night.

'Stuart Pivar sent his car to pick Andy up,' Ken Leland recalled.

Andy was in the back room rummaging through stuff and I was hurrying him up because the car was waiting. A gate outside his house was broken and he said he wanted to get it fixed once the weather was warmer . . . He didn't let on to me that he was scared.

At New York Hospital, we checked in with this lady named Barbara, who smoothed Andy's way into hospital, and she said, 'If you want to change your room, you can.' Andy just asked if there were any big stars at the hospital at the time. Barbara replied, 'You're the biggest.' He explained that he didn't want any visitors or anything, so she asked what name he would like to be disguised under. Because she was so nice, Andy said, 'Oh, make it Barbara.' She couldn't do that, so he said, 'Just make it Bob Robert.' So Andy's hospital name was Bob Robert.

Once in his hospital bed, Andy complained that he was cold. As Leland put his black leather jacket around him, he noticed that an intravenous bag of clear liquid had run out. 'Andy, are you thirsty, because your bag's empty?' he said. Leland alerted a nurse. Her 'oh

yeah' attitude was perturbing but Leland let it pass. Andy gave him the cab fare home.

According to a report compiled for the *New York Times* magazine by M. A. Farver and Lawrence Altman,

> After fifteen hours of preparation, Warhol's surgery was performed between 8.45 a.m. and 12.10 p.m. on Saturday 21 February 1987. There were no complications at the time – and none were found during the autopsy or by any of the doctors who have reviewed the case.
>
> Warhol spent three hours in recovery following surgery, and at 3.45 p.m. was taken to his private room on the twelfth floor of Baker Pavilion. For comfort, precaution and on the recommendation of Dr Cox, his regular physician, Warhol was placed in the hands of a private duty nurse, rather than the normal complement of staff nurses. He was examined during the afternoon and early evening by the senior attending physicians, who noted nothing unusual. Alert and seemingly in good spirits, Warhol watched television and, around 9.30 p.m., spoke to the housekeeper at his East Side home, a few blocks away.

Whether the private Korean nurse, Min Chou, remained at her post throughout the night is not known. Subsequent investigations have alleged that she did not, and that she failed to record Warhol's vital signs, urine output, and the time and dosage of painkilling drugs. New York Hospital has also been faced with allegations of neglect in failing to obtain Warhol's complete medical records; ignoring his allergy to penicillin by administering Cefoxitin, a drug which may cause similar allergic reactions; failure of the staff nurses to properly measure his fluid intake and output; and of hospital staff members to replace a malfunctioning suction device to permit reduction of fluids even after it was noted by a physician.

The chances of dying from complications of routine gallbladder surgery are thousands to one, but whether any of these factors contributed to Andy Warhol's death is uncertain.

According to Farber and Altman,

> At 10 p.m. and at 4 a.m. on Sunday 22 February Min Chou, the private nurse who had been selected by the hospital from a registry, took Warhol's blood pressure and found it stable. She gave a progress report to the chief surgical resident by telephone at 11 a.m., presumably while the patient slept.
>
> At 5.45 a. m., Ms Chou noticed that Warhol had turned blue, and his pulse had weakened. Unable to waken him, she summoned the floor nurse who, in the words of a colleague, 'almost had a stroke'. A cardiac arrest team began resuscitation efforts but, according to hospital sources, had difficulty putting a tube in Warhol's windpipe because rigor mortis had started to set in. At 6.31 a.m. the artist was pronounced dead.

*

INTERVIEWER: What would you like your famous last words to be?
WARHOL: Goodbye.

The Cable News Network broke the story of Andy Warhol's death at about noon on Sunday 22 February. There was no network coverage until later that day and the news was conveyed around the world in the interim by telephone messages of stunned disbelief enquiring if the rumour was true.

Vincent Fremont's wife Shelly feared that Vincent was going to have a heart attack when he heard the news. Most of those closest to Andy were almost as shocked and tearful as Fremont. By the early evening, throughout New York small groups had gathered to mourn.

New York artist Peter Halley spoke for many in an interview with Trevor Fairbrother.

Andy Warhol's dying bothers me. He really represented a standard of nonconformism, no matter how bad he might have gotten in terms of hanging out with jet-setters or whatever. Somebody said social life in New York was so staid before Warhol people wore tuxedos to go to cocktail parties, then went home. He singlehandedly shattered all of that. I'm almost worried about the New York economy, post-Warhol. Who'll want to come here? I hope that there's another figure in culture who is as smart as he was, someone who can fill such a popular role and be accessible to so many people, and still have something interesting to say.

The following day the newspapers splashed the story across their front pages, venerating Andy in hastily prepared eulogies. 'Andy Warhol, the soft-spoken king of Pop Art who turned soup cans and other commonplace objects into museum treasures, died of a heart attack yesterday,' began the article in the *New York Post*. 'Posterity may well decide that his times deserved him and were lucky to have got him,' John Russell wrote in the *New York Times*.

Others were less kind, as they had been when Andy was shot nearly twenty years earlier. 'Only in a culture where art has lost all seriousness and standards have become meaningless could an illustrator and self-publicist such as Warhol be accepted as an artist, much less a practitioner of "high art",' lectured one commentator. 'His life was about as exciting as celery,' wrote another. The obituaries that poured in from around the world in the following week were more balanced in their assessment, but then Andy had always been better understood outside America. Very little had changed.

The first to be alerted, Fred Hughes, together with his lawyer Edward Hayes and a security guard, arrived at the East 66th Street house shortly after 7 a.m. Fred had phoned Nena and Aurora, who were in tears when he arrived.

The safe was opened and Hayes began to pore over its contents –

Andy's will, his papers, the keys to safe-deposit boxes – while Fred, shaken, wandered around the clutter of the vast museumlike house, remembering.

Andy had been perhaps more meticulous in planning for his death than for his life. Most of the multimillion-dollar estate was to be set aside to fund the Andy Warhol Foundation for the Visual Arts. *Interview* and Andy Warhol Enterprises were to continue as non-profit businesses with Fred Hughes as chairman of the board and heir apparent. According to the terms of the will, Fred was to receive, in addition, $250,000, the same amount as was to be received by each of Andy's brothers.

At eleven o'clock, John Warhola called for his customary brief Sunday chat with his brother. Hughes, who was not aware of how close the brothers had remained over the years, answered the phone and, without warning or introduction, said, 'John, you're calling for Andy. Andy died.'

John was very shaken up.

I'll never forget the day I heard that strange voice on the phone. I said, 'Well, we're coming up, what happened?'
'Well, he died in the hospital.'
'Well, we're coming up.'
'Don't bother even coming to the house,' Fred replied. 'We're putting a padlock on it.'

'My brother called me and he kind of put it to me boldly too,' Paul recalled, 'he said, "Andy's dead." I says, "Andy who?" He says, "Andy, you know, your brother." John called at eleven o'clock, Andy was already dead for five hours. They didn't notify nobody, they went right over to the house and started rooting through.'

Paul called his son James, who lived in Long Island City, and told him to drive over to East 66th Street and find out what was happening. When James Warhola got there he found Ed Hayes rifling through Andy's possessions. Hughes told him there was nothing he could do to help and he soon departed, as bemused as John and Paul by the swift turn of events.

Daniella Morera:

I called Andy's house on Sunday morning and I heard Fred's voice on the phone and I immediately thought, What is Fred doing on Sunday morning at Andy's house? And he said, 'Oh, Daniella, I think you don't know this yet but Andy died a few hours ago.'
I started to cry. I said, 'Oh, Fred, can I go and see him, can I go and see him, please?'
And he said, 'No, no, Daniella, what are you saying? It's impossible. He wouldn't like that.' Fred was sweet with me because he heard that I was so

chaotic emotionally and he said, 'Daniella, calm down, calm down, we have to face this, we are very crazy here, it's already full of people and we are receiving millions of phone calls and I'm here with Vincent and there are all the lawyers . . .'

John and Paul flew to New York that evening. Though Hughes had told them not to come to the house because it was going to be locked up, they had determined to stop there anyway, and to stay there if possible. Paul felt that there must have been some conspiracy to murder Andy. Even John thought that something was not right about the way Andy had died. 'We got off the plane and went over to the hass and they were there rooting through the place,' said Paul. 'Ed Hayes was in his T-shirt sweating. I says, "Who are you?" '

They couldn't stay at the house, Hughes insisted. They would have to take a hotel room. They would meet the following morning to go over the papers.

Hiring Ed Hayes had been an absolute stroke of genius on Fred's part, thought Suzi Frankfurt, who had returned to New York from the country on hearing the news. She thought that Fred was probably a little bit in love with Ed and that Ed thought of Fred as the greatest American aristocrat.

Before meeting Fred and Ed that Monday, Paul and John had the grim responsibility of identifying Andy's body at the morgue. Paul recalled that Elliot Gross, the chief medical examiner of the city of New York, seemed agitated, pacing back and forth in front of his desk as if something was wrong, which only added to his feelings of apprehension. From there they took a cab to Hayes's office. Fred Hughes, who had arrived there earlier, tried to handle the agenda like a business meeting, urging John and Paul that if they signed a waiver promising not to contest the will they would each receive $250,000.

Paul, who believed accurately that Andy was worth $100 million, objected.

I says, 'Just a minute. You throw all this up and want me to sign that waiver. You don't even give me the courtesy of having counsel with me. I can't sign anything like that.Give me a day to think about it.' I says, 'You know Andy has to have a lot of money around because we know for a fact that his agents had brought suitcases full over to the Factory.'

John also felt pressured but when Fred made it clear that if they didn't sign the waiver, he had the power to negate their inheritance, John seemed ready to sign, although he had mixed emotions about Fred being in charge. Paul continued to object that he needed more time. Andy had separated his two brothers so intricately over the years that despite their suspicions, they could not confer with each other, and nothing was concluded.

'What about the funeral?' Paul asked. It had been Julia's request that Andy be buried next to her, and a plot had been purchased several years earlier at the St John the Divine Byzantine Cemetery.

'Oh, you can have the body,' Hughes replied.

Arrangements were made to transport the body back to Pittsburgh the following morning, after Gross had performed an autopsy.

'Dying is the most embarrassing thing that can ever happen to you, because someone's got to take care of all your details,' Andy had written the previous year in *America*.

You've died and someone's got to take care of the body, make the funeral arrangements, pick out the casket and the service and the cemetery and the clothes for you to wear and get someone to style you and put on the make-up. You'd like to help them, and most of all you'd like to do the whole thing yourself, but you're dead so you can't.

The 'embarrassing' details of death were attended to by Paul and John the next day. When they had first seen the body, Paul recalled that 'Andy looked as if he was asleep, but after the autopsy he didn't look too good'. It took the full-time efforts of the Thomas P. Kunsak Funeral Home staff to make him presentable for the open-coffin wake on Wednesday 25 February.

'The competition is sure jealous today,' the funeral-home director boasted to an astonished reporter. 'It was all the talk of the funeral trade about how I landed the Warhol body.'

Andy was dressed in a black cashmere suit, a loud paisley tie and one of his favourite platinum wigs. After considerable argument, Paul and John agreed that he should be buried in his sunglasses. The sight of Andy lying in a white upholstered bronze coffin, holding a small black prayer book and a red rose, struck one observer as 'Warhol's final discomfiting work'.

'When they came to the wake Ed Hayes grabbed me and he says, "Come here," ' said Paul.

He says, 'I understand you're not satisfied. I mean, what'dya want?' I says, 'Well, I'll tell you, Mr Hayes, this isn't no place to talk about it. We're still feeling bad about Andy passing away. Can't this wait a little later?' and then he left. It had done me a lot of harm because I got up in the middle of the night shaken up thinking, Why would somebody want to snuff out Andy's life? He had so much potential to go.

Marge Warhola told Fred:

Andy's life and death was a mystery. He says his life was no mystery, but it was, because people thought him other than what he was. In Pittsburgh people really thought he was a playboy, because they've seen him in pictures

with different girls on his arm, they thought he was like Hugh Hefner, and this was the opposite . . .

Fearing that gatecrashers might interrupt the services, Paul and John posted a guard at the door of the funeral home. But the mourners who attended the wake and the funeral the next day were mostly Andy's relatives and their friends from Pittsburgh, among them Joseph Fitzpatrick, Warhol's art teacher at Schenley High School. Though baskets of orchids were sent by Leo Castelli, Mick Jagger and Jerry Hall, and the staff of *Interview*, only Fred Hughes, Brigid Polk, Vincent Fremont, Paige Powell and a small contingent of staff members attended on behalf of the Factory and none of the bright names Andy had so happily associated with were there. The Warhola family had issued no instructions limiting attendance, but Hughes had untruthfully announced that they wanted as few guests as possible, wishing to preserve the distance between Andy's family and his public life. Several family members were confused and disappointed by the lack of celebrities.

On Thursday 26 February, a mass was held at the Holy Ghost Byzantine Catholic Church, where a male choir sang and Monsignor Peter Tay, who had never met the artist, offered prayers in English and Old High Church Slavonic, and delivered Andy's eulogy: 'The whole world will remember Andy. While he said everybody would be famous for fifteen minutes, his own fame spanned three decades . . . Andy never knocked anyone. He had a deep loving trust in God . . . This Mass will reach to the steps of the very throne of God . . .' But even Monsignor Tay was not totally unreserved in his reviews. 'Though it seems at times that he wandered far from his church, we do not judge him,' the priest said, then added, 'Jesus forgave the thief on his right. He did not forgive the thief on his left . . . It means there is always hope but it also means nobody should take salvation too much for granted.' The disturbing parable left members of the Warhola family exchanging nervous glances across the hardwood pews.

When the service was over, a cortege of twenty cars accompanied the coffin, covered by a blanket of white roses and asparagus ferns, on the 25-mile journey through the working-class Northside of Pittsburgh to St John the Baptist Byzantine Catholic Cemetery in suburban Bethel Park. Paul Warhola:

When Ed Hayes and Fred came to the funeral they were whistling. Ed Hayes jumped into my limousine. I says, 'Gee!' And then two seconds later Fred jumped in. I said, 'Gee! There isn't enough room,' and Fred says, 'We have to talk to you. We're going to be your attorneys.' I says, 'Gee, can't this thing wait, give me a chance to consult my attorneys? I can't sign anything,' I said. 'At least have the courtesy enough Andy isn't even buried.'

On a barren hillside overlooking Route 88, a trolley line and a cluster

of matchbox homes on a nearby hill, they stopped. A brief service was held at a small chapel near the entrance, then the mourners walked behind the hearse as it drove to the grave site beside the tombstone of Andrew and Julia Warhola. Andy had once written that he wanted his own tombstone to be blank or inscribed with the word 'figment'. Instead, a small, simple marble slab, carved only with his name and the dates of his birth and death, marks the spot.

The priest said a prayer and sprinkled holy water three times over the casket.

Paige Powell dropped a copy of *Interview* and a bottle of Estée Lauder perfume into the grave before the casket was lowered, and in the cold, bright sunlight, Wilfredo and Paige – Andy's kids – took turns posing for photographers at the graveside. Fred Hughes did not join in, one observer noted. 'Aloof by nature, Hughes stood apart from Warhol's family and friends in his natty blue topcoat and slicked-back hair, clasping his hands in front of him like an elegant headwaiter.'

Nearby, three gravediggers – and a girlfriend – waited discreetly, their shovels face down on the cold ground. 'This is my first famous burial,' one of them, named Billy Gemmel, whispered to a reporter, beaming.

AFTERWORD

The first thing the appraisers saw when they opened the doors of Andy Warhol's New York townhouse at 57 East 66th Street was a larger-than-life bust of Napoleon, staring at them from an antique table in the center of the soaring entrance hall. Looking to their left, they paused to take in superb busts of the Marquis de Lafayette and Benjamin Franklin, standing amid bronze statues of horses, hounds, boxers, and dancers. Beyond them was a fine Chippendale sofa, and opposite that a George I wing armchair. On the cream-and-gold walls, above boxes of tulips, hung an impressive assortment of American ancestral portraits. A life-size oil of a male nude, signed 'George Bellows, 1906,' leaned against the far wall. Moving across the dark, polished floorboards, they passed a small elevator and came to a set of doors. Opening them, they stopped—dumbfounded.

There, in the spacious dining room, was a handsome Federal dining table, surrounded by a dozen Art Deco chairs. Underneath lay a luxurious carpet—obviously an Aubusson. The paintings, hanging or leaning against the walls, most of them American primitives, and a small woodcut by the Norwegian master Edvard Munch, were all of the first order. But entrance to the room was blocked. Occupying every inch of floor, table, and sideboard space were so many boxes, shopping bags, and wrapped packages—so much sheer stuff—that the appraisers could not penetrate farther. This was not a room where anyone had dined, at least not in years. It wasn't even the room of a collector who liked to gaze on his treasures with the eye of a connoisseur. It was, instead, the room of a shopper, an accumulator, a pack rat with all the money in the world. 'I was flabbergasted,' recalled Barbara Deisroth, Sotheby's curator for Art Deco. 'Most of what Andy Warhol bought never saw the light of day.'

Their wonder deepened as they proceeded upstairs. On the second floor they entered a sitting room of almost severe formality. Here, the furniture was largely French Art Nouveau and Art Deco of the very highest quality—pieces, Deisroth estimated, that might fetch as much as sixty thousand dollars. The art on the walls was a jarring flash-forward: major works by such Warhol contemporaries as Jasper Johns, Claes Oldenburg, Roy Lichtenstein, James Rosenquist, and Cy Twombly, many in the bright, bold hues of pop art. They would be worth, Sotheby's curator of contemporary art noted at a glance, several million dollars.

Beyond double doors, they found themselves in the back parlor—and another century. Here, the look was neoclassical and neo-Egyptian, the Empire-style taste of a nineteenth-century robber baron: elaborately carved and gilded mahogany furniture and massive marble-topped

sideboards; bronzes of mythological creatures; florid urns and candelabras; gold-framed nineteenth-century American and French academic paintings; another bust of Napoleon.

Opulent as these rooms were, they seemed dead: they had the air of a never-visited but exceedingly well-kept provincial museum. Deisroth thought: 'There was no life, no laughter.'

Upstairs in the elegant sleeping quarters, the appraisers found objects that revealed something more personal about the man who had lived there: the green boxes of wigs stacked next to the television set; an antique crucifix on a side table next to the Federal four-poster bed; an American primitive painting of two little girls in red dresses and white pantaloons that clearly occupied a pride of place over a mantelpiece, directly facing the bed; and in the sparkling white bathroom a cabinet overflowing with skin creams, makeup tubes and jars, and bottles of perfume.

What they soon realized was that they were seeing only the tip of an astonishing iceberg. In the folds of the four-poster's canopy they found women's jewels squirrelled away. In every closet and cupboard, in the guest bedrooms on the third and fourth floors, in the basement kitchen, they found more of what they had seen in the dining room—unopened shopping bags and boxes, crates and packages, stuff and more stuff. Every drawer was crammed with jewels, watches, cigarette cases, gadgets, gewgaws, and bric-à-brac. Masterpieces rubbed shoulders with junk. What remained wrapped often had as much value as what had been unwrapped.

Two months later, when the appraisers finished their inventory of this Xanadu, they had catalogued on computer more than ten thousand items to be put on the auction block, ranging from Picassos to Bakelite bracelets, rare silver tea services to Fiestaware, museum-quality American Indian art to cigar-store Indians, Austrian Secessionist furniture to vending machines, rare books to cookie jars—47 lots of them. Conspicuously absent, apart from one small painting of Chairman Mao in a guest bedroom, was anything by the owner himself, the man who may have been the most prolific American artist of the twentieth century.

It should have surprised nobody. Had there ever been a more 'public' artist than Andy Warhol? Had there ever been an artist more eager to send his art out, to cover the globe with it, to make it as recognizable as one of his favorite images, a Coca-Cola bottle? Andy Warhol had not made art in a studio; he had turned it out with assembly-line regularity in a populous workshop he called the Factory. And he had been, without question, the most-publicized artist of his time, a social butterfly who had once cracked that he would even attend the 'opening of a toilet seat,' an artist whose most famous work of art was himself.

At the same time he had been, as his strange hoard suggested, the most 'unwrapped' of public figures, as elusive as he was ubiquitous, a man of whom it could be said that he used the limelight in order to

hide in it. From the early sixties, when he seemed to turn 'high art' on its head with his paintings of subjects as lowly as Campbell's soup cans, the debate over whether he was 'important' or 'worthless' has never ceased to rage.

Who *was* Andy Warhol? Was he, as *Time* magazine had persisted in vilifying him, the supreme 'huckster of hype'? Or was he, as his legions of collectors and followers insist, a seer whose vision captured the true, ephemeral fragmentation of our time? And the man: was he, as many claimed, a modern Mephistopheles, coldly indifferent to the self-destructiveness that overtook so many who had pledged allegiance to him, including one deranged groupie who had tried to assassinate him? Or was he, as others said, something of a 'saint'?

On April Fool's Day 1987, a little more than two months after Andy Warhol's death, the critic John Richardson came down on the latter side in his eulogy of the artist at a memorial service before 2,000 mourners in St. Patrick's Cathedral in New York. Citing the deceased's little-known practice of going to Catholic mass 'more often than is obligatory,' Richardson went on to say: 'Never take Andy at face value. The callous observer was, in fact, a recording angel. And Andy's detachment—the distance he established between the world and himself—was, above all, a matter of innocence and of art. Isn't an artist usually obliged to step back from things? In his impregnable innocence and humility Andy always struck me as a *yurodstvo*—one of those saintly simpletons who haunt Russian fiction and Slavic villages.'

So, perhaps, he *had* struck the 6,000 people who turned up at Sotheby's auction house in New York on Saturday, 23 April, more than a year later, hoping to buy one of the *yurodstvo's* relics. More than 5,000 of them were turned away: the bidding room could hold only a thousand, all of whom had to produce evidence of their seriousness as buyers.

The outcome far exceeded anyone's imagination. In the course of ten days of bidding for a piece of Andy, nearly every item went for many times the price that had been hoped for: Andy's Rolls-Royce, estimated at $15,000, went for $77,000; a ring, estimated at $2,000, fetched $28,000; a Cy Twombly painting racked up a record price for the artist of $990,000. And the cookie jars? During his lifetime they had cost Warhol perhaps as much as $2,000. When the gavel came down on the last one, the total for the batch had reached $247,830. Sotheby's appraisers had anticipated that the Warhol collection would bring in as much as $15 million. What it yielded was $25.3 million.

To be sure, there must have been not a few who, upon returning to the cold light of day, felt disillusioned by their purchases, even swindled: when all is said and done, an Andy Warhol cookie jar is still only a cookie jar. Such feelings had always accompanied the adulation of Andy. Indeed, it was one of his most remarkable qualities that he had

never done anything to discourage them. And this, of course, had only added to his great, confounding mystery.

In the deluge of comment that descended on Sotheby's disposition of Andy Warhol's earthly possessions, perhaps the only unarguable point was made by Fran Lebowitz, the humorist, who had written a column for the artist's *Interview* magazine. Asked how *he* might be feeling about the event, she said: 'Andy must be so furious that he is dead.'

'It will take my death for the Museum of Modern Art [MOMA] to recognize my work,' Andy Warhol had once lamented to Henry Geldzahler. So it did. Within weeks after Warhol's death, the premier museum of twentieth-century art in the world began organizing its most ambitious recognition of an artist's work since the Picasso blockbuster in 1980.

Nearly two years later, on 1 February, 1989, MOMA celebrated the opening of *Andy Warhol: A Retrospective* by throwing a party that might have exceeded even Andy's wildest dreams. There, spread over two floors, was an overwhelming array of three hundred paintings, drawings, sculptures, photographs, and films. Culled by the curator Kynaston McShine from dozens of public and private collections in nine countries, it was not just a testament to the astonishing output of Warhol and his Factory, but a replay of more than three decades of American cultural, social, and political taste and turbulence.

There, from the time of Andy's first break in the New York commercial-art world in the fifties, were the pen-and-ink drawings of ladies' shoes, still arresting for the lyrical line and loving detail invested in such frivolous objects. There, marking his crossover into the fine-art world, was an installation reminiscent of a window display he had designed for Bonwit Teller in 1961: mannequins in prim dresses posturing in front of an exploding world of painted, blown-up comic strips and newspaper ads.

With the passage of time Warhol's early pop paintings and objects had taken on the presence of totems: the infamous painted cartons with their brand names of Brillo, Del Monte, Campbell's, and Kellogg's now seemed less banal than eerie—old household ghosts. The silkscreened canvases of Marilyn Monroe, Elizabeth Taylor, Jackie Kennedy, Elvis Presley, and others were more disturbing and moving than ever—icons burnished by the 'rubbing' of so many eyes, so many fantasies.

The rarely seen series of 'disasters'—car crashes, race riots, a gangster funeral—now seemed definitive reflections of a society's numbing obsession with violence. From the long period of celebrity portraits, beginning with the epic Mao series, many faces—his mother, Truman Capote, Mick Jagger, Lana Turner—appeared as cunningly colored, as sharply poignant, as a Gauguin. And the late works—the 'Camouflage Self-Portrait,' the enormous pop pastiche of 'The Last Supper'—gave the lie to those who had complained that Warhol had never 'developed.' Here

was the fully mature artist, looking back and looking beyond, as summed up in his very last image, 'Moonwalk (History of TV Series),' which showed the famous image of the astronaut Neal Armstrong, having just planted the American flag on the moon. In Andy's hands, the hero's face had been made to resemble a television screen, across which he had scrawled like a flash of lightning the initials A. W.

Here, too, elbow-to-elbow under a ceiling of helium-filled replicas of Andy's 'Silver Pillows,' craning to see and be seen in the glare of TV lights and camera flashes, to hear and be heard against thumping music by the Velvet Underground, was perhaps the greatest family reunion the American art world had ever known. Among the thousands of celebrants were Philip Pearlstein, Leo Castelli, Henry Geldzahler, John Giorno, Billy Name, Gerard Malanga, Fred Hughes, Christopher Makos, Paul Morrissey, Emile de Antonio, Bianca Jagger, Ronnie Cutrone, John Richardson, Irving Blum, Dennis Hopper, David Bourdon, Tony Shafrazi, Roy Lichtenstein, Geraldine Stutz, Keith Haring, Brigid Polk, members of the de Menil family, Bob Colacello, Vito Giallo, Stuart Pivar, Ultra Violet, Nathan Gluck, Vincent Fremont, and Steve Rubell, to name only a few of those present who had loved, hated, worked, and fought with Andy Warhol, and become, in the process, members of a new race: Warhol People.

And here from Pittsburgh were the Warholas—the eldest brother, Paul, retired from the scrap metal business, and John, a retired appliance parts clerk for Sears. Two of John's sons were there, too, as was Paul's son James, whom Andy had taught to stretch canvases when he was eight. Not a day had gone by since Andy's death, they said, when they hadn't thought of him, and they still could not believe that he was dead.

If you glanced around for a stunning second, he wasn't: there, off to one side, was a figure with the platinum-white wig, thick-rimmed glasses, pancake-white pallor, dark jacket, loose tie, jeans and tentative, half-open smile of Andy himself. It was Allen Midgette, the Warhol actor who had impersonated the artist on college campuses in the sixties, doing it all over again at the end of the eighties.

For Paul and John Warhola, this was the first time in all those years that they had been to a show of their brother's art. For many others, it was an event that seemed always to have been and would always be— another Warhol opening. Before the revels were over, they would pull down the silver pillows and run out into the night to release them into the New York sky.

The Last Interview

PAUL TAYLOR: If you were starting out now, would you do anything differently?

ANDY WARHOL: I don't know. I just worked hard. It's all fantasy.

PAUL TAYLOR: Life is fantasy?

ANDY WARHOL: Yeah, it is.

PAUL TAYLOR: What's real?

ANDY WARHOL: Don't know.

PAUL TAYLOR: Some people would.

ANDY WARHOL: Would they?

PAUL TAYLOR: Do you believe it, or tomorrow will you say the opposite?

ANDY WARHOL: I don't know. I like this idea that you can say the opposite.

APPENDIX

Painting Exhibitions by Andy Warhol

This is a list of the significant shows in Andy Warhol's career. No complete list of every show he ever had exists and it seems doubtful that it will since he was so prolific and had a number of shows in places like the glorified ice-cream shop, Serendipity, that were not considered exhibitions in the conventional sense. By the same token some chroniclers might consider Warhol's first show to have been in the corridor of the art department of Carnegie Tech in September 1946, or might credit the window display of his first pop paintings at Bonwit Teller in April 1961 as a show. Others would not. The intention of this list is to pinpoint the major steps in his career and indicate how international Warhol's audience was and is. All are one-man shows unless otherwise stated. They are listed by year; specific dates are included when available.

1952
Hugo Gallery, New York, 16 June–3 July.

1954
Loft Gallery, New York. Warhol showed three times in small group shows.

1956
Bodley Gallery, New York, 14 February–3 March.
Museum of Modern Art, New York, 25 April–5 August. Recent Drawings USA group show.
Bodley Gallery, New York, 3–22 December.

1957
Bodley Gallery, New York, 2–24 December.

1959
Bodley Gallery, New York, 1–24 December.

1962
Ferus Gallery, Los Angeles, 9 July–4 August.
Pasadena Art Museum, Pasadena, California, 25 September–19 October. New Paintings of the Common Object group show.
Sidney Janis Gallery, New York, 31 October–1 December. The New Realists group show.
Stable Gallery, New York, 6–24 November.

1963
Solomon R. Guggenheim Museum, New York, 14 March–12 June. Six Painters and the Object group show.
Washington Gallery of Modern Art, Washington DC, 18 April–2 June. Popular Image group show.
Oakland Art Museum, Oakland, California, 7–29 September. Pop Art USA group show.
Ferus Gallery, Los Angeles, 30 September–October.
Institute of Contemporary Art, London, 24 October–23 November. Popular Image group show.

1964
Galerie Ileana Sonnabend, Paris, January–February.
Moderna Muséet, Stockholm. 29 February–12 April, and tour. Amerikansk pop-konst group show.
New York World's Fair, April.
Stable Gallery, New York, 21 April–9 May.
Leo Castelli Gallery, New York, 21 November–17 December.

1965
Palais des Beaux-Arts, Brussels, 5 February–1 March, and tour. Pop art, nouveau realisme group show.
Jerrold Morris International Gallery, Toronto, March.
Galerie Ileana Sonnabend, Paris, May.
Galeria Rubbers, Buenos Aires, 29 July–14 August.
Institute of Contemporary Art, University of Pennsylvania, Philadelphia, 8 October–21 November.
 During 1965 Warhol also had one-man shows at:
Galerie M. E. Thelen, Essen;
Gian Enzo Sperone Arte Moderna, Milan;
Galerie Buren, Stockholm;
Gian Enzo Sperone Arte Moderna, Turin.

1966
Solomon R. Guggenheim Museum, New York, 1–28 January. The Photographic Image group show.
Leo Castelli Gallery, New York, 2–27 April.
Institute of Contemporary Art, Boston, 1 October–6 November.
 Warhol also had one-man shows at:
Ohio Contemporary Arts Center, Cincinnati;
Galerie M. E. Thelen, Essen;
Galerie Hans Neundorf, Hamburg;
Ferus Gallery, Los Angeles;
Gian Enzo Sperone Arte Moderna, Milan;
Gian Enzo Sperone Arte Moderna, Turin.

1967
Galerie Rudolf Zwirner, Cologne, 24 January–February.
United States Pavilion, Expo '67, Montreal, 28 April–27 October, and tour. Group show.
Galerie Ileana Sonnabend, Paris.
Galerie Rudolf Zwirner, Cologne, 12 September–30 October.
Museu de Arte Moderna, São Paulo, Brazil, 22 September–8 January, 1968.
Museum of Art, Carnegie Institute, Pittsburgh, 27 October–7 January. 1967 International group show.
Whitney Museum of American Art, New York, 13 December–4 February 1968. Annual Exhibition of Contemporary Painting group show.

1968
Moderna Muséet, Stockholm, 10 February–17 March, and tour to Stedelijk Museum, Amsterdam; Documenta, Kassel, West Germany; Kunsthalle Bern, Bern, Switzerland; and Kunstneres Hus, Oslo.
Pasadena Art Museum, Pasadena, California. 17 September–27 October, and tour. Serial Imagery group show.
 Warhol also had one-man shows at:
Galerie der Spiegel, Cologne;
Galerie Rudolf Zwirner, Cologne;
Rowan Gallery, London;
Galerie Heiner Friedrich, Munich.

1969
Nationalgalerie und Deutsche Gesellschaft für Bildende Kunst, Berlin, 1 March–14 April.
Castelli/Whitney Graphics, New York, 8 March–April.
Ferus Gallery, Los Angeles.
Hayward Gallery, London, 9 July–3 September. Pop Art group show.
Metropolitan Museum of Art, New York, 18 October–1 February 1970. New York Painting and Sculpture group show.
Pasadena Art Museum, Pasadena, California, 24 November–11 January 1970. Painting in New York: 1944–1969 group show.

1970
Pasadena Art Museum, Pasadena, California, 12 May–21 June, and tour to Museum of Contemporary Art, Chicago; Stedelijk van Abbemuseum, Eindhoven, the Netherlands; Musée d'Art Moderna de la Ville de Paris; Tate Gallery, London.
Galerie Folker Skulima, Berlin.

1971
Cenobio-Visualità, Milan, February–March.
Modern Art Agency, Naples, 13–28 February.
Tate Gallery, London, 17 February–28 March.
Whitney Museum, New York, April–June.
Gotham Book Mart Gallery, New York, 26 May–26 June.

1972
Kunstmuseum, Basel, 21 October–19 November.
Galleria Galatea, Turin, 20 November–10 February 1973.
Modern Art Agency, Naples.

1973
New Gallery, Cleveland, Ohio, 10 March–4 April.

1974
Jared Sable Gallery, Toronto, 16 February–2 March.
Musée Galliera, Paris, 22 February–22 March.
Galerie Ileana Sonnabend, Paris, 23 February–March.
Milwaukee Art Center, 17 July–24 August.
Max Protech, Washington DC, 25 November–December.

1975
Margo Leavin Gallery, Los Angeles, 3 April–3 May.
Baltimore Museum of Art, 22 July–14 September.
Locksley Shea Gallery, Minneapolis, 17 September–22 October.
Greenberg, Gallery, St Louis, 15 October–November.
Romani Adami, Rome, 27 October–November.
Max Protech, Washington DC, 6–31 December.

1976
Württembergischer Kunstverein, Stuttgart, 12 February–28 March, and tour to Stadtische Kunsthalle, Düsseldorf; Kunsthalle, Bremen; Stadtische Galerie im Lembachhaus, Munich; Haus am Waldsee, Berlin; Museum Moderner Kunst, Museum des 20. Jahrhunderts, Vienna.
Galerie Bischofberger, Zurich, 13 February–6 March.
Freeman-Anacker, New Orleans, 16 March–April.
Arno Schefler, New York, 25 May–11 June.
Coe Kerr Gallery, New York, 3 June–9 July.
Mayor Gallery, London, 29 June–13 August.
Centro Internazionale di Sperimentazioni Artische Marie-Louise Jeanneret, Boissano, Italy, 29 July–12 September.

1977
Leo Castelli Gallery, New York, 8–29 January.
Pyramid Galleries, Washington DC, 17 January–18 February.
ACE Gallery, Venice, California, 19 February–19 March.
Sable-Castelli Gallery, Toronto, 19 February–12 March.
Optica, Montreal, 11–28 April.
Galerie Daniel Templon, Paris, 31 May–9 July.
Hokin Gallery, Chicago, 9 September–11 October.
Musée d'Art et d'Histoire, Geneva, 28 October–22 January 1978.
Galerie Heiner Friedrich, Cologne, 18 November–23 December.
Coe Kerr Gallery, New York, 9 December–7 January 1978.

1978
Virginia Museum, Richmond, 23 January–26 February.
University Gallery, Meadows School of the Arts, Southern Methodist University, Dallas, 19 February–19 March.
Texas Gallery, Houston, 2–29 April.
Kunsthaus, Zurich, 26 May–30 July.
Institute of Contemporary Art, London, July.
ACE Gallery, Venice, California, 24 September–21 October.
Louisiana Museum, Humlebaek, Denmark, 6 October–26 November.
Blum-Helmann Gallery, New York, December–13 January 1979.

1979
Heiner Friedrich, New York, 27 January–10 March.
Ace Gallery, Vancouver, April.
Michael Zivian, New York, 15 May–16 June.
Arts Gallery, Baltimore, 15 November–13 December.
Whitney Museum of American Art, New York, 20 November–27 January 1980.

1980
Boehm Gallery, Palomar College, San Marcos, California, 11 February–March.
Galerie Bischofberger, Zurich, 14 May–11 June.
Centre d'Art Contemporain, Geneva, 7–30 June.
Museum Ludwig, Cologne, 28 August–26 October.
Stedelijk Museum, Amsterdam, 28 August–26 October.
Lowe Art Museum, University of Miami, Coral Gables, Florida, 6–28 September.
Lisson Gallery, London, 16 September–18 October.
Jewish Museum, New York, 17 September–4 January 1981.
Galerie Daniel Templon, Paris, 20 September–23 October.
Portland Center for the Visual Arts, Portland, Oregon, 26 September–7 November.

1981
Museum Moderner Kunst, Museum des 20. Jahrhunderts, Vienna, 9 April–10 May.
Colorado State University, Fort Collins, 1–25 September.
Kestner Gessellschaft, Hanover, 23 October–13 December, and tour to Stadtische Galerie im Lembachhaus, Munich.
Castelli Graphics, New York, 21 November–22 December.

1982
Leo Castelli Gallery, New York, 9–30 January.
National Galerie, Staatliche Museum Preussischer Kulturbesitz, Berlin, 2 March–12 April. Group show with Joseph Beuys, Robert Rauschenberg and Cy Twombly.
Galerie Daniel Templon, Paris, 6–31 March.
Sammlung der Stadt Thun, Thun, Switzerland, 17 June–22 August.

Fernando Vijande, Madrid, 20 December–12 February, 1983.

1983
Portrait Screenprints 1965–80, Wansbeck Square Gallery, Ashington, Northumb-
erland, England, 10–28 January, and tour to University of York, York; Usher
Gallery, Lincoln; and Aberystwyth Arts Centre, Aberystwyth, Wales.
Warhol's Animals: Species at Risk, American Museum of Natural History, New
York, 12 April–8 May, and tour to Cleveland Museum of Natural History.
Drawings from 'The American Indians', Gloria Luria Gallery, Miami.
Electric Chairs, Frankel Gallery, San Francisco.
Andy Warhol in the 1980s, Aldrich Museum of Contemporary Art, Ridgefield,
Connecticut.
Endangered Species, Givinda Gallery, Washington DC.
Paintings for Children, Galerie Bischofberger, Zurich.

1984
Three portraits of Ingrid Bergman, Galleri Börjeson, Malmö, Sweden.
Paintings and Prints, Delahunty, Dallas; Galerie Bischofberger, Zurich.

1985
Ads, Amelie A. Wallace Gallery, SUNY at Old Westbury, New York.
Linda Farris Gallery, Seattle.
Warhol verso de Chirico, Maris Del Rey Gallery, New York.
Ads, Gicinda Gallery, Washington DC.
Vesuvius by Warhol, Fondazione Amelio Napoli Museo di Capodimonte,
Naples.
Paintings for Children, Vanguard Gallery, Philadelphia.
Ads: 10 Silkscreens, Center Gallery, Bucknell University, Lewisburg,
Pennsylvania.
Andy Warhol's Children's Show, Newport Art Museum, Newport, Rhode
Island.
Warhol, Basquiat: Paintings, Tony Shafrazi Gallery, New York.
Reigning Queens 1985, Castelli Uptown, New York.
Paul Maenz Gallery, New York.

1986
Major Prints, Galerie Daniel Templon/Impasse, Beaubourg, Paris.
Liberty and Justice, Alternative Museum, New York.
Cowboys and Indians, Texas Christian University.
Disaster Paintings 1963, DIA Foundation, New York.
10 Statues of Liberty, Lavignes-Bastille, Paris.
Cowboys and Indians, Museum of the American Indian, New York.
Self-Portraits, Anthony d'Offay, London.
Hand-Painted Images, DIA Art Foundation, New York.

1987
Last Supper, Alexandre Iolas/Credito Valtalinese, Milan.

Films by Andy Warhol
There can be no totally complete list of films by Warhol since during the 1960s
he shot prolifically and his attitude towards the product was so casual – not
really caring being essential to his hardcore aesthetic – that many films were
never developed. In many instances he may have been shooting without film
in the camera just to get people to do things he wanted to watch. This is a list
of the films he made which were shown and made his still often overlooked
reputation as an American film director during his lifetime.

1963
Sleep
Kiss
Andy Warhol films Jack Smith filming Normal Love
Tarzan and Jane, Regained . . . Sort of
Dance Movie
Haircut
Eat
Salome and Delilah

1964
Blow Job
Batman Dracula
Empire
Henry Geldzahler
Drunk
Couch
Shoulder
Mario Banana
Soap Opera
Taylor Mead's Ass
13 Most Beautiful Women
13 Most Beautiful Boys
50 Fantastics and 50 Personalities
Harlot
The End of Dawn
Messy Lives
Naomi Kisses Rufus
Apple
Pause
Lips

1965
Ivy and John
Screen Test #1
Screen Test #2
The Life of Juanita Castro
Horse
Vinyl
Suicide
Poor Little Rich Girl
Bitch
Restaurant
Kitchen
Prison
Face
Afternoon
Beauty #2
Outer and Inner Space
Space
My Hustler
Camp
Paul Swan
Lupe

1966
Hedy
More Milk Yvette
The Velvet Underground and Nico
The Closet
Bufferin
Eating Too Fast
The Chelsea Girls
Whips

1967
24 Hour Movie (also known as **** or *Four Stars*) filmed during late 1966 and throughout 1967, this film was made up of 48 hours of footage that was shown on a split screen so that the total running time of the film was 24 hours.
The Loves of Ondine
The Imitation of Christ
I, a Man
Bikeboy
Nude Restaurant
Withering Sighs
Construction – Destruction

1968
Lonesome Cowboys
San Diego Surf
Blue Movie
Flesh

1969
Trash

1970
Heat
Women in Revolt (filmed sporadically through 1972)

1971
L'Amour

1973
Andy Warhol's Frankenstein
Andy Warhol's Dracula

1976
Bad

Books by Andy Warhol
Andy Warhol's Index Book (New York: Random House, 1967)
a, a novel (New York: Grove Press, 1968)
The Philosophy of Andy Warhol (From A to B and Back Again) (New York: Harcourt Brace Javonovich, 1975)
Andy Warhol's Exposures, photos with a text by Andy Warhol and Bob Colacello (New York: Andy Warhol Books/Grosset and Dunlap, 1979)
Popism: The Warhol Sixties by Andy Warhol and Pat Hackett (New York: Harcourt Brace Jovanovich, 1980)
America, photos and text by Andy Warhol (New York: Harper and Row, 1985)
Andy Warhol's Party Book by Andy Warhol and Pat Hackett (New York: Crown, 1988)

Books about Andy Warhol

Bailey, David, *Andy Warhol, Transcript of David Bailey's ATV Documentary* (London: a bailey litchfield/mathews miller dunbar co-production, 1972)

Brown, Andreas, *Andy Warhol, His Early Works, 1947–1959* (New York: Gotham Book Mart, 1971)

Catalogues of The Andy Warhol Collection, six volumes, boxed (New York: Sotheby's, 1988)

Coplans, John, with contributions by Jonas Mekas and Calvin Tomkins, *Andy Warhol* (New York Graphic Society Ltd., 1970)

Crone, Rainer, *Andy Warhol*, translated by John William Gabriel (London: Thames & Hudson, 1970)

Andy Warhol, A Picture Show by the Artist, translated by Martin Scutt (New York: Rizzoli, 1987)

Gidal, Peter, *Andy Warhol: Films and Painting* (London: Studio Vista Dutton Paperback, 1971)

Koch, Stephen, *Stargazer, Andy Warhol and His Films* (New York: Praeger, 1973)

Makos, Christopher, *Warhol Makos, A Personal Photo Memoir* (London: Virgin, 1988)

Ratcliff, Carter, *Andy Warhol* (New York: Modern Masters Series, Abbeville Press, 1983)

Smith, Patrick S., 'Art *in Extremis*: Andy Warhol and his art' (3 vols, unpublished PhD dissertation, Northwestern University, Evanston, Illinois, 1982. A shortened version was published 1986 by UMI Research Press, Illinois, as *Andy Warhol's Art and Films*.)

Stein, Jean, edited with George Plimpton, *Edie, An American Biography* (New York: Alfred A. Knopf, 1982)

Ultra Violet, *Famous for Fifteen Minutes* (San Diego and New York: Harcourt Brace Jovanovich, 1988)

Viva, *Superstar* (New York: G. P. Putnam's Sons, 1970)

Wilcock, John, *The Autobiography and Sex Life of Andy Warhol* (New York: Other Scenes Inc., 1971)

SOURCE NOTES

Title page: Alan Solomon, *Andy Warhol*. Exhibition catalogue, Institute of Contemporary Art, Boston, 1 October–6 November 1966.

The Honolulu Incident
Based on interviews with Charles Lisanby.
Andy Warhol, *The Philosophy of Andy Warhol*.

Hunkie Roots
Based on interviews with Paul Warhola, John Warhola, Lillian Gracik (née Lanchester), Justina Swindell (née Preksta).
Bernard Weintraub, 'Andy Warhol's Mother', *Esquire*, vol. 64, no. 5, November 1966.
John Richardson, 'The Secret Warhol', *Vanity Fair*, vol. 50, no. 7, 1987.
David Bailey, *Andy Warhol, Transcript of David Bailey's ATV Documentary*.
Andy Warhol, 'Why I love to live fast', *High Times*, May 1978, no. 33.
Andy Warhol, *The Philosophy of Andy Warhol*.
Fotios K. Litsas (ed.), *A Companion to the Greek Orthodox Church* (New York: Department of Communication, Greek Orthodox Archdiocese of North and South America, 1984).
Jean Stein, edited with George Plimpton, *Edie*.
Stefan Lorant, *Pittsburgh: The Story of an American City* (New York: Doubleday, 1964).
Burton Hersh, *The Mellon Family* (New York: William Morrow, 1978).
H. L. Mencken, *A Mencken Chrestomathy* (New York: Knopf, 1927).
Philip Klein, *A Social Study of Pittsburgh* (1938).
Lester Goran, *The Paratrooper of Mechanic Avenue* (Boston: Houghton Mifflin, 1960).
Eva Windmüller, 'A Conversation with Andy Warhol', *Stern*, 8 October 1981.
Viva, *Superstar*.

Slaves of Pittsburgh
Based on interviews with John Warhola, Paul Warhola, Lillian Gracik, Justina Swindell, John Elachko, Margaret Warhola, Margaret Girman, Mina Kaveler, Ann Madden (née Elachko), Catherine Metz, Robert Heidie, Ann Warhola, Benjamin Liu.
Bernard Weintraub, 'Andy Warhol's Mother', *Esquire*, vol. 64, no. 5, November 1966.
Robert Tomsho, 'Looking for Mr Warhol', *Pittsburgher Magazine*, vol. 3, no. 12, 1980.
Ralph Pomeroy, 'The Importance of Being Andy', *Art and Artists* (London) February 1971.
Andy Warhol, *The Philosophy of Andy Warhol*.

The Education of Andy Warhol
Based on interviews with Catherine Metz, Joseph Fitzpatrick, Gretchen Schmertz, Lee Karageorge, Mary Adeline McKibbin, Ann Warhola, Mina Serbin, Avram Blumberg, Bill Shaffer, John Warhola, Paul Warhola.
Robert Tomsho, 'Looking for Mr Warhol', *Pittsburgher Magazine*, vol. 3, no. 12, 1980.

Gretchen Berg, 'Andy Warhol: My True Story', *Los Angeles Free Press*, vol. 6, no. 11, 1967.

Ultra Violet, *Famous For Fifteen Minutes.*

George Anderson, '"Hope": Child's view of war', *Pittsburgh Post Gazette*, 22 January 1988.

Great American Audio Corp., *The Fabulous Forties* (cassette tapes).

Ben Kartmen and Leonard Brown, *Disaster* (A Berkeley Medallion Book, 1960).

Andy Warhol, *The Philosophy of Andy Warhol.*

Andy Warhol, *America.*

Class Baby
Based on interviews with Albert Goldman, Robert Lepper, Gretchen Schmertz, Russell Twiggs, Perry Davis, Walter Steding, Betty Ash Douglas, Philip Pearlstein, Leonard Kessler, Arthur and Lois Elias, George Klauber, Dorothy Kantor Pearlstein, Grace Regan, Leila Davies, Dorothy Kanrich, Lawrence Vollmer, Harold Greenberger, Irene Passinski, Elvira Peake, Libby Rosenberg.

Sam McCool, *Sam McCool's New Pittsburghese: How to Speak like a Pittsburgher* (Pittsburgh: New Image Press, 1982).

Rainer Crone, *Andy Warhol.*

Patrick Smith, 'Art *in Extremis*: Andy Warhol and His Art'.

Jean Stein, edited with George Plimpton, *Edie.*

John Costello, *Love, Sex and War* (London: Pan Books, 1986).

Andy Warhol, *The Philosophy of Andy Warhol.*

John Malcolm Brinnin, *Sextet: T. S. Eliot & Truman Capote & Others* (New York: Delacorte/Seymour Lawrence, 1981).

Kiss Me with Your Eyes
Based on interviews with John Warhola, Paul Warhola, Albert Goldman, George Klauber, Leonard Kessler, Carl Willers, Grace Regan, Francesca Boas, Nathan Gluck, Leila Davies, Perry Davis, Lois Elias, Vito Giallo, Ralph Ward.

Gerald Clarke, *Capote* (New York: Simon and Schuster, 1988).

Calvin Tomkins, *Off the Wall: Robert Rauschenberg and the Art of Our Times* (New York: Penguin, 1981).

Patrick Smith, 'Art *in Extremis*: Andy Warhol and His Art'.

Stephen Koch, 'Warhol', *Motion Picture*, vol. 11, no. 1, 1987.

Philip Pearlstein, 'Andy Warhol 1928–1987', *Art in America*, vol. 75, no. 5, 1987.

Calvin Tomkins, 'Raggedy Andy', *Andy Warhol* by John Coplans.

Andreas Brown, *Andy Warhol: His Early Works, 1947–1959.*

Vance Packard, *The Hidden Persuaders* (New York: David McKay, 1957).

Martin Duberman, *About Time: Exploring the Gay Past* (New York: A Seahorse Book, Gay Presses of New York, 1986).

Jean Stein, edited with George Plimpton, *Edie.*

Lawrence Grobell, *Conversations with Capote* (New York: New American Library, 1985).

Andy Warhol, 'Sunday with Mister C: An Audio-Documentary by Andy Warhol Starring Truman Capote', *Rolling Stone*, no. 132, 12 April 1973.

Andy Warhol, *The Philosophy of Andy Warhol.*

The Odd Couple
Based on interviews with John Warhola, Paul Warhola, George Klauber, David Mann, Nathan Gluck, Seymour Berlin, Carl Willers, Leonard Kessler, Stephen Bruce, Vito Giallo and Bert Greene.

Andy Warhol and Pat Hackett, *Popism.*

John Richardson, 'The Secret Warhol', *Vanity Fair*, vol. 50, no. 7, 1987.

Ann Curran, 'CMU's Other Andy', *Carnegie Mellon Magazine*, vol. 3, no. 3, 1985.

Calvin Tomkins, 'Raggedy Andy', *Andy Warhol* by John Coplans.

Bernard Weintraub, 'Andy Warhol's Mother', *Esquire*, vol. 64, no. 5, 1966.
Hilton Als, review of Rainer Crone's *'Andy Warhol, A Picture Show by the Artist'*, *Village Voice*, 1987.

Everything Was Wonderful
Based on interviews with Charles Lisanby, Vito Giallo, Arthur Elias, Seymour Berlin, Nathan Gluck, David Mann.
Rainer Crone, *Andy Warhol*.
Robert Hughes, 'The Rise of Andy Warhol', *New York Review of Books*, vol. 29, no. 2, 1982.
A symposium at the Ingber Gallery on Warhol's work in the 1950s.
Calvin Tomkins, 'Raggedy Andy', *Andy Warhol* by John Coplans.
Philip Pearlstein, 'Andy Warhol 1928–1987', *Art in America*, vol. 75, no. 5, 1987.
Andy Warhol and Pat Hackett, *Popism*.

So What?
Based on interviews with Charles Lisanby, Duane Michaels, Nathan Gluck, George Warhola, David Mann, Seymour Berlin, Ralph Ward, Emile de Antonio, John Wallowitch, Robert Heidie, Suzi Frankfurt, John Warhola, Paul Warhola.
Andy Warhol, *The Philosophy of Andy Warhol*.
Life, vol. 42, no. 3, 1957.
Douglas T. Miller and Marion Nowak, *The Fifties* (New York: Doubleday, 1975).
Patricia Bosworth, *Diane Arbus* (New York: Knopf, 1984).
Patrick Smith, 'Art *in Extremis*: Andy Warhol and His Art'.

The Birth of Andy Warhol
Based on interviews with David Dalton, Leonard Kessler, Ivan Karp, Emile de Antonio, John Giorno, Taylor Mead, David Mann, Leo Castelli, Patti Oldenburg.
Jean Stein, edited with George Plimpton, *Edie*.
Andy Warhol and Pat Hackett, *Popism*.
Barbara Haskell, *Blam! The Explosion of Pop, Minimalism and Performance 1958–1964* (New York: Whitney Museum of American Art in association with W. W. Norton & Company, 1984).
Laura de Coppet and Alan Jones, *The Art Dealers* (New York: Clarkson Potter, 1984).
Emile de Antonio and Mitch Tuchman, *Painters Painting* (New York: Abbeville Press, 1984).
Tom Wolfe, *The Painted Word* (New York: Farrar Straus & Giroux, 1975).
Patrick S. Smith, 'Art *in Extremis*: Andy Warhol and His Art'.
Calvin Tomkins, 'Raggedy Andy', *Andy Warhol* by John Coplans.
John Richardson, 'The Secret Warhol', *Vanity Fair*, vol. 50, no. 7, 1987.
Henry Geldzahler, 'Andy Warhol, A Tribute', *Vogue* (UK), vol. 144, no. 5, 1987.
Jean Stein, edited with George Plimpton, *Edie*.
Frederick Eberstadt, 'Andy Warhol', *Quest*, October 1987.

The Campbell's Soup Kid
Based on interviews with Robert Heidie, Ray Johnson, David Bourdon, John Wilcock, George Warhola, Patti Oldenburg, David and Sarah Dalton, Irving Blum, Ivan Karp, John Coplans, Taylor Mead, Alan Groh, Emile de Antonio, Nathan Gluck, Ruth Kligman, Bert Greene, George Klauber, John Giorno, Charles Lisanby, John Wallowitch, Vito Giallo, David Mann.
Stephen Koch, 'Warhol', *Motion Picture*, vol. 11, no. 1, 1987.
John Heilpern, 'The Fantasy World of Andy Warhol', *Observer* (London), 12 June 1966.
John Wilcock, *The Autobiography and Sex Life of Andy Warhol*.

Francis, Brother of the Universe, vol. 1, no. 1, 1982 (Marvel Comics Group).

Gretchen Berg, 'Andy Warhol: My True Story', *Los Angeles Free Press*, vol. 6, no. 11, 1967.

Ronald Sukenick, *Down and In* (New York: Beech Tree Books, 1987).

Peter Schjeldahl, *Andy Warhol* (London: Saatchi Collection Catalogue, 1985).

William O'Neil, *Coming Apart, An Informal History of America in the 1960s* (Chicago: Quadrangle Books, 1971).

Gene Swenson, 'What is Pop Art?', *Art News*, vol. 62, no. 7, 1963.

Jean Stein, edited with George Plimpton, *Edie*.

The Editors of Rolling Stone, *The Sixties* (San Francisco, Straight Arrow Books, 1977).

Winston Leyland, *Gay Sunshine Interviews* (San Francisco: Gay Sunshine Press, 1978).

John Rublowsky, *Pop Art* (New York: Basic Books, 1965).

Ann Curran, 'CMU's Other Andy', *Carnegie Mellon Magazine*, vol. 3, no. 3, 1985.

Christopher Makos: *Warhol Makos*.

Kenneth E. Silver, 'Andy Warhol 1928–1987', *Art in America*, vol. 75, no. 5, 1987.

Kurt Loder, 'Andy Warhol 1928–1987', *Rolling Stone*, no. 497, 1987.

Mario Amaya, *Pop Art . . . and After* (New York: Viking Press, 1965).

Arthur C. Danto, *Art in America*.

Tom Wolfe, *The Painted Word* (New York: Farrar Straus & Giroux, 1975).

Henry Geldzahler, Introduction to catalogue for a travelling Pop Art show in Australia, 1986.

Henry Geldzahler, 'Andy Warhol, A Tribute', *Vogue* (UK), vol. 144, no. 5, 1987.

Like a Machine

Based on interviews with David Bourdon, Patti Oldenburg, John Giorno, Ruth Kligman, Charles Lisanby.

Jeff Goldberg, interview with Marisol, unpublished.

Andy Warhol and Pat Hackett, *Popism*.

Gerard Malanga and Charles Giuliano, 'Working with Warhol', *Art New England*, 1988.

Sam Hunter, *Masters of the Sixties* (Marisa Del Rey Gallery, 1984).

Emile de Antonio and Mitch Tuchman, *Painters Painting* (New York: Abbeville Press, 1984).

Jean Stein, edited with George Plimpton, *Edie*.

Jeff Goldberg, interview with Robert Indiana, unpublished.

Robert Hughes, 'The Rise of Andy Warhol', *New York Review of Books*, vol. 29, no. 2, 1982.

Gretchen Berg, 'Andy Warhol: My True Story', *Los Angeles Free Press*, vol. 6, no. 11, 1967.

Gene Swenson, 'What is Pop Art?' *Art News*, vol. 62, no. 7, 1963.

John Rublowsky, *Pop Art* (New York: Basic Books, 1965).

David Bailey, *Andy Warhol, Transcript of David Bailey's ATV Documentary*.

Alain Jouffroy, Ileana Sonnabend Death and Disasters Catalogue, Paris 1964.

Bruce Glaser, 'Oldenburg, Lichtenstein, Warhol: A Discussion', *Artforum*, vol. 4, no. 6, February 1966.

Sex

Based on interviews with John Giorno, Gerard Malanga, Ondine, Billy Linich, Sterling Morrison, Robert Heidie, Charles Lisanby, Suzi Frankfurt, Ruth Kligman, Carl Willers, George Klauber, Taylor Mead, Nathan Gluck, Alan Groh.

Marshall McLuhan, *The Mechanical Bride* (New York: Vanguard Press, 1951).

Ultra Violet, *Famous for Fifteen Minutes*.

Jean Stein, edited with George Plimpton, *Edie*.

Stephen Koch, *Stargazer*.

Gretchen Berg, 'Andy Warhol: My True Story', *Los Angeles Free Press*, vol. 6, no. 11, 1967.

Stephen Koch, Andy Warhol, *Art and Auction*, 1984.

Andy Warhol and Pat Hackett, *Popism*.

John Wilcock, *The Autobiography and Sex Life of Andy Warhol*.

Gene Swenson, 'What is Pop Art?', *Art News*, vol. 62, no. 7, 1963.

Violent Bliss

Based on interviews with John Giorno, Gerard Malanga, Ondine, Billy Linich, Sterling Morrison, Robert Heidie, Charles Lisanby, Suzi Frankfurt, Ruth Kligman, Carl Willers, George Klauber, Taylor Mead, Nathan Gluck, Alan Groh.

Gerard Malanga, 'Introduction to the Secret Diaries', *Radar* (Basel), Nr. 3, 1986.

Mario Amaya, *Pop Art . . . and After* (New York: Viking Press, 1965).

Peter Schjeldahl, *Andy Warhol* (London: Saatchi Collection Catalogue, 1985).

Jonas Mekas, 'Notes on Re-seeing the Films of Andy Warhol', *Andy Warhol* by John Coplans.

Gretchen Berg, 'Andy Warhol: My True Story', *Los Angeles Free Press*, vol. 6, no. 11, 1967.

Jonas Mekas, 'Andy Warhol Sixth Annual Film-Makers' Co-op Awards', *Film Culture*, no. 33, Summer 1964.

David Bailey, *Andy Warhol, Transcript of David Bailey's ATV Documentary*.

Peter York, 'The Voice', *Vanity Fair*, April 1984.

Stephen Koch, 'Andy Warhol', *Art and Auction*, 1984.

Mary Josephson, 'Warhol: The Medium as Cultural Artifact', *Art in America*, May–June 1971.

Jeff Goldberg, interview with Robert Indiana, unpublished.

Irving Hershel Sandler, *New York Post*, 2 December 1962.

John Heilpern, 'The Fantasy World of Andy Warhol', *Observer* (London) 12 June 1966.

Marguerite Littman, 'Warhol, A Tribute', *Vogue* (UK), vol. 144, no. 5, 1987.

Jean Stein, edited with George Plimpton, *Edie*.

John Wilcock, *The Sex Life and Autobiography of Andy Warhol*.

Patrick Smith, 'Art *in Extremis*: Andy Warhol and His Art'.

Lester Bangs, *Psychotic Reactions and Carburetor Dung* (New York: Knopf, 1987).

Andy Warhol Uptight

Based on interviews with Ronald Tavel, Ondine, Mary Woronov, John Wilcock, John Giorno, Emile de Antonio, Taylor Mead, Gerard Malanga.

Gerard Malanga, lecture notes, unpublished.

David Bailey, *Andy Warhol, Transcript of David Bailey's ATV Documentary*.

Rainer Crone, *Andy Warhol*.

Andy Warhol and Pat Hackett, *Popism*.

Stephen Koch, *The Bachelor's Bride* (London: Marion Boyars, 1986).

Jean Stein, edited with George Plimpton, *Edie*.

Gerard Malanga, 'Working with Warhol', *Village Voice*, vol. 111, no. 1, 1987.

Gary Indiana, 'I'll Be Your Mirror', *Village Voice*, vol. 111, no. 1, 1987.

Gerard Malanga and Charles Giuliano, 'Working with Warhol', *Art New England*, 1988.

Patrick Smith, 'Art *in Extremis*: Andy Warhol and His Art'.

Carter Ratcliff, *Andy Warhol*.

Lucy Lippard, *Pop Art* (New York and Toronto: Oxford University Press, 1966).

Otto Hahn, Ileana Sonnabend Flowers catalogue, Paris 1965.

Jonas Mekas, Sixth Annual Film-Makers' Co-op Award, *Film Culture*, no. 33, Summer 1964.

Philip Leider, 'Saint Andy: Some notes on an artist who for a large section of a younger generation can do no wrong', *Artforum*, vol. 3, no. 5, 1965.
John Heilpern, *Observer* (London) 12 June 1966.
John Gruen, *Close Up* (New York, 1965).
Lester Bangs, *Psychotic Reactions and Carburetor Dung* (New York: Knopf, 1987).

Femme Fatale
Based on interviews with Ronald Tavel, Gerard Malanga, David Bourdon, Paul Morrissey, Robert Heidie, James Warhola, Sam Green.
Stephen Koch, *Stargazer*.
John Heilpern, *Observer* (London) 12 June, 1966.
Ninette Lyon, 'Robert Indiana, Andy Warhol. A Second Fame: Good Food', *Vogue*, vol. 145, March 1965.
John Wilcock, *The Sex Life and Autobiography of Andy Warhol*.
Gerard Malanga, letter to Stephen Sprouse, unpublished.
Jonas Mekas, Filmography, *Andy Warhol* by John Coplans.
Peter Manso, *Mailer* (New York: Simon & Schuster, 1985).
Andy Warhol, *The Philosophy of Andy Warhol*.
Ultra Violet, *Famous for Fifteen Minutes*.
Andy Warhol and Pat Hackett, *Popism*.
Gerard Malanga and Charles Giuliano, 'Working with Warhol', *Art New England*, 1988.
Marilyn Bender, *The Beautiful People* (New York: Dell, 1967).
John Ashbery, 'Andy Warhol Causes Fuss in Paris', *International Herald Tribune* (Paris), 18 May, 1965.
Patrick Smith, 'Art *in Extremis*: Andy Warhol and His Art'.
Andy Warhol, *a*, a novel.
David Bourdon, *Village Voice*, November 1964.
Gretchen Berg, 'Nothing to Lose', *Cahiers du Cinéma*, in English, no. 10, May 1967.
Jean Stein, edited with George Plimpton, *Edie*.
Leo Lerman, 'Andy and Edie', *Mademoiselle*, New York, 15 December 1965.
The Editors of Rolling Stone, *The Sixties* (San Francisco: Straight Arrow Books, 1977).
Peter Schjeldahl, 'Andy Warhol 1928–1987', *Art in America*, May 1987.
Gerard Malanga, Paris Diary, unpublished.
Andy Warhol, Film-Makers' Cinemathèque Program Note for *Kitchen*.
Andy Warhol and Pat Hackett, *Popism*.
Neal Weaver, *After Dark*, 1969.
David Bourdon, 'Andy Warhol 1928–1987', *Art in America*, May 1987.

Andy Warhol's Exploding Girls
Based on interviews with Billy Linich, Robert Heidie, Gerard Malanga, Ronald Tavel, Paul Morrissey, Mary Woronov, Ronnie Cutrone, Sterling Morrison.
Andy Warhol, *a*, a novel.
Jean Stein, edited with George Plimpton, *Edie*.
Jordan Crandall, interview with Ultra Violet, *Splash*.
Bill Holdship, interview with Lou Reed, *Creem*, vol. 19, no. 3, 1987.
John Wilcock, *The Autobiography and Sex Life of Andy Warhol*.
Victor Bockris and Gerard Malanga, *Uptight: The Velvet Underground Story* (New York: Morrow, 1984).
Viva, *Superstar*.
Bob Spitz, *Dylan* (New York: McGraw Hill, 1988).
Andy Warhol, *Popism*.
Charles F. Stuckey, 'Andy Warhol 1928–1987', *Art in America*, May 1987.

Gerard Malanga and Charles Giuliano, 'Working with Warhol', *Art New England*, 1988.

Gretchen Berg, 'Andy Warhol: My True Story', *Los Angeles Free Press*, vol. 6, no. 11, 1967.

Andy Warhol, *The Philosophy of Andy Warhol*.

Jonas Mekas, 'Notes on Re-Seeing the Movies of Andy Warhol', *Andy Warhol* by John Coplans.

Kurt Loder, 'Andy Warhol 1928–1987', *Rolling Stone*, no. 497, 1987.

Richard Morphet, Tate Gallery Catalogue for Andy Warhol Retrospective, London 1971.

Gerard Malanga, 'Working with Warhol', *Village Voice*, vol. 111, no. 1, 1987.

Stephen Koch, *Stargazer*.

David Fricke, 'Lou Reed', *Rolling Stone*, no. 512, 1987.

Roy Trakin, interview with John Cale, *Creem*, vol. 19, no. 3, 1987.

Calvin Tomkins, 'Raggedy Andy', *Andy Warhol* by John Coplans.

Lester Bangs, *Psychotic Reactions and Carburetor Dung* (New York: Knopf, 1987).

The Chelsea Girls

Based on interviews with Paul Morrissey, Ondine, Ronald Tavel, Ronnie Cutrone, Billy Linich, Gerard Malanga, Mary Woronov, Gore Vidal.

Ultra Violet, *Famous for Fifteen Minutes*.

Gretchen Berg, 'Andy Warhol: My True Story', *Los Angeles Free Press*, vol. 6, no. 11, 1967.

Patrick Smith, 'Art *in Extremis*: Andy Warhol and His Art'.

Robert Levinson, interview with Paul Morrissey, *Coast FM & Fine Arts*.

Jean Stein, edited with George Plimpton, *Edie*.

Gerard Malanga, Secret Diaries, unpublished.

Barbara Rose, *Rauschenberg* (New York: Elizabeth Avedon Editions, Vintage, 1987).

Jonas Mekas, advertisement flyer for *The Chelsea Girls*, 1966.

Shirley Clarke, advertisement flyer for *The Chelsea Girls*, 1966.

John Wilcock, *The Sex Life and Autobiography of Andy Warhol*.

Bernard Weintraub, 'Andy Warhol's Mother', *Esquire*, vol. 64, no. 5, November 1966.

Calvin Tomkins, *Off the Wall: Robert Rauschenberg and the Art World of Our Time* (New York: Doubleday, 1980).

Stephen Koch, *Stargazer*.

Rex Reed, *Big Screen, Little Screen* (New York: Macmillan, 1971).

Andy Warhol, 'Sunday With Mr C: An Audio-Documentary by Andy Warhol Starring Truman Capote', *Rolling Stone*, no. 132, 12 April 1973.

Bosley Crowther, 'The Underground Overflows', *New York Times*, 11 December 1966.

The Original American Genius

Based on interviews with Ondine, Allen Midgette, Gerard Malanga, Billy Linich, Taylor Mead, Paul Morrissey, Lou Reed, Geraldine Smith.

Serge Gavronsky, *Cahiers du Cinéma*, in English, no. 10, May 1967.

Gretchen Berg, 'Nothing to Lose', *Cahiers du Cinéma*, in English, no. 10, May 1967.

Bill Holdship, interview with Lou Reed, *Creem*, vol. 19, no. 3, 1987.

Ultra Violet, *Famous for Fifteen Minutes*.

Andy Warhol and Pat Hackett, *Popism*.

Jean Clay, 'Andy's warhorse', *Réalités*, no. 205, December 1967.

Ted Castle, 'Occurrences: Cabride with Andy Warhol', *Art News*, vol. 66, February 1968.

Susan Pile and Joel Klaperman, 'Everything Happens, a Discussion at Andy Warhol's Factory', *Kings Crown Essays*, vol. 15, no. 1, 1967.
Grace Glueck, 'Warhol Unveils * of **** Film', *New York Times*, 8 July 1967.
Viva, 'Viva and God', *Village Voice*, vol. 111, no. 1, 1987.
Roger Wolmuth, 'Flower Power Revisited', *People*, 22 June 1987.
Tom Baker, 'In an Above Ground Society', *Cinema*.
Pat Patterson, 'Nico: Chelsea Girl' (liner notes on album), Verve 1967.
Viva, *Superstar*.
Gerard Malanga, Secret Diaries, unpublished.

The Most Hated Artist in America
Based on interviews with Viva, Billy Linich, Terry Noel, Fred Hughes, Ronald Tavel, Ondine, Taylor Mead, Louis Waldon.
John Richardson, 'The Secret Warhol', *Vanity Fair*, vol. 50, no. 7, 1987.
Rex Reed, *Big Screen, Little Screen* (New York: Macmillan, 1971).
Susan Pile and Joel Klaperman, 'Everything Happens, a Discussion at Andy Warhol's Factory', *Kings Crown Essays*, vol. 15, no. 1, 1967.
Viva, 'Viva and God', *Village Voice*, vol. 111, no. 1, 1987.
Viva, 'The Superstar and the Heady Years', *New York Woman*, May–June 1987.
Stephen Koch, Warhol, *Motion Picture*, vol. 11, no. 1, 1987.
Gerard Malanga, Rome Diaries, unpublished.
Viva, *Superstar*.
Andy Warhol, 'Sunday with Mr C: An Audio-Documentary by Andy Warhol Starring Truman Capote', *Rolling Stone*, no. 132, 12 April 1973.
Jane Kramer, *Allen Ginsberg in America* (New York: Random House, 1968).
Andy Warhol and Pat Hackett, *Popism*.
Steven M. L. Aronson, 'Andy's Heir Apparent', *Vanity Fair*, vol. 50, no. 7, 1987.
Robert Hughes, 'The Rise of Andy Warhol', *New York Review of Books*, vol. 29, no. 2, 1982.
Andy Warhol, *Andy Warhol's Index Book*.

You Can't Live if You Don't Take Risks
Based on interviews with Gerard Malanga, David Bourdon, Fred Hughes, Louis Waldon, Viva, Taylor Mead.
Barbara Goldsmith, 'La Dolce Viva', *New York*, April 1968.
The Federal Bureau of Investigation Files on Andy Warhol, FBI Headquarters, Washington DC, 1969.
Gerard Malanga, 'Introduction to the Secret Diaries', *Radar* (Basel) Nr. 3, 1986.
Phyllis and Eberhard Kronhausen, *Erotic Art* (New York: Grove Press, 1968–1970).
Derek Hill, interview with Paul Morrissey, 1969.
Andy Warhol and Pat Hackett, *Popism*.
Robert Marmorstein, 'A Winter Memory of Valerie Solanas', *Village Voice*, 13 June 1968.
Interview with Taylor Mead, The American New Wave, Whitney Museum Catalogue.

The Assassination of Andy Warhol
Based on interviews with Billy Linich, Jed Johnson, Gerard Malanga, John Warhola, Paul Warhola, Taylor Mead, Ultra Violet, Louis Waldon, George Warhola, James Warhola, Paul Morrissey, Ondine, Margaret Warhola.
John Wilcock, *The Sex Life and Autobiography of Andy Warhol*.
Howard Smith, 'The Shot that Shattered the Velvet Underground', *Village Voice*, vol. 15, no. 34, 1968.
Viva, *Superstar*.
Andy Warhol and Pat Hackett, *Popism*.

Joseph Mancini, 'Andy Warhol Fights for Life', *New York Post*, 4 June 1968.

Richard F. Shepherd, 'Warhol Gravely Wounded in Studio', *New York Times*, 4 June 1968.

Peter Coutros, 'Off-beat Artist-Producer Used Girls as Film Props', *Daily News*, 4 June 1968.

Frank Faso, Martin McLaughlin and Richard Henry, 'Andy Warhol Wounded by Actress', *Daily News*, 4 June 1968.

Maurice Girodias, Publisher's Preface, *SCUM Manifesto* by Valerie Solanas (New York: Olympia Press, 1968).

Jean Stein, edited with George Plimpton, *Edie*.

Leticia Kent, 'Andy Warhol "I thought Everyone was Kidding,"' *Village Voice*, 12 September 1968.

Barbara Rose, 'In Andy Warhol's Aluminum Foil, We All Have Been Reflected', *New York*, 31 May 1971.

From Fuck to Trash

Based on interviews with Fred Hughes, John Warhola, Paul Warhola, Louis Waldon, Viva, Paul Morrissey, Gerard Malanga, Geraldine Smith, Billy Linich, Tom Hedley, Taylor Mead, John Wilcock, Jed Johnson, Vincent Fremont, Emile de Antonio, Frank Cavestani, Robert Heidie, Daniella Morera.

Andy Warhol and Pat Hackett, *Popism*.

John Wilcock, *The Sex Life and Autobiography of Andy Warhol*.

Rex Reed, *Big Screen, Little Screen* (New York: Macmillan, 1971).

Viva, 'Viva and God', *Village Voice*, vol. 111, no. 1, 1987.

Phyllis and Eberhard Kronhausen, *Erotic Art* (New York: Grove Press, 1968–1970).

Viva, *Superstar*.

Jean Stein, edited with George Plimpton, *Edie*.

Gerard Malanga, Secret Diaries, unpublished.

Jim Carrol, *Forced Entries: The Downtown Diaries 1971–1973* (New York: Penguin Books, 1987).

Patrick Smith, 'Art *in Extremis*: Andy Warhol and His Art'.

Robert Mazzocco, 'aaaaaa . . .', *New York Review of Books*, vol. 12, no. 8, 1969.

Andy Warhol, *a*, a novel.

Stephen Koch, *Stargazer*.

John Perrault, 'Andy Warhol', *Vogue*, no. 155, March 1970.

Parker Tyler, *Underground Film, A Critical History* (New York: Grove Press, 1969).

Margo Howard-Howard with Abbe Michaels, *I Was a White Slave in Harlem* (New York: Four Walls Eight Windows, 1988).

John Hallowell, *After Dark*, 1969.

Calvin Tomkins, 'Raggedy Andy', *Andy Warhol* by John Coplans.

David Bailey, *Andy Warhol, Transcript of David Bailey's ATV Documentary*.

Leticia Kent, 'Andy Warhol: Movieman "it's hard to be your own script"', *Vogue*, no. 155, March 1970.

Dotson Rader, 'Andy's Children: They Die Young', *Esquire*, March 1974.

Paul Carrol, 'What's a Warhol?', *Playboy*, vol. 16, no. 9, 1969.

Gerard Malanga, lecture notes, unpublished.

John Russell Taylor, *Directors and Direction, Cinema for the Seventies* (New York: Hill and Wang, 1975).

Grace Glueck, *New York Times*, 9 May 1971.

Jonas Mekas, 'Notes on Re-Seeing the Movies of Andy Warhol', *Andy Warhol* by John Coplans.

An International Superstar

Based on interviews with John Coplans, Catherine Guinness, John Giorno, Vincent Fremont, Fred Hughes, Jed Johnson, Suzi Frankfurt, Beauregard Houst-

on-Montgomery, Gerard Malanga, Heiner Bastian, Glenn O'Brien, Tom Hedley, David Bourdon, Louis Waldon, Felix Dennis.

Robert Colacello, 'King Andy's German Conquest', *Village Voice*, 11 March 1971.

John Wilcock, *The Sex Life and Autobiography of Andy Warhol*.

Emile de Antonio and Mitch Tuchman, *Painters Painting* (New York: Abbeville Press, 1984).

David Bailey, *Andy Warhol, Transcript of David Bailey's ATV Documentary*.

Calvin Tomkins, 'Raggedy Andy', *Andy Warhol* by John Coplans.

John Perrault, 'Expensive Wallpaper', *Village Voice*, 13 May 1971.

Fred Hughes, Preface, The Andy Warhol Collection Catalogues, Sotheby's.

Paul Morrissey quoted in *Daily Telegraph*, London, 1971.

Richard Morphet, Tate Catalogue of Warhol Retrospective, London, 1971.

Bob Colacello, 'Working for Warhol', *Vanity Fair*, vol. 50, no. 7, 1987.

George Rush, 'Andy Warhol Inc.', *Manhattan Inc.*, vol. 29, no. 2, 1984.

Pseuds' Corner, *Private Eye*, London, 1971.

Mary Josephson, 'Warhol: The Medium as Cultural Artifact', *Art in America*, no. 59, May–June 1971.

Anthony Zanetta and Henry Edwards, *Stardust: The David Bowie Story* (New York: McGraw Hill, 1986).

Peter Watson, 'Andy Warhol's Final Sale', *Observer*, 6 March 1988.

Nicholas Coleridge, *The Fashion Conspiracy* (New York: Harper and Row, 1988).

Barbara Catoir, 'The New German Collectors', *Art News*, April 1986.

Peter and Leni Gillman, *Alias David Bowie* (London: Hodder & Stoughton, 1986).

Andy Warhol, 'Sunday with Mr C: An Audio-Documentary by Andy Warhol starring Truman Capote', *Rolling Stone*, no. 132, 12 April 1975.

Lou Reed, Rock n Roll Animal (London: Babylon Books, no author, no date).

Giovanni Dadomo, 'The Legend of the Velvet Underground', *Sounds*, 1972.

Tony Sanchez, *Up and Down with the Rolling Stones* (New York: Morrow, 1979).

Andy Warhol and Pat Hackett, *Popism*.

Ray Coleman, *Lennon* (New York: McGraw Hill, 1984).

Jann Wenner, *Lennon Remembers* (San Francisco: Straight Arrow Books, 1971).

Peter Watson, 'Andy Warhol's Final Sale', *Observer* (London) 6 March 1988.

The Death of Julia Warhola

Based on interviews with Gerard Malanga, Paul Warhola, John Warhola, Jed Johnson, Margaret Warhola, Suzi Frankfurt, George Warhola, Ronald Tavel, Glenn O'Brien, Paul Morrissey, Fred Hughes, Vincent Fremont, Geraldine Smith, Daniella Morera, Tom Hedley.

Andy Warhol, *The Philosophy of Andy Warhol*.

Paul Carrol, 'What's a Warhol?', *Playboy*, vol. 16, no. 9, 1969.

John Wilcock, *The Sex Life and Autobiography of Andy Warhol*.

Barbara Rose, *Rauschenberg* (New York: Elizabeth Avedon Editions, Vintage Books, 1987).

David Bailey, *Andy Warhol, Transcript of David Bailey's ATV Documentary*.

Jesse Kornbluth, 'Andy: The World of Warhol', *New York*, vol. 20, no. 10, 1987.

Patrick Smith, 'Art *in Extremis*: Andy Warhol and His Art'.

Ultra Violet, *Famous for Fifteen Minutes*.

Dotson Rader, 'Andy's Children: They Die Young', *Esquire*, March 1974.

Jim Carrol, *Forced Entries, The Downtown Diaries 1971–1973* (New York: Penguin Books, 1987).

Andy Warhol, 'Sunday with Mr C: An Audio-Documentary by Andy Warhol Starring Truman Capote', *Rolling Stone*, no. 132, 12 April 1973.

Paul Gardner, *New York Times*, 1972.

Natalie Robins and Steven L. Aronson, *Savage Grace* (New York: Morrow, 1985).

Tennessee Williams, *Memoirs* (New York: Doubleday, 1975).

To Appreciate Life You Must First Fuck Death in the Gallbladder

Based on interviews with Paul Morrissey, Jed Johnson, Daniella Morera, Taylor Mead, Ronald Tavel, Vincent Fremont, Geraldine Smith, Ronnie Cutrone.
Laurel Delp, 'Joe Dallesandro', *L.A. Style*, April 1986.
Roman Polanski, *Roman* (New York: Morrow, 1984).
Andy Warhol, interview with Anna Karina, *Interview*, 1973.
Paul Gardner, 'Warhol – from Kinky Sex to Creepy Gothic', *New York Times*, 14 July 1974.
Kitty Kelley, *Elizabeth Taylor, The Last Star* (New York: Simon and Schuster, 1981).
Robert Colacello, 'The Liz and Andy Show', *Vogue* (USA), January 1974.
Andy Warhol, 'Sunday with Mr C: An Audio-Documentary by Andy Warhol Starring Truman Capote', *Rolling Stone*, no. 132, 12 April 1973.
George Rush, Andy Warhol, Inc., *Manhattan Inc*, vol. 29, no. 2, 1984.
Bob Colacello, 'Out', *Interview*, 1974.
Carter Ratcliff, *Andy Warhol*.
John Wilcock, *The Sex Life and Autobiography of Andy Warhol*.

Andy Warhol Enterprises Takes Off

Based on interviews with Vincent Fremont, Ronnie Cutrone, Daniella Morera, Paul Warhola, Victor Hugo, Benjamin Liu, Fred Hughes, Susan Sontag, Jed Johnson, Suzi Frankfurt.
John Richardson, 'The Secret Warhol', *Vanity Fair*, vol. 50, no. 7, 1987.
John Richardson, 'Warhol the Collector', The Andy Warhol Collection Catalogues.
Christopher Makos, *Warhol Makos*.
Bob Colacello, 'Working with Warhol', *Vanity Fair*, vol. 50, no. 7, 1987.
David Bourdon, 'Andy Warhol and the Society Icon', *Art in America*, January–February 1975.
George Rush, 'Andy Warhol, Inc.', *Manhattan Inc*, vol. 29, no. 2, 1984.
Rupert Smith, 'Acquisition and Accumulation', The Andy Warhol Collection Catalogues.
Lewis Lapham, *Money and Class in America* (New York: Weidenfeld & Nicolson, 1988).
Robert Hughes, 'King of the Banal', *Time*.
William Shawcross, *The Shah's Last Ride* (New York, 1988).
Bob Colacello, 'Out', *Interview*, 1974.
Andy Warhol and Bob Colacello, *Andy Warhol's Exposures*.
John Wilcock, *The Sex Life and Autobiography of Andy Warhol*.
Norman Mailer, *Marilyn* (New York: Grosset and Dunlap, 1974).
John Philips, *Papa John* (New York, 1986).
Andy Warhol, *The Philosophy of Andy Warhol*.
Barbara Goldsmith, 'The Philosophy of Andy Warhol', *New York Times Book Review*, 14 September 1975.
Jack Kroll, 'Raggedy Andy', *Newsweek*, no. 86, September 1975.
Andy Warhol, 'Sunday with Mr C: An Audio-Documentary by Andy Warhol Starring Truman Capote', *Rolling Stone*, no. 132, April 1973.
Jed Johnson, 'Inconspicuous Consumption', The Andy Warhol Collection Catalogues.
Steven L. Aronson, 'Possession Obsession', *House and Garden*, vol. 159, no. 12, 1987.

Bad

Based on interviews with John Warhola, Vincent Fremont, Catherine Guinness, Fred Hughes, Ronnie Cutrone, Henry Geldzahler, Jed Johnson.
Bob Colacello, 'Out', *Interview*, 1976.

Parviz Radji, *In the Service of the Peacock Throne* (New York: Hamish Hamilton/ David and Charles, 1984).
Alexander Cockburn, *Corruptions of Empire* (London, New York: Verso, 1987).
Andy Warhol and Bob Colacello, *Andy Warhol's Exposures*.
David Bourdon, 'Warhol Serves up Retooled Icons à la Russe', *Village Voice*, 24 January 1977.

Dancing Under Fire
Based on interviews with Muhammad Ali, Vincent Fremont, Daniella Morera, Walter Steding, Catherine Guinness, David Bourdon, Vito Giallo, Margaret Warhola, Ronnie Cutrone, Victor Hugo.
Bob Colacello, 'Out', *Interview*, 1977.
Christopher Makos, *Warhol Makos*.
Gary Indiana, 'I'll Be Your Mirror', *Village Voice*, vol. 111, no. 1, 1987.
Stephen Koch, 'Warhol', *Motion Picture*, vol. 11, no. 1, 1987.
Patrick Smith, 'Art *in Extremis*: Andy Warhol and His Art'.
Andy Warhol and Bob Colacello, *Andy Warhol's Exposures*.
Fred Hughes, Preface, The Andy Warhol Collection Catalogues.
Peter Watson, 'Andy Warhol's Final Sale', *Observer* (London), 6 March 1988.
Sandra Brant, *Andy Warhol's Folk and Funk* (New York: The Museum of American Folk Art, 1977).
Ultra Violet, *Famous for Fifteen Minutes*.
Patrick Smith, 'Art *in Extremis*: Andy Warhol and His Art'.

Screech to a Halt
Based on interviews with Albert Goldman, Vincent Fremont, Toni Brown, Raymond Foye, Walter Steding, Paul Warhola, Daniella Morera, Suzi Frankfurt, Ronnie Cutrone, Catherine Guinness.
William Shawcross, *The Shah's Last Ride* (New York: 1988).
Jane Addams Allen, 'Speculating', *Insight*, 31 March 1986.
Bob Colacello, 'Out', *Interview*, 1979.
Andy Warhol, 'Liza Minnelli', *Interview*, 1979.
Peter Schjeldahl, 'Warhol and Class Content', *Art in America*, May 1980.
Hilton Kramer, 'Whitney Shows Warhol Work', *New York Times*, 23 November 1979.
John Richardson, 'The Secret Warhol', *Vanity Fair*, vol. 50, no. 7, 1987.
John Richardson, 'Warhol the Collector', The Andy Warhol Collection Catalogues.
Lita Hornick, *Night Flight* (New York: The Kulchur Foundation, 1982).
Donald Kuspit, 'Andy's Feelings', *Artscribe*, Summer 1987.

A Bourgeois Maniac
Based on interviews with Heiner Bastian, Ronnie Cutrone, Catherine Guinness, Suzi Frankfurt, Daniella Morera, Christopher Makos, Vito Giallo, Benjamin Liu, Dr Andrew Bernsohn, Dona Peltin, Walter Steding, Vincent Fremont.
Fred Hughes, Preface, The Andy Warhol Collection Catalogues.
Dorothea Baumer, 'Ich Mach's Halt Nur', *Süddeutsches Zeitung*, 7 May 1980.
Maura Moynihan, 'The Cover Girl and the Prosperous Years', *New York Woman*, May–June 1987.
Andy Warhol, *America*.
Exquisite Corpse, vol. 6, nos. 10–12, October–December 1988.
Eva Windmüller, 'A Conversation with Andy Warhol', *Stern*, 8 October 1981.
Christopher Makos, *Warhol Makos*.
Bob Colacello, 'Out', *Interview*, 1980.
Alexander Cockburn, *Corruptions of Empire* (London and New York: Verso, 1987).

Robert Hughes, 'The Rise of Andy Warhol', *New York Review of Books*, vol. 29, no. 2, 1982.
Dona Peltin, unpublished article on working at *Interview*.
Bob Colacello, 'Working with Warhol', *Vanity Fair*, vol. 50, no. 7, 1987.
Peter Watson, 'Andy Warhol's Final Sale', *Observer* (London), 6 March 1988.

Too Much Work
Based on interviews with Walter Steding, Ronnie Cutrone, Emile de Antonio, Heiner Bastian, Christopher Makos, Vincent Fremont, Benjamin Liu, Stellan Holm, Daniella Morera, Dr Andrew Bernsohn, Raymond Foye.
Achille Bonito Oliva, *Industrial Metaphysics, Warhol verso de Chirico* (Milan: Electa, 1982).
The Bob Dylan quote is taken from three interviews published in *Rolling Stone*, 26 January 1978, *Maclean* (Canada), 29 March 1978, *Los Angeles Times*, 22 January 1978.
George Rush, 'Andy Warhol Inc.', *Manhattan Inc*, October 1984.
Peter Plagens, *Art in America*, March 1982.
Roberta Bernstein, *Andy Warhol Prints* (New York: Abbeville Press, 1985).
Meryle Secrest, 'Leo Castelli, Dealing in Myths', *Art News*, Summer 1982.
Rainer Crone and Georgia Marsh, *Clemente* (New York: Elizabeth Avedon Editions, Vintage 1987).
Jessica Berens, 'In Warhol's Footsteps', *HG*, April 1988.
Carter Ratcliff, *Andy Warhol*.
Maura Moynihan, 'The Cover Girl and the Prosperous Years', *New York Woman*, May–June 1987.
Christopher Makos, *Warhol Makos*.
Andy Warhol, 'Jodie Foster', *Interview*, 1982.
John Wilcock, *The Sex Life and Autobiography of Andy Warhol*.
Barry Blinderman, 'Andy Warhol', *Arts Magazine*, October 1981.
Stephen Koch, 'Warhol', *Motion Picture*, vol. 11, no. 1, 1987.
Keith Haring interview, *New York Talk*, 1985.
Peter Schjeldahl, *David Salle* (New York: Elizabeth Avedon Editions, Vintage, 1987).
Leroy Neiman, 'Ultra Violet', *Cover*, vol. 3, no. 1, 1989.
Adam Edwards, *Daily Mail* (London), 1985.

Everything Is Boring
Based on interviews with Victor Hugo, Benjamin Liu, George Warhola, Heiner Bastian, Suzi Frankfurt, Daniella Morera, Marianne Erdos, Raymond Foye, Dr Andrew Bernsohn, Catherine Guinness, Michelle Loud, John Warhola, Vincent Fremont, Stellan Holm.
Andy Warhol, *America*.
Eva Windmüller, 'A Conversation with Andy Warhol', *Stern*, 8 October 1981.
Fiona Powell, interview with Andy Warhol, *The Face*, 1985.
Stephen Saban, interview with Boy George, *Details*, 1985.
John Richardson, 'The Secret Warhol', *Vanity Fair*, vol. 50, no. 7, 1987.
John Richardson, 'Warhol the Collector', The Andy Warhol Collection Catalogues.
Jason Crandall, 'Andy Warhol', *Splash*, no. 6, 1986.
Christopher Makos, *Warhol Makos*.
Beauregard Houston-Montgomery, 'Remembering Andy Warhol: An Impressionist Canvas', *Details*, May 1987.

Goodbye
Based on interviews with George Warhola, Vincent Fremont, John Hanhardt, John Warhola, Margaret Warhola, Dr Andrew Bernsohn, Vito Giallo, Daniella

Morera, John Giorno, Victor Hugo, Taylor Mead, Michelle Loud, Paul Warhola, James Warhola.

Robert Katz, *Fassbinder: Love is Colder Than Death* (New York: Random House, 1987).

John Caldwell, *Carnegie Mellon Magazine*, 1986.

Gordon Burn, with Liz Jobey, Michael Watts and Georgina Howell, 'Andy Warhol 1928–1987', *Sunday Times* magazine, 29 March 1987.

Carter Ratcliff, 'Andy Warhol, Inflation Artist', *Artforum*, March 1985.

Nicholas Haslam, 'Andy Warhol, A Tribute', *Vogue* (UK), vol. 144, no. 5, 1987.

David Bourdon, 'Andy Warhol 1928–1987', *Art in America*, vol. 75, no. 5, 1987.

Laura de Copet and Alan Jones, *The Art Dealers* (New York: Clarkson Potter, 1984).

Pierre Restany, 'Andy Warhol, Less is More', *Galeries*, no. 18, April–May 1987.

John Richardson, 'The Secret Warhol', *Vanity Fair*, vol. 50, no. 7, 1987.

John Richardson, 'Warhol the Collector', The Andy Warhol Collection Catalogues.

Paul Taylor, 'Andy Warhol', *Flash Art*, no. 133, April 1987.

Fiona Powell, interview with Andy Warhol, *The Face* 1985.

Jesse Kornbluth, 'Andy: The World of Warhol', *New York*, vol. 20, no. 10, 1987.

Beauregard Houston Montgomery, 'Remembering Andy Warhol: An Impressionist Canvas', *Details*, May 1987.

M. A. Farber and Lawrence K. Altman, 'A Great Hospital in Crisis', *New York Times* magazine, 24 January 1988.

Trevor Fairbrother, *American Art of the Late 1980s* (Cologne: Institute of Contemporary Art, Dumont Buchverlag, 1988).

Jason Crandall, 'Andy Warhol', *Splash*, no. 6, 1986.

Denis Hamill, 'Enigma Wrapped in Style', *New York Newsday*, 23 February 1987.

Andy Warhol, *America*.

Martin Filler, 'Andy Warhol, A Tribute', *Art in America*, May 1987.

Patricia Lowry, 'Warhol Was a Drug and We Were Addicted', *Pittsburgh Press*, 27 February 1987.

Doug Feiden, 'Andy's Home at Last', *New York Post*, 27 February 1987.

Jonathan Yardley, 'Andy Warhol's Artless Achievement', *New York Post*, 4 March 1987.

Doug Feiden, 'Warhol Goes to the Grave in Paisley Tie and Shades', *New York Post*, 26 February 1987.

INDEX

a, 318–319
A is an Alphabet, 94
Abstract Expressionism, 79, 128, 135, 136
Advertisement paintings, 135, 281
Agnelli, Johnny, 365, 378
AIDS, 467, 485
Albee, Edward, 243
Albert, Hotel, 318
Ali, Muhammad, 411–412
All the King's Men, 70–71
Allen, Barbara, 382, 407
Allen, Joe, 370, 397, 405
Allyson, Bob, 92
Amaya, Mario, 158, 297–302, 307, 356, 372, 485
America, Paul, 231–232, 279
'American Indian' paintings, 416
'American Myths' paintings, 452
Amman, Thomas, 380
L'Amour, 339
Andrews, Julie, 11, 124
Andy and Edie Show, The, 463
Anka, Paul, 430
Anliker, Roger, 71
Anselmino, Luciano, 391
Anthony d'Offay Gallery, 480–481
Anvil, the (club), 441
Arcade, Penny, 317
Arias, Joey, 463
Arnaz, Lucie, 411
Artforum, 149, 212
Arthur (disco), 225, 229, 240
Art News, 185–186
Ash, Betty, 64–65, 68, 74, 84
'Athletes' paintings, 411–412, 452
Auden, W. H., 164
Avedon, Richard, 311
AVG Productions (automaton), 458–459
Ayers, Gerald, 322–323

Bad, 396–398, 402, 404–405, 411
Bailey, David, 224, 335, 347–348, 358, 429
Baker, Carroll, 396, 404
Baker, Tom, 272–273
Balcomb Greene, 71, 74–75, 77, 93
Bardot, Brigitte, 269, 378
Barn, the (studio), 69
Barr, Richard, 243
Barzini, Benedetta, 262, 269
Basquiat, Jean-Michel, 449, 450–451, 460–464, 468–470
Bastian, Heiner, 171, 435–436, 455, 472, 478
Baumann, Elaine, 85–87, 88, 92, 93
Beaber, Jack, 85

Beard, The, 263
Beard, Peter, 420, 422
Beaton, Cecil, 11, 115, 116, 324
Beatty, Warren, 151
Beauty #2, 226–227, 228, 254
Beck, Jack Wolfgang, 112
Beddows, Margery, 85, 87
Bellamy, Richard, 140
Berg, Gretchen, 272, 305
Bergé, Pierre, 339, 405
Berlin, Brigid, *see* Polk, Brigid
Berlin, Seymour, 116, 132, 134
Bernhardt, Sarah, 451
Bernsohn, Dr Andrew, 465, 467–468, 476, 482, 487
Beuys, Joseph, 436–437, 455, 458, 485–486
Bhutto, prime minister of Pakistan, 398
Bidlo, Mike, 463
Bikeboy, 272, 273, 276
Bischofberger, Bruno, 357, 370, 380, 450, 460, 462
Bischofberger, Yoyo, 379
Bitch, 234
Black and White Ball, the, 262
'Black Transvestites' paintings, 391
Blond, Susan, 397
Blondie, 402, 432, 456
Blood for Dracula, 366–369, 373
Blow Job, 190, 197, 277
'Blue Electric Chair', 171
Blue Movie, 315–316, 326–327
Blum, Irving, 148–149, 178, 181, 182, 378
Boas, Francesca, 83, 84, 85
Bodley Gallery, the, 119–120, 124, 127, 130, 165
Bonwit Teller's, 118, 128, 142
Boone, Mary, 449, 460, 462, 469
Borscheit, Randy, 263
'Bosoms I', 'Bosoms II', 167
Bosquet, Carol, 422
Bottomly, Susan, *see* International Velvet
Bourdon, David, 145, 148, 155, 157, 158, 210, 234, 286–288, 315, 348–349, 379–380, 386, 411, 416, 484
Bowie, David, 344–345, 346, 402
Boy George, 475
Brakhage, Stan, 190–191, 211–212
Brand, Stewart, 275
Brandeis, Louis, 451
Braniff Airlines, 337
Brant, Peter, 338–339, 365, 370, 397, 405
Brant, Sandy, 338–339, 365, 416
Brasserie, the, 176, 185
Braunsberg, Andrew, 366, 373
'Brillo Boxes', 189, 198–200, 217, 334, 432

Brown, James, 243
'Brown Spots', 462
Brown, Toni, 424–425
Bruce, Stephen, 105, 118, 123
Brynner, Doris, 282
Buber, Martin, 451
Buckley, Mrs William F., 373
Bugarin, Augusto, 462, 471–472
Bugarin, Aurora and Nena, 394, 414, 475, 489
Burke, Karen, 465, 486
Burnett, Carol, 115
Burroughs, Julian Jr, 285
Burroughs, William, 174, 285, 438
Burton, Will, 81, 100
Butler, John, 92, 103, 113

Café Nicholson, 101, 103, 105, 106
Cage, John, 67, 129, 150, 348
Caldwell, John, 480
Cale, John, 240, 248, 252 see also Velvet Underground
'Campbell's Elvis', 166
'Campbell's Soup Cans', 144–145, 148–149, 150, 154, 155, 157, 159–160, 165, 334, 335, 336, 343, 390, 432–433, 437
Cannes Film Festival, 268–269
Cano, The, 76
Capote, Nina, 91–92, 98, 100
Capote, Truman, 73, 86, 91–92, 99, 100, 101, 116, 124–125, 223, 262, 345, 346, 347, 359, 369, 382, 392, 394, 403, 420, 426–427, 432, 433, 485
Carey, Ted, 127, 132, 135, 142–143, 153, 485
Carnegie Institute of Technology, 59–77, 119
Carnegie Museum, 480, art course, 49–51
Carrol, Jim, 317, 325–326, 360
Carter, Jimmy, 399, 410–411, 432
Carter, Lillian, 411, 452
Cartoon paintings, 136, 281
Casey's, 311, 315
Cassen, Jackie, 246
Castelli Gallery, the, 129, 139, 210, 248–249, 281, 337, 453–454, 470
Castelli, Leo, 136, 137, 141–142, 156, 171, 200, 233, 248, 281, 301, 302, 324, 334, 335, 336, 400, 428, 449, 453–454, 460, 493
Castle, Ted, 271
Castle, the, 250–251
25 Cats Named Sam and One Blue Pussy, 116
Caulfield, Patricia, 260
Cavestani, Frank, 332–333
Cedar Bar, the, 79
Chairman Mao paintings, 356–357, 358, 371–372, 390, 393, 432, 435
Chaitman, Jennifer, 467
Chamberlain, John, 137, 286, 288
Chamberlain, Wynn, 169, 179–180, 182–183, 190, 332–333

Charbin, Genevieve, 221–222, 225, 231–232
Charm, 81
Chelsea Girl (album), 273
Chelsea Girls, 256–260, 263–264, 265, 268–269, 275–276, 355
Chelsea Hotel, the, 254, 261
Cher, 250
Cherry Orchard, The, 110
Chia, Sandro, 449, 450
Chou, Min, 488
Chow, Tina, 481
Clash, the, 402
Clemente, Francesco, 449, 450, 451, 455, 460
Clockwork Orange, A, 218
Closet, 263
Cocaine Cowboys, 423–424
Cock Book, 92
Cocksucker Blues, 346
Coe-Kerr Gallery, 397
Coke bottles paintings, 136, 137, 150, 155
Colacello, Bob, 341, 342, 364, 366–367, 369, 370–371, 375, 376–378, 381–387, 388–390, 398, 399, 404, 407–409, 411, 413, 414, 416, 420, 425, 426, 428, 429, 433, 434, 445–448, 457
Collin-Dufresne, Isabelle, see Ultra Violet
Collins, Rufus, 203
'Coloured Mona Lisa', 166, 200
Columbia Pictures, 322–323
Columbia Records, 81
Columbia University film society, 277
Columbus Hospital, 392–309
Complete Book of Erotic Art, The, 315
Complete Book of Etiquette, 89
Cooper, Michael, 224
Coplans, John, 149, 334
Cornell, Joseph, 150
Corso, Gregory, 280
Couch, 202, 203
County, Wayne, 344
'Cow Wallpaper', 249
Cox, Dr Denton, 465, 487, 488
Cramer, Doug, 466
'Crazy Golden Slippers', 124–125, 165
Croland, David, 268, 304
Cruise, Vera, 286, 306
Cucchi, Enzo, 450
Cunningham, Merce, 129
Curtis, Jackie, 317–318, 326, 331–333, 345, 485
Cutrone, Ronnie, 244, 257, 375, 376–378, 388, 400, 403, 409, 414, 416–417, 419, 421, 425, 426–427, 433, 434, 435, 436–437, 438, 440, 443, 450–455, 457, 480

D'Amboise, Jacques, 92
de Antonio, Emile, 129–130, 131, 134, 136, 150, 155, 176, 199, 205, 207–208, 324, 335, 452, 459, 463, 469, 472

525

D'Arbanville, Patti, 309, 318, 328, 339, 444
de Chirico, Giorgio, 456

Daimuru department store, 385
Dalí, Salvador, 71–72, 247, 266
Dallesandro, Joe, 285–286, 309, 314, 323, 325, 328–329, 340, 342, 345, 354, 359, 366–367
Dalton, David, 147, 148, 149, 171
Dalton, Sarah, 147, 148, 156
Darling, Candy, 317–318, 331–332, 373
Davies, Leila, 65, 84, 85–87, 110
Davis, Miles, 486
Davis, Perry, 68, 69, 71, 72, 74, 75, 84, 93
Dean, James, 115, 124
Death and Disaster paintings, 88, 161, 169–172, 281, 334, 336, 343, 390, 482
Death of Lupe Velez, The, 235
Deisroth, Barbara, 440
Deren, Maya, 67
DIA Foundation, the, 400, 457, 482
Diaz, Al, 450
'Dick Tracy', 458
Dietrich, Marlene, 87
Dine, Jim, 139, 470
'Dollar Bills', 150, 155
'Dollar Sign' paintings, 453–454, 455
Dom, the, 246–248, 250, 253, 273
Donahue, Troy, 151, 181
Dorritie, Kathy, 344
Dracula, 202, see Blood For Dracula
Drawings for a Boy Book, 119–120
15 Drawings Based on the Writings of Truman Capote, 99–100
Driver's Seat, The, 369
Drugs, 175–176, 193–194, 196, 202, 204, 207, 214, 218–219, 220, 224, 225, 226, 228–230, 231, 235, 237, 238, 240, 255, 257, 260, 266, 273, 288, 293, 296, 316–317, 328, 330, 332, 349, 356, 425, 472
Drunk, 207–208
Duchamp, Marcel, 159, 178, 182, 335
Duchamp, Teeny, 182, 401
Duchess, the, 192
Duchin, Peter, 464
Duran Duran, 475
Dylan, Bob, 228–231, 235–236, 241, 244–245, 254, 260, 273, 451, 475

Easy Rider, 323
Eat, 190–191
Eberstadt, Frederick, 140
Einstein, Albert, 451
Elachko, Alexander, 31
Elachko, Ann, 34
Elachko, John, 39–40, 45
'Electric Chair' paintings, 188, 217, 343, 390, 435
Electric Circus, the, 253
Elias, Arthur, 65, 69, 72, 87, 109, 110, 112
Elias, Lois, 85, 87, 109
Elkron, Robert, 140

Emerson, Eric, 256, 266, 268–269, 285–288, 293–294, 388
Empire, 206–207
'Endangered Species' paintings, 458
Epstein, Brian, 269–270
'Ethel Scull 36 Times', 166–167, 254
Evert, Chris, 411
Exploding Plastic Inevitable, the, 246–248, 250–252, 253–254, 257, 262, 270, 378

'100 Faces of Happy Rockefeller', 310
Factory, the, 66, the 1st Factory (the Silver Factory), 188–201, 202–215, 216, 219, 222, 225–226, 228, 229, 232–233, 235, 238–245, 249, 253–264, 266–268, 270–275, 278–284, 286, 289
 the 2nd Factory (33 Union Square West), 290, 292, 293, 294, 297, 308–309, 313–320, 327–328, 332–333, 336–337, 340, 348, 356–357, 370–371, 374–375
 the 3rd Factory (860 Broadway), 376–381, 394, 400–403, 409, 410, 412–414, 417, 419, 425, 431, 447
 the 4th Factory, 457, 460–461, 462, 467, 471, 473, 493
Factory, the (disco), 323
'Factory' installation, 463
Fagan, Philip, 209, 212, 216–217
Faggots, 441
Fainlight, Harry, 212
Falaise, LouLou de la, 339
Farah Diba, Empress of Iran, 384, 387, 389, 398–399, 411
FBI, 288, 291–292, 293, 322, 414
Feldman, Andrea, 266, 318, 326, 328–329, 354, 359–361
Feldman, Ronald, 451–452
Ferus Gallery, the, 148–149, 178
Fields, Danny, 243
Film Culture Award, 211
Film-Makers' Co-op, the, 176, 180, 190, 212
Film-making, 176–178, 183, 189–191, 192, 197, 202–209, 211–215, 216–236, 238–248, 253–256, 258–264, 265–276, 281, 284, 285–288, 292–295, 309, 314–333, 339, 341, 354, 366–369, 396–397, 404–405, 481
Film retrospective, 481
Fine, Aaron, 110, 154
Fire Island, 231–233, 428
Firyal, Princess of Jordan, 408
Fitzpatrick, Joseph, 49–51, 53–54, 64, 65, 76–77, 493
Fleischer, Robert, 92–93
Flesh, 309, 313, 314, 317, 318, 328, 329, 334, 341
Flesh for Frankenstein, 366–369, 372–374
Flower paintings, 210, 223–224, 260, 334, 337, 343, 390, 435
Fluxus group, 336
Fonda, Jane, 323

Ford, Betty, 389–390
Ford, Charles Henri, 155, 164, 176–177
Ford, Jack, 389–390
Forth, Jane, 318, 329, 339, 340
Fortune, 73
Foster, Jodie, 458
Foxe, Cyrinda, 396
Foye, Raymond, 438–439
Francine, Francis, 285–286
Frankfurt, Suzi, 130–134, 156, 196, 339, 352, 357–358, 363, 365, 394, 426, 437, 438, 444, 467, 472, 491
Fraser, Robert, 224, 269
Fredericks, Tina, 72, 80, 87, 129
Fremont, Vincent, 323–324, 337, 358, 360, 362, 371, 373–375, 376–377, 380–381, 384, 388, 394, 396–397, 404–405, 408, 411, 413, 414, 419, 420, 423–424, 425, 426, 430–431, 447, 457–458, 460–461, 462, 463, 466, 473, 481, 489, 491, 493
Freud, Sigmund, 41, 451
Friendly, Fred, 481
Fries, Tony de, 345
Fuck, see *Blue Movie*

Galeria Fernando Vijande, 456–457
Gallerie D, 407
Garland, Judy, 86, 226
Gary Moore Show, The, 11
Gay, Jan, 83, 85
Geldzahler, Henry, 138–140, 146, 147, 148, 155, 156, 160, 167, 169, 171, 176, 188, 198, 200, 203–204, 205, 206–207, 209–210, 220, 222, 228, 234, 238, 256, 262, 294, 356, 431–432, 450, 460–461, 462
'German National Monuments' paintings, 442, 455
Gershwin, George, 451
Giallo, Vito, 112–115, 117–118, 157, 415, 443, 483
Gierke, Christopher, 423
Gino, 226
Ginsberg, Allen, 192, 198, 211, 224, 246, 274, 276, 278, 280
Giordano, Joseph, 133
Giorno, John, 171, 174–178, 179, 186, 190, 204, 336, 337
Girman, Margie, 33–35, 41, 54, 222
Girodias, Maurice, 273, 305, 320
Glamour, 72, 80, 82–83
'Glass – Handle with Care', 150, 156
Gluck, Nathan, 100, 112, 113, 118, 123, 133, 134, 138, 145, 151, 152, 156, 164, 181, 199
Goddard, Paulette, 364, 367, 382, 384, 385, 432
Gold Book, The, 127–128
'Gold Marilyn', 152, 156, 336
'Gold Pictures', 127
Goldman, Albert, 66–68, 422–423
Gordon, Edward, 374
Gottlieb, Adolph, 155

Gould, Jon, 443–445, 465, 467–468
Graffiti, 449–450
Graham, Bill, 251
Graham, Martha, 67, 103, 388
'Green Disaster Twice', 170
Green Gallery, the, 139
Green, Richard, 263–264, 267
Green, Sam, 233, 324
Greenberger, Harold, 35, 75
Greene, Bert, 109, 110, 153–154
Greer, Germaine, 340
Grenfeldt, Natasha, 456
Grimes, Tammy, 124
Groell, Joseph, 83, 88
Groh, Alan, 150, 153, 158, 198, 200
Grooms, Red, 139
Grosset & Dunlap, 428–429
Grossman, Albert, 228, 253
Grosz, George, 75
Guest, C. Z., 445
Guest, Cornelia, 445
Guinness, Catherine, 381, 401–403, 405, 410, 412, 414, 416, 420, 422, 433–434, 437, 476
Gun paintings, 388, 453–454, 456–457
'Guns, Knives and Crosses', 456–457
Gustaf, King of Sweden, 414
Guston, Philip, 155
Gymnasium, the (club), 266
Gysin, Brion, 174

Hackett, Pat, 101, 358–359, 367, 377, 390, 396–397, 404, 428, 437
Hahnhardt, John, 481
Haircut, 190
Hailey, Peter, 489
Hall, Jerry, 402, 493
Hallowell, John, 322–323
Halston, 378–379, 382, 383, 388, 403, 417, 419, 420, 428–429, 444
Hamill, Dorothy, 411
'Hammer and Sickle' paintings, 400, 407–408
'Hand Painted Images', 482
Hansa Gallery, the, 139
Haring, Keith, 449–450, 451, 463–464
Harlot, 212–213
Harper's Bazaar, 82, 100, 133
Harrington, Kate, 473
Harrington, Patch, 105
Harrison, Ken, 419
Harry, Debbie, 413, 432, 456
Hartford, Huntington III, 282
Harvey, James, 198
Haslam, Nicholas, 483
Hatfield, Hurd, 86–87
Hayes, Edward, 489–493
Hayes, Robert, 447, 467, 485
Hayward, Brooke, 178, 182, 378, 432
Heat, 354, 359, 361
Hedy, 244
Hefner, Hugh, 452

527

Heidie, Robert, 126, 144, 195, 225, 226, 229, 235–236, 237–238, 240, 243, 313, 332
Heintici, Alexander, 379
Heliczer, Kate, 203
Heliczer, Piero, 203, 243
Herko, Freddie, 191, 192–193, 197, 208–209, 214, 227, 236
High Spot, the, 55
High Times, 424–425, 427
Hockney, David, 340, 385, 441
Hoffman, Abbie, 276, 278
Hoffman, Susan, *see* Viva
Holt, Calvin, 105, 123
Holzer, Baby Jane, 194, 202, 203, 219, 222, 324, 444
Hompertz, Tom, 285
Hood, Ed, 231–232
Hopper, Dennis, 149, 178, 181, 182
Hopps, Walter, 154
Horne's, Joseph, department store, 71, 72
Hornick, Lita, 378–379, 433
Horse, 218
Howard-Howard, Margo, 332
Hoyveda, Fereydoun, Iranian ambassador, 384
Hoyveda, Gisela, 384
Hudson Theater, 271
Hughes, Francis, 93
Hughes, Frederick W., 280–282, 286, 287, 290, 292–293, 296, 297–303, 305, 308, 313, 319, 328, 329, 331, 335, 337, 338–340, 341, 346, 347, 356, 357–358, 359, 362, 364–365, 366, 370, 371, 372–375, 376–378, 380–381, 384–386, 390, 392–394, 396, 398, 399, 401, 404–405, 407, 409, 411, 413, 414, 416, 425–426, 428, 429, 430, 434, 438, 447, 453–454, 456, 457, 458, 462, 471–472, 478, 480, 481, 484, 489–494
Hugo, Victor, 382–383, 417–419, 424, 428, 444, 447, 461, 476, 486
Hujar, Peter, 408
Huston, Anjelica, 402
Hyatt, Mrs, 62
Hyde, Russell (Papa), 61, 63–64

I, A Man, 271–273
Imitation of Christ, 265, 284, 318
Indiana, Robert, 139, 150, 154–155, 162–163, 167, 169, 190, 197, 198
Ingrassia, Anthony, 344
Institute of Contemporary Art, Los Angeles, 452
Institute of Contemporary Art, Philadelphia (ICA), 233–234
Internal Revenue Service, 127, 336, 358, 380, 399
International Velvet, 254, 260–261, 262, 268, 284, 304
Interview, see *Andy Warhol's Interview*

Iolas, Alexandre, 99, 119, 339, 378, 391, 447, 484

Jabar, Kareem Abdul, 411
Jackson, Martha, 139, 140
Jagger, Bianca, 346, 369, 378, 382–383, 388–390, 403, 407–408, 420, 428, 477
Jagger, Jade, 369, 388
Jagger, Mick, 346, 369, 388, 402, 403, 432, 493
Jane Eyre Bear, 282
Janis, Sidney (gallery), 140, 154–155
Janowitz, Tama, 475, 481
Joey, 286–287
Johns, Jasper, 128–129, 131, 134, 136, 139, 147, 162, 174, 199, 281, 321, 384, 393, 449
Johnson, Don, 444
Johnson, Jay, 290, 351, 385, 420, 425–426
Johnson, Jed, 290, 297, 299–303, 310, 317, 323, 330, 331, 334, 339, 340, 341, 346, 351–352, 354, 362, 363, 364–365, 366–369, 371, 373, 377, 385, 389, 390, 392–395, 396–397, 398, 405–406, 417, 420, 425–426, 437–439, 457, 472
Johnson, Lady Bird, 222
Johnson, Philip, 156, 197–198, 336
Johnson, Ray, 145, 155
Johnson, Susan, 368, 369, 420
Jones, Brian, 269, 273
Jones, Grace, 475
Jordan, Donna, 339
Judson Gallery, the, 139

Kafka, Franz, 451
Kanrich, Dorothy, 67
Karageorge, Lee, 52–53
Karina, Anna, 368
Karp, Ivan, 136–138, 140–141, 149, 155, 157, 166, 210, 248, 302, 378, 408, 421
Kaufman, Corkie, 67
Kay, Aaron, 425
Kennedy Assassination, The, 262
Kennedy assassination prints: 'Flash – November 23, 1963', 292
Kennedy, Caroline, 392
Kennedy, Jackie, 186, 343 *see also* Onassis
Kennedy, Patricia Lawford, 373
Kent, Rosemary, 370
Kessler, Leonard, 65, 67, 77, 84, 101–103, 110, 135
Kettle of Fish, the, 235–236
Kier, Udo, 366–368
King, Perry, 396
Kiss, 190, 194
Kissinger, Nancy, 389
Kitchen, 225–227, 355
Klauber, George, 65, 68, 71, 73, 76, 80, 81, 83, 85, 87, 89, 90, 93–95, 99, 101, 102, 103, 109, 110, 153–154, 197
Klee, Paul, 69, 72

Kligman, Ruth, 161–163, 177, 178, 180, 197, 402
Kline, Franz, 79, 162
Kooning, Willem de, (Bill), 79, 128, 155, 162, 320
Koshinskie, Carol, 212
Kramer, Joan, 72–73
Kramer, Larry, 441

'Ladies and Gentlemen' (Drag queen portraits), 388, 391
Ladies' Home Journal, 100
Lagerfeld, Karl, 339
La Mama Theater, 344
Lambton, Lady Ann, 381, 390–392
Lambton, Lady Isabella, 381
Lambton, Lady Rose, 381
Lanchester, Lillian (Kiki), 34–35, 38, 42
Landmark Films, 374
'Last Supper, The', 480, 482, 484–485
Latow, Muriel, 143, 144
'Lavender Disaster', 170
Lawrence, Jacob, 410–411
Leary, Timothy, 276, 278
Lebowitz, Fran, 371
Leisser Prize, 64
Leland, Ken, 486–488
Lenin portraits, 482
Lennon, John, 348–349
Leory, 76
Lepper, Robert, 61, 70–71, 75
Levine, Naomi, 180–181, 183–184, 190, 194, 203, 219, 222
Li, Linda, 465, 486
Lichtenstein, Roy, 128, 137, 138, 139, 141, 143, 155, 167, 168, 170, 197, 199, 234, 384, 393, 411
Lichtenstein, Stuart, 326
Life, 124–125
Life of Juanita Castro, The, 217–218
Limon, José, 67
Linich, Billy, 191–193, 194, 198–200, 202, 204, 206, 212, 222, 229, 238–239, 243, 257, 258, 259, 260, 267, 268, 275–276, 278, 281, 282–283, 290, 291–292, 298–301, 305, 306, 310, 315, 318–320, 327–238
Lisanby, Charles, 11–14, 115–116, 119, 121–123, 125, 134, 156–157, 168, 196
Liston, Sonny, 337
Littman, Marguerite, 199
Litvinoff, Sy, 244, 296
Liu, Benjamin, 383, 444–445, 461, 462, 463, 467–468, 471, 472, 474, 477
'Lobster' paintings, 453
Loft Gallery, the, 112, 113
Lommel, Ulli, 423
Lonesome Cowboys, 285–288, 292, 322
Loud, Michelle, 472, 483
Love Boat, The, 466
Love, Gael, 473
Love is a Pink Cake, 94

Loves of Ondine, 265
Love You Live, 402
Lyons, Donald, 243

Maas, Willard, 279–280
Madonna, 475
Magnuson, Ann, 463
Mailer, Norman, 225
Makos, Christopher, 380, 413, 440–445, 456–457, 463, 465, 466, 467, 471, 473, 477, 478, 480, 483, 484
Malanga, Gerard, 164–165, 170–171, 175, 176–177, 179–181, 183–185, 189, 190, 192, 195, 198, 200, 203, 204, 205, 206–207, 209, 210, 212, 217, 218–219, 220–221, 223–225, 229, 231, 232–234, 237–252, 253, 254, 256, 257–258, 259, 261–263, 268, 269, 274–276, 277, 279–280, 281, 285–286, 290, 300, 302, 304, 306, 310, 315, 317, 325–326, 329, 339–340, 345–346, 350, 370, 483
Mann, David, 99, 100, 119–120, 124, 125, 129, 131, 140, 159
Mapplethorpe, Robert, 483–484
Marcos, Ferdinand, 411, 445–446
Marcos, Imelda, 386–387, 411, 445–446
Maria, Walter de, 147
Marisol, 150, 155, 161–163, 190
Markoupolous, Gregory, 211
'Martinson's Coffee Cans', 150
Marx Brothers, the, 451
Marx, Dr, 428, 435, 455
Mass, Steve, 420
Matisse, Henri, 14, 72
Maura, Maury, 271
Max's Kansas City, 258–259, 270, 278–279, 280, 313, 325, 326, 330, 345, 348, 360, 388
Mayor, the, 192
Mead, Taylor, 149, 179–183, 189, 199, 200, 203, 208, 253, 269, 270, 282–283, 284, 285–287, 292–295, 302, 324, 370, 452
Meir, Golda, 432, 451
Mekas, Jonas, 190–191, 204, 206–207, 211, 218, 219, 227, 243, 247, 255, 256, 258, 284, 330
Mellon, Andrew, 21
Mencken, Marie, 189, 256
Menil, Dominique de, 281–282, 337, 457
Menil, John de, 281–182, 384, 400, 457
Metropolitan Museum, 138, 222
Metz, Catherine, 35
Michaels, Duane, 18
Michaels, Lorne, 431
Mick Jagger portrait series, 388
Mickey Mouse, 452
Midgette, Allen, 266–267, 268, 276, 285, 291
Midnight Cowboy, 309
Miles, Sylvia, 354, 359
Miller, Fritzie, 100
Miller, Geri, 328–329

Miller, I., 117–118, 131
Mine Shaft, the (club), 441
Minnelli, Liza, 382–383, 391, 403, 428, 432, 434
Modern Language Association Award, 387
Mole people, the, 192–195, 200, 267, 319
'Mona Lisa' paintings, 166, 435
Monroe, Marilyn, 151–152, 155, 157, 169, 200, 282, 343, 390, 430, 435
Montauk, 354, 388, 398, 422–423, 444
Montez, Mario, 212–213
Moore, Gene, 118, 128, 129, 142
Morera, Daniella, 325, 364, 367, 368, 371, 380, 383, 385, 388, 391, 409, 426, 438, 441, 444, 462–463, 467, 472, 484–485, 490
Morris, Robert, 451
Morrison, Sterling, 240, 250, see also Velvet Underground
Morrissey, Paul, 231–232, 239–247, 250–251, 254–257, 259, 260, 267, 268, 269, 270, 271, 273, 274–276, 278, 282, 284, 285–290, 292–294, 296, 297, 298–300, 302, 305, 308–309, 311, 313–317, 319, 322–333, 334, 339, 340, 341–342, 349, 354, 359, 360, 361, 366–369, 373–374, 382, 387, 459
Mothers of Invention, the, 250
Motherwell, Robert, 155
Moynihan, Maura, 439, 456
Mr Chow's, 469, 481
Mr Clean, 192
Mudd Club, the, 420–421
Munch, Edvard, 480
Museum of American Folk Art, 416
Museum of Modern Art, 72, 120, 128, 135, 156
Museum of Natural History, 458
Myerberg, Michael, 240, 246
My Hustler, 231–232, 249, 253, 271

McCall's, 100
McCartney, Paul, 269–270
McClure, Michael, 263
McDermott, John, 232
McDougal, Alan Ross (Dougie), 93, 126
McKendry, Maxine, 367
McKibbin, Mary Adeline, 53
MacLise, Angus, 300
MacLise, Hettie, 300
McLuhan, Marshall, 248

Name, Billy, see Linich, Billy
National Gallery, Berlin, 455
National Organization for Women (NOW), 307
NBC TV, 88
Neel, Alice, 311
Neiman, Leroy, 452
Nell's, 475
Neo-expressionism, 449
Neuwirth, Bobby, 228–229, 235
New Directions, 88, 130

'New Portraits', 462
New York Academy of Art, 487
New York Hospital, 487–488
New York Times, the, 283
Newell, Jimmy, 53
Newman, Barnett, 79
Niarchos, Philip, 365, 407
Nicholson, Ivy, 260, 265, 270–271, 272–273, 302, 304
Nicholson, Jack, 402
Nicklaus, Jack, 411
Nico, 240–244, 246–248, 250–252, 254, 256, 257, 261, 263, 270, 273, 276, 282, 284, 304
Nixon, Richard, 358
Noel, Terry, 279
'Nosepicker', 75
Nothing Special, 430–431
Nude Restaurant, 272, 273, 288
Nureyev, Rudolf, 226, 385

Oakland Museum, 178
O'Brien, Glenn, 346, 349, 421
O'Grady, Panna, 235
O'Hara, Frank, 156
O'Higgins, Patrick, 124
Oldenburg, Claes, 138, 139, 142, 155, 168, 170, 178, 182, 199, 384
Oldenburg, Patti, 142, 147–148, 161, 178, 182
Onassis, Jacqueline, 346, 392, see also Kennedy
Ondine, 192–193, 195, 196, 200–201, 202, 204, 209, 214, 218, 225, 228, 229, 230–231, 232, 237, 239, 245–246, 254, 255–256, 258, 259, 260, 262, 265, 266, 268, 270, 275–276, 281, 309, 310, 318–319, 328
'200 One Dollar Bills', 482
Ono, Yoko, 348–349
Other Voices, Other Rooms, 73
Outlines, the (film club), 67
'Oxidation' paintings, 417, 419
Oz defence fund, 340

Page, Rona, 255, 280
Pahlavi, Princess Ashraf, 384, 398–399, 427
Palance, Jack, 423
Palazzo, Peter, 117
Pallenberg, Anita, 269
Palmer, John, 206–207
Paramount Pictures, 444–445
Park East, 99
Parsons, Betty, 79
Pearlstein, Dorothy (née Kantor), 65, 69, 85, 95, 110
Pearlstein, Philip, 65, 67, 69, 70, 71, 72, 75–76, 77, 78–85, 95, 110, 119
Pele, 411, 413
Peltin, Dona, 446
Persky, Lester, 219, 268
Phillips, John, 373, 387, 388

Phillips, Michelle, 373
Picasso, 72, 123, 224
Picasso, Paloma, 339, 407
'Piss' paintings *see* 'Oxidation'
Pittsburgh Associated Artists, 75, 76
Pivar, Stuart, 439–440, 486–487
Playboy, 452
Podber, Dorothy, 194, 200–201, 282
Poetry on Film, 325
Polanski, Roman, 366–367, 402
Polaroids of genitals, 321, 418
Police raids, 264
Polk, Brigid, 193–194, 205, 219, 232, 254, 256, 262, 265, 266, 270, 273, 284, 289, 306, 321, 325, 332, 335, 339, 344, 347, 354, 357, 362, 382, 390, 396, 401, 431, 433, 462, 473, 486, 493
Pollock, Jackson, 79, 162, 402
Ponti, Carlo, 366, 373–374
Poons, Larry, 147
Poor Little Rich Girl, 221, 254
Pop art, 128, 130, 135, 140, 142, 145, 148, 149–150, 152, 154–160, 162, 166, 168–169, 171, 174, 178, 181, 185, 189, 199, 210–211, 223–224, 234, 249, 273, 284
Popular Culture Association, 387
Porter, Fairfield, 112
Portrait of Julia (his mother), 363
'Portraits of the Seventies', 432–433
Powell, Paige, 469, 474, 475, 478, 487, 493, 494
Preksta, Justina (Tinka), 17, 35, 45
Preksta, Mary (aunt), 17, 25, 26, 35, 43, 45, 107
Presley, Elvis, 124, 151, 165–166, 175, 178, 181–182, 229
Prima, Diane di, 194
PS 1, 450, 463
'Purple Jumping Man', 170

Race riots paintings, 390
Radgi, Parviz, 398
Radziwill, Lee, 346, 381, 384
Rauschenberg, Robert, 129, 131, 134, 135, 139, 147, 150, 166 (portraits of), 174, 197, 281, 358, 411, 455, 458
Ray, Man, 150
Readio, Wilfrid, 61, 64, 70, 75
Reagan, Doria, 446
Reagan, Nancy, 446, 447
Reagan, Ronald, 445–446
Recherche du Shoe *Perdu, A la*, 118
'Red Elvis', 166
Reed, Lou, 240, 241–242, 248, 250, 251, 257, 259, 266, 270, 305, 322, 324, 328, 345, 402, 427, *see also* Velvet Underground
Reese, Arthur, 74
Regan, Grace (née Hirt), 65, 82
Regan, Jack, 65, 69, 82
Reilly, Victor, 85

Religious paintings, 480, 484–485
Restany, Pierre, 484
'Retrospectives', 435
'Reversals', 435
Rhodes, Nick, 475
Ricard, René, 225, 234, 260, 265, 404
Riefenstahl, Leni, 388
Rivers, Larry, 155
Robert Miller Gallery, 482–484
Rochas, Hélène, 393
Rock Stars' Funeral, the, 421
Rod la Rod, 267–168, 270, 276
Rolling Stones, the, 346, 402
Rosado, Wilfredo, 473–474, 476–477, 478–479, 486, 494
Rose, Barbara, 257, 305, 308, 324
Rosenberg, Sam, 62–63, 71
Rosenquist, James, 138, 139, 143, 145, 154–155, 199, 222
Rossellini, Franco, 367, 369
Rossi, Dr Giuseppe, 301–302
Rothchild, Charlie, 250, 253
Rothko, Mark, 79, 155, 162–163
Rothschild, Eric, 339, 385, 393
Rotten Rita, 192
Roundhouse, the, 344
Rubell, Steve, 402–403, 428, 433, 475
Rubin, Barbara, 240, 243, 246, 257
Rubinstein, Helena, 124
Rutledge, Dick, 126
Ryan, D. D., 124–125

'S & H Green Stamps', 150
Saatchi brothers, 428
St John Stevas, Norman, 342
St Laurent, Yves, 339, 378, 393, 405, 432, 474
Salle, David, 449, 464
Samaras, Lucas, 139, 147–148
Sammy the Italian, 282–283
Sanctuary (club), 346
San Diego Surf, 292–295
San Francisco Film Festival Award, 322
Satoh, Koshnin, 486
'Saturday's Popeye', 458
Savalas, Telly, 430
Scharf, Kenny, 449, 450, 464, 470
Schenley High School, 51–56, 493
Schippenburg, Mr, 110, 127
Schlumberger, Sao, 408
Schmertz, Gretchen, 60–61, 62, 65, 67
Schmidt, Gladys, 60
Schnabel, Julian, 449, 464, 470
Scholastic, 50–51
Schraeger, Ian, 402, 433
Schwarzenegger, Arnold, 410–411, 475
Screen Actors' Guild, 397
Screen Test #1, 216–217
Screen Test #2, 212, 213, 355
Scull, Ethel, 142, 166–167, 185, 198, 199
Scull, Robert, 128, 142, 166–167, 185, 198, 199

SCUM Manifesto, 272, 320
Seaver, Tom, 411, 413, 414
Sedgwick, Edie (Edith Minturn), 219–236,
 240, 243, 244–245, 253, 260, 261, 273,
 280, 309, 354, 382
Segal, George, 128, 139
Segovia, Andrés, 268
Seitz, William, 156
Selz, Peter, 156
Serbin, Mina, 33, 53–55, 57, 76
Serendipity, 104–105, 118–119, 123, 185
Sesnick, Steve, 270
Seventeen, 81
'Sex Parts' paintings, 417, 418–419
Shadow, the, 57
'Shadow, The' (self-portrait), 452
'Shadows' paintings, 427–428, 435
Shaffer, Bill, 55–56
Shafrazi, Tony, 450, 455, 469
Shah of Iran, 384, 389, 398–399, 411, 427,
 428
Shahn, Ben, 69, 70, 72
Shand, Mark, 392
Shoemaker, Willi, 411
Shriver, Maria, 475
Sica, Vittorio de, 367
'Silver Pillows', 249
Simon, Ellie, 54, 55, 60–61, 62, 63, 65, 84
Simpson, O. J., 411
Sims, Patterson, 145
Sinatra, Frank, 55
'Six Painters and the Object' Exhibition,
 178
Sklar, Michael, 339
'Skulls' paintings, 400, 428
Slaves of New York, 481
Sleep, 108, 177–178, 189–191
Smith, Foo Foo, 313
Smith, Geraldine, 309, 318, 323, 328–329,
 360, 396
Smith, Jack, 212
Smith, Maria, 396
Smith, Rupert, 377, 380–381, 418
Snow, Carmel, 82
Snowdon, Lord, 432
Society for Cutting Up Men, the (SCUM),
 272, 290
SoHo Gallery, 449
Solanas, Valerie, 272–273, 280, 290–291,
 294, 296–299, 305, 307–308, 311, 320,
 324, 331, 356, 437, 453
Sonnabend Gallery, the, 171–172, 223
Sonnabend, Ileana, 171, 223, 378
Sonnier, Keith, 451
Sontag, Susan, 384
Spelling, Erica, 481
Spencer, Joe, 276
Spender, Stephen, 398
Sperone Westwater Gallery, 450
Sprouse, Stephen, 475, 478–479
Stable Gallery, the, 139, 140, 150, 153,
 155–156, 166, 198–200

Stage 54 (bar), 347
Stallone, Sylvester, 432
'Statue of Liberty' paintings, 478
Steding, Walter, 409–410, 414, 416–419,
 421, 425, 434, 438, 447, 450, 462
Stein, Gertrude, 451
Stella, Frank, 128, 138, 139, 305, 384
Stern, Rudi, 246
Stettheimer, Florine, 138
Sticky Fingers, 346
Stigwood, Robert, 396–397
'Still Lives' see Hammer & Sickle
Sting, 475
Studio 54, 402–404, 406, 408–409, 411, 415,
 417, 418, 420–421, 422, 424, 428, 433
'Studio 54 drink ticket' paintings, 427
Stutz, Geraldine, 117
Sugar Plum Fairy, the, 192, 237, 345
Suicide, 214–215
'Suicides' paintings, 188, 336, 390
Sullivan, Tom, 422–424
Superman, 452
Superstar, 316
Superstar, Ingrid, 235, 237, 254, 256, 261,
 293–294, 302, 486
Surfing Movie, The, see San Diego Surf
Sutner, Ladislav, 82
Swenson, Gene, 155, 158, 167, 169, 173,
 185–186

Take It Easel Club, 77
Talking Heads, 402
Tambourlaine (club), 346
Tamplon, Daniel, 455
Tanager Gallery, the, 119, 139
Tarzan and Jane, Regained Sort of, 183–184,
 189
Tavel, Ronald, 212–215, 216–219, 225–228,
 235, 239, 254, 259–260, 282, 355, 371
Taylor, Elizabeth, 57, 178, 181–182, 369,
 398, 403–404, 420
Taylor Mead's Ass, 208
Taylor, Paul, 103, 495
Temple, Shirley, 41, 73, 389
'Ten Portraits of Jews of the 20th Century',
 451–452
'That Was the Week That Was', 186
Theater Arts, 73, 87
Theater 12 Group, 109–110
Theatre of the Ridiculous, 212, 344
there was snow in the street, 94
'Thirteen Most Wanted Men, The'
 (mural), 197–198, 209, 379
Tilden, Patrick, 266, 276, 282, 284
Time, 148
Tinguely, Jean, 154–155
Toilet, the (club), 441
Tornberg, Jeffrey, 397
'Torsos' paintings, 417, 418–419, 428
Toulouse-Lautrec, 137
Trader Vic's, 276, 424
Trash, 272, 328–331, 334, 340, 359

532

Tremaine, Burton & Emily, 155
Trip, the (club), 250
'Triple Elvis', 458
Trudeau, Margaret, 386, 387, 422–423
Trudeau, Roger, 225
Truth Game, The, 322–323
Tucker, Maureen, 240, see also Velvet Underground
Tunnel, the (club), 486
Turner, Lana, 466
24 Hour Movie, 266, 271, 276, 278, 284
Twiggs, Lorene, 62, 63
Twiggs, Russell, 63
Twombly, Cy, 150, 455, 470
Tyrell, Susan, 396

Ultra Violet, 50, 221, 238, 266, 274, 276, 288, 302–303, 309, 325, 418
'Uncle Sam', 452
Up Against the Wall Motherfuckers, the, 307–308
UpJohn Pharmaceuticals, 81
Up Your Ass, 272, 291

Valaja, Aarston, 486
Valerie, 114, 117
Van Vooren, Monique, 367, 373
Vanity Fair, 11
Vaughn, Imelda, 109, 157
Velvet Underground, the, 240–244, 246–248, 250–252, 253, 257, 266, 269–270, 284, 300, 328, 345, 391, 421
Velvet Underground and Nico, the, (album), 266, 284
Venice Film Festival, 359
Venus in Furs, 243
'Vertical Orange Car Crash', 170
Vibrations, 265–266
Vickermann, Annie, 49
Vidal, Gore, 264, 369
Vinyl, 218–219
Viva, 273–274, 278, 280, 283, 285, 287–289, 292–294, 297–298, 300–304, 306, 307, 309, 311, 314–316, 317, 326
Vivian's Girls, 430.
Vogue, 100
Vollmer, Larry, 71–72, 73
von Furstenberg, Diane, 373, 378
Von Scheflin, Ingrid, see Superstar, Ingrid
'Vote McGovern' paintings, 358
Vreeland, Diana, 364, 377, 382, 384, 394, 403, 420, 432

Waite, Genevieve, 373, 387
Waldon, Louis, 284, 285, 288–289, 292–293, 294, 302, 304, 314–315, 348
Wallowitch, Ed, 126–128, 130, 131, 132, 157, 225
Wallowitch, John, 125–128, 130
Walton, Tony, 124
Ward, Elinor, 140, 150, 153, 155–156, 161, 171, 177, 189, 199–200, 281

Ward, Ralph Thomas (Corkie), 93–95, 96, 109, 126
Warhol, Andy:
America, 56, 57–58, 476, 478
Andy Warhol Books, 428–429
Andy Warhol Enterprises, 127, 280, 290, 323, 336, 370, 373–374, 376–378, 425, 447, 457, 462, 490
Andy Warhol's Exposures, 428–429, 440
Andy Warhol Foundation for the Visual Arts, 490
Andy Warhol's Index Book, 284
Andy Warhol's Interview, 370–371, 374, 376–378, 383, 384, 388, 389–390, 399, 401–404, 409, 419, 420, 421, 426–427, 428, 429, 431, 433, 434, 445, 446, 447, 458, 473, 474, 482, 490, 494
Andy Warhol Story, The, 260
Andy Warhol's Theater: Boys to Adore Galore (male porno films), 325–326
Andy Warhol's TV (cable TV show), 431–432, 481
Andy Warhol's Up (disco), 240, 241, 243
Andy Warhol Uptight, 244, 245–246
Assassination attempt, 296–312
Bauhaus influence, 66, 70, 119
Blotted-line drawing technique, 70, 73, 80, 87, 88, 94, 113, 124
Book illustrations, 70–71, 76, 88, 89, 94, 99
Business art projects, 411
Chiropractors, 465
Collecting, 123, 338–339, 348, 393–395, 415–416, 439–440
Dermatologist, 465, 486
Drella – Warhol's Factory nickname, 200
Earhol record label, 410
Exercise, 441, 465
Marbled-paper sculptures, 112
Philosophy of Andy Warhol, The, 37, 38, 56, 134, 390, 392, 407
Photography, 482–484
Popism, 40, 428, 437
Pork (play), 344–345
Portrait commissions, 254, 281–282, 310, 337, 367, 377, 378–380, 388, 397, 398–400, 403, 411, 413–414, 416–417, 427, 430, 436, 481
Real estate, 338, 354, 457–459
Religion, 82, 204, 454–455, 476, 485–485
Repetition, 130, 150–152, 166, 171, 249, 310, 372, 433, 435, 456
Rock videos, 482
Screen 'tests', 203, 229
Self-portraits, 281, 452, 480, 483
Shiatsu massage, 465, 486
Shoe fetishism, 80, 92, 117, 118, 124, 177
Silkscreen technique, 70, 151–152, 164, 169, 186, 189, 372, 375, 377, 379, 388, 400, 427, 435
Slide projection, 135
Superstars, 194, 218, 221, 222, 228, 234–235, 241, 260–261, 266, 269, 270,

273, 275, 280, 281, 283–284, 303, 317–318, 321, 323, 329, 331, 335, 341, 361
Television, 430–432, 458, 466, 481
Warhol Retrospective Exhibition, 334–335, 340, 343
 His works – paintings, prints, films, etc. – are listed under their titles. *See also* Drugs; Exploding Plastic Inevitable; Factory; Film-making
Warhol (photo memoir), 444
Warhola, Ann, 45, 46–47, 53, 352–354, 363
Warhola, Donald (nephew), 477–478
Warhola, George (nephew), 124, 147, 306–307, 352–354, 362–363, 471–472, 473, 477, 480
Warhola, George (uncle), 27
Warhola, James (nephew), 223, 490
Warhola, John (brother), 17, 19, 20, 21–24, 29–48, 52, 53, 59, 63, 69, 76, 77, 96–97, 102, 124, 132, 142, 146, 280, 304–305, 309–310, 314, 324, 330, 338, 350–353, 361–363, 416, 477–478, 482, 490–493
Warhola, Joseph (uncle), 17, 25, 27, 31–32, 43
Warhola, Julia (mother), 15–17, 20, 22–28, 29–48, 52, 54, 59, 75, 76–77, 82, 96–99, 101–108, 114, 118, 121, 123, 124, 126–127, 130–133, 144, 146–147, 157, 164–165, 179, 185, 204, 253, 262–263, 282, 296, 300, 302–304, 306–307, 308, 310, 350–354, 361–363, 432, 477, 480, 491–492, 494
Warhola, Justina, 26–27, 38
Warhola, Marge, 32, 310, 338, 351–353, 363, 416, 482, 492
Warhola, Ondrej (Andrew/Andrei) (father), 15–17, 20, 22–28, 29, 31–32, 38, 39, 41–45, 97, 494
Warhola, Paul (brother), 17, 20, 22–24, 29–48, 62, 63, 64, 69, 75, 77, 82, 96–97, 102, 116, 121, 122, 124, 127, 132, 146, 147, 157, 179, 224, 262, 304, 307, 310, 350–353, 361–363, 380, 425–426, 471, 490–493
Warhola, Paul Jr (nephew), 47, 307, 363
Warhola, Strina (aunt), 31, 46
Warsaw Poster Biennale Prize, 308
Washington Square Gallery, 197
Wein, Chuck, 219–220, 223–226, 231–233, 235, 237
Wesselmann, Tom, 138, 139, 155, 169, 199
West, Mae, 124

'White', 188
White House, the, 389–390, 410–411, 441, 446
White, Miles, 296
Whitman, Robert, 139
Whitney, David, 337
Whitney Museum, 432–433, 481
'Wicked Witch of the West, The', 453
Wilcock, John, 425
'Wild Raspberries', 130–131
Willers, Carl (Alfred Carlton), 105–109, 153, 197
Williams, Danny, 237–238, 243, 252, 257
Williams, Tennessee, 79, 226, 359, 362
Wilson, Jack, 65
Wilson, Tom, 251
Windsor, Duchess of, 389
Winter, Orion de, 194, 267, 275, 276
Wirtschafter, Buddy, 225
Wise, Peter, 444, 445
Wiseman, Richard, 411
Wolfe, Tom, 158
Women in Revolt, 331–333
Women's Wear Daily, 11
Wood, Natalie, 151
Woodlawn, Holly, 318, 329, 330–331, 345
Woodstock, 228, 230
World's Fair, the, 197–198, 209
Worner, Howard, 71, 77
Woronov, Mary, 242, 244–245, 249, 254, 259, 260, 261–262, 263, 274
Wunsche, Herman, 441–442
Wyeth, Andrew, 397–398, 470
Wyeth, Jamie, 397–398, 410, 411, 414

Xenon, 421

Yasmin, Princess Aga Khan, 373
Yerkovich, Anthony, 444
Young, La Monte, 147, 240

Zahedi, Firooz, 398
Zahedi, Iranian ambassador, 389
Zanetta, Anthony, 344–345
Zappa, Frank, 250
Zavacky, Anna, 34, 107
Zavacky, Ella, 26, 27, 35
Zavacky, Eva, 26, 27, 35
Zavacky, Ondrej (grandfather), 16, 25, 26
Zavacky, Ondrej (uncle), 16, 25, 26
Zavacky, Yurko, 27
Zeitgeist, Berlin, 455
Zipkin, Jerome, 124

All Fourth Estate books are available at your local bookshop or newsagent, or can be ordered direct from the publisher.

Indicate the number of copies required and quote the author and title.

Send cheque/eurocheque/postal order (Sterling only), made payable to Book Service by Post, to:

Fourth Estate Books
Book Service By Post
PO Box 29, Douglas
I-O-M, IM99 1BQ.

Or phone: 01624 675137

Or fax: 01624 670923

Or e-mail: bookshop@enterprise.net

Alternatively pay by Access, Visa or Mastercard

Card number: ⬚⬚⬚⬚⬚⬚⬚⬚⬚⬚⬚⬚⬚⬚⬚⬚

Expiry date ..

Signature ..

Post and packing is free in the UK. Overseas customers please allow £1.00 per book for post and packing.

Name ..

Address ..

..

..

Please allow 28 days for delivery. Please tick the box if you do not wish to receive any additional information. ⬚

Prices and availability subject to change without notice.